THE DESIGN HOTELS™ BOOK

Edition 2012
A curated collection of 220 Design Hotels™ worldwide.

AMERICAS

BRAZIL
026 — **BARRA DE SÃO MIGUEL**
KENOA – EXCLUSIVE BEACH SPA & RESORT
028 — **BÚZIOS**
INSÓLITO BOUTIQUE HOTEL
030 — **SÃO PAULO**
HOTEL UNIQUE

CANADA
032 — **MONTREAL**
HOTEL ST. PAUL
034 — **TORONTO**
TEMPLAR HOTEL

COLOMBIA
036 — **BOGOTÁ**
B.O.G. HOTEL

GRENADA
038 — **GRENADA**
LALUNA

JAMAICA
040 — **NEGRIL**
ROCKHOUSE HOTEL

MEXICO
042 — **ACAPULCO**
BOCA CHICA
044 — **BAJA CALIFORNIA**
ENDÉMICO
046 — **MÉRIDA**
ROSAS & XOCOLATE
048 — **MEXICO CITY**
CONDESA*DF*
050 — **MEXICO CITY**
DISTRITO CAPITAL
052 — **MEXICO CITY**
DOWNTOWN
054 — **MEXICO CITY**
HABITA
056 — **MONTERREY**
HABITA MONTERREY
058 — **PLAYA DEL CARMEN**
BE PLAYA
060 — **PLAYA DEL CARMEN**
DESEO [HOTEL + LOUNGE]
062 — **PLAYA DEL CARMEN**
HOTEL BÁSICO
064 — **PUEBLA**
LA PURIFICADORA
066 — **SAN MIGUEL DE ALLENDE**
HOTEL MATILDA
068 — **TULUM**
BE TULUM
070 — **VERACRUZ**
AZÚCAR
072 — **VERACRUZ**
MAISON COUTURIER

PANAMA
074 — **PORTOBELO**
EL OTRO LADO

SAINT BARTHÉLEMY
076 — **SAINT BARTHÉLEMY**
HOTEL LA BANANE

UNITED STATES
078 — **HEALDSBURG**
HOTEL HEALDSBURG
080 — **HOLLYWOOD**
THE STANDARD, HOLLYWOOD
082 — **LOS ANGELES**
THE STANDARD, DOWNTOWN LA
084 — **MIAMI**
THE STANDARD SPA, MIAMI BEACH
086 — **NEW YORK CITY**
CROSBY STREET HOTEL
088 — **NEW YORK CITY**
GRAMERCY PARK HOTEL
090 — **NEW YORK CITY**
HÔTEL AMERICANO
092 — **NEW YORK CITY**
THE STANDARD, NEW YORK

EUROPE

AUSTRIA
096 — **GRAZ**
AUGARTENHOTEL ART & DESIGN
098 — **GRAZ**
HOTEL DANIEL
100 — **KITZBÜHEL**
HOTEL KITZHOF MOUNTAIN DESIGN RESORT
102 — **LANGENLOIS**
LOISIUM WINE & SPA RESORT LANGENLOIS
104 — **SÖLDEN**
BERGLAND HOTEL SÖLDEN
106 — **SOUTHERN STYRIA**
LOISIUM WINE & SPA RESORT SÜDSTEIERMARK
108 — **VIENNA**
25HOURS HOTEL WIEN
110 — **VIENNA**
DAS TRIEST
112 — **VIENNA**
DO & CO HOTEL VIENNA
114 — **VIENNA**
HOTEL LAMÉE
116 — **VIENNA**
HOTEL TOPAZZ
118 — **VIENNA**
THE LEVANTE PARLIAMENT

BELGIUM
120 — **BRUSSELS**
THE DOMINICAN

CROATIA
122 — **ROVINJ**
HOTEL LONE

CYPRUS
124 — **PAPHOS**
ALMYRA

CZECH REPUBLIC
126 — **PRAGUE**
HOTEL JOSEF

FINLAND
128 — **HELSINKI**
KLAUS K

FRANCE
130 — **CANNES**
FIVE HOTEL & SPA
132 — **CORSICA**
CASADELMAR
134 — **GASSIN**
KUBE HOTEL GASSIN
136 — **PARADOU**
HOTEL B DESIGN & SPA
138 — **PARIS**
BEL-AMI
140 — **PARIS**
HOTEL GABRIEL PARIS MARAIS
142 — **PARIS**
HÔTEL SEZZ PARIS
144 — **PARIS**
KUBE HOTEL
146 — **PARIS**
LA MAISON CHAMPS ELYSÉES
148 — **PARIS**
LA RÉSERVE PARIS
150 — **PARIS**
MURANO RESORT
152 — **RAMATUELLE**
LA RÉSERVE RAMATUELLE HOTEL, SPA AND VILLAS
154 — **SAINT-TROPEZ**
HÔTEL SEZZ SAINT-TROPEZ

→

EUROPE

GERMANY
- 156 — **COSMO HOTEL BERLIN MITTE** *Berlin*
- 158 — **DAS STUE** *Berlin*
- 160 — **HOTEL Q!** *Berlin*
- 162 — **THE MANDALA HOTEL** *Berlin*
- 164 — **CERÊS** *Binz*
- 166 — **HOTEL ÜBERFLUSS** *Bremen*
- 168 — **25HOURS HOTEL BY LEVI'S** *Frankfurt*
- 170 — **GERBERMÜHLE** *Frankfurt*
- 172 — **GOLDMAN 25HOURS HOTEL** *Frankfurt*
- 174 — **ROOMERS** *Frankfurt*
- 176 — **ROOMERS LOFT** *Frankfurt*
- 178 — **THE PURE** *Frankfurt*
- 180 — **25HOURS HOTEL HAFENCITY** *Hamburg*
- 182 — **25HOURS HOTEL HAMBURG NO. 1** *Hamburg*
- 184 — **EAST** *Hamburg*
- 186 — **GASTWERK HOTEL HAMBURG** *Hamburg*
- 188 — **SIDE** *Hamburg*
- 190 — **THE GEORGE** *Hamburg*
- 192 — **DIE TRÄUMEREI** *Michelstadt*
- 194 — **CORTIINA HOTEL** *Munich*
- 196 — **LOUIS HOTEL** *Munich*
- 198 — **FACTORY HOTEL** *Munster*
- 200 — **HOTEL BACHMAIR WEISSACH** *Rottach-Egern*
- 202 — **BECKER'S HOTEL & RESTAURANT** *Trier*

GREECE
- 204 — **ATHENS** FRESH HOTEL
- 206 — **ATHENS** NEW HOTEL
- 208 — **ATHENS** PERISCOPE
- 210 — **ATHENS** SEMIRAMIS
- 212 — **HALKIDIKI** EKIES ALL SENSES RESORT
- 214 — **MYKONOS** MYKONOS THEOXENIA
- 216 — **THESSALONIKI** THE MET HOTEL

HUNGARY
- 218 — **BUDAPEST** LÁNCHÍD 19

ICELAND
- 220 — **REYKJAVIK** 101 HOTEL

ITALY
- 222 — **BERGAMO** GOMBITHOTEL
- 224 — **BOLZANO** HOTEL GREIF
- 226 — **CASSAGO BRIANZA** C-HOTEL & SPA
- 228 — **FLORENCE** CONTINENTALE
- 230 — **MATERA** SEXTANTIO LE GROTTE DELLA CIVITA
- 232 — **MILAN** MAISON MOSCHINO
- 234 — **MILAN** STRAF
- 236 — **NAPLES** ROMEO HOTEL
- 238 — **PORTO ERCOLE** ARGENTARIO GOLF RESORT & SPA
- 240 — **RIMINI** DUOMO
- 242 — **ROME** LEON'S PLACE HOTEL IN ROME
- 244 — **SANTO STEFANO DI SESSANIO** SEXTANTIO ALBERGO DIFFUSO
- 246 — **SOUTH TYROL/LANA** VIGILIUS MOUNTAIN RESORT
- 248 — **VENICE** CA' PISANI
- 250 — **VENICE** HOTEL PALAZZO BARBARIGO SUL CANAL GRANDE
- 252 — **VENICE** PALAZZINAG

NORWAY
- 254 — **OSLO** GRIMS GRENKA

PORTUGAL
- 256 — **CASCAIS** FAROL DESIGN HOTEL
- 258 — **LISBON** FONTANA PARK HOTEL
- 260 — **MADEIRA** ESTALAGEM DA PONTA DO SOL
- 262 — **MADEIRA** THE VINE
- 264 — **PORTO** HOTEL TEATRO
- 266 — **SAGRES** MEMMO BALEEIRA

SPAIN
- 268 — **ALICANTE** HOSPES AMÉRIGO
- 270 — **BARCELONA** GRAND HOTEL CENTRAL
- 272 — **BARCELONA** HOTEL CLARIS
- 274 — **BARCELONA** HOTEL GRANADOS 83
- 276 — **BARCELONA** HOTEL OMM
- 278 — **BILBAO** HOTEL MIRÓ
- 280 — **CORDOBA** HOSPES PALACIO DEL BAILÍO
- 282 — **GRANADA** HOSPES PALACIO DE LOS PATOS
- 284 — **GRAN CANARIA** BOHEMIA SUITES & SPA
- 286 — **GRAN CANARIA** SEASIDE PALM BEACH
- 288 — **IBIZA** AGUAS DE IBIZA LIFESTYLE & SPA
- 290 — **IBIZA** OCEAN DRIVE HOTEL
- 292 — **MADRID** HOSPES MADRID
- 294 — **MADRID** HOTEL ÚNICO MADRID
- 296 — **MADRID** HOTEL URBAN
- 298 — **MALLORCA** HOSPES MARICEL
- 300 — **MALLORCA** PURO OASIS URBANO
- 302 — **PUIGCERDÀ** HOSPES VILLA PAULITA
- 304 — **SEVILLA** HOSPES LAS CASAS DEL REY DE BAEZA
- 306 — **VALENCIA** HOSPES PALAU DE LA MAR

SWEDEN
- 308 — **ÅRE** COPPERHILL MOUNTAIN LODGE
- 310 — **GOTHENBURG** AVALON HOTEL
- 312 — **GOTHENBURG** ELITE PLAZA HOTEL
- 314 — **STOCKHOLM** HOTEL J
- 316 — **STOCKHOLM** HOTEL SKEPPSHOLMEN
- 318 — **STOCKHOLM** NOBIS HOTEL
- 320 — **STOCKHOLM** NORDIC LIGHT HOTEL
- 322 — **STOCKHOLM** STALLMÄSTAREGÅRDEN HOTEL & RESTAURANG

SWITZERLAND
- 324 — **ADELBODEN** THE CAMBRIAN
- 326 — **BERN** HOTEL SCHWEIZERHOF BERN
- 328 — **GENEVA** LA RÉSERVE GENÈVE HOTEL AND SPA
- 330 — **LAAX** ROCKSRESORT
- 332 — **LUCERNE** THE HOTEL
- 334 — **SILVAPLANA** NIRA ALPINA
- 336 — **VERBIER** HOTEL NEVAÏ
- 338 — **ZERMATT** CERVO MOUNTAIN BOUTIQUE RESORT
- 340 — **ZERMATT** THE OMNIA
- 342 — **ZURICH** 25HOURS HOTEL ZÜRICH WEST
- 344 — **ZURICH** THE DOLDER GRAND
- 346 — **ZURICH** WIDDER HOTEL

THE NETHERLANDS
- 348 — **AMSTERDAM** CONSERVATORIUM HOTEL AMSTERDAM
- 350 — **MAASTRICHT** KRUISHERENHOTEL MAASTRICHT

TURKEY
- 352 — **ANTALYA** HILLSIDE SU

ISTANBUL
- 354 — **ISTANBUL** BENTLEY HOTEL
- 356 — **ISTANBUL** THE SOFA HOTEL & RESIDENCES
- 358 — **ISTANBUL** WITT ISTANBUL HOTEL

UNITED KINGDOM
- 360 — **CORNWALL** THE SCARLET
- 362 — **LONDON** BLAKES HOTEL
- 364 — **LONDON** BOUNDARY
- 366 — **LONDON** CHARLOTTE STREET HOTEL
- 368 — **LONDON** COVENT GARDEN HOTEL
- 370 — **LONDON** ECCLESTON SQUARE HOTEL
- 372 — **LONDON** HAYMARKET HOTEL
- 374 — **LONDON** KNIGHTSBRIDGE HOTEL
- 376 — **LONDON** NUMBER SIXTEEN
- 378 — **LONDON** SANCTUM SOHO HOTEL
- 380 — **LONDON** THE PELHAM HOTEL
- 382 — **LONDON** THE SOHO HOTEL
- 384 — **LONDON** TOWN HALL HOTEL & APARTMENTS

AFRICA / MIDDLE EAST

ISRAEL
388 — **JERUSALEM**
MAMILLA HOTEL

KENYA
390 — **NAIROBI**
TRIBE HOTEL

MOROCCO
392 — **MARRAKECH**
ANAYELA
394 — **MARRAKECH**
HOTEL LA RENAISSANCE
396 — **MARRAKECH**
THE GREAT GETAWAY
MARRAKECH HOTEL
& SPA

SOUTH AFRICA
398 — **JOHANNESBURG**
TEN BOMPAS

ASIA / PACIFIC / OCEANIA

AUSTRALIA
402 — **BRISBANE**
LIMES HOTEL
404 — **SYDNEY**
QT SYDNEY

CHINA
406 — **HONG KONG**
THE MIRA HONG KONG
408 — **SHANGHAI**
THE PULI HOTEL & SPA
410 — **SHANGHAI**
THE WATERHOUSE
AT SOUTH BUND

INDIA
412 — **BANGALORE**
ALILA BANGALORE
HOTEL & RESIDENCE
414 — **BANGALORE**
THE PARK BANGALORE
416 — **CHENNAI**
THE PARK CHENNAI
418 — **CHENNAI**
THE PARK POD CHENNAI
420 — **GOA**
ALILA DIWA GOA
422 — **GOA**
THE PARK
ON CANDOLIM BEACH
424 — **HYDERABAD**
THE PARK HYDERABAD
426 — **JODHPUR**
RAAS
428 — **KOCHI**
THE PARK KOCHI
430 — **KOLKATA**
THE PARK KOLKATA
432 — **NEW DELHI**
THE PARK NEW DELHI

INDONESIA
434 — **BALI**
ALILA MANGGIS
436 — **BALI**
ALILA UBUD
438 — **BALI**
ALILA VILLAS SOORI
440 — **BALI**
ALILA VILLAS ULUWATU
442 — **BALI**
LUNA2 PRIVATE HOTEL
444 — **BALI**
LUNA2 STUDIOS
446 — **BALI**
THE ELYSIAN BOUTIQUE
VILLA HOTEL
448 — **JAKARTA**
ALILA JAKARTA

JAPAN
450 — **NISEKO - HIRAFU**
KIMAMAYA BOUTIQUE
HOTEL
452 — **TOKYO**
PARK HOTEL TOKYO

LAO PEOPLE'S DEMOCRATIC REPUBLIC
454 — **LUANG PRABANG**
3 NAGAS
456 — **LUANG PRABANG**
HOTEL DE LA PAIX
LUANG PRABANG

NEW ZEALAND
458 — **AUCKLAND**
HOTEL DEBRETT

SINGAPORE
460 — **SINGAPORE**
KLAPSONS, THE
BOUTIQUE HOTEL
462 — **SINGAPORE**
NEW MAJESTIC HOTEL
464 — **SINGAPORE**
WANDERLUST

THAILAND
466 — **KHAO LAK**
CASA DE LA FLORA
468 — **KOH SAMUI**
THE LIBRARY
470 — **PHUKET**
THE SURIN PHUKET

COVER — *Design Hotels™ is proud to collaborate with Chicago-based designer* **JENNY BEORKREM** *on the cover illustration for the Design Hotels™ Book 2012. Jenny has developed her unique graphic view of neighborhoods and communities gaining widespread acclaim throughout the creative world.*
www.orkposters.com

1 + 3 + 4 — *New York City's vibrant street life. Photography by* **TODD RICHARDSON**
www.todd-richardson.com

2 + 5 — *Engaging interiors at* GRAMERCY PARK HOTEL, *which borders New York's only private park. Interior Design by* **JULIAN SCHNABEL**
www.designhotels.com/gramercy_park_hotel

DON'T BUY THE HOUSE, BUY THE NEIGHBORHOOD

Cover Illustration **JENNY BEORKREM**

IF, AS URBAN THEORIST RICHARD FLORIDA RECENTLY NOTED, **CITIES ARE THE NEW COUNTRIES**, THEN WE AT DESIGN HOTELS™ FIRMLY BELIEVE THAT NEIGHBORHOODS ARE THE NEW CITIES. AFTER ALL, LIKE CITIES, NEIGHBORHOODS OFFER THE EXCITEMENT OF BEING IN THE MIDDLE OF **SOMETHING LARGE AND FULL OF ENERGY**. BUT NEIGHBORHOODS HAVE THE ADDED BONUS OF PROVIDING LOCAL FLAVOR AND THE FEELING OF **COMMUNITY**; THUS, FOR THE VISITOR, THEY ALSO CREATE A SENSE OF **IDENTITY AND BELONGING**.

Identity and *belonging*. Those are two words that have been on our minds of late. As we have grown over the past 20 years — representing and curating more than 200 independent properties in over 40 countries around the globe — we've taken heart in the fact that a hotel should be much more than a beacon of creativity and welcome. It should be a member of the community. At times it's a valued partner standing alongside other businesses in a local scene. But at other times it can be a leading figure, helping a neighborhood transform itself as it takes on an exciting new shape and purpose.

But how can some hotels do this, while others can't? The answer determines what is — and what is not — a Design Hotel. When choosing a hotel to be a member of our group, we look for a property that is not only cutting edge in its design, but that also serves as a gateway to experiences locals enjoy — its staff is absorbed in the fabric of the neighborhood, so that what was hot last week isn't offered up to guests this week. Our hotels are meeting places for creative folks or business leaders looking for inspiration or like-minded company. And they certainly do not adhere to any formulas. Authenticity, challenge, surprise — these are the attributes of an interesting city and an interesting neighborhood. And, more and more, they're what we are looking for in properties that are hoping to become Design Hotels™. So it is with much excitement that we present here some of our newest member hotels. If you haven't already heard about them, trust us, you will soon — from friends, from fellow travelers, and from folks in and around the neighborhoods they are defining.

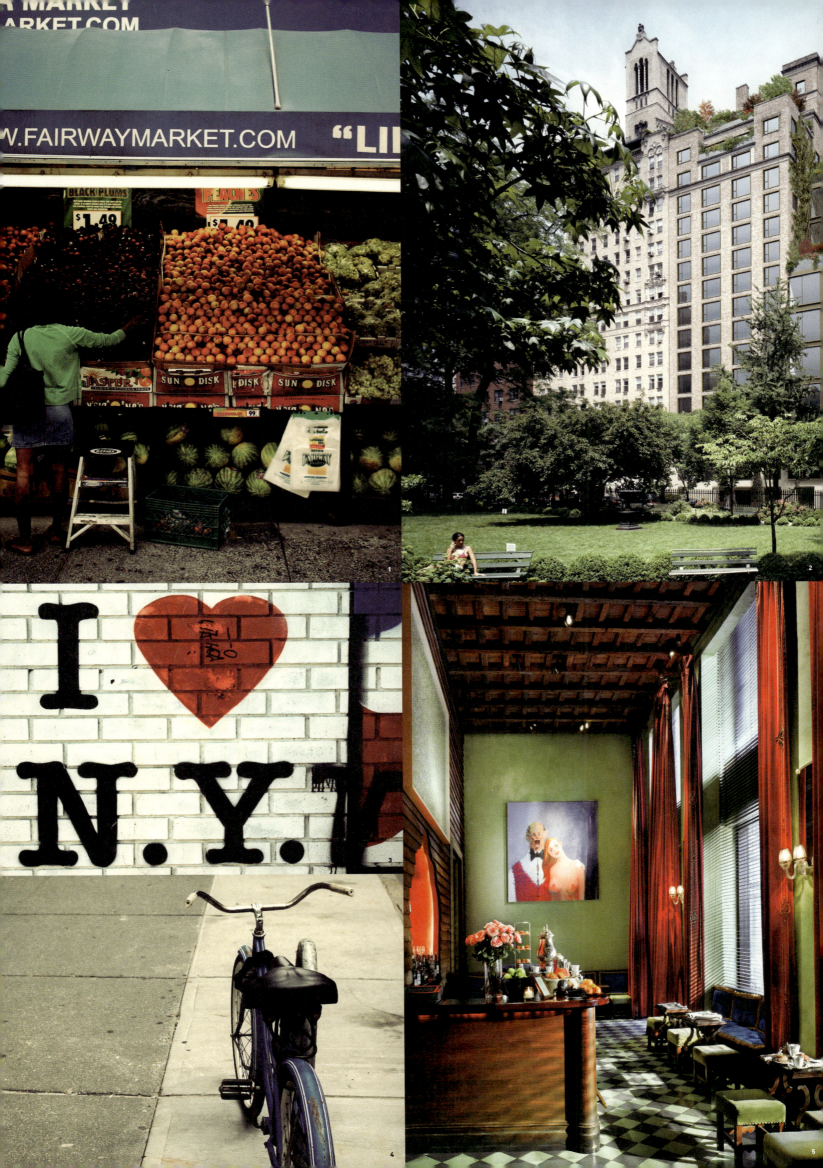

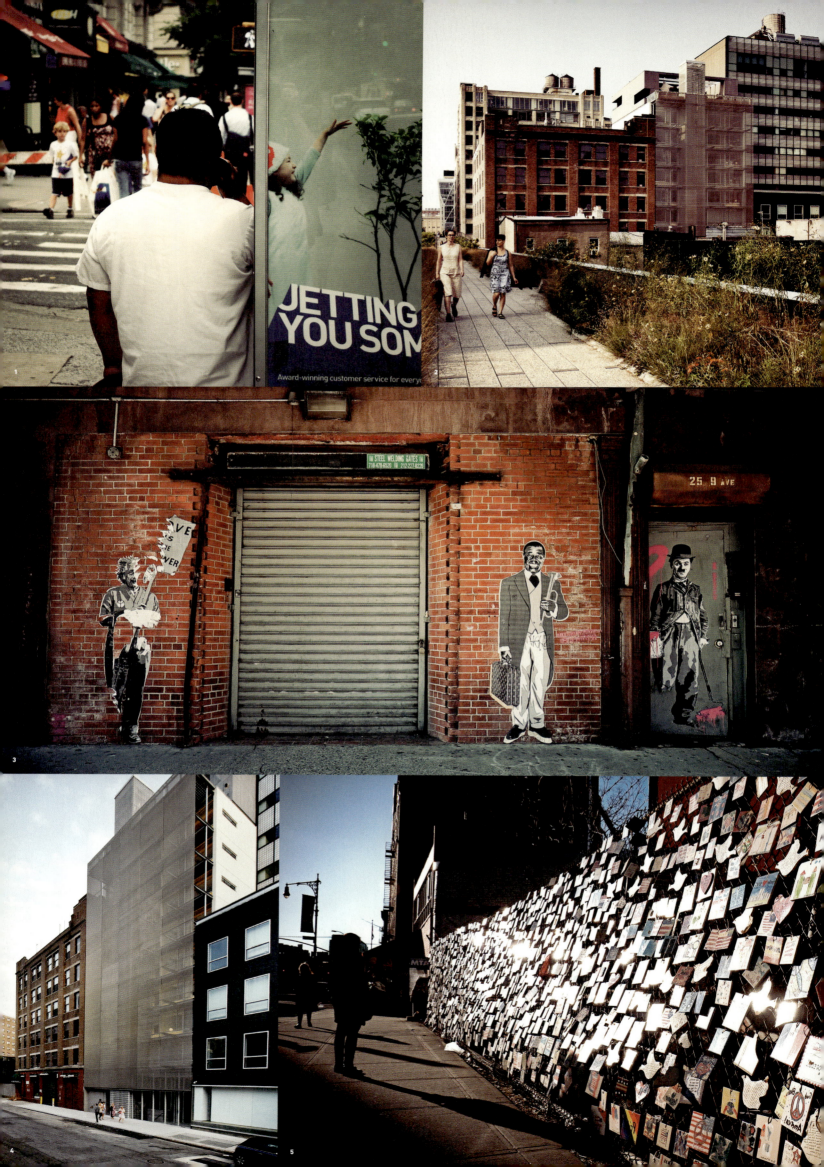

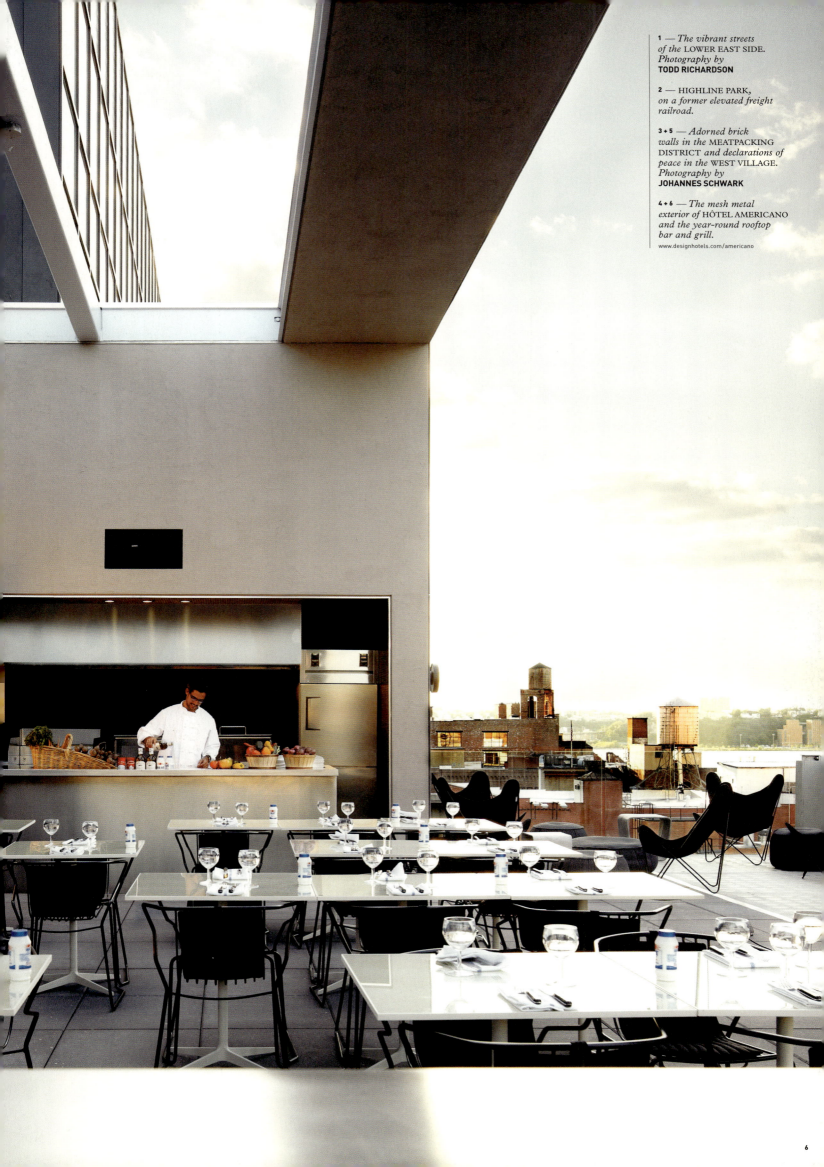

1 — The vibrant streets of the LOWER EAST SIDE. Photography by **TODD RICHARDSON**

2 — HIGHLINE PARK, on a former elevated freight railroad.

3 + 5 — Adorned brick walls in the MEATPACKING DISTRICT and declarations of peace in the WEST VILLAGE. Photography by **JOHANNES SCHWARK**

4 + 6 — The mesh metal exterior of HÔTEL AMERICANO and the year-round rooftop bar and grill.
www.designhotels.com/americano

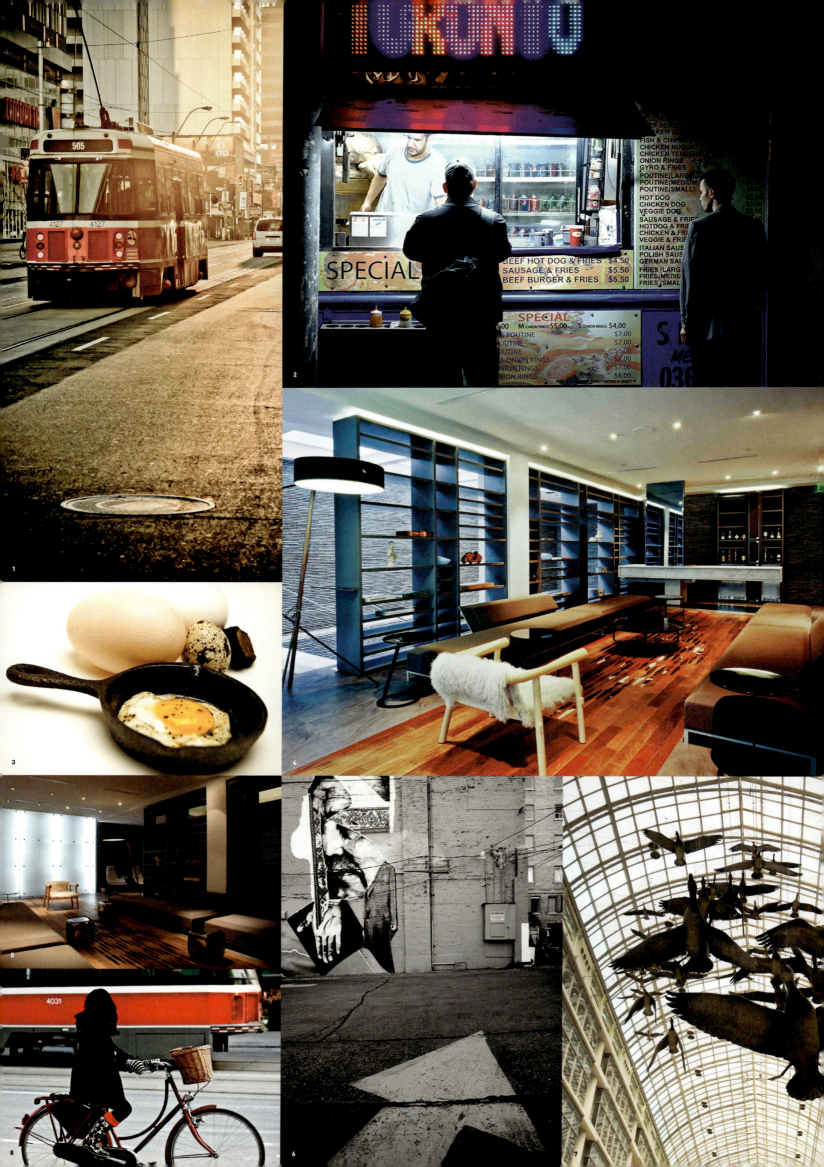

URBAN

Take the **Gramercy Park Hotel**. This stunning property in one of New York City's most coveted neighborhoods represents everything one could hope for in an urban hotel. The artistic vision of Julian Schnabel, the culinary grace of Danny Meyer and the sure hand of developer Aby Rosen attract a cadre of artists, literati, designers and cognoscenti who come here not only to be inspired, entertained and informed, but to be on the pulse of what's going on in this quarter of Manhattan and beyond.

Another New York City standout — **Hôtel Americano**, smack in the middle of Chelsea's art gallery district — is in many ways an extension of the very neighborhood it inhabits. Guests strolling from gallery to gallery have a seamless experience as they return to the Americano, which itself feels like a work of art, attracting the very artists whose works can be seen throughout the neighborhood.

The new **Templar Hotel** in Toronto, set in the heart of the city's pulsing theater, fashion and entertainment districts, is poised to stimulate an already vibrant local scene in fitting style with its fashionable, theatrical look (*its shimmering glass and aluminum facade is a marvel*) and lively, entertaining soul (*contemporary art installations abound*).

The **Blakes Hotel** in London's South Kensington neighborhood, meanwhile, proudly flaunts praise that others might shy away from — "naughty," "daring," "dramatic," "decadent" and "sexy" are just some of the adjectives fans and critics have lovingly heaped onto this property for its passionate fusion of Victorian-style-meets-the-East.

In Spain, **Hotel Único Madrid** and Barcelona's **Grand Hotel Central** both stand out, but in vastly different manners. Único, a one-time private noble home in the city center, is a picture of subtle sophistication with its high ceilings, marble floors and elegant 19th-century façade, while the Grand Hotel Central is a mixture of 1920s grandeur and contemporary chic; the Grand also offers guests its very own city guide — which helps demonstrate that Design Hotels™ is about more than just luxury, it's about luxury with a purpose.

In Hamburg and Frankfurt, hipsters and artists have been flocking for several years now to the high-glam-budget-minded 25hours Hotels — and given that they offer up rehearsal space for local bands and libraries dedicated to vintage vinyl albums, it's easy to see why they've quickly become mainstays in their neighborhoods. That same local vitality can be claimed by their newest cousins as well: **25hours Hotel HafenCity**, an iconic representation of the maritime lifestyle and a signature component of the revitalization of Hamburg's old harbor quarter; and **25hours Hotel Wien**, a display of joy and invention (*think: circus meets luxurious extravagance*) that serves as a home base for artists in the heart of Vienna's young, creative scene.

In Stockholm, no place better captures the city's architectural heritage and grandeur— or inspires visitors to immerse themselves in the city's cultural goings-on—than **Nobis Hotel**, two grand 19th-century buildings that put guests at ease with their clean spaces, natural materials and comfortable, muted colors.

1 — *Downtown Toronto's tram network. Photography by* **MEL ROMEO**

2 — *A street food stall serving late-night snacks. Photography by* **IAN MUTTOO**

3-5 — *From the breakfasts to the ecclectic interiors, the* TEMPLAR HOTEL *is a a relaxed and homey hangout.*
www.designhotels.com/templar

6 — *Vibrant street art adorns Toronto's buildings. Photography by* **PAUL GETTLICH**

7 — *Canadian geese suspended from the ceiling of Toronto's* EATON CENTRE. *Photography by* **OWEN G RICHARDS**

8 — *Locals bike the city. Photography by* **AVIVA COHEN**
www.theurbancountry.com

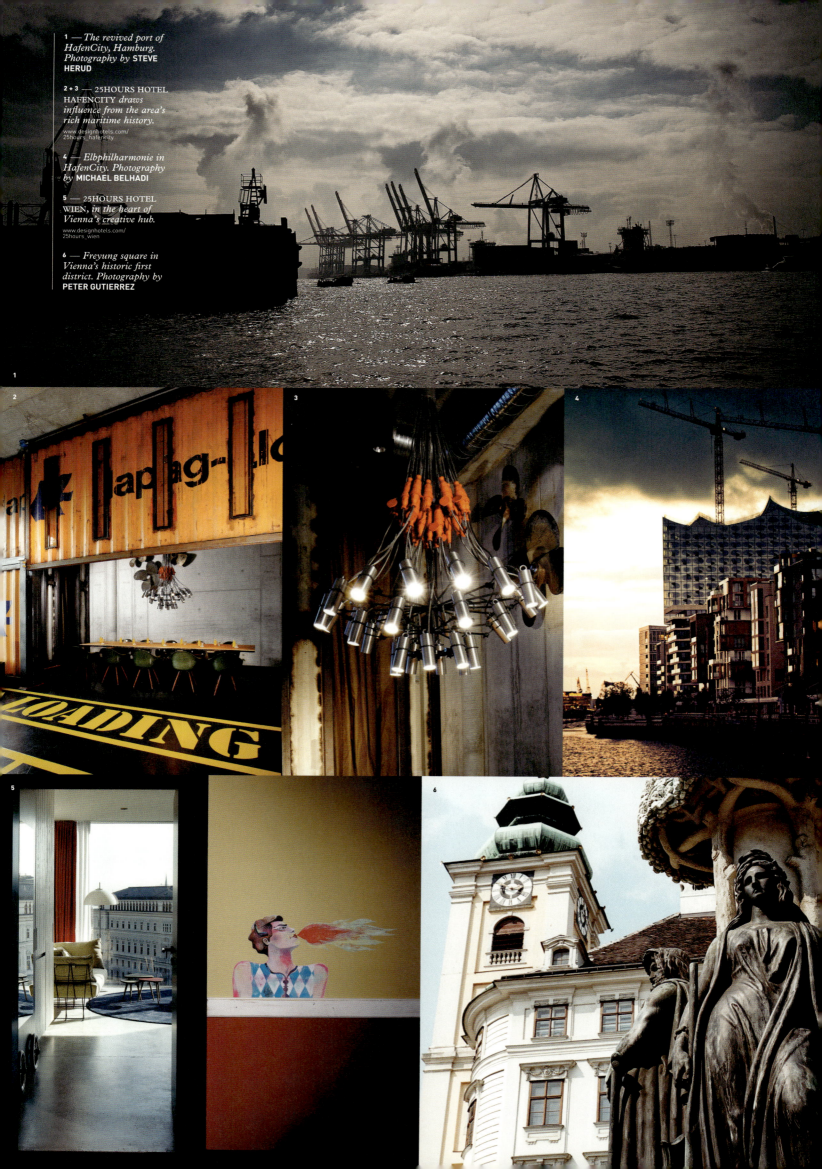

1 — The revived port of HafenCity, Hamburg. Photography by **STEVE HERUD**

2 + 3 — 25HOURS HOTEL HAFENCITY *draws influence from the area's rich maritime history.*
www.designhotels.com/
25hours_hafencity

4 — Elbphilharmonie in HafenCity. Photography by **MICHAEL BELHADI**

5 — 25HOURS HOTEL WIEN, *in the heart of Vienna's creative hub.*
www.designhotels.com/
25hours_wien

6 — Freyung square in Vienna's historic first district. Photography by **PETER GUTIERREZ**

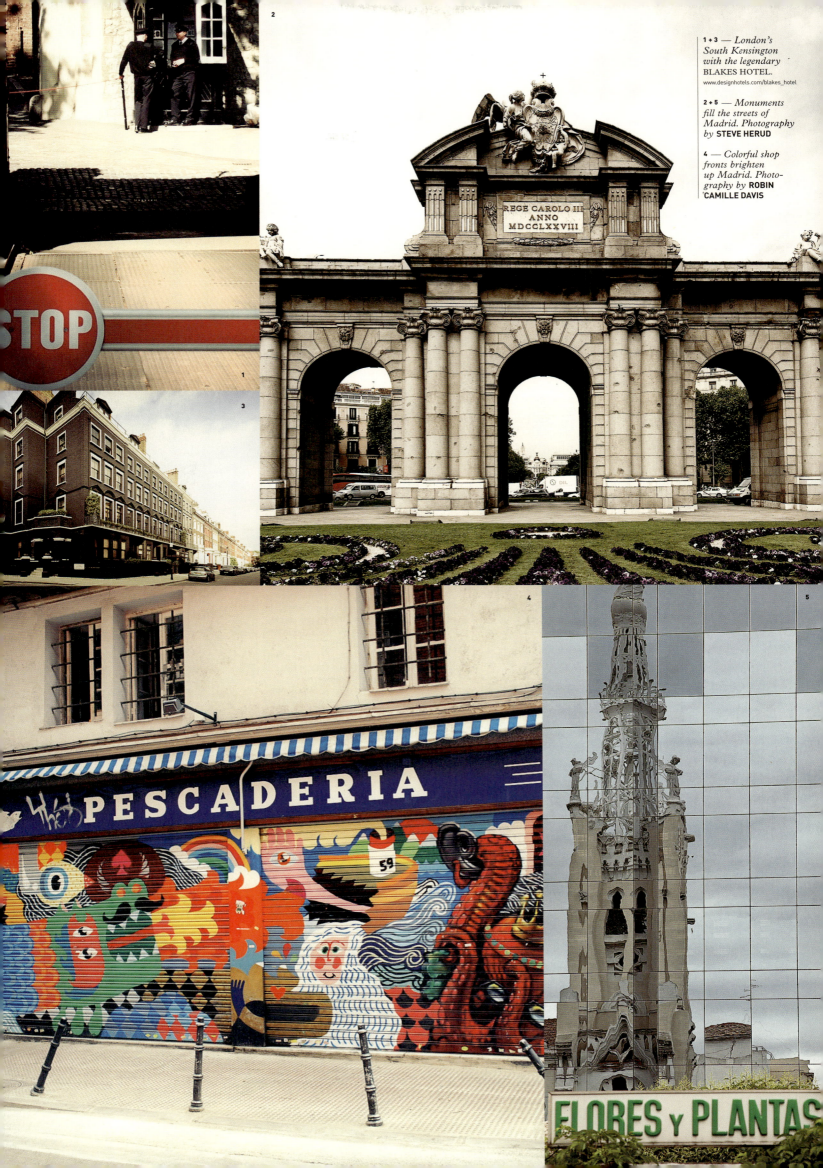

1 + 3 — London's South Kensington with the legendary BLAKES HOTEL. www.designhotels.com/blakes_hotel

2 + 5 — Monuments fill the streets of Madrid. Photography by **STEVE HERUD**

4 — Colorful shop fronts brighten up Madrid. Photography by **ROBIN CAMILLE DAVIS**

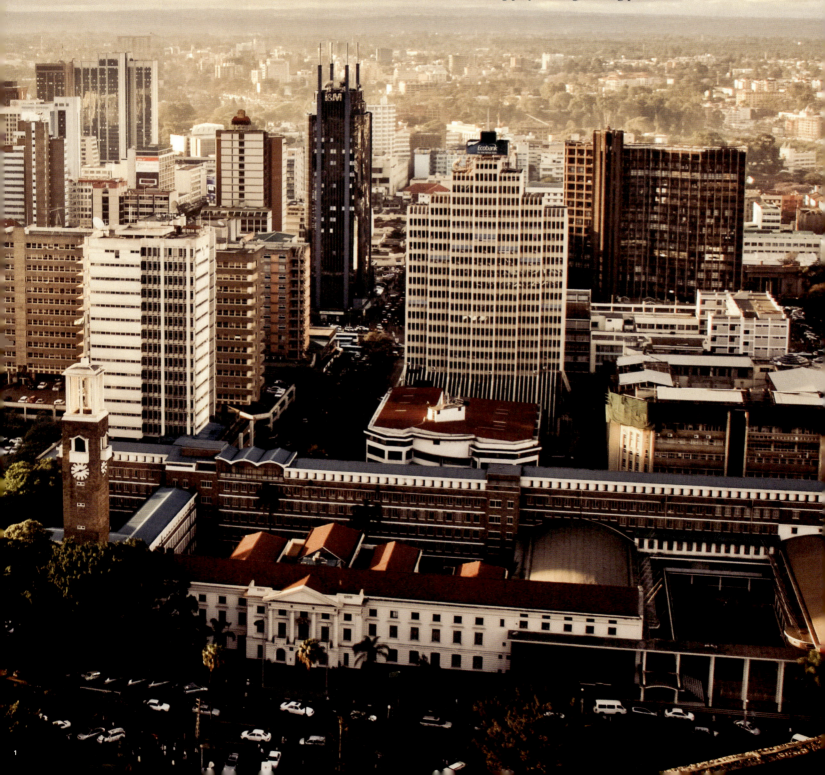

1 — *Nairobi's Central Business District.*

2 — THE KENYATTA CONFERENCE CENTER – *Africa's premier meeting venue.*

3 — *Nairobi's* CITY HALL, *constructed in the 1950s.*

4 — *The entrance to the* TRIBE HOTEL. www.designhotels.com/tribe_hotel

5 — *Nairobi's railway station. Photography by* BRIAN MCMORROW

6 — *African artifacts at the* TRIBE HOTEL. www.designhotels.com/tribe_hotel

7 — *A statue of* JOMO KENYATTA, *the founding father of Kenya.*

1 - 3 + 7 — *Photography by* BIRGER MEIERJOHANN

URBAN FAR AFIELD

Some hotels put their neighborhood on the map, but **Tribe Hotel**, in Nairobi, Kenya, is going a long way to putting its country on the hospitality map. When this asymmetrical wonder, with its rippling walls and polished granite, was just two months old, it attracted the likes of Angelina Jolie and Nicole Kidman, as well as luminaries from MTV's Africa Music Awards, including former Fugee Wyclef Jean.

Sometimes it takes a country's natural treasures to inspire a city hotel. Such is the case with the gold- and emerald-themed **B.O.G. Hotel**, located in Bogotá, Colombia, and buffed to a scintillating luster by the famed Portuguese designer Nini Andrade Silva. And when **QT Sydney** comes online in August 2012, the treasures that are Sydney's historic State Theatre and Gowings department store will become a new leading player and gathering point.

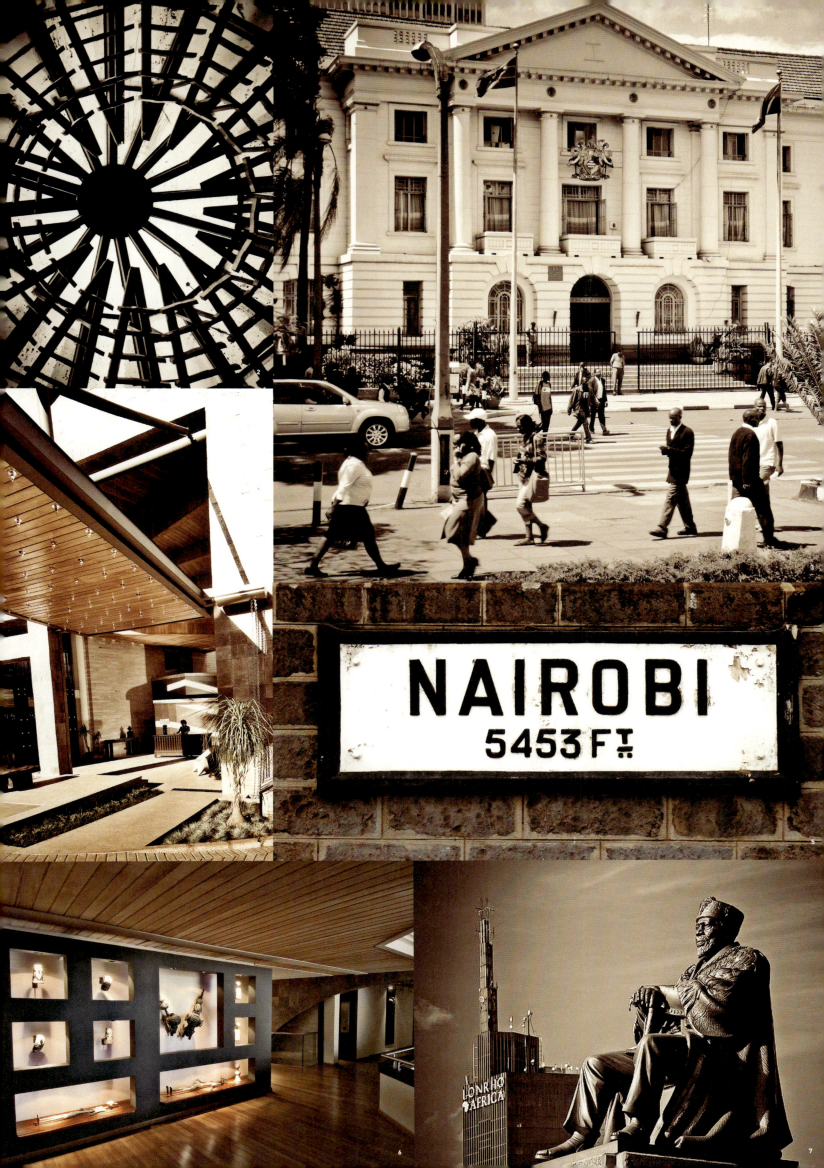

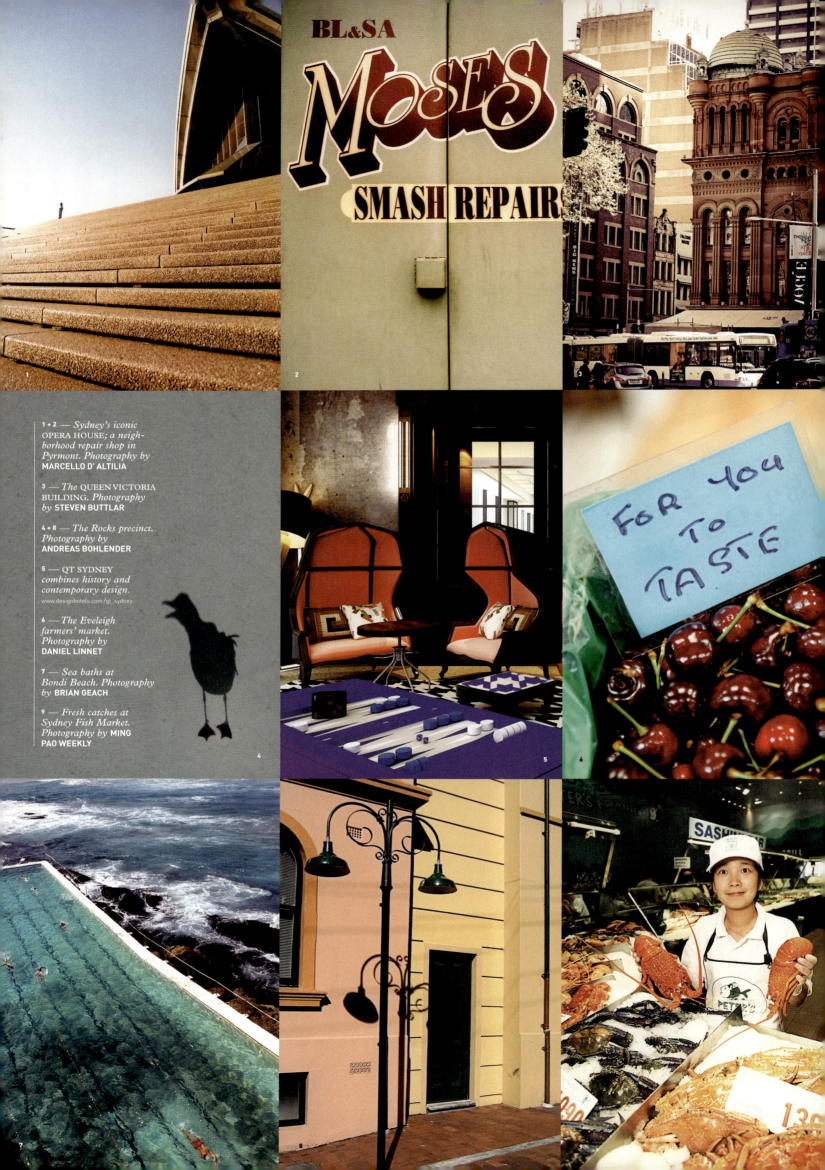

1 + 2 — Sydney's iconic OPERA HOUSE; a neighborhood repair shop in Pyrmont. Photography by MARCELLO D'ALTILIA

3 — The QUEEN VICTORIA BUILDING. Photography by STEVEN BUTTLAR

4 + 8 — The Rocks precinct. Photography by ANDREAS BOHLENDER

5 — QT SYDNEY combines history and contemporary design.
www.designhotels.com/qt_sydney

6 — The Eveleigh farmers' market. Photography by DANIEL LINNET

7 — Sea baths at Bondi Beach. Photography by BRIAN GEACH

9 — Fresh catches at Sydney Fish Market. Photography by MING PAO WEEKLY

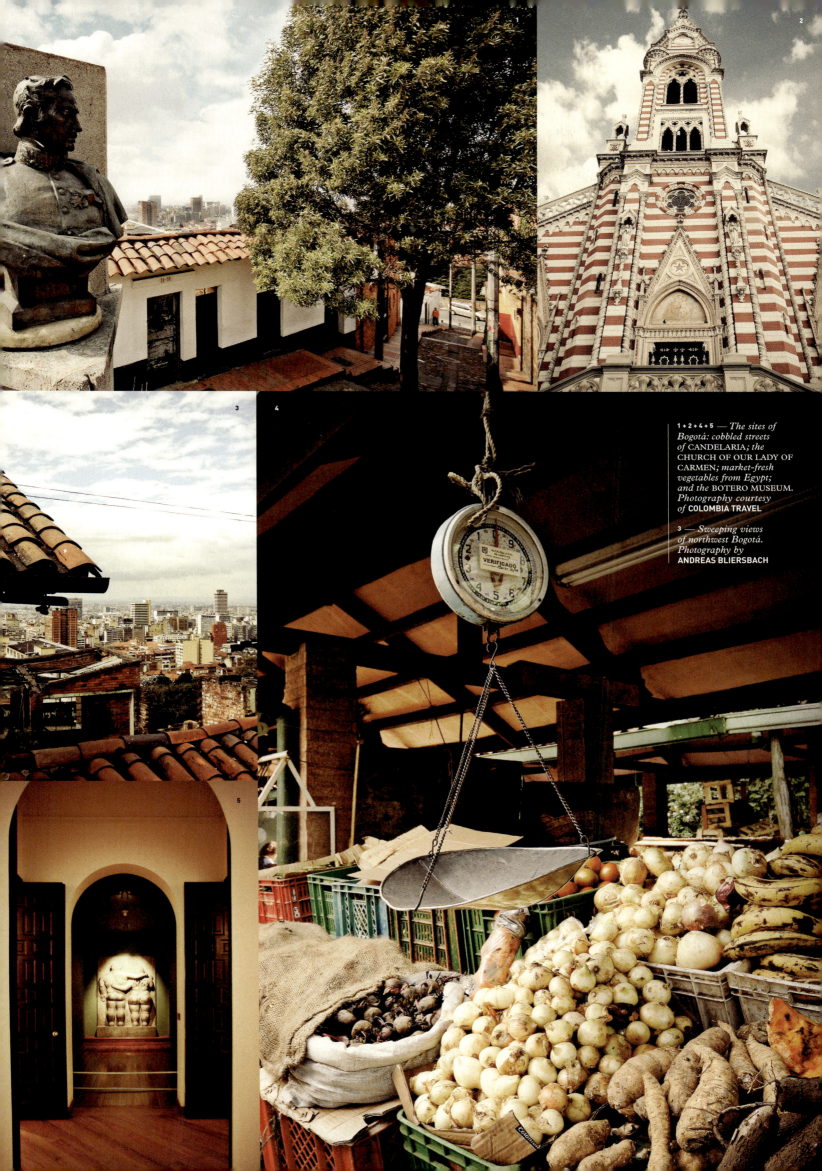

1 + 2 + 4 + 5 — *The sites of Bogotá: cobbled streets of* CANDELARIA; *the* CHURCH OF OUR LADY OF CARMEN; *market-fresh vegetables from Egypt; and the* BOTERO MUSEUM. *Photography courtesy of* COLOMBIA TRAVEL

3 — *Sweeping views of northwest Bogotá. Photography by* ANDREAS BLIERSBACH

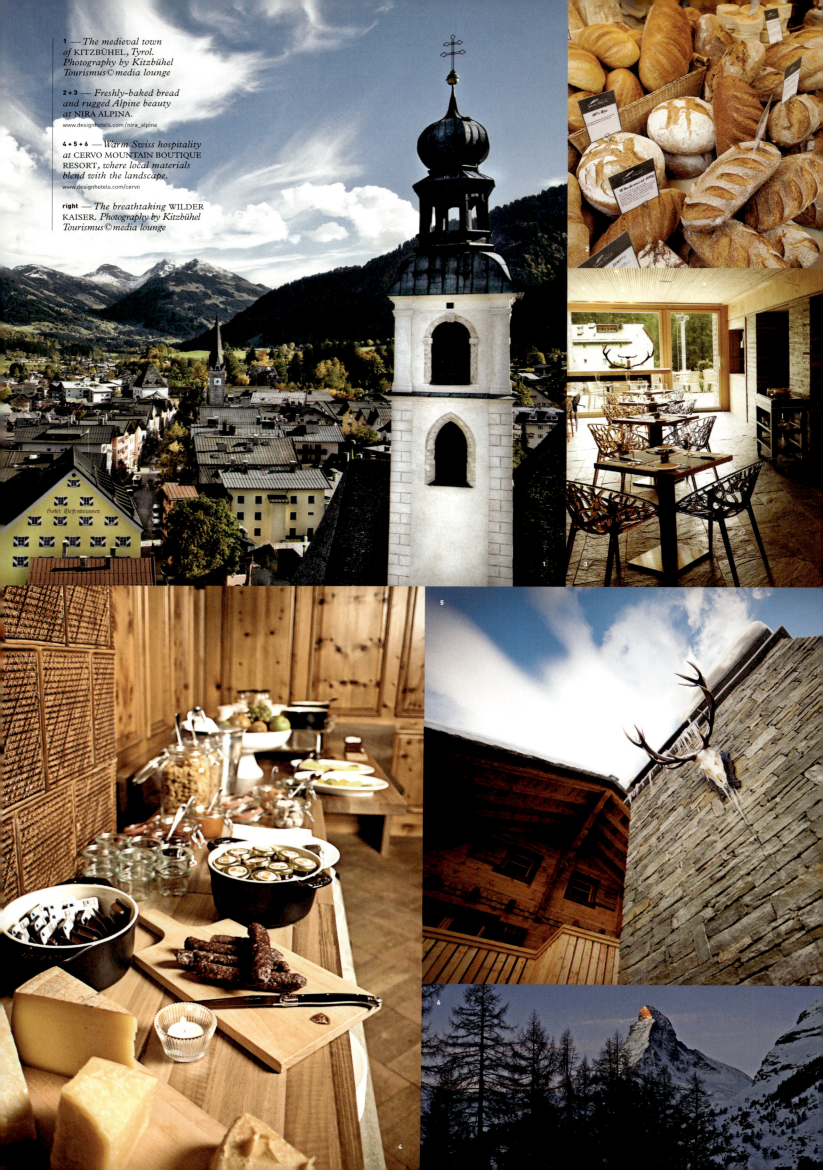

1 — *The medieval town of* KITZBÜHEL, *Tyrol. Photography by Kitzbühel Tourismus©media lounge*

2 + 3 — *Freshly-baked bread and rugged Alpine beauty at* NIRA ALPINA.
www.designhotels.com/nira_alpina

4 + 5 + 6 — *Warm Swiss hospitality at* CERVO MOUNTAIN BOUTIQUE RESORT, *where local materials blend with the landscape.*
www.designhotels.com/cervo

right — *The breathtaking* WILDER KAISER. *Photography by Kitzbühel Tourismus©media lounge*

MOUNTAIN

But, of course, one cannot survive on a constant diet of city life. The boom-boom pace of urban living demands that we escape and disconnect in order to recharge and reinvigorate. Thus, the leisure destinations we choose must enable guests to refresh themselves. And while these hotels are not usually part of neighborhoods in the traditional or geographic sense, they are in the spiritual one—that is, they've created the feeling of neighbors coming together in one place to immerse themselves in the culture and lifestyle of a local scene.

This certainly holds true at our many ski hotels, which use this sense of community to stand out from their competition. **Hotel Kitzof Mountain Design Resort**, a mere five minute walk from the center of Kitzbühel, creates a neighborly feeling of warmth and welcome with an inspiring blend of rustic wooden beams and Tyrolean flavor. **CERVO Mountain Boutique Resort**, on the slopes above Zermatt, Switzerland, does it with a sense of exclusivity and an amalgam of local materials like felt, loden and stone. **Bergland Hotel Sölden**, high in the Austrian Alps, does it by combining unexpected sleek, contemporary design with all the familiar trappings of a traditional Alpine lifestyle. **Nira Alpina**, a glass-and-timber-built mountain sanctuary just five kilometers from the resort town of St. Moritz, does it with a blend of wood, granite, elegant swathes of glass, and panoramic views that unite guests with a shared sense of awe. And **Kimamaya Boutique Hotel**, a ski haven on the northern Japanese island of Hokkaido, achieves it through intimacy — with just a handful of rooms, the resort gives visitors the sense that they've gathered with their closest neighbors to experience something both unique and spiritually lasting.

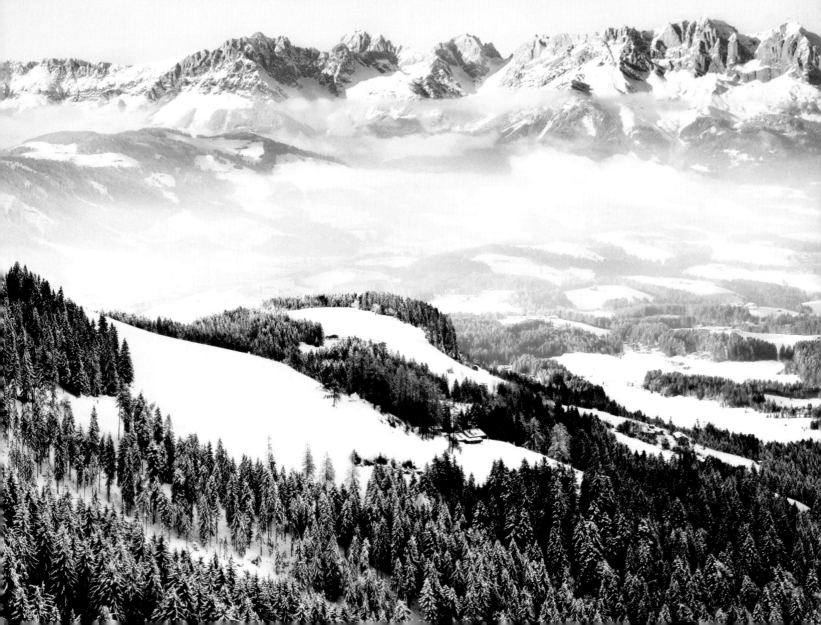

left — EKIES ALL SENSES
RESORT– *on a peninsula
reaching out to the AEGEAN
SEA – is surrounded by clear
waters, sandy beaches and
pine forests.*
www.designhotels.com/ekies

BEACH

This sense of permanence and belonging is integral to our seaside properties as well. **Hotel La Banane**, on the Caribbean island of Saint Barthélemy, achieves it with an assortment of individually-designed bungalows and vintage furniture that evoke an intimate, communal play space for the hedonistically minded. **Be Tulum**, on a secluded stretch of the Mayan Caribbean, does it mystically and powerfully — the surrounding relics of one of the world's most ancient cultures informs the hotel's design and the mindset of all who visit. And **Ekies All Senses Resort**, in Sithonia, on the Greek peninsula of Halkidiki, achieves it through a rare blend of a remote location and high-minded design — the resort's stellar contemporary interior accents contrast strikingly with traditional Greek elements, and together it all respectfully and harmoniously blends in with the surrounding beach, caves and pine forests.

Indeed, this sense of coming together and then venturing out — to share, to experience, to return to your hotel informed and enriched — is what the best properties and the best neighborhoods are all about. We at **Design Hotels**™ are proud to be able to handpick hotels that don't just offer guests a place to stay — they offer them a place to be.

Claus Sendlinger
Founder & CEO,
Design Hotels™

THE KEY TO YOUR EXPERIENCE

Every member hotel provides a unique ambience and experience for guests. To help you navigate through our portfolio and to give you an idea of what experience you can expect, we have grouped our hotels into three loose categories: **SIGNATURE**, **RARE** *and* **OFFBEAT**. *Each hotel in the Design Hotels™ Book Edition 2012 is marked with one of these categories.*

AT THE END OF THE DAY – OR EVEN AT THE BEGINNING – YOU KNOW YOU'RE IN JUST THE RIGHT PLACE, WHEREVER YOU ARE IN THE WORLD.

✳ SIGNATURE

NO TWO SIGNATURES ARE THE SAME

Reliable, yet with an unpredictable kind of style, these hotels are like signatures – no two are alike. Each hotel's singular approach to form, function, comfort and attention creates an appealing look that always has a distinctive personality, but never overpowers.

✳ RARE

RARE GRANDEUR: BESPOKE SERVICES MEET MODERN DESIGN

From extravagant to classic, from luxurious to minimal, these hotels provide boundary-pushing experiences. The appeal of these properties lies in their striking concepts that cast familiar objects, materials, colors and scents in a new light to create an unforgettable experience.

✳ OFFBEAT

ALTERNATIVE, EXPERIMENTAL – OR SIMPLY OFFBEAT

These hotels take the amenities and services of a traditional grand hotel and offer them in a more contemporary, casual package. They give guests looking for a posh experience exactly what they want and need: rare grandeur in an utterly relaxing atmosphere.

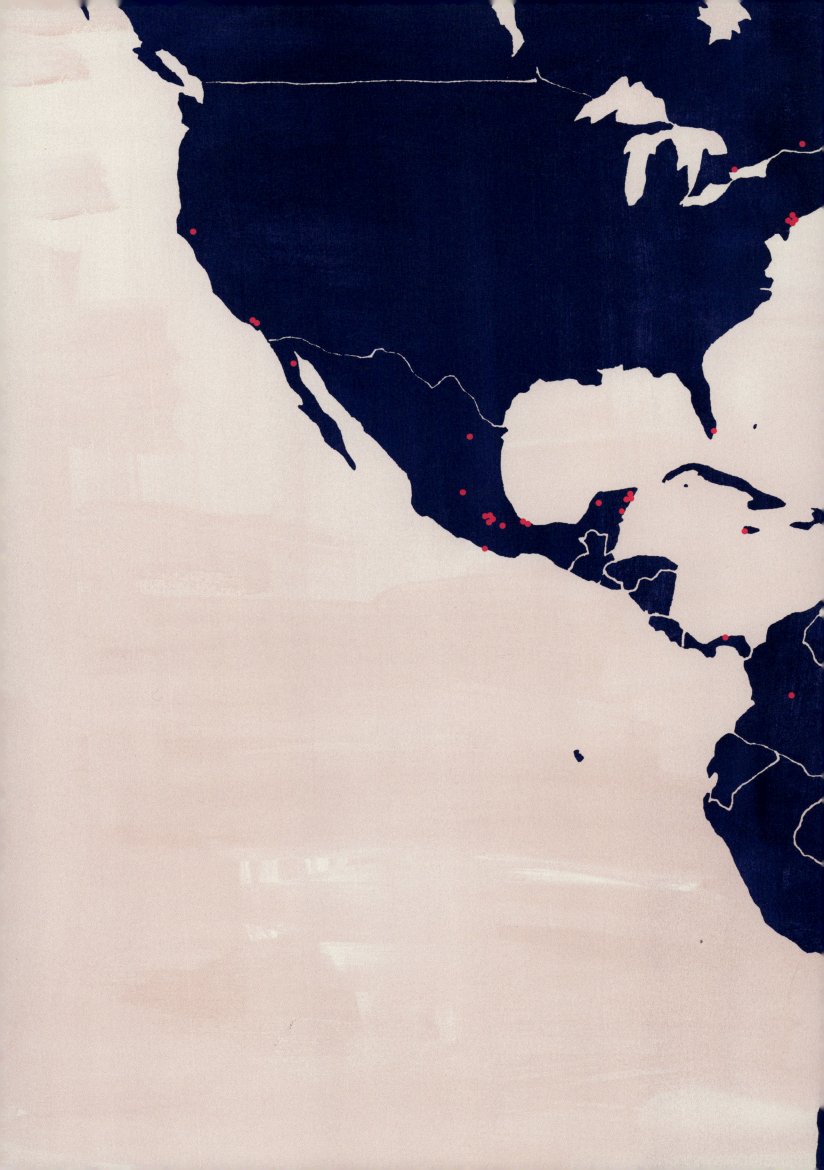

AMERICAS

BRAZIL
026 — KENOA – EXCLUSIVE BEACH SPA & RESORT
Barra De São Miguel
028 — INSÓLITO BOUTIQUE HOTEL
Búzios
030 — HOTEL UNIQUE
São Paulo

CANADA
032 — HOTEL ST. PAUL
Montreal
034 — TEMPLAR HOTEL
Toronto

COLOMBIA
036 — B.O.G. HOTEL
Bogotá

GRENADA
038 — LALUNA
Grenada

JAMAICA
040 — ROCKHOUSE HOTEL
Negril

MEXICO
042 — BOCA CHICA
Acapulco
044 — ENDÉMICO
Baja California
046 — ROSAS & XOCOLATE
Mérida
048 — CONDESA*DF*
Mexico City
050 — DISTRITO CAPITAL
Mexico City
052 — DOWNTOWN
Mexico City
054 — HABITA
Mexico City
056 — HABITA MONTERREY
Monterrey
058 — BE PLAYA
Playa Del Carmen
060 — DESEO [HOTEL + LOUNGE]
Playa Del Carmen
062 — HOTEL BÁSICO
Playa Del Carmen
064 — LA PURIFICADORA
Puebla
066 — HOTEL MATILDA
San Miguel De Allende
068 — BE TULUM
Tulum
070 — AZÚCAR
Veracruz
072 — MAISON COUTURIER
Veracruz

PANAMA
074 — EL OTRO LADO
Portobelo

SAINT BARTHÉLEMY
076 — HOTEL LA BANANE
Saint Barthélemy

UNITED STATES
078 — HOTEL HEALDSBURG
Healdsburg
080 — THE STANDARD, HOLLYWOOD
Hollywood
082 — THE STANDARD, DOWNTOWN LA
Los Angeles
084 — THE STANDARD SPA, MIAMI BEACH
Miami
086 — CROSBY STREET HOTEL
New York City
088 — GRAMERCY PARK HOTEL
New York City
090 — HÔTEL AMERICANO
New York City
092 — THE STANDARD, NEW YORK
New York City

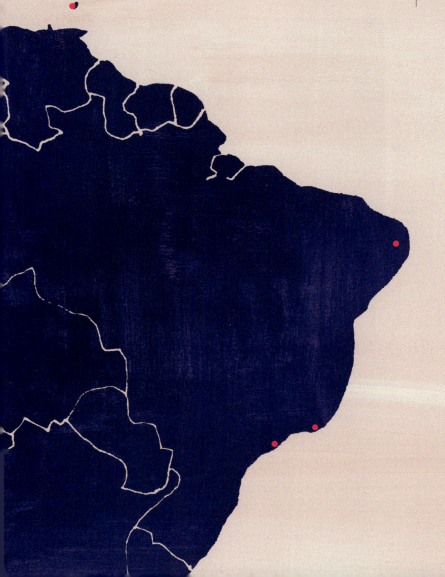

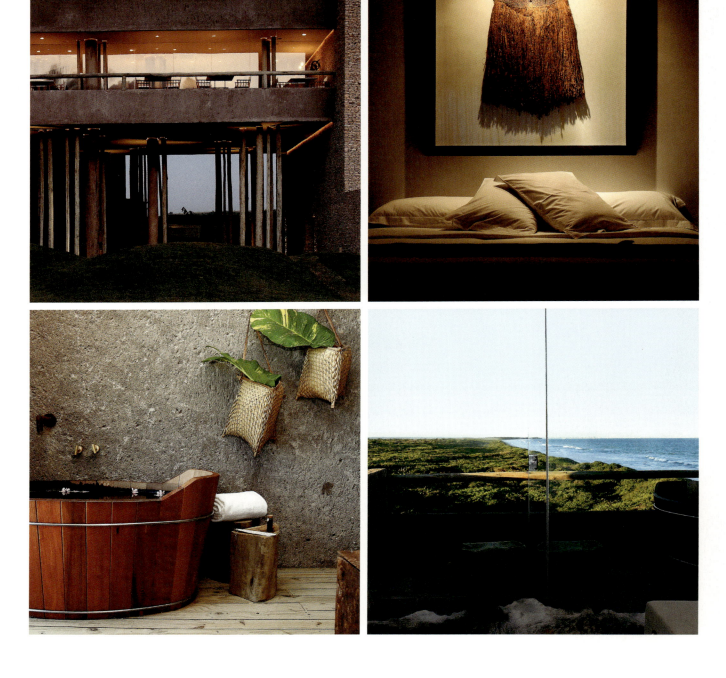

KENOA – EXCLUSIVE BEACH SPA & RESORT
Barra de São Miguel

Kenoa – Exclusive Beach Spa & Resort is located on Brazil's stunning northeastern coast, caressed by an emerald-colored, seemingly infinite ocean and miles of pristine sandy white beach. Its location just nine degrees south of the equator ensures year-round summer temperatures. When founder Pedro Marques first dreamed up the lush haven, he instantly envisioned the stylish resort would provide for a mental, physical, and environmental equilibrium. Keen on environment-sparing solutions such as recycled glass water bottles, tree trunks of reclaimed wood, energy-saving LED lights, locally produced foods, and even non-ironed staff uniforms, the eco-chic retreat's intimate setup offers repose for those ready to wind down. Each of the 23 exclusive villas and suites bristles with singular features, from unparalleled views over the neighboring sanctuary to private pools and outstanding interior design enriched with indigenous works of art. A Shiseido-equipped spa, fitness center with ocean views, wine bar, lounge, and world-class cuisine tantalize the senses and satisfy the soul.

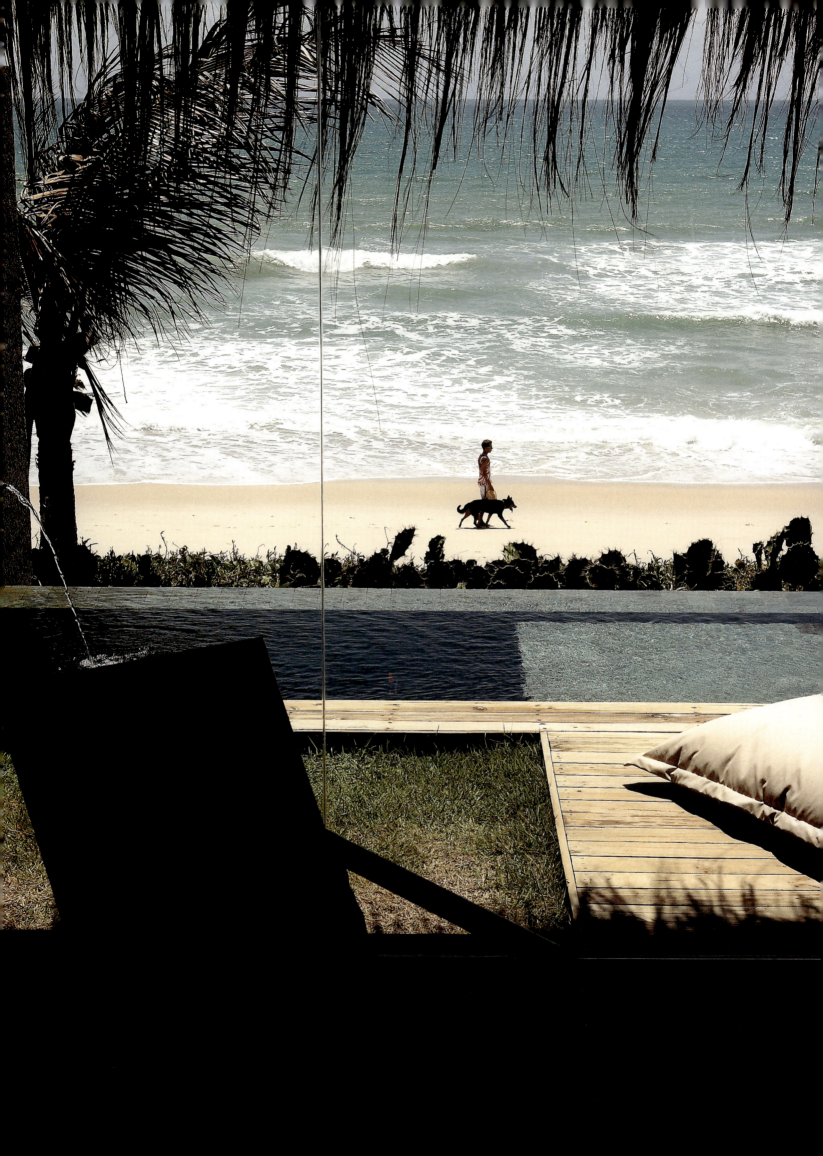

✻ SIGNATURE

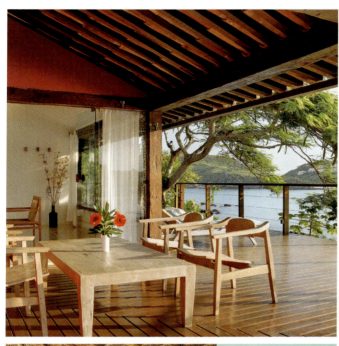
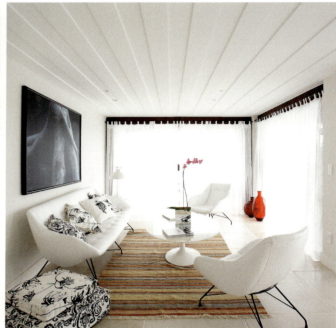
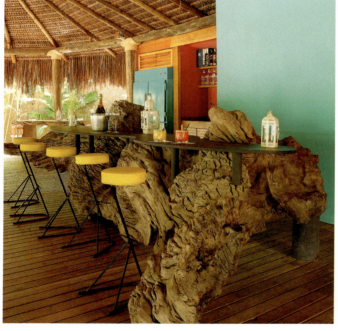

WWW.DESIGNHOTELS.COM/
INSOLITO

ADDRESS
RUA E1, LOTES 3 E 4,
CONDOMÍNIO ATLÂNTICO,
28950-000 ARMAÇÃO DE BÚZIOS
BRAZIL

ROOMS
20

RATES
BRL 964 –
BRL 8322

OPEN
12/2007

BRAZIL
BÚZIOS

028

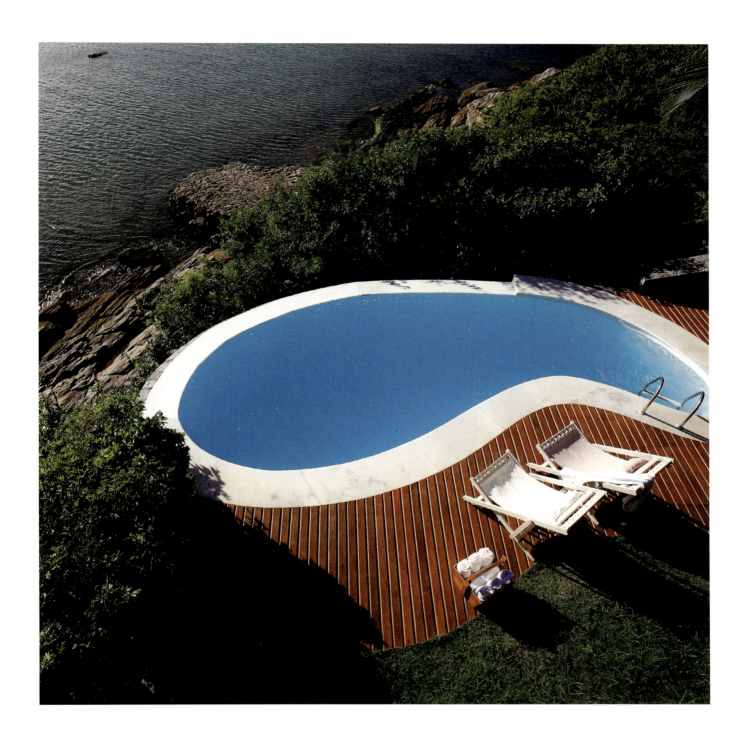

INSÓLITO BOUTIQUE HOTEL
Búzios

Just a two-hour drive from the bright lights of Rio de Janeiro, there is an oasis of calm awaiting guests at the Insólito Boutique Hotel – a resort that combines personalized service with a beachfront experience and ambience that revitalize the soul. Nestled in a rocky hillside, with stunning views of Ferradura Beach, the solar-heated Insólito blends perfectly into its natural surroundings thanks to the skills of celebrated architect Otavio Raja Gabaglia. The hotel's 20 rooms are full of arts and crafts from Brazilian legends, local artisans, and socially responsible companies, reflecting the style of its owner, the French-born Emmanuelle de Clermont Tonnerre. She has lovingly chosen and curated each room's unique theme; and whether the theme celebrates Cultura Negra, South American photography, or Brazilian modern art, prepare to have your senses wowed. All rooms come with a king-size bed, LCD TV, DVD player, Wi-Fi, iPod docking station, and plenty of interesting books. Most rooms have a veranda with a whirlpool and panoramic ocean views, while the suites also come with a lounge and American bar where guests can mix their own cachaça drinks. The hotel owns two speedboats with which guests can discover over twenty neighboring beaches on the peninsula whenever they choose. When guests want to mingle they can enjoy drinks in the pool bar, or they can dine at the 3,000-square-meter beach lounge, which has become "the place to be" for locals and guests alike.

*SIGNATURE

WWW.DESIGNHOTELS.COM/ HOTEL_UNIQUE

ADDRESS
AVENIDA BRIGADEIRO LUIS ANTONIO 4700 JARDIM PAULISTA
01402-002 SÃO PAULO
BRAZIL

ROOMS 95

RATES BRL 870 – BRL 15000

OPEN 12/2002

BRAZIL SÃO PAULO

HOTEL UNIQUE
São Paulo

Rising proudly above São Paulo like a graceful ocean liner, Hotel Unique is sculptural architecture at its most original – and a must for savvy architecture fans and well-traveled urbanites alike. The spacey, green-weathered copper that adorns the facade stretches across the building's unusual shape, a large inverted arch with circular windows like oversized portholes. The effect of the geometric forms, dark glass, and desert gardens is nothing less than spectacular, nor does the interior disappoint. There, the curvilinear theme continues in a choreographed spectrum of circles, squares, ellipses, and sine curves that flow into and out of each other. Nothing is superfluous, and no space is wasted; the harmony is palpable. In guestrooms, high-tech details are combined with natural elements to create an otherworldly effect that still manages to seem welcoming. Unusual accessories from around the globe add to the ultra-cool, something-special feel, which is accented by the staff's coolly impeccable service. Upstairs, what is perhaps São Paulo's finest rooftop terrace offers amazing views of the city: that is, if guests can take their eyes off the fascinating crimson swimming pool that runs along its edge. A night at Hotel Unique is definitely a singular experience.

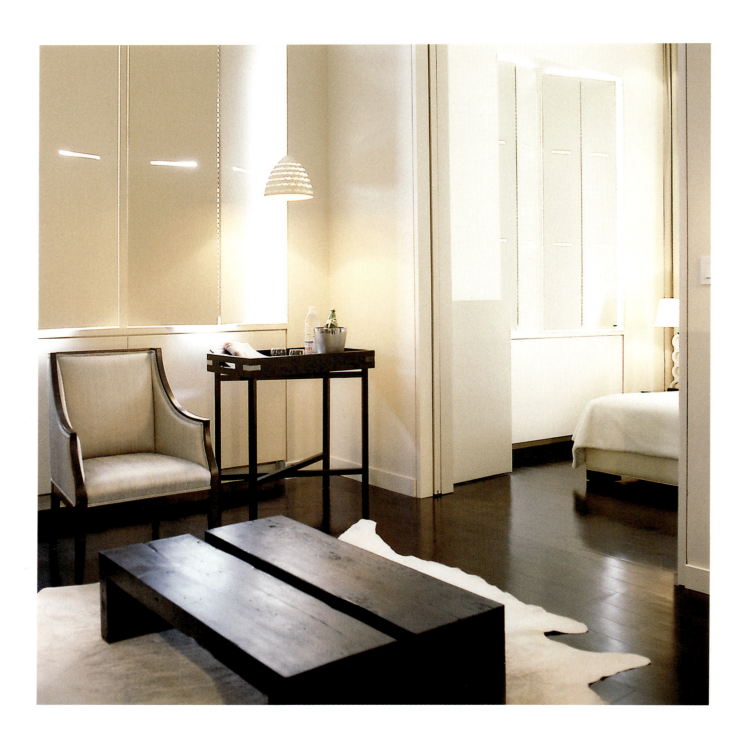

HOTEL ST. PAUL
Montreal

Given that this ten-story high-rise is often stylistically described as "muscular Beaux Arts," it comes as a surprise that the Hotel St. Paul's interior is so soft and ethereal. Located in one of Montreal's hippest quarters and housed in what was one of the city's first high-rises when it was built in 1900, the hotel artfully blends old and new. Several majestic details, such as a massive lobby fireplace now covered in a layer of translucent alabaster, reveal the property's rich history. The rest has been charged with a contemporary flair that's long attracted the attention of design aficionados as well as travelers looking for urban elegance. Drawing inspiration from the Canadian landscape, guestrooms feature fire, ice, earth, and sky as abstract metaphorical design themes that comfort and soothe guests in different ways: earth rooms are solid, grounded, and tactile in their colors and textures, while sky rooms are atmospheric spaces that focus on light and air. Furnishings and accents in silk, stone, and metal are consistently understated, while windows on each of the hotel's nine floors of guestrooms afford beautiful views of the skyline and Montreal's historic Old Port.

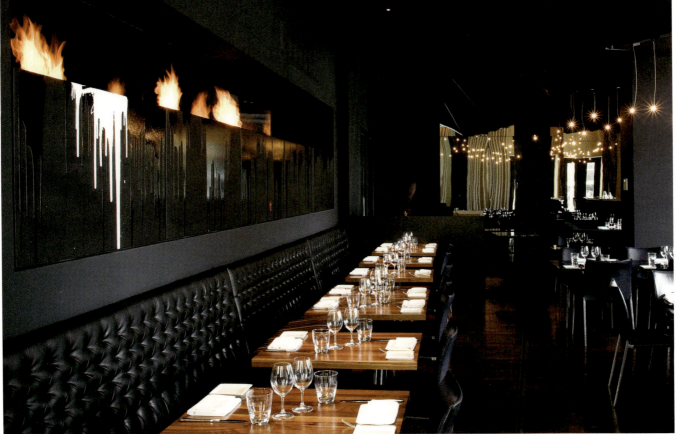

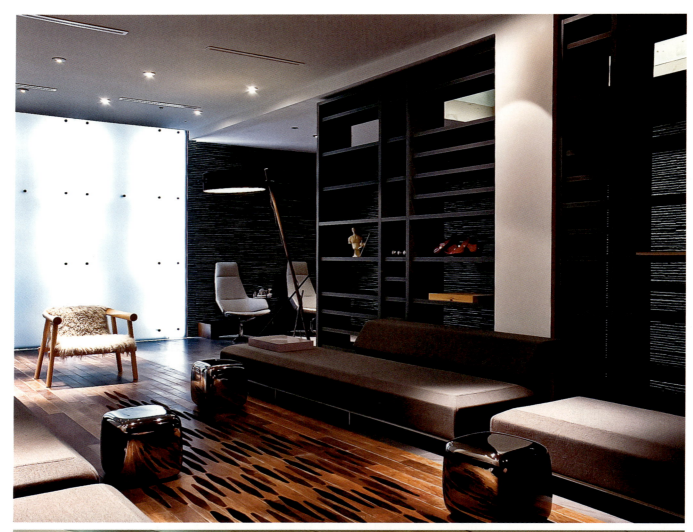

TEMPLAR HOTEL
Toronto

When guests arrive at the Templar Hotel, an eight-story construction in the beating heart of Toronto's chic entertainment district, they quickly realize that this is no ordinary city hangout. Whether they are dropped off by the stylish airport shuttle (a Porsche Panamera) or walk from the nearby Metro Toronto Convention Center, they're seen craning their necks to marvel at its shimmering glass and aluminum facade. Beyond the narrow entrance, visitors find glowing modern art installations and specially designed Poliform furnishings giving the lobby an air of cool, custom-built luxury. Here, at the spiritual center of a subconsciously eclectic world created by Toronto-based designer Del Terrelonge, guests can choose to soak up the elegant surroundings or shop for some of the furnishings and artworks that dot the walls. A similarly relaxed vibe oozes through the rest of the building, from the 27 marble-dressed rooms and suites to the spectacular rooftop bar, which offers exceptional views of the colossal CN Tower. There's even a Japanese-style spa, complete with a deep, sand blasted pool, through which you can gaze down into the Templar's design-inspired bar.

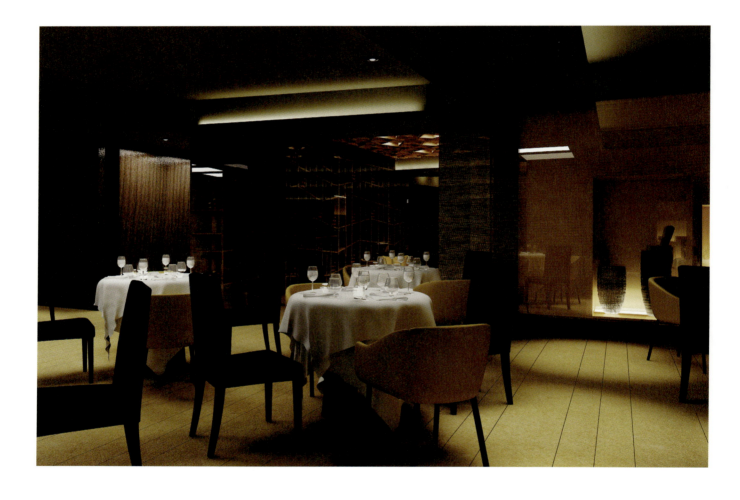

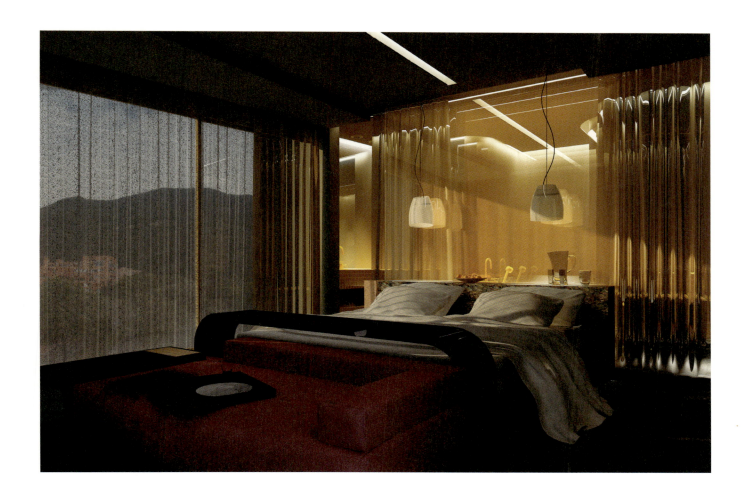

B.O.G. HOTEL
Bogotá

With a design inspired by Colombia's greatest natural treasures – gold and emeralds – the geometric B.O.G. Hotel, in the north of Bogotá, is a decadent base from which to explore this burgeoning city. Tipped as an exciting destination bursting with creativity, clubs and great cuisine, B.O.G. Hotel itself is home to one of Colombia's most respected chefs, Leonor Espinosa. In B.O.G.'s main restaurant, La Leo of 86th Street, Espinosa aims to preserve and enhance the gastronomic heritage of Colombia, using traditional ingredients to create fusion dishes that blend international flavors with longstanding, local recipes. In the Lounge Bar, an expert barman mixes a similarly inventive range of cocktails. The stark yet luxuriously textured interior of the hotel complements the building's utilitarian exterior. All 55 rooms by award-winning designer Nini Andrade Silva focus on bronze, green, greys and beige combined with natural stone, bronze, mirrors, mosaics and tinted glass to create pared-down and restful spaces. While the in-room décor is intentionally simple, every comfort is assured, including soundproofed windows, 500-thread linens and bathroom products and scents exclusively designed for the hotel. After a day discovering the vibrant surroundings, the rooftop's heated swimming pool offers a welcome respite, with views over the city.

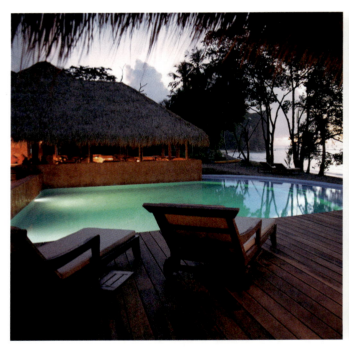

LALUNA
Grenada

Trickling down a picturesque hillside in Grenada and overlooking Portici Beach, Laluna stirs a tasty melange of Caribbean, Balinese, and Italian design elements to create a smart and utterly tropical hotel. Designed by Gabriella Giuntoli, who has built villas for Giorgio Armani and Sting, Laluna is a masterpiece on ten acres of untouched land in the West Indies, surrounded by emerald hills, crystal waters, and leafy bougainvillea-filled grounds. Each of the 16 traditional, thatched-roof cottages offers an open-air bathroom, an exquisite line of bath products made exclusively in a monastery in the Italian Alps, and a king-sized Balinese bed that opens onto an expansive bamboo-framed veranda with a plunge pool. In Laluna's yoga beach pavilion, guests can take daily classes in such varying yoga techniques as Hatha, Kundalini, and Vinyasa. The Asian spa features parallel treatment rooms that are convertible into a single unit for couples massage, and there is a tatami room with handwoven mats for massages that optimize stretching and pressure from the therapist's body weight. The wet room, in which a Vichy shower gives the sensation of soft rain, is used between mud applications and massages. As the sun sets, guests can dine at the beachside Italian restaurant, where chef Daniele Gaetano prepares authentic Italian cuisine with ingredients imported directly from Italy and fresh herbs from his organic garden. The evening closes on silk-covered daybeds, watching the the silver moon, Laluna's namesake, rise in the cobalt sky.

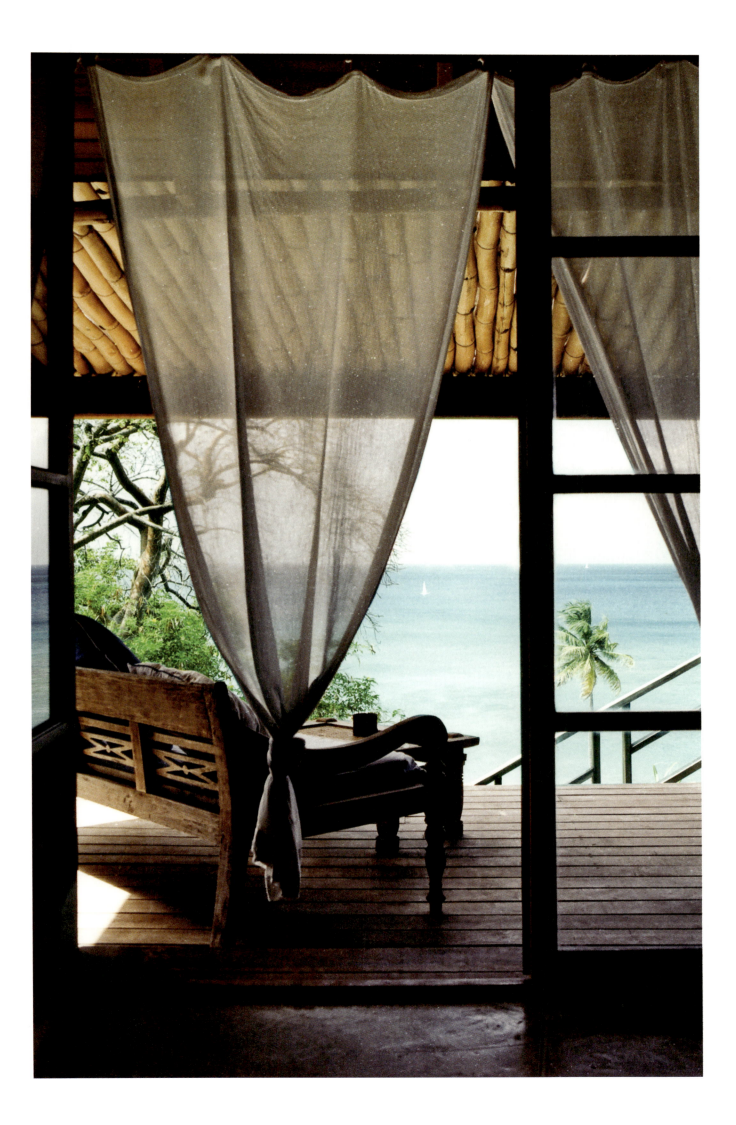

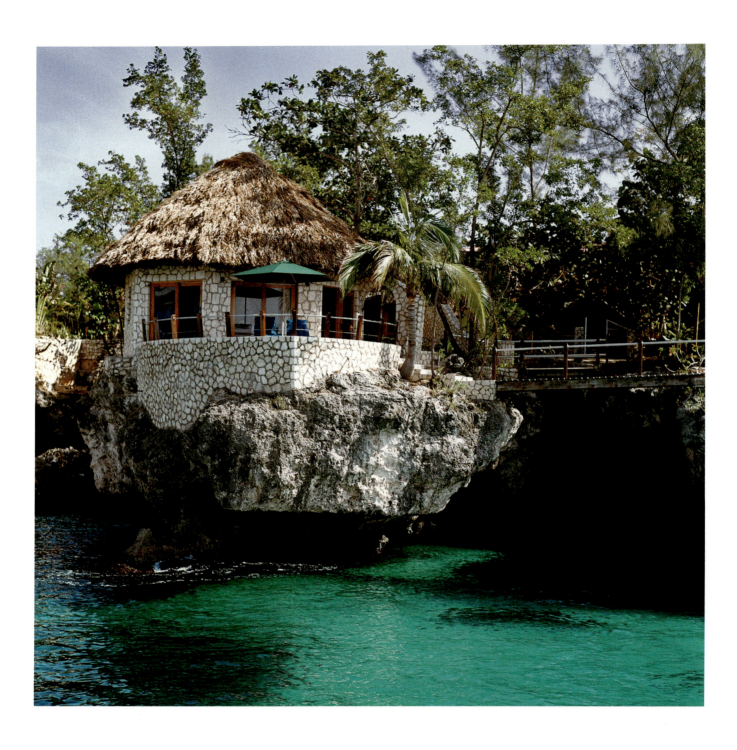

ROCKHOUSE HOTEL
Negril

Hexagonal thatched-roof buildings, volcanic Jamaican coastline, and sparkling turquoise waters give the Rockhouse Hotel a look and feel that's straight out of a Robinson Crusoe fantasy. The truth is not far off: the resort designers sought to mimic the seamless merging of man and nature so beautifully exemplified by African village life. Together, the hotel's bar and restaurant constitute the central square of the Rockhouse "village," perched on a gorgeous deck suspended above the Pristine Cove. Alternatively, guests can integrate locally in the restaurant and rum bar Pushcart, which features nightly live reggae music and a menu inspired by the best of Jamaican and Caribbean street food. A stunning infinity pool set in a clifftop rock garden perfects the back-to-nature atmosphere, while ubiquitous references to the Caribbean Sea and surrounding Jamaican countryside complete the picture of an island getaway. But the true highlights are the generous timber bungalows overlooking either glowing Caribbean waters or the hotel's expansive, lush tropical gardens. Rockhouse also offers a number of studios, whose custom-made furniture of local wood adds to the overall in-tune-with-nature ambience. Throughout the property, ladders and stairs carved into the rock provide easy access to the water, while a new temple-like spa pavilion – complete with massage cabana, Caribbean drench hut, and yoga pavilion – rounds out this laid-back haven of relaxation.

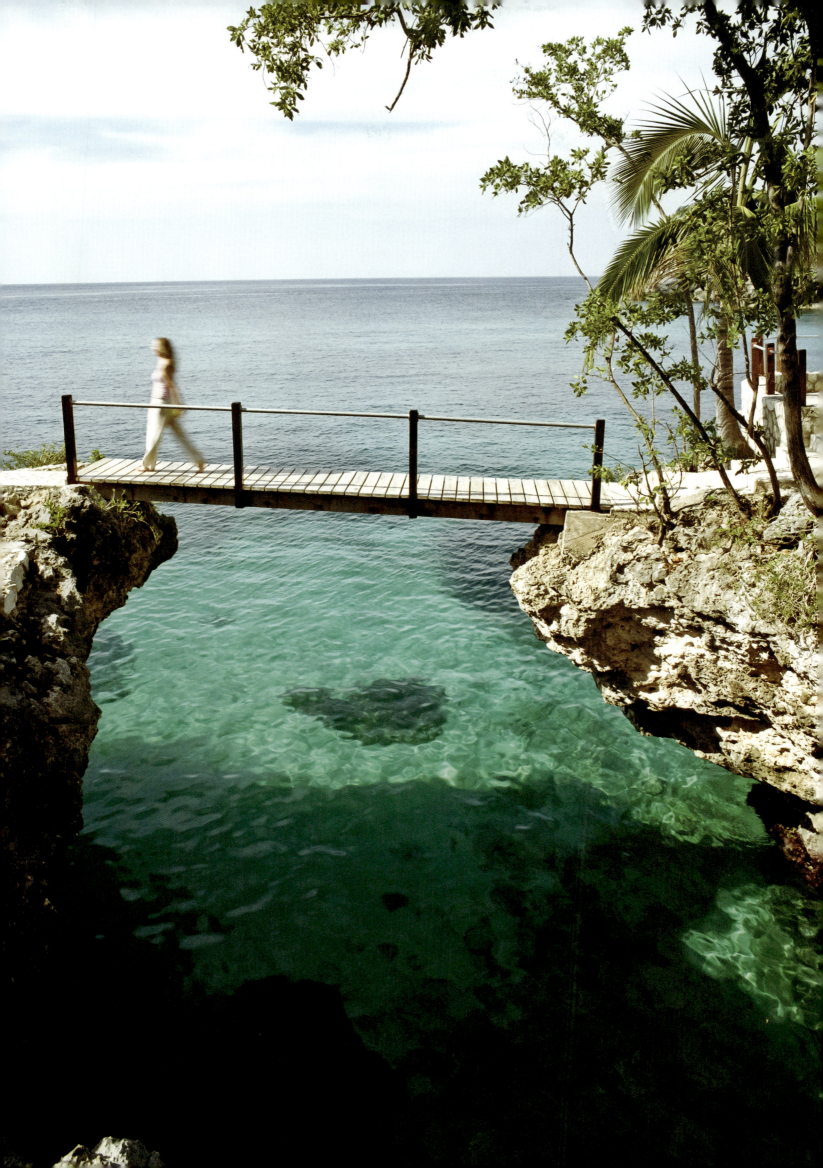

✴ OFFBEAT

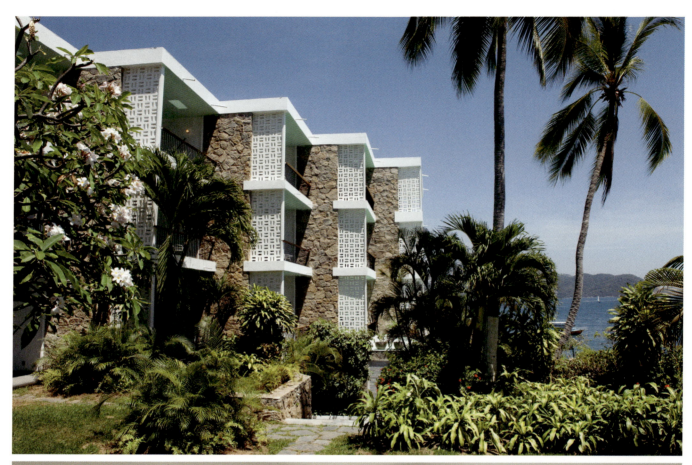

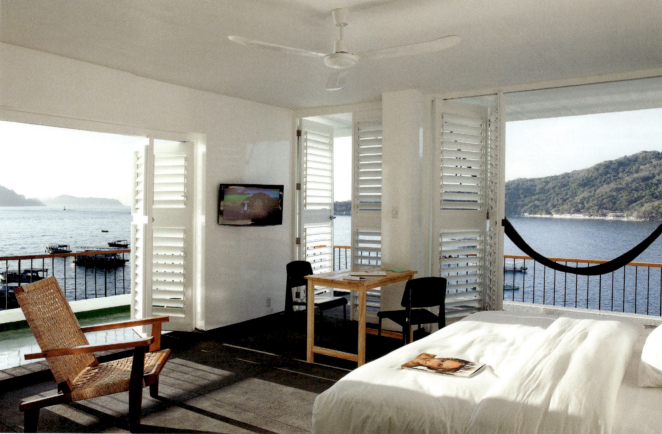

WWW.DESIGNHOTELS.COM/
BOCA_CHICA

ADDRESS
PUNTA CALETILLA,
FRACCIONAMIENTO LAS PLAYAS
39390 ACAPULCO
MEXICO

ROOMS
36

RATES
USD 120 –
USD 325

OPEN
10/2009

MEXICO
ACAPULCO

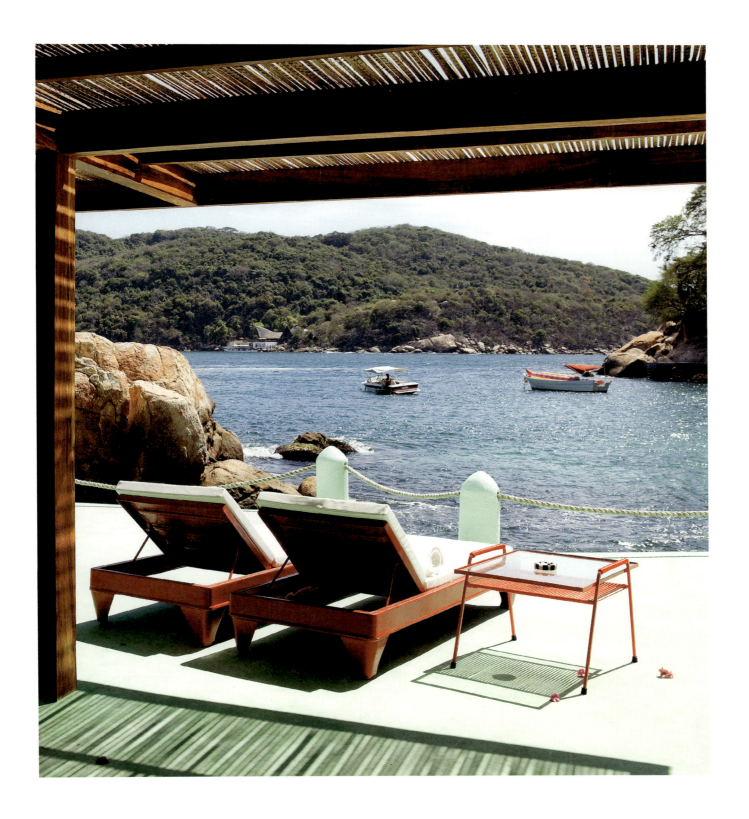

BOCA CHICA
Acapulco

Just steps from an idyllic cove, Boca Chica is a grand addition to Acapulco's new era. Once the playground of the Hollywood elite, this upscale area first came to prominence when Orson Welles filmed *The Lady from Shanghai* in the old city center in the late 1940s. Located in the district of Caleta, the 36-room hotel was constructed in the late 1950s next to the glamorous Club de Yates and the famed Los Flamingos Hotel. Today, the vintage exterior looks like it's straight out of a 1950s movie set, but inside, the reinvigorated interior has been chicly remodeled by designers Frida Escobedo and José Rojas. Vintage pieces were curated by Mexican contemporary artist Claudia Fernández, and the spacious, tropically designed rooms come with large hammocks, outdoor living rooms, and private gardens. Guests can venture downstairs to get a massage, chill out with a frozen margarita at the popular in-house disco, hang out on a pool terrace, or order 24-hour sushi room service. Welcome back, Acapulco. You've still got it.

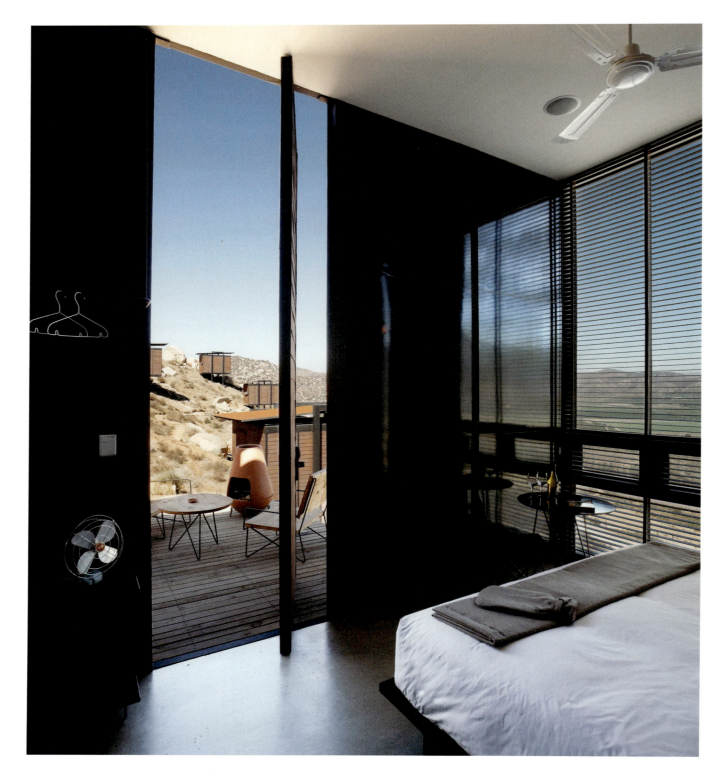

ENDÉMICO
Baja California

Staggered among boulders on a secluded hill in the wine-growing region of Baja California, these luxury cabins bring guests into direct contact with nature. Blending seamlessly with the surrounding landscape, the expansive views of the mountains and fertile wine-growing soils are given pride of place. Endémico, Spanish for endemic, was designed to highlight the isolation of the desert, singling out the qualities that are native to this specific region – something owners Carlos Couturier and Moises Micha planned to emphasize. Situated in the northernmost municipality of Ensenada, in the village of Valle de Guadalupe, this unique landscape is home to some of Mexico's largest wineries and offers a blend of Mexican culture and artisanal activity. To complement the hotel's location, the property was designed by a hand-selected local team, who worked in collaboration with Gracia Studio to give it a distinct ambience. Each of the 20 luxury cabins has unobstructed views of the valley. On the private wooden terraces, guests can sit under a blanket of stars and sip regional wines while being warmed by a roaring fire. Minimal and understated the cabins may be, but modern comforts and deluxe touches have not been overlooked. Monochromatic and with an edited selection of furnishings, they provide comfortable spaces for retreat. From the pool and whirlpool, guests can soak up the calming solitude, while gazing out over the vast expanse. And although the location is remote, the onsite restaurant and bar ensure every comfort is met.

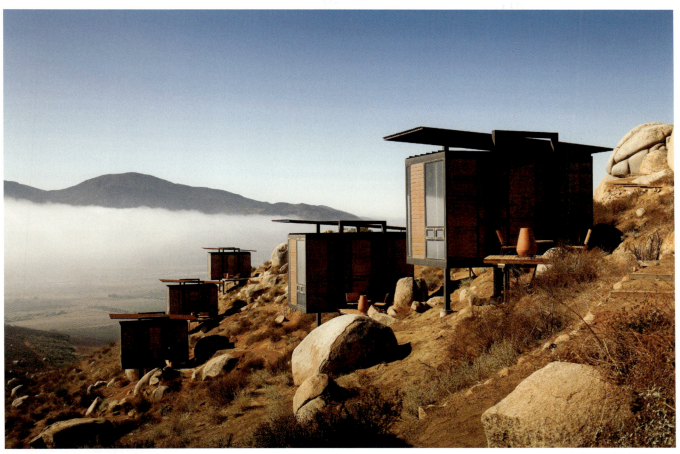
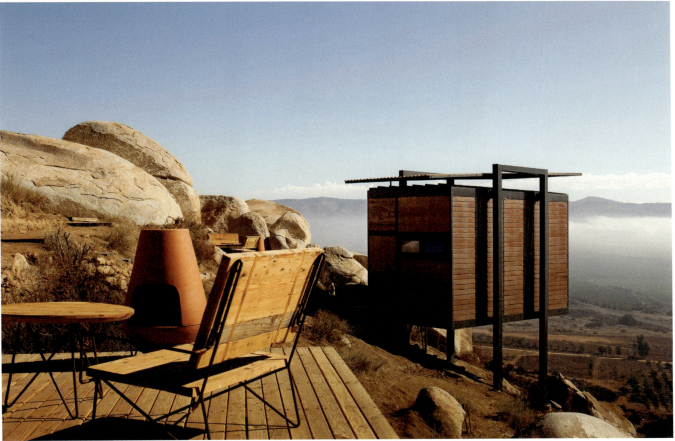

ROSAS & XOCOLATE
Mérida

Named after the two most popular gift items exchanged between lovers, Rosas & Xocolate is designed for guests who take romance seriously. Located in Mérida, the capital of the Mexican state of Yucatan, this all-natural getaway lies in the rich area where the Mayan civilization first discovered cocoa and offered it up to their gods long ago. Reconstituted from two colonial mansions, hotel owner Carol Kolozs has created a haute-pueblo experience that perfectly melds the charm of the historic mansions with modern amenities, such as state-of-the-art entertainment systems and dazzling open-sky bathtubs for guests who desire the utmost in under-the-stars indulgence. Upping the romance factor, fresh-cut roses have been placed liberally throughout the 17 rooms and suites, and chocolate-based spa treatments and sweet-smelling amenities were lovingly engineered by master chocolatier Mathieu Brees, the force behind the hotel's own Belgian-Mexican fine chocolates boutique. Rosas & Xocolate has breathed *new* life into the once glorious avenue, Paseo Montejo, and now stands as the cornerstone in its rehabilitation into the cultural capital's main drag. The hotel's stylish use of local materials like hand-fabricated cement tiles and chucum stucco allows guests to Rosas & Xocolate to fully experience Yucatan's old-world charm as it meets the city's contemporary spirit.

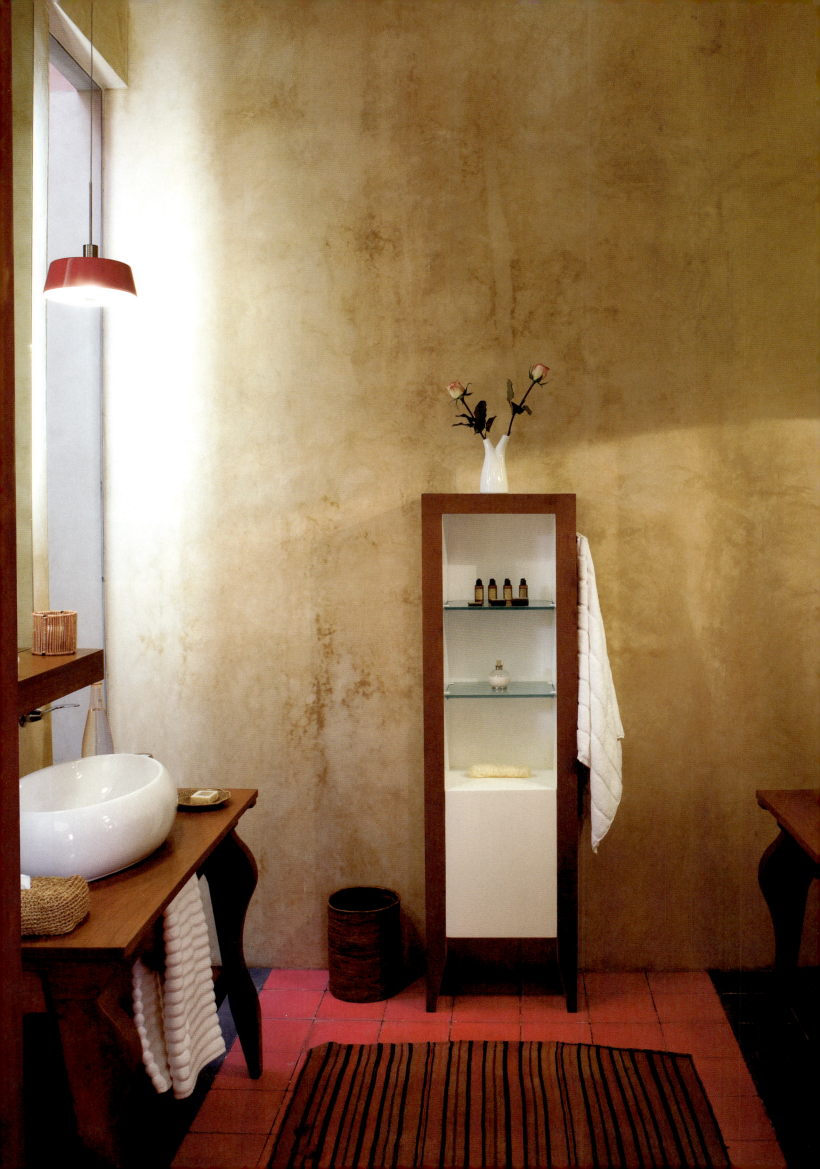

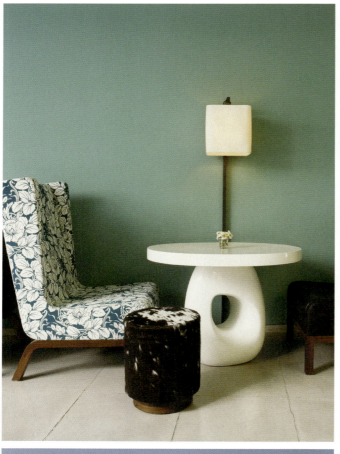
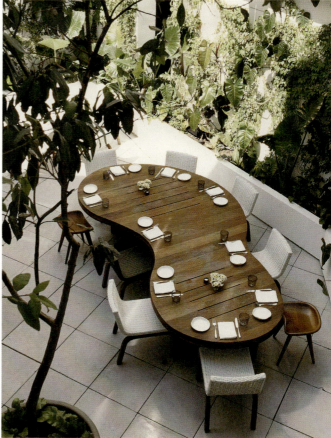
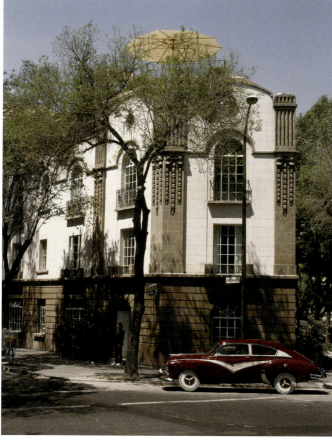
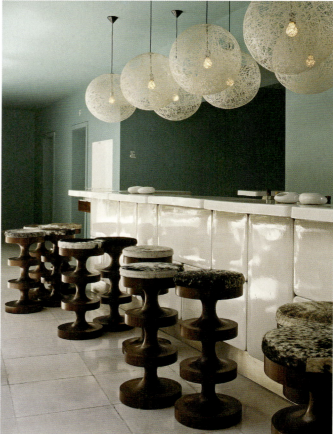

SIGNATURE

WWW.DESIGNHOTELS.COM/CONDESA_DF

ADDRESS
AVENIDA VERACRUZ 102
06700 MEXICO CITY
MEXICO

ROOMS
40

RATES
USD 180 –
USD 700

OPEN
01/2005

MEXICO
MEXICO CITY

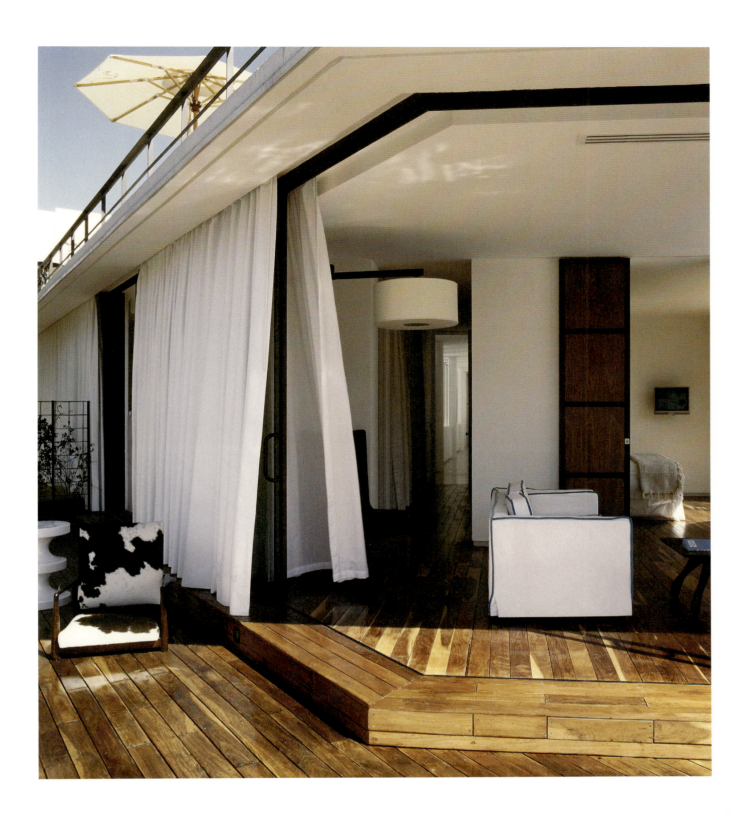

CONDESA*df*
Mexico City

Tucked between historic facades on a tree-lined road in Mexico City's stylish Condesa neighborhood, the CONDESA*df* fuses the spirit of its bohemian surroundings with a playfully simple design aesthetic. Housed in a 1928 building in the French neoclassical style, the hotel is filled from head to toe with custom furniture designed by Parisian India Mahdavi, stone tiles, and an abundance of local color. The feel is modern yet warm, hip but not haughty. The 40 rooms and suites were inspired by the tranquillity of monastic bedrooms – but without a lack of amenities, of course. The result is 40 calming, airy spaces, some of which open onto wooden terraces. But the most prominent interior feature is the flora-filled inner courtyard, El Patio, where a destination restaurant serves delicious fare in a series of scattered privacy-optional rooms both indoor and out. Downstairs, a basement bar offers a whimsically modern cocktail spot, while further aloft, the rooftop bar La Terraza affords stunning castle views. At the charmingly named Myself area, a hammam, thermal bath, wet area, and gym invite guests to indulge in relaxation. Meanwhile, an overarching floral theme – visible on everything from cushion covers to chopstick wrappers – serves to enhance the relaxed warm-weather vibe.

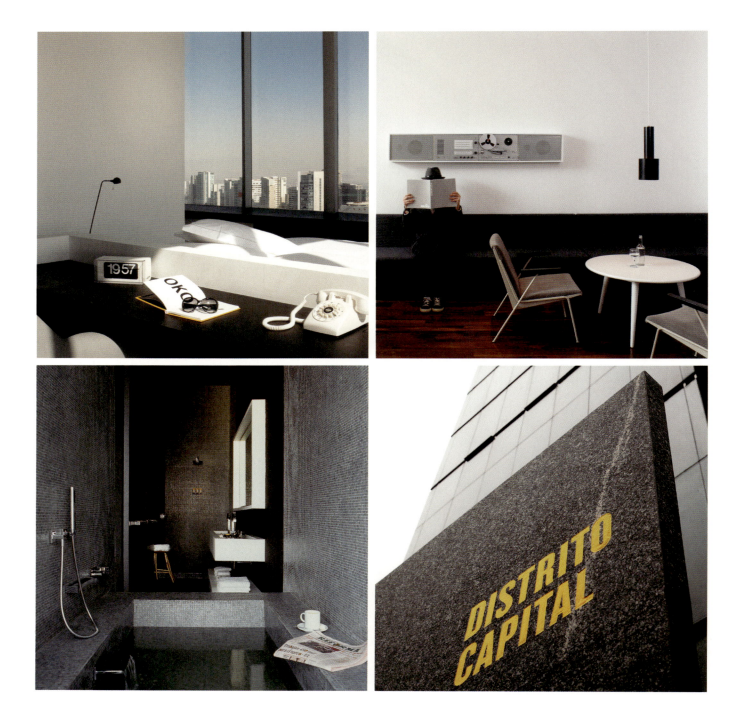

DISTRITO CAPITAL
Mexico City

Surprising interiors, dazzling panoramic views, and double-height ceilings are a few of the eye-catching highlights of Distrito Capital. Located in the highest area of Mexico City – the skyscraper district of Santa Fe – this hotel is a testament to how cool Mexico's capital has become in recent years. Designed around the idea of creative minimalism, the 30 well-appointed guestrooms and suites look more like chic art spaces than hotel rooms. Any visitor will be simultaneously awed by impeccable design touches and excited by personal service flourishes. Fashionable without being zeitgeist-y, the inviting decor allows visitors to truly kick back and relax. The hotel is punctuated by vintage furnishings courtesy of famous mid-century designers. And Parisian interior designer Joseph Dirand has successfully created thought-provoking social spaces within the property, such as a lounge-friendly pool area and several spectacular terraces. In fact, the Enrique Olvera-curated restaurant on the fifth floor is one of Mexico City's newest and most fashionable meeting places. Guests will feel like they've stepped into their dream apartment.

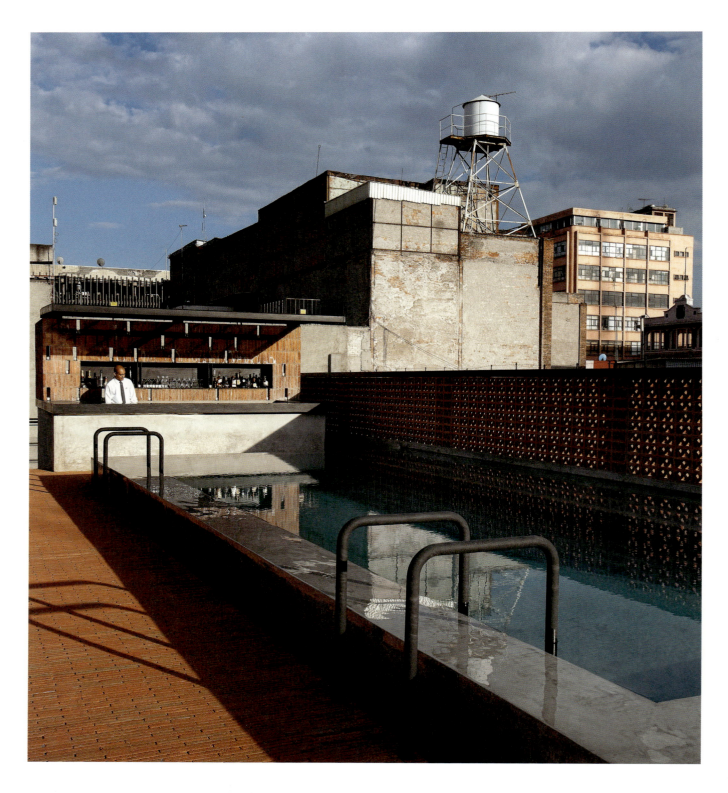

DOWNTOWN
Mexico City

Blending colonial 17th century grandeur with a raw industrial edge, Downtown integrates local indigenous culture into its concept while celebrating its location in the Centro Historico borough of Mexico City. Known as the "Palacio de los Condes de Miravalle", it sits comfortably next to other colonial landmarks on the cobbled streets of this UNESCO World Heritage Site. For each of his properties, owner Carlos Couturier uses a local team and integrates the local culture into the concepts. Such was the case when lovingly renovating the Downtown, one of the oldest residences in the area that still maintains this particular Mexican viceregal style. The property blends elements of colonial style with local, indigenous culture. Characteristics such as ornate detailing around the windows of the façade and a spectacular stone-forge staircase with intricate handrails sit alongside red volcanic rock walls and handmade cement tiles. The 17 rooms and suites possess a stripped-back, bohemian-chic elegance. They range from the simple and unadorned, decorated with little more than white walls and tiled floors, to the stylish, with light timber detailing, exposed concrete walls and vaulted high brick ceilings. Street-side rooms have balconies to take in the views, while the others look over the lush and perfectly manicured patio. This palace grandeur is contrasted by the edgy character of the immense terrace which covers the entire rooftop. From these sun-soaked surroundings guests can get a glimpse over the historic buildings, while cooling off in the pool or sipping on a drink from the bar.

*SIGNATURE

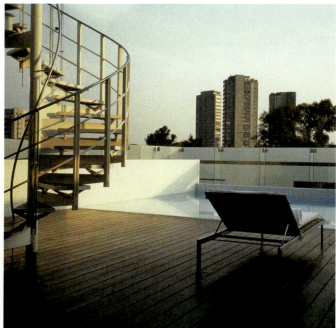
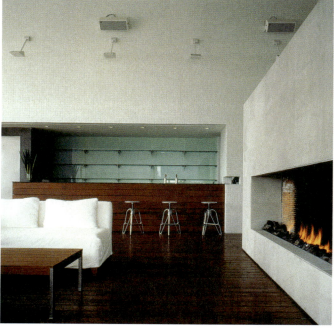
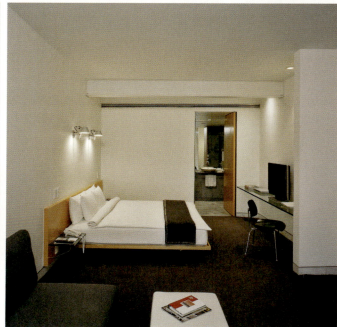

MEXICO
MEXICO CITY

OPEN
10/2000

RATES
USD 160 –
USD 415

ROOMS
36

ADDRESS
AV. PRESIDENTE MASARYK 201
11560 MEXICO CITY
MEXICO

WWW.DESIGNHOTELS.COM/
HOTEL_HABITA

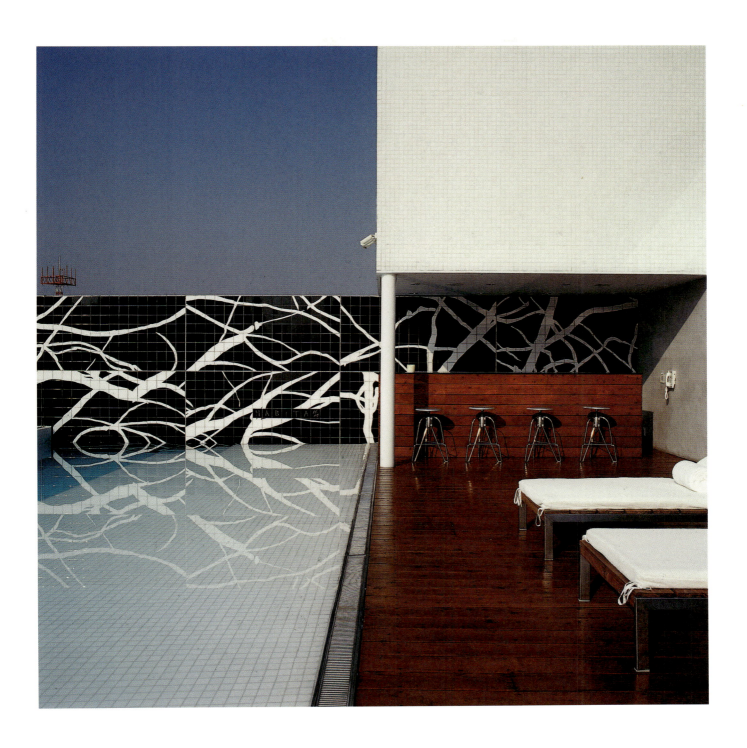

HABITA
Mexico City

Like an ice cube on a hot street corner, Mexico City's Habita exudes a paradoxically austere luxury at the heart of one of the world's most populous cities. The complete makeover of the 1950s building by Mexican group TEN Arquitectos has encapsulated the 36-room hotel in a sensational floating glass box suspended from the five-story structure's facade, mediating views and providing a stylish privacy for the cosmopolitan jet set. Sandwiched between new and old facades are original balconies and new corridors. Contemporary art is served by the metal Jan Hendrix mural hanging in the reception area; guestroom space contains only a bed, Eames chairs and a cantilevered plane of glass serving as both desk and table, while everything else is concealed behind a polished paneled wall – a spatial clarity that gives travelers peace of mind. The daylight from the floor-to-ceiling glass windows and doors onto balconies is aesthetically matched by Artemide and Flos lamps. The ground-floor Mexican bistro and rooftop pool and bar offer radical refueling and spectacular views after explorations among the chic boutiques and tree-lined boulevards of the fashionable Polanco district.

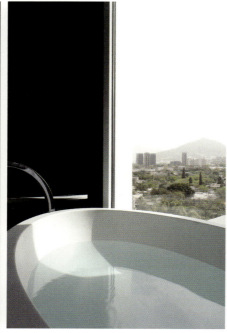
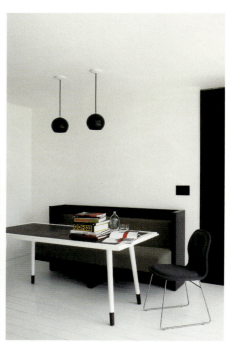

HABITA MONTERREY
Monterrey

Why would a world traveler, a global nomad, an itinerant businessperson, or just an aesthete want to check into the Habita Monterrey? Because it's the seventh property by Mexican hoteliers extraordinaire Grupo Habita – a group known for its style, energy, innovation, and even intuition. Because the 39-room building is a curvilinear vision in clean, clear black and white; a true oasis in the desert and an homage to classic mid-century design. Because it's already a hopping nightlife and social hub in the northern Mexican city of Monterrey, the crossroads between the United States, Mexico, and the world. Because the rooftop terrace, with two pools and a bar, has jaw-dropping 360-degree views of the mountainous surroundings and rests under a cool concrete canopy. Because guests here find not just wireless Internet, but also a computer, and even the peace and quiet to concentrate as they make deals and move mountains. Because service is five-star – always cordial, never cold. Because chef Enrique Olvera's restaurant Lobby and a musical concept by Parisian DJ Monsieur X make eating and lounging here unforgettable. That's why.

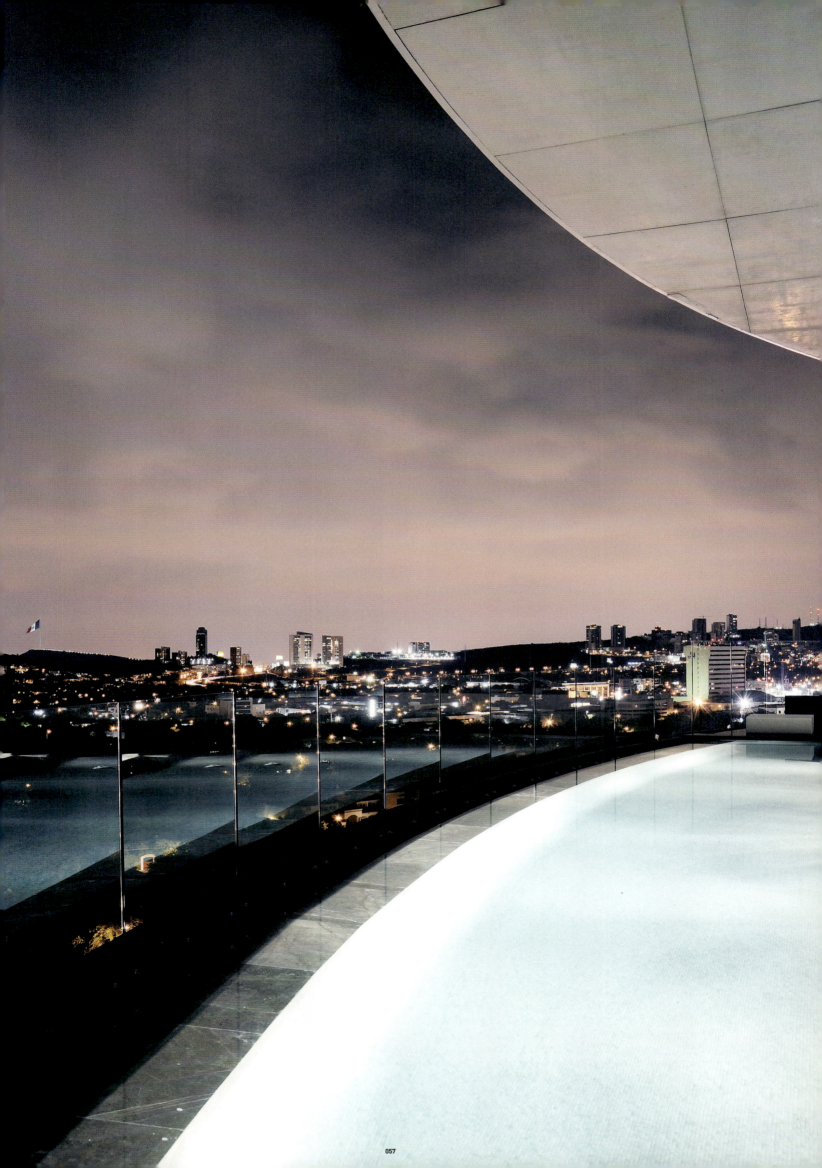

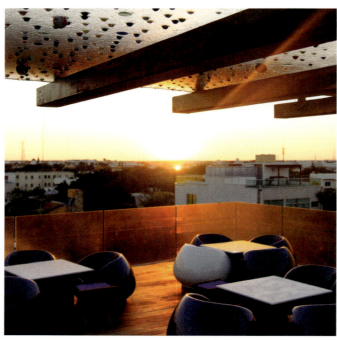

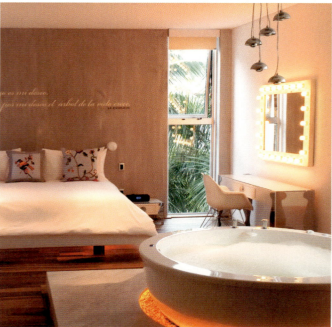

BE PLAYA
Playa del Carmen

In the sassy Mexican beach resort of Playa del Carmen, midway between Cancun and Tulum, there's one hotel that stands out from the crowd. With a fresh, bohemian vibe and a cool rooftop infinity pool that is a meeting point for the city's "next generation" of movers and shakers, Be Playa is undoubtedly one of the most sophisticated hangouts in town. And it's not really surprising that a sociable, chilled-out vibe figures so highly here – after all, Argentinean owner and designer Sebastian Sas has already proved his design ethos at sister hotel Be Tulum, which also puts a strong emphasis on creating communities. With spacious public areas accented by simple, straightforward lines, Sas designed Be Playa as a calming place where mature revelers can meet and mingle before hitting the bars. Soothing, high-quality materials like fair-faced concrete and white marble dominate all 23 of the imaginative suites, which feature hammocks and huge whirlpool hot tubs; a rooftop sushi restaurant provides uplifting views over the Riviera Maya. Tucking into the fine, soy-drenched sashimi up here, you'll feel like you're on top of the world.

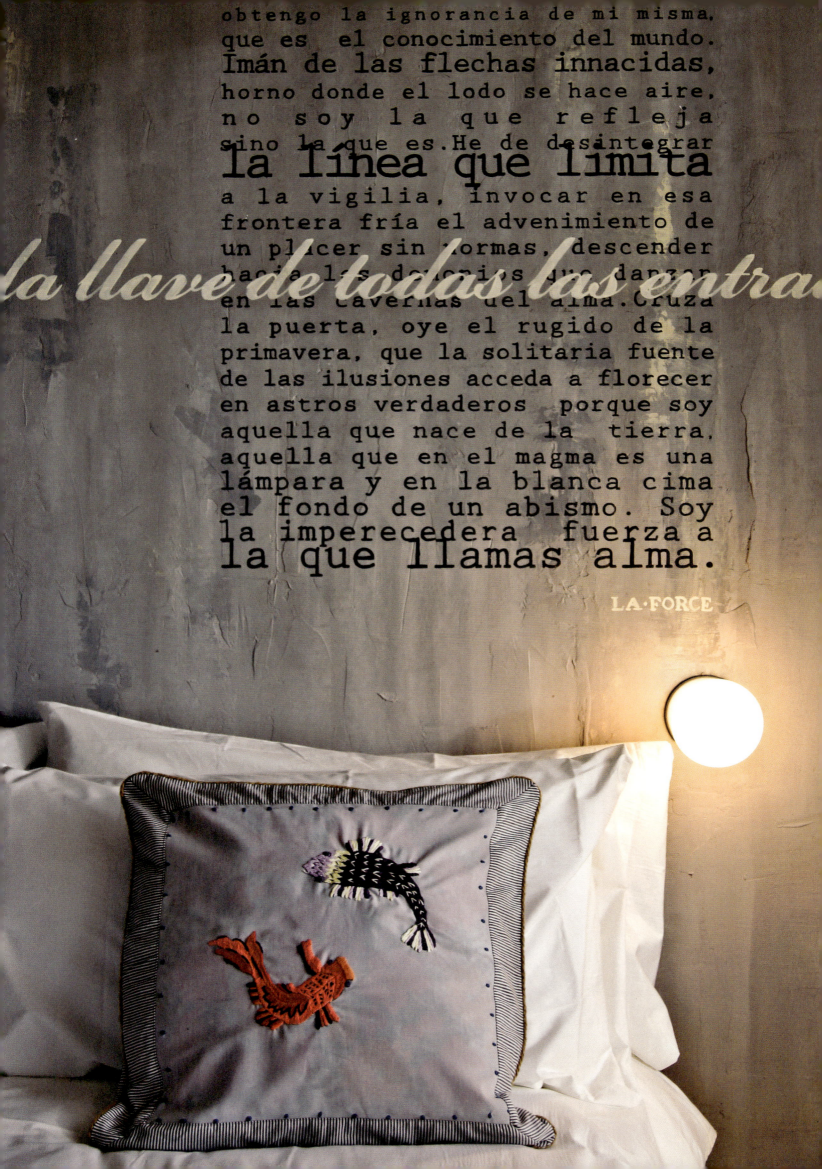

DESEO
[HOTEL + LOUNGE]
Playa del Carmen

A glowing white two-story structure in the mellow fishing village of Playa del Carmen, the Deseo has become one of the hottest spots on the Yucatán Peninsula. Created by the groundbreaking Mexican Grupo Habita, the hotel evokes the charm of the Caribbean coast while creating a level of sophistication aimed directly at the discerning international style connoisseur. The hotel's focal point is the lounge area, which combines the functions of lobby, restaurant, bar, and pool. Set on a raised open-air platform, it is furnished with comfortable Belize chairs, generous day beds, and breezy linen curtains that provide a relaxed Caribbean flavor and encourage social interaction. The DJ's chilled-out tunes provide the perfect sonic backdrop to the comfortable setting. Each of the 15 sound-proof rooms and suites provides a literally and emotionally cool retreat from the heat with the help of cream marble floors and a natural color palette designed to soothe both the eye and the mind. Comfortable, visually striking guestrooms boast fun details like sliding wood doors, beach fiesta kits, and hammocks. More traditional style elements, like the imposing stone entrance modeled on a Mayan temple, manage to ground the design concept with local tastes.

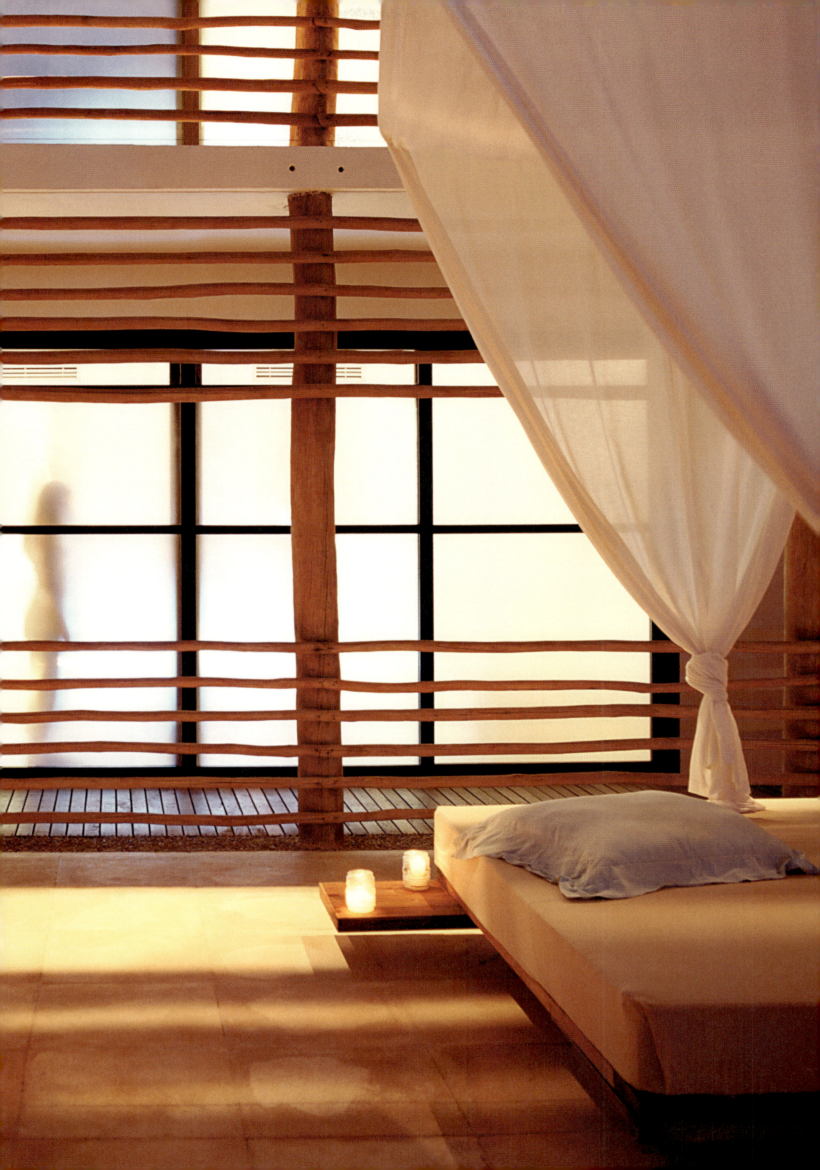

HOTEL BÁSICO
Playa del Carmen

Located steps from the ocean in the bustling center of Playa del Carmen, Hotel Básico attracts a style-savvy young crowd with 15 quirky rooms distributed over four floors. Here, traditional ideas of everyday Mexico are brought to life: references to public schools, cantinas, and the petroleum industry permeate the property, imbuing the hotel with an exciting local feel. The Básico's first two stories house air-conditioned guestrooms whose pink neon lamps, intentionally exposed plumbing, and subdued lighting create an almost sexual tension, punctuated with surprises like floating beds and whimsical objects such as autographed footballs, floating tires for swimming, and even beach club passes. In the top floor's Azotea Bar and pool area, two petroleum water tanks act as pools, offering superb views of the Caribbean and the vibrant beach town below. On steamy evenings, guests can enjoy sea breezes and the sounds of local DJs from customized truck fronts that serve as cabanas with built-in mattresses. Speckled with amusing popular accents and made mostly from recycled materials that challenge preconceived notions of what a design hotel should be, the Básico updates Mexican nationalism and makes it something for the world to enjoy.

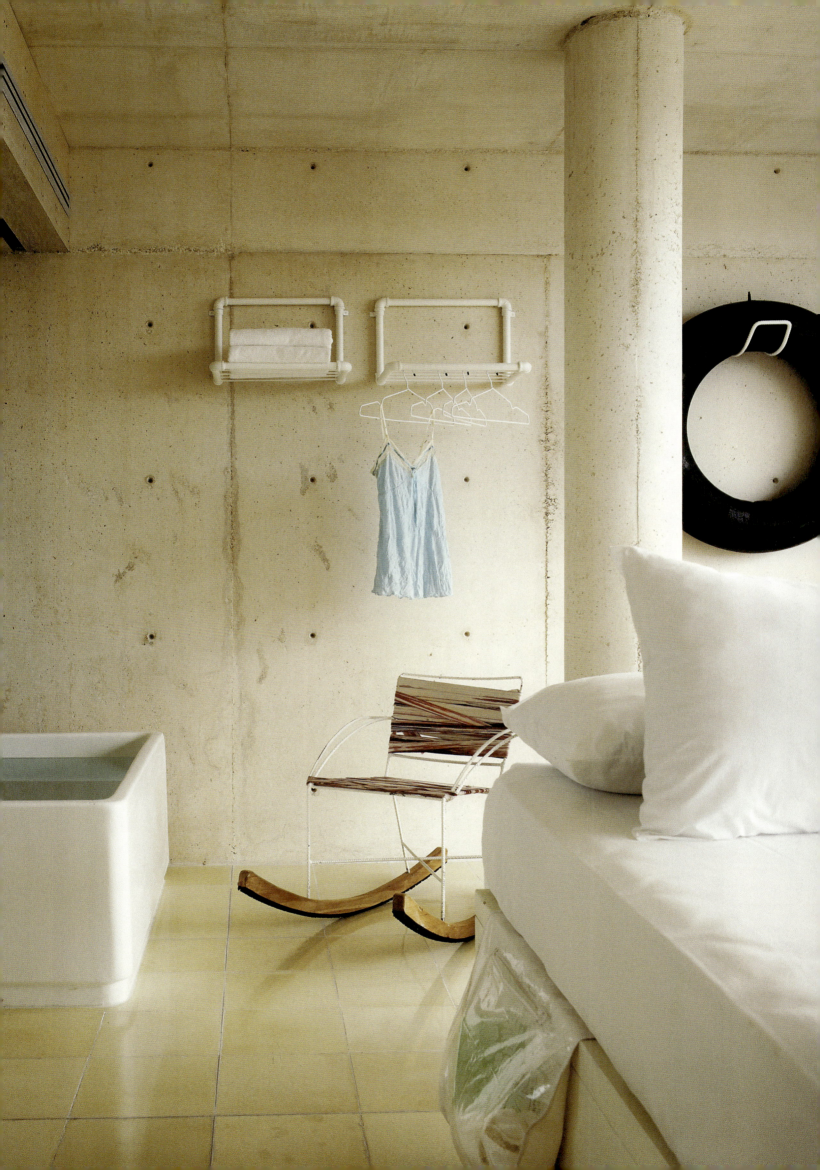

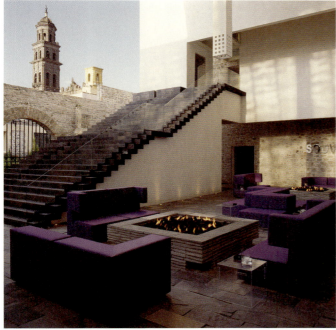
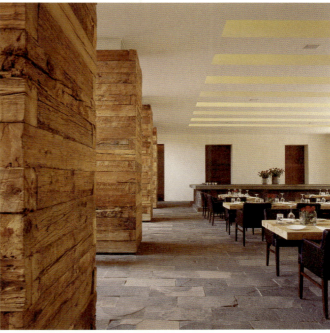
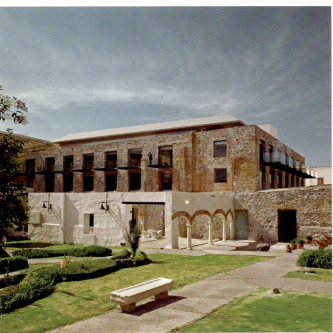
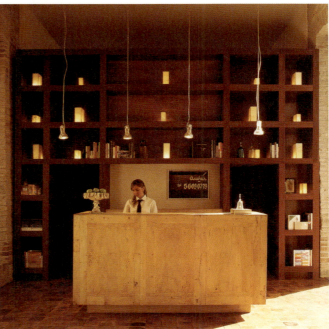

LA PURIFICADORA
Puebla

Located in the historic center of Puebla, a colonial city on the road between Mexico City and Veracruz, La Purificadora is the new incarnation of a late 19th-century factory long used to purify water for the production of ice. The tradition of purity is still the guiding leitmotif at this minimalist yet modern and edgy hotel designed by Legorreta + Legorreta, the sixth by Mexico's trend-setting Grupo Habita. The retention of many of the building's original elements, including crumbling walls and stone aqueducts, lends La Purificadora an air of authenticity, while modern juxtapositions like a glass-walled swimming pool and sleek purple lounge chairs create a clean, sophisticated ambience. The resulting mix of new and old is truly stunning, nowhere more so than in the hotel's public spaces, which include a rooftop terrace with lively bar and pool, ground-floor patio, restaurant, library and wine cellar. Most of the hotel's 26 guestrooms – including three suites with private whirlpools – offer spectacular views of the hotel gardens and the city center beyond, a UNESCO World Heritage Site. As would be expected from the innovative hoteliers at the Grupo Habita, La Purificadora offers travelers and locals alike a comforting yet always stimulating experience, a mix of tradition and contemporary flavor in its purest form.

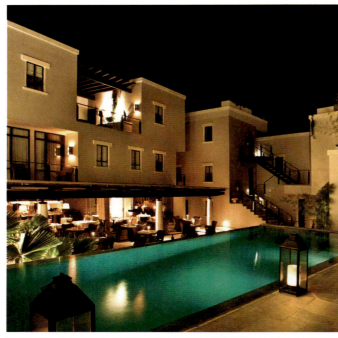

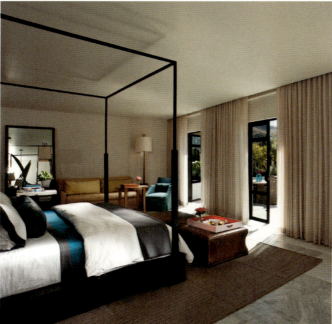
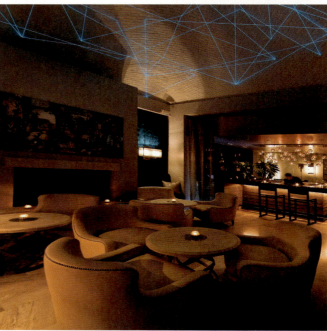

HOTEL MATILDA
San Miguel de Allende

Nestled among terracotta houses and colonial-era church spires, Hotel Matilda distinguishes itself from the rest of the UNESCO-listed San Miguel de Allende with straight white exterior lines and an edgy landscape concept that invites visitors to take a closer look. Expat artists have gathered in this colonial city for generations, forming a tight community. That's why these cobbled streets were the ideal location for this hotel, with its eclectic collection of contemporary art. Beyond the glass doors, strategically placed works by emerging and established stars of the Mexican art world sit against a blank canvas of marble and quarried rock. While these rotate, many of the pieces are on display permanently, like the Diego Rivera portrait of the hotel owner's mother Matilda, which hangs in the lobby. The hotel's design fuses the traditional colonial style of San Miguel with Mexican touches like textured wood and warm stucco, set against a backdrop of creamy blacks, browns and beiges. This motif continues in the 32 rooms and suites where marble floors are accented with rich caramel and bold turqoise-colored pieces. A verdant meditation garden and indigenously-decorated Hammam await guests at the spa, which offers holistic treatments from around the globe. The food and beverage concept takes a more local approach: the restaurant's "farm-to-table" menu serves up creative regional fare made with locally-sourced ingredients, while drink options include tequila tastings and cocktails crafted from indigenous fruit and herbs by the hotel's mixologist.

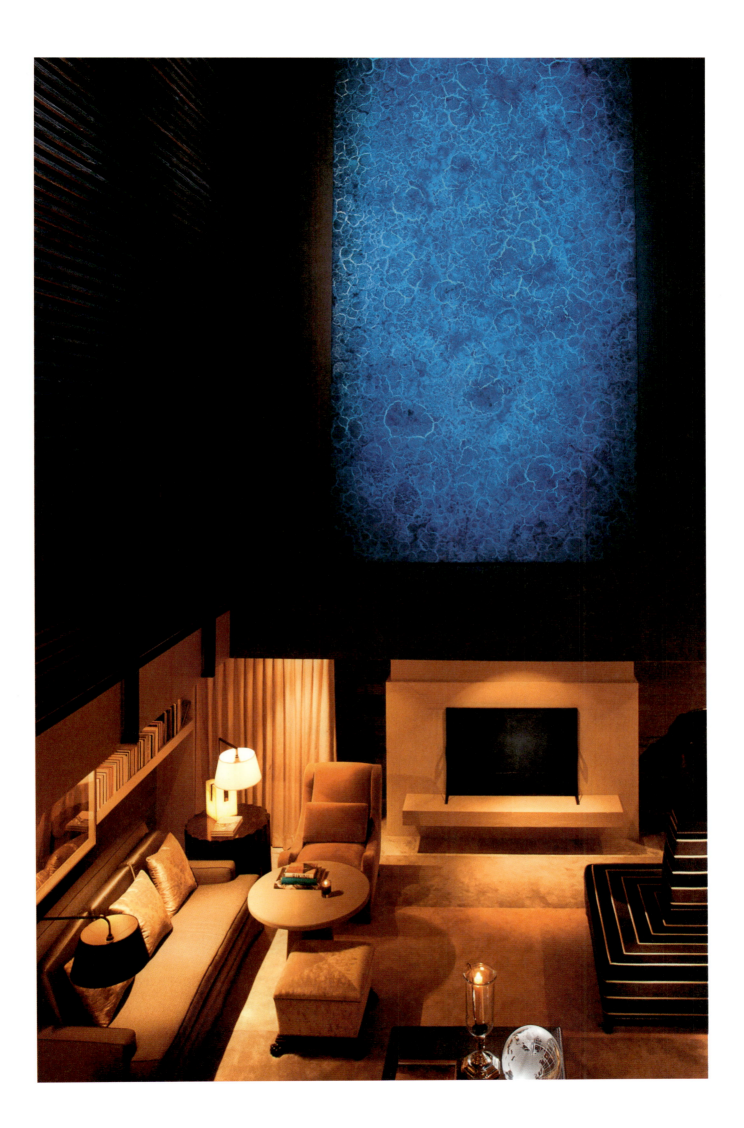

BE TULUM
Tulum

Perched on a secluded expanse of the luminous Mayan Caribbean, and surrounded by legendary relics of one of the world's most ancient cultures, Be Tulum's comfort and tranquillity offer a fast track to peace of mind. It is the only full-service resort in the area and features contemporary design in perfect harmony with the untouched natural setting. While serving as a haven of relaxation, the resort is also the place to be for the region's creative scene. Establishing a community of locals and guests is very important to the Argentinean-born Sas brothers – the co-owners of the Be Hotel group. Their reputation as Cordoba's preeminent event organizers becomes evident in the hotel's celebrated restaurant and in the rooftop bar, where like-minded people come together to enjoy the laid-back ambience. Be Tulum's twenty spacious suites are housed in five buildings sharing a contemporary, minimalist design mix of local limestone, warm Brazilian wood, and bold Bisazza mosaic tiles. Ground-floor suites come with a private pool and terrace, while upper floors offer free-standing Jacuzzi tubs and balconies. Two private penthouses feature their own terrace pools and treat guests to a breathtaking view of the UNESCO World Heritage site of Sian Ka'an, the "birthplace of the sky." With full-service hospitality, vibrant spaces to see and be seen, and a chic, laid-back ambience, Be Tulum is a secret gem hidden on the lush Mayan Riviera. Just Be.

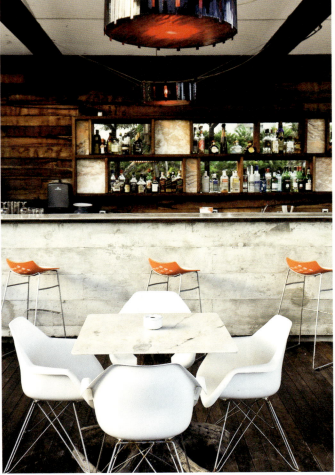
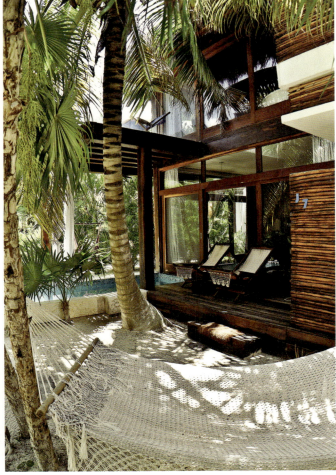

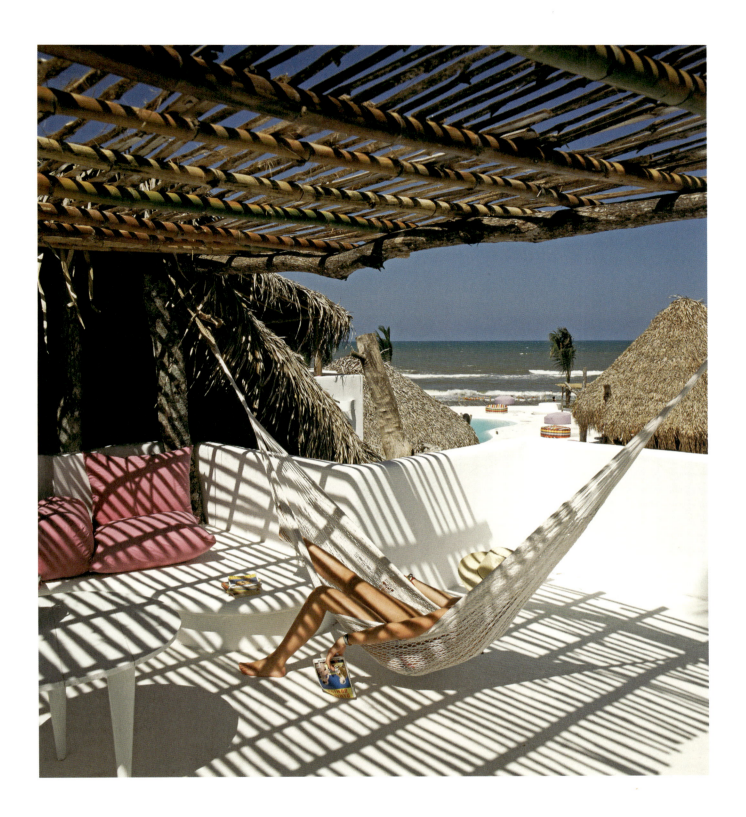

AZÚCAR
Veracruz

From the founders of ultrahip Mexican hotels CONDESA*df* and Deseo comes Azúcar, named for the sugar cane grown in the state of Veracruz, where this hideaway is located. The "sweet" resort is effortlessly elegant, featuring 20 low-lying whitewashed *palapas* (bungalows), each topped with a thatched roof. "I wanted to recuperate a lifestyle gone by," explains hotelier Carlos Couturier. "To give guests the pleasures of simple things." Thus chairs are reproductions of those his grandparents had in their 1930s ranch, and each bungalow is named after a Veracruz sugar mill. A back-to-basics white-on-white aesthetic offers an authentic style that both hearkens to the past and fulfills the modern traveler's aesthetic demands. A locally made hammock stretches across the private patio featured in every *palapa*, inviting guests to swing as the Gulf breezes blow; the airy ease makes the resort a haven for those weary of mass tourism. Highlights include a relaxing *biblioteca* (library) where guests can lounge in wicker chairs under an open thatched ceiling, as well as an outdoor spa that features a yoga space and an array of holistic spa services. True to its name, Azúcar is like a sweet treat that keeps guests coming back for more.

*OFFBEAT

WWW.DESIGNHOTELS.COM/
MAISON_COUTURIER

ADDRESS
APARTADO POSTAL 110
93620 SAN RAFAEL, VERACRUZ
MEXICO

ROOMS
9

RATES
MXN 1200 –
MXN 3900

OPEN
09/2009

MEXICO
VERACRUZ

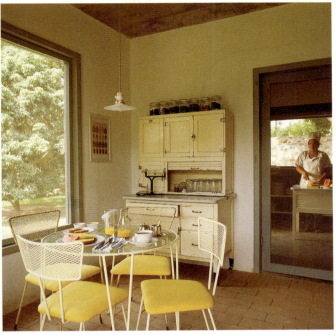
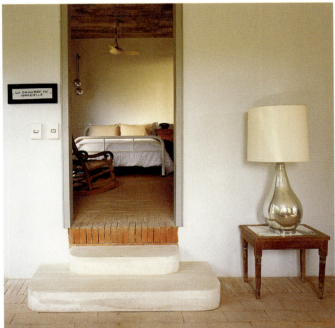
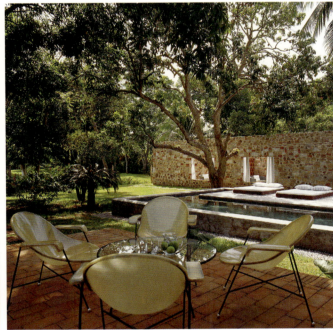

MAISON COUTURIER
Veracruz

Built by French immigrants in the 19th century, Maison Couturier is an agricultural estate in the tropics of Veracruz, Mexico. Based on family traditions handed down through generations, the resort preserves the heritage of its French founders in this secluded tropical enclave in Mexico. Maison Couturier is a place where guests and visitors alike can come to breathe in the fresh scent of nature and drink of the refreshing waters of history preserved. Guests can choose between eight bungalows and the landowner's suite, "la chambre du maître," in which they can enjoy massages, private terraces and hammocks, and all the amenities of contemporary living such as wireless Internet, air conditioning, and plasma-screen televisions. The restaurant in the main house draws on the best of French bucolic culinary tradition, offering "fait maison." Guests are also invited to enjoy a cocktail full of fresh local fruit at the bar, sit by the pool in a palm's shade, or partake in an excursion to the region's secret archaeological sites. When the best of the Mexican and French traditions are combined, along with a splash of contemporary luxury, the result is pure, natural bliss…and that is what Maison Couturier provides.

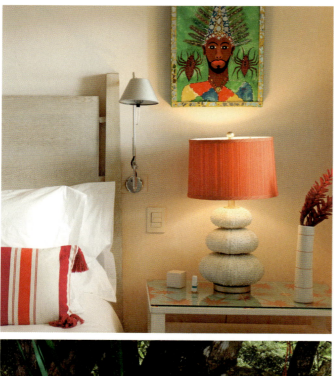
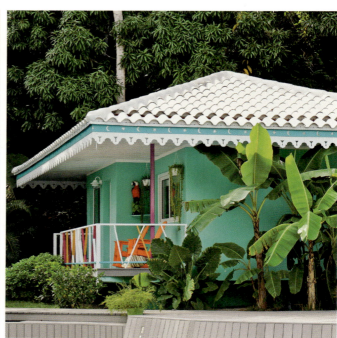

EL OTRO LADO
Portobelo

Panama's steamy rainforests, swampy mangroves and kaleidoscopic coral reefs are all within easy reach of El Otro Lado, a remote retreat on 110 hectares of land that prides itself on local integration. Guests are invited to sit back and take in these idyllic surroundings, while sipping a passion fruit mojito, and encouraged to discover more about the region's Afro-Panamanian heritage. Situated near Portobelo, and adjacent to centuries old fortifications that are a UNESCO World Heritage Site, the surrounding jungle buzzes with natural life. This thriving landscape provides the backdrop for endless hours of relaxation. But there are countless options to explore should an active mood strike you, including fishing, rainforest tours, and snorkeling at one of the nearby beaches, transported by one of the hotel's four motor launches. With a tropical soundtrack curated by renowned broadcaster, Gladys Palmera, it's possible to gaze across an azure bay to Portobelo, a 400-year-old town built by Spanish colonists. Closer by, sensory thrills come straight from El Otro Lado's interiors, which integrate Arte Povera with 20th century sculptures and contemporary black-and-white photography throughout the hotel's four villas. Social activity centers on the Gazebo – the hotel's restaurant, bar and lounge – adorned with carnival masks and white sofas splashed with brightly colored cushions. Here, chefs bring Caribbean ingredients and colonial flavors together nightly and guests can while away hours gazing over the infinity-edge pool, which appears to flow seamlessly into the pristine bay.

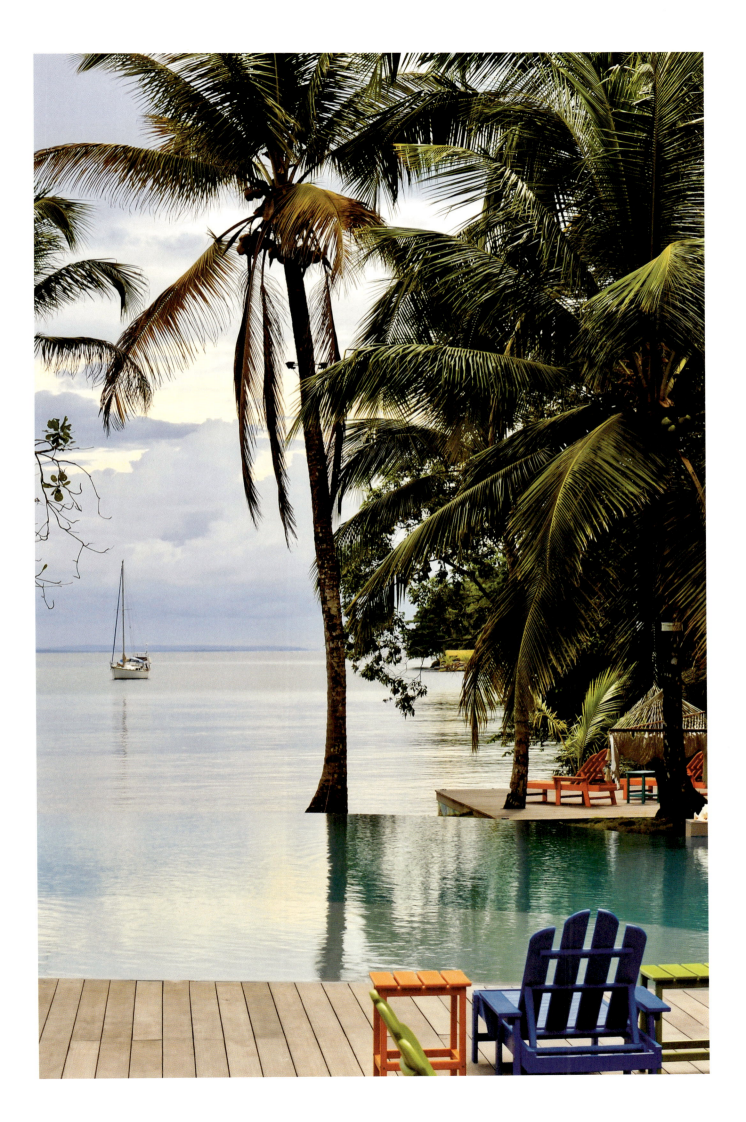

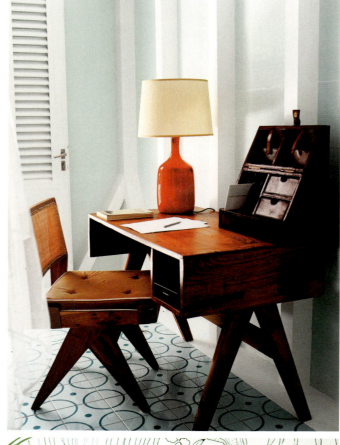
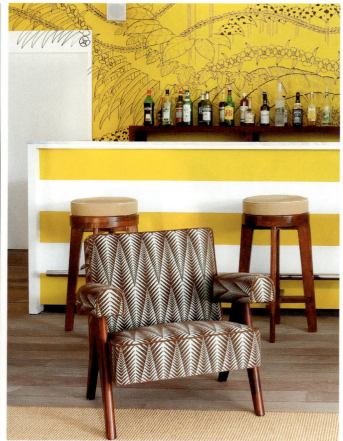
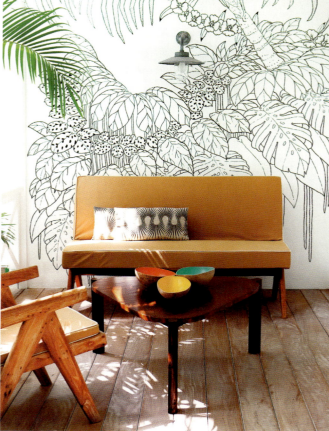
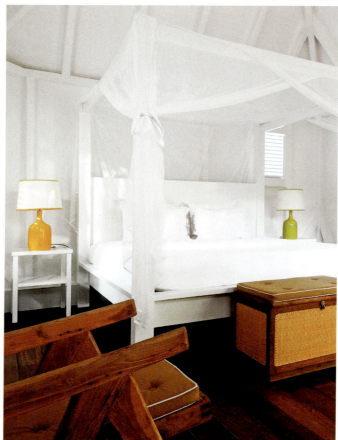

Saint Barthélemy

Entering Hotel La Banane on the Caribbean island of Saint Barthélemy, visitors instantly feel immersed in a world of vintage luxury. Hotel owners Jean Marc Israël and Benjamin Fabbri have a passion for highly-collectable furniture from the 1950s. Vibrant splashes of color such as raspberry red and canary yellow liven up the white bungalows and wooden terraces, providing a colorful backdrop to showcase their impressive collection. Famed Swiss architect Pierre Jeanneret designed many of the hotel's furnishings for the administrative buildings of Chandigarh, the capital of Punjab, a planned city by Jeanneret's cousin Le Corbusier. The 1950s furniture fuses tropical charm with modernism. The tropical whimsicality carries throughout the property, from the bright bar with playful hand-painted murals, to the private garden nestled in a coconut grove planted with fragrant frangipani, jasmine and hibiscus. In this lush, shady enclave, guests can while away hours on a recliner, stretched out by one of the two shimmering pools. Set around the garden, the nine individually-designed bungalows are all named after artists, designers and craftsmen who were at their zenith in the 1950s such as Serge Mouille and Jean Royère. Each of the light and airy rooms has a private tropical garden, a terrace or an open-air bathroom, bringing the surrounding nature right into the living spaces. Light snacks are available for lunch and a full menu is available in the evening. Room service can be enjoyed poolside or in the privacy of the bungalows, and meals can be ordered in from neighboring restaurants. Lorient Beach, still undiscovered by most tourists, is just 50 meters away, but with in-room massages on offer and inviting swimming pools glistening, guests are often tempted to stay right where they are.

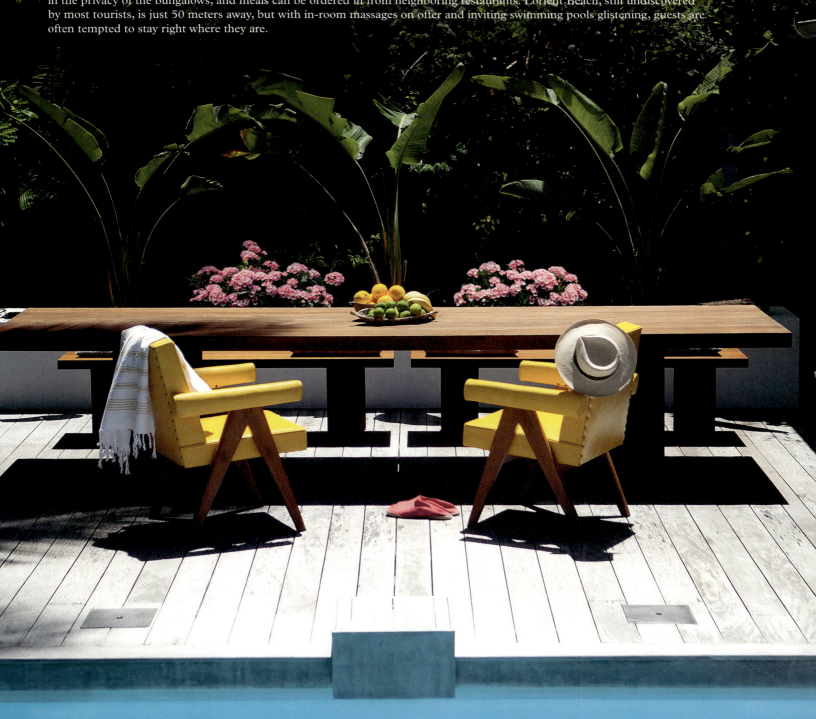

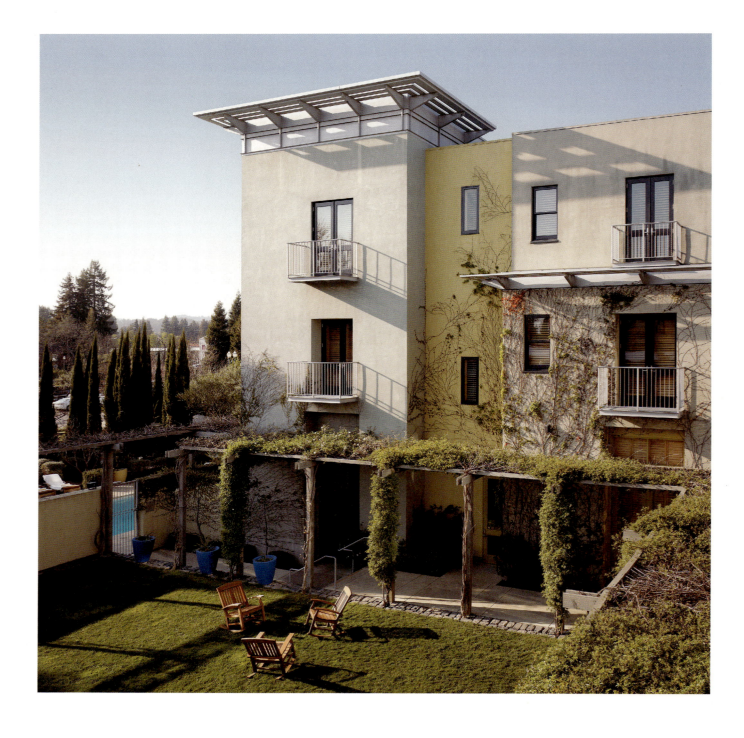

HOTEL HEALDSBURG
Healdsburg

Located in the heart of California's North Sonoma wine country, Hotel Healdsburg stands on a historic town square, minutes away from some of the world's best vineyards. The three-story stucco building's warm ambience invites guests to embrace the healthy local lifestyle. Light floods through French doors leading onto private balconies, and artfully landscaped garden paths snake through the well-kept grounds. A garden pool and spa offer everything in the way of serenity and relaxation, while an extensive bar provides a menu of inventive cocktails. The real highlight, though, is star chef Charlie Palmer's Dry Creek Kitchen restaurant, a celebration of fresh seasonal ingredients straight from the Healdsburg Farmer's Market, served either indoors or out on a garden patio overlooking the historic plaza – usually with a bottle of exclusive local wine. Twice a week, the hotel hosts complimentary tastings featuring local wineries, while live jazz plays in the hotel Fireplace Lounge, completing the picture of tranquil sophistication. Guestrooms display a bountiful mix of comforting elements, including teak furniture, hickory-pecan wood floors, Tibetan rugs, goose-down duvets, and six-foot soaking tubs.

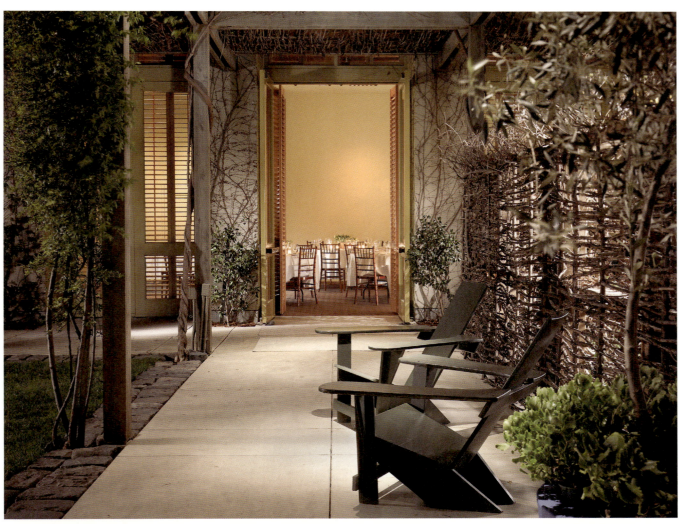
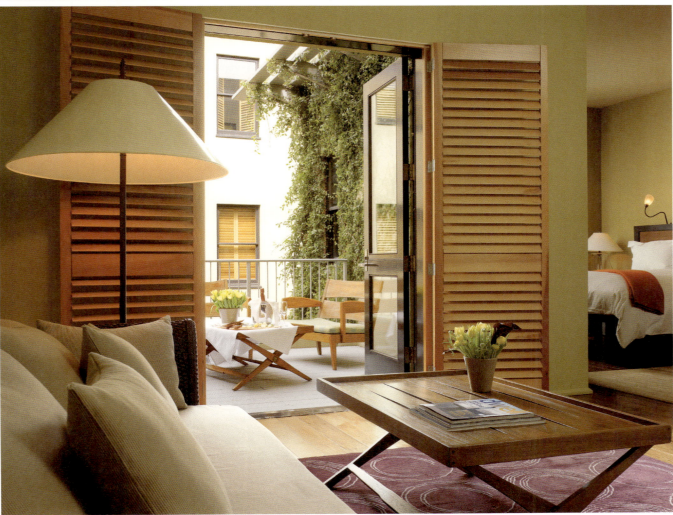

THE STANDARD, HOLLYWOOD
Hollywood

The Sunset Strip is where the Hollywood legend began and continues to this day. Enter André Balazs, hotelier and real-estate developer extraordinaire. It was at this location in 1999 that André launched the iconic Standard, Hollywood, which represented the beginning of a bicoastal and groundbreaking shift in the hospitality industry. Converted from the original 1963 Thunderbird Motel to the snoozy Golden Crest Retirement Home, the curvaceous and supple building was given room to breathe as The Standard, Hollywood. *Newsweek* calls the result, "chic, spare & super cool." And indeed it is anything but standard – from the upside-down entrance sign to the Cactus Lounge with a wall-to-wall desertscape and the reception desk adorned with a glass vitrine featuring nightly performance art pieces. The Standard, Hollywood is the place to see and be seen for its youthfully chic and sophisticated clientele. Its 139 rooms range from Budgets to Suites, and each is decked out with Warhol poppy print curtains, iHome stations, flat-screen TVs, silver beanbag chairs, and rockin' minibars with all the essentials. The 24-hour restaurant, the barber shop, business center, lounges, and a cobalt blue Astroturf poolside sundeck are just a few of the elements that have firmly established the hotel as a Hollywood classic. The hotel's pioneering and irreverent take on hospitality has turned convention on its head at every corner.

THE STANDARD, DOWNTOWN LA
Los Angeles

Upon seeing the elegant former headquarters of the Superior Oil Co. in 2000, André Balazs fell in love and bought it virtually on the spot. By May 2002 the Carrara-marble-clad construction had become his second Standard hotel, this time in the heart of downtown LA. The *Business Traveller* calls it, "A visual treat from the moment you step inside." But this 12-story hotel and its 207 guestrooms far surpass the established corporate hotel paradigm: the grand lobby is partially a historic architectural landmark with 1950's-era ornaments such as a 15-time zone clock encased in stainless steel. The generously sized guestrooms, ranging from "Cheap" – 28 square meters to the "Bigger Penthouse" – 93 square meters, embody The Standard's distinctive decor with such highlights as platform beds, oversize bathtubs or showers, custom bath amenities, and mood lighting. The Rooftop Bar, bejeweled with a heated swimming pool, a red Astroturf sundeck, and vibrating waterbed pods (not to mention a bar and dance floor with nightly DJs), is one of Los Angeles's most coveted nightlife destinations.

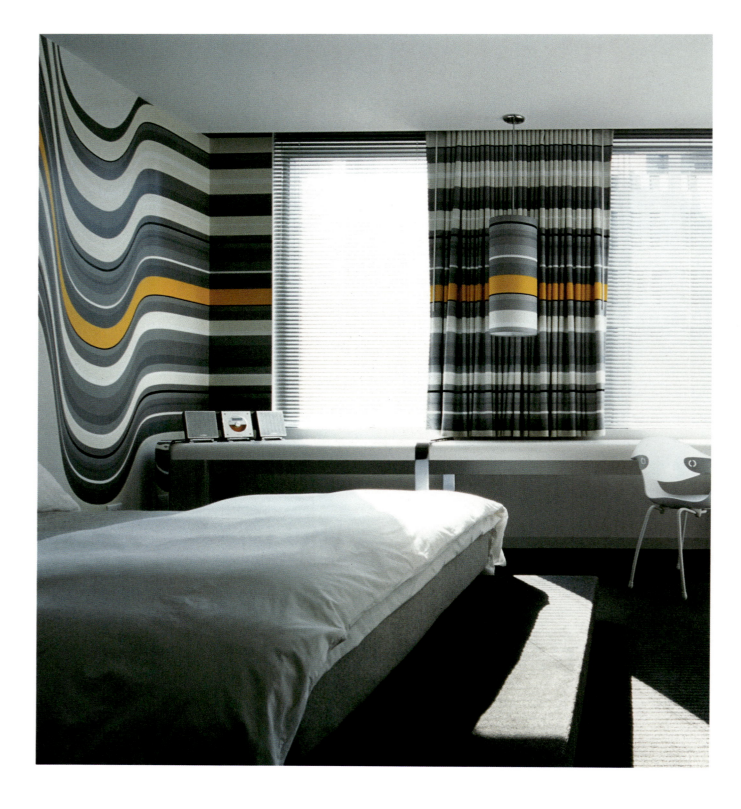

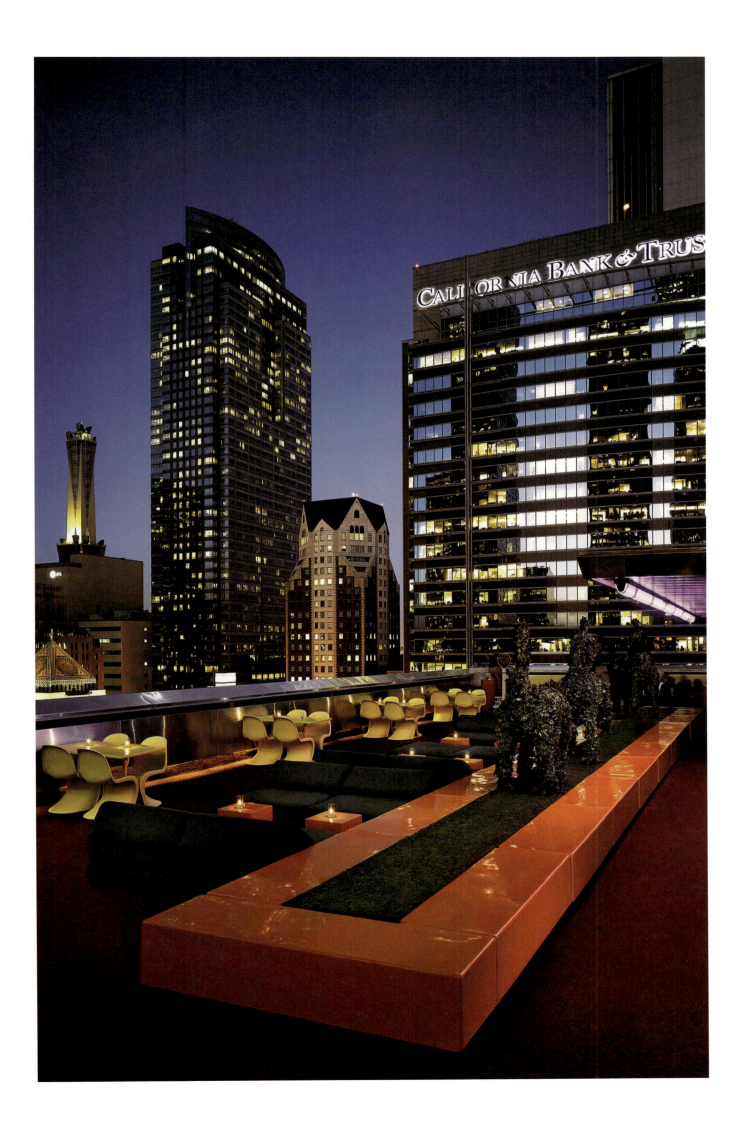

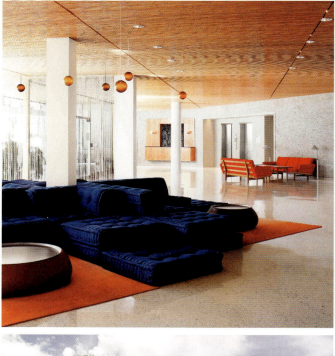

THE STANDARD SPA, MIAMI BEACH
Miami

The third link in André Balazs' Standard collection sits on the aptly named Belle Isle, a lush residential island in South Beach, Miami's Biscayne Bay. Over the past decade and a half, Balazs has come to be known as the man who transformed the concept of hospitality through his string of Standard hotels. Ocean Drive Magazine refers to the holistic and hydrotherapy spa hotel as "an oasis of comfort and serenity." It opened in 2006 in a building originally constructed in 1957 to house The Lido Spa. Balazs transformed the antiquated property, maintaining allusions to its origins. The hotel's general aesthetic scheme is something of a juxtaposition of the authenticity of an old-world European bathhouse with the sleek coolness of Scandinavian design. Its 107 guestrooms, including one "Full Spread" suite, are graced with minimalist, Scandinavian design and cool slate-colored walls, lending an air of calm and refinement to the experience of each stay. The guestrooms range from "Dry" to "Lush" and finally to "Wet," while also varying in size within these categories. After a long day of yoga, lounging by the pool, swimming laps, being pampered at the full-service spa, or sitting in the hammam, perhaps even more notable for guests are the exquisite Lido Restaurant and Bayside Grill, both offering the best in health-conscious, Mediterranean-inspired cuisine and biodynamic wines.

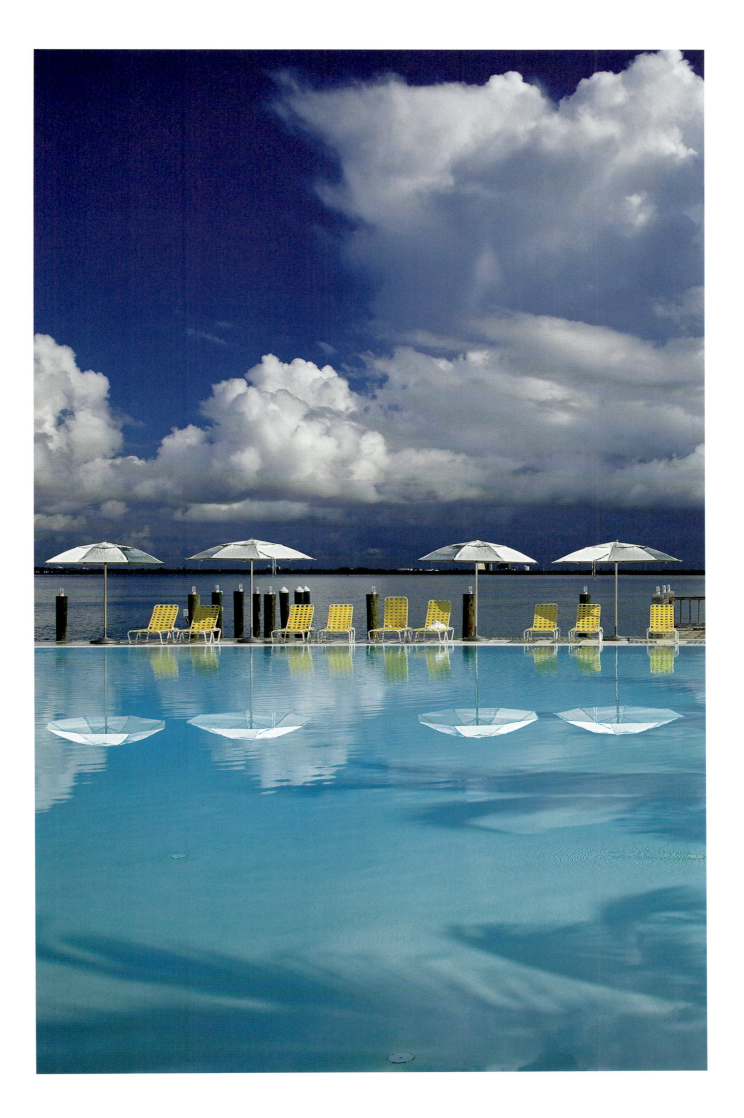

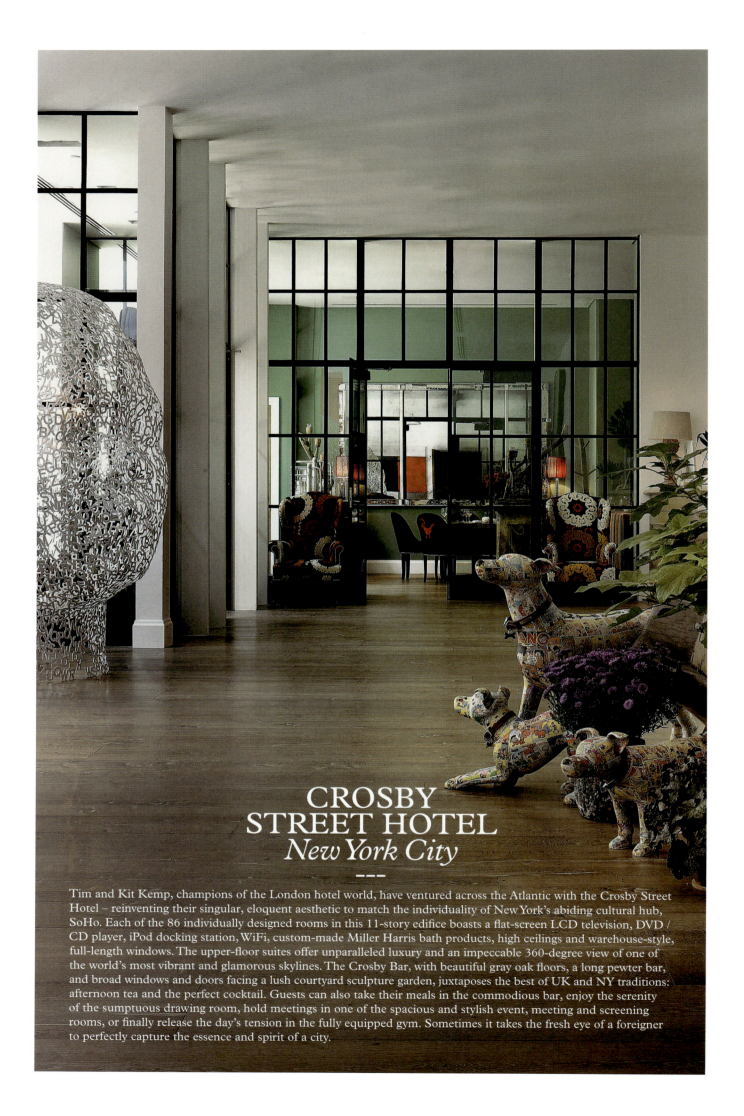

CROSBY STREET HOTEL
New York City

Tim and Kit Kemp, champions of the London hotel world, have ventured across the Atlantic with the Crosby Street Hotel – reinventing their singular, eloquent aesthetic to match the individuality of New York's abiding cultural hub, SoHo. Each of the 86 individually designed rooms in this 11-story edifice boasts a flat-screen LCD television, DVD / CD player, iPod docking station, WiFi, custom-made Miller Harris bath products, high ceilings and warehouse-style, full-length windows. The upper-floor suites offer unparalleled luxury and an impeccable 360-degree view of one of the world's most vibrant and glamorous skylines. The Crosby Bar, with beautiful gray oak floors, a long pewter bar, and broad windows and doors facing a lush courtyard sculpture garden, juxtaposes the best of UK and NY traditions: afternoon tea and the perfect cocktail. Guests can also take their meals in the commodious bar, enjoy the serenity of the sumptuous drawing room, hold meetings in one of the spacious and stylish event, meeting and screening rooms, or finally release the day's tension in the fully equipped gym. Sometimes it takes the fresh eye of a foreigner to perfectly capture the essence and spirit of a city.

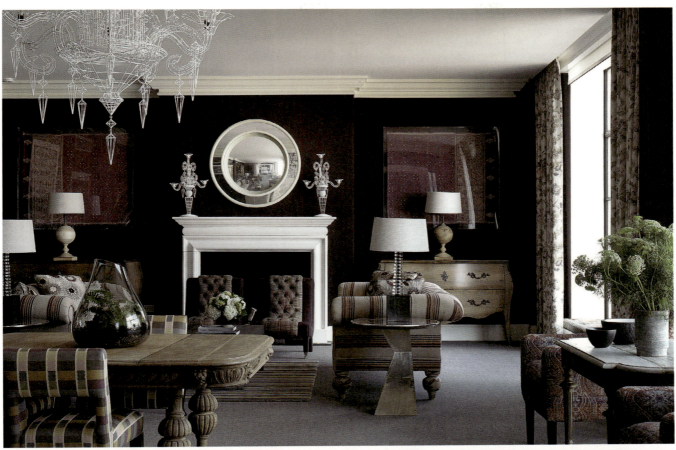

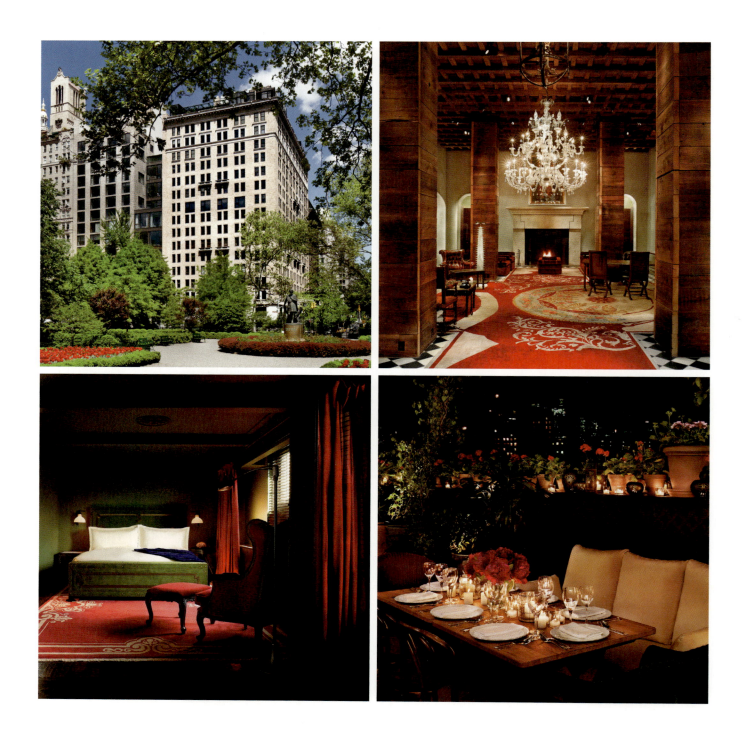

GRAMERCY PARK HOTEL
New York City

With one-of-a-kind furnishings, paintings and sculptures created by Julian Schnabel, the Gramercy Park Hotel is more than a unique luxury property – it's a work of art. Set in one of the most coveted areas of Manhattan, the legendary hotel has, for almost nine decades, opened its doors, night after night, to international artists, literati, fashion designers and intellectuals. With a lushly landscaped rooftop garden, al fresco dining and engagingly designed interior spaces, the hotel offers many evocative places in which to lounge. Danny Meyer's Maialino serves Roman-style trattoria dishes; while Gramercy Terrace, a private roof club and landscaped garden, is suitable for casual dining, from breakfast to late-night dinners. Located on the lobby level, Rose Bar and Jade Bar – two eclectically decorated and candlelit spaces – both have a long list of classic and exotic cocktails, as well as all-day bar dining menus. For those in need of retreat, in-room massages and spa services can easily be arranged. In guest rooms, hotel staff leaves thoughtfully chosen books in a bedside stack and Red Flower bath salts for a fragrant dip. The property's seven specialty suites are each unique, with spacious living rooms, some with dining rooms, and bathrooms with custom sculpted soaking tubs. Outside the hotel is yet another work of art – Gramercy Park, New York City's only private park, to which guests of the hotel have exclusive access.

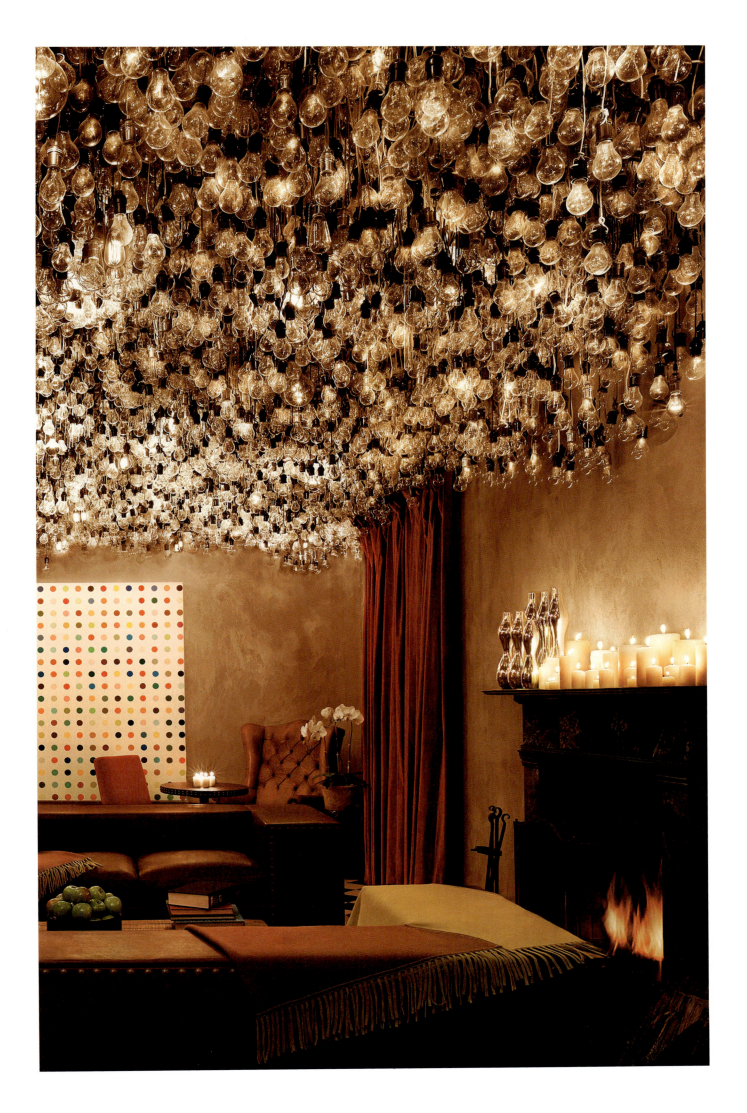

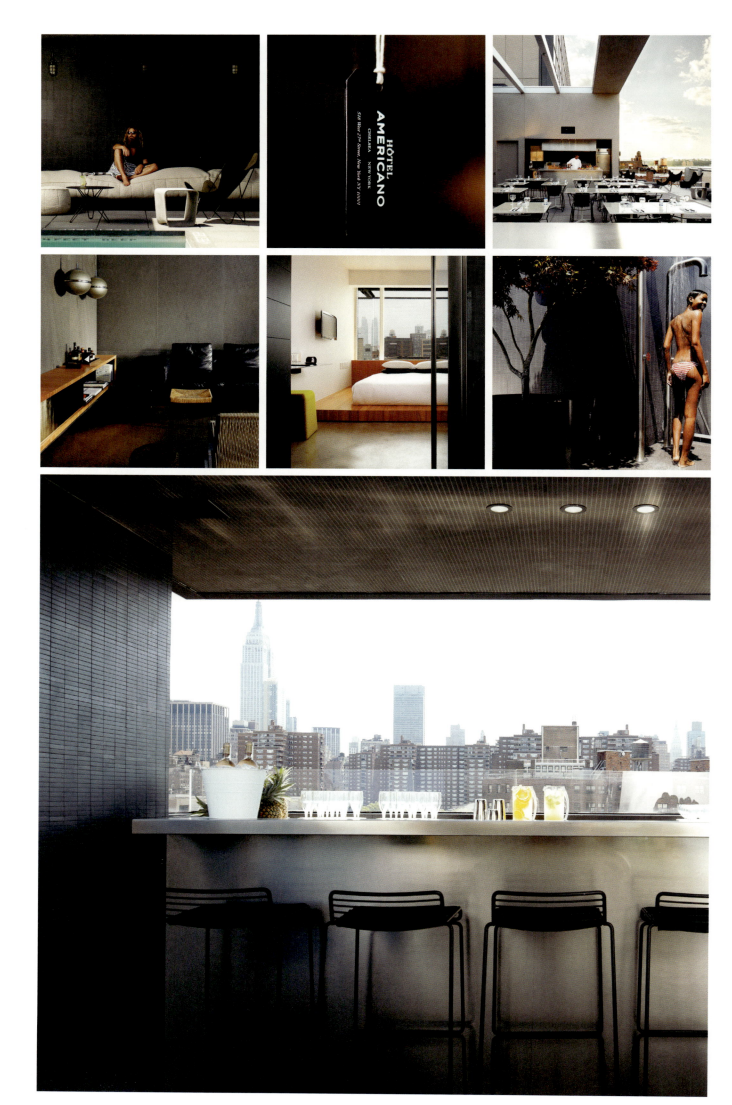

HÔTEL AMERICANO
New York City

A decade after bringing a distinctly high design sensibility to cities and resorts in their native Mexico, Carlos Couturier and Moises Micha are tackling an entirely different market: New York City. With their new Hôtel Americano, located in the heart of Chelsea's art gallery district, the partners celebrate their love of contemporary art and their passion for Manhattan. As Couturier explains, "We want to tell a story about Latin America and New York. A New Yorker is always an Americano, because New Yorkers live in a city where they have to adapt all the time." Set in a former parking garage, the Hôtel Americano has a cool industrial Manhattan veneer but a warm Latin soul. The 56-room hotel features decidedly Mexican touches, like an outdoor rooftop pool that becomes a hot tub in winter, along with New York-style details like iPads in every room are full of recommendations for the best local galleries, restaurants and shops. Hôtel Americano has two restaurants and bars, as well as locally produced bicycles that guests can use to explore the High Line and Hudson River Park. "New York can be overwhelming for visitors. In our hotel, guests feel safe, and they feel comfortable," says Micha. "We have this Latin American approach, so that you'll feel the warmth."

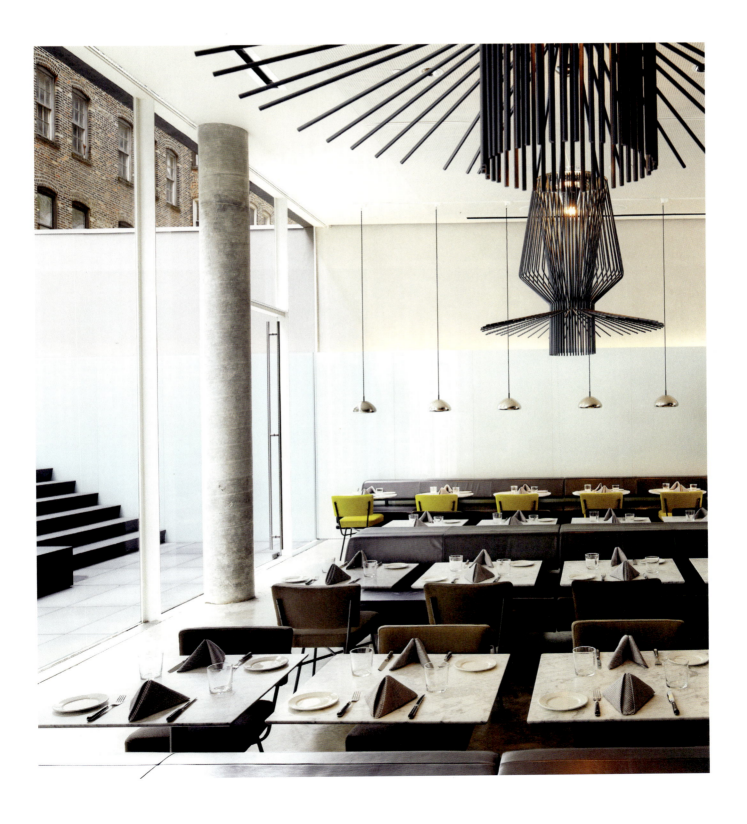

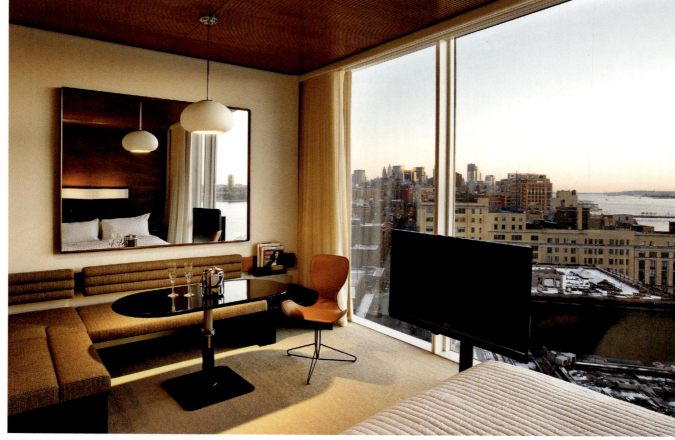

WWW.DESIGNHOTELS.COM/STANDARD_NYC

ADDRESS
848 WASHINGTON STREET
NEW YORK CITY, NY 10014
UNITED STATES OF AMERICA

ROOMS 337

RATES USD 295 – USD 2500

OPEN 12/2008

UNITED STATES NEW YORK CITY

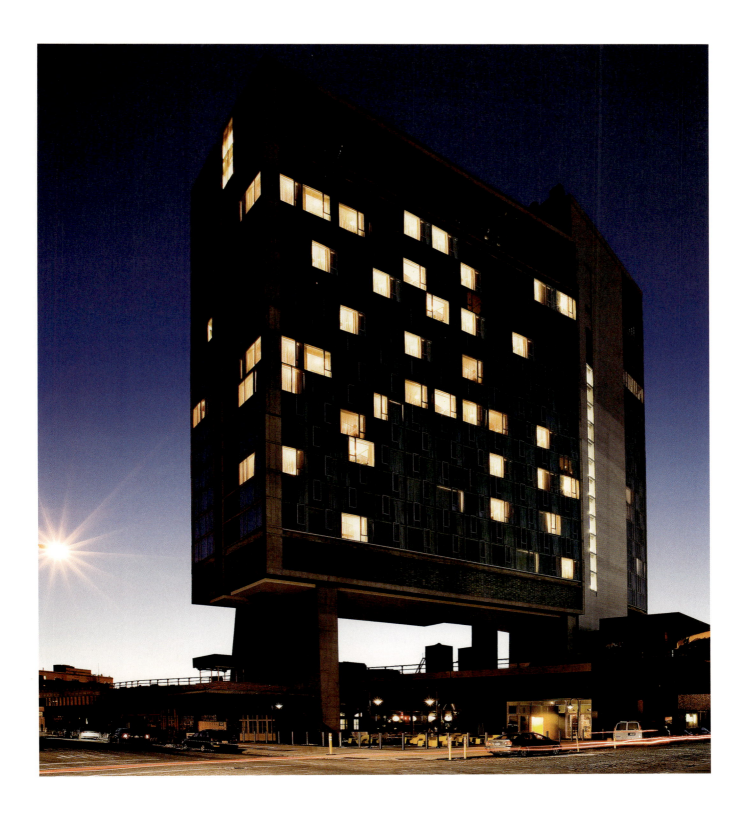

THE STANDARD, NEW YORK
New York City

The Standard, New York, the youngest in André Balazs's Standard hotels collection, opened in late 2008 and has since taken the New York City hotel scene by storm. The "King Standard," as the *New York Daily News* calls it, is a delicate colossus straddling the High Line, a brand-new elevated park, which runs up Manhattan's West Side. The glass and concrete monolith was André Balazs's first hotel project built from the ground up and recalls such iconic New York structures as the Lever House and the United Nations, with a twist of contemporary decadence. Situated inside Manhattan's Meatpacking District, now one of the city's most sought-after plots, The Standard, New York is the new heart and soul of the prodigious New York fashion, art, and media worlds. The hotel's panoramic views overlooking the Hudson River and Manhattan's magnificent skyline afford each of the 337 guestrooms on 18 floors with a sense of particular privilege. The Standard Grill and The Living Room attract not only hotel guests, but also the New York City creative scene on a daily and nightly basis. Experiencing the "city that never sleeps" takes on a new meaning at The Standard, New York.

EUROPE

AUSTRIA
- 096 — AUGARTENHOTEL ART & DESIGN, *Graz*
- 098 — HOTEL DANIEL, *Graz*
- 100 — HOTEL KITZHOF MOUNTAIN DESIGN RESORT, *Kitzbühel*
- 102 — LOISIUM WINE & SPA RESORT LANGENLOIS, *Langenlois*
- 104 — BERGLAND HOTEL SÖLDEN, *Sölden*
- 106 — LOISIUM WINE & SPA RESORT SÜDSTEIERMARK, *Southern Styria*
- 108 — 25HOURS HOTEL WIEN, *Vienna*
- 110 — DAS TRIEST, *Vienna*
- 112 — DO & CO HOTEL VIENNA, *Vienna*
- 114 — HOTEL LAMÉE, *Vienna*
- 116 — HOTEL TOPAZZ, *Vienna*
- 118 — THE LEVANTE PARLIAMENT, *Vienna*

BELGIUM
- 120 — THE DOMINICAN, *Brussels*

CROATIA
- 122 — HOTEL LONE, *Rovinj*

CYPRUS
- 124 — ALMYRA, *Paphos*

CZECH REPUBLIC
- 126 — HOTEL JOSEF, *Prague*

FINLAND
- 128 — KLAUS K, *Helsinki*

FRANCE
- 130 — FIVE HOTEL & SPA, *Cannes*
- 132 — CASADELMAR, *Corsica*
- 134 — KUBE HOTEL GASSIN, *Gassin*
- 136 — HOTEL B DESIGN & SPA, *Paradou*
- 138 — BEL-AMI, *Paris*
- 140 — HOTEL GABRIEL PARIS MARAIS, *Paris*
- 142 — HÔTEL SEZZ PARIS, *Paris*
- 144 — KUBE HOTEL, *Paris*
- 146 — LA MAISON CHAMPS ELYSÉES, *Paris*
- 148 — LA RÉSERVE PARIS, *Paris*
- 150 — MURANO RESORT, *Paris*
- 152 — LA RÉSERVE RAMATUELLE HOTEL, SPA AND VILLAS, *Ramatuelle*
- 154 — HÔTEL SEZZ SAINT-TROPEZ, *Saint-Tropez*

GERMANY
- 156 — COSMO HOTEL BERLIN MITTE, *Berlin*
- 158 — DAS STUE, *Berlin*
- 160 — HOTEL Q!, *Berlin*
- 162 — THE MANDALA HOTEL, *Berlin*
- 164 — CERÊS, *Binz*
- 166 — HOTEL ÜBERFLUSS, *Bremen*
- 168 — 25HOURS HOTEL BY LEVI'S, *Frankfurt*
- 170 — GERBERMÜHLE, *Frankfurt*
- 172 — GOLDMAN 25HOURS HOTEL, *Frankfurt*
- 174 — ROOMERS, *Frankfurt*
- 176 — ROOMERS LOFT, *Frankfurt*
- 178 — THE PURE, *Frankfurt*
- 180 — 25HOURS HOTEL HAFENCITY, *Hamburg*
- 182 — 25HOURS HOTEL HAMBURG NO. 1, *Hamburg*
- 184 — EAST, *Hamburg*
- 186 — GASTWERK HOTEL HAMBURG, *Hamburg*
- 188 — SIDE, *Hamburg*
- 190 — THE GEORGE, *Hamburg*
- 192 — DIE TRÄUMEREI, *Michelstadt*
- 194 — CORTIINA HOTEL, *Munich*
- 196 — LOUIS HOTEL, *Munich*
- 198 — FACTORY HOTEL, *Munster*
- 200 — HOTEL BACHMAIR WEISSACH, *Rottach-Egern*
- 202 — BECKER'S HOTEL & RESTAURANT, *Trier*

GREECE
- 204 — FRESH HOTEL, *Athens*
- 206 — NEW HOTEL, *Athens*
- 208 — PERISCOPE, *Athens*
- 210 — SEMIRAMIS, *Athens*
- 212 — EKIES ALL SENSES RESORT, *Halkidiki*
- 214 — MYKONOS THEOXENIA, *Mykonos*
- 216 — THE MET HOTEL, *Thessaloniki*

HUNGARY
- 218 — LÁNCHÍD 19, *Budapest*

ICELAND
- 220 — 101 HOTEL, *Reykjavik*

ITALY
- 222 — GOMBITHOTEL, *Bergamo*
- 224 — HOTEL GREIF, *Bolzano*
- 226 — C-HOTEL & SPA, *Cassago Brianza*
- 228 — CONTINENTALE, *Florence*
- 230 — SEXTANTIO LE GROTTE DELLA CIVITA, *Matera*
- 232 — MAISON MOSCHINO, *Milan*
- 234 — STRAF, *Milan*
- 236 — ROMEO HOTEL, *Naples*
- 238 — ARGENTARIO GOLF RESORT & SPA, *Porto Ercole*
- 240 — DUOMO, *Rimini*
- 242 — LEON'S PLACE HOTEL IN ROME, *Rome*
- 244 — SEXTANTIO ALBERGO DIFFUSO, *Santo Stefano Di Sessanio*
- 246 — VIGILIUS MOUNTAIN RESORT, *South Tyrol/Lana*
- 248 — CA' PISANI, *Venice*
- 250 — HOTEL PALAZZO BARBARIGO SUL CANAL GRANDE, *Venice*
- 252 — PALAZZINA G, *Venice*

NORWAY
- 254 — GRIMS GRENKA, *Oslo*

PORTUGAL
- 256 — FAROL DESIGN HOTEL, *Cascais*
- 258 — FONTANA PARK HOTEL, *Lisbon*
- 260 — ESTALAGEM DA PONTA DO SOL, *Madeira*
- 262 — THE VINE, *Madeira*
- 264 — HOTEL TEATRO, *Porto*
- 266 — MEMMO BALEEIRA, *Sagres*

SPAIN
- 268 — HOSPES AMÉRIGO, *Alicante*
- 270 — GRAND HOTEL CENTRAL, *Barcelona*
- 272 — HOTEL CLARIS, *Barcelona*
- 274 — HOTEL GRANADOS 83, *Barcelona*
- 276 — HOTEL OMM, *Barcelona*
- 278 — HOTEL MIRÓ, *Bilbao*
- 280 — HOSPES PALACIO DEL BAILÍO, *Cordoba*
- 282 — HOSPES PALACIO DE LOS PATOS, *Granada*
- 284 — BOHEMIA SUITES & SPA, *Gran Canaria*
- 286 — SEASIDE PALM BEACH, *Gran Canaria*
- 288 — AGUAS DE IBIZA LIFESTYLE & SPA, *Ibiza*
- 290 — OCEAN DRIVE HOTEL, *Ibiza*
- 292 — HOSPES MADRID, *Madrid*
- 294 — HOTEL ÚNICO MADRID, *Madrid*
- 296 — HOTEL URBAN, *Madrid*
- 298 — HOSPES MARICEL, *Mallorca*
- 300 — PURO OASIS URBANO, *Mallorca*
- 302 — HOSPES VILLA PAULITA, *Puigcerdà*
- 304 — HOSPES LAS CASAS DEL REY DE BAEZA, *Sevilla*
- 306 — HOSPES PALAU DE LA MAR, *Valencia*

SWEDEN
- 308 — COPPERHILL MOUNTAIN LODGE, *Åre*
- 310 — AVALON HOTEL, *Gothenburg*
- 312 — ELITE PLAZA HOTEL, *Gothenburg*
- 314 — HOTEL J, *Stockholm*
- 316 — HOTEL SKEPPSHOLMEN, *Stockholm*
- 318 — NOBIS HOTEL, *Stockholm*
- 320 — NORDIC LIGHT HOTEL, *Stockholm*
- 322 — STALLMÄSTAREGÅRDEN HOTEL & RESTAURANG, *Stockholm*

SWITZERLAND
- 324 — THE CAMBRIAN, *Adelboden*
- 326 — HOTEL SCHWEIZERHOF BERN, *Bern*
- 328 — LA RÉSERVE GENÈVE HOTEL AND SPA, *Geneva*
- 330 — ROCKSRESORT, *Laax*
- 332 — THE HOTEL, *Lucerne*
- 334 — NIRA ALPINA, *Silvaplana*
- 336 — HOTEL NEVAÏ, *Verbier*
- 338 — CERVO MOUNTAIN BOUTIQUE RESORT, *Zermatt*
- 340 — THE OMNIA, *Zermatt*
- 342 — 25HOURS HOTEL ZÜRICH WEST, *Zurich*
- 344 — THE DOLDER GRAND, *Zurich*
- 346 — WIDDER HOTEL, *Zurich*

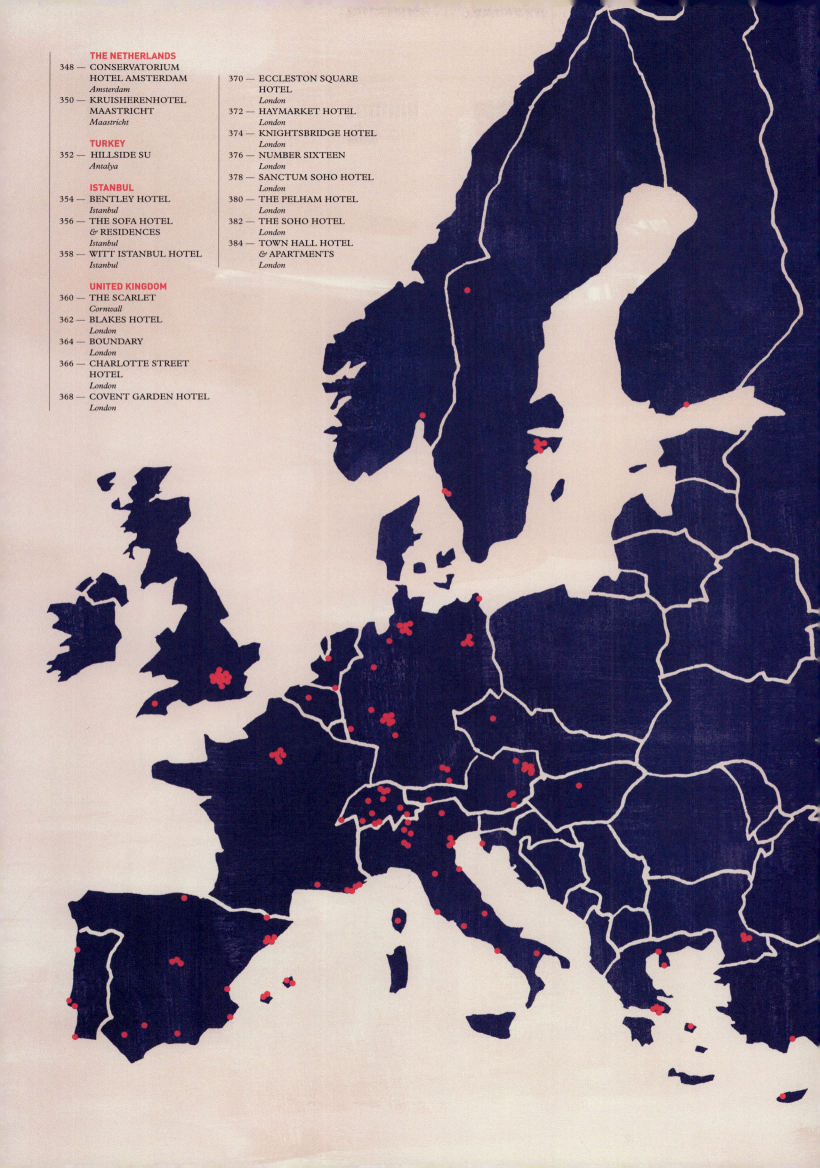

THE NETHERLANDS
348 — CONSERVATORIUM HOTEL AMSTERDAM
Amsterdam
350 — KRUISHERENHOTEL MAASTRICHT
Maastricht

TURKEY
352 — HILLSIDE SU
Antalya

ISTANBUL
354 — BENTLEY HOTEL
Istanbul
356 — THE SOFA HOTEL & RESIDENCES
Istanbul
358 — WITT ISTANBUL HOTEL
Istanbul

UNITED KINGDOM
360 — THE SCARLET
Cornwall
362 — BLAKES HOTEL
London
364 — BOUNDARY
London
366 — CHARLOTTE STREET HOTEL
London
368 — COVENT GARDEN HOTEL
London
370 — ECCLESTON SQUARE HOTEL
London
372 — HAYMARKET HOTEL
London
374 — KNIGHTSBRIDGE HOTEL
London
376 — NUMBER SIXTEEN
London
378 — SANCTUM SOHO HOTEL
London
380 — THE PELHAM HOTEL
London
382 — THE SOHO HOTEL
London
384 — TOWN HALL HOTEL & APARTMENTS
London

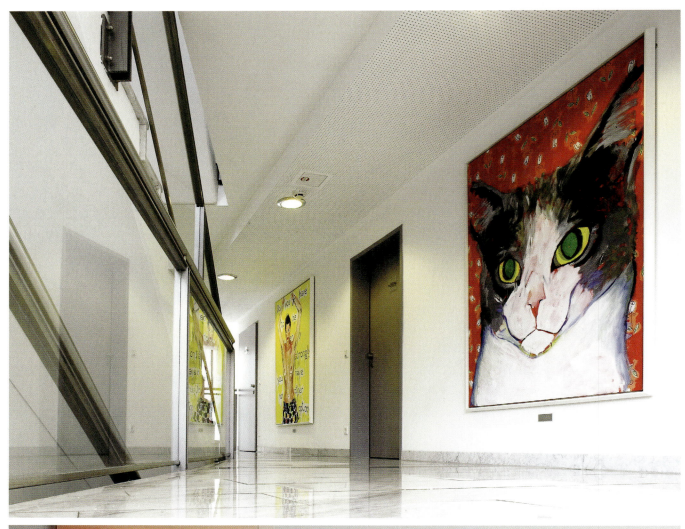
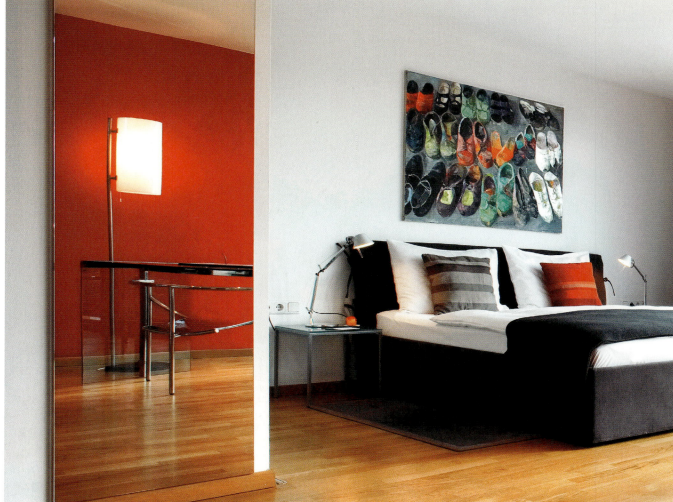

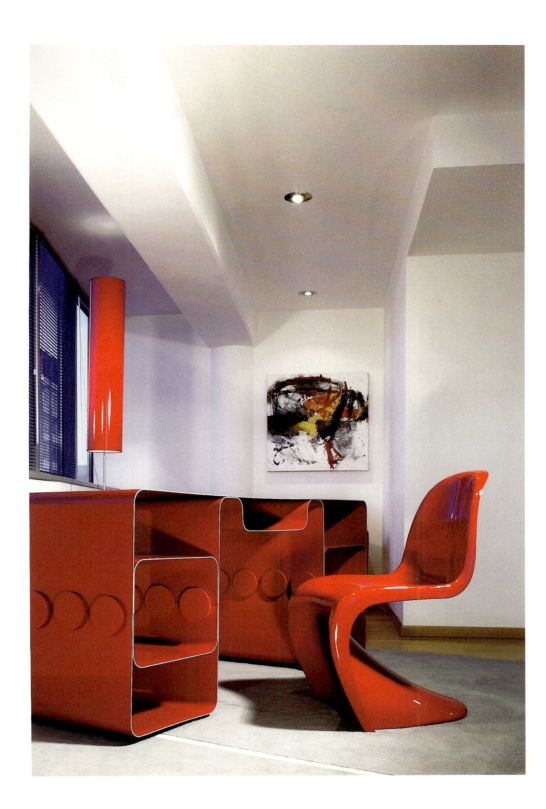

AUGARTENHOTEL ART & DESIGN
Graz

In this eclectically and strikingly designed glass and metal structure, open communication between the universe within and the environment without is the name of the game – literally. Architect Günter Domenig's Auguartenhotel makes a unique statement for modernity in Graz – an Austrian city dominated by Gothic, Renaissance and Baroque architecture. To Domenig, good architecture is all about capacity, economy and stature. At the same time, Domenig is the "architect of the game," meaning that Auguartenhotel invites its guests to play. In the guestrooms and apartments, straightforward streamlined furnishings and interiors by various designers provide striking accents throughout. The hotel also boasts a collection of over 400 original artworks by modern and contemporary masters, which adorn the rooms and public spaces. This fusion of design and art creates spaces that are conducive to work, contemplation and play. In fact, no space is overlooked as a creative and potentially inspiring venue: take, for example, the 24-hour bar and indoor pool. Vibrant works by 200 different contemporary painters and sculptors are displayed in surprising places, such as the courtyard, stairwells, rooftop terrace – which offers magnificent views of the old city below – and Suite 601 overlooking the clock tower, equipped with fine art and design pieces.

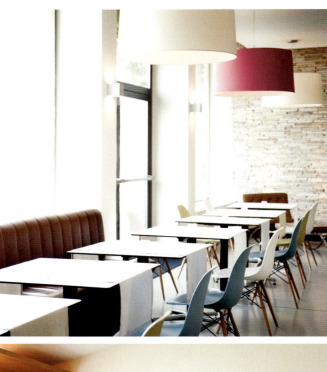

HOTEL DANIEL
Graz

A prime example of slick modular modernity by award-winning Berlin architectural firm Studio Aisslinger, Hotel Daniel is only a few minutes' walk from Graz's historic old town, the convention center, and the eye-popping Kunsthaus. Visitors are instantly put at ease by the composed atmosphere of simple elegance and warm functionality. Modern furniture-design classics are featured against a background of sleek planes of oak and natural stone. The 107 guestrooms stylishly emphasize compact multi-functionality and a warm simplicity. With a large public area, an Internet corner, and a meeting room for up to 70 people, executives have everything they need. So do more spontaneous guests, who can mix and mingle with the local scene in the open-plan bar and restaurant. While the breakfast terrace, fireside lounge, and library cater to the more leisurely at heart, the espresso bar with tapas counter offers guests a flexible range of modern cuisine before they hop onto one of the house Vespas, the bikeboards, or the Piaggio Ape Calessino for a self-guided tour of this lovely Austrian city. It's the perfect "trend-proof" place for well-traveled culture vultures and business travelers alike.

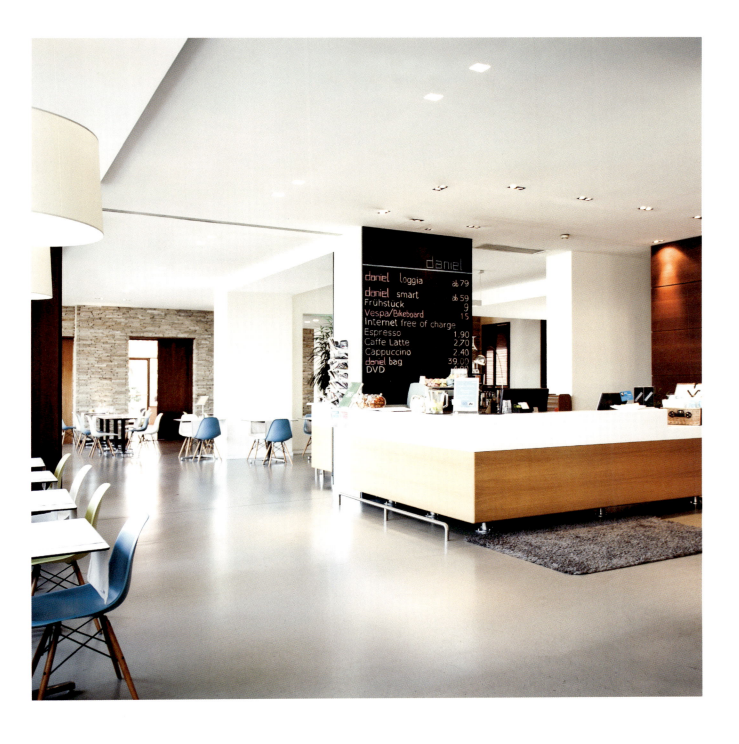

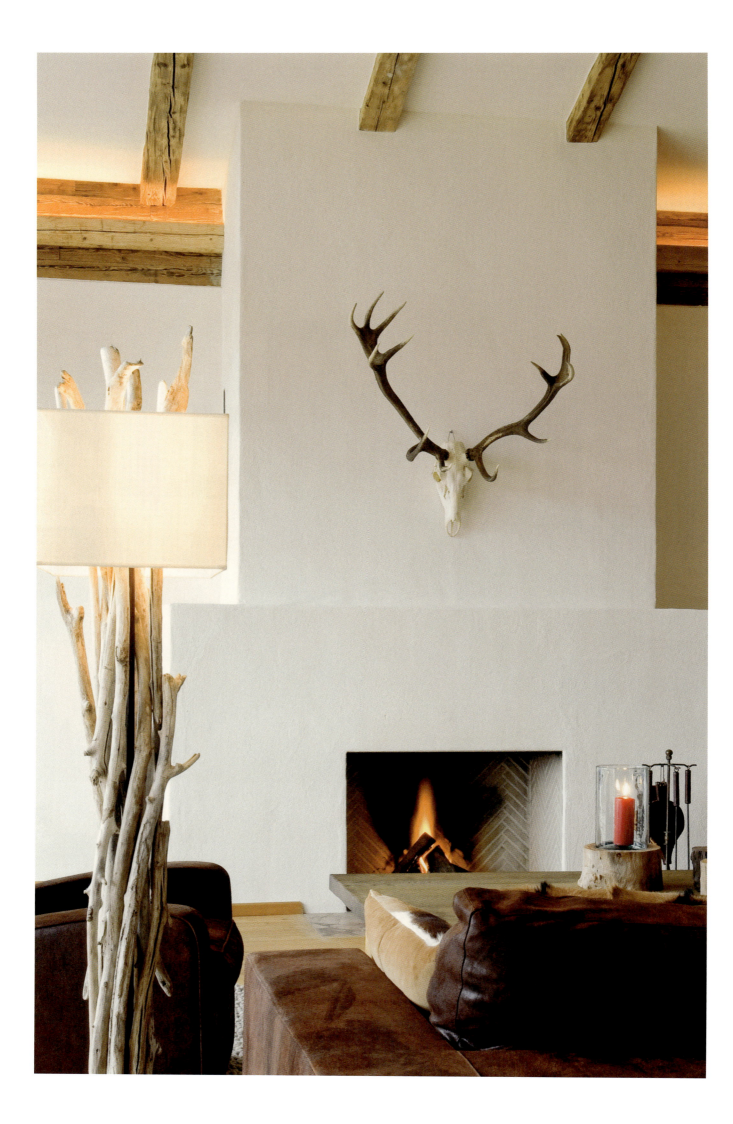

SIGNATURE

AUSTRIA
KITZBÜHEL

OPEN
01/2005

RATES
EUR 180 –
EUR 790

ROOMS
163

ADDRESS
SCHWARZSEESTRASSE 8-10
6370 KITZBÜHEL
AUSTRIA

**WWW.DESIGNHOTELS.COM/
KITZHOF**

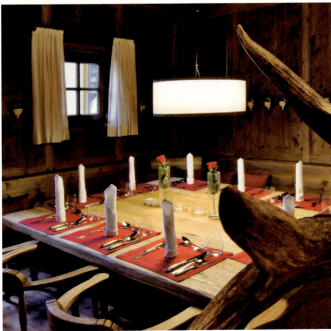

HOTEL KITZHOF
MOUNTAIN DESIGN RESORT
Kitzbühel

In the chandelier-studded lobby of Hotel Kitzhof Mountain Design Resort, just a five minute walk from the center of Kitzbühel, the beauty of the Austrian Alps is all around you. This elegant retreat combines natural splendor and design, offering its guests of a full experience of the region's natural beauty: glimpses of the snow-laden peaks stream through the hotel's panoramic windows, while traditional alpine materials accent the spacious public areas. Rustic wooden beams and floorboards lead the way to the Jagdstube, an intimate Tyrolean-style restaurant, while the 600 square meter blossom-scented Kitz Spa will draw you deeper into the building. Co-owner Ursula Schelle-Müller has expertly woven the town's spirit of glamour and indulgence through the hotel's 163 rooms and suites, seamlessly blending contemporary lines with textured, locally sourced materials like leather and loden. Some rooms have inspirational views over the powder-covered slopes, and even the bathrooms, with Raindance showers and luxurious amenities by Just Pure, invite guests to leave their everyday lives behind them. Hotel Kitzhof Mountain Design Resort is a serene wellness destination, just minutes away from the center of Kitzbühel, where guests can experience contemporary Austrian design and tempting Tyrolean cuisine.

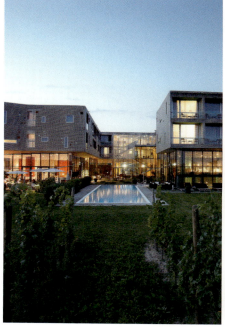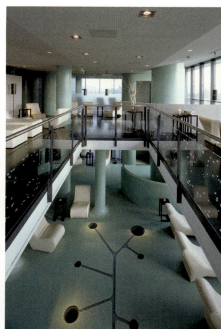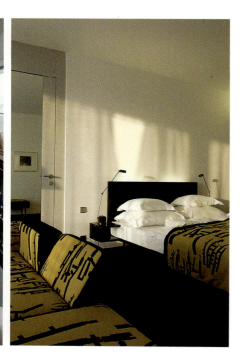

LOISIUM WINE & SPA RESORT LANGENLOIS
Langenlois

It's an innovative concept: a hotel and spa for wine-lovers with an outstanding architectural approach. Set amid rolling vineyards in Austria's most popular white-wine region and just opposite of the famous LOISIUM Wine World, which is built over an underground labyrinth of 900-year-old wine cellars, the Loisium Hotel, designed by American architect Steven Holl, seems to float on pillars and glass. From the light fixtures in the restaurant to the lobby staircase, wine & cork is part of the hotel's design and space. The 82 guestrooms feature the wine theme and another widely used motif throughout the hotel: a map of the cellars. Airy rooms have large windows overlooking vineyards and the wonderfully rural lifestyle of the surrounding villages. The hotel has a lovely all-year heated outdoor swimming pool, and guests can indulge in a full array of Aveda spa treatments in an award-winning spa. They can also sample intriguing local treatments involving grape and wine products before settling down to a wine-themed meal in the spectacular restaurant. Another main attraction is a trip to the educational (and Holl-designed) wine center next door for individual wine tasting in the wine shop or participating in wine seminars. Don't miss one of the trekking tours through the lovely surrounding vineyards or a visit of the Danube valley with its monasteries and old castles (UNESCO world heritage area.) Cheers.

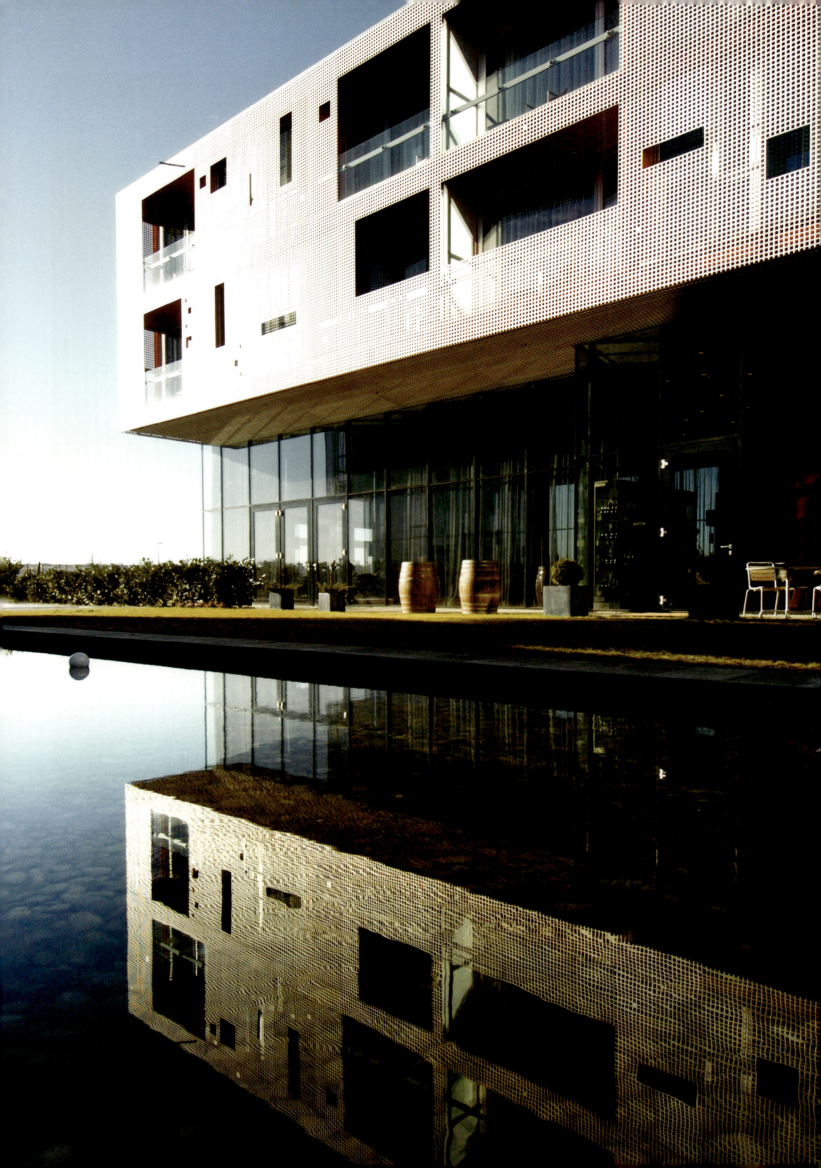

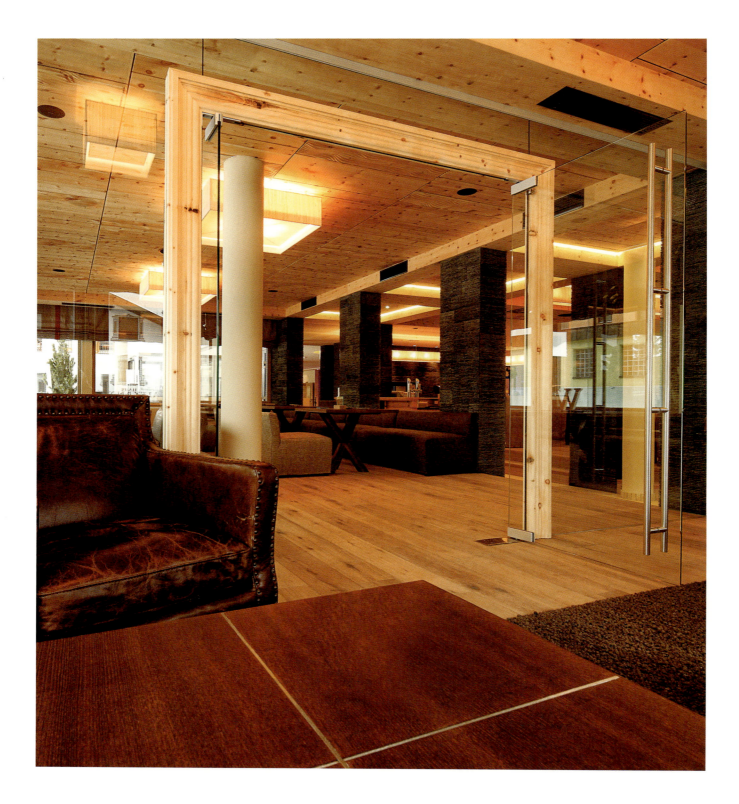

BERGLAND HOTEL SÖLDEN
Sölden

When local deep-snow and synchronized skiing hero Sigi Grüner turned hotelier, he ordered the complete demolition of Sölden's old Bergland Hotel in favor of another refurbishment. The result of its rebirth was a self-contained playground for active travelers and adrenalin-seekers that come here to carve down some of Austria's highest peaks on skis and bikes. Crafted by local tradespeople, the new 86-room resort has subtle hints of old Austria, such as rocking chairs and oiled oak floors. But the main concept – that all of the ingredients for an active and stress-free holiday should be kept under one roof – aligns with 21st century values. Next to the main entrance, there's a direct lift to the ski slopes and an in-house sports shop gives guests the flexibility to turn up empty handed and still enjoy a day of skiing, mountain or race biking, hiking or other outdoor activities in Tyrol's Ötztal Valley. Herbs from the hotel's Alpine garden are used at the 1,700 sqm Sky Spa, high above the rooftops of Sölden, where treatments are based on promoting lasting wellbeing rather than voguish health fads. Massages and beauty therapies are often followed by raw snacks and cups of herbal tea at the poolside Sky Bar, with its clued-in staff and a chilled atmosphere. After an active day, guests can refuel at one of the hotel's three restaurants.

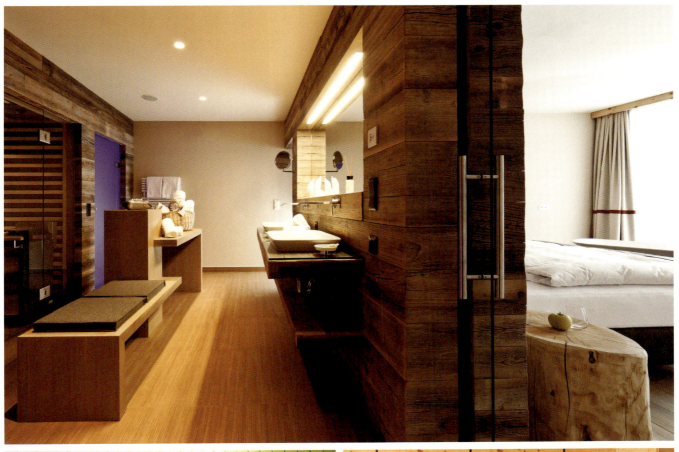
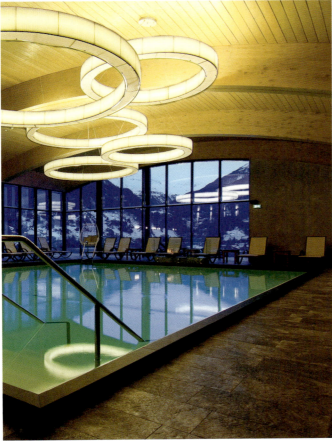

LOISIUM WINE & SPA RESORT SÜDSTEIERMARK
Southern Styria

Rolling vineyards and a mild, Mediterranean-style climate attract nature lovers to Styria in Austria's southeast corner. Known as the 'Tuscany of Austria', the region's prize-winning wine – given a fruity characteristic and dry finish by the clay-heavy soil – makes them linger here even longer. At LOISIUM Wine & Spa Resort Südsteiermark, only 40 minutes from the Austrian city Graz and 25 minutes from the Slovenian border, these delights blend with a bold, geometrical architectural concept. Unrefined local materials and carefully selected colors have been used to harmonize with the surrounding landscape, providing roomy, thought-provoking spaces for guests who want to wine, dine and relax. With views across the hotel's private vineyard and a well-stocked Vinothek, offering wine tasting sessions and seminars, wine is central to the Loisium experience. Sommeliers are present throughout the property to offer personal advice to wine novices and experts, from the LOISIUM Weinclub Bar to the wine gallery and panoramic terrace restaurant. But wine is not the only thing on the menu. After a day spent hiking and biking along the nearby river Mur, guests can relax in the LOISIUM Wine Spa, with eight treatment rooms, environmentally friendly Aveda amenities and a Spa living room, complete with bar and open fireplace. Like the public areas, the 105 rooms and suites are stripped down and spacious, allowing reflections of the landscape to rebound off the glazy-white walls. Even the meeting rooms are lit by the amber-colored sunshine, and glimpses of nearby Ehrenhausen Castle can be caught around almost every corner.

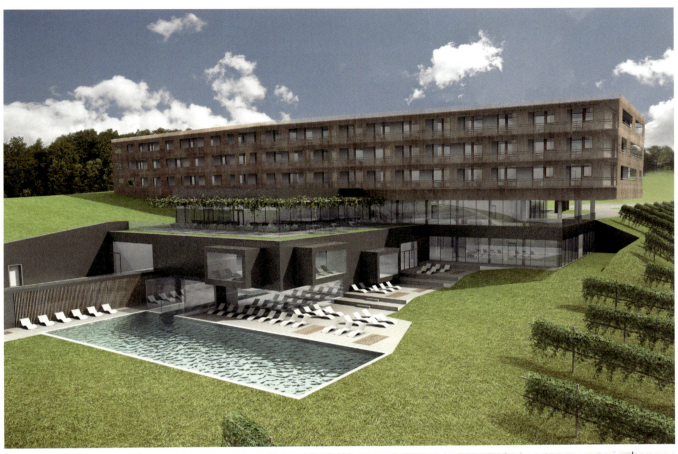
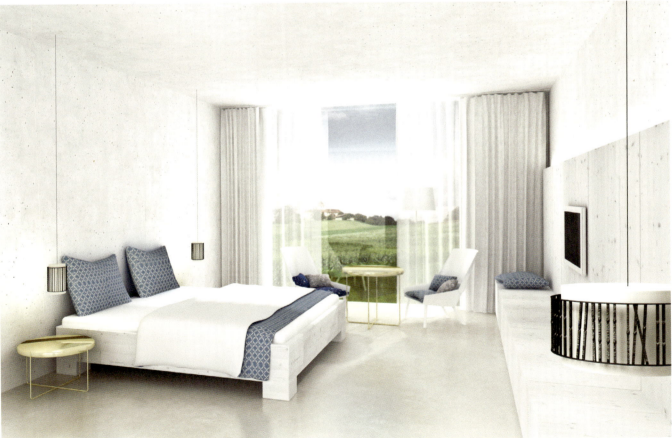

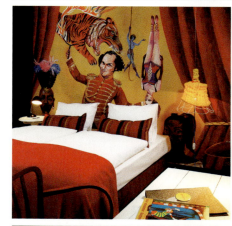

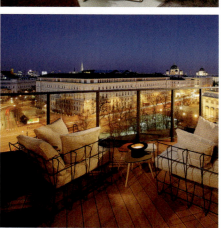

25HOURS HOTEL WIEN
Vienna

The 25hours Hotel Wien is located in Vienna's 7th district, home to shopping quarter Neubaugasse, the MuseumsQuartier and the heart of Vienna's young, liberal, creative scene. The hotel creates a fantastical world of circus, spectacle and extravagance, with just a touch of madness. For Christoph Hoffmann, CEO of the 25hours Hotel Company, design is an expression of the company's philosophy. Each hotel design is inspired by its location, thus each is organically distinctive. The hotel will unveil in two phases: in spring 2011, 34 suites each featuring a kitchenette, safe, minibar and state-of-the-art technology came to life. Joining them will be a lobby lounge/bar and a terrace roof deck perched high above Vienna's rooftops. In the fall of 2012, 187 guestrooms will be added, in addition to wellness and fitness facilities, meeting and convention facilities, a summer garden and a restaurant with a terrace facing Weghuberpark. In cooperation with BWM Architekten und Partner and dreimeta's interior designer Armin Fischer, the 25hours creative team once again turned their imaginations loose to create a brash, fanciful aesthetic that mixes antiques and bespoke wall treatments with memorabilia from the city's three permanent circus buildings, as well as from Empress Elisabeth's own circus within Vienna's riding school.

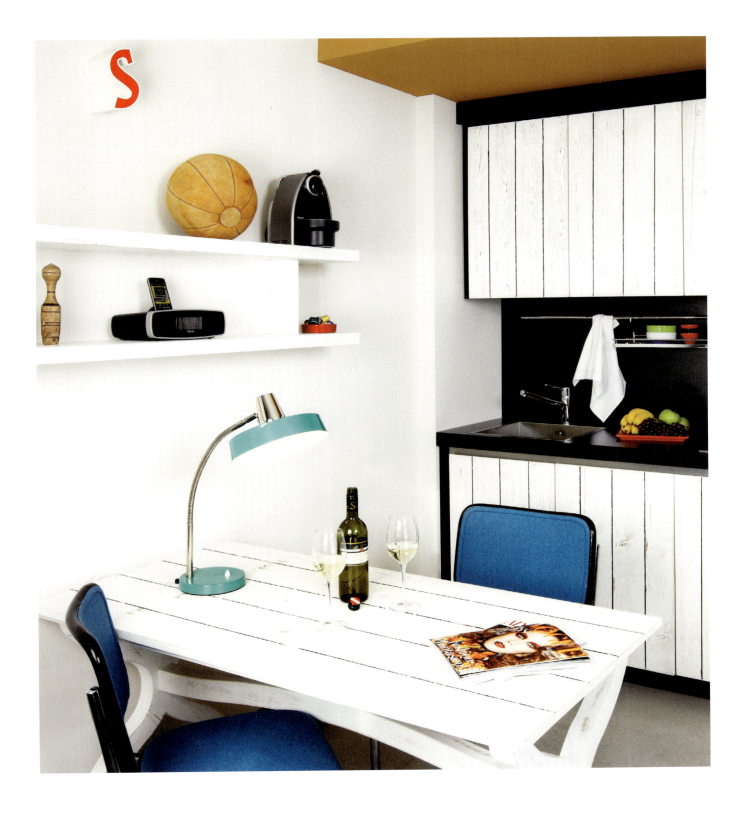

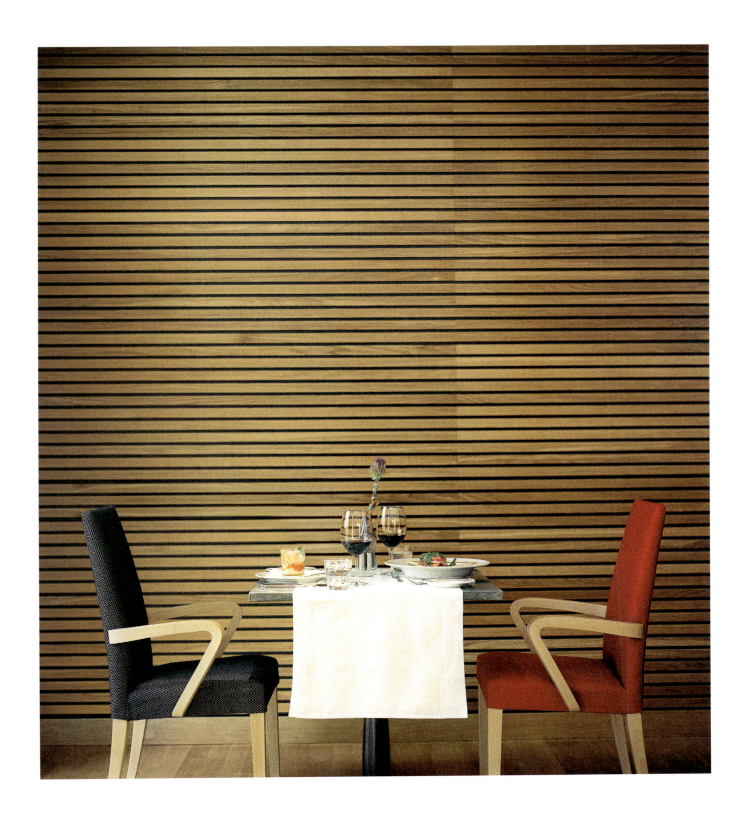

DAS TRIEST
Vienna

One of Vienna's first design hotels was born in 1995 in an old coach station used by travelers en route to the spas of Trieste, formerly part of the Austro-Hungarian Empire. Austrian architect Peter Lorenz and British interior designer Sir Terence Conran preserved parts of the original structure, combining elements of imperial elegance with sober lines, and providing well-heeled guests with a haven of refinement and warm color among the city's 19th-century buildings and Art Nouveau facades. Cross-vaulted rooms give the building a distinctive Viennese flair, while the rooms are casually broken up by solid planes of reds, yellows, and royal blues in the carpeting and armchairs. Guests can enjoy the subtle luxury handcrafted upholstered pieces by the Austrian firm Wittmann. Conran's choice of instantly recognizable modern classics also includes Artemide light fixtures. The bathrooms have porthole windows, which, along with railings and flag motifs in the rest of the hotel, offer an emotional link to the Adriatic port of Trieste. Specially commissioned black-and-white photographs of Trieste and Vienna further celebrate a connection to the building's historic role in international travel. Today's travelers yearning for a certain reserved nostalgia combined with modern comforts will have found what they're looking for.

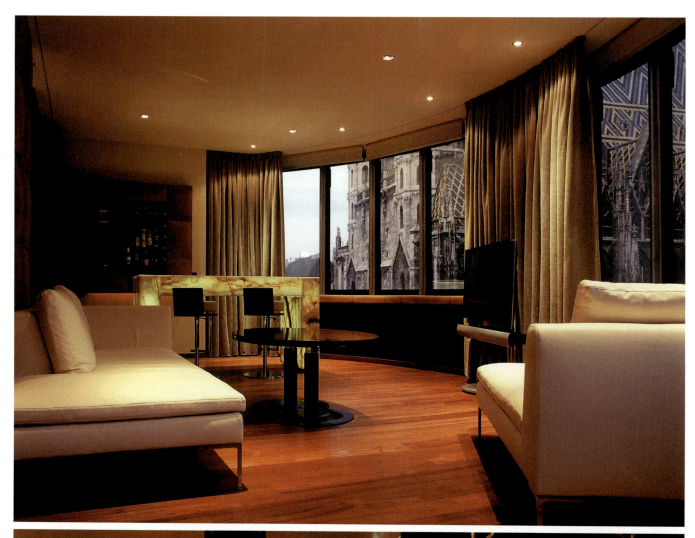
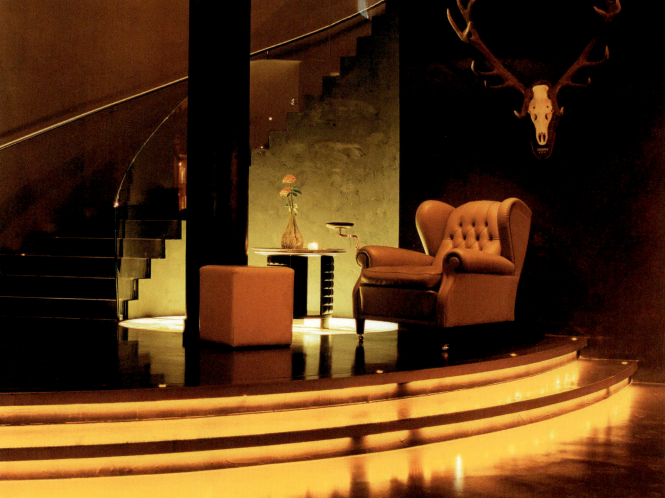

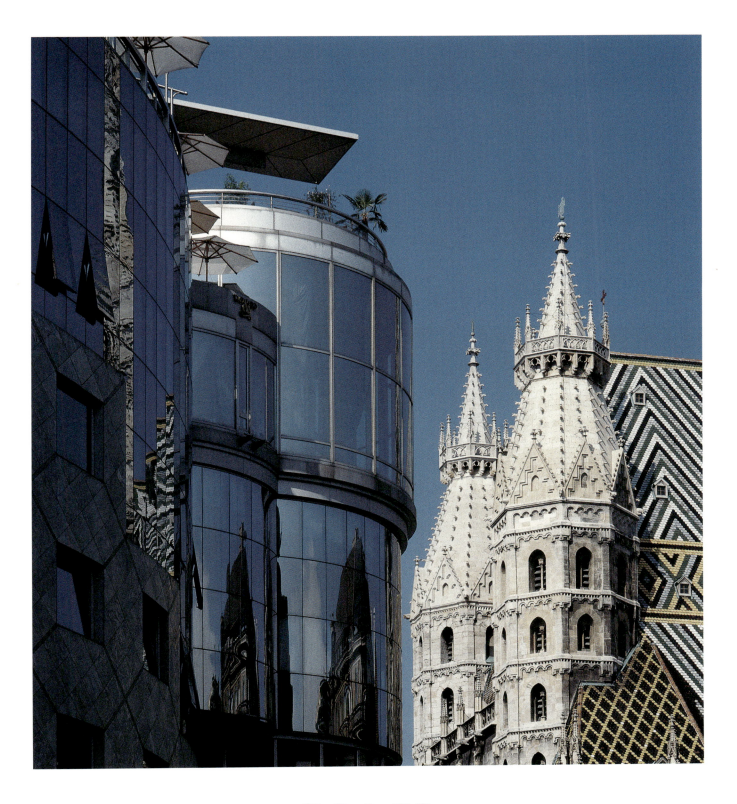

DO & CO
HOTEL VIENNA
Vienna

DO & CO already enjoyed global notoriety as gastronomic genius Attila Dogudan's exclusive catering company. Now, with the brilliant renovation of its flagship property in Vienna's Haas Haus, it has firmly established itself as a purveyor of elite hospitality. Pritzker prize winning architect Hans Hollein upgraded his iconic building with the additional design expertise of FJ Stijl, creating a futuristic interior that seamlessly blends both high- and low-tech accents. Four floors of the sparkling glass and metal structure have been transformed into 43 cone-shaped, distinct, and spacious guestrooms and suites that offer luxurious comfort as well as unparalleled views of the city's most majestic square. In the rooms, high-quality natural materials underline the hotel's more tech-savvy furnishings, such as generous two-square-meter showers, Bang & Olufsen mega flat screens, and even Nintendo Wiis. Sophistication is also reflected in the property's culinary offerings, which are given an equally sparkling setting in the hotel's restaurants, the chic, sixth-story Onyx Bar and the "Temple," a 12-seat private dining pavilion. Adjacent to St. Stephen's Cathedral, Hollein's cantilevered structure, despite its sci-fi style, remains reassuringly anchored in Viennese tradition, giving guests an unrivaled taste of past and future in the Austrian capital.

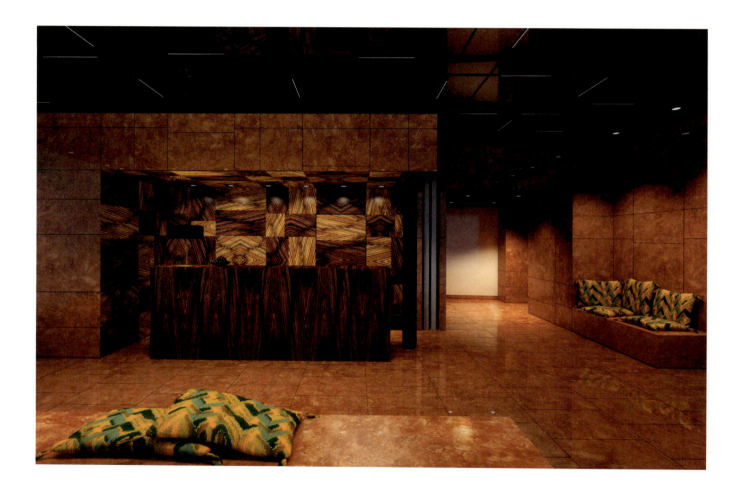

SIGNATURE

**WWW.DESIGNHOTELS.COM/
HOTEL_LAMEE**

ADDRESS
ROTENTURMSTRASSE 15
1010 VIENNA
AUSTRIA

ROOMS
32

RATES
EUR 248 –
EUR 1328

OPEN
04/2012

AUSTRIA
VIENNA

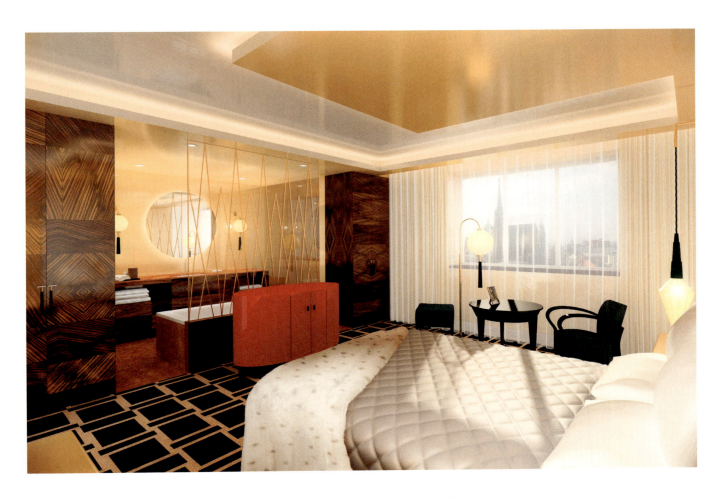

HOTEL LAMÉE
Vienna

Escape to another era at Hotel Lamée, where a harmonious mix of old and new harks back to the glamour of 1930s Hollywood, while maintaining a distinct Viennese charm. Located in Vienna's historic 1st district – surrounded by museums, galleries, luxury shopping and famous coffee houses – the original 1930s building offers a modern interpretation of a little grand hotel. Renovated with a strong focus on sustainability, the hotel follows a philosophy of resource conservation. The interiors reflect the dramatic, slim exterior, warm lighting bounces off the reddish-brown natural stone that covers every surface of the entrance, where guests are presented with a lively mix of exclusivity and vivacity. High-gloss wood, splashes of sassy red, brass detailing and oversized tassels recreate the private recesses of a graceful movie star. The suites, partially equipped with terraces, can even be used for photo shootings or small events. Another highlight of the hotel is its innovative food and beverage concept. At Bloom, the hotel's two-story café, bar and bistro, guests and locals alike enjoy Austrian interpretations of innovative delicacies. The specialties are prepared using organic products and served alongside owner Martin Lenikus' own brand of eco-friendly wines. Located on a busy corner, the large glass doors open onto the street, inviting a lively buzz into the richly decorated space. From the breezy rooftop garden, views of the old town and the spires of St. Stephen's cathedral will bring guests back to the Vienna of here and now, before being whisked away again inside.

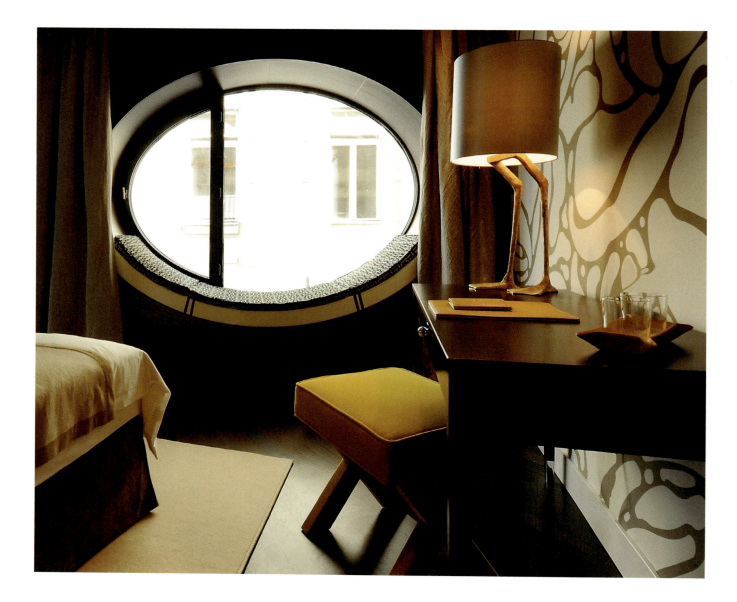

HOTEL TOPAZZ
Vienna

Vienna's first green upscale hotel sets the precedent for the future of the city, while honoring its rich artistic past. Located in the historic 1st district, Hotel Topazz combines landmark architecture with a holistic, resource-saving philosophy that starts with low-energy usage and extends to locally-sourced food and the use of green building materials. Surrounded by the most sought after attractions – including more than 60 museums, cathedrals, churches, luxury shopping, wining, dining and famous coffee houses – the hotel pays tribute to Vienna's artistic heritage of the late 19th and early 20th century. Its name, cylindrical form and staggered large oval windows draws influence from a silver vase, studded with amber gems, made by iconic Viennese artist Koloman Moser. Inside, each window is fitted with a divan bed integrated into the windowsill – the ideal spot to gaze down on the old town. The Viennese Modern Age is celebrated and revived throughout the hotel, particularly in the Salon, which recreates the easy-going yet luxurious vibe of a private turn-of-the-century Viennese house. Its 33 rooms, including a penthouse suite with terrace, spread over nine floors and feature custom-made furnishings, light fixtures and lush curtains, all in earthy and natural tones. The penthouse suite not only serves as a home for guests but can also be used as a function room for receptions with breathtaking views over Vienna or for meetings. Across the street at sister property Hotel Lamée, the innovative Bloom combines a café, bar and bistro where guests mingle with locals over an interpretation of Austrian delicacies and Lenikus' own brand of eco-friendly wines.

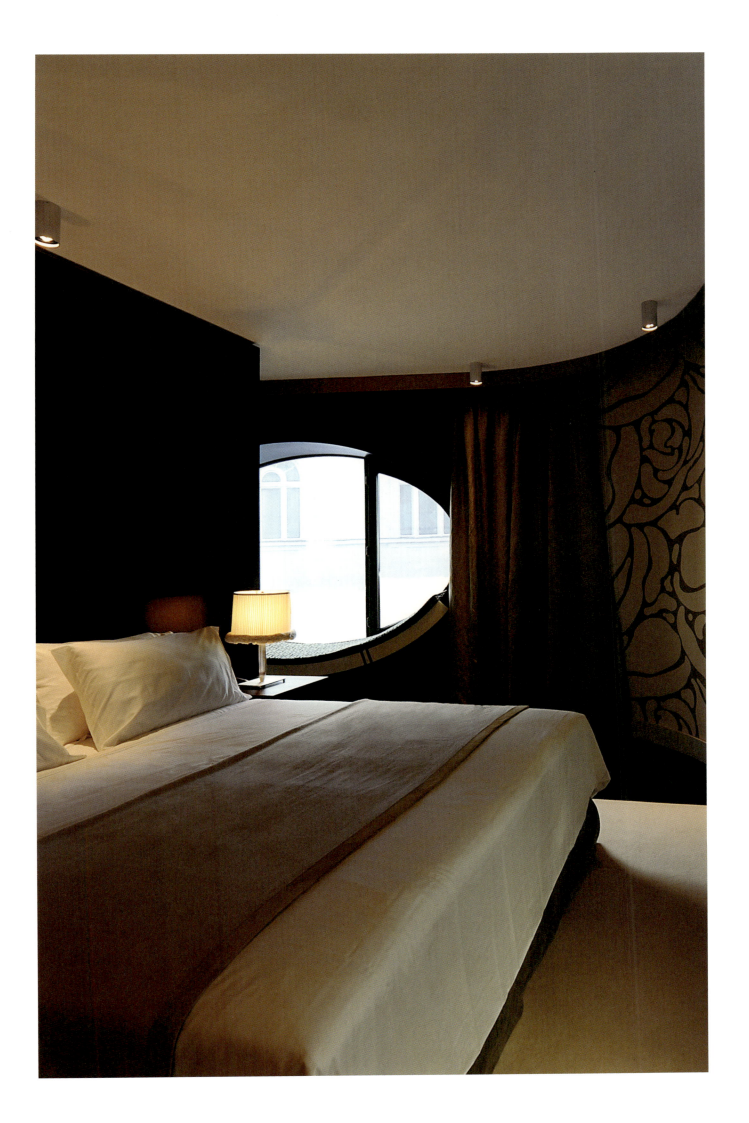

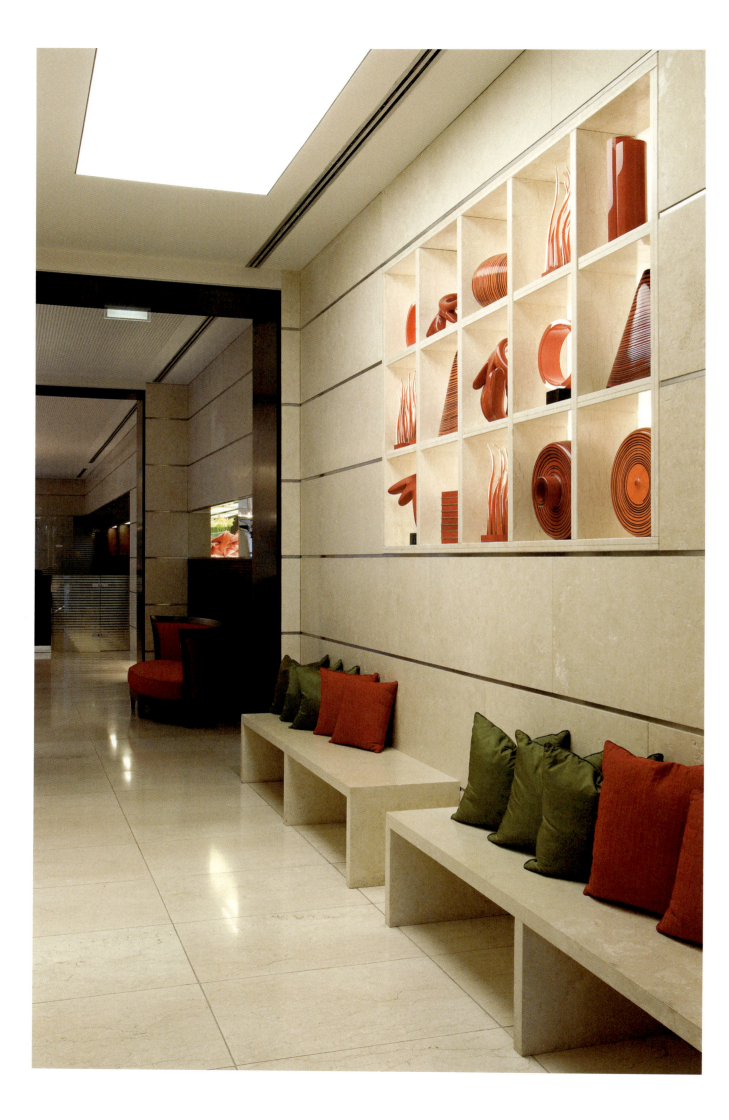

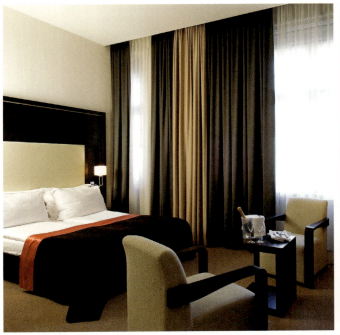
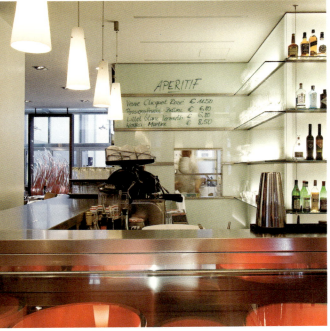
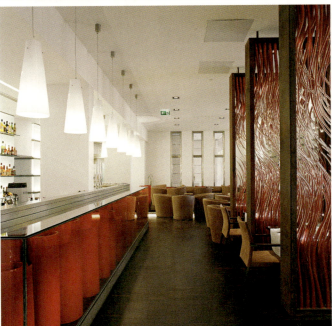
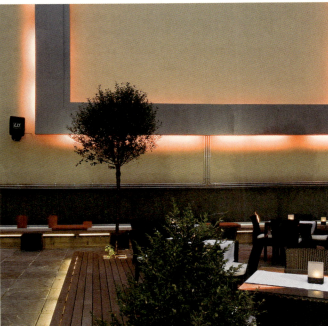

THE LEVANTE PARLIAMENT
Vienna

Just behind Austria's parliament building in central Vienna, The Levante Parliament is located around an elegant 400-square-meter courtyard. Here, separated from the bustling city, guests find a relaxing lounge ambience; an oasis of tranquillity detached from summer heat and winter's frost. Like the rest of the property, the courtyard reflects a concept based on the four natural elements. In this airy space, water features are complemented by fire-orange details and contemporary sculpture, all set against a background of earthy natural materials. Guests are also surrounded by high culture and a little history: in an original Bauhaus building dating from 1908, modern design influences infuse the property, and the space also functions as an art gallery. Black-and-white portraits of dancers from the State Opera by noted Viennese photographer Curt Themessl grace the hotel's walls, and glass objects by artist Ioan Nemtoi are on display in the prominent exhibition area. Nemtoi was also instrumental in the hotel's design – a restaurant-bar bearing his name pays homage to his vision with both eye-catching works of glass art and seasonally rotating multicultural fusion cuisine. An engaging urban getaway, The Levante Parliament represents a successful marriage of art and design, and of historical and contemporary Viennese culture.

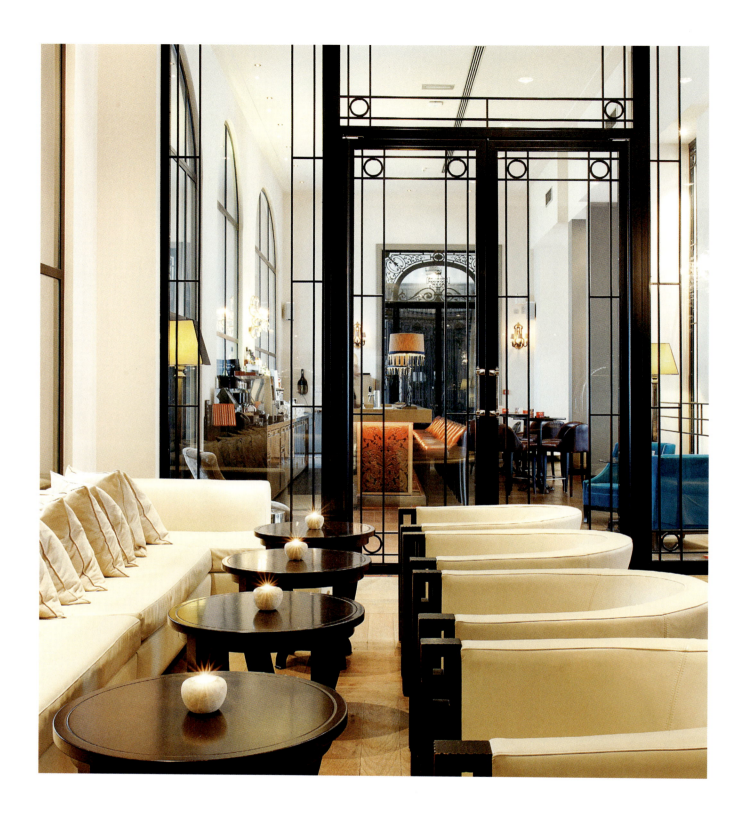

THE DOMINICAN
Brussels

Tucked behind Brussels' famous theater and opera house La Monnaie, The Dominican makes impressive use of its historical status, but with the added flavor of forward-thinking, eclectic design. The renowned Dutch duo FG stijl and architect Bart Lens designed the hotel's sweeping archways, which channel the spirit of the Dominican abbey that once stood on this site in the 15th century. A stroll through the monastery corridor evokes an almost medieval feeling of elegance with original Belgian stone flooring, and the Grand Lounge, considered the heart of the hotel, calls to mind the extravagance of old European decadence in its soaring windows and exquisite metalwork. The 150 guestrooms and suites – each with an individual look – are situated around a quiet inner courtyard and feature a rich combination of contemporary design and luxurious textiles, offering peaceful comfort in a cloister-like setting. It's a wonderful respite from the Continent's new governmental hub, and a space in which old and new Europe effortlessly meld.

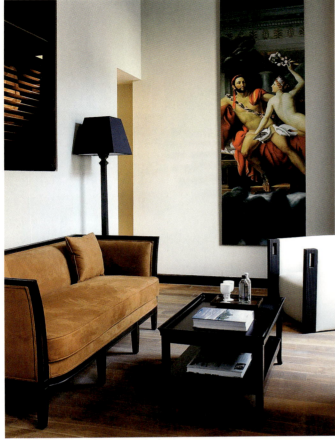

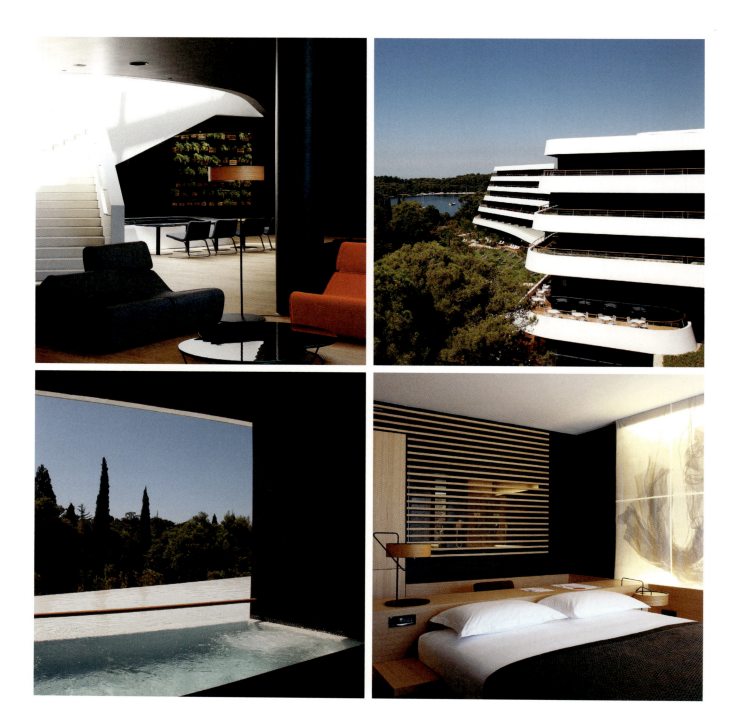

HOTEL LONE
Rovinj

Enticed by the fragrant Mediterranean forests and warm waters, the ancient woodlands and wave-lapped coves of Croatia's Adriatic coast are a magnet for holidaymakers. Like a luxury cruise liner nestled on the hillside, the seductive minimalist curves of Hotel Lone's design are influenced by the area's unique natural landscape. Situated in picturesque Rovinj, only a ten minute walk from the central town square, the hotel was created by Maistra Inc. and architecture studio 3LHD to offer guests the perfect symbiosis of work and play. The 248 rooms and 11 suites gracefully bend away from the coastine in a distinctive Y-shape, offering each room views of the island-speckled coast. The hotel's impressive business facilities combine minimalism, elegance and state-of-the-art technology. With four large auditoriums and three large meeting rooms featuring high ceilings and wide spaces, guests are given the freedom to brainstorm and ruminate. Delicate strains of locally grown rosemary, lavender and olive oil tempt guests into the Mediterranean-inspired wellness spa, while the open-plan lobby – bedecked in mirrors and cool white stones – allows the outstanding natural beauty of the surrounding area to flood inside.

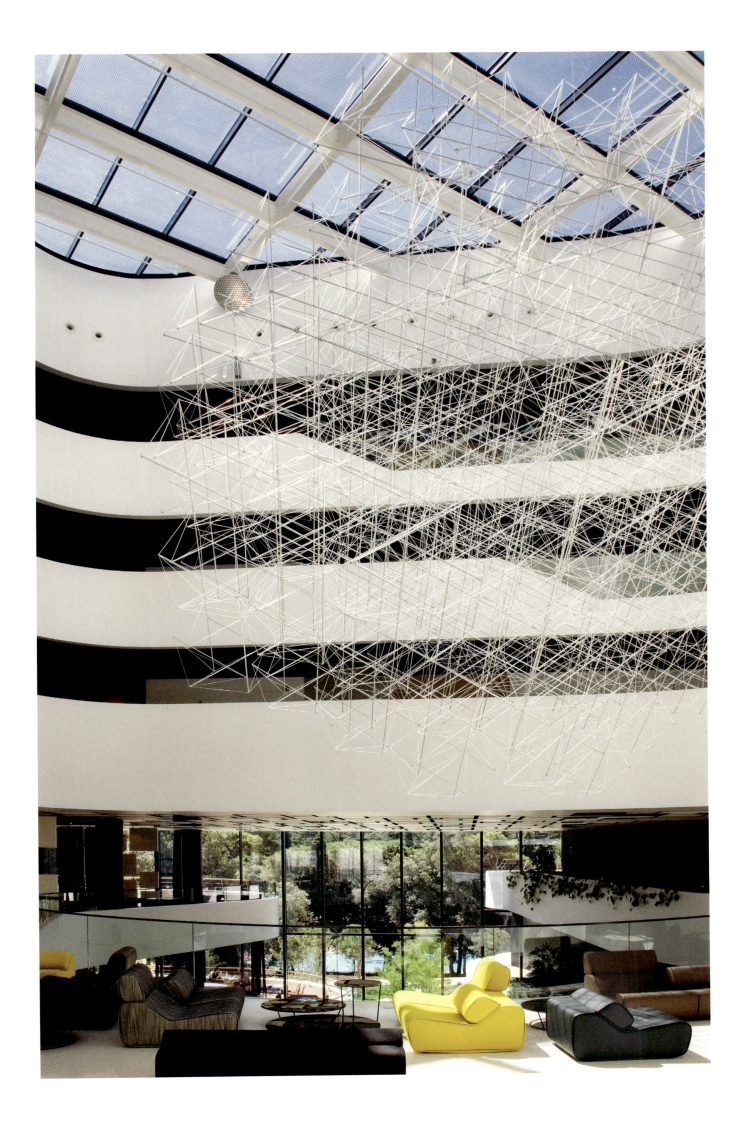

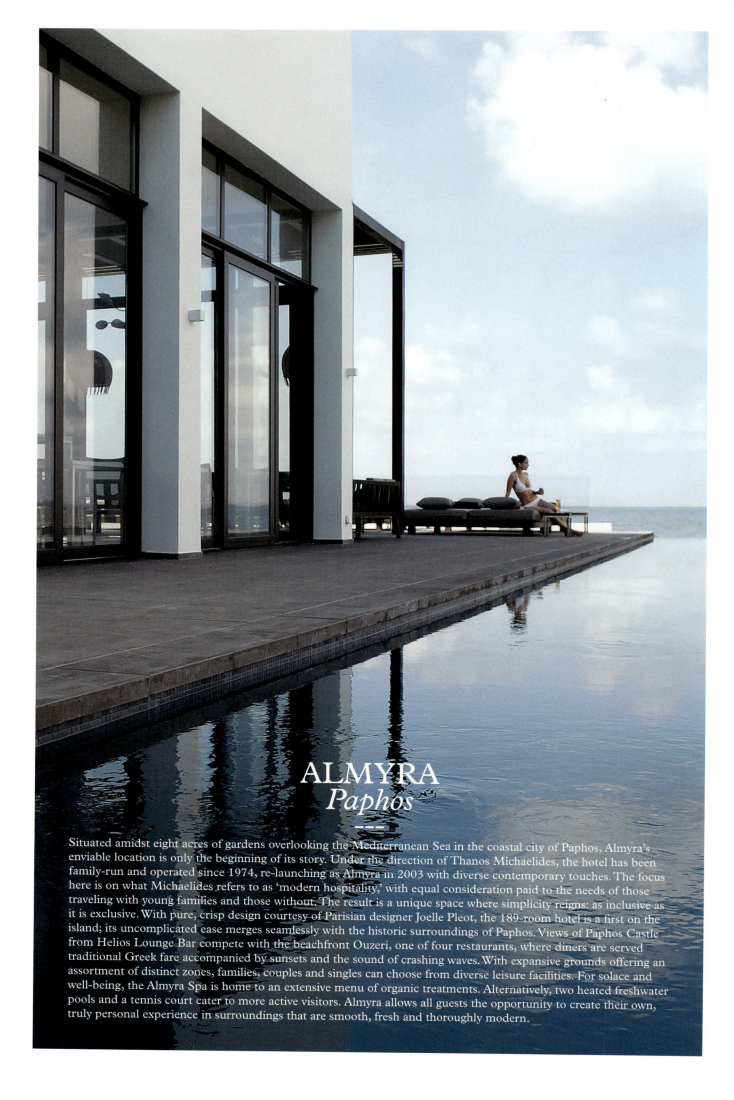

ALMYRA
Paphos

Situated amidst eight acres of gardens overlooking the Mediterranean Sea in the coastal city of Paphos, Almyra's enviable location is only the beginning of its story. Under the direction of Thanos Michaelides, the hotel has been family-run and operated since 1974, re-launching as Almyra in 2003 with diverse contemporary touches. The focus here is on what Michaelides refers to as 'modern hospitality,' with equal consideration paid to the needs of those traveling with young families and those without. The result is a unique space where simplicity reigns: as inclusive as it is exclusive. With pure, crisp design courtesy of Parisian designer Joelle Pleot, the 189-room hotel is a first on the island; its uncomplicated ease merges seamlessly with the historic surroundings of Paphos. Views of Paphos Castle from Helios Lounge Bar compete with the beachfront Ouzeri, one of four restaurants, where diners are served traditional Greek fare accompanied by sunsets and the sound of crashing waves. With expansive grounds offering an assortment of distinct zones, families, couples and singles can choose from diverse leisure facilities. For solace and well-being, the Almyra Spa is home to an extensive menu of organic treatments. Alternatively, two heated freshwater pools and a tennis court cater to more active visitors. Almyra allows all guests the opportunity to create their own, truly personal experience in surroundings that are smooth, fresh and thoroughly modern.

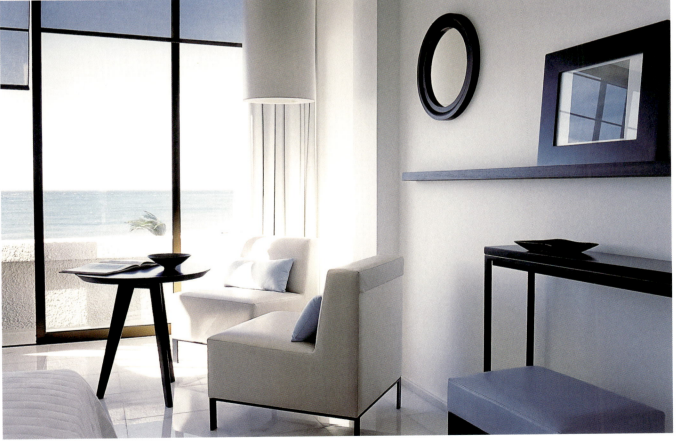

HOTEL JOSEF
Prague

In the heart of one of Europe's most beautiful medieval cities, Eva Jiricna's award-winning design for Hotel Josef is a masterpiece of contemporary cool, building on a great 20th-century tradition of modern Czech design. The 109-room Hotel Josef comprises two buildings centered around a peaceful, landscaped courtyard that create chilled-out counterpoint to the active, urban lifestyle of Prague's old town. Evoking a stark white modernist utopia, the reception and bar area features lines, glossy surfaces and a magnificent example of Jiricna's signature high-tech steel and glass staircases, which connects the conference area with the lobby, which its floor-to-ceiling windows leading out to the Zen-inspired courtyard. A well-proportioned mix of efficiency and luxury pervades the rest of the hotel and guestrooms are fully equipped with the latest communications technology. A business center and gymnasium, along with a new sauna and massage room, complete the sophisticated environment of Hotel Josef, which has already become a favorite destination in Prague's growing business and tourist economy.

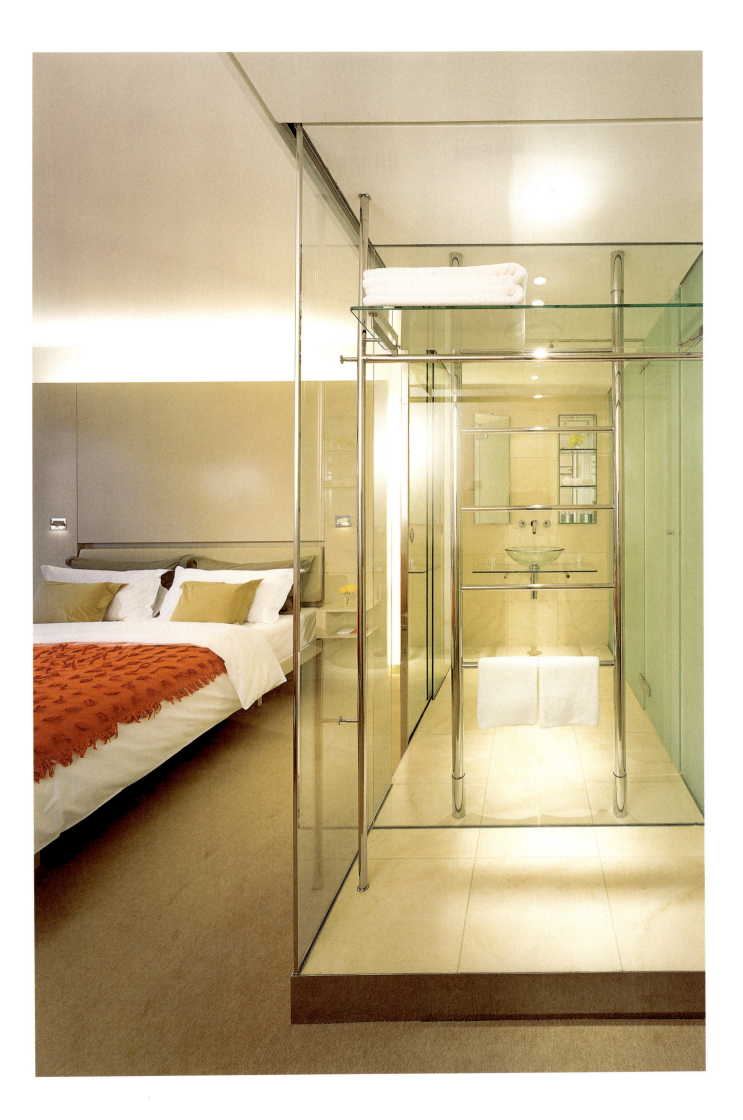

✴ SIGNATURE

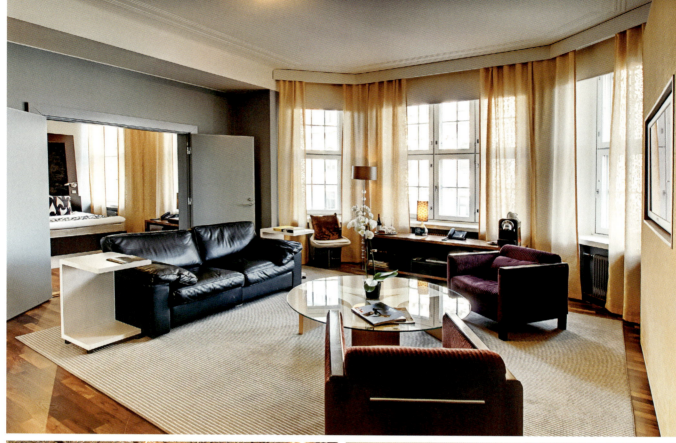

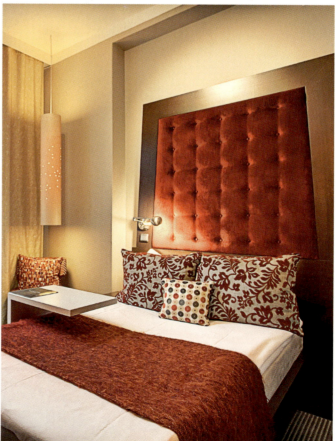

WWW.DESIGNHOTELS.COM/
KLAUS_K

ADDRESS
BULEVARDI 2-4
00120 HELSINKI
FINLAND

ROOMS
137

RATES
EUR 155 –
EUR 550

OPEN
11/2005

FINLAND
HELSINKI

KLAUS K
Helsinki

Located in the late 19th-century Rake building, the hotel is inspired by Finland's national epic, the Kalevala, which can be seen on an intimate, human scale throughout the space. The hotel also has two strikingly distinctive restaurants. Toscanini serves delicious flavors from Tuscany and is inspired by the Finnish national painter Akseli Gallen-Kallela who spent time in Florence studying fresco painting techniques. The Ilmatar restaurant, named after the goddess of air, is home to "The Best of Finland" breakfast celebrating hyper-pure Finnish products from around the country. Events such as brunches and wine dinners are held in the restaurants, as well as in the small Ahjo Bar and Club. With space for up to 350 people, the club is a meeting place for guests and young urbanites who like good music and inventive cocktails served up in a welcoming atmosphere.

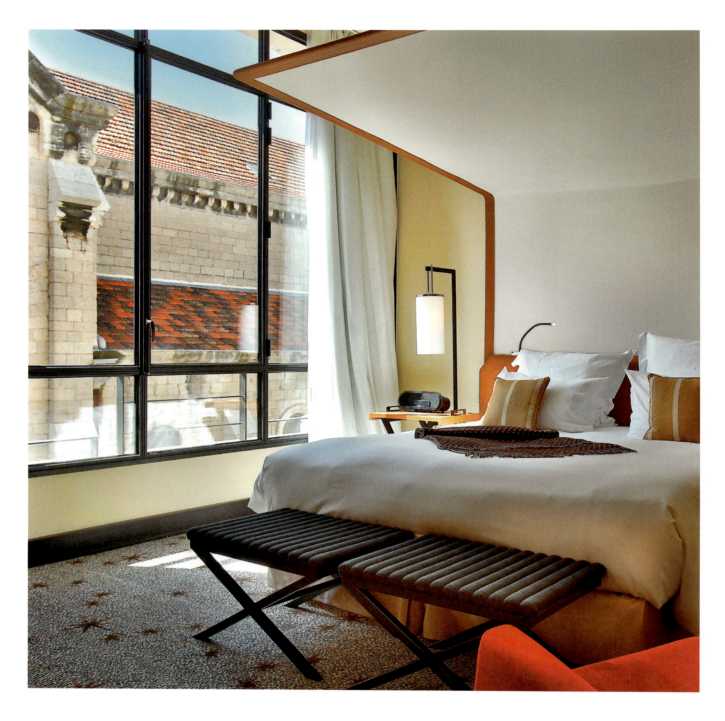

FIVE HOTEL & SPA
Cannes

Guests are taken on a visual journey around the world at the Five Hotel & Spa, where a fine selection of handcrafted furnishings and adornments excite all the senses. Each object and painting that embellishes the public spaces, rooms and suites, has been designed specifically for the hotel by the best craftsmen around the world. From superb embroidered folding screens, to an antique collection of blue porcelain, each piece alludes to exotic landscapes, creating spaces that are unique, authentic and intimate. Located behind the famous Croisette, the hotel is ideally situated to take in the best that Cannes has to offer, including the Old Town, the harbor, Festival Beach, luxury shopping and the Palais des Festivals. But guests need look no further than the hotel's rooftop for world-class dining, extravagant lounging and views over the roofs of Cannes. At Sea Sens restaurant, the menu is curated by Michelin-starred twins Jacques and Laurent Pourcel. Here, exotic cuisine prepared using herbs and spices from Asia is served in an opulent space filled with lanterns, suede banquettes, Bivouac-style armchairs and floral wall panels. These lively surroundings extend out onto the terrace and towards the infinity pool, where cocktails can be enjoyed on crisp white daybeds splashed with bright accents of turquoise. All the desserts are sweet creations by World Pastry Champion Jérôme de Oliveira who is also at the helm of his own Salon-Boutique, "Intuitions by J," serving freshly-baked, tasty treats. The Spa By Cinq Mondes, and three private yachts for mini-cruises between Monaco and Saint-Tropez, round out the decadent voyage.

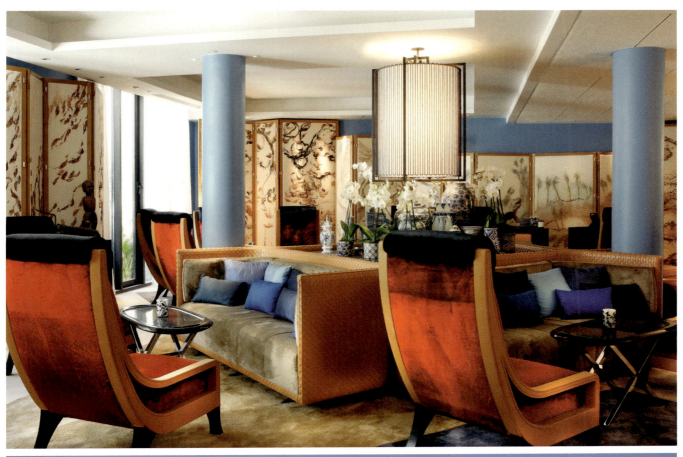

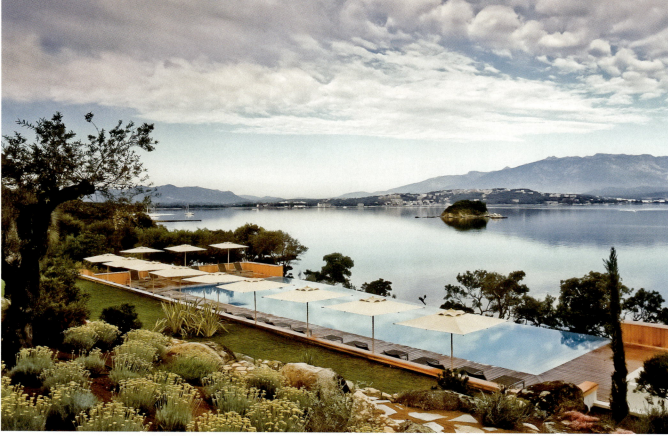

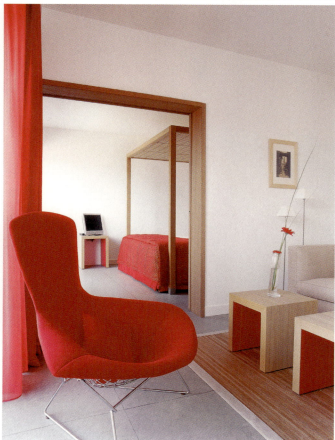

RARE

WWW.DESIGNHOTELS.COM/ CASADELMAR

ADDRESS
ROUTE DE PALOMBAGGIA BP 93
20538 PORTO VECCHIO CEDEX
FRANCE

VILLAS
1

ROOMS
34

VILLA RATES
EUR 2700 –
EUR 6500

ROOM RATES
EUR 390 –
EUR 2700

OPEN
05/2004

FRANCE
CORSICA

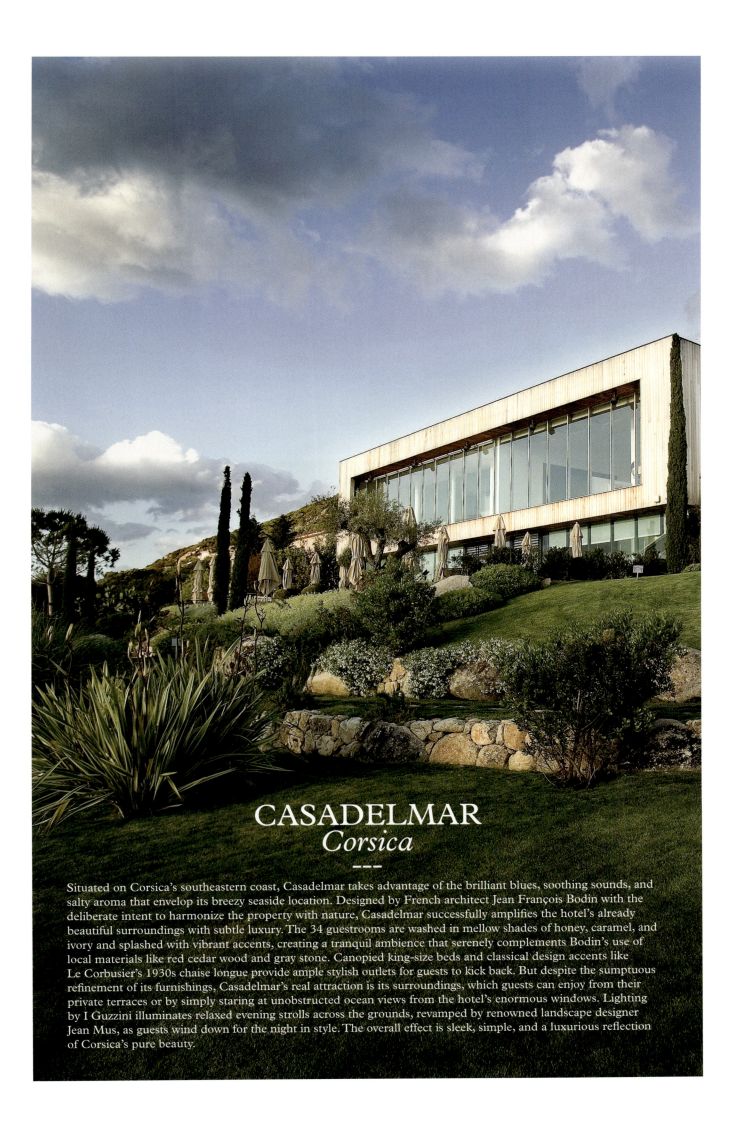

CASADELMAR
Corsica

Situated on Corsica's southeastern coast, Casadelmar takes advantage of the brilliant blues, soothing sounds, and salty aroma that envelop its breezy seaside location. Designed by French architect Jean François Bodin with the deliberate intent to harmonize the property with nature, Casadelmar successfully amplifies the hotel's already beautiful surroundings with subtle luxury. The 34 guestrooms are washed in mellow shades of honey, caramel, and ivory and splashed with vibrant accents, creating a tranquil ambience that serenely complements Bodin's use of local materials like red cedar wood and gray stone. Canopied king-size beds and classical design accents like Le Corbusier's 1930s chaise longue provide ample stylish outlets for guests to kick back. But despite the sumptuous refinement of its furnishings, Casadelmar's real attraction is its surroundings, which guests can enjoy from their private terraces or by simply staring at unobstructed ocean views from the hotel's enormous windows. Lighting by I Guzzini illuminates relaxed evening strolls across the grounds, revamped by renowned landscape designer Jean Mus, as guests wind down for the night in style. The overall effect is sleek, simple, and a luxurious reflection of Corsica's pure beauty.

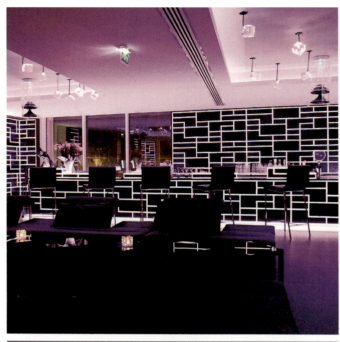
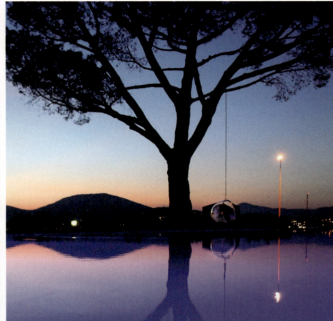
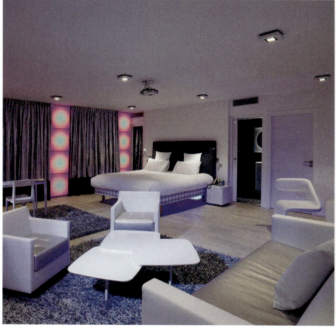

*OFFBEAT

WWW.DESIGNHOTELS.COM/
KUBE_HOTEL_GASSIN

ADDRESS
ROUTE DE ST-TROPEZ
83580 GASSIN
FRANCE

ROOMS
41

RATES
EUR 265 –
EUR 2200

OPEN
06/2009

FRANCE
GASSIN

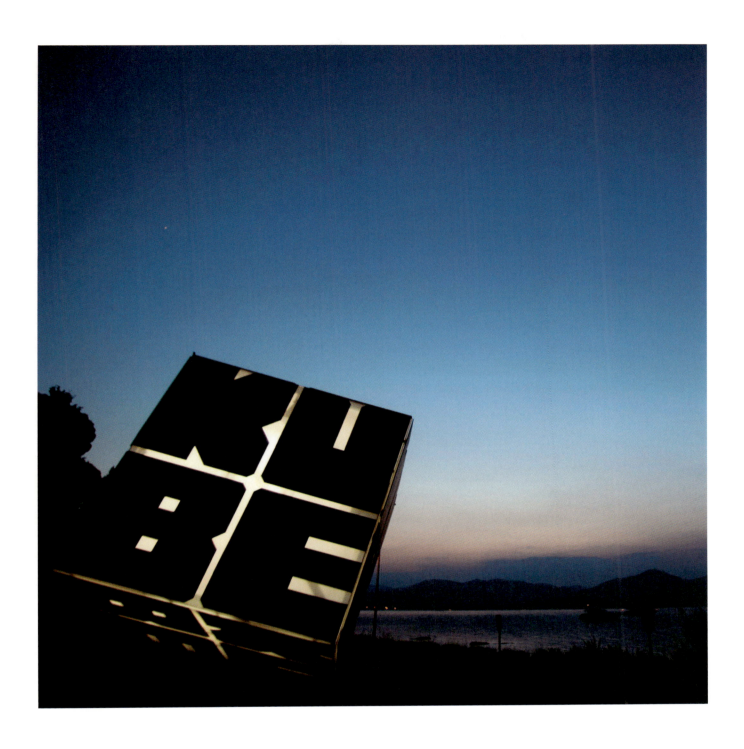

KUBE HOTEL GASSIN
Gassin

Equally suited for romantic getaways and business retreats, the KUBE Hotel Gassin offers a timeless concept with universal appeal: exclusive luxury on the French Riviera. The latest tour de force from Murano Hotels & Resorts – the hotel group behind the celebrated KUBE Hotel in Paris – this year-round mini-resort is at once an elegant event venue, a hopping nightclub and a quiet Mediterranean refuge. The KUBE Hotel Gassin is far enough from the hustle and bustle of neighboring Saint-Tropez to serve as a seaside retreat, but close enough to the Riviera's nightlife to satisfy those in search of a more boisterous experience. The hotels's bold main restaurant is supplemented by a garden restaurant and several unusual private lounges, including the chef's table in the hotel kitchen, where guests can even enjoy cooking classes and the 10,000-bottle-strong wine cellar. Cocktails are on offer at the pool and rooftop sky bars, where DJs spin tunes all night long and well-heeled guests can mingle and schmooze. Conference rooms offer flexible space for business meetings, and, in fact, any area of the hotel can be set for a private event – from the pool decks to the roof terrace, the sea-view gardens to the ice bar.

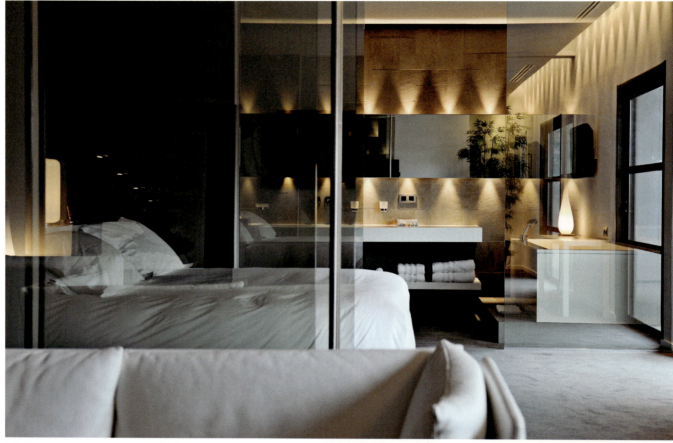

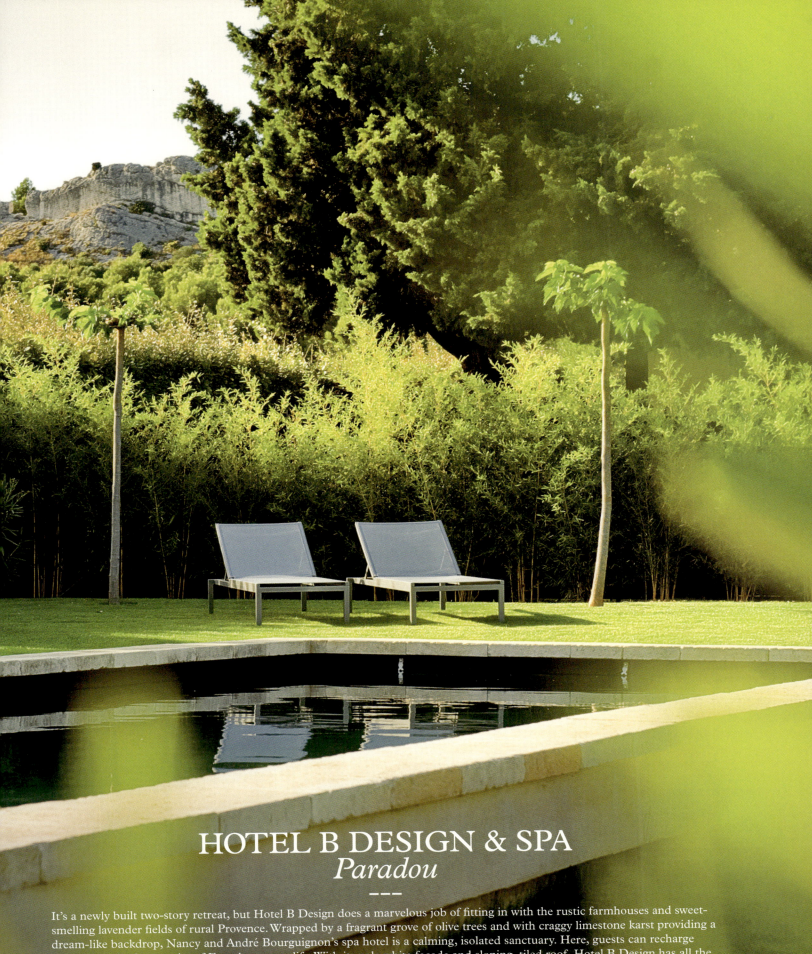

HOTEL B DESIGN & SPA
Paradou

It's a newly built two-story retreat, but Hotel B Design does a marvelous job of fitting in with the rustic farmhouses and sweet-smelling lavender fields of rural Provence. Wrapped by a fragrant grove of olive trees and with craggy limestone karst providing a dream-like backdrop, Nancy and André Bourguignon's spa hotel is a calming, isolated sanctuary. Here, guests can recharge and indulge in the serenity of French country life. With its pale white facade and sloping, tiled roof, Hotel B Design has all the external architectural charm of a traditional pastoral residence. But inside, designer Christophe Pillet (who has already made his mark on Design Hotels™ properties in Paris and Saint-Tropez) has worked hard to ensure the emphasis is on swooping modern contours and broad open spaces. Mineral shades of white, brown, black, and gray pervade each of the 14 airy suites. Each room has access to a cerulean private pool, while the outdoor terrace rewards with energizing views over the rolling green-and-purple countryside. In the spacious 250-square-meter spa, delicately fragranced products by Carita and Decléor help guests unwind in their own private treatment rooms. Here in southern France, gastronomy is central to the joie de vivre, and Nancy – part hotel owner and part culinary superstar – wows guests nightly with simple, seasonal dishes infused with locally produced herbs and oils. There aren't any menus, but with the markets of Provence providing an endless variety of fresh, flavorsome ingredients, there's always something new to try.

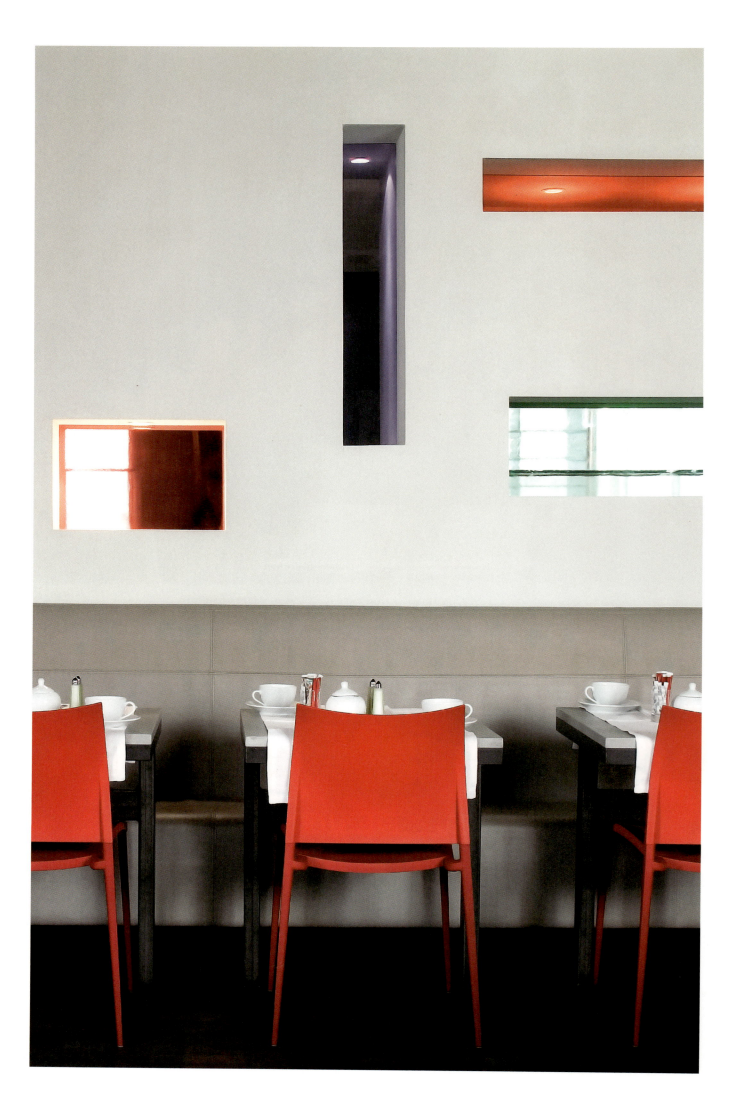

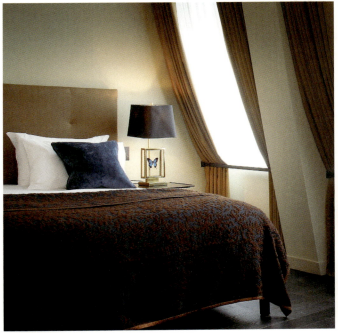

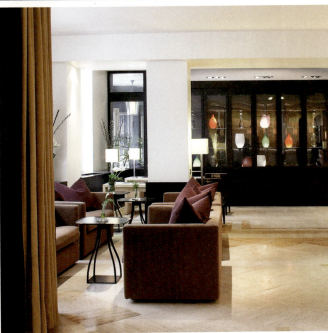
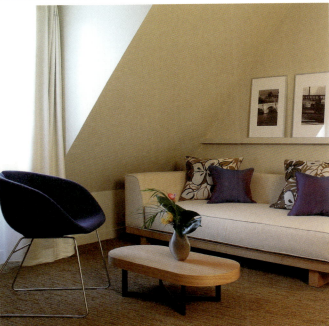

BEL-AMI
Paris

Originally an 18th-century abbey on Rue Saint-Benoît in Paris, the Bel-Ami has been transformed by a new generation of French designers into a modern masterpiece of pared-down luxury. French design duo Nathalie Battesti and Veronique Terreaux – known for their invigorating interiors scattered around Paris and Tokyo – accomplish a pristine simplicity that offers warmth and character, style and comfort. In 2008, French designer Pascal Allaman created new rooms and suites with pure, simple lines enhanced with contemporary tones. Now, guests can bask in the spaces' calm, informal sophistication. Natural materials such as Wenge wood give the rooms an earthy touch, while a rich, subtle palette of chocolate, pistachio, coffee, and caramel tones produces an understatement and artistic refinement within the two-century-old French abbey that gently intertwines the themes of nature and urbanism. Very recently, Marina Bessé, the fashion hat creator and designer, took some liberties with the Bel-Ami design codes for the new design of the two suites on the first floor and a collection of 20 new bedrooms with ebony and ivory or ocher and beige themes. The custom-designed furniture, the harmony of the shapes, and the interplay of the materials give the spaces a unique style. The Bel-Ami dares to be fun and exerts an unpretentious appeal to global fashionistas, all the while providing a soothing backdrop to the urban bustle of the Left Bank outside.

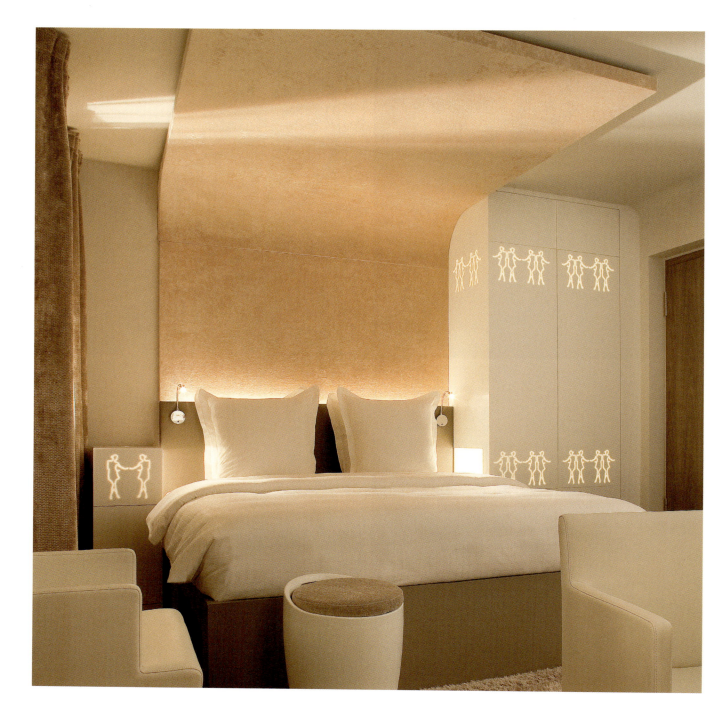

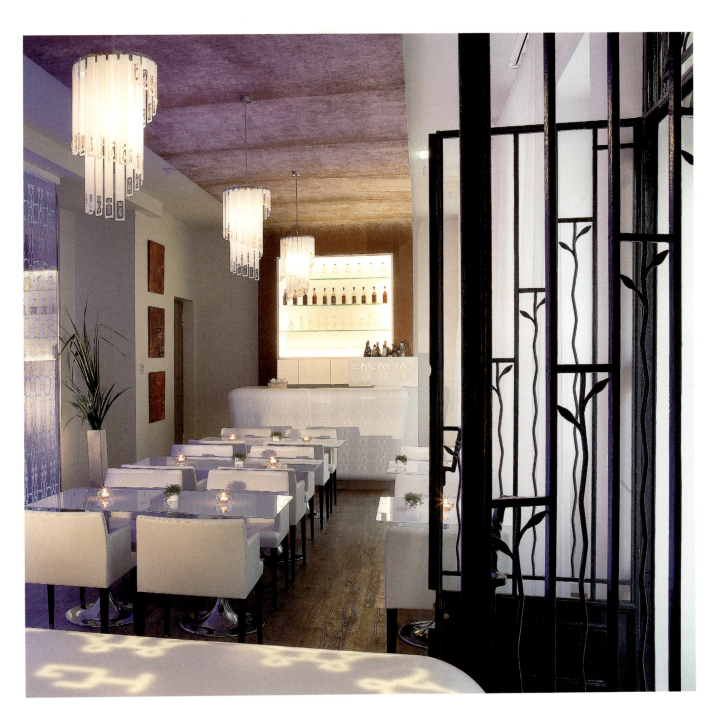

HOTEL GABRIEL PARIS MARAIS
Paris

To travelers exhausted by the stresses of modern life, the aura of the Hotel Gabriel Paris Marais is the epitome of privacy and elegance, apparent as soon as one sets foot in the entrance hall. The hotel's facade is highlighted by its gorgeous art deco ornamentation, and in conjunction with the minimalist interiors, conceived by the wonderful architect/designer Axel Schoenert, an overarching atmosphere of calm and relaxation is created. Located in the heart of the Marais district of Paris, known for its stunning 17th- and 18th-century architecture, the hotel is surrounded by fashionable and unusual shops, restaurants, cafés and galleries – perfectly situated for those travelers interested in indulging in an incredibly fulfilling relaxation routine, as well as enjoying the finest aspects of Parisian urban living. Schoenert's white decor and Zen atmosphere in subdued shades are enhanced by Australian Mark Stuart's beautiful artwork, as well as original furnishings, sophisticated lighting and cutting-edge technologies. All 41 rooms – Glowing, Deluxe and Lone Star – come equipped with decadently comfortable bedding, plush rugs and calming LED lighting. A haven of relaxation in the middle of the city's thriving cultural hub, the Hotel Gabriel Paris Marais has a little bit of everything and welcomes guests to come and discover it all.

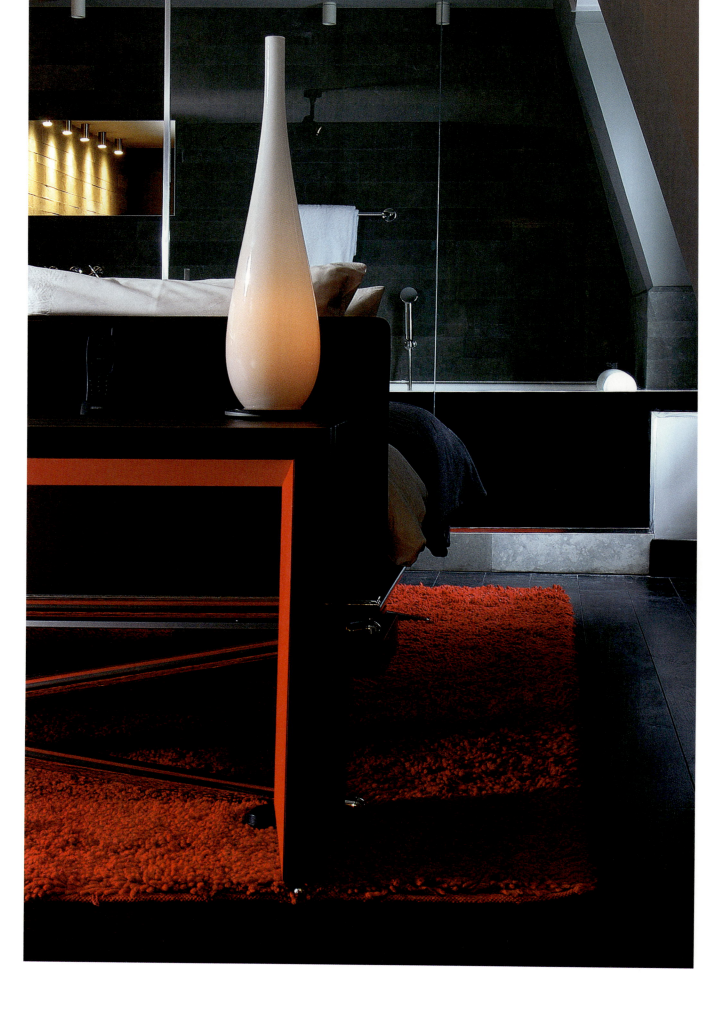

*OFFBEAT

WWW.DESIGNHOTELS.COM/
HOTEL_SEZZ_PARIS

ADDRESS
6 AVENUE FRÉMIET
75016 PARIS
FRANCE

ROOMS
26

RATES
EUR 335 –
EUR 1800

OPEN
04/2005

FRANCE
PARIS

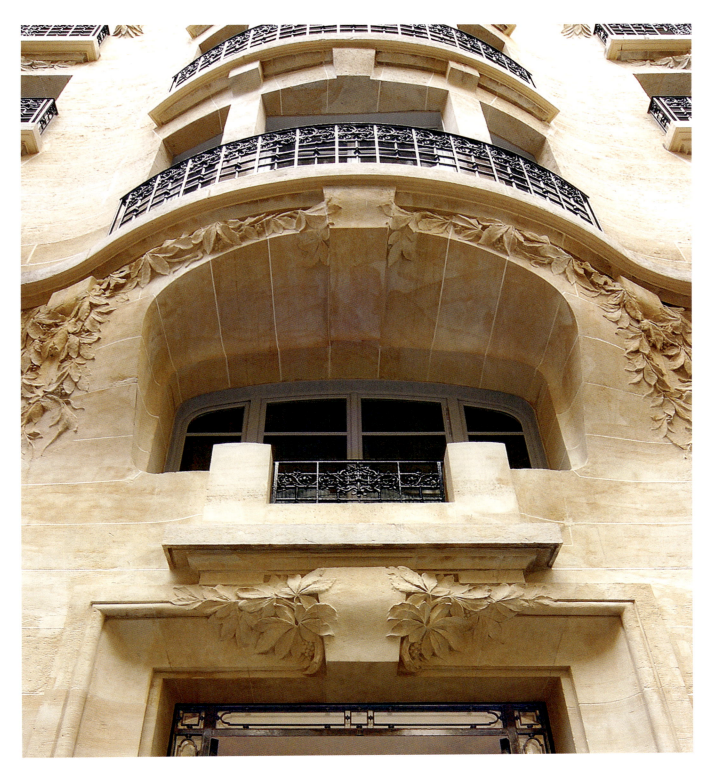

HÔTEL SEZZ PARIS
Paris

Paris is known as a city for romance. Few locations typify Parisian charm as assuredly as the 16th arrondissement. Away from Paris's hustle, each guest in this striking, unconventional hotel enjoys the service of an unobtrusive but meticulously attentive personal assistant, and is welcomed to taste Oriental delicacies in a breakfast room under a glorious glass dome. Though designer Christophe Pillet, a protégé of celebrated stone and chrome devotee Philippe Starck, crafted the Sezz's minimal aesthetic, the space's defining virtue is simple space and privacy. Instead of an intimidating concierge desk looming in the hotel's entrance, two salons in muted colors greet guests as they arrive. Even the smallest room is vast for a city as cramped as Paris. But this rare luxury only highlights the hotel's other delicate design treasures, such as austere khaki-gray stones from the Portuguese town of Cascais, and a chic Parisian palette of slate, blue-gray, and red leather, which Pillet uses generously throughout the hotel. With quiet French chic and refinement, the Sezz will win even the most worldly guest's heart.

* OFFBEAT

WWW.DESIGNHOTELS.COM/
KUBE_HOTEL

ADDRESS
1-5, PASSAGE RUELLE
75018 PARIS
FRANCE

ROOMS
41

RATES
EUR 375 –
EUR 875

OPEN
11/2005

FRANCE
PARIS

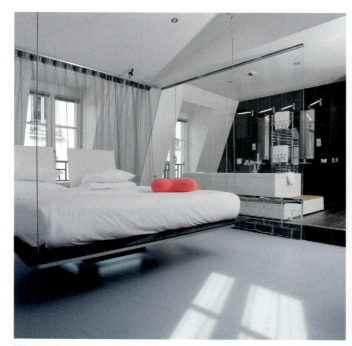

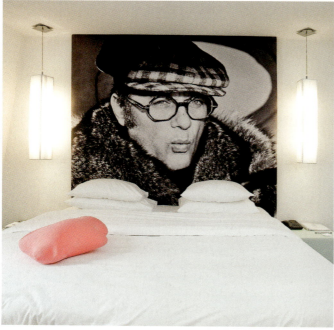

KUBE HOTEL
Paris

Tucked into a tiny, quiet street at the summit of Paris's multicultural Montmartre district is a retro-future hotel that defies the city's classical clichés. Upon entering KUBE Hotel, visitors will be forgiven for thinking they've walked onto the set of an achingly smart 1960s sci-fi film. A glowing Plexiglas cube serves as the reception area, while at the heart of the hotel is a spacious lounge-restaurant-bar: a futuristic, low-lit space with high ceilings, stainless steel accents, and a state-of-the-art sound system camouflaged in red ceiling lanterns. The supremely cool "Ice KUBE" bar on the mezzanine features an icy blue-lit igloo, Eero Aarnio's 1968 Bubble Chairs, and a Grey Goose vodka-only drinks menu. The 29 sleek guestrooms and 12 suites are arranged around an open courtyard and accessed via colorful elevators. This gives a hint of the playful features in store, including faux-fur, cubic bathtubs, and beds lit from beneath. Biometric fingerprint technology controls room access, and each room is fitted with a flat-screen TV and Playstation 3. Welcome to the future!

*SIGNATURE

WWW.DESIGNHOTELS.COM/
MAISON_CHAMPSELYSEES

ADDRESS
8, RUE JEAN GOUJON
75008 PARIS
FRANCE

ROOMS
57

RATES
EUR 250 –
EUR 1315

OPEN
03/2010

FRANCE
PARIS

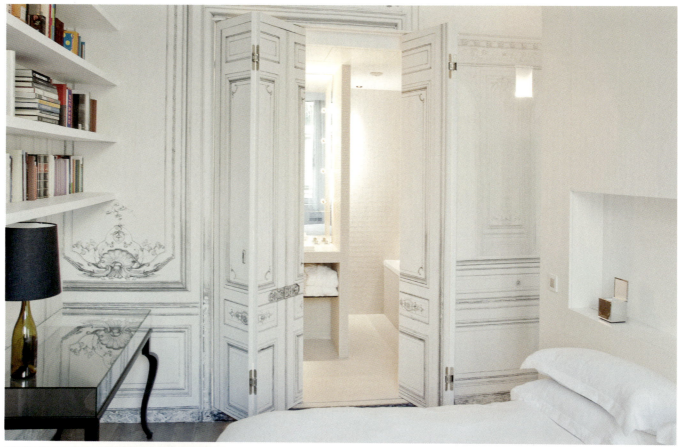
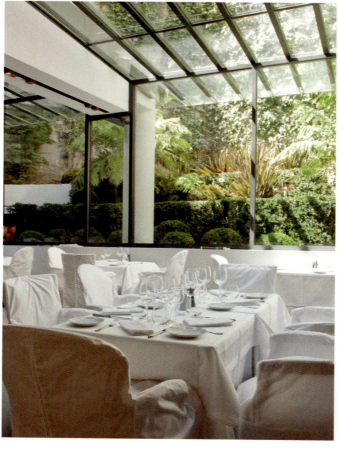

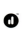

146

LA MAISON, CHAMPS ELYSÉES
Paris

Reality blends with surreal style to create a world of comfort and French elegance at La Maison Champs Elysées, situated in the heart of the Parisian Golden Triangle. The entrance to the townhouse at No. 8 rue Jean Goujon is discreet, an address you must know to discover. Behind its doors, the stage is set for fashion house Maison Martin Margiela's first hotel interior. The 57 rooms and suites boast state-of-the-art bedding, high-quality linen sheets, and mattress pads and duvets in pure goose down. Whimsical experiments with proportion and perception abound in the 17 rooms and suites belonging to the Couture Collection. Persian rugs are woven into the carpets; walls are covered in wallpaper made from black and white photographs; and squares of painted light give the illusion of sun streaming in from the windows. With a philosophy that revolves around light-heartedness, the service is attentive without being too formal. This laid-back style can be felt in La Table du 8 restaurant and bar, where innovative French cuisine is served, right through to The Cigar Bar, and The White Lounge, which is surrounded by a terrace and a dense year-round garden. Discovering No. 8 rue Jean Goujon is a unique experience, combining generosity, poetry, luxury and lightness, pleasure and an offbeat vision. La Maison Champs Elysées is a destination in its own right.

LA RÉSERVE PARIS
Paris

Located directly across from the Eiffel Tower, La Réserve Paris stays true to its name through interior architect Remi Tessier's refined take on discreet opulence. La Réserve prides itself on the soft lighting and subdued monochromatic aesthetic, inviting guests to relish the noble grace of rosewood, ebony, sycamore, stone, and slate. Tessier, who has collected accolades for luxury yacht designs, demonstrates an iron grasp of the linkage between functional design and clean elegance. Guests can imagine soaring away on sublimely modernist furnishings by Andrée Putman, Maxalto, Flos, and Vitra. And with the exception of the sumptuous four-poster beds and the high double windows, everything from the plush Flexform chairs to the twin marble sinks in the bathrooms is symmetrically aligned. A sofa or a nightstand is never without its mate, making this ultramodern space an ode to old-fashioned romance. Combining the latest technological advances with stunning contemporary decor, La Réserve Paris is an exceptional, prestigious base designed for total comfort and privacy, right down to the smallest details: a broad range of hotel services on request, a concierge, a daily housekeeper, exclusive valet parking, a home chef … Everything has been considered to ensure guests' ease and luxury.

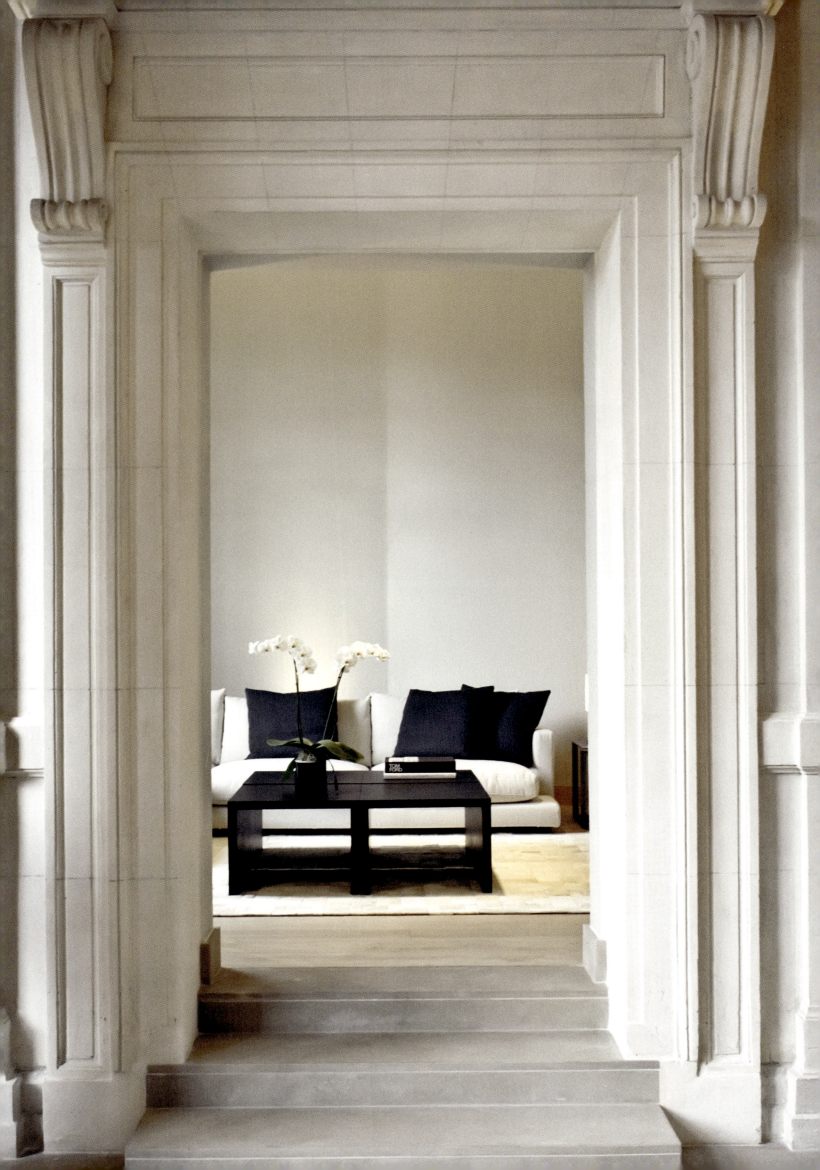

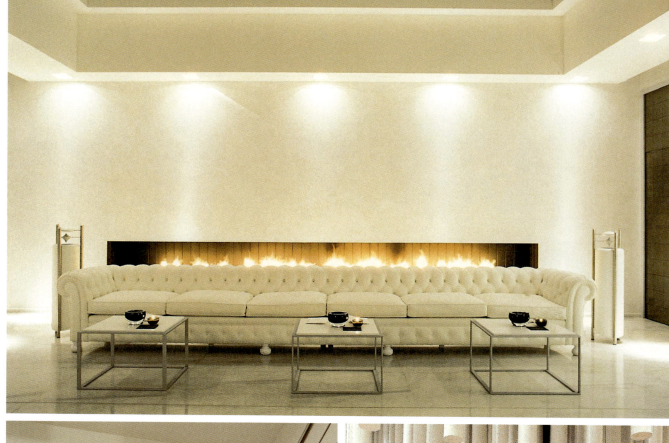

WWW.DESIGNHOTELS.COM/
MURANO_RESORT_PARIS

ADDRESS
13 BOULEVARD DU TEMPLE
75003 PARIS
FRANCE

ROOMS
51

RATES
EUR 440 –
EUR 10000

OPEN
09/2004

FRANCE
PARIS

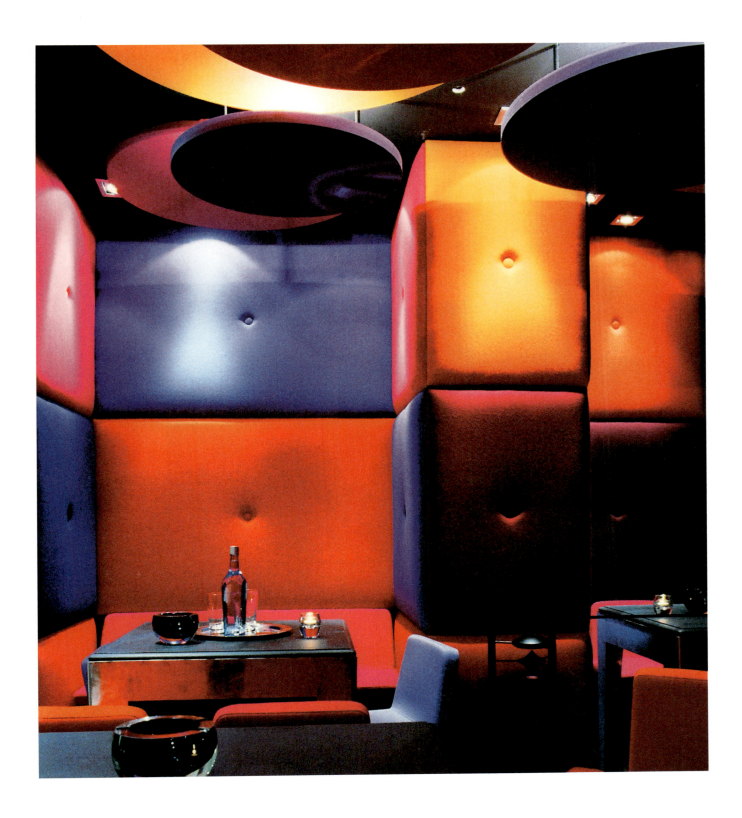

MURANO RESORT
Paris

Standing proud on a wide boulevard at the edge of the hip Marais district, the MURANO Resort Paris's unadorned facade reveals little of the flamboyance hidden within. Playful yet sophisticated, this urban resort is an intriguing melange of quirky design, evocative lighting, and technological innovation, perfectly executed to stimulate the senses. Its 51 rooms feature discreetly placed customizable lights controlled from a bedside panel according to the guest's desire. The guestrooms also come equipped with natural argan-oil cosmetics, pillow menus, and extra-wide beds. Two of the suites even come with private, outdoor heated swimming pools for the utmost in luxury. Downstairs, the acclaimed MURANO restaurant spreads across a five-meter-high main dining room, two cozy lounges, and the sun-drenched Martini Terrace. Its avant-garde kitchen offers delicate and creative cuisine equally suited to meat-lovers and vegetarians. The hotel lounge bar is no less impressive, offering a staggering 180 types of vodka and a poker lounge, as well as live music during the week and house DJs every night.

*RARE

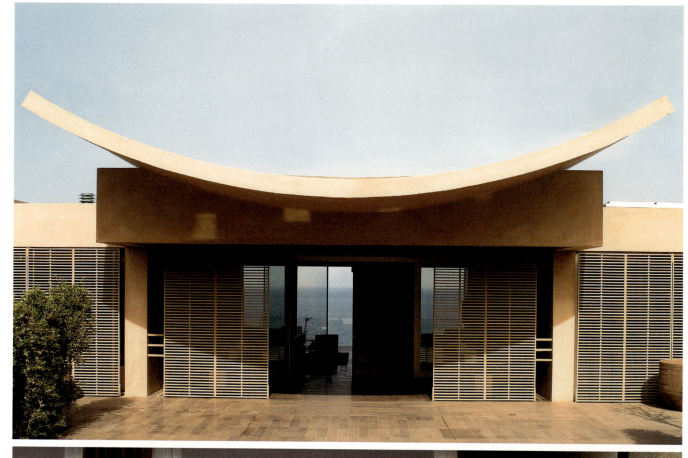

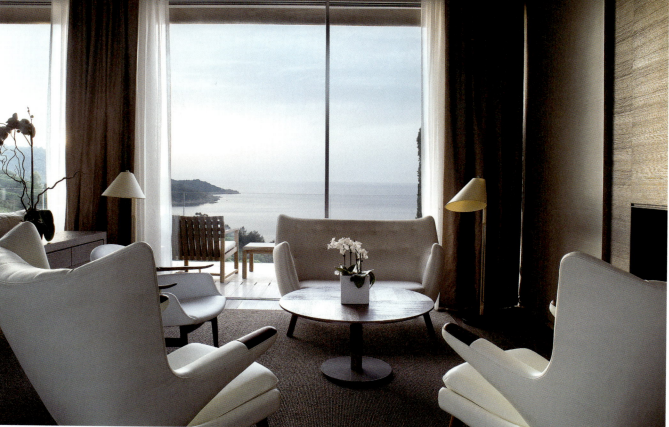

WWW.DESIGNHOTELS.COM/
LA_RESERVE_RAMATUELLE

ADDRESS
CHEMIN DE LA QUESSINE
83350 RAMATUELLE
FRANCE

VILLAS
12

ROOMS
23

VILLA RATES
EUR 3200 –
EUR 6800

ROOM RATES
EUR 430 –
EUR 4000

OPEN
05/2009

FRANCE
RAMATUELLE

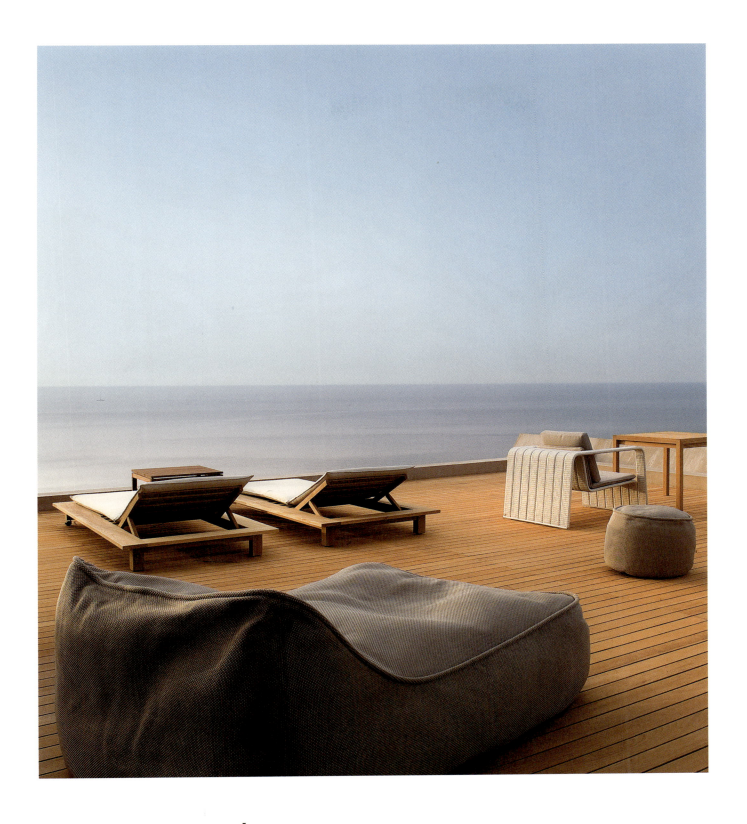

LA RÉSERVE RAMATUELLE
HOTEL, SPA AND VILLAS
Ramatuelle

Perched on a quiet hill by the Mediterranean Sea stands a temple of well-being called La Réserve Ramatuelle. Just minutes outside the legendary Saint-Tropez, this hilltop hideaway is part spa, part hotel, and all serenity. Its seven guestrooms, 16 suites, and 1,000-square-meter spa are seamlessly integrated into La Réserve's private domain, a gorgeous pine-covered expanse, also home to 12 private villas that can be rented on a short-term or long-term basis. The luxuriously spacious bedrooms range from 50 to 100 square meters, and each is equipped with a private terrace or scented garden offering unrestricted views over the Mediterranean Sea below. A lounge, bar, and restaurant serving Mediterranean cuisine provide for gastronomic needs, and a private chef is available to prepare meals and cater parties. The heart of La Réserve is its enormous spa, which includes 10 treatment cabins, indoor pool, fitness studio, steam bath, and solarium. Organized around four major objectives – stress reduction, fitness, slimming, and beauty – these customized programs help guests detoxify, relax and, regenerate in a tranquil environment. The spa team draws up an individualized treatment plan as well as a healthy and controlled diet based on high-quality ingredients.

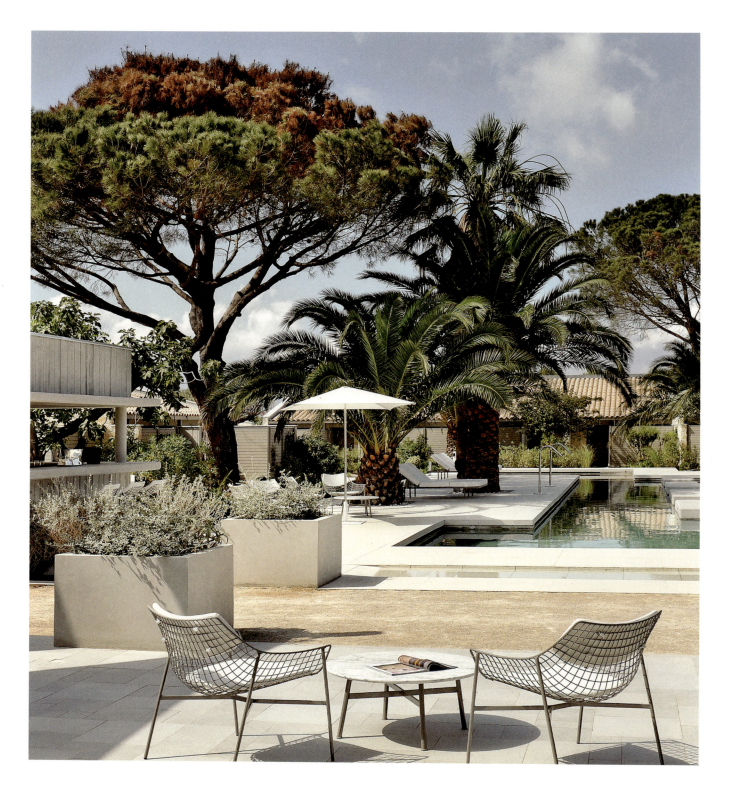

HÔTEL SEZZ SAINT-TROPEZ
Saint-Tropez

Saint-Tropez has seen it all. At the heart of the French Riviera, the beautiful town has come to be known for the row of private yachts lining the quay and the stream of movie stars that file through during peak season. It is the region's natural beauty that attracts them, of course. But the modish lifestyle doesn't hurt much either. It is here, in Saint-Tropez, that we encounter Shahe Kalaidjian and Christophe Pillet's beautiful second collaboration. With their first joint endeavor, Hôtel Sezz in Paris's 16th arrondissement, they developed a language of their own. In Saint-Tropez, they translate it from an urban lexicon into one that exudes the ultimate in luxury vacation. Situated on the town's Route des Salins, the hotel is built of light and air – guests can smell and feel salt water and warm breezes from their beds and baths. With 37 guestrooms and villas engulfed by a lush wooded park and a swimming pool at its hub, Sezz Saint-Tropez is as warm and inviting as it is fresh and full of vision. The Personal Assistant Program devised at Sezz Paris has been carried over to Saint-Tropez, but the new collaborations – the Dom Pérignon bar, the restaurant led by world-renowned chef Pierre Gagnaire and the spa developed in partnership with Payot – are unique to Sezz Saint-Tropez. Each of the hotel's guestrooms, suites and villas is individualized and has its own private balcony leading out to the central pool or into a private garden.

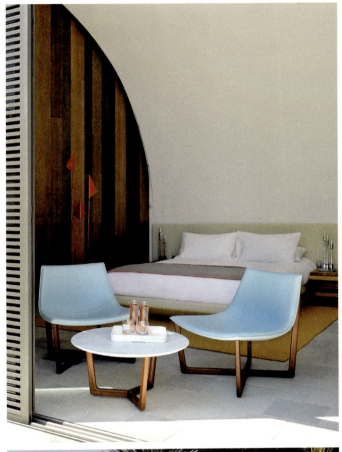
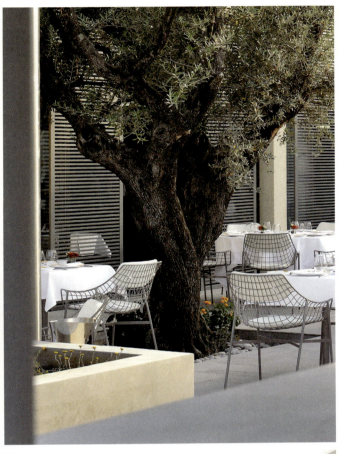
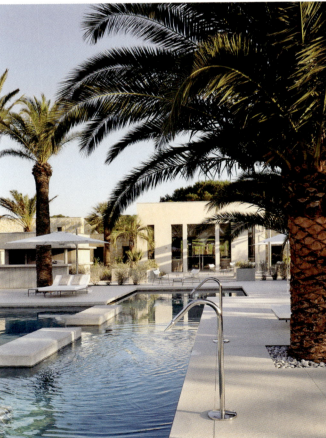
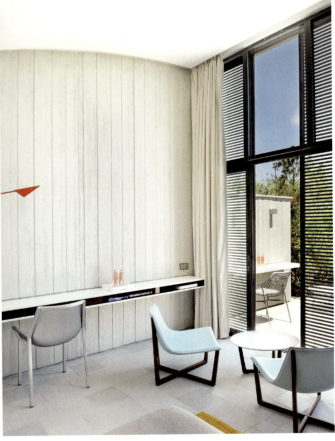

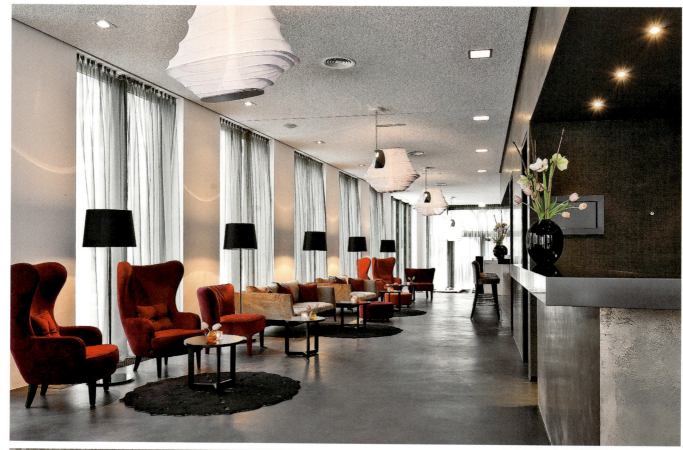

*SIGNATURE

WWW.DESIGNHOTELS.COM/COSMO

ADDRESS
SPITTELMARKT 13
10117 BERLIN
GERMANY

ROOMS
84

RATES
EUR 109 –
EUR 359

OPEN
01/2010

GERMANY
BERLIN

COSMO HOTEL BERLIN MITTE
Berlin

Situated in the heart of Berlin's Mitte district, the Cosmo Hotel is the perfect urban retreat for travelers who appreciate individualized style and hospitality. From its elegant and timeless scent restaurant specializing in "aroma cuisine" to its 84 minimalist-designed rooms and relaxation spaces, it offers cosmopolitan citizens personal attention and access to the best of real Berlin. The hotel's dedicated concierge service reserves tables at the hippest restaurants, opens doors to the city's chic and underground clubs, and leads guests to the latest art and culture destinations or to the top boutiques to splurge on Berlin style. Cosmo understands what its guests need: direct access to the right places in the right parts of the city. Cosmo's design and outlook epitomizes the flavor of contemporary Berlin: a juxtaposition between light, inviting spaces and the gritty, insular underground, an ever-evolving hub of cultural activity where artists, architects, designers, and other creatives continually redefine their city and regularly launch international trends. Cosmo is the ideal location both for first-timers discovering this vibrant city and for regular visitors who want the easiest access to all of their favorite haunts while enjoying the utmost in comfort, luxury and style.

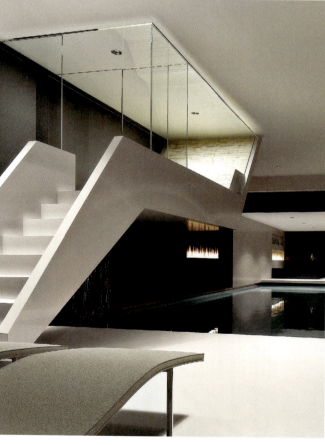

WWW.DESIGNHOTELS.COM/ DASSTUE

ADDRESS
DRAKESTRASSE 1
10787 BERLIN-TIERGARTEN
GERMANY

ROOMS
80

RATES
EUR 250 –
EUR 3000

OPEN
08/2012

GERMANY
BERLIN

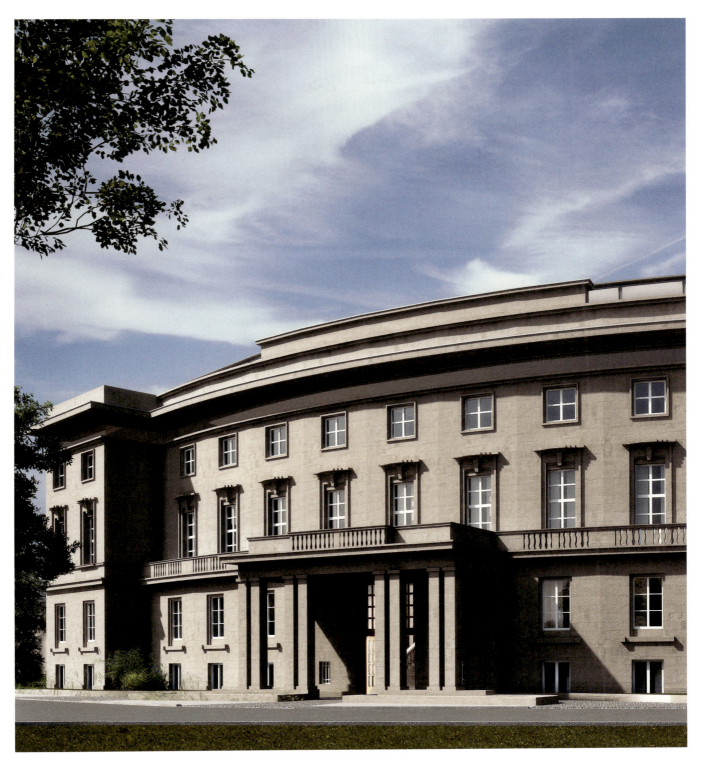

DAS STUE
Berlin

Occupying a 1930s building that originally was Berlin's Royal Danish Embassy, Das Stue's unique heritage is reflected in its name, the Danish term for "living room". The hotel incorporates the prominence of its classicist facade and the natural beauty of its leafy Tiergarten address, formerly the city's royal hunting grounds. Not far from the Neue Nationalgalerie, the Berlin Philharmonie, and the grand shopping boulevard Kurfürstendamm, Das Stue is centrally located in an idyllic setting exalting history, romantic wilderness, and cosmopolitan culture. The owners have created a sophisticated urban retreat with personalized comforts – much like the living room of someone who is well connected in Berlin and has immediate access to the city's countless attractions. The interior of the historic building and its modern extension was designed by the Barcelona firm GCA Arquitectos Asociados and features 80 guestrooms, many with captivating views of the Berlin zoo's neighboring grounds and exotic wildlife. Four suites on the heritage building's Bel Etage can be interconnected to serve as venues for exclusive private events. Michelin-starred Catalan chef Paco Pérez, mastermind behind "5 - Culinary Art by Paco Pérez", the food concept of Das Stue, serves avant-garde Mediterranean cuisine combined with local accents in the Gourmet Restaurant, and will surely impact Berlin's epicurean legacy. In addition, two Berlin-based local heroes stand behind the hotel's spa and bar concept: while the spa is the work of Yi-Spa, renowned for its mastery of Asian massages and treatments, the bar is the brainchild of one of Berlin's most creative nightlife impresarios.

*OFFBEAT

WWW.DESIGNHOTELS.COM/HOTEL_Q

ADDRESS
KNESEBECKSTRASSE 67
10623 BERLIN
GERMANY

ROOMS
77

RATES
EUR 105 –
EUR 400

OPEN
04/2004

GERMANY
BERLIN

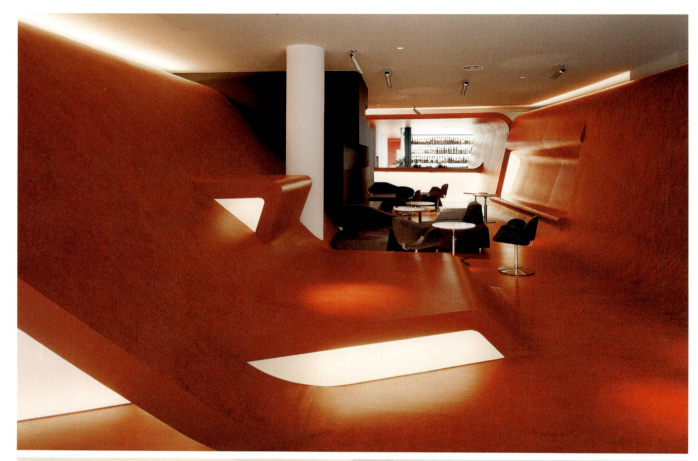

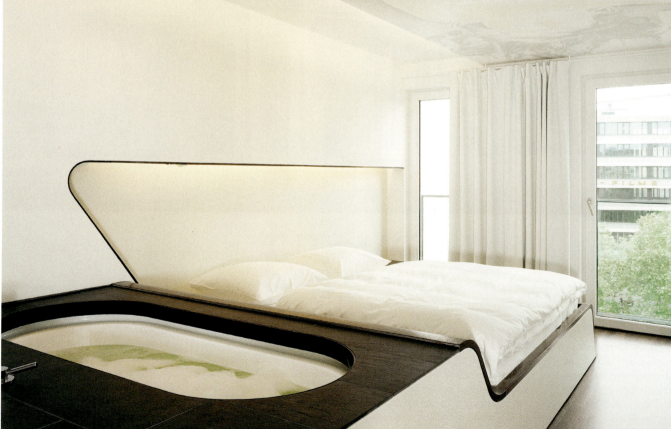

HOTEL Q!
Berlin

Situated just off Berlin's grand boulevard Kurfürstendamm, Hotel Q!'s avant-garde aesthetic combines futuristic forms with simple elegance. Owner and visionary Wolfgang Loock developed Q!'s distinct design together with the renowned architecture studio Graft, perhaps most famous for creating Brad Pitt's Hollywood studio. With its focus on fluid lines and undulating spaces, Q! does not have any right angles. The hotel's shimmery red lobby and lounge, earthy spa, and "sand room" were designed to create a continuous flow in both form and space. The 77 guestrooms, including four studios and one penthouse, feature dramatic bed frames that wrap around the bathtub and sink, forming a sculptural statement as the room's centerpiece. Strikingly minimal, the chosen color scheme of primarily neutral tones, whites, and dark oak, with the occasional deep red accent, keeps attention on the rooms' rounded edges and rich textures, like (artificial) ostrich leather and soothing slate. Since opening in 2004, Q! has become a much-loved destination for international celebrities, as well as for a loyal circle of local tastemakers in the fashion, music, and entertainment industries, who frequent the restaurant and intimate members-only bar. Lounge seating is sculpted out of the sweeping walls, so that guests are literally embraced by the hotel's interior, offering an *über*-modern yet comforting retreat from Berlin's jagged urban landscape and nonstop nightlife.

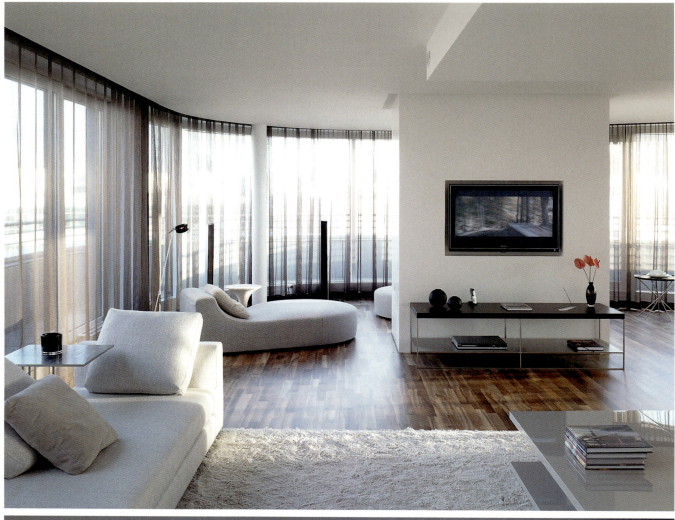
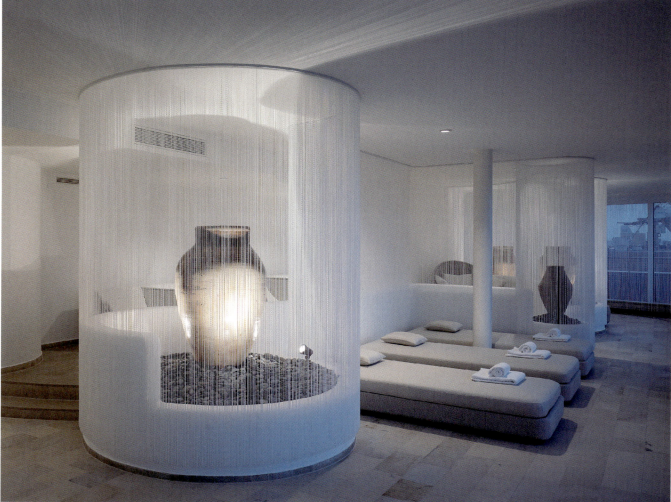

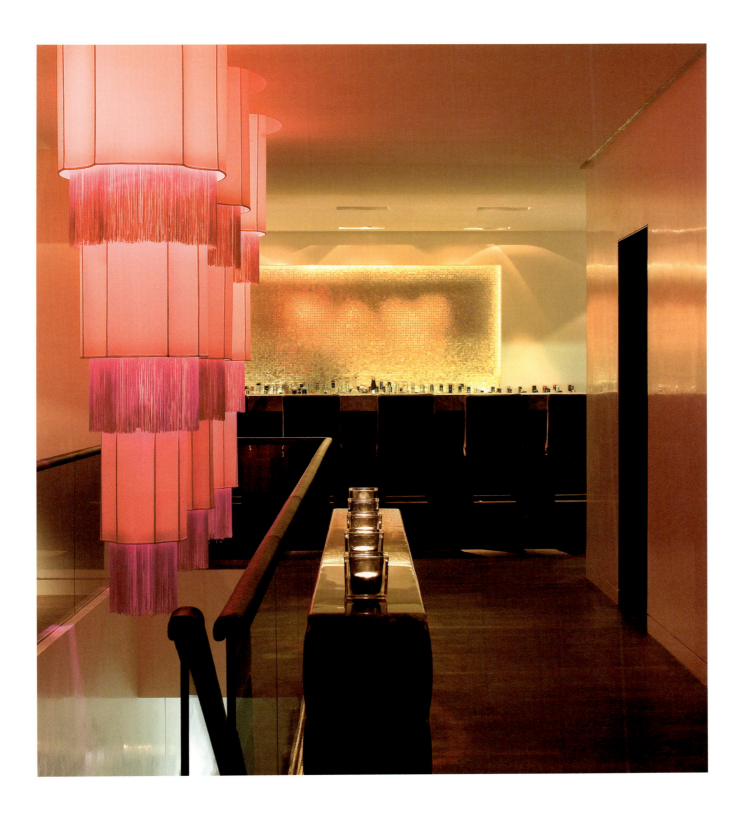

THE MANDALA HOTEL
Berlin

Potsdamer Platz is Berlin's epicenter of modern architecture, which puts The Mandala Hotel in good company. With an unassuming entrance and small lobby, the all-suites residence provides long-term and business guests discreet relief from the area's bustle. Most rooms face the inner courtyard and service is impeccably professional, but never intrusive. Interiors pare luxury down to its serene and subtle essence, but spare no expense with furnishings by Donghia and Chinese antiques hand-picked by proprietor Lutz Hesse. Windows of the first-floor QIU lounge hideaway offer glimpses of the rush outside, but the mohair sofas and water cascading down a Bisazza glass mosaic wall are welcome distractions. The Michelin-starred restaurant FACIL is hidden on the fifth-floor courtyard, which is nearly entirely open-air in summer. In the spacious guestrooms, handcrafted tables and ornaments provide solid dark accents among the soft colors of raw silk curtains and cherry wood floors. The 600-square-meter, top-floor ONO Spa is a world of holistic well-being high above Berlin. Lucky guests get panoramic city views during indulgent treatments tailor-made for those who value individualism and privacy.

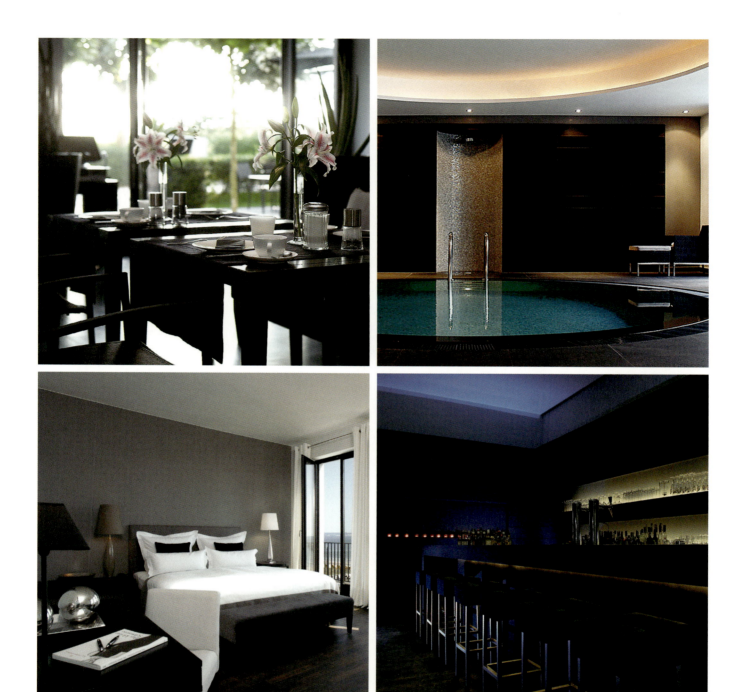

CERÊS
Binz

As a cosmopolitan highlight of Binz's liveliest beach promenade, CERÊS complements the beauty of Rügen's seaside. Architect and interior designer Moritz Lau-Engehausen's singular vision infuses this idyllic haven with a clear, sensual, and modern sensibility through his use of smoked-oak wood parquet flooring and natural black Chinese stone. A soft, neutral mood is found in all the elegant, spacious rooms. Tall French windows lead to each room's balcony or terrace, overlooking a panoramic view of the island's velvety white sand beaches and glistening blue water. The impression that the Caribbean has been transplanted to northeastern Germany is central to the hotel's design concept. In the Senso Spa, luxurious treatments focus on water in all of its forms and temperatures, while the restaurant, Negro, extends the aquatic theme even as its roof terrace location offers a spectacular glass cupola for nighttime stargazing. From that perch, guests can perhaps spy the small black orb that gives this dreamy hotel its name. With immaculate charm and classical lines, the Baltic's new star – already the winner of multiple awards – is a veritable love letter to purity, and Germany's ultimate seaside experience.

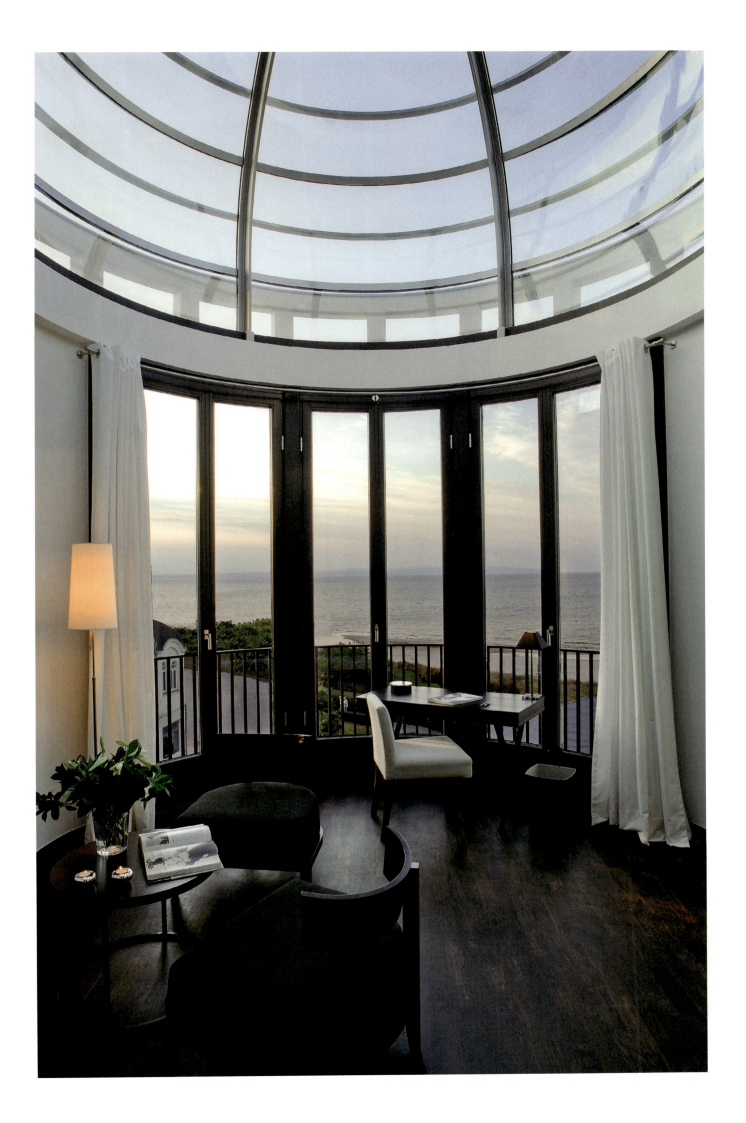

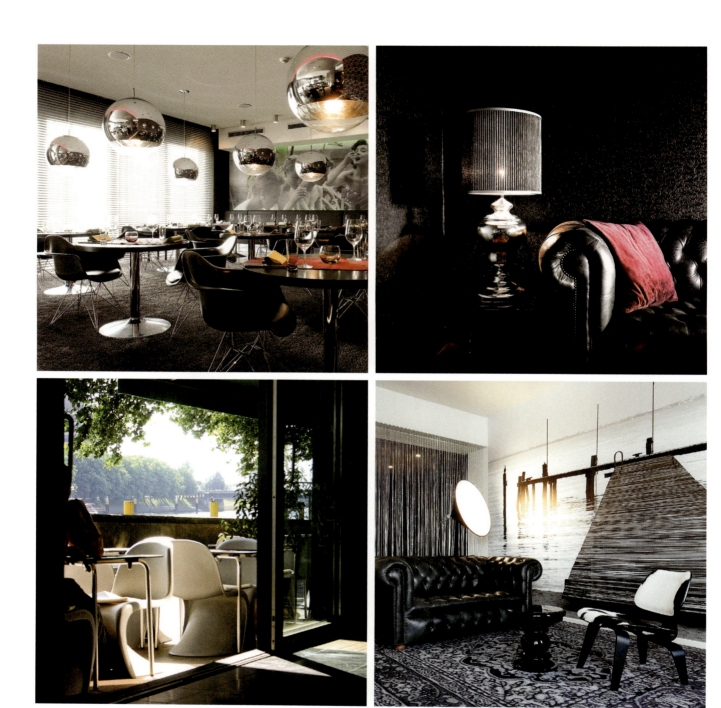

HOTEL ÜBERFLUSS
Bremen

On a small, quiet street on the banks of the River Weser sits Hotel ÜberFluss, Bremen's first member of Design Hotels™. During its construction, pieces of the city's wall and the relics of four 1184 AD masonry chambers were discovered under its foundations. Hotel ÜberFluss incorporates this historical architectural legacy into its design scheme in combination with a sleek, contemporary approach. ÜberFluss, which in German means "abundance," is Bremen's optimal location for relaxation and revitalization. Some of the 51 guestrooms are endowed with baths and showers that open onto the rooms themselves, while the suites comfortably accommodate open whirlpools and Finnish saunas, offering guests a relaxing vantage to take in views of the Weser. Using a charcoal oven from Tuscany, restaurant Loui & Jules Le Gril interprets old home-style Italian and French cooking in a contemporary fashion – all lovingly prepared with carefully selected, fresh ingredients. For meetings and festivities, Hotel ÜberFluss provides two options: an airy, river-view space on the first floor that accommodates up to 60 people or an intimate rooftop space with city views that holds up to 40 guests. The rooftop penthouse features two roof terraces with a private bar and lounge.

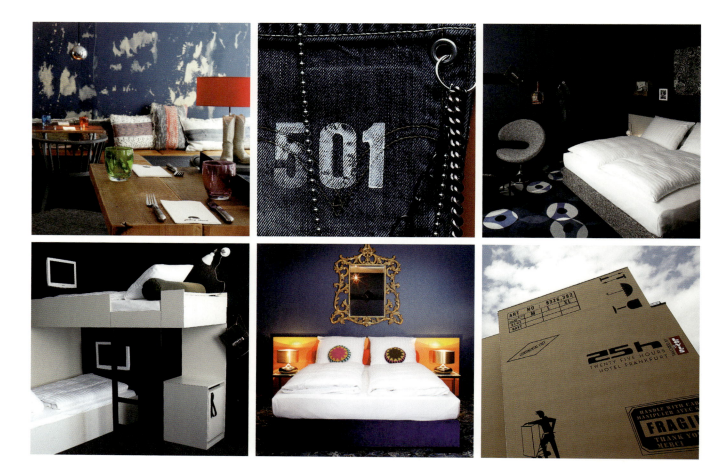

25HOURS HOTEL BY LEVI'S
Frankfurt

The unlikely-yet-exciting collaboration between the 25hours German hotel group and the classic American brand Levi's is the result of Frankfurt real-estate fate. The two companies independently leased adjacent buildings in Frankfurt's Main Station district. As good neighbors do, they started talking, and a lifestyle hotel began to take shape. Au courant designers Michael Dreher and Delphine Buhro, and architect Karl Dudler were brought in to seamlessly integrate the two brands. Fittingly sized M, L, and XL, 76 distinctive guestrooms were kitted out in inviting shades of indigo and blue. Each of the six floors is dedicated to a different decade of the twentieth century, evoked through the use of varying color palettes, furniture and music, with a special emphasis on the rock 'n' roll era most often associated with the iconic jeans brand. Elements of American popular culture are incorporated throughout, from the rooftop lounge, to the neon-lit basement where a fully-equipped practice room is available for aspiring musicians and performances by the hotel's house bands. An iMac workstation and the Chez IMA restaurant, with its fresh, light interiors and cuisine, round out 25hours' commitment to making guests feel absolutely comfortable … as if they've slipped into the perfect pair of jeans.

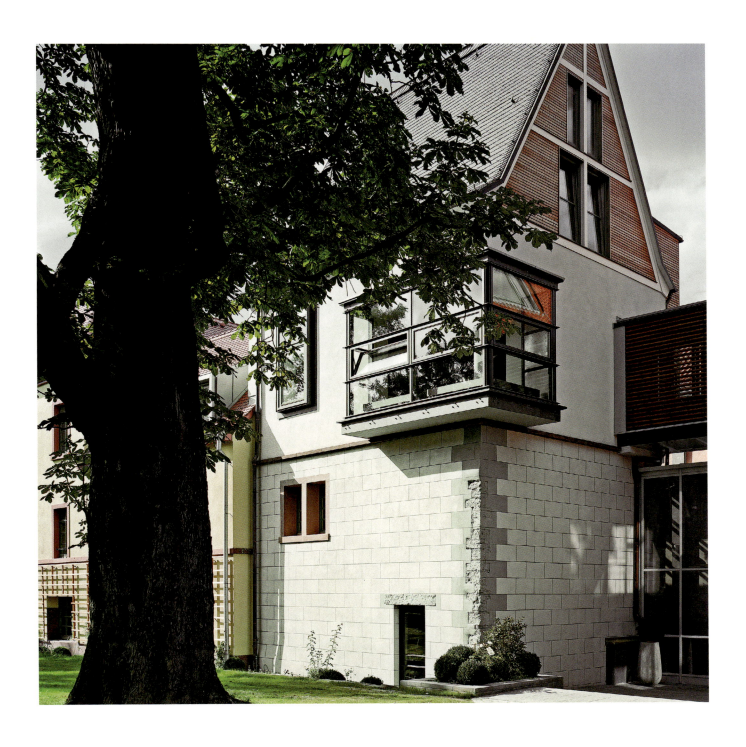

GERBERMÜHLE
Frankfurt

German author Johann Wolfgang von Goethe met the love of his life here on the banks of the Main river. Interspersing cozy architecture with sleek modernity, the Gerbermühle creates an amorous alliance between medieval and contemporary Frankfurt. Originally a flour mill built in the 1520s, the property contrasts masculine elements, like exposed beams and mezzanines, with feminine, ultramodern magenta lighting in its charming rustic stairwells. Dashes of trendy design accent the property, like the full-sized horse lamp by Front Design in the lobby. The restaurant's lodge-like atmosphere, complete with antlers on the wall and old-fashioned light fixtures, makes it the ultimate place to sip regional apple wine, while the modern bedrooms and suites evoke the best of European hospitality with handsome leather furniture and glossy parquet floors. The old-world-meets-new feeling continues outdoors: along the river Main is a lovely 500-seat summer garden that's long been a favorite place for locals. Yes, it was near this embankment that Goethe met Marianne Willemer in 1814. This elegant 18-room hotel now carries on its literary legacy on the outskirts of what has become Germany's financial capital.

GERMANY ✱ OFFBEAT

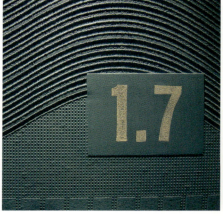

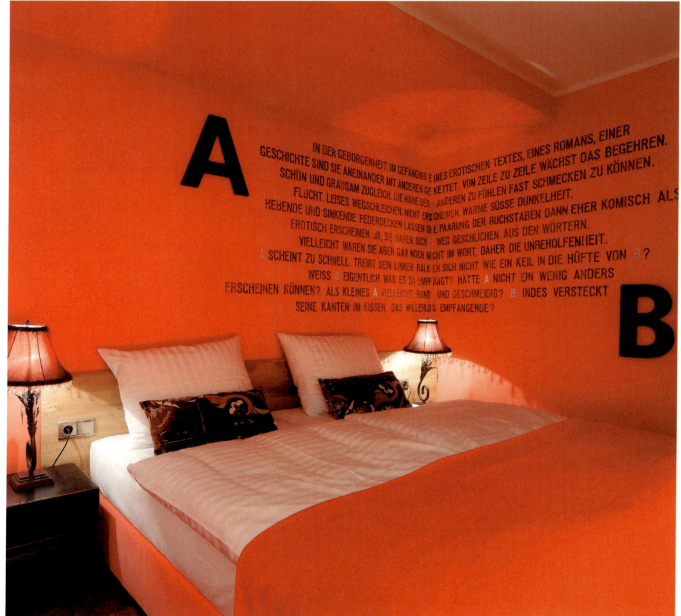

WWW.DESIGNHOTELS.COM/ GOLDMAN25HOURS

ADDRESS
HANAUER LANDSTRASSE 127
60314 FRANKFURT
GERMANY

ROOMS
49

RATES
EUR 107 –
EUR 265

OPEN
12/2006

GERMANY
FRANKFURT

GOLDMAN
25HOURS HOTEL
Frankfurt

A repurposed hotel in Frankfurt's bustling Ostend district, Goldman 25hours is both a hideaway and a local hot spot. Influenced and inspired by the diversity of "Mainhattan," designers Delphine Buhro and Michael Dreher created a homey boutique hideout displaying a flamboyant mix of colors, details, and stories. Each of the seven floors has its own consistent color scheme, and the 49 guestrooms are individually designed around local celebrities – or "godfathers" – whose personal stories are expressed in the rooms. Guests get a never-ending variety of vintage eclecticism, and the themed rooms – like the Princess, Paris, and Casino rooms – add to the sense of fun. Goldman Restaurant provides the perfect social outlet as well as a Mediterranean-influenced menu that has already put the hotel on the culinary map. Frankfurt's burgeoning cosmopolitanism is here to see, bright and clear, 25 hours a day.

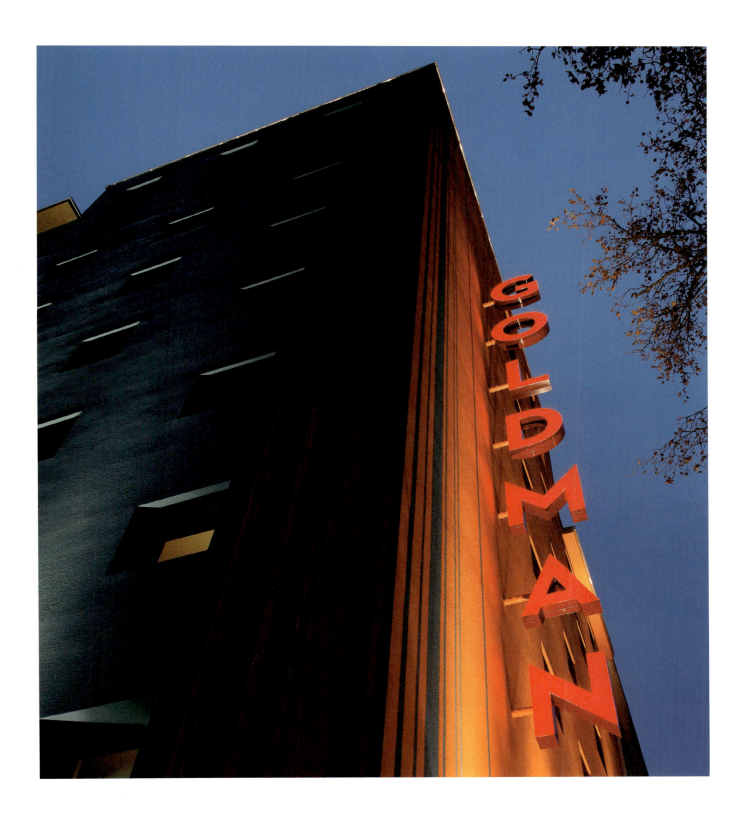

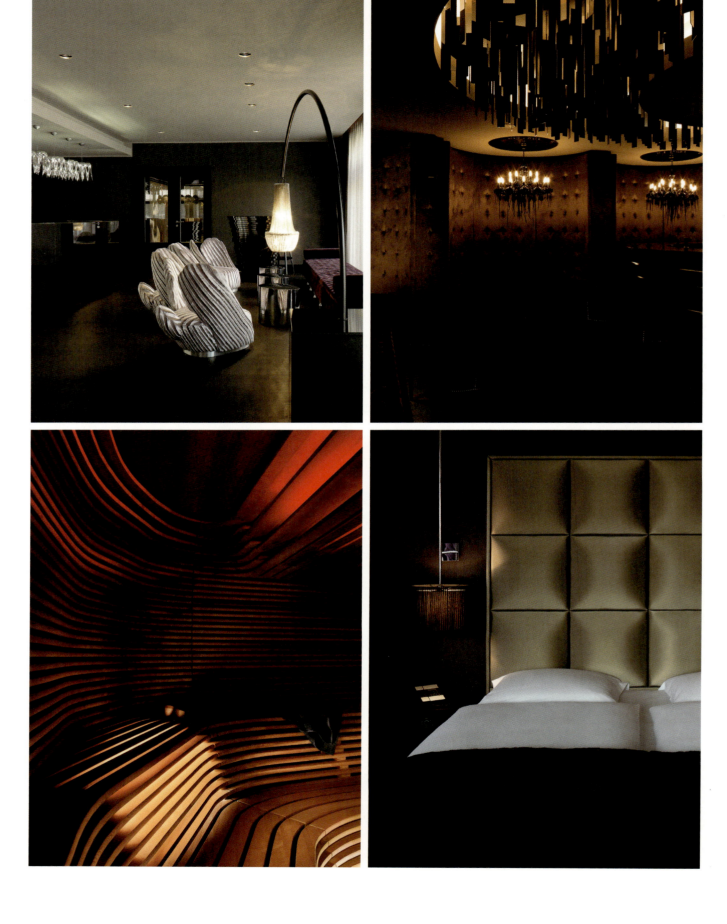

ROOMERS
Frankfurt

Classic curves meet progressive design at Roomers, an ambitious venture in Germany's business capital. With its gleaming glass facade set in specially glazed white concrete, Roomers offers a glossy snapshot into the city it inhabits: all timeless charm and modern architecture. Conceptualized by Grübel architects and designer Oana Rosen (known for her work at The Pure and Gerbermühle), Roomers is an elegantly futuristic six-story hotel full of electrifying design flourishes, such as an illuminated bubble-domed wellness center on the rooftop designed by 3deluxe-biorhythm. Once an office building, Roomers has morphed into the exact opposite: a cozy space full of swirling dark colors. Guests enter the lobby and are transported into a world of luxury. The 116 guestrooms' interior design is both indulgent and minimalist, but these two seemingly contradictory concepts meet to superb effect. Three conference areas in Roomers' illuminated top level are kitted out with the chicest accoutrements, making them the ultimate business experience for up to 25 people. Located just minutes away from the river Main, visitors are hard-pressed to find a better backdrop to relax and indulge in Frankfurt.

*SIGNATURE

WWW.DESIGNHOTELS.COM/
ROOMERS_LOFT

ADDRESS
KAISERSTRASSE 73
60329 FRANKFURT
GERMANY

ROOMS
1

RATES
EUR 650 –
EUR 7000

OPEN
12/2009

GERMANY
FRANKFURT

ROOMERS LOFT
Frankfurt

On bustling Kaiserstrasse, a pedestrian zone a few steps from Frankfurt's main train station and around the corner from the Roomers hotel, Roomers Loft is an urban oasis. Its 240 square meters of exquisitely appointed space is for guests who want five-star service in a single stand-alone suite. Owners Alex Urseanu and Micky Rosen were able to create a space that can shape-shift from an extended-stay apartment to a film set, a conference venue or a romantic retreat. On request, the loft can come with services like a butler, a private shopper, a chef, a bartender or anything else a discerning guest could want. Wi-fi, on-site parking, housekeeping services, and, on arrival, a full refrigerator are considered standard. There's access to the hotel's concierge services and the wonderful top-floor spa; guests can even use the loft's Audi A8. But it can also be a place to simply settle into an aesthetically holistic, absolutely private environment that is integrated into the very fabric of Frankfurt. It's so integrated, in fact, that hotelier Micky Rosen lives in the same building. The loft's two sumptuous, spacious bedrooms, a spa-like master bathroom poured in bespoke Italian concrete, carefully curated furnishings, generous living space and an open chef's kitchen make Roomers Loft the ideal location for enjoying the spirit of Germany's financial capital.

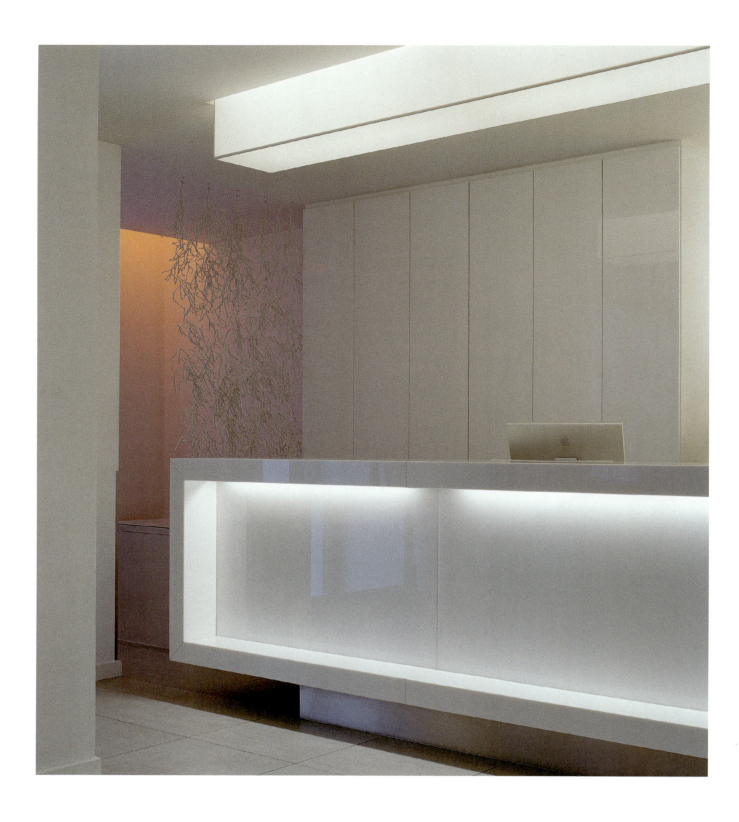

THE PURE
Frankfurt

A completely renovated loft in the heart of Frankfurt, The Pure captures the city's cosmopolitan spirit. Here, amidst light-colored materials such as white leather, Thassos marble, white lacquer, and light gray floors, guests are invited to relax into a welcoming, family atmosphere. The harmonious public space with lobby, breakfast room, bar and lounge reinterprets the feeling of homeyness; a concept that is emphasized by the work of artist Stefan Strumbel, who explores what 'home' means to different people. The black-clad staff is attentive and friendly, a bountiful breakfast buffet stays fresh until noon and lighting and music add ambience that changes throughout the day. Soft illumination and tunes create a calming vibe in the morning; by night the hotel is an energetic oasis, with vibrant orange visual effects. Outfitted with oversize Fatboy beanbags, fountains and bamboo, The Pure's patio effortlessly extends the communal space. The comforting guestrooms offer clean-lined furnishings, light fabrics and high ceilings, given a dash of warmth by glossy African zebrawood and oak parquet. Just around the corner, visitors will find the Pure Basement, a gargantuan loft-like event space with a chic atmosphere perfect for any occasion.

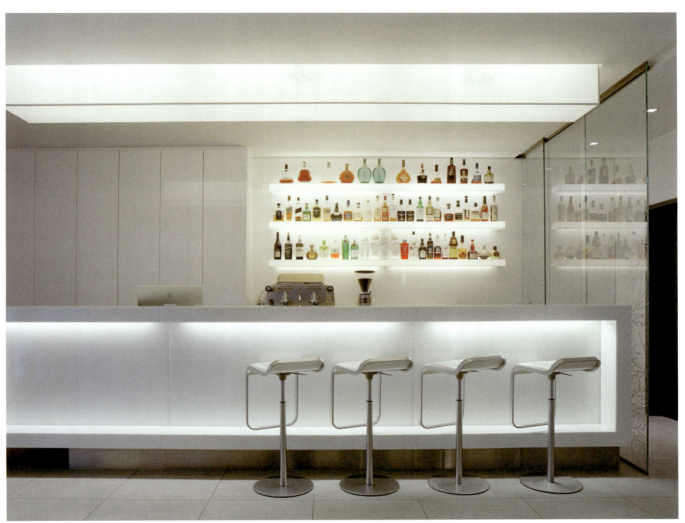
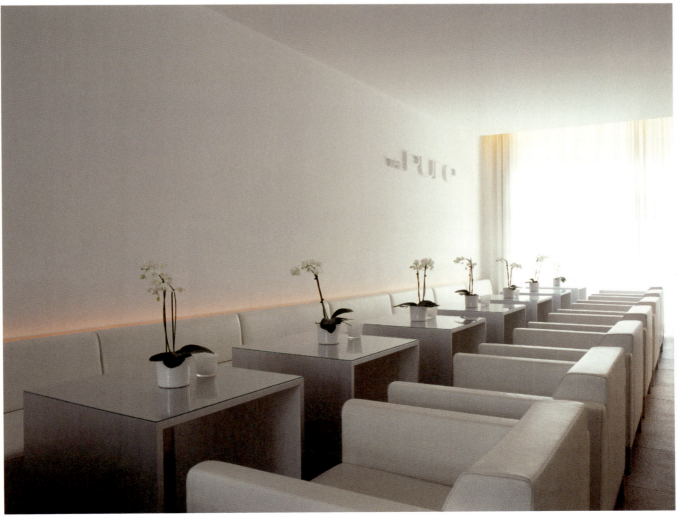

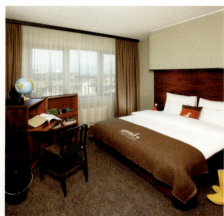

OFFBEAT

WWW.DESIGNHOTELS.COM/
25HOURS_HAFENCITY

ADDRESS
ÜBERSEEALLEE 5
20457 HAMBURG
GERMANY

ROOMS
170

RATES
EUR 105 –
EUR 205

OPEN
07/2011

GERMANY
HAMBURG

25HOURS HOTEL HAFENCITY
Hamburg

Reviving and reinventing Hamburg's old harbor quarter into a hub of urban life that features restaurants, shops, and the world-class Herzog & de Meuron-designed Elbe Philharmonic Hall, HafenCity is Europe's largest development project of the 21st century. In the midst of it all stands the 25hours Hotel HafenCity, the first hotel development to open in this neighborhood. The hotel draws from the area's rich maritime history in a radical re-imagining of a traditional seamen's club, complete with 170 cabin-style suites, a rooftop sauna, Heimat restaurant, bar, art gallery, private wharf, and a conference room housed in a repurposed shipping container. For Christoph Hoffmann, CEO of the 25hours Hotel Company, design is an expression of the company's philosophy. Each hotel design finds inspiration in its location, thus each is organically distinctive. The hotel's narrative is inspired by 25 personal chronicles collected by storyteller Markus Stoll and gathered in a "ship logbook" in each cabin. The ground floor recreates the rough world of a contemporary harbor, with old import/export crates, timber planks, and stacks of oriental carpets scattered like the detritus of a shipping warehouse. As the mood shifts from daytime to evening, the ground floor's laid-back lounge becomes a buzzing bar that is the place to be for guests and locals alike.

* OFFBEAT

WWW.DESIGNHOTELS.COM/
25HOURS_HOTEL_NO.1

ADDRESS
PAUL-DESSAU-STRASSE 2
22761 HAMBURG
GERMANY

VILLAS
1

ROOMS
128

VILLA RATES
EUR 515 –
EUR 1515

ROOM RATES
EUR 95 –
EUR 375

OPEN
11/2003

GERMANY
HAMBURG

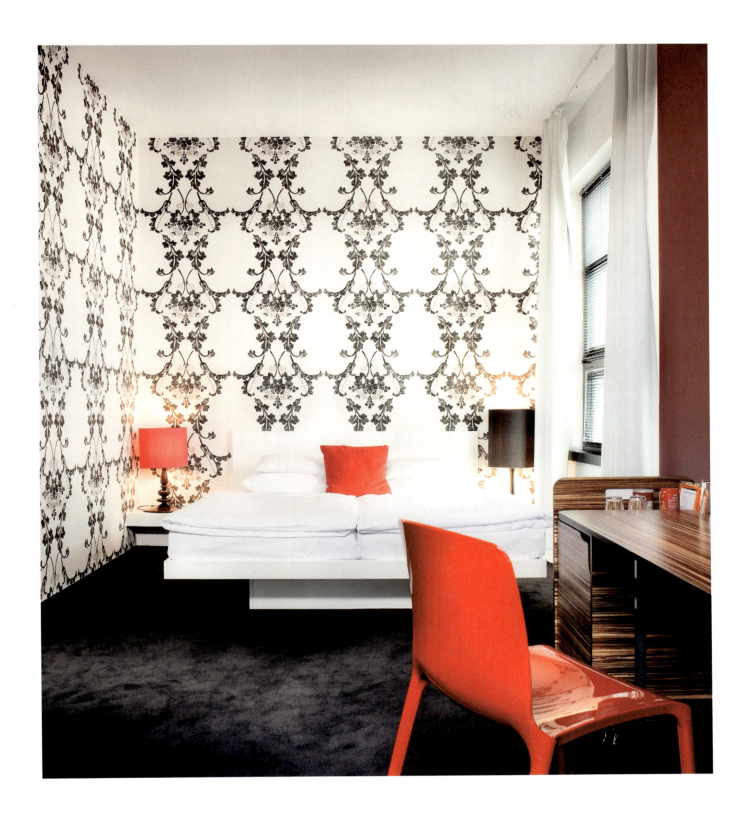

25HOURS HOTEL HAMBURG NO. 1
Hamburg

The eye-popping candy colors and inviting communal spaces dotted throughout 25hours Hotel Hamburg No.1 create a playful atmosphere equally suited to relaxation and revelry. Sixties and seventies-inspired design details begin with a dramatic metal-studded reception desk, hand-tufted pile rugs from Kasthall and curved geometrical shapes in varying shades of pink, red and orange. Located in the western part of the city at Otto von Bahrenpark, the hotel's communal spaces encourage young guests to meet and mingle. Low lounge seats by Zanotta and the spiraling flicker of disco balls transport clients to another era, while Tiki vibe of the retro rooftop offers the ideal spot to soak up the sun or enjoy a cocktail. Guest rooms are more refined with patterned wallpaper, stark whites and exposed concrete softened by pale blues and mossy greens. Families of up to four may share one of the specially created XL-Family rooms. Small groups of up to ten enjoy even more privacy across the street at the 25hours guesthouse, with five rooms, hardwood floors and a communal kitchenette that is just as inviting as the main building's living and dining rooms.

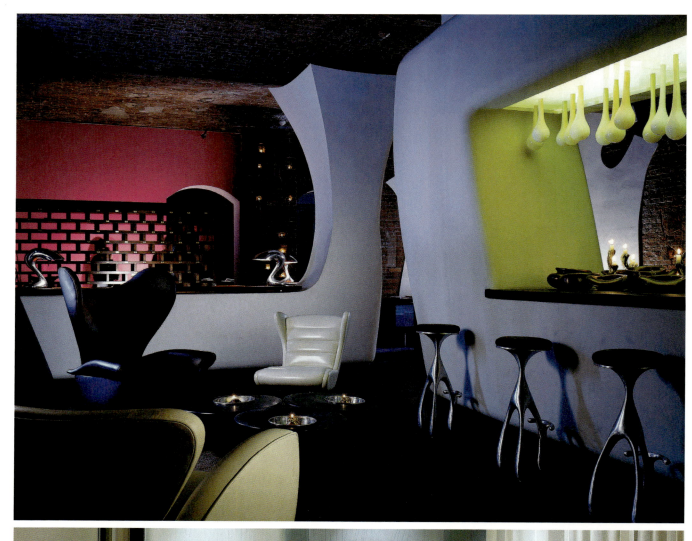
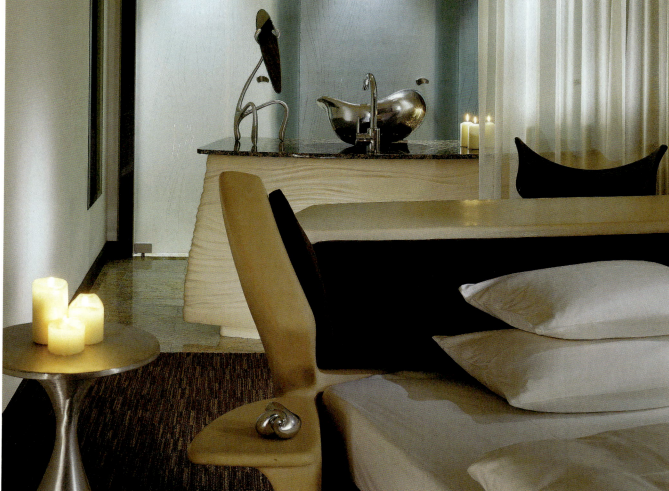

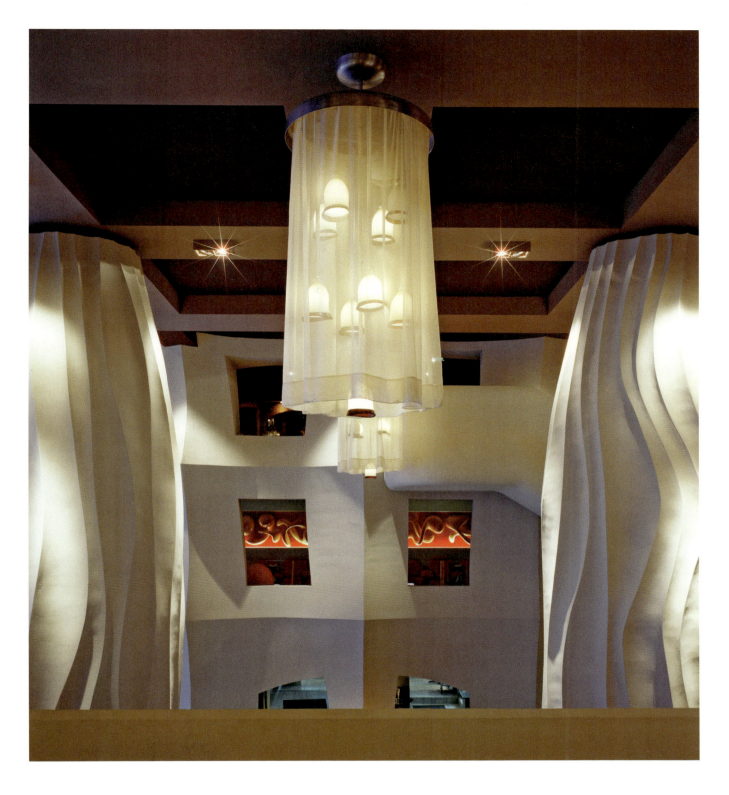

EAST
Hamburg

Since its opening in a former iron foundry situated in Hamburg's famed St. Pauli entertainment district, East has evolved into its own cosmos. Chicago-based architect-designer Jordan Mozer created an ornate environment with floor-to-ceiling curtains, handmade furnishings and wrought-iron fixtures, all illuminated by candlelight. Bright tones, futuristic curved forms and subtle references to Eastern culture are complemented by the textures of natural fabrics and leather. At the center of it all, the three-story Eurasian restaurant and lounge space never fails to elicit impressed gasps from first-time visitors. Four pillars tower from the ground to the top floor, while dramatic lighting illuminates parts of the original exposed-brick foundation. Beyond the main restaurant are several separate bar areas and an interior courtyard decked out in stone, timber and greenery. But the focus is not only on the visual design: the use of scent creates instantly recognizable identities for each area of the hotel – ginger, cinnamon, tangerine, jasmine and lotus – a lasting experience for all five senses. Set over several stories, 127 rooms, lofts and suites range in size from 25 to 150 square meters. Interlocking public spaces offer a multitude of diversions, such as a spa zone, a high tech gym, a private screening room and the private members club uppereast. Underlying the atmospheric exterior is a management team whose concept of hospitality is so warm and welcoming that even the employees don't like to leave. Like a balanced chi, east presents the perfect blend of gastronomy, hospitality and nightlife.

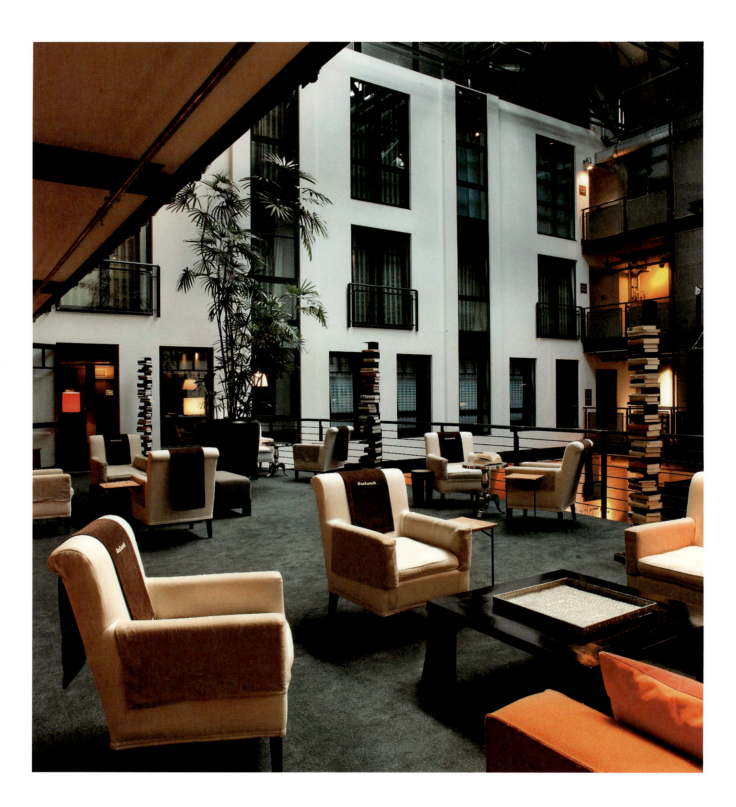

GASTWERK HOTEL HAMBURG
Hamburg

Seasoned hotelier Kai Hollmann turned Hamburg's 19th-century municipal gasworks (or "Gaswerk") into Europe's first loft-style hotel as easily as he dropped a "t" into its name, instantly transforming the red-brick complex into a "guest works" in every sense. Natural light floods into the atrium lobby's heights through two enormous arched windows. A gigantic, green industrial machine and an old tower clock serve as reminders of the building's days as a power station. Suspended overhead is a bridge leading to the white modern elements housing the guestrooms, where interior designers Regine Schwethelm and Sybille von Heyden have created an ambience combining modern functionality with original features and materials like carved stone and Asian wood. When visiting "Mangold," the in-house restaurant, guests will enjoy a creative cuisine composed of the freshest ingredients from around the globe. The Moroccan-influenced Gastwerk spa offers a sauna, steam bath, massages, beauty treatments, yoga, and pilates. Oversize chairs, neutral light, and soothing textures soften the rough industrial structure, giving its once purely functional form new life. Guests can kick back in comfy rooms with exposed brick walls and arched multipaned windows, then head down to business meetings in the ultramodern conference rooms (seven of them!) or the buzz of the low-lit bar, which is just as popular with locals as with visitors.

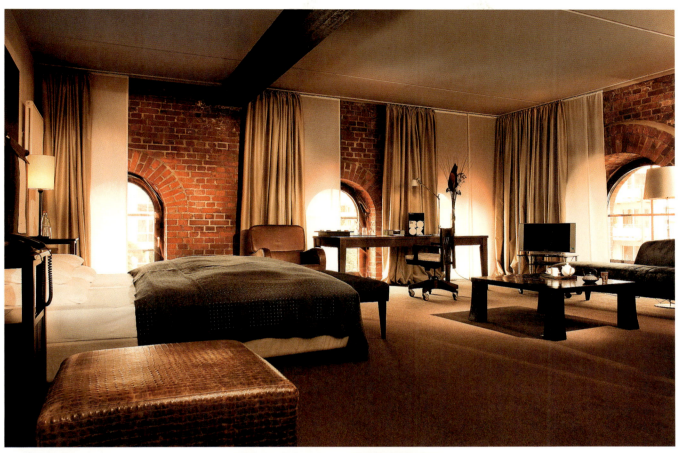
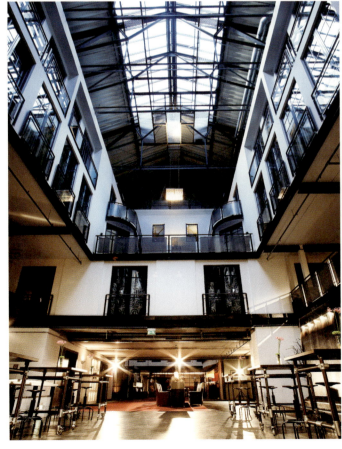

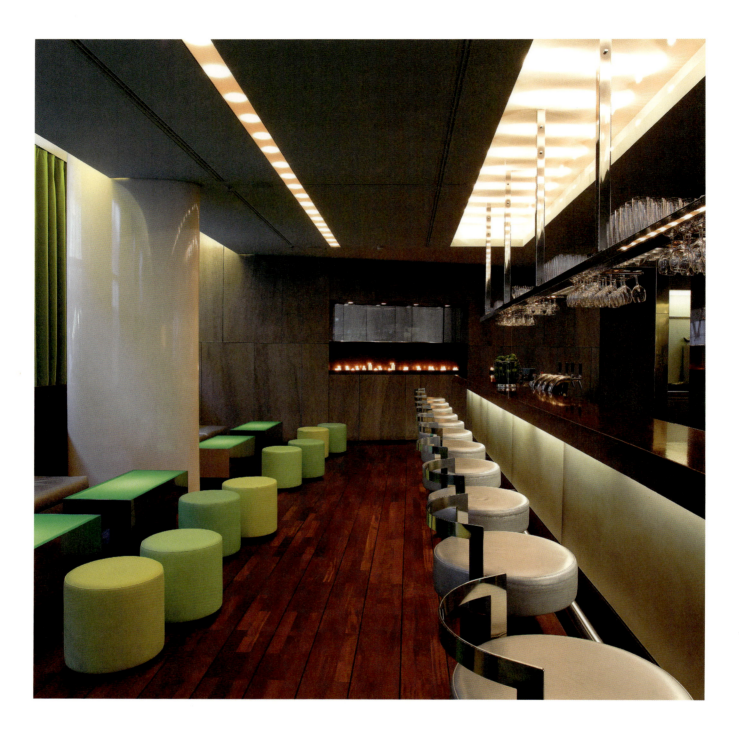

SIDE
Hamburg

Architect Jan Störmer's glass and steel facade emerges from Hamburg's staid residential area as a potent urban-chic style statement. Though only eleven stories high, SIDE evokes visions of luminescent skyscrapers. A spectacular light show designed by iconic light choreographer Robert Wilson pulses through the hotel's soaring atrium with ever-changing intensity, mimicking the breaking of waves. Complementing Wilson's work is star designer Matteo Thun's eighth-floor lounge, its suggested weightlessness achieved with curved furniture and, floating disk lighting and 360-degree views of Hamburg's rooftops. Guests and in-the-know locals enjoy the lounge's voluptuous, round furnishings and [m]eatery bar + restaurant, where a 800-degree infrared oven and an exclusive dry-aging process create unimaginably good steaks made with the best quality meats from Argentina, the United States and Germany. While the color palette in the bar is a dark and stormy affair, guests enjoy a soothing and sumptuous canvas of buttery creams in their rooms. The public spaces feature strong color and lush velvets, such as energetic oranges and the warm yellow walls in the restorative spa treatment rooms. At SIDE, private spaces feel like sanctuaries and public areas bubble with fun and possibility.

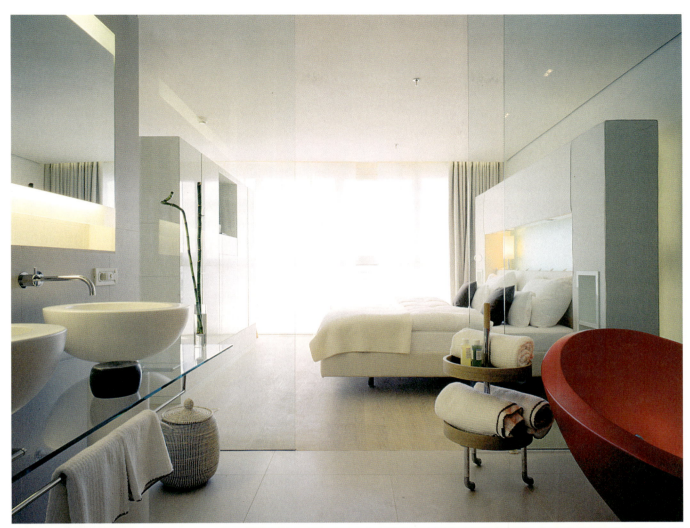
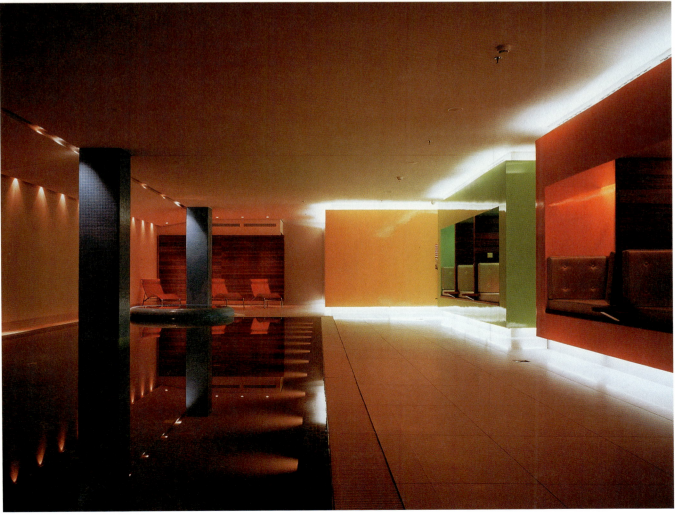

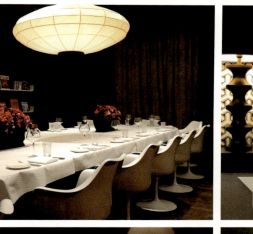

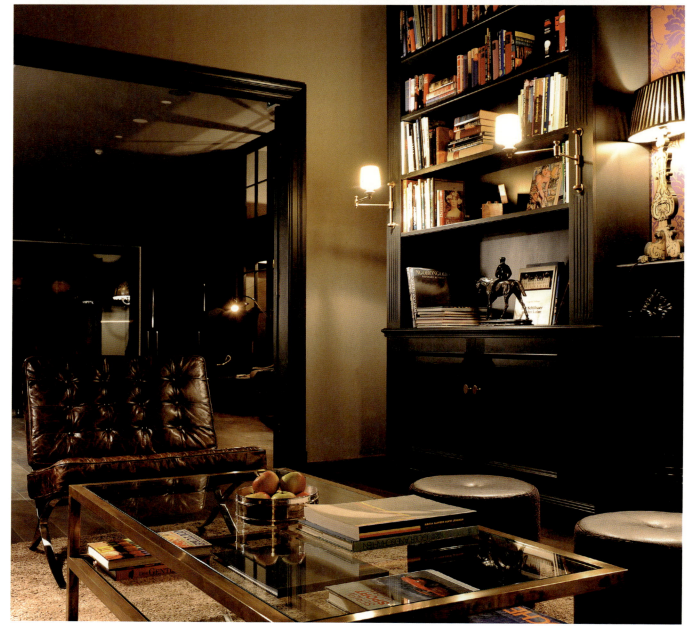

SIGNATURE

WWW.DESIGNHOTELS.COM/THE_GEORGE

ADDRESS
BARCASTRASSE 3
22087 HAMBURG
GERMANY

ROOMS 125

RATES EUR 145 – EUR 355

OPEN 10/2008

GERMANY HAMBURG

THE GEORGE
Hamburg

No membership is required at this smart interpretation of an English-style club, which light-heartedly evokes the old while lending a touch of timeless glamour to the new. Offering 125 impeccably dressed guestrooms and suites, The George is ideal for savvy travelers seeking the utmost in privacy. Designer Sibylle von Heyden of SynergyHamburg has also created regally appointed common spaces for discreet deal-making, after-dinner reflection, and civilized conversation – notably the handsome meeting club rooms with dark timber flooring, a light-flooded rooftop spa, a sophisticated restaurant-bar and a cozy, beautifully wallpapered library. Each offers its own made-to-measure take on the privileged surroundings of an exclusive club. And each can be privately hired for any event that a guest or visitor would like to host. Nothing's too much trouble in this unhurried haven of refined seclusion. The hotel provides an immensely enjoyable contrast to the bright and bustling neighborhood outside. St. Georg is one of Hamburg's most inclusive, multicultural districts, where hip boutiques, cosmopolitan restaurants, and bohemian cafés jostle with the evocative remnants of the area's intriguingly disreputable past.

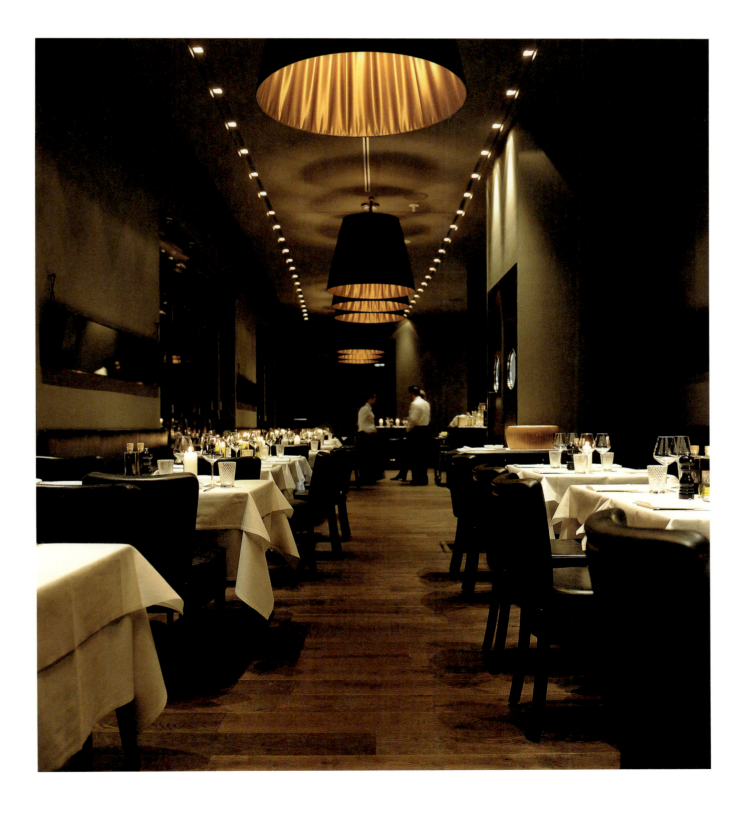

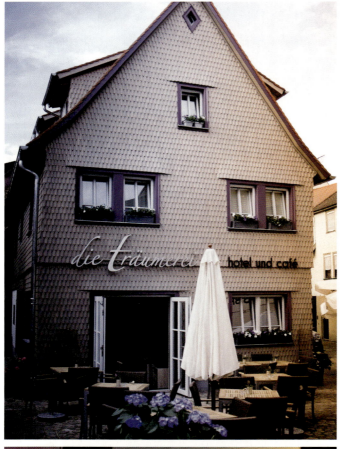
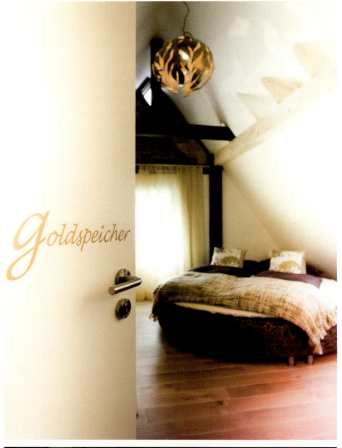

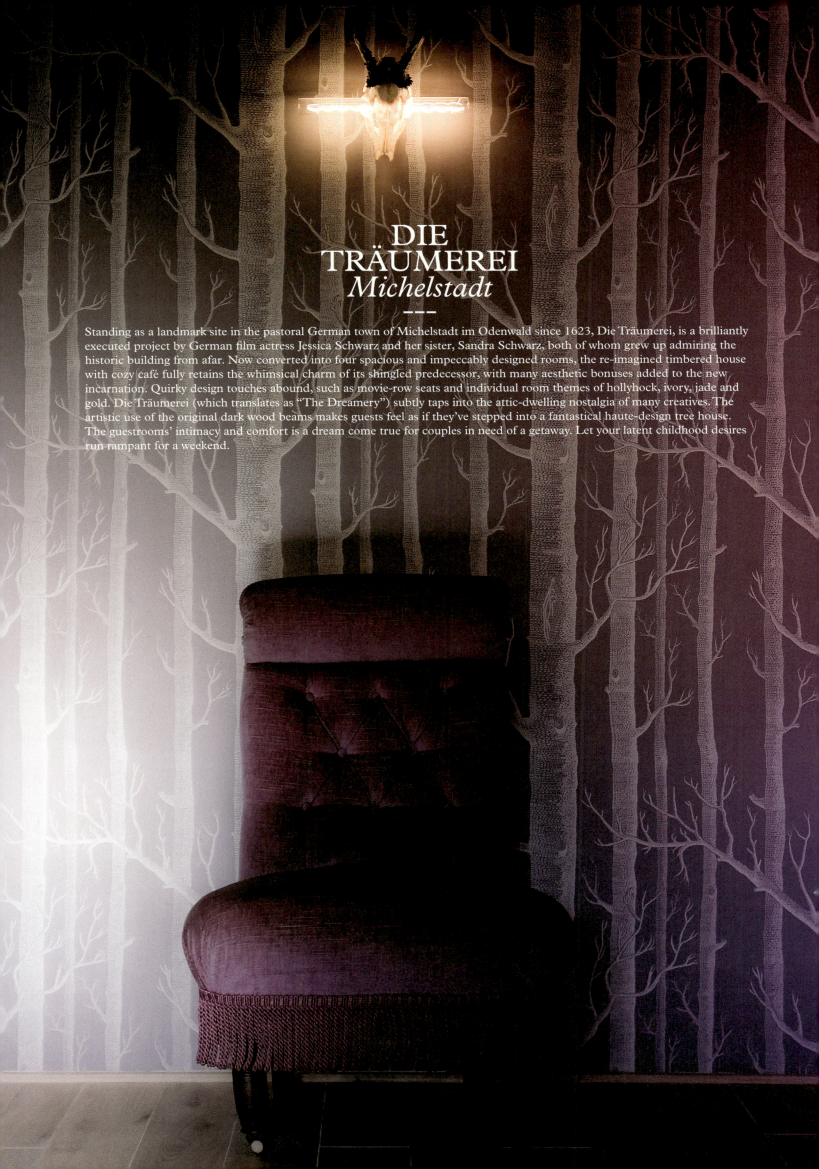

DIE TRÄUMEREI
Michelstadt

Standing as a landmark site in the pastoral German town of Michelstadt im Odenwald since 1623, Die Träumerei, is a brilliantly executed project by German film actress Jessica Schwarz and her sister, Sandra Schwarz, both of whom grew up admiring the historic building from afar. Now converted into four spacious and impeccably designed rooms, the re-imagined timbered house with cozy café fully retains the whimsical charm of its shingled predecessor, with many aesthetic bonuses added to the new incarnation. Quirky design touches abound, such as movie-row seats and individual room themes of hollyhock, ivory, jade and gold. Die Träumerei (which translates as "The Dreamery") subtly taps into the attic-dwelling nostalgia of many creatives. The artistic use of the original dark wood beams makes guests feel as if they've stepped into a fantastical haute-design tree house. The guestrooms' intimacy and comfort is a dream come true for couples in need of a getaway. Let your latent childhood desires run rampant for a weekend.

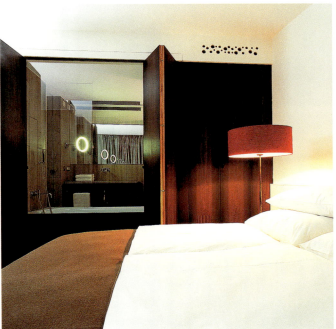

CORTIINA HOTEL
Munich

Cortiina Hotel is the result of one of Munich's most inspired partnerships – that of gastronome Rudi Kull and architect Albert Weinzierl. Similarly to Kull and Weinzierl's other establishments, the Cortiina is situated in the idyllic heart of the city's old town, neighbored by cultural venues such as Munich's opera house. A sanctuary of refined design, the Cortiina boasts unparalleled access to the city's creative scene thanks to its well-connected owners. The Cortiina Hotel, with its feng shui-inspired ambience, exemplifies Kull and Weinzierl's shared philosophy, synthesizing sophisticated design, impeccable service, and a uniquely authentic relationship with the surrounding community. Encompassing 75 rooms spread across the hotel's main building, a rear wing, and a more recently added apartment wing, the Cortiina's aesthetic is one of relaxed elegance and soothing minimalism. Tranquil feng shui aesthetics permeate every aspect of the Cortiina, including the hotel's name itself, which was modified to express harmonious balance. Regional materials such as stone pine, bronze, linen, and bog oak coalesce in each guestroom's harmonious arrangement, underscored by warm, mood-enhancing hues of deep crimsons and rich earth tones. While the sun terrace offers picturesque views of the city's most historic rooftops, the golden glow of the classic Cortiina Bar invites guests to partake in Munich's well-heeled social scene late into the night.

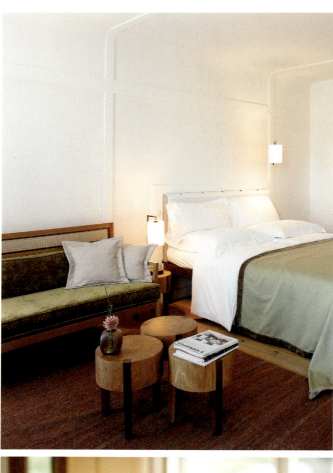

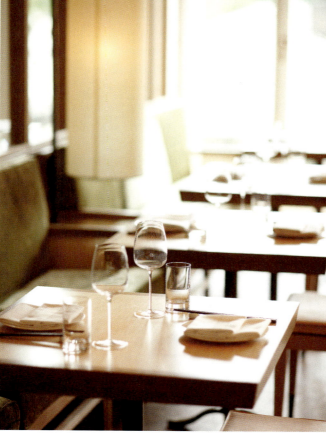

WWW.DESIGNHOTELS.COM/ LOUIS_HOTEL

ADDRESS
VIKTUALIENMARKT 6
80331 MUNICH
GERMANY

ROOMS
72

RATES
EUR 195 –
EUR 450

OPEN
09/2009

GERMANY
MUNICH

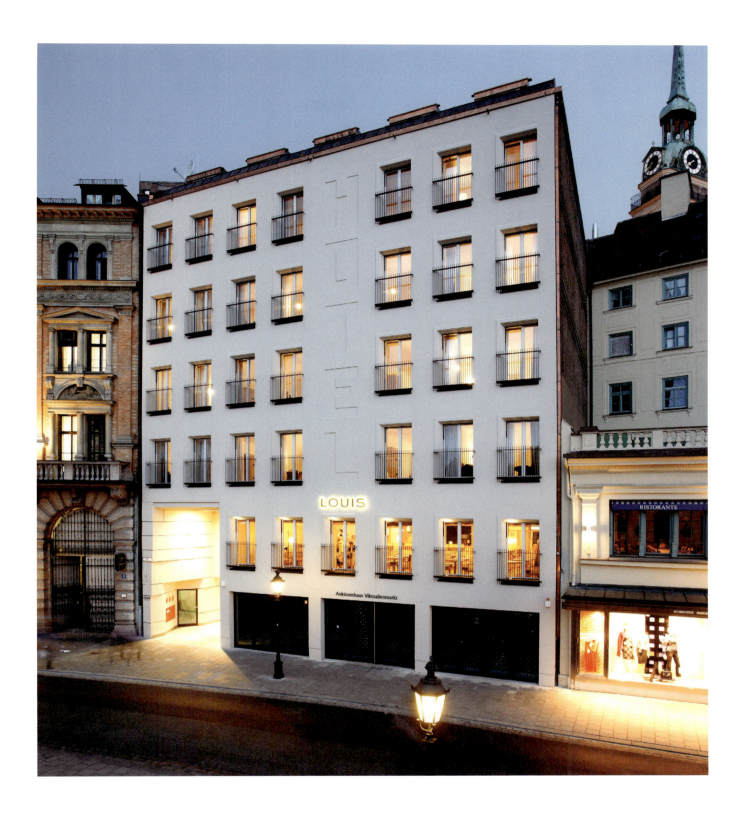

LOUIS HOTEL
Munich

The first member of Design Hotels™ to grace the streets of Munich, the Louis Hotel, is a perfect reflection of the Bavarian capital in which it stands: chic, poised, and full of heart. Located directly on the bustling Viktualienmarkt, the Louis is an ideal starting point for any Munich visitor, a short stroll away from all the main sights of the city – Glockenspiel, Hofbräuhaus, and famed Maximilianstrasse, the neo-gothic avenue extraordinaire. Its 72 individually designed rooms offer a delightful retreat after a jam-packed day of exploration, its wide range of services ensures the utmost in guest comfort, and its fully equipped gym with sauna and roof terrace provides for all wellness needs. Gastronomy at the Louis is overseen by Tokyo-trained chefs who combine traditional Japanese dining culture with modern international flair, using fresh foods sourced directly from the Viktualienmarkt. At the Emiko Restaurant, guests can dine communally according to the Japanese "sharing principle," and at the Emiko Bar next door, they can enjoy signature cocktails specially mixed to harmonize with the aromas of the Asian kitchen.

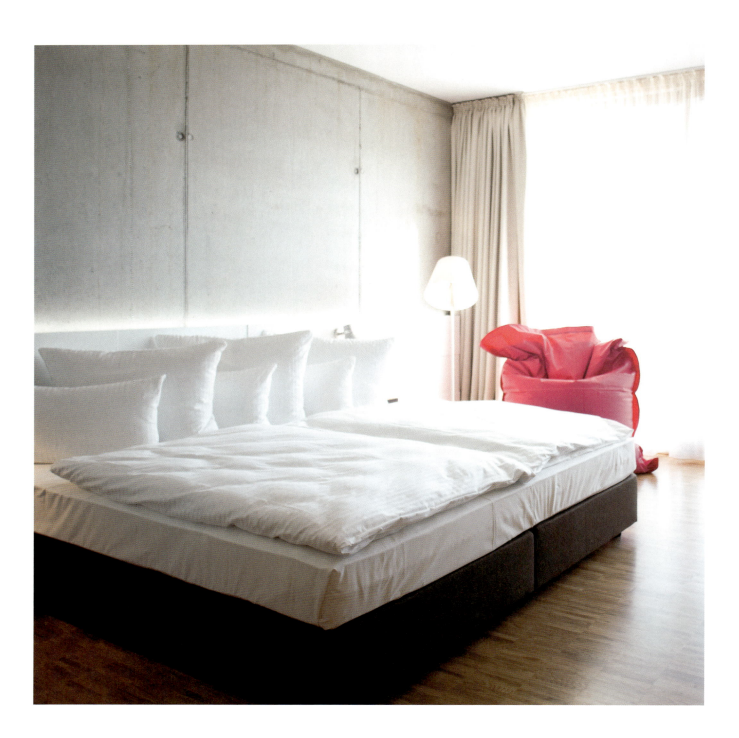

FACTORY HOTEL
Munster

The old Germania Brewery in Munster has found a second life as The Factory, a surprising and successful combination of old and new buildings that fuse urban buzz with quiet haven. The landmarked brewery building at the complex's center looks out over a relaxing lake and is surrounded by a lively combination of shops, restaurants, and clubs. The modern wing created by architect Andreas Deilmann houses the Factory Hotel with 128 rooms and 16 luxury suites designed with elements such as wood, concrete, and felt that reflect the original site's industrial flair while fostering a comfy sophistication. Guests can get some personal training or simply relax at the amazing and expansive 3,500-square-meter fitness center with its swimming pool, spa, and roof terrace before they re-emerge into Factory life. It's a life that serves up traditional German and Austrian cuisine in the main restaurant and Mediterranean snacks and tapas at the Spanish restaurant. Things heat up at night with dancing till dawn in the brewery basement nightclub.

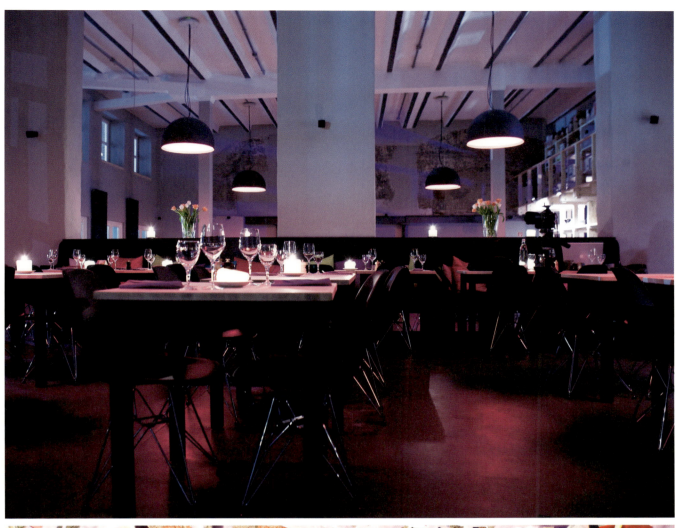

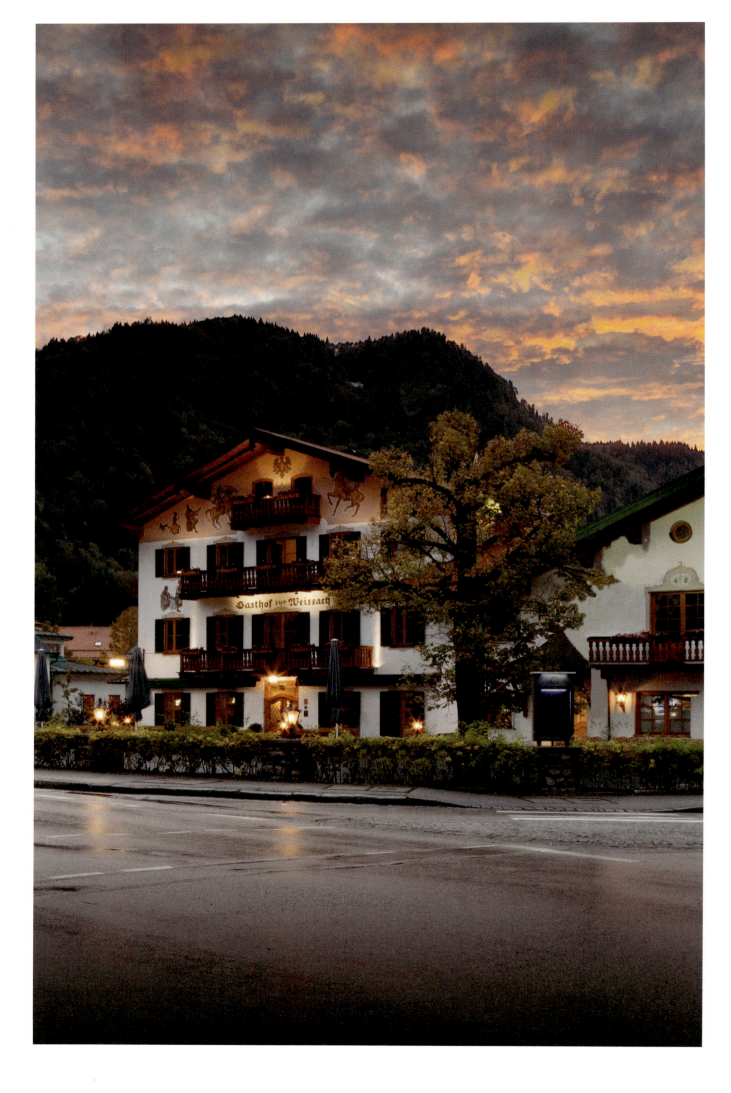

*SIGNATURE

GERMANY
ROTTACH-EGERN

OPEN
01/1862

RATES
EUR 149 –
EUR 900

ROOMS
146

ADDRESS
WIESSEER STRASSE 1
83700 WEISSACH (ROTTACH-EGERN)
GERMANY

WWW.DESIGNHOTELS.COM/
HOTEL_BACHMAIR_WEISSACH

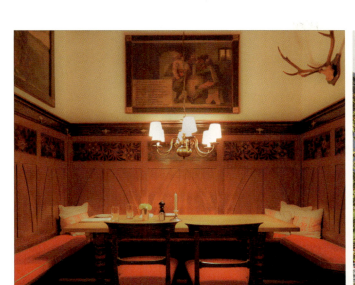
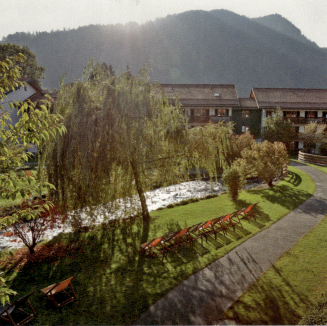
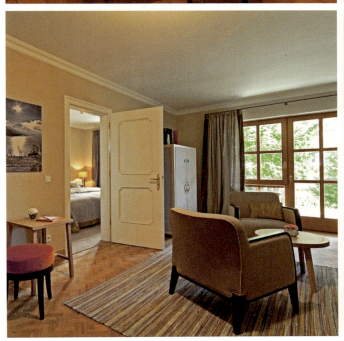
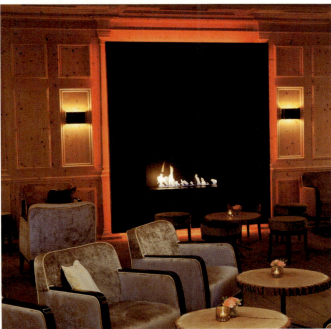

HOTEL BACHMAIR WEISSACH
Rottach-Egern

Majestic Alpine beauty, a warm atmosphere and expansive estate grounds unite at Hotel Bachmair Weissach in Rottach-Egern. In 1862, local mill owners the Bachmair family, built a small inn on the southern shore of Lake Tegernsee. Now comprising several buildings with 146 rooms and suites surrounded by parkland, the hotel has since been restored to its former glory. Ideally situated in close proximity to Munich, this Bavarian lifestyle resort for business and leisure combines simple elegance and countryside cool to convey the atmosphere of a private country club. Owner Korbinian Kohler's vision to re-establish Hotel Bachmair Weissach as a hive of social activity is illustrated in the fireside Kaminlounge, where Bavarian tradition is given a contemporary spin, with a fireplace set on a black wall and backlit by sultry red lighting. More authentic and cozy spaces for wining and dining are peppered throughout the property, such as the Gasthof zur Weissach, five separate parlors serving sophisticated interpretations of Bavarian cuisine. The impressive conference and event spaces range in size and can cater any occasion, be it an intimate meeting, celebration or a gathering of up to 2,000 people. But it's not all hard work – the 700 sqm Spa offers unique treatments in sleek surroundings, with an indoor pool that offers views out onto the surrounding parkland. The large estate grounds, and outdoor areas, offer endless opportunities for relaxation and play, including tennis, golfing, hiking, skiing, mountain biking and sailing.

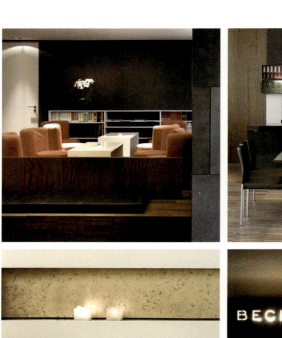
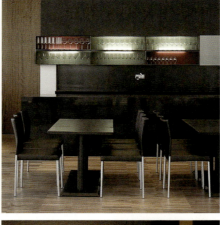
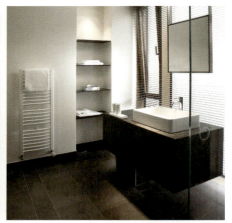

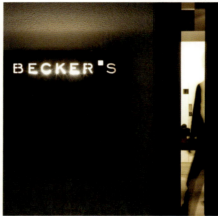

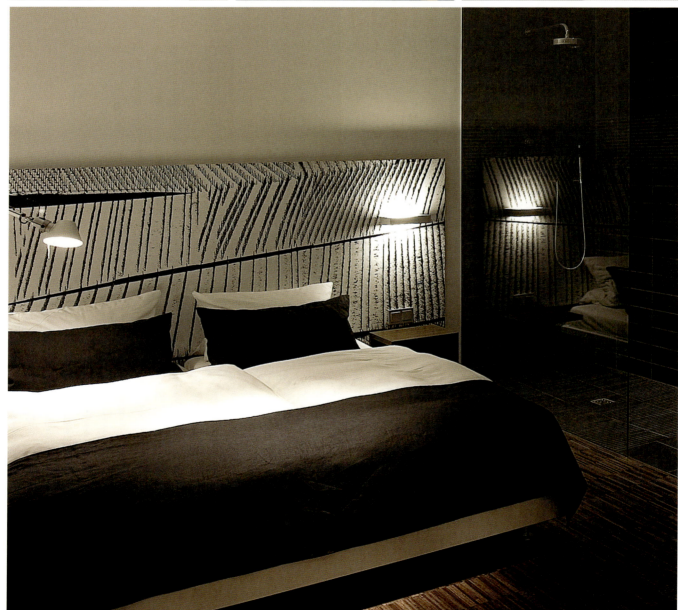

GERMANY TRIER

OPEN 04/2007

RATES EUR 110 – EUR 240

ROOMS 32

ADDRESS OLEWIGER STRASSE 206
54295 TRIER
GERMANY

WWW.DESIGNHOTELS.COM/ BECKERS

BECKER'S HOTEL & RESTAURANT
Trier

Nestled amid the vineyards and rolling hills of the ancient German city of Trier, Becker's Hotel & Restaurant is a family tradition that proudly dates back five generations, but also is a tribute to modern style despite its historic status. From the outside, the lobby glows through large-paned windows, greeting guests with an inviting warmth. Still, Becker's self-professed heart is its kitchen, which prepares true German comfort cuisine. Done in black and white, the restaurant suggests a sophistication befitting a black-tie event or a white wedding, while the wine bar's deeper, darker tones evoke a cosmopolitan night out. The serene stone floors of the lobby and restaurant give way to the guestrooms' finely patterned dark wood, combined with the mellow mood of low spot lighting. A simple pane of glass separates the dark tiled shower from the sleeping area, adding a hint of airiness to the otherwise earthy elements embodied in the hotel's design. At Becker's, German wine-country hospitality is writ large, but it is characterized by its own brand of modern sophistication.

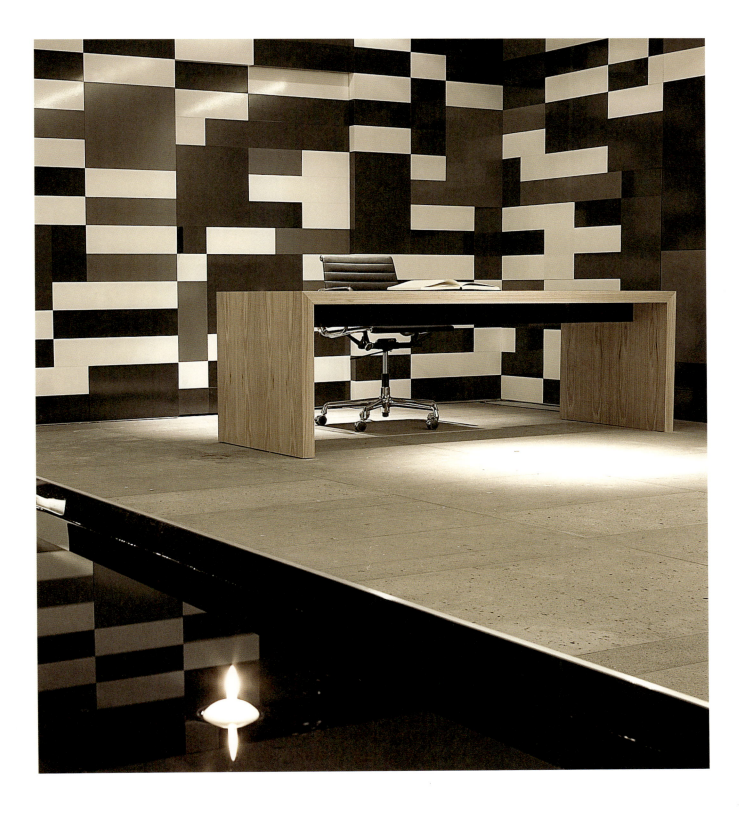

SIGNATURE

WWW.DESIGNHOTELS.COM/ FRESH_HOTEL

ADDRESS
26 SOFOKLEOUS & KLISTHENOUS STREET
105 52 ATHENS
GREECE

ROOMS 133

RATES EUR 90 – EUR 400

OPEN 04/2004

GREECE ATHENS

Set in a historical backdrop in central Athens, Fresh Hotel offers an electrifying medley of sleek formality and ancient splendor, where bold design fuses with a traditional location. This urban resort, a creation by owner Ada Yfanti, remains true to its name with a fresh palette of striking tones such as lime, fuchsia and tangerine set against a simple white backdrop. The design and architecture, courtesy of local studio Tassos-Georgiadi + Associates, uses natural materials that seamlessly merge with bursts of intense color. The choice of materials was intended to simultaneously contrast and enhance Fresh's surroundings. Peppered with an impressive selection of design furniture handpicked by Yfanti, pieces by Charles Eames, Phillippe Stark and Zaha Hadid inject Fresh with a thoroughly distinctive interior. Each of the 133 rooms is a clean, modern space; every one interspersed with the hotel's signature bold colors, with several accommodations featuring their own calm and concealed private gardens. The relaxed atmosphere that permeates the hotel extends to the popular Air Bar Lounge. With a rooftop swimming pool surrounded by olive trees and furniture by Paola Navone, guests can take in unbeatable views of the Acropolis. For even more low-key moments, Fresh's sauna and hammam are on hand, while the hotel's location in the hub of Athens allows guests to take in the city at their own pace.

NEW HOTEL
Athens

For Greek Cypriot art collector Dakis Joannou, New Hotel has been a true labor of love. After picking apart the tired Olympic Palace Hotel, which was built in the heart of modern Athens in 1958, he set about restructuring it, piece by piece, without discarding anything. The result is an astonishing work of art – a Gesamtkunstwerk, in which all the senses are brought together in an overall intensified form of visual, tactile and somatic interaction with the objects, structures and materials. Throughout the chunky modernist building, chairs and doors salvaged from the old property reappear as masterful artworks that awaken guests' senses. Thanks to interiors by Brazilian visionaries Humberto and Fernando Campana, who have earned a reputation for creating living art from castoffs and leftovers, key elements of design and culture collide on every floor. From the spa and fitness area to the top-floor terrace, which affords one of the best views in Athens, the designs are consistently intense. Each of the hotel's 79 rooms and suites engages its guests by making them feel like they're a part of the vivid in-room installations. There are three separate interior design concepts, each inspired by Greek culture, floating above the walls, challenging perceptions of depth and space. And in the public lounges, there are incredible tree-like sculptures crafted lovingly from a jumble of different-colored woods. Both physically and mentally, New Hotel provides endless possibilities for exploration.

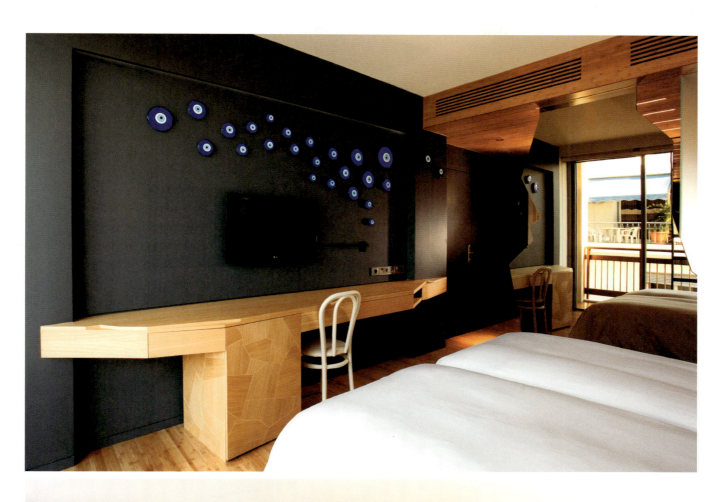
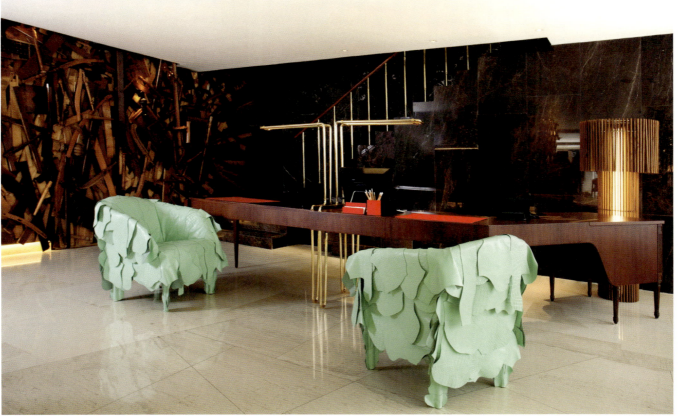

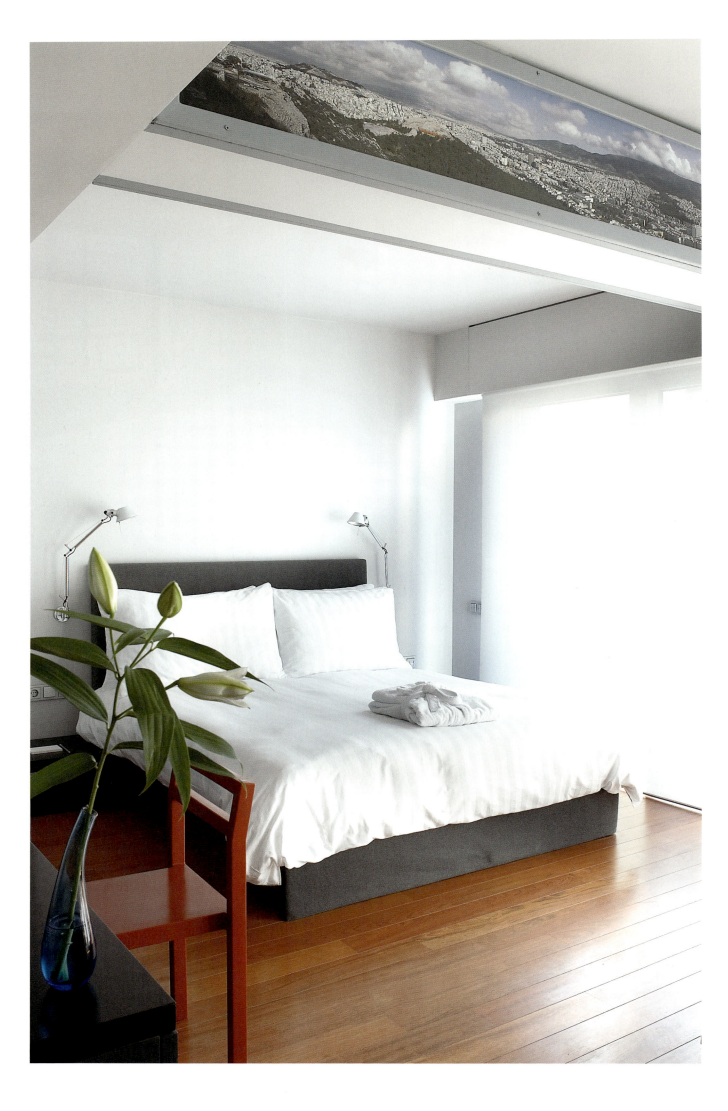

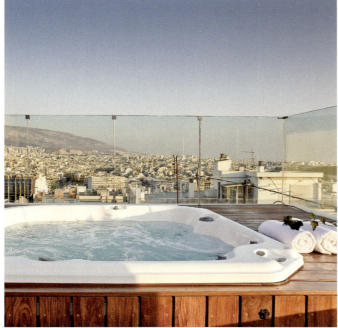
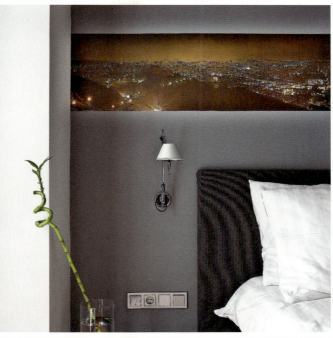
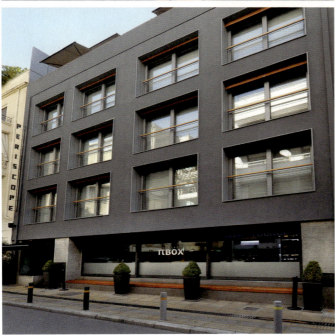
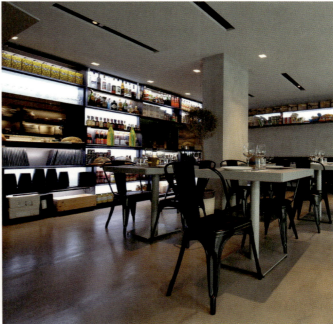

PERISCOPE
Athens

High above the glittering jewelry stores and sweet-smelling chocolate boutiques of Kolonaki, the Greek capital's most opulent shopping district, a periscope keeps watch. Not over individual streets, like the CCTV cameras you'll see bolted to the city's steel lampposts, but over the entire Athenian skyline. Controlling its movements, several stories below, are guests at the aptly named Periscope Hotel – an intimate urban hub created by industrialist and contemporary art connoisseur Dakis Joannou. Here, surveying the city and its people is just part of the guest experience. In the hotel's public areas, which are delineated by chunky concrete supports, interactive art installations stimulate guests to question their preconceived ideas about surveillance. Huge screens show dystopian images of an Athens stalked by giant three-dimensional animals, while on the main staircase trunk, a kind of primitive altimeter tracks your journey to bed, showing you how high you are above sea level with every step. All 21 bedrooms and suites are a study in pared-down style, with celluloid cityscapes and splashes of blue, red and black adding warmth to the functional decor. But catch your first view of the real Athens, crowned by the classical pillars of the Parthenon, and you might just be tempted to head out for a day of city-center exploration.

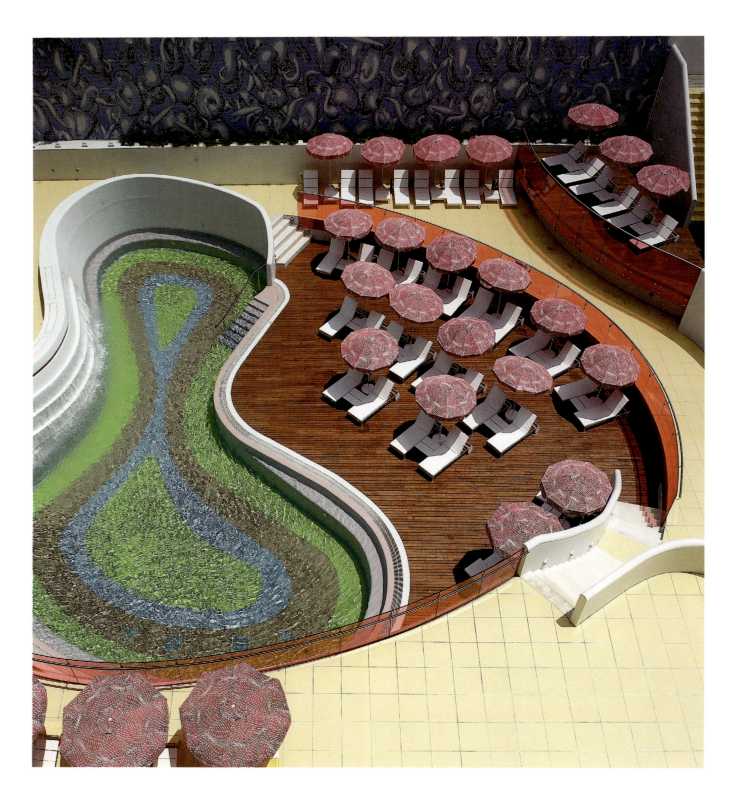

SEMIRAMIS
Athens

The Semiramis is what happens when you give a hot designer control over every aspect of a building and its interior. Design star Karim Rashid's dazzling display of lollipop colors and organically shaped furniture plays happily alongside a rotating collection of contemporary fine art, hand-picked by owner and art collector Dakis Joannou. Situated in the leafy, upscale Kifissia district of Athens, it's a feast for the eyes for any guest. The hotel's rotating art collection, which might include works by Tim Noble, Sue Webster, or Jeff Koons, presents the best of contemporary art, while Rashid's juicy pinks, oranges, greens, and yellows bathe lobby couches, transparent glass partitions, and other surfaces. It all adds up to an atmosphere – and almost exuberant service culture – that positively pulses with energy. With an extra element of cheekiness, guests are encouraged to play with Rashid's device for communicating with the outside world. Instead of the boring "Do Not Disturb" signs, he offers electronic message boards, which guests can personalize from their in-room keyboards. He describes his overall view of Semiramis as "an intimate hotel that focuses on positive energy, heightened experiences, culture, design, and art. Semiramis is a place for new contemporary experiences – to enjoy, relax, work, and engage a new memorable experience unlike any other or anywhere else in the world."

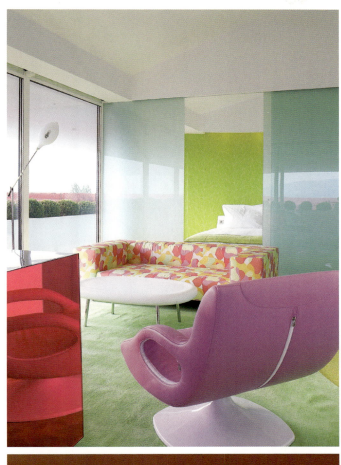
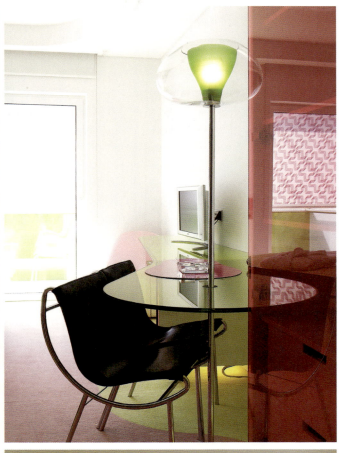
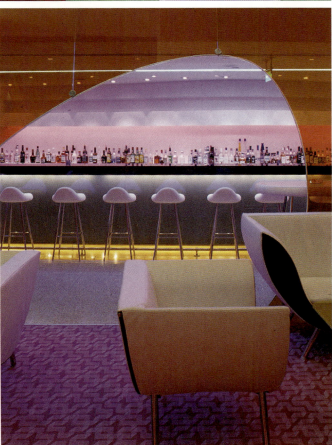

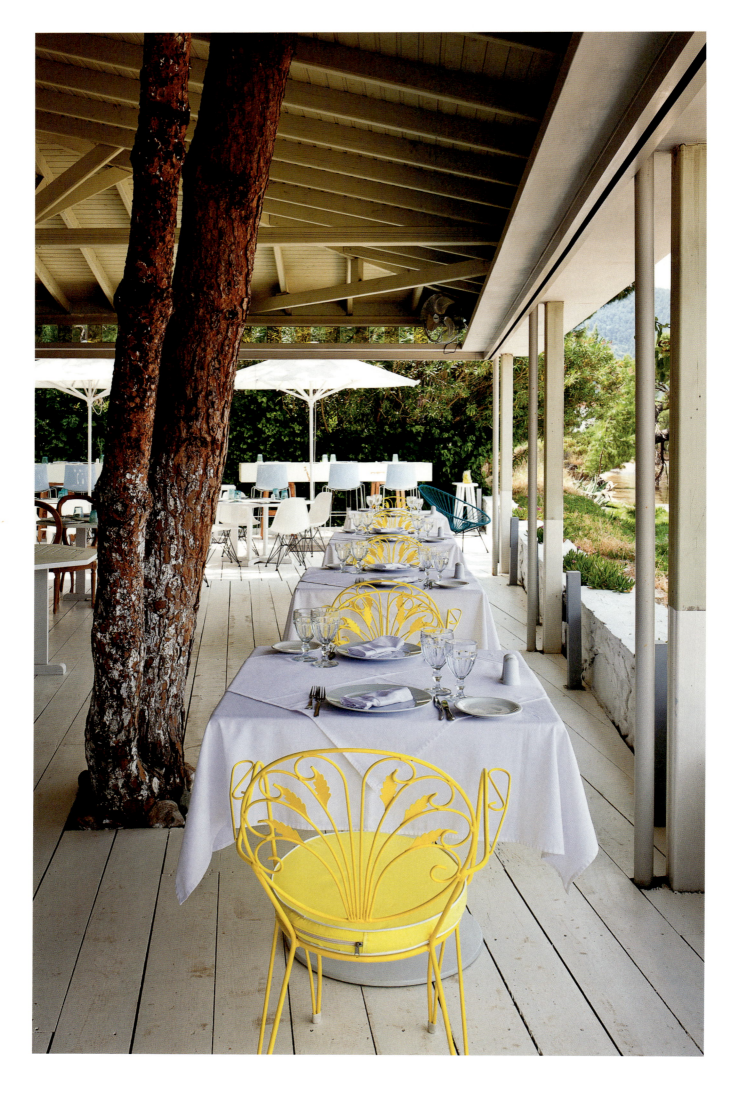

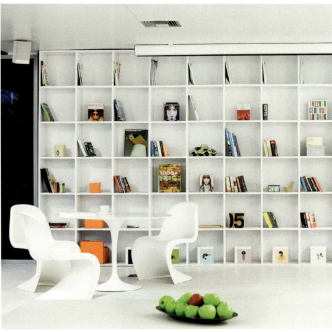

EKIES ALL SENSES RESORT
Halkidiki

Kick off your shoes, wiggle your toes in the sand and slip into the languid pace of Ekies All Senses Resort, a pared-down retreat that takes a barefoot approach to holiday relaxation. Celebrating its Greek roots and stunning natural location, the simple design lets the pristine surroundings shine and embraces the notion that luxury should be measured by one's ecological footprint. On an unspoiled beach in Vourvourou on the east side of Sithonia – one of three peninsulas in Halkidiki that reach out to the translucent waters of the Aegean Sea – the resort is surrounded by small rocky islands, caves, crystal clear waters, sandy beaches and pine tree forests. With respect for these idyllic surroundings, the design blends harmoniously with the landscape through the use of natural, unrefined materials, such as solid wood and Greek grey marble. The 64 rooms and suites weave elements of Greek tradition with distinctive and original designs, while organic forms, sustainability, metal-free Coco Mat mattresses and an ethos of minimal waste complete the resort's eco-philosophy. Diners can enjoy a fresh take on Greek food, made using local products and recipes, wherever and whenever they please, be it by the pool, on the beach or at one of the three restaurants. This ease of indoor-outdoor living continues at Ekies Spa, where treatments are accompanied by the sights and sounds of nature in the "Spa cabanas." For further relaxation, guests only have to look to the surrounding landscape, where the azure, tepid waters and rugged coastline provide endless activities to fill the days.

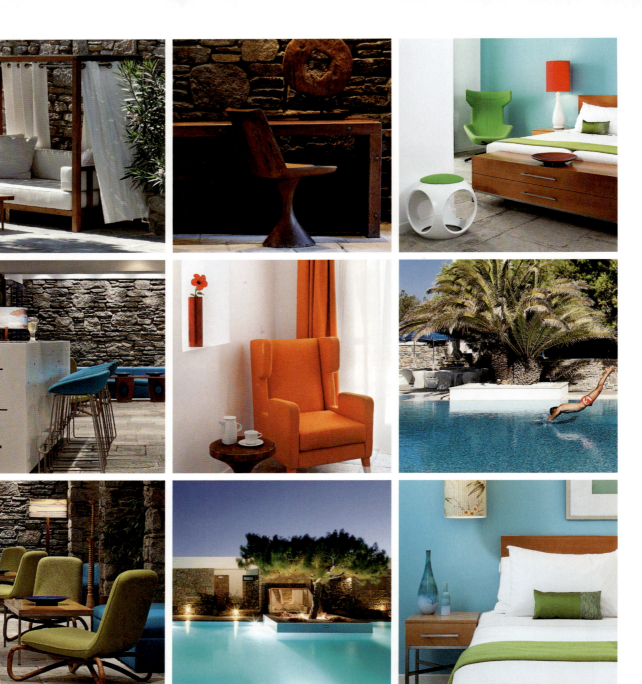

MYKONOS THEOXENIA
Mykonos

A legendary classic of 1960s hotel architecture, the Mykonos Theoxenia hotel has made a glamorous comeback: revamped in 2004, the 52-room property manages to harmoniously meld with Mykonos's radiant seascape as well as perfectly suit the Greek island's dynamic local nightlife culture. During the day, sun-worshippers can soak up golden rays on white Moroso beach chairs or luxuriate within curtained four-poster beds overlooking the Aegean Sea. Later, they can chill out among the cool stone details and crisp turquoise, lime, orange, and bright white decor emblazoned in the interior of Aris Kostantinides's iconic structure by designer Angelos Angelopoulos. His novel use of energetic colors renders the design experience as exciting and joyful as a bowl of ripe fruit; the rest of any guest's experience is in the expert hands of the relaxed spa, restaurant, and service staff. The voluptuous curves of Patricia Urquiola's deep-blue Fjord bar stools, the organic sensibility of stone pillars, and the clean feel of beech period furniture evoke the relaxed elegance of mod-era jet-setter luxury. It's something the Mykonos Theoxenia exemplified in its first heyday and that it now embodies once again.

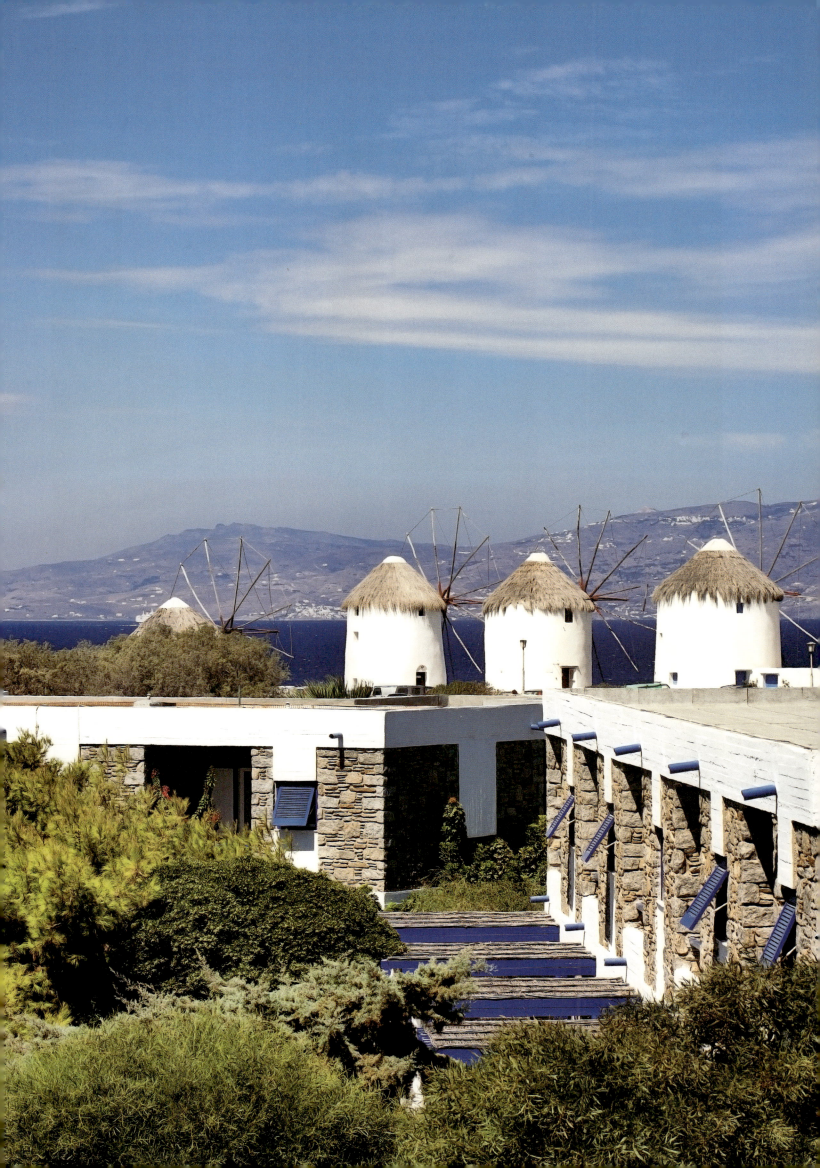

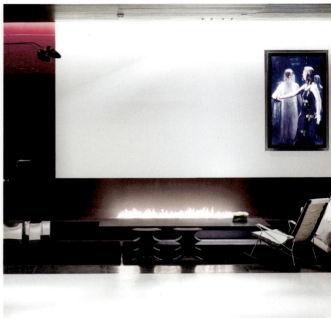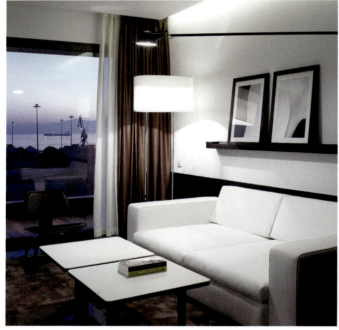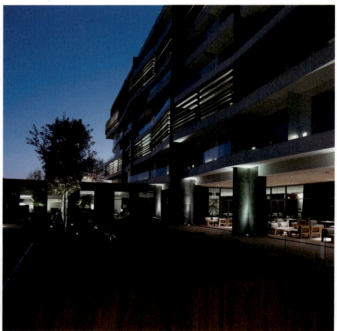

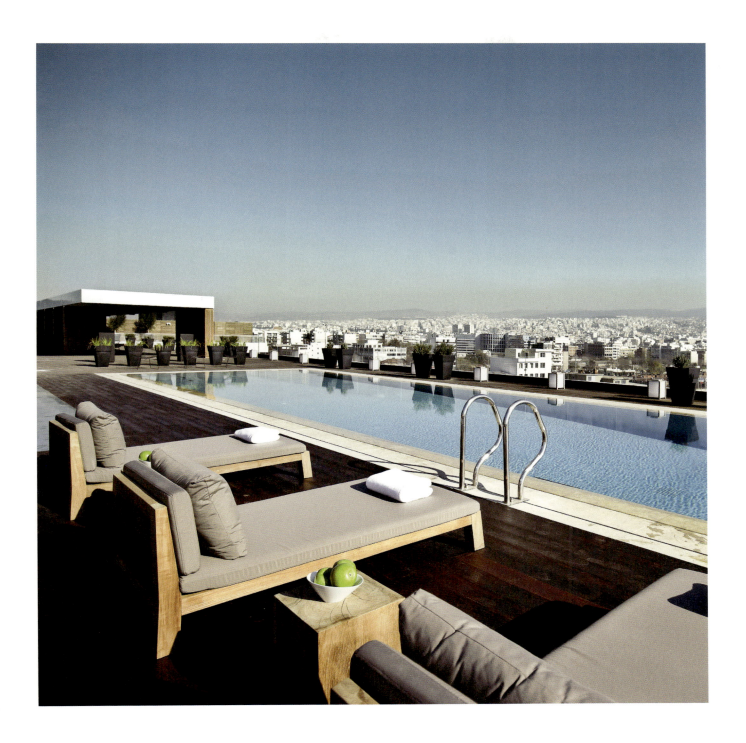

THE MET HOTEL
Thessaloniki

The ancient coastal city of Thessaloniki is speckled with fascinating art galleries, but just one of them, The Met Hotel, doubles as an extravagant luxury hotel. Wandering through its roomy, avant-garde hallways, it's hard to believe people are actually allowed to sleep here. On the piano-black walls, there are bold shots by famous fine-art photographers like Andreas Gursky and Thomas Struth. And in the generous public spaces between the lobby and the spa, you'll find sculptures and video works by some of the world's most revered contemporary artists. Of course it's not down here, but upstairs, in the 212 seductively simple rooms and suites, that guests really lay their heads. By decking the floors in dark tropical timber, and allowing sea views to flood in through huge glazed panes, the designer has managed to soften and smooth the overwhelmingly sharp contours of the furniture. Art still plays an important role, however, with stark black-and-white photos by German visual artist Ralph Baiker hanging from the walls. Even in the spa, which features an indoor heated pool, edgy lamps and glass partitions blur the lines between form and function. At The Met Hotel, situated in the heart of Thessaloniki's happening new harbor area, hospitality and contemporary art really do exist side by side.

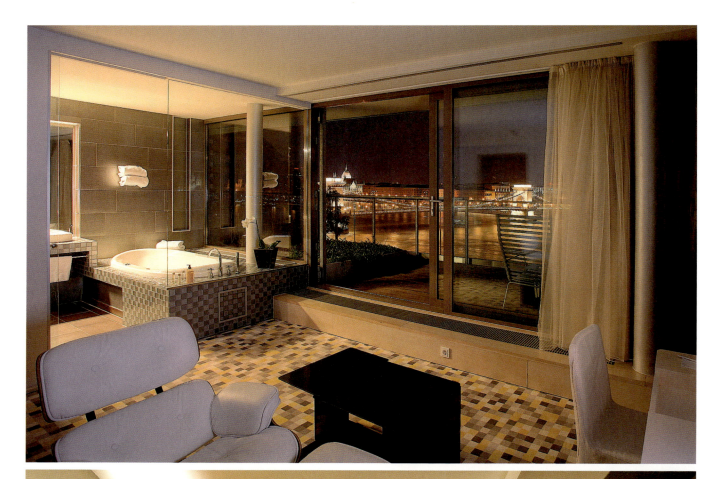

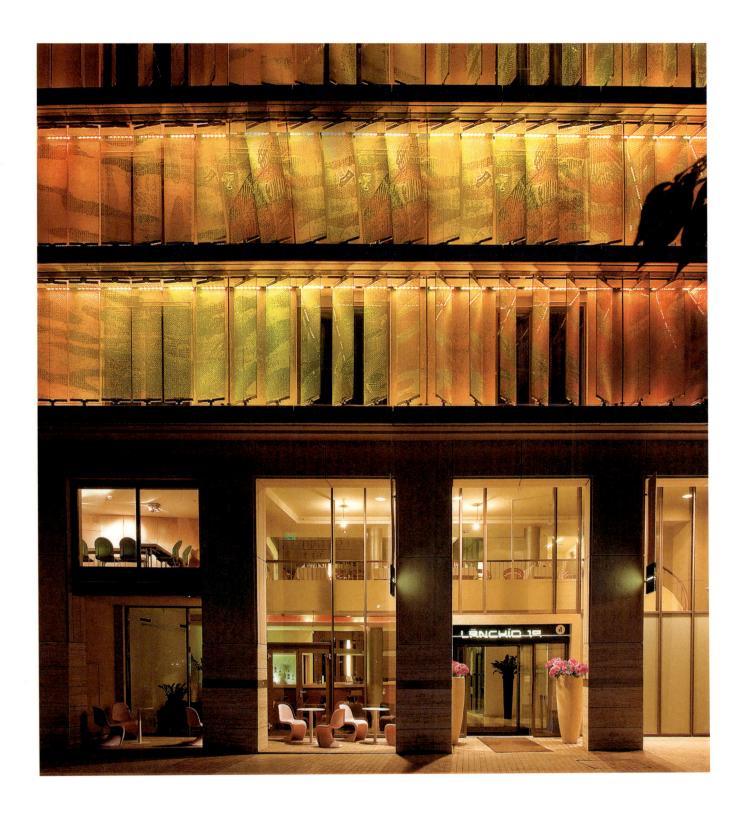

LÁNCHÍD 19
Budapest

Situated on the Danube riverbank, at the foot of the Buda Royal Castle just a few minutes walk from the city center, Lánchíd 19 provides sweeping views of the UNESCO World Heritage sites of Budapest. The hotel's remarkable moving glass facade glows with subtly changing light effects while the ultramodern chairs in its equally dramatic lobby seem to float on a glass floor revealing ancient medieval ruins below. Flowing space and light define the experience of this stylish urban getaway, from the glass atrium towering above the foyer to the open-plan design of the rooms and suites. The team of Hungarian architects took every opportunity to magnify the hotel's fantastic views of the city, which can be enjoyed from all of the rooms and the suites' terraces or even from the deep bathtub. The feeling of openness and transparency is enhanced by the clear views from the lounge to the restaurant and the intimate garden beyond. The Lánchíd 19 is a beacon of innovation while still paying homage to its historical setting: a perfect point of departure for discovering Budapest's wonders.

*SIGNATURE

WWW.DESIGNHOTELS.COM/
101_HOTEL

ADDRESS
HVERFISGATA 10
101 REYKJAVIK
ICELAND

ROOMS
38

RATES
ISK 35900 –
ISK 144900

OPEN
03/2003

ICELAND
REYKJAVIK

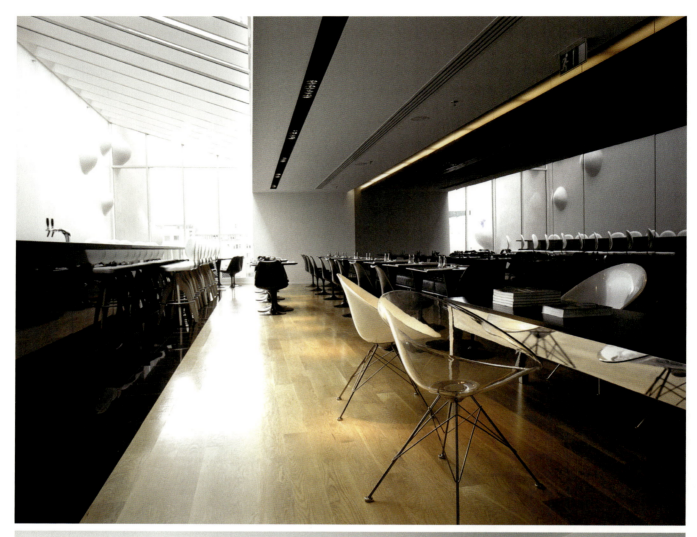

101 HOTEL
Reykjavik

101 Hotel is undeniably cool. For Iceland's first foray into the realm of chic hotels, owner and designer Ingibjörg S. Pálmadóttir has transformed the Icelandic Social Democratic Party's former home into the quintessence of Nordic style. This former office building erected in the 1930s is now Iceland's casual-chic lightning rod, where guests and locals gather around tree-trunk tables and classic pieces by Eero Saarinen and Philippe Starck, bathed in the warm glow of a communal lounge fireplace. The spare, glossy, and masculine bar's style is an innovative mixture of Chinese lacquered tables, wooden blocks, and Edwardian chairs. In contrast is the restaurant's ladylike atmosphere, where a white dimpled mural runs alongside the glass roof and guests can perch on iconic Eros chairs. Throughout the public areas, monochromatic design and clear lines showcase the hotel's collection of art by Icelandic artists. But coolness melts away in the guestrooms' rustic warmth. Here visitors can bask in Iceland's famous hospitality with heated oak floors, white Italian bed linen, mate and glossy black furnishings, Artemide lamps, and a bathroom with a freestanding bathtub waiting to be filled with geothermal waters.

ITALY BERGAMO

OPEN 07/2010
RATES EUR 150 – EUR 450
ROOMS 13
ADDRESS VIA MARIO LUPO, 6 24129 BERGAMO ITALY
WWW.DESIGNHOTELS.COM/ GOMBIT

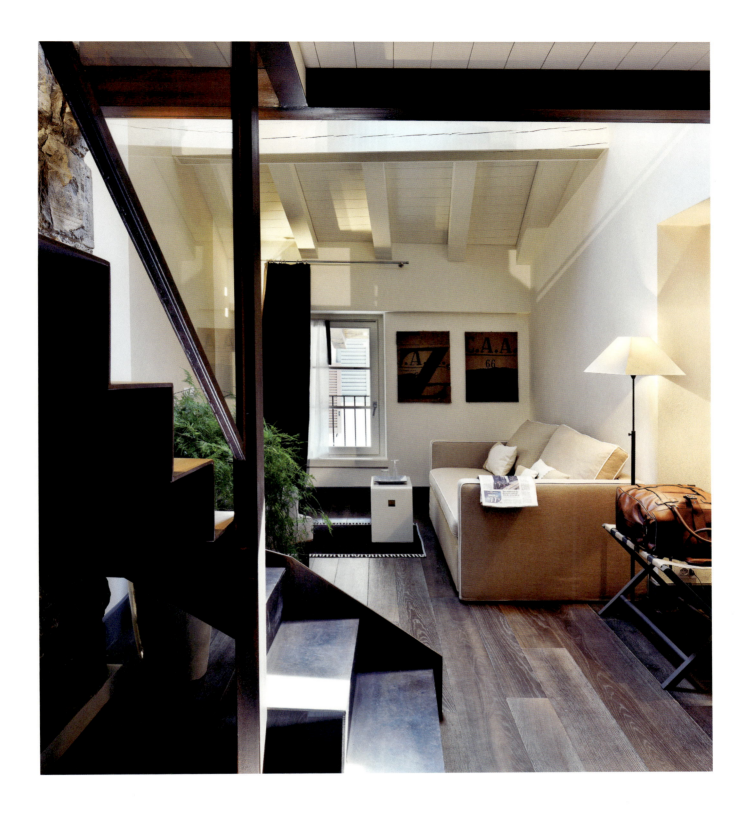

GOMBITHOTEL
Bergamo

Situated at the intersection of two ancient Roman roads in the charming *città alta* of Bergamo, a medieval walled city close to both the Alps and Milan, the GombitHotel has turned a historic crossroads into contemporary luxury. The hotel is adjoined by a monumental 13th-century watchtower that rises above the old town's clustered rooftops. "The entire historical building comes back to live a new life in the sign of art, and therefore of continuity," according to owner and Bergamo native Nadia Galeotti. Having chosen this symbolic address as a physical link to the city's remarkable past, Galeotti envisions the hotel as an arena for creative exchange, a platform for local artists, and, above all, a space for cultural discovery. The GombitHotel's interiors lighten the austerity of its stonewall aesthetic with hints of surreal artistry. Bright red books adorn the ceiling leading to the library nook, while sculptures, such as bundles of rolled manuscripts, are nestled within the ancient walls' crevices. Original wooden ceilings aged hundreds of years create a monastic ambience that interior designer Gio Pozzi complemented with her choice of textiles, primarily handmade lightweight linens in unostentatious earth tones. With 13 distinctive guestrooms and a daily regional breakfast, the GombitHotel is an intimate sanctuary that promises an exceptional experience in hospitality: it is an enchanting point of departure for cultural and epicurean exploration, bridging the ancient and the contemporary.

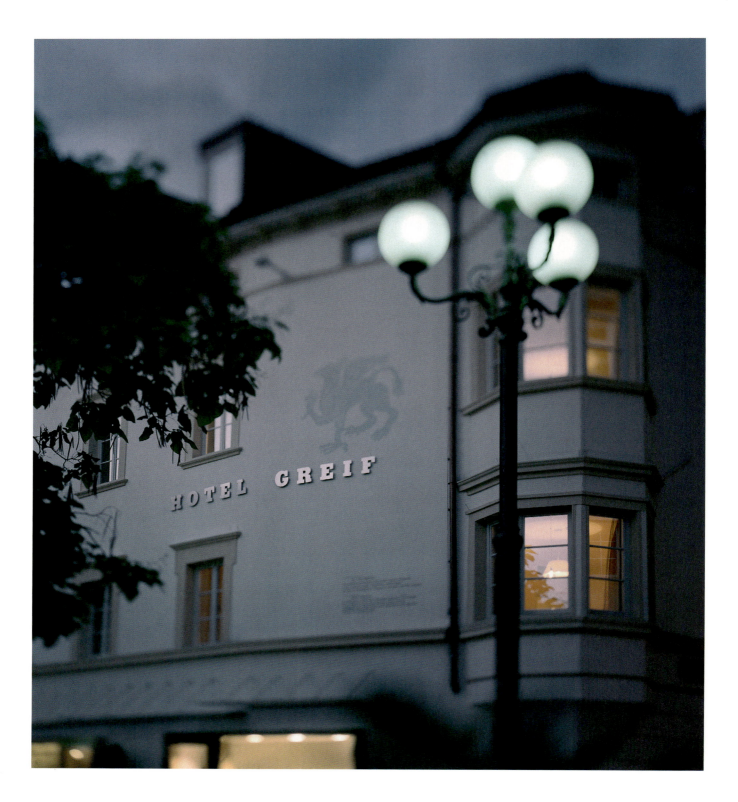

HOTEL GREIF
Bolzano

The family-owned Hotel Greif exudes a rare mixture of honored tradition, modernity and passionate creativity. Perched at the base of Italy's epic Dolomite mountain range, now a Unesco World Natural Heritage site, South Tyrol's Bolzano blends Austrian and Italian cultures, resulting in a charming Alpine lifestyle. Owner Franz Staffler elegantly redesigned the centuries-old guest house with lauded Viennese architect Boris Podrecca. The new design carefully preserved much of the original structure's integrity. Spaces were then sparingly appointed with antique furniture from the original hotel and custom-designed pieces built from local maple or knotted walnut. Each of the 33 rooms has a very special touch: some feature terrace views of the Dolomites or bay windows looking onto Bolzano's ancient Walther Square, while others boast steam saunas or marble whirlpool baths. Gracious details such as custom-made textiles, raw silk curtains and dark brown African Wenge wood floors topped with Persian carpets elicit an air of refined comfort. Staffler commissioned local artists – painters, sculptors, photographers and installation artists from Austria, Germany and Northern Italy – to create unique artwork for each of the Hotel Greif's suites, making the hotel a focal point of local creative activity. Its bar, Grifoncino, lures guests and locals to mingle with its clever lighting, projections and signature cocktails. A park, swimming pool, world-class restaurant and meeting space for up to 180 people is available across the piazzetta at the sister hotel Parkhotel Laurin.

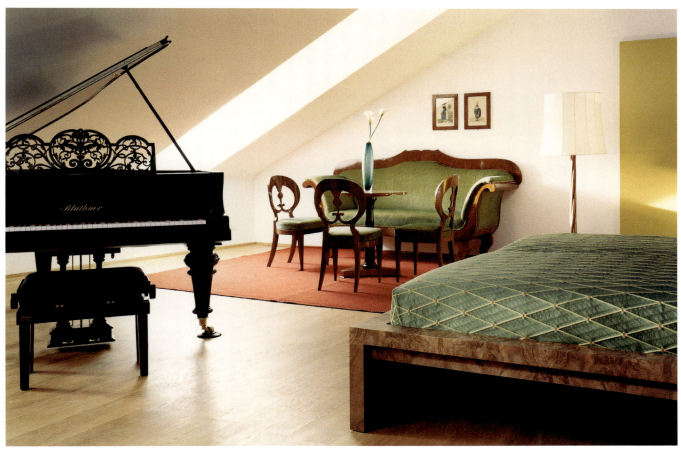
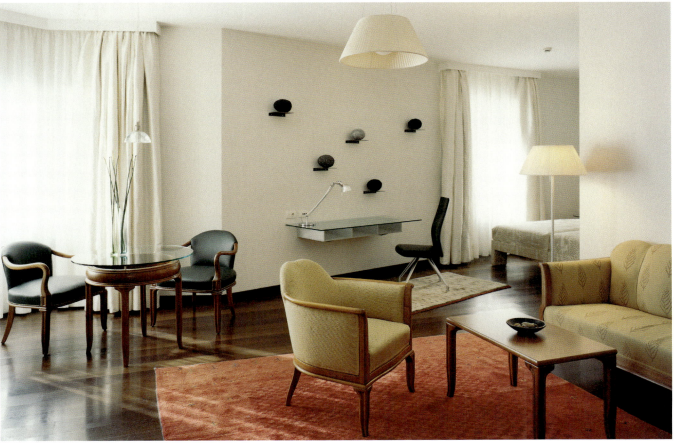

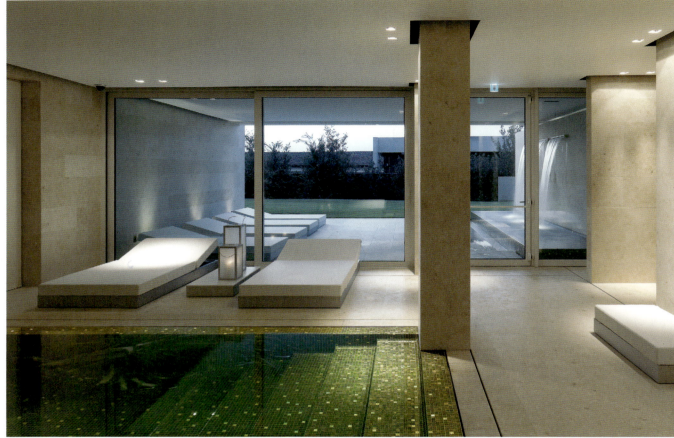
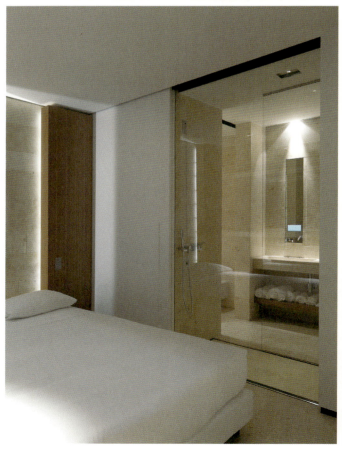

C-HOTEL & SPA
Cassago Brianza

Stepping into the stone-clad lobby of C-Hotel & Spa, around 20 kilometers from the shores of Lake Como, you know you're in for a sensory experience. First you'll be hit by the warm, chocolatey smell of freshly ground coffee beans, which lures you deeper into the building. Then, you'll notice the stretched teak reception desk sandwiched between a bustling Italian bar and a family-run confectionary shop that's been baking mouthwatering delicacies on this site for more than 30 years. Although the shop has been completely rebuilt as a minimalist *enoteca*, complete with a wine cellar that fuels legendary tasting sessions, the locals still love it. At Materiaprima restaurant chef Fabrizio Colzani creates fine Italian cuisine, using fresh regional ingredients from nearby farms. The hotel also boasts a concept store, C-Colzani, and the award-winning C-Caffe. The young entrepreneur who built C-Hotel & Spa around his family's existing businesses, Andrea Colzani, hasn't relied on former glories. Instead, he has used his self-taught architectural skills to create a forward-thinking minimalist retreat in the hills. By cleverly threading locally quarried limestone through the naturally lit hallways of the glass-fronted building, he's created a blank canvas for artists to decorate during the exhibitions that are often held here. And as if to make the building immune from the effects of time, all 18 suites have been stripped back to a functional minimum. Soundproofed, climate-controlled, and with great swathes of natural materials, the effect is extraordinarily soothing.

CONTINENTALE
Florence

Considered by many to be the crown jewel of the fashion design Ferragamo family's small chain of hotels, the Continentale in Florence pays tribute to the retro spirit of the 1950s and 1960s with a candy-colored mix of both vintage and contemporary style, offset by just the right amount of playful kitsch. Pink-upholstered chairs greet guests in the reception, a mellow space second only to the fabulous Relax Room on the second floor, overlooking the Ponte Vecchio, the Arno river, and the Corridoio Vasariano. The cocktail lounge's bar glows in pastel tones, and the cosy breakfast room's pink-upholstered furnishings continue the mood, but without crossing into camp. Nods to glamorous vintage design are scattered throughout the hotel, but evenly balanced out by the color composition's happy-go-lucky charm, as intended by interior designer Michele Bönan. The hotel's 43 guestrooms are appointed with sheer-draped beds and flowing curtains that catch the Tuscan light, but the rooms also manage to evoke the noir feeling of a 19th-century steamer cabin, thanks to well-placed steel and leather accents. Reassuringly retro black-and-white photomontages complete the glorious modern look that goes hand in hand with a positive mid-century feel in the heart of this romantic Italian city.

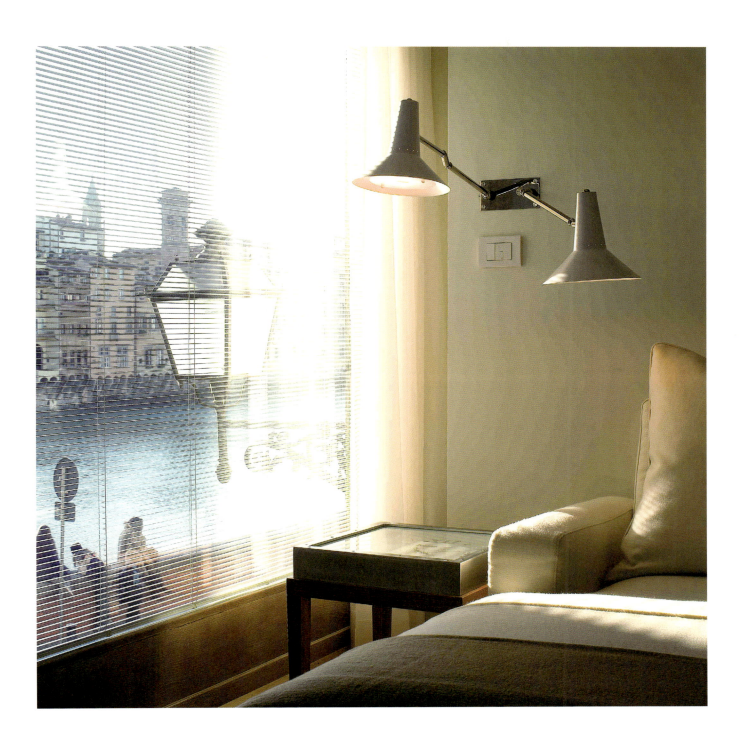

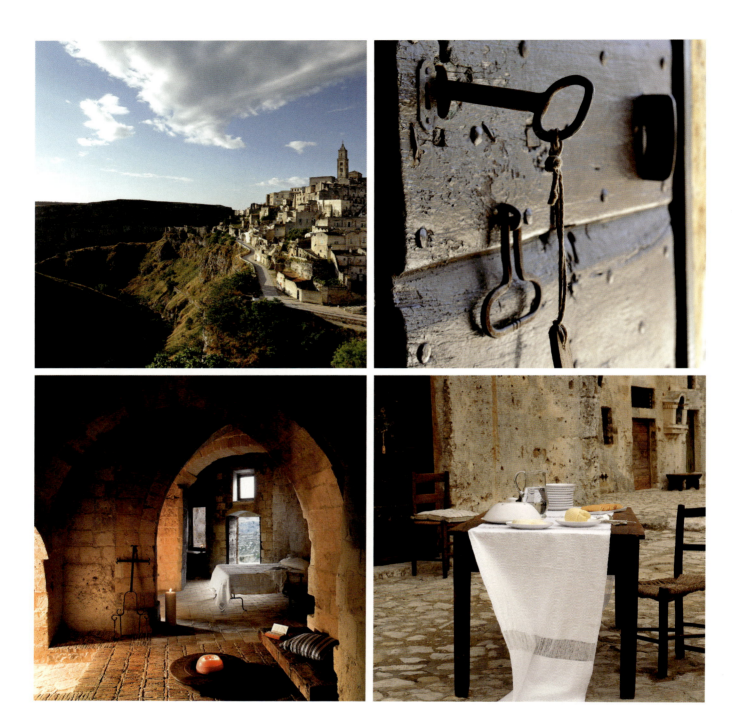

SEXTANTIO
LE GROTTE DELLA CIVITA
Matera

Restored from decaying, abandoned ancient caves in the Basilicata village of Matera in southern Italy, Sextantio Le Grotte Della Civita offers guests a new take on authenticity. Daniele Kihlgren spearheaded the campaign to resuscitate the caves. The Swedish-Italian entrepreneur, hotelier and philanthropist breathed new life into the caves while honoring and highlighting the lives previously spent dwelling in their depths. Situated in the arch of the proverbial Italian boot, Matera is not widely known by foreigners: historically impoverished, it fell into local seclusion. The importance of maintaining the traditional local aesthetic and preserving the existing architecture is thus intensified in this UNESCO World Heritage Site. Kihlgren has created 18 impeccable rooms in Sextantio Le Grotte Della Civita, the oldest part of the ancient *Sassi*. He composed a synthesis that integrates traditional design made from local materials with a minimum of contemporary amenities. In order to provide its guests with proper standards of luxury, the site was meticulously taken apart, entirely wired and piped, and finally reassembled, with each stone replaced in its original location. The result is a marvel of beauty providing a truly once-in-a-lifetime experience.

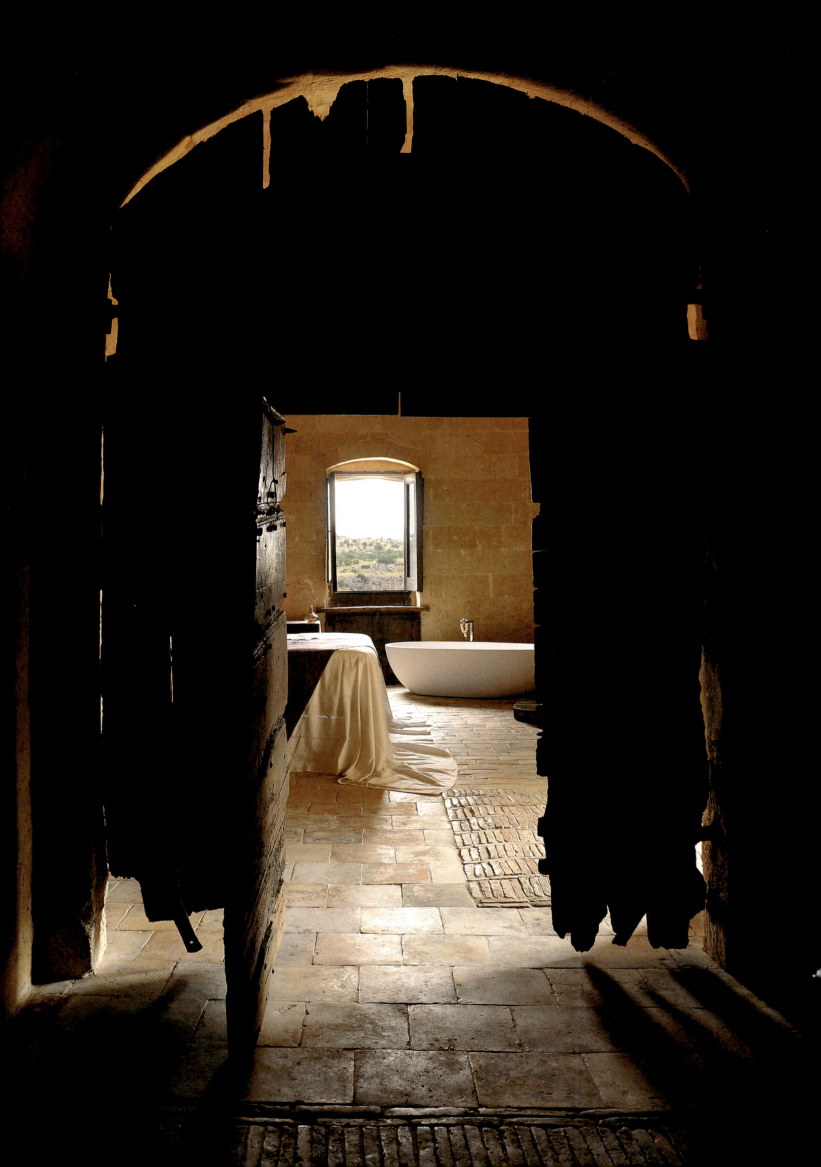

MAISON MOSCHINO
Milan

Developed from an 1840s neoclassical railway station on Milan's Viale Monte Grappa, the Maison Moschino invites guests to realize their dreams and entertain their fantasies. This newest concept hotel from the renowned Moschino fashion label is the splendid result of a design project supervised by Rossella Jardini in cooperation with Jo Ann Tan. Divided into four floors, the building boasts 63 guestrooms and 2 junior suites, each one unique, as well as a bar, a restaurant by Michelin-starred chef Moreno Cedroni, a SPA by Culti and a gym. The Maison Moschino offers an alternative life, fabricated into a world of imagination and surrealism. In the hotel's entrance hall, a lamp in the shape of one of Moschino's dresses greets guests. By applying its fashion flair to the hotel industry, Moschino has created a stellar example of a new approach in hotel hospitality where fantastical fairy tales come to three-dimensional life. "Alice's Room," "Life Is a Bed of Roses," "Little Red Riding Hood," "The Forest" and "Gold" are some of the names of the rooms, arranged in 16 different designs that transform sleep into a dreamy experience, continuously weaving between a fairy-tale dream and upbeat, optimistic reality. One guestroom sees rose petals dripping down from the lights to cover the bed; in another, guests will feel as though they really are sleeping in the enormous ballgown that flowingly transitions down from the bed board. The theme is sewn into its scenic background in "The Forest" room, echoing the enchanted forests of our dreams.

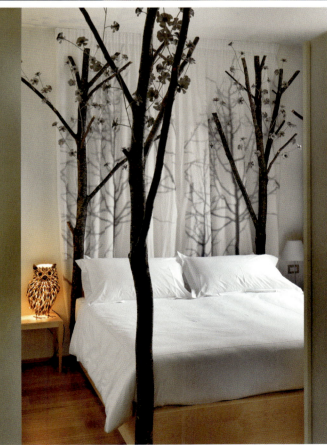

✷ OFFBEAT

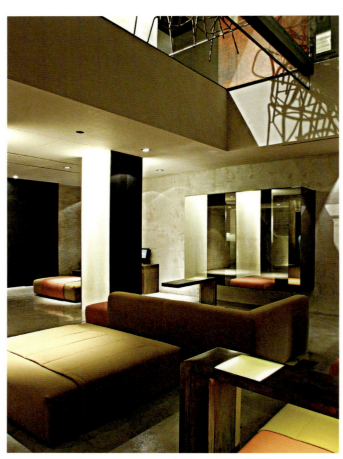
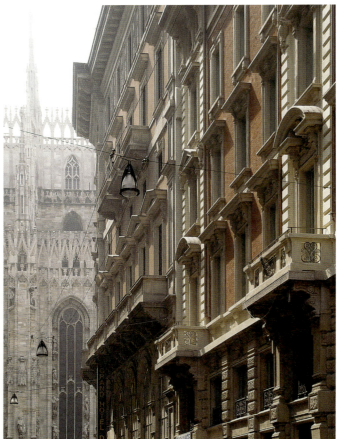

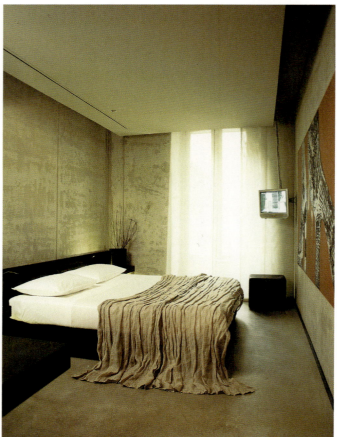

WWW.DESIGNHOTELS.COM/
STRAF

ADDRESS
VIA SAN RAFFAELE 3
20121 MILANO
ITALY

ROOMS
64

RATES
EUR 325 –
EUR 729

OPEN
12/2003

ITALY
MILAN

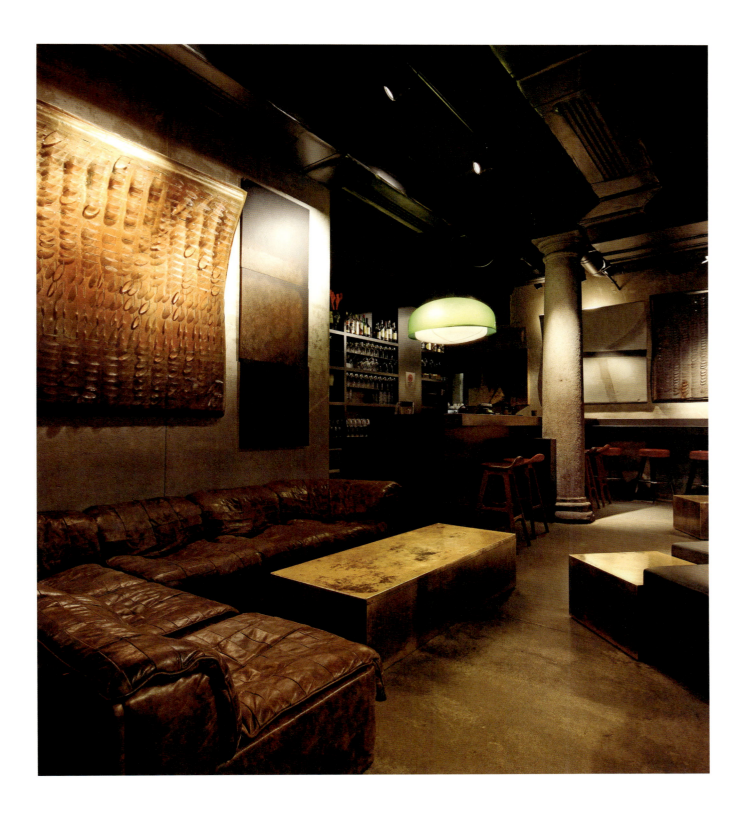

STRAF
Milan

The Straf began its life as a 19th-century palazzo a few steps from Milan's Duomo cathedral and La Scala opera house before it spent years as a "normal" hotel. But now the hotel is a mesmerizing monument to the deconstructivist design aesthetic of Milanese architect/artist/fashion designer Vincenzo de Cotiis. With bare cement floors and stairs, rooms featuring oxidized copper and split slate, scratched mirrors, burnished brass and torn, aged gauze captured between sheets of glass, de Cotiis summons an atmosphere of warmth and well-being from scrappy, hard-edged materials. The 64 guestrooms come in either a light or dark color palette and exude intimacy despite (or perhaps because of) the hints of industrial design. Guests can bask under color-therapy light panels in some rooms; all offer tactile pleasures in fine textiles, decadent bathrooms and mirrored surfaces. Public areas offer slightly unfinished odes to fashion and relaxation: a reading area invites guests to a couch formation in a glass-roofed courtyard, and the slick Straf Bar has become a magnet for sunglassed fashion mavens from around the world. "The hotel is almost like an installation," says de Cotiis. An experience here is indeed nothing less than artistry.

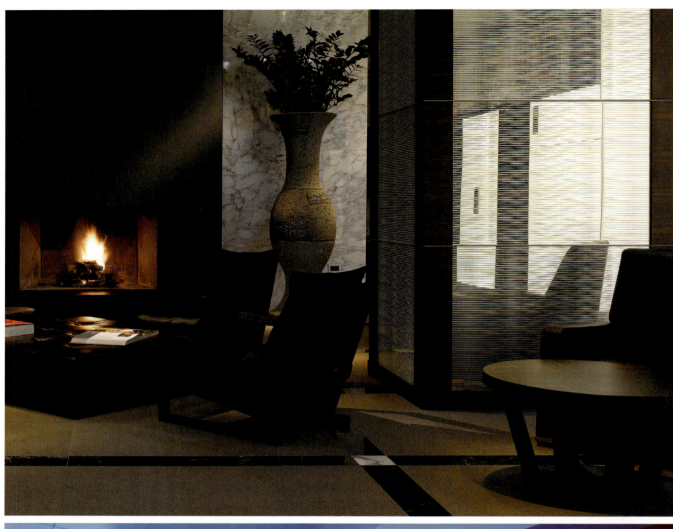

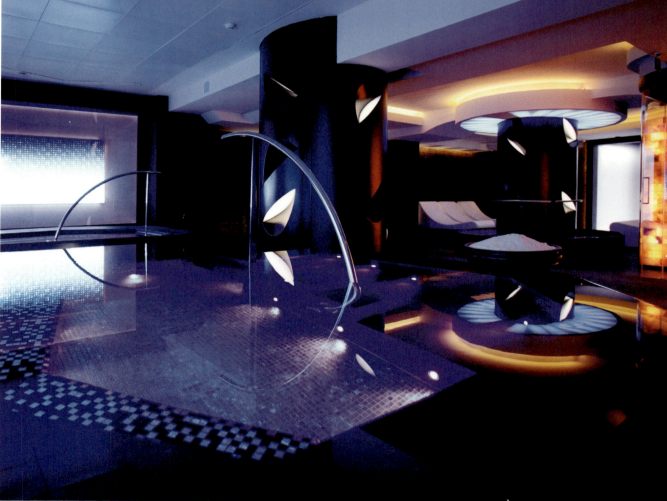

ITALY NAPLES

OPEN 12/2008

RATES EUR 190 – EUR 1400

ROOMS 83

ADDRESS VIA CRISTOFORO COLOMBO, 45 80133 NAPLES ITALY

WWW.DESIGNHOTELS.COM/ ROMEO_HOTEL

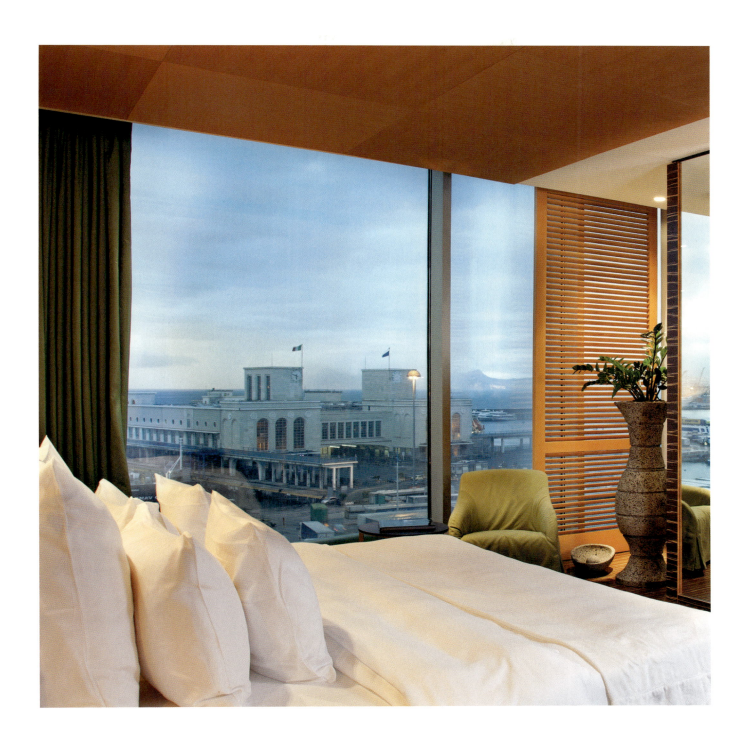

ROMEO HOTEL
Naples

In the heart of ancient Naples, the Romeo hotel balances a fine line between sea and city; modernity and tradition; and East and West. Designed by Kenzo Tange, and created by his son Paul, the hotel overlooks the Amalfi Coast and Capri Island. Each of the 59 rooms and 24 suites is a fusion of elegance and modern comfort. Carefully selected materials, fabrics and furnishings provide simple ornamentation throughout the property, including Tabu wood floors, glass surfaces and precious marbles. An impressive array of contemporary art is on display throughout the hotel, and bespoke furniture is specifically designed and selected to create fresh, new spaces. The hotel's long list of leisure and service options aims to provide the utmost of comfort for its guests – from the Dogana del Sale SPA, which blends supreme beauty technology with sophisticated design, to the open-space lobby, intimate Cigar room and dedicated gaming lounge. Dining options span from the East, with Zero Sushi Bar and Restaurant, to the West with Il Comandante, serving local flavors with a modern flair. Immersed in rich cultural traditions, guests can relax in stylish comfort, all while surrounded by panoramic views over the Gulf of Naples and Vesuvius.

*SIGNATURE

WWW.DESIGNHOTELS.COM/
ARGENTARIO

ADDRESS
VIA ACQUEDOTTO LEOPOLDINO SNC
58018 PORTO ERCOLE (GROSSETO),
TUSCANY
ITALY

ROOMS
73

RATES
EUR 190 –
EUR 1400

OPEN
02/2008

ITALY
PORTO ERCOLE

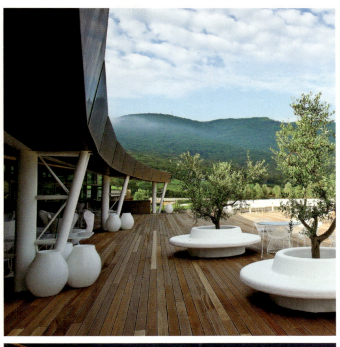
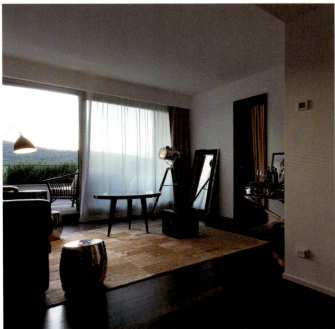
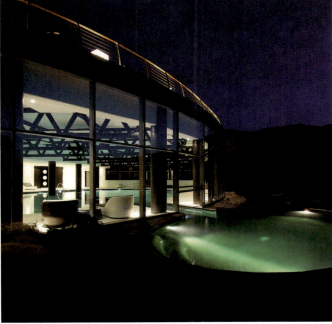

ARGENTARIO GOLF RESORT & SPA
Porto Ercole

In a verdant valley in Tuscany's Monte Argentario Peninsula, Augusto Orsini has created a masterpiece in contemporary design unlike any the region has seen. Instead of a traditionally rustic Tuscan resort adorned in the typical terracotta and wrought iron, the Argentario Golf Resort & Spa offers an alternative vision – one that looks forward not only aesthetically and architecturally, but also ecologically. Its 18-hole golf course is BioAgriCert accredited for its minimal environmental impact; its Dama Dama Restaurant and The Bar specialize in locally inspired cuisine made from indigenous, regional ingredients; even the hotel's luxurious Espace Spa treatments are based largely on organic products. Argentario Golf Resort & Spa, the only golf resort in the Design Hotels™ collection, has 73 guestrooms and suites throughout its dragonfly-shaped structure with flaxen limestone facade. Its seven suites are all different, offering guests the option of a new experience with every stay. The 55 junior suites and 11 superior rooms all have terraces overlooking the beautiful, eco-conscious golf course. For those avid golfers and spa aficionados familiar with Tuscany, as well as for those visiting the region for the first time, Argentario presents a new, distinctive luxury experience to this classic hotbed. Just steps away from the beautiful sandy beaches of Feniglia and Giannella, this resort and golf haven breathe new life into Tuscan luxury service and recreation.

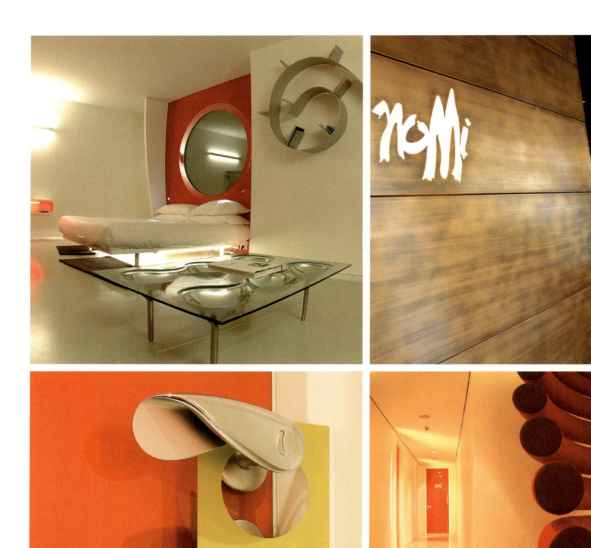

DUOMO
Rimini

Celebrated designer Ron Arad injected the duoMo hotel with his own brand of eccentric, futuristic style. Immediately set apart by its shining, metallic facade, duoMo makes no attempt to blend in with its more traditional surroundings: a narrow street in downtown Rimini, one of Italy's long-standing seaside resorts. Oversize accents, dramatic angles, daring colors and adventurous shapes create an unconventional atmosphere for the hotel's stylish clientele. Individual bathroom pods in each room give the feeling of otherworldly comfort, heightened by Arad's use of light and shadow to evoke the sensation of infinite spaces. At the much hyped noMi Club, guests can make eyes at each other via of the bar's myriad distorted reflective surfaces, World-renowned DJs draw crowds to the hotel's regular Sunday parties. The bar's walls literally open on balmy nights and the party spills out onto the streets of the town's lively historical center, thus helping to spur Rimini's ascent as one of the top trendy destinations for a new generation of jet-setters.

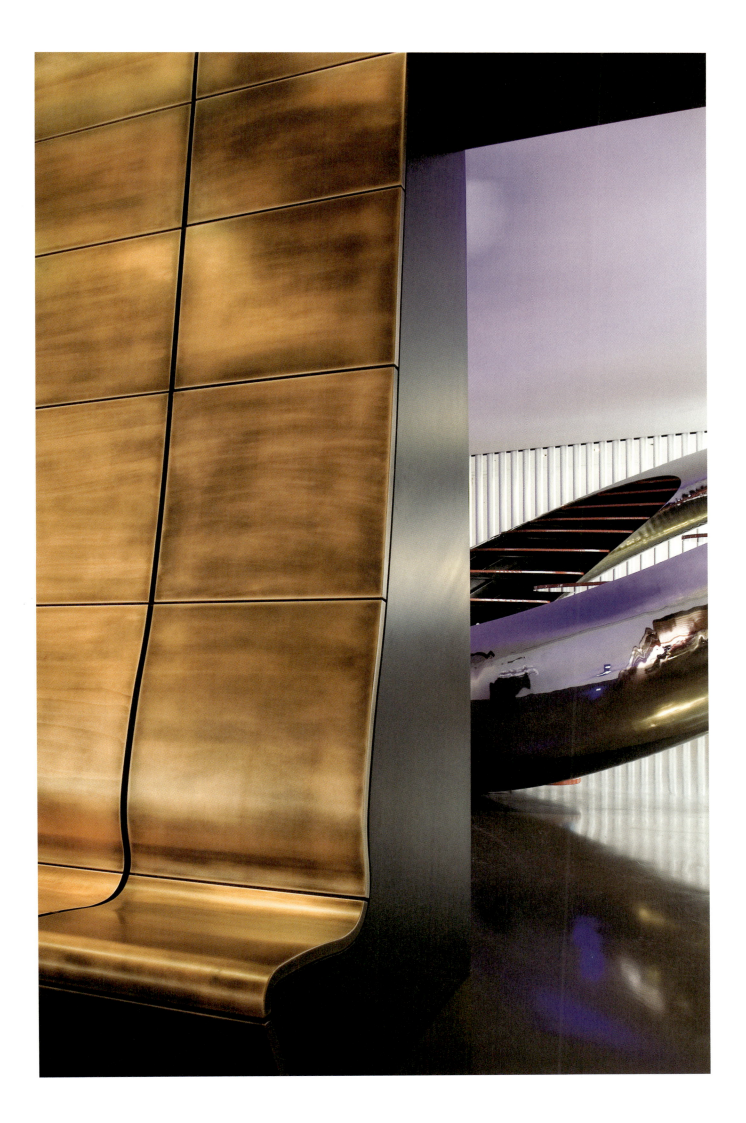

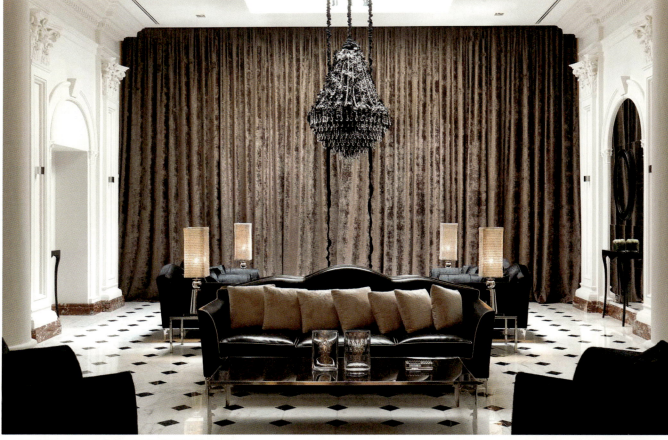
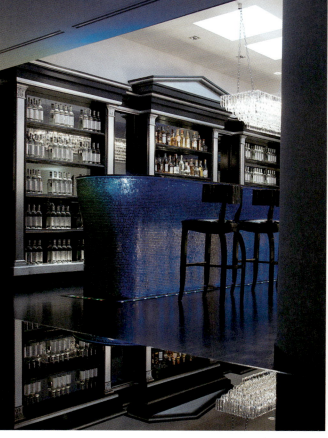

WWW.DESIGNHOTELS.COM/ LEONS_PLACE

ADDRESS VIA XX SETTEMBRE, 90/94
00187 ROME
ITALY

ROOMS 56

RATES EUR 220 – EUR 490

OPEN 08/2008

LEON'S PLACE HOTEL IN ROME
Rome

Set in an 18th-century aristocratic palace a short walk away from famous Roman sights like Via Veneto, the Spanish Steps, and Trevi Fountain, Leon's Place is a beacon for the most contemporary travelers and the perfect home base from which to explore the Italian capital. Hundreds of years ago the palace was a sacred place, a characteristic visible immediately on entering the building. The wide spaces and decorative components attract the guest's attention while walking through the entrance toward the majestic main hall. An enormous black velvet swing hangs from the central chandelier, made of elegant crystals and fabrics and creating an almost neo-Gothic vision. The imposing draperies, the carefully studied lighting, the surfaces covered with precious objects restore the original majestic atmosphere. The Visionnaire Café again represents the originality of the creative vision thanks to its mosaic-decorated counter, its rich lamps and spotlights joining the mirrored walls in the lounge area to open up the spectator's view. The 56 guestrooms and spacious junior suites with luxurious French beds, marble bathrooms, and generous natural light have been elegantly thought through and provide the guests with a cool, clear backdrop in which they can fully unwind. The hotel's guests can also enjoy a small fitness area equipped with jacuzzi, sauna and Turkish bath, two meeting rooms, a Wi-Fi Internet connection in all common areas, and valet parking nearby. Leon's Place goes beyond the modern conception of the design hotel and assertively becomes a new reality in the luxury hotel sphere.

*OFFBEAT

ITALY
SANTO STEFANO
DI SESSANIO

OPEN
09/2005

RATES
EUR 100 –
EUR 1000

ROOMS
27

ADDRESS
VIA PRINCIPE UMBERTO
67020 SANTO STEFANO DI SESSANIO
ITALY

**WWW.DESIGNHOTELS.COM/
SEXTANTIO_ALBERGO_DIFFUSO**

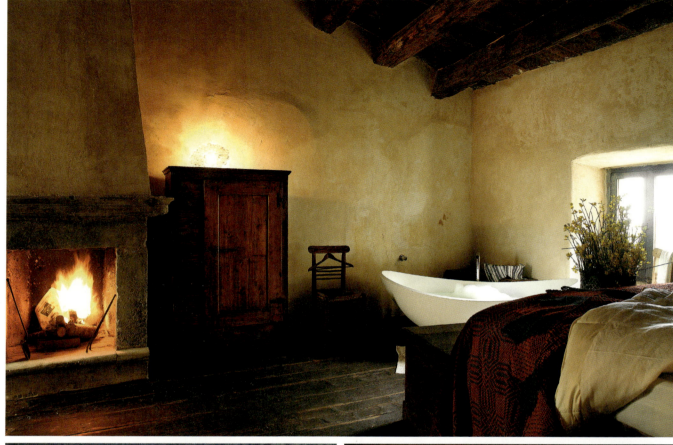

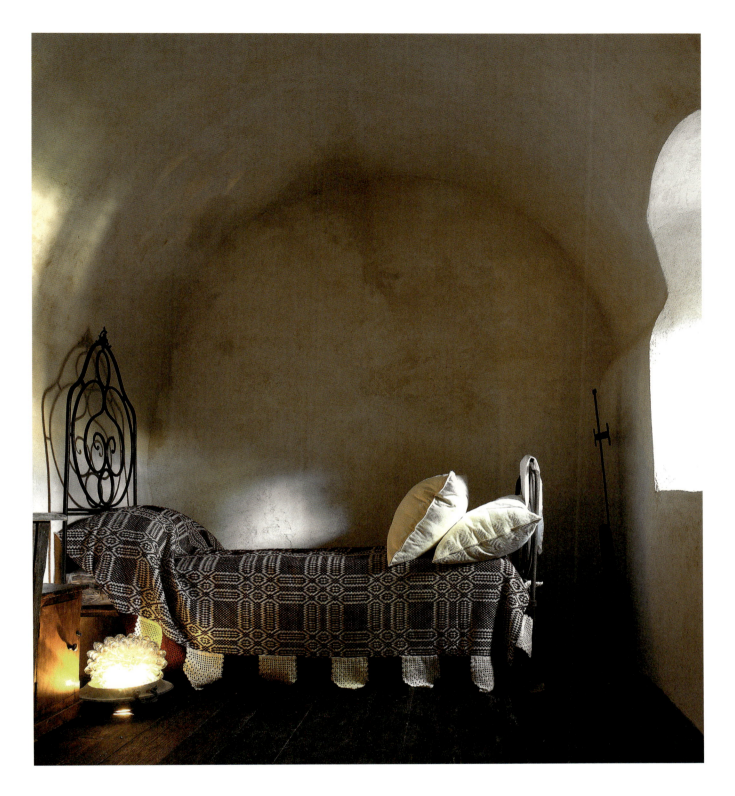

SEXTANTIO ALBERGO DIFFUSO
Santo Stefano di Sessanio

One and a half hours northeast of Rome, Santo Stefano di Sessanio nestles in the middle of Abruzzo, between the 2,912-meter peak of the Corno Grande and the sandy beaches of the Adriatic. It is one of the region's most striking hilltop towns and the home of the 27-room Sextantio Albergo Diffuso. Named after some of the area's first settlers, Sextantio's gorgeous series of buildings spreads throughout the handsome village, which was purchased and then meticulously revived by Swedish-Italian entrepreneur, philanthropist and hotelier Daniele Kihlgren. Kihlgren committed himself entirely to the restoration, using strictly local materials – primarily terracotta tiles, wood, and limestone – and striving for historical accuracy. Sextantio is not part of the hip Italian hotel route of idealized glamour and luxury. It attracts people with a strong sense of adventure, a passion for history and authenticity and a thirst for new experiences. But Sextantio equally draws those who value a beautiful local meal and cozy, elegant accommodation. While not a traditional hotel, tradition is deeply ingrained in Sextantio's foundations.

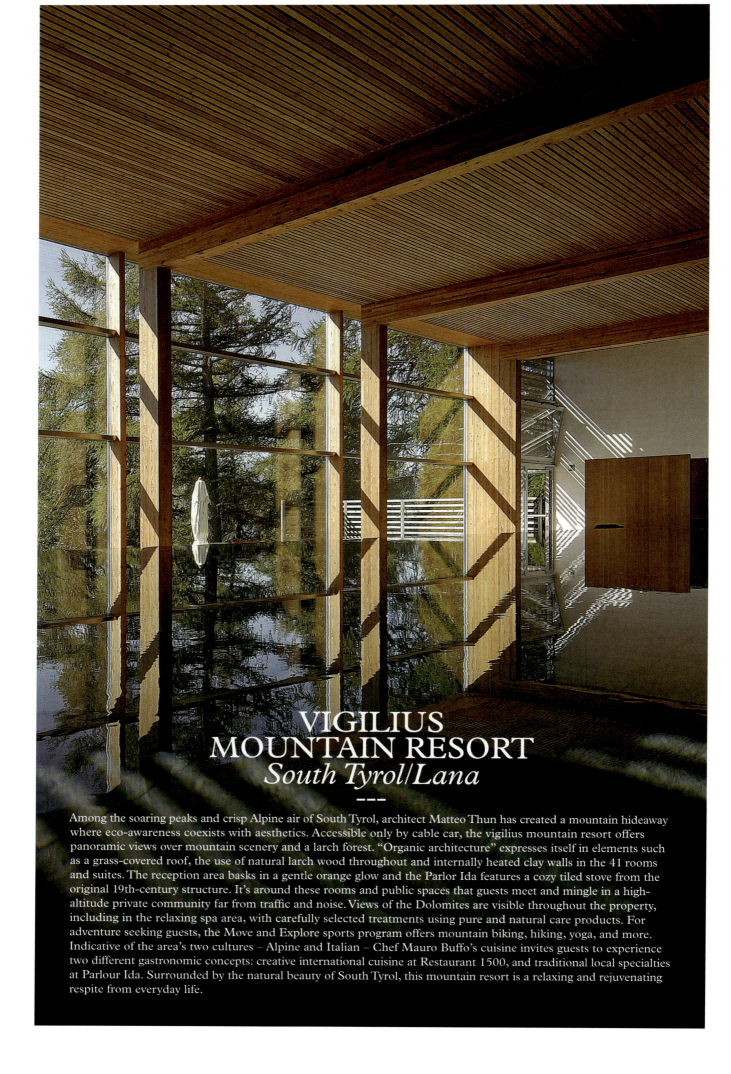

VIGILIUS MOUNTAIN RESORT
South Tyrol/Lana

Among the soaring peaks and crisp Alpine air of South Tyrol, architect Matteo Thun has created a mountain hideaway where eco-awareness coexists with aesthetics. Accessible only by cable car, the vigilius mountain resort offers panoramic views over mountain scenery and a larch forest. "Organic architecture" expresses itself in elements such as a grass-covered roof, the use of natural larch wood throughout and internally heated clay walls in the 41 rooms and suites. The reception area basks in a gentle orange glow and the Parlor Ida features a cozy tiled stove from the original 19th-century structure. It's around these rooms and public spaces that guests meet and mingle in a high-altitude private community far from traffic and noise. Views of the Dolomites are visible throughout the property, including in the relaxing spa area, with carefully selected treatments using pure and natural care products. For adventure seeking guests, the Move and Explore sports program offers mountain biking, hiking, yoga, and more. Indicative of the area's two cultures – Alpine and Italian – Chef Mauro Buffo's cuisine invites guests to experience two different gastronomic concepts: creative international cuisine at Restaurant 1500, and traditional local specialties at Parlour Ida. Surrounded by the natural beauty of South Tyrol, this mountain resort is a relaxing and rejuvenating respite from everyday life.

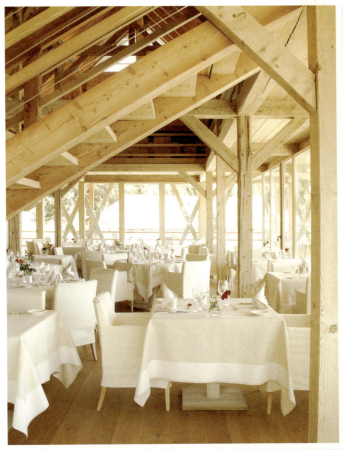
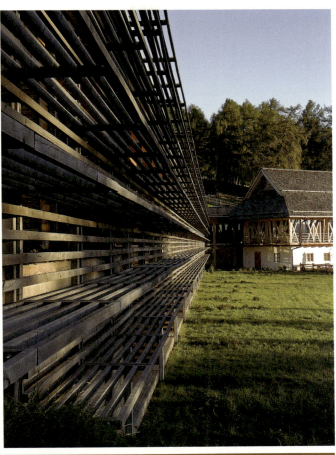
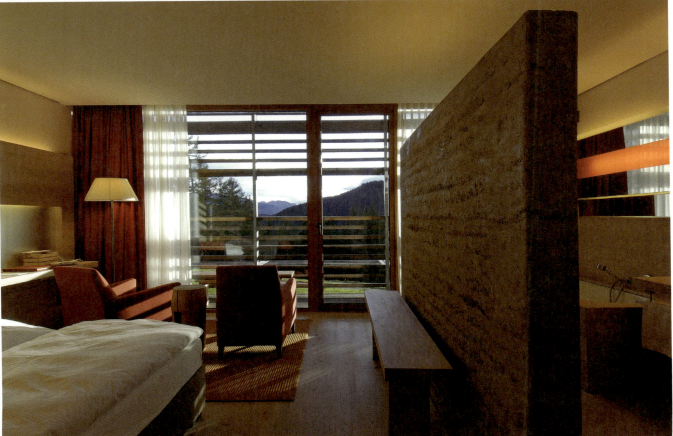

CA' PISANI
Venice

A revived merchant's townhouse owned by the Serandrei family, Venice's noble Ca' Pisani hotel is more than 500 years old, but has been brilliantly modernized by architects Roberto Luigi Canovaro and Gianluigi Pescolderung into an experience that's nothing less than inspiring. The pair blended elements of the Italian Futurist movement with original architectural features such as exposed wooden beams. Each of the 29 guestrooms boasts original furniture from the first half of the last century, collected from across Italy by the Serandrei family. Posters from the same period inspire one-of-a-kind guestroom doors, offering guests their first encounter with their distinctive room. Bathrooms feature a special masonry technique that gives the effect of sparkling stars. The hotel's wine and cheese bar, La Rivista, offers freshly made snacks and another variation on the "starlight" theme, with glistening blue tables that underscore a dreamy and unreservedly romantic atmosphere. Located in a quiet, picturesque part of the city, Canovaro and Pescolderung's clean, sharp lines imbue the hotel with a calming effect. The hotel cooperates with two Venetian galleries, and periodically holds exhibitions in Salone Nobile on the first floor, enhancing its status as an exclusive Venetian spot. At Ca' Pisani guests enjoy the successful melding of two contrasting design eras in a setting that is both relaxing and elegant.

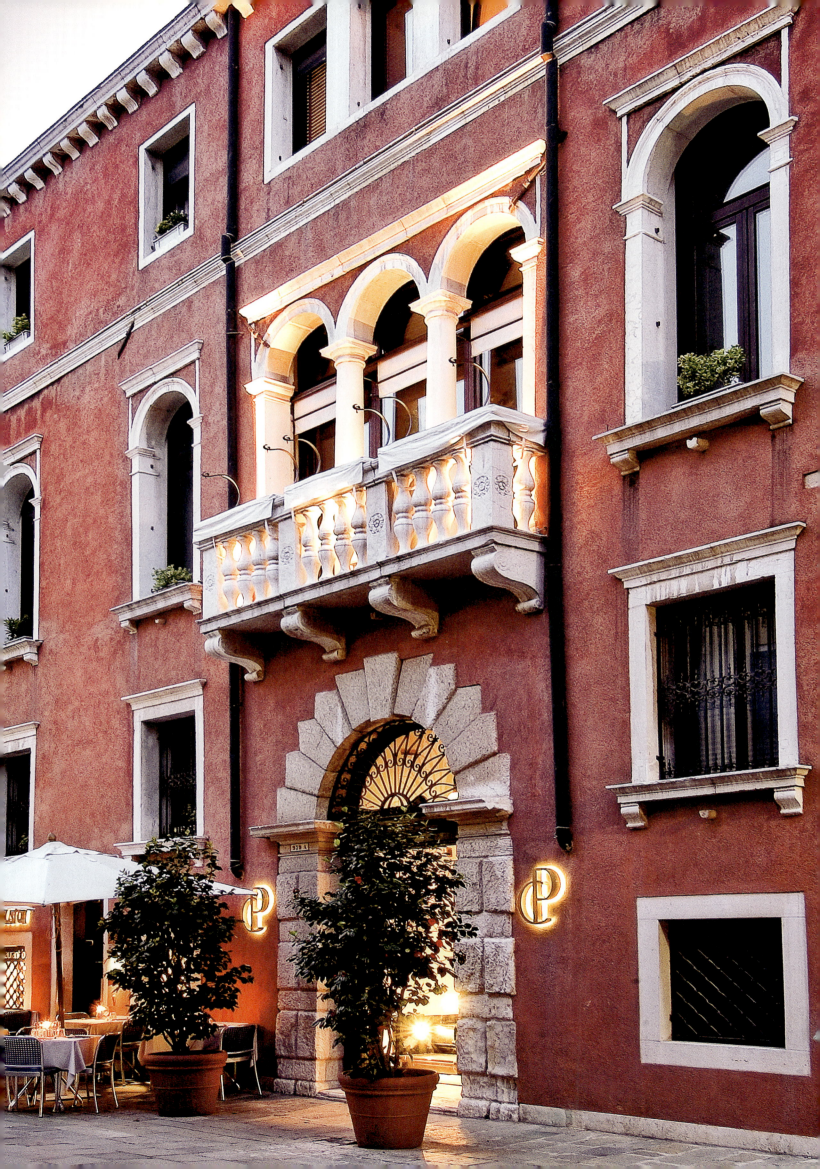

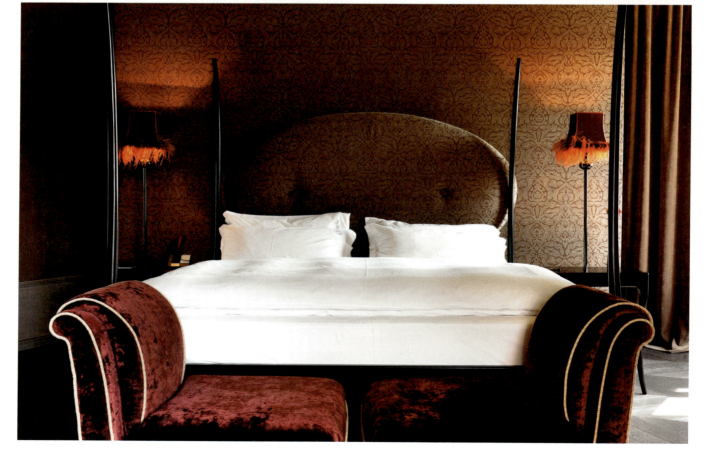

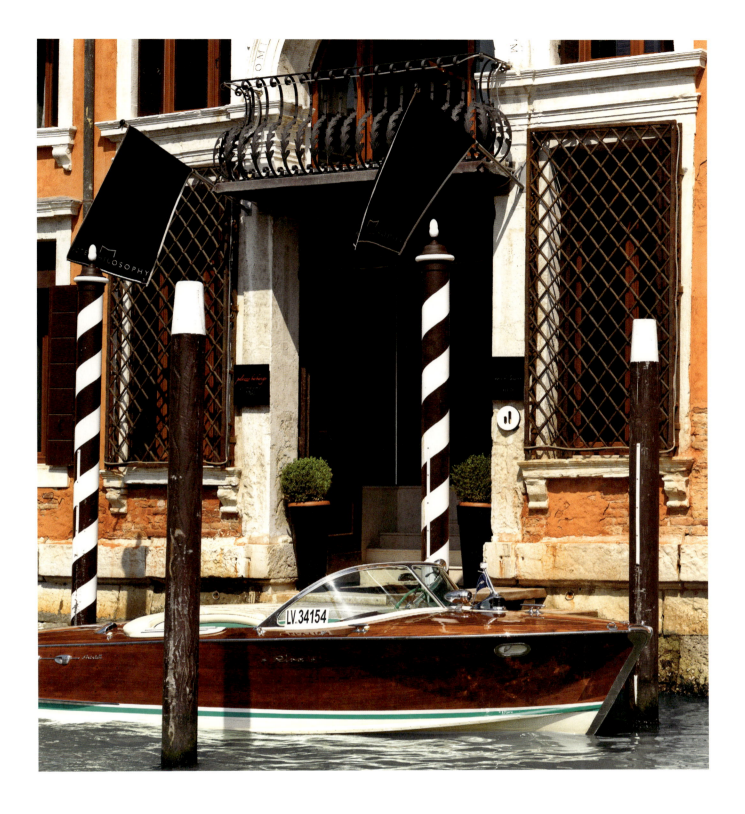

HOTEL PALAZZO BARBARIGO SUL CANAL GRANDE
Venice

A private dock on the Grand Canal opens to the entrance of this exclusive and charming hotel set in the heart of Venice. Art deco's influence soars in the hotel's beautiful black back-painted glass bar, a space recalling this unique city's Golden Twenties. The materials' sophistication reflects the incorporeal essence of the water. Palazzo Barbarigo Sul Canal Grande fuses the emotion and playfulness of the Venetian style, resulting in a new, extraordinary design hotel that has emphasized the architectural beauty of this 16th-century palace through its renovation work. At Palazzo Barbarigo, different styles and different times blend in a perfect balance. Recast in feminine terms, the hotel's appeal reaches its highest expression in the moonlit suites overlooking the Grand Canal or in the beautiful rooms facing the romantic Rio San Polo. Fine textiles and damask fabrics inspired by Venetian artist Fortuny elegantly combine with an undulating tone poem of understated dove grays, browns and charcoals. All of the design touches in this 18-room property channel an era of elegant intimacy. Like a 1940s film set, the hotel's luminous mise en scène is alluring, vibrant and disarmingly regal. The magnificent natural location adds appeal to this incomparable hotel.

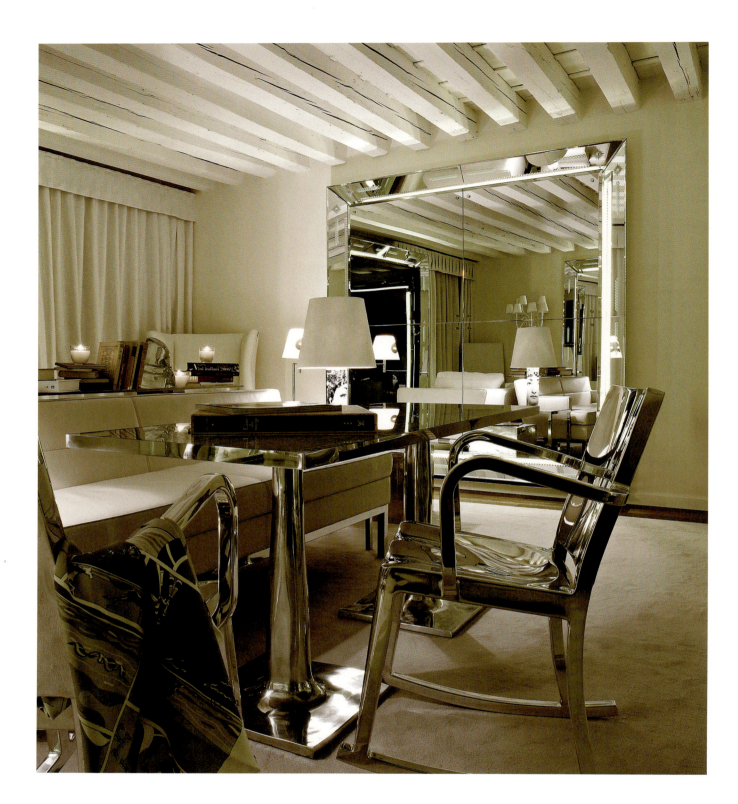

PALAZZINA G
Venice

Situated on the Grand Canal, the PalazzinaG offers its guests the opportunity to experience the melancholy grandeur of Venice like true Venetians. Privacy, flexibility, luxury and elegance are the fundamental elements of this exclusive property, designed by Philippe Starck. With no reception desk at the entrance area, a personalized check-in marks the beginning of the customized service guests can expect throughout their stay. The façade of the three-story hotel is a classical 16th-century shell, which once housed generations of noble and haute-bourgeois families; several centuries earlier, the site served as a Roman spa. Today, classical references abound, including a restored central colonnade and modern columns. The 21 rooms, including 6 suite apartments are characterized by a marriage of contemporary and romantic design, highlighted by bespoke furnishings, glass works by the French artist Aristide Najean and sophisticated collector's items, with some rooms offering glimpses of lagoon landscape. PGs Club Restaurant reflects the philosophy of PalazzinaG: a warm, informal, yet decadent atmosphere, where chef Luigi Frascella interacts with diners from a show-cooking counter. Continuing inside to the sixteenth-century wing of the palazzo, guests can enjoy the Krug Lounge, the second in the world. Overlooking the Grand Canal, it is open only for members and hotel guests and is the ideal spot for an aperitif before dinner or a champagne nightcap. In these surroundings guests will experience the enchanting history of Venice, accompanied by exclusive and personalized service.

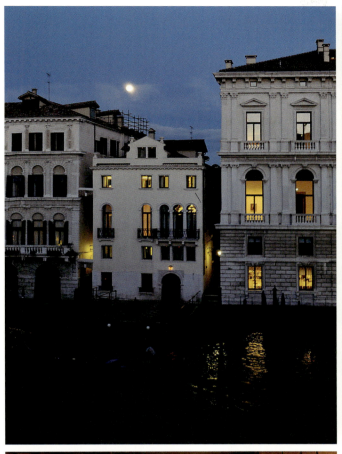
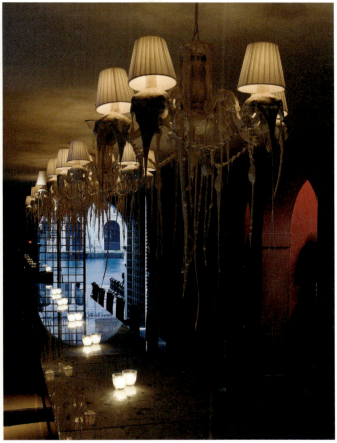
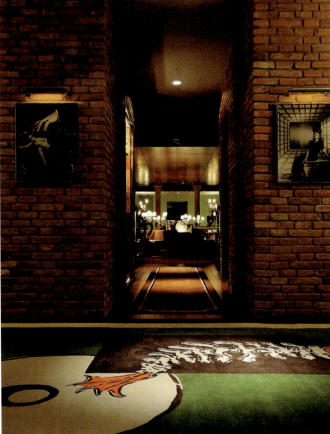
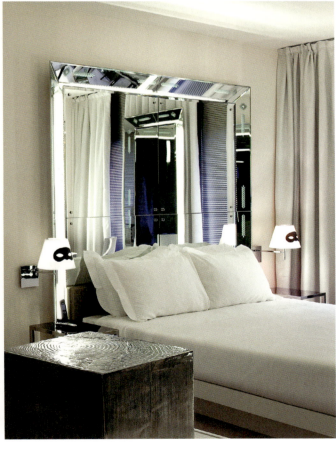

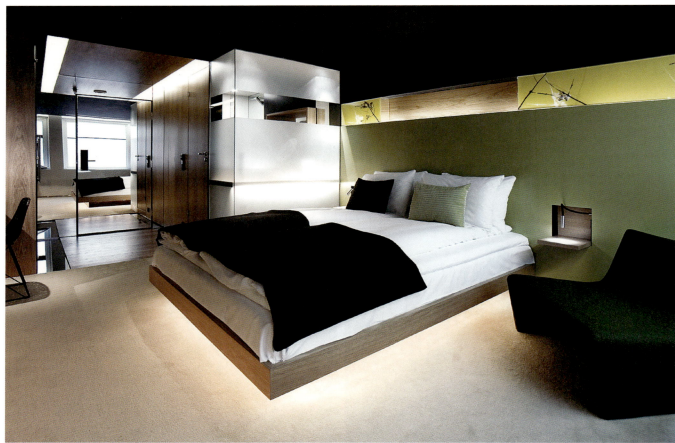

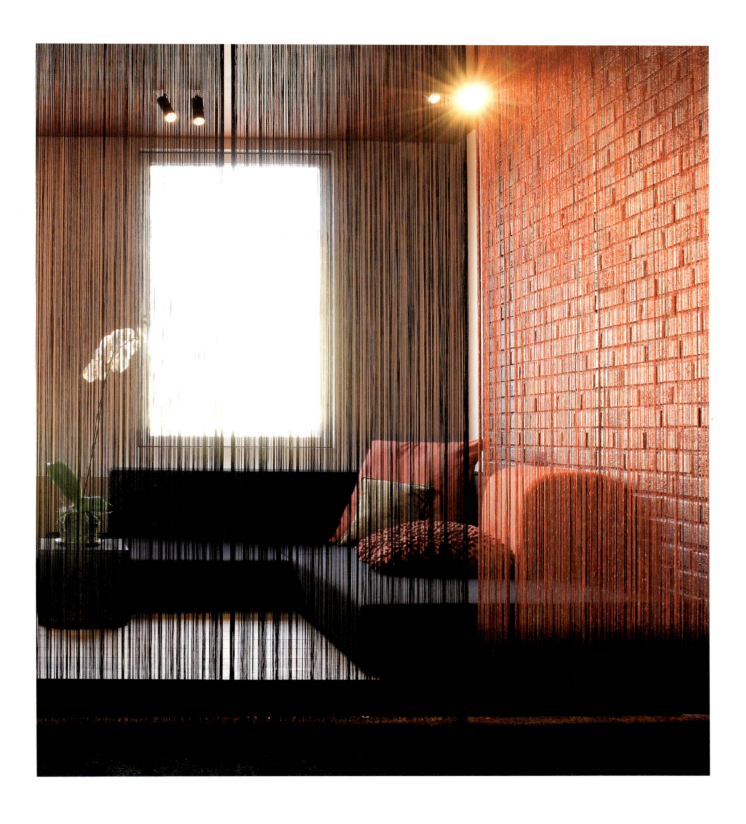

GRIMS GRENKA
Oslo

Devotees of organic chic will appreciate the traditionally Norwegian touches artfully woven into the luxurious and sensual atmosphere of Oslo's Grims Grenka hotel. Here, tactile stone, wood, and leather are paired with folk art, lamps made from reindeer antlers, and a moss garden embedded in the reception desk. Ancient Norwegian wooden stave churches are the inspiration for the long, continuous walnut paneling running throughout the space. An ultramodern twist comes from integrated lighting, which varies according to the time of day and season, and niches where guests can retreat into privacy at the bars. This fascinating sensitivity to season extends to the 40 rooms and 10 suites, where guests can choose their own time of year: "summer rooms" fuse green and black tones with natural oak, while "winter rooms" combine shades of blue, white and gray with a darker, warmer oak. Throughout, one finds a joyful sense of organic harmony, which appeals to fashion-forward travelers seeking timeless Norwegian élan.

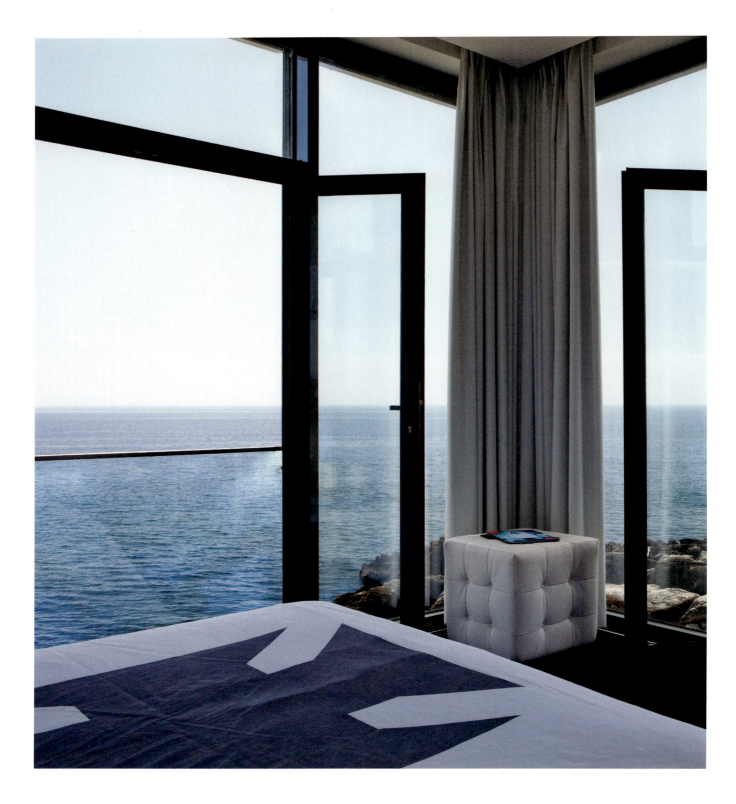

FAROL DESIGN HOTEL
Cascais

Nestled between the powdered sands of Guincho Beach and the picturesque fishing village of Cascais, this luxurious seaside retreat on the Portuguese Riviera was once the royal hideaway of the Kings and Queens of Europe in the 1950s. The Farol Design Hotel is a masterpiece of Portuguese palatial architecture, originally built in 1890 for the Count of Cabral. The 33 guestrooms are "dressed" by acclaimed Portuguese fashion designers, and sumptous accents punctuate the ever-so-cool black and white interiors, hinting at the building's regal history. The pool deck and salt water pool is a restful sanctuary: directly on top of the ocean it provides a space to relax on exquisite deck chairs that give the distinct impression of floating on water. Endless ocean views also amaze – with waves occasionally crashing onto the pool deck – the entire structure has been designed to blur the boundaries between the building and its stunning natural surroundings. The hotel's outdoor areas flow gracefully into one garden terrace area for wining and dining. Visitors can enjoy the hydro-massage bathtubs in each of the rooms, a creative house cocktail at the On the Rocks bar, or head to The Mix restaurant, which spreads over three distinct dining areas, extending towards the sandy beach. Bliss is guaranteed.

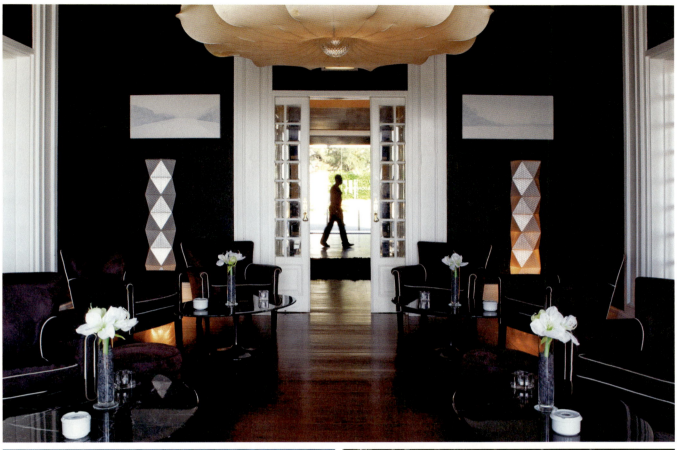
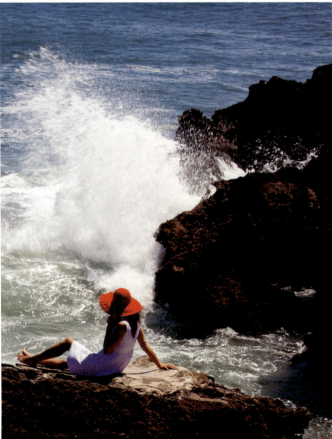
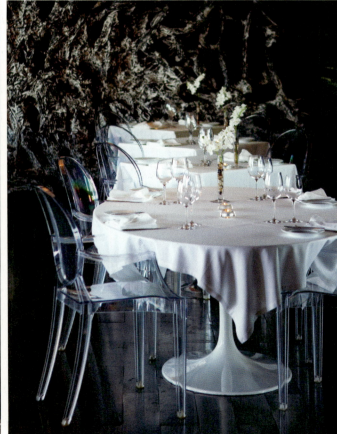

✱ SIGNATURE

WWW.DESIGNHOTELS.COM/
FONTANA_PARK_HOTEL

ADDRESS
RUA ENGENHEIRO VIEIRA DA SILVA, 2
1050-105 LISBON
PORTUGAL

ROOMS
139

RATES
EUR 95 –
EUR 565

OPEN
12/2007

PORTUGAL
LISBON

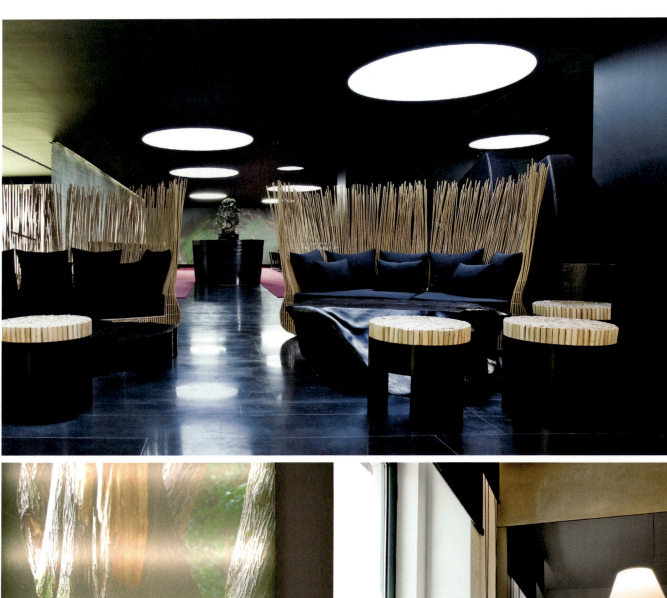

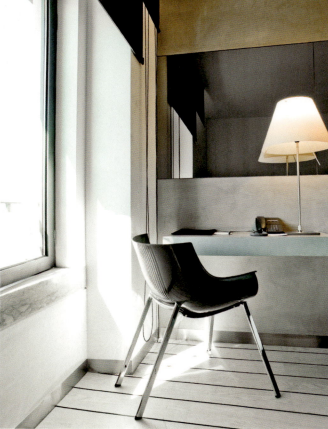

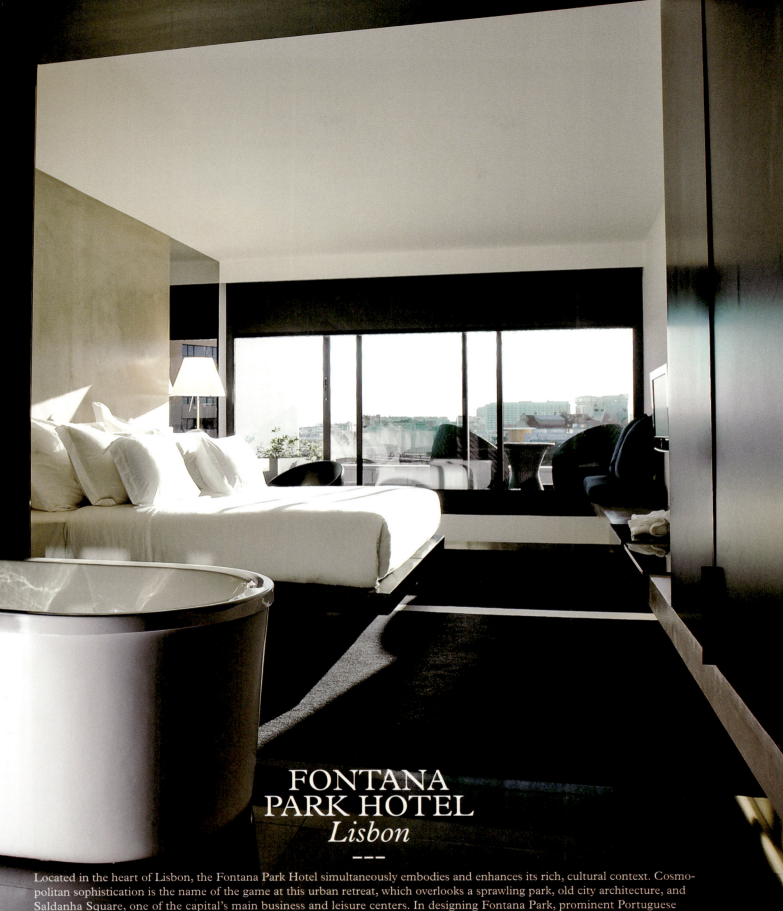

FONTANA PARK HOTEL
Lisbon

Located in the heart of Lisbon, the Fontana Park Hotel simultaneously embodies and enhances its rich, cultural context. Cosmopolitan sophistication is the name of the game at this urban retreat, which overlooks a sprawling park, old city architecture, and Saldanha Square, one of the capital's main business and leisure centers. In designing Fontana Park, prominent Portuguese architect Francisco Aires Mateus reclaimed an existing early 20th-century building, thereby incorporating historical Lisbon into his otherwise very modern design. Meanwhile, minimalist Portuguese designer Nini Andrade Silva created clean, comfortable interiors using pared-down geometry and a simple palette of black, white, and gray accented with a few, well-placed touches of green and purple. The reception area incorporates various iron elements in homage to the building's original function as a small factory for iron structures, and the 139 rooms, in keeping with the reclamation theme, feature concrete walls softened by the sleek, clean furniture that extends out from them. Windows generous in size and number ensure that visitors are in constant communication with the dynamic urban landscape surrounding them, while an interior, open-air courtyard – complete with waterfall and bamboo trees – references the green side of Lisbon, specifically, the Parque Eduardo VII a short walk away. Common areas, too, celebrate the multifaceted, multicultural city in whose midst the Fontana Park stands: the black-and-purple themed Saldanha-Mar restaurant serves modern Portuguese seafood fare, while the sun-lit Bonsai restaurant, home to a bonsai tree more than 100 years old, celebrates Asian gastronomy. The hotel also houses nine multipurpose rooms that can be used for meetings, banquets, cocktail hours, seminars, and the like.

ESTALAGEM DA PONTA DO SOL
Madeira

This stark white getaway is all simplicity and straight edges, framing the raw magnificence of its clifftop setting high above the Portuguese village of Ponta do Sol. Layering itself down a slate cliff, the hotel is cut into the rocky landscape in a series of thick stone wall terraces. Here, walkways let visitors explore the meticulously manicured grounds and drink in the endless blue of the breathtaking ocean views – which they can also enjoy from private balconies. Inside, interior designer Carvalho Araújo created a monochrome look using white walls adorned with classic black-and-white photography, black stone floors strewn with gray rugs, and minimalist furnishings in light wood. Outside, the swimming pool's infinity edge makes the vast Atlantic seem just a dive away. The restaurant is completely stripped of any superfluous decor, emphasizing the vista across the coastline of Madeira, extensive banana plantations, and the village below. It all adds up to an utterly relaxing retreat in a sophisticated atmosphere … perfect for couples looking to connect, singles looking to recharge, or anyone looking for all-round beauty.

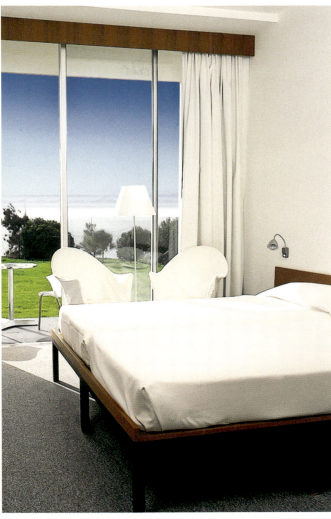
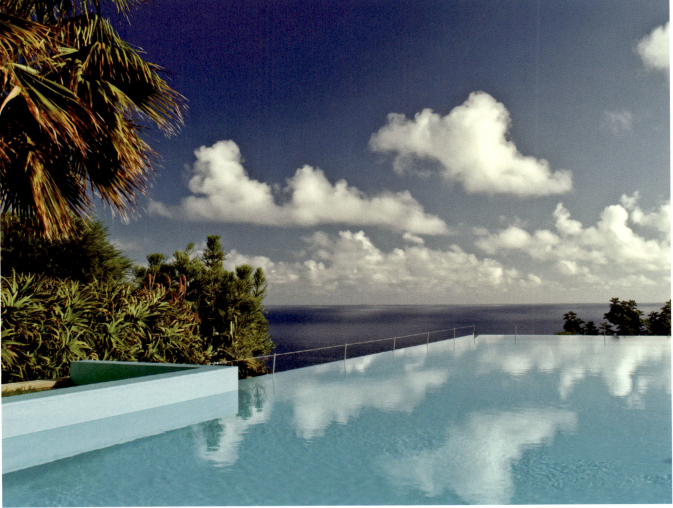

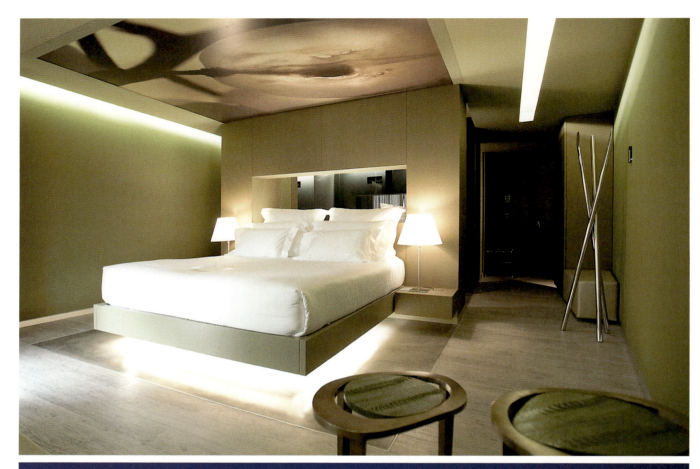
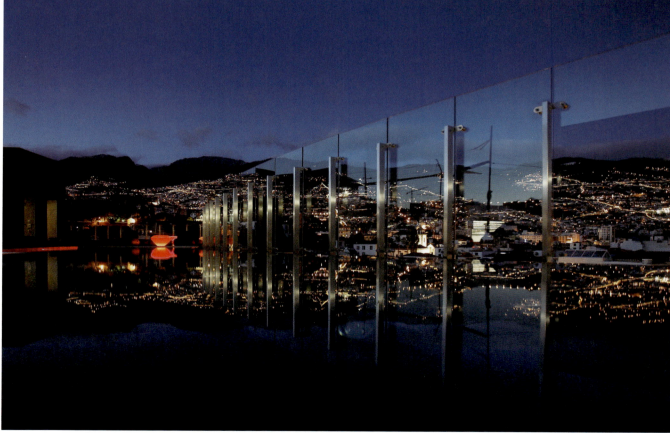

THE VINE
Madeira

A visit to the "island of eternal spring" wouldn't be complete without a luxurious stay at The Vine, located in the heart of Funchal, the picturesque capital of Madeira. Generous space and pared-down sophistication are the trademarks of the property, which takes its name and inspiration from the island's world-famous Madeira wine. Interiors reflect the vision of award-winning Portuguese designer Nini Andrade Silva, whose 79 rooms and suites offer the ideal blend of soothing neutral color palettes and breathtaking city or harbor views. In-room check-in and a welcome massage ensure that guests can immediately start rejuvenating. Vine therapy treatments at the spa will detox and revitalize the body while relaxing and refreshing the mind. Meanwhile, tantalizing culinary creations envisioned by three-star Michelin chef Antoine Westermann at the rooftop restaurant UVA (Portuguese for "grape") tickle the palate with a fusion of French cuisine complemented by the use of savory local ingredients. Social life at the hotel revolves around the lobby lounge with all-day dining, as well as 360° – the open-air bar with heated rooftop swimming pool – which offers, as its name suggests, spectacular panoramic views.

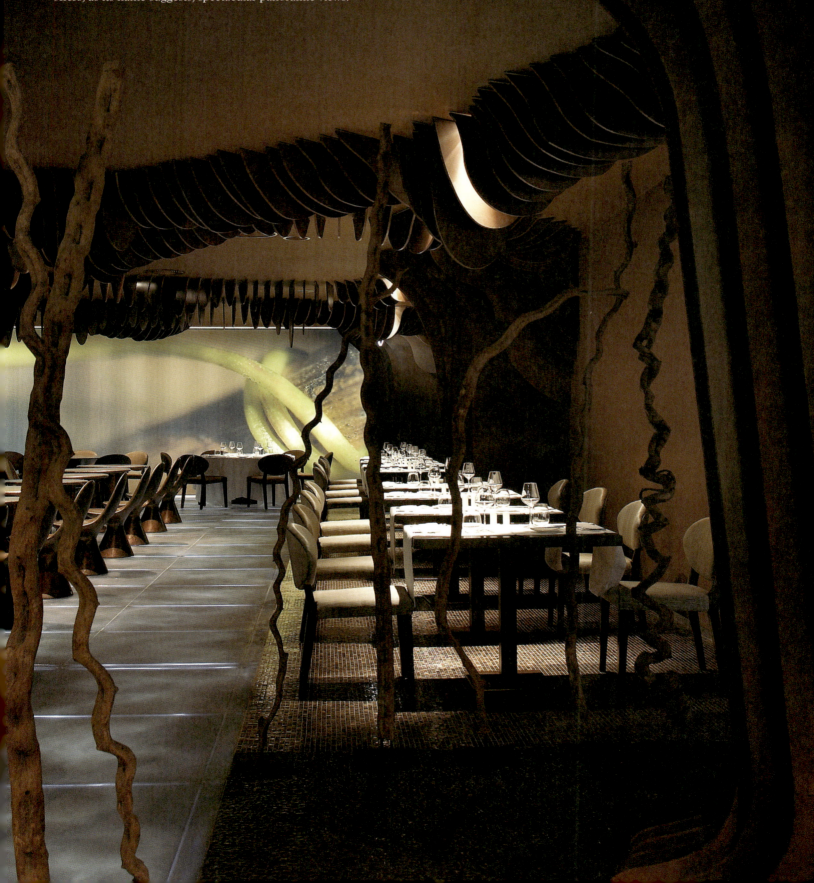

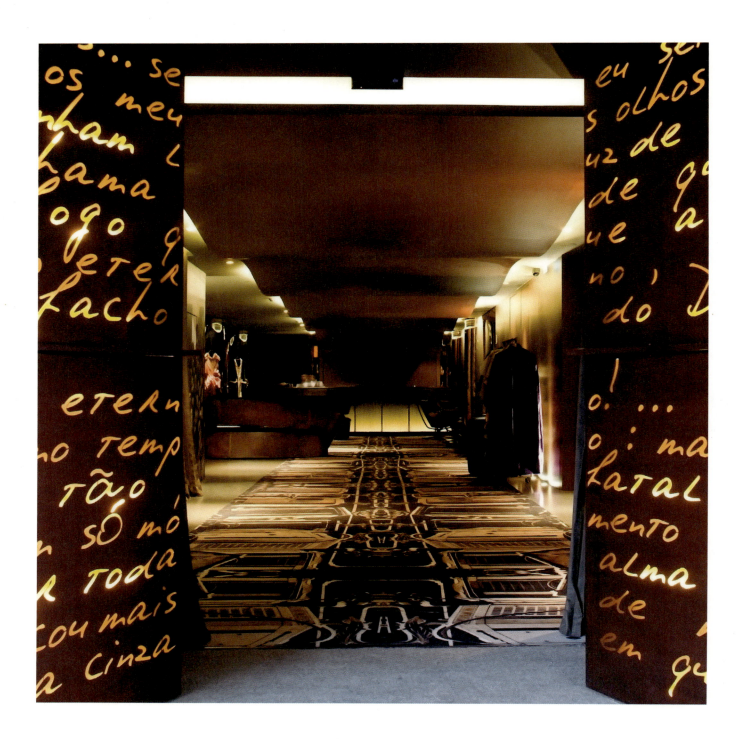

HOTEL TEATRO
Porto

In the center of the beautiful and historic Portuguese city of Porto, declared a UNESCO World Heritage Site, Hotel Teatro is an elegant innovation set in shades of bronze and gold. It has been built on the site where the revered 1859 Teatro Baquet once stood. The theater, which was destroyed by fire in 1888, had been a cultural hub for Porto, not only as a vibrant center for music and performance, but also as a meeting place for the city's people. Now, 122 years later, the internationally celebrated designer Nini Andrade Silva, the Design Hotels™ Original behind Fontana Park and The Vine, brings the spirit of the Teatro Baquet back to life in the Hotel Teatro. The hotel reflects its theatrical and spectacular roots with stylish and contemporary urbanity. Silva displays her trademark style throughout the 74 rooms: guests are gradually enticed to participate in an integrated experience that becomes an elaborate show. The illusion continues through the top-floor Restaurant Palco's exotic flavors and the Bar Plateia's stage-inspired decor. While gently guiding guests to indulge in every contemporary amenity, this unique exercise in set design and staging invites visitors to understand the historic city as it was and – thanks to its ensured preservation – as it will be. Hotel Teatro's dramatic atmosphere, its heart-of-the-action location and its historical roots offer its guests Porto's finest.

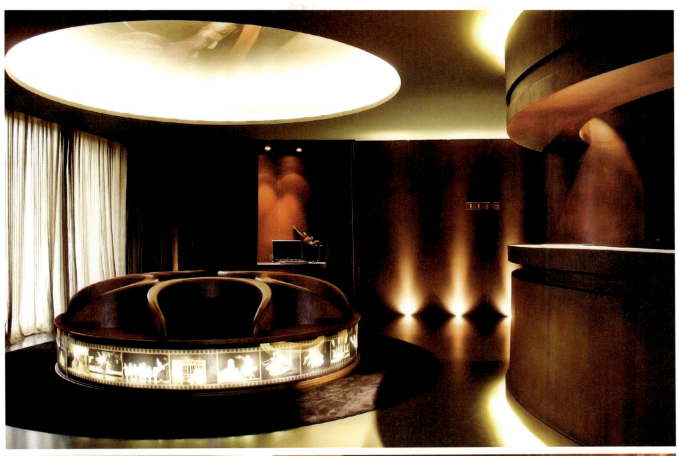
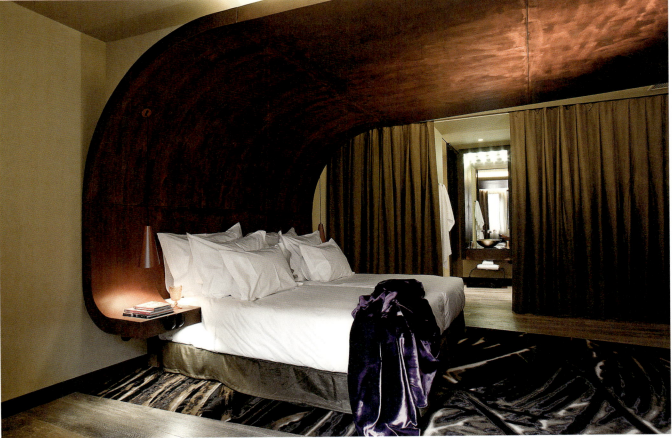

*SIGNATURE

WWW.DESIGNHOTELS.COM/
MEMMO_BALEEIRA_HOTEL

ADDRESS
SITIO DA BALEEIRA
8650-357 VILA DE SAGRES
PORTUGAL

ROOMS
144

RATES
EUR 80 –
EUR 400

OPEN
08/2007

PORTUGAL
SAGRES

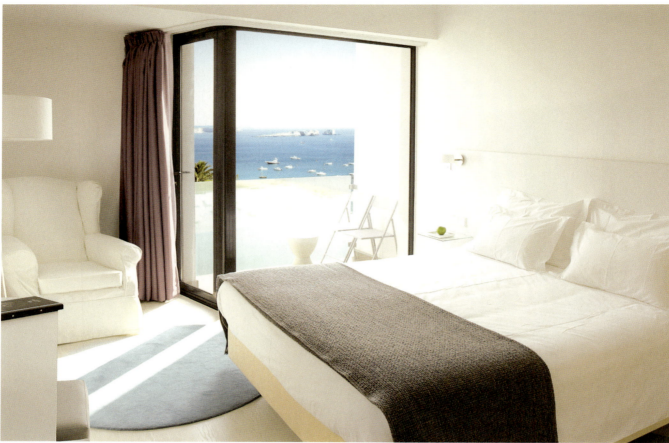

Sagres

It was on Portugal's Sagres peninsula that in the 15th century, Prince Henry the Navigator planned and organized the journeys that marked the beginning of Europe's era of world exploration. Located in Costa Vicentina Natural Park at Europe's southwestern-most point, Sagres boasts both a rich history and stunning natural beauty. Amid this wild and pure landscape lies the Memmo Baleeira. The brainchild of Portuguese hotelier and surfer Rodrigo Machaz has 144 rooms, each with views over either leafy gardens or glittering Atlantic waters. The hotel's minimal and stripped-back aesthetic adapts to the natural landscape. Rooms are furnished simply and elegantly in a monochrome palate. Decorative details are avoided and instead the blues from the ocean seep in through the panoramic windows to color the room. With a restaurant serving local produce, a bar, a café and swimming pool set against the backdrop of Martinhal Bay, guests will have everything they need. But Machaz encourages visitors to mix with the locals, taste the flavors of the region and make the most of the surrounding nature. This family-friendly hotel offers a wide range of recreational activities, from surfing lessons to jeep tours, as well as a Kid's Club, where professional supervisors organize educational and outdoor activities for children. For a respite from the action, the Memmo Spa is equipped with a sauna, Turkish bath, heated indoor pool and treatment rooms offering a range of body and facial treatments.

*RARE

SPAIN
ALICANTE

WWW.DESIGNHOTELS.COM/
HOSPES_AMERIGO

ADDRESS
C/ RAFAEL ALTAMIRA Nº 7
03002 ALICANTE
SPAIN

ROOMS
80

RATES
EUR 115 –
EUR 795

OPEN
09/2003

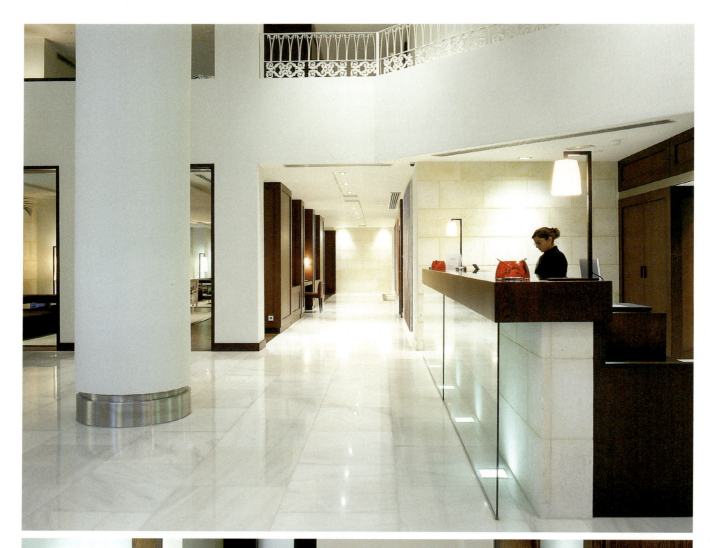

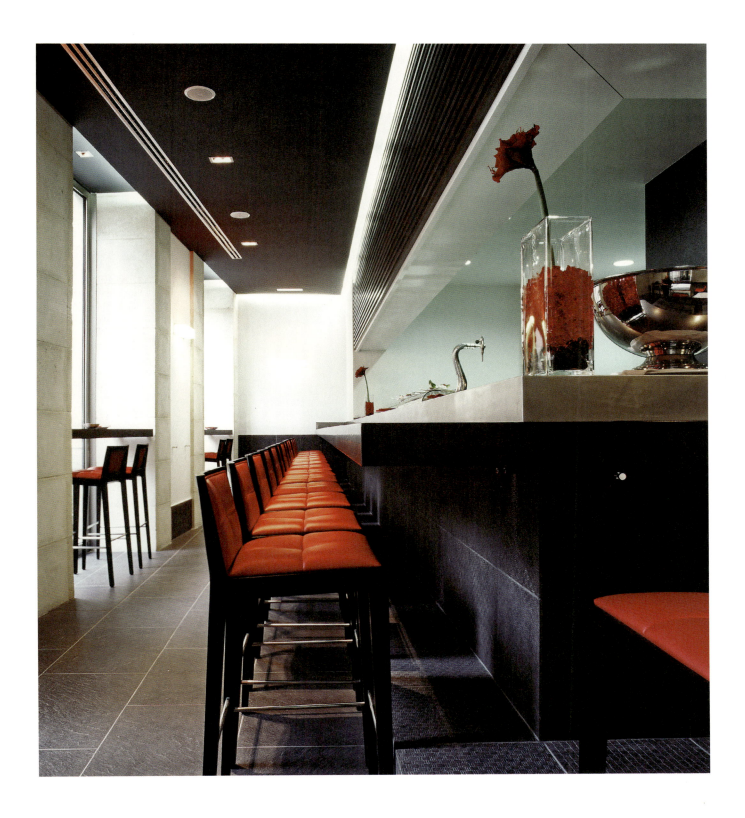

HOSPES AMÉRIGO
Alicante

In the center of Alicante, close to La Esplanada avenue and El Postiguet beach, the grand facade of Hospes Amérigo draws your attention upward to its Juliet balconies and arched neo-gothic windows. Other hints of previous lives as Dominican convent, office complex, and apartment block emerge in the salvaged stones that form parts of the walls on each floor and in the wrought-iron work surrounding the balcony above the modern, polished marble, light-filled lobby. Guests are sent back to a luscious past but also can bask in a luxe present in guestrooms decorated with a warm and cosy palette of neutral colors and simple textures that would have likely thrilled even the site's 19th-century residents. A sensual aesthetic suffuses every intimate corner and gleaming surface of this truly exceptional property. Guests inspired by the romance can retreat to the roof terrace, where striking views of Alicante's castle can be enjoyed while languishing in the heated pool, savoring a dinner under the stars, or relaxing with a natural treatment in the crystal Bodyna Spa.

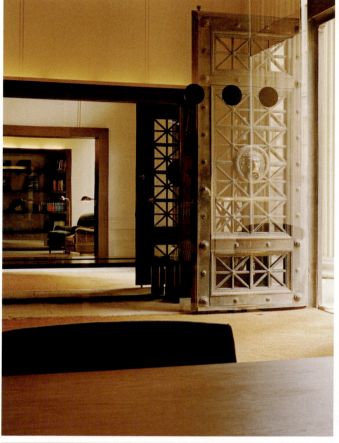
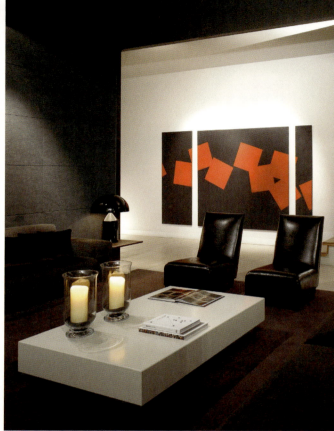

WWW.DESIGNHOTELS.COM/ GRAND_HOTEL_CENTRAL

ADDRESS
VIA LAIETANA, 30
08003 BARCELONA
SPAIN

ROOMS
147

RATES
EUR 195 –
EUR 540

OPEN
11/2005

SPAIN
BARCELONA

GRAND HOTEL CENTRAL
Barcelona

The Grand Hotel Central offers a discreet and luxurious hideaway amid the bustle of Barcelona's fashionable El Born district. Established in the 1920s by architect Adolf Florensa, the building was inspired by the newly created skyscrapers of Chicago and New York. Eighty-five years later, owner Pau Guardans has completely reworked the building to create a hotel that evokes the splendor of Barcelona's high society in the early part of the 20th century. The result is a tranquil property infused with timeless elegance and urban soul. Guardans' reputation as a trendsetter and visionary is evident in the finer details of the hotel. With his very own city guide 'Barcelona Around,' Guardans offers guests an insider view of this vibrant city. Twenties-style grandeur is everywhere you look, starting with the original bronze doors of the impressive structure's elegant entrance. This motif continues in the oversized rooms, which feature preserved wrought iron lamps, stone cornicing and flooring. The dark oak floors and clean lines of the 147 rooms and suites ooze urban modernity through smooth materials such as glass and wood. Within the bedrooms, transparent panels and semi-opaque materials are used as dividers, so that sleeping spaces, bathrooms and even the wardrobes all merge seamlessly. Enjoy dinner or a cocktail at Ávalon restaurant by Michelin-starred chef Ramón Freixa. A modern space with timber flooring, industrial lamps and huge windows, the restaurant offers a modern twist on Catalan classics. Alternatively, book a massage in the seventh-floor Wellness Suite or relax in the library. With the rooftop Sky Bar, infinity pool and panoramic views, guests will feel completely immersed in the buzz of the city without leaving the comfort of their chaise longue.

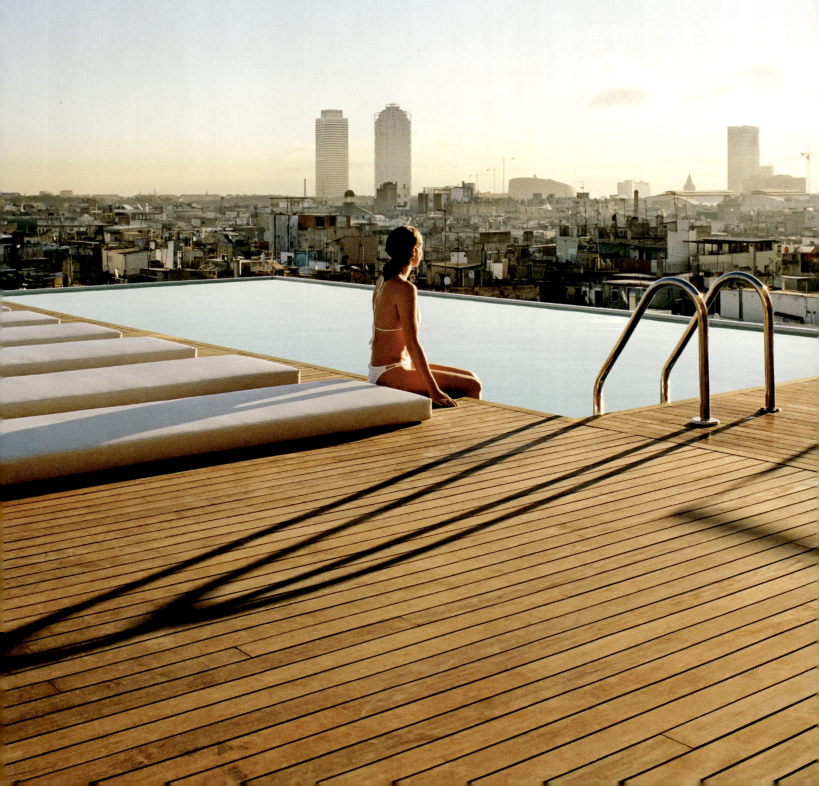

SPAIN
BARCELONA

OPEN
02/1992

RATES
EUR 235 –
EUR 1500

ROOMS
120

ADDRESS
C/ PAU CLARIS, 150
08009 BARCELONA
SPAIN

WWW.DESIGNHOTELS.COM/
HOTEL_CLARIS

✴ SIGNATURE

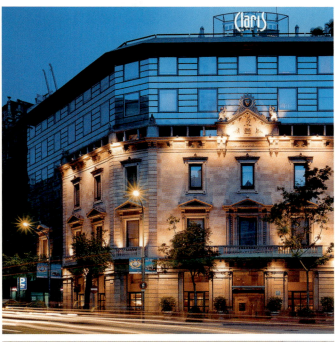

HOTEL CLARIS
Barcelona

Part of Barcelona's renaissance as a center for commerce and the arts, the Claris has been a beacon for outstanding design and luxury since 1992. Built 100 years earlier as the exterior of the neoclassical Vedruna Palace, the facade was reworked by MBM Architects and incorporated into the hotel space. The lobby's alcove lighting and copper accents segue into elegant stair rails that lead to a retro-cool rooftop pool with a view. The 120 guestrooms' modern, elegant lines soothe, while steel and copper details subtly stimulate. No two rooms are alike: from furniture construction to the choice of marble and wood, everything has been traditionally handcrafted, and combinations of old and new come into their own. More than 400 *objets d'art* are scattered throughout the building and rooms and include a group of Indian and Burmese sculptures from the 5th to the 13th centuries, more than 100 engravings commissioned by Napoleon in 1812, Turkish kilims, Roman and Carthaginian mosaics, and engravings by the Catalan artist Guinovart. It's all a feast for the eyes as well as food for the soul at one of the best addresses in this Catalan city.

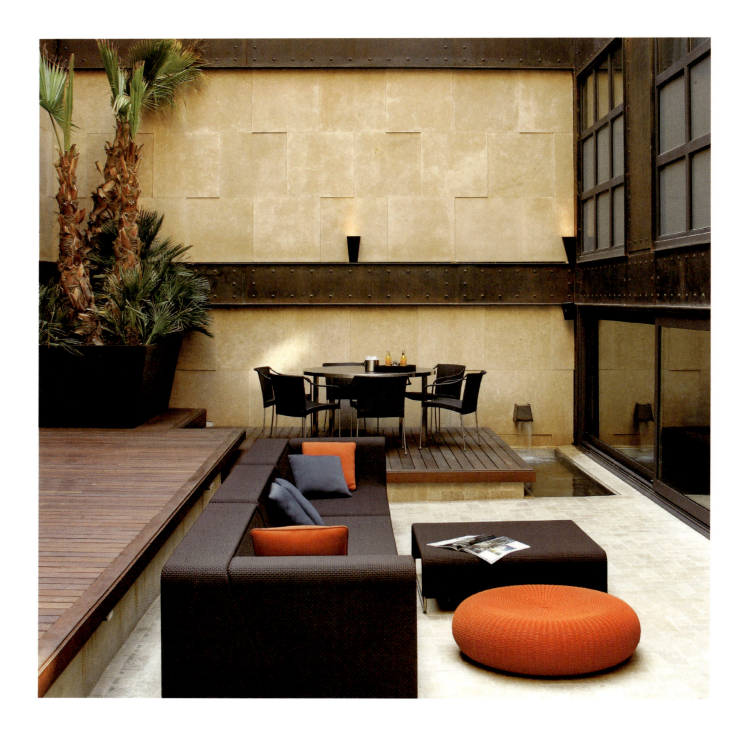

HOTEL GRANADOS 83
Barcelona

A unique experience in remixed neoclassicism, built on the site of Barcelona's venerable Pujol i Brull clinic, the Hotel Granados 83 brings an entirely modern concept of luxury to a notable Old City location. Constructed around a luminous central courtyard crowned by a glass ceiling, the building looks just as good in real life as it does in pictures. Original colonnades are enhanced by steel, red marble, glass, and iron, but the lobby's also dotted with antiques and art objects. The soothing atmosphere and low, social buzz give guests a sense of constant, languid movement; friendly, generous service ensures that they are absolutely comfortable not only in public spaces but also in the 77 loft-style guestrooms. Here, Asian pieces of art soften the high-tech facilities and ultramodern materials, while there's a literal Asian flavor in the "3" restaurant. With its "8 Terrace Bar" located on the rooftop, the hotel offers the perfect place for pre-dinner cocktails and snacks. Extensive use of white Thassos marble and zebrawood as well as phosphorescent iron pieces adds chic throughout; raw leather inserts on headboards and chairs lend a wonderful warmth. It's a textural mix that's as inspiring and soothing as everything else in this smart urban getaway.

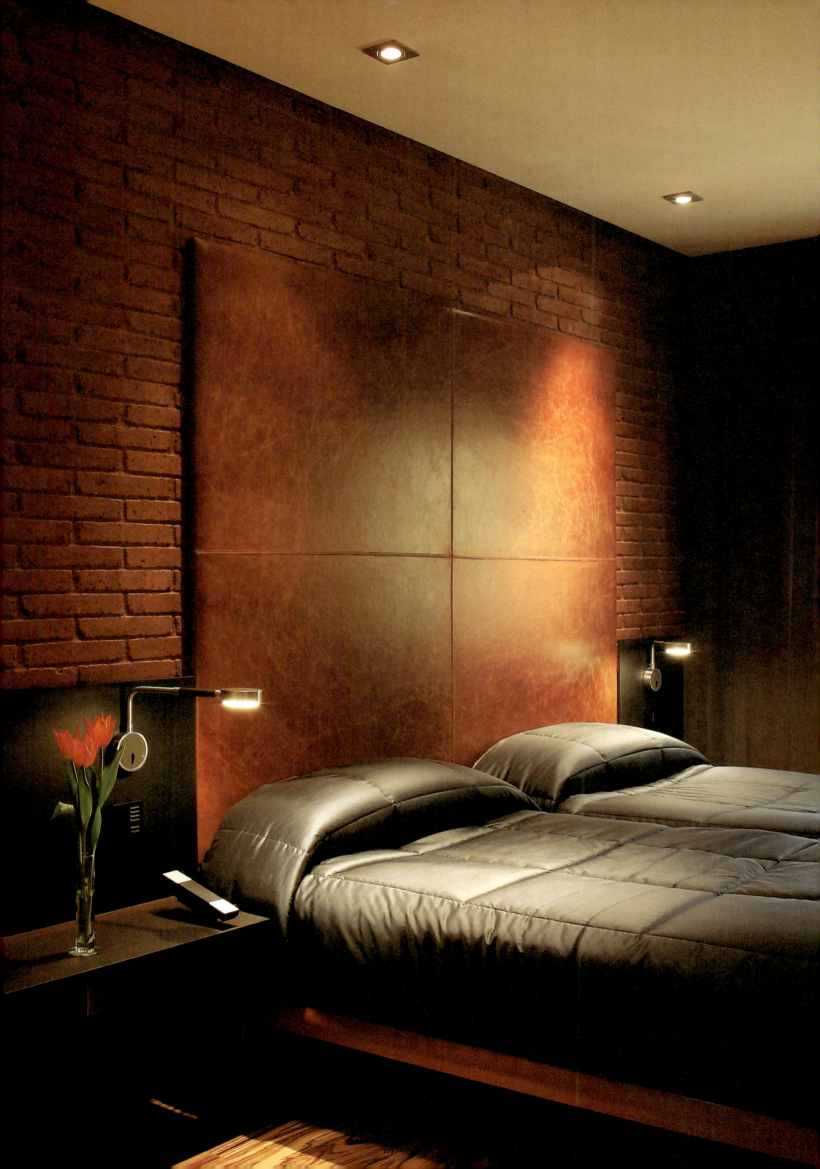

HOTEL OMM
Barcelona

In Barcelona's elegant Passeig de Gràcia district, Hotel Omm at first looks like the ultimate meeting place for international movers and shakers. But behind the captivating appearance is also a kind of smooth, effortless usability. Sections of the unusual limestone facade teasingly peel back like pages of a book, about to reveal the rooms inside. Yet what seems like decorative fantasy is actually functional: the angled windows shield guests from outside views and street noise, but allow direct sunlight to flood in. The spacious lobby cleverly flows into a sleek bar, and then into the restaurant Moo, with furnishings kept at a low, uniform height to allow guests to glide through just as freely; a full-service spa in an adjacent wing echoes the hotel's jet-set elegance. Interior designers Sandra Tarruella and Isabel López based their concept on simple lines, a balance of colors and volumes, and the use of natural materials, but chic surprises abound. Yes, the black rubber-lined corridors absorb sound, but with two tubes of light spanning their length, they also create a fantastically futuristic atmosphere. Guests pass through, enter their wide-open light-filled rooms, and immediately feel the perfect marriage of form and function.

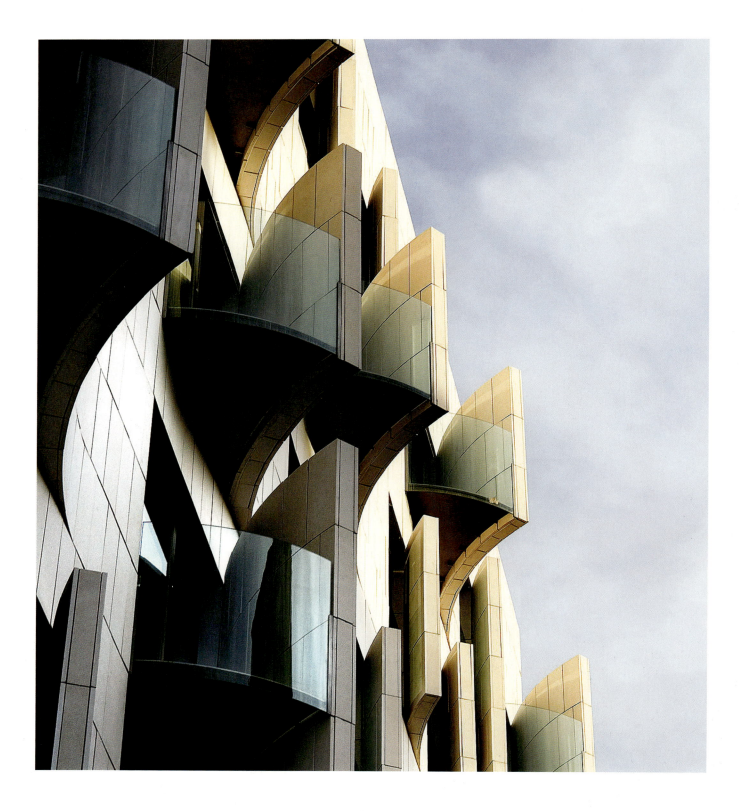

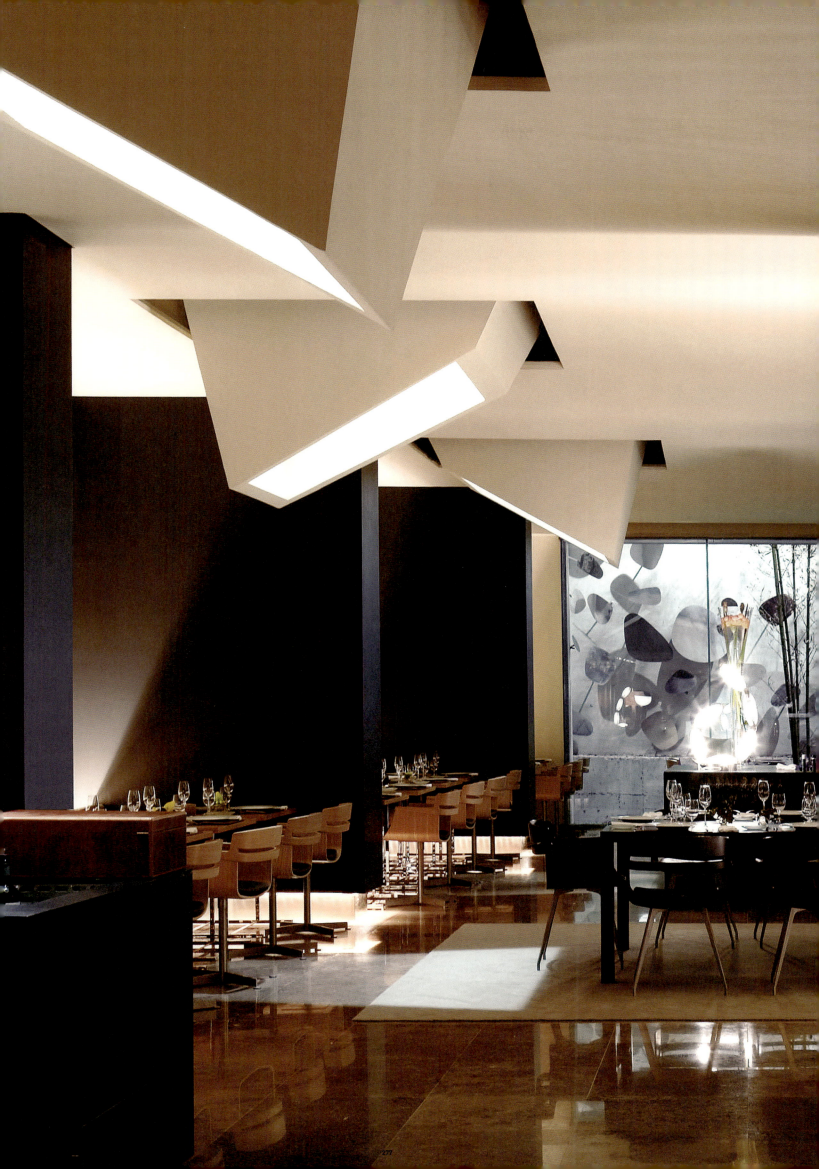

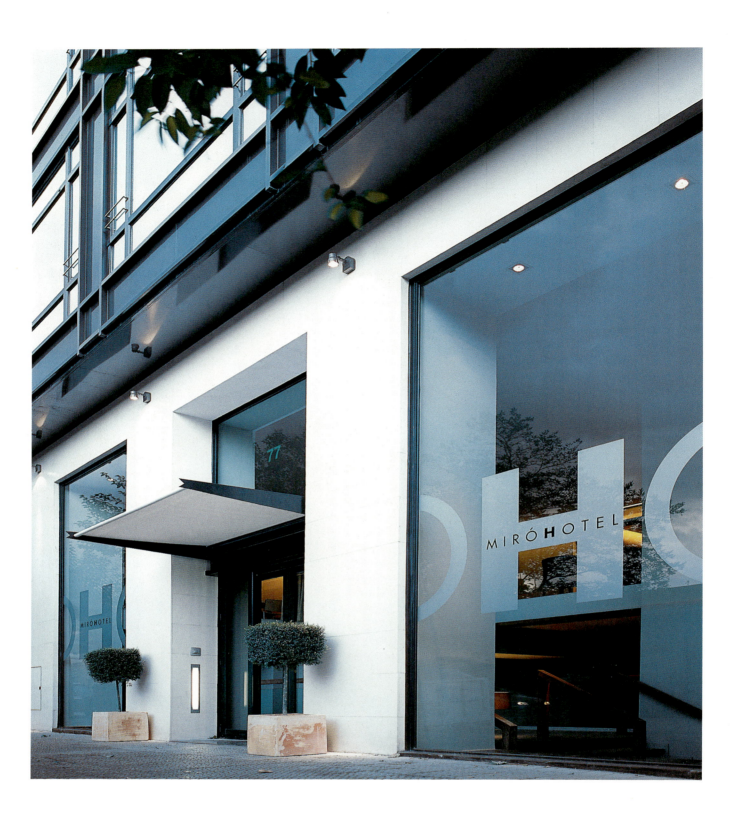

HOTEL MIRÓ
Bilbao

Antonio Miró, Spain's answer to Donna Karan and Calvin Klein, has transferred his elegantly understated mens- and womenswear aesthetic to an interior in which international sophisticates can meet and be mellow. In an area known for its artistic attractions, Carmen Abad Ibáñez de Matauco's dignified architectural design holds court with the nearby spectacles of Bilbao's Guggenheim Museum and the Museum of Fine Arts. In addition to making its own strong style statement, the light-soaked, ten-story green structure doubles as an inviting showcase space for Hotel Miró's striking in-house contemporary art collection. At Bar Miró, guests can have a drink at the Courtesy Bar while admiring work by artists such as famed Spanish photographers Concha Prada and Marc Viaplana. It's a plethora of visual stimulation, but the 50-room hotel's real rewards are cleanly designed rooms where the sleek decor is done largely in the palest beige, and flowing draperies, not walls, separate living from work areas. From their wall-sized windows, guests can view the city's enticements, or simply retreat into their private cocoons by drawing the curtain.

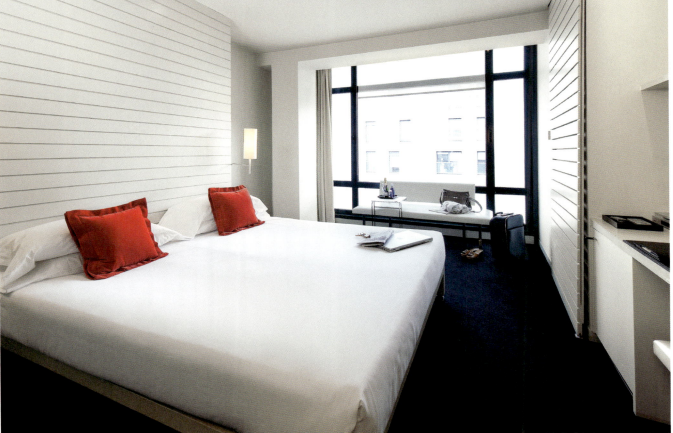

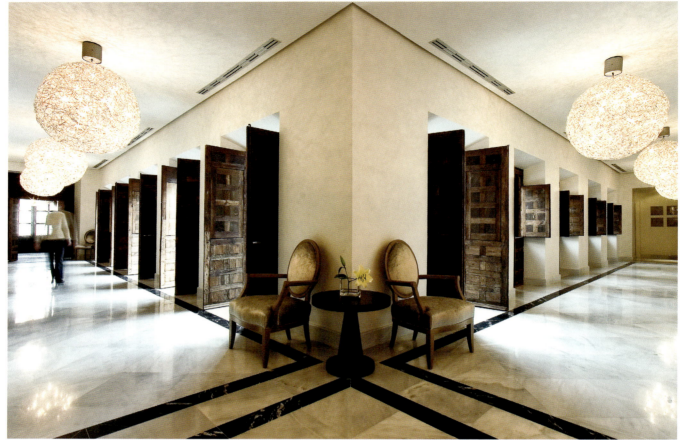
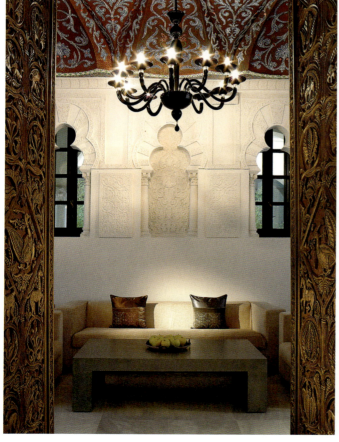
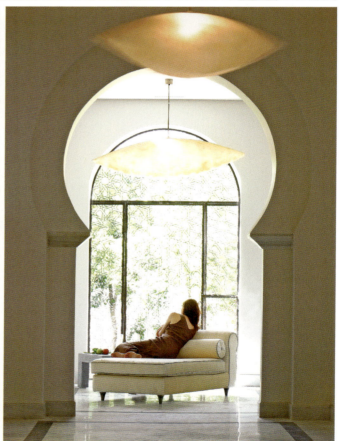

SPAIN CORDOBA

OPEN 10/2006

RATES EUR 245 – EUR 1600

ROOMS 53

ADDRESS RAMIREZ DE LAS CASAS DEZA, 10-12 14001 CORDOBA SPAIN

WWW.DESIGNHOTELS.COM/ HOSPES_PALACIO_DEL_BAILIO

RARE

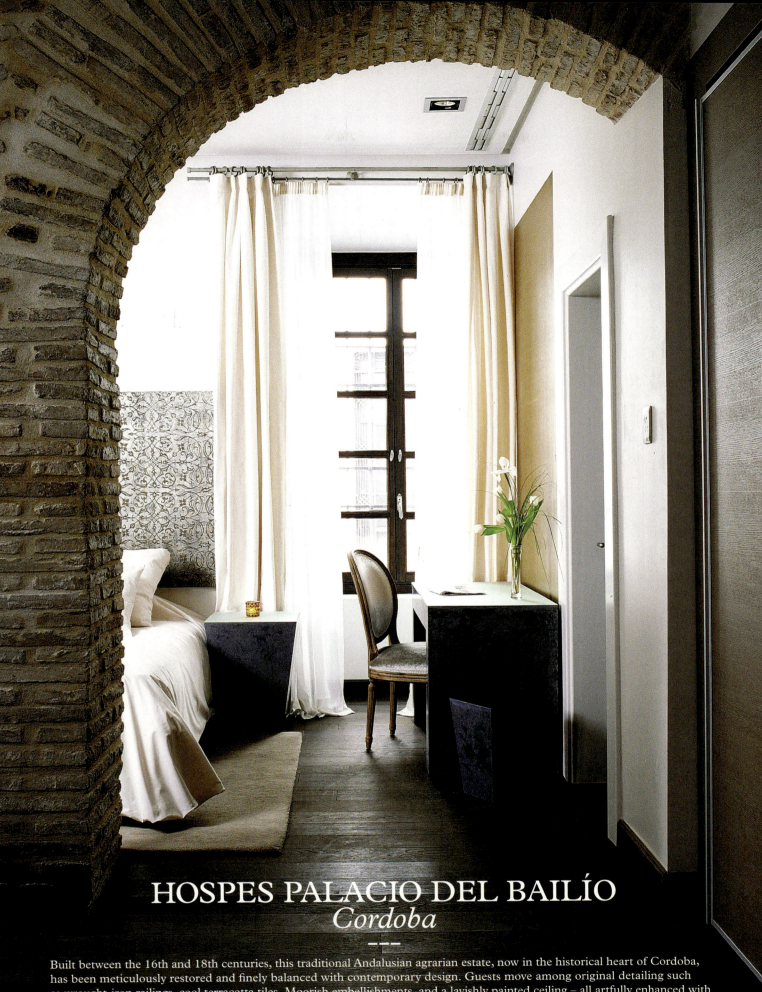

HOSPES PALACIO DEL BAILÍO
Cordoba

Built between the 16th and 18th centuries, this traditional Andalusian agrarian estate, now in the historical heart of Cordoba, has been meticulously restored and finely balanced with contemporary design. Guests move among original detailing such as wrought-iron railings, cool terracotta tiles, Moorish embellishments, and a lavishly painted ceiling – all artfully enhanced with understated modern touches. Rich fabrics and textures in champagne and copper are offset by dark walnut and light polished marble floors throughout. Solid slabs of black local stone lure guests to the lush, flowery gardens outside, the perfect place to linger over a drink, a book, or a loved one. The estate is composed of several buildings – the palace itself, designated a "place of cultural interest," along with its coach houses, stables, and granaries – arranged around a mosaic of five patios. In the spectacular main patio, traditional paving has been replaced with a dramatic glass floor to reveal Roman ruins 4.5 meters below. The restored frescoes further reflect a care for cultural detail, while a sense of serene luxury invites guests to be revitalized by history, just as history itself has been so subtly revitalized.

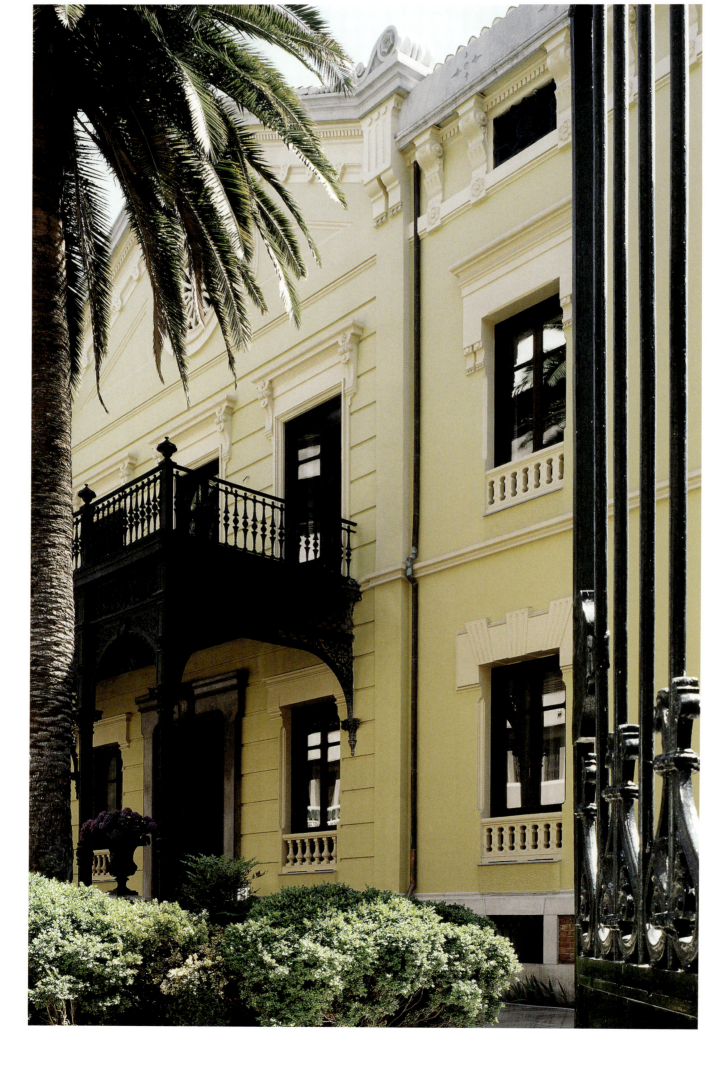

*RARE

SPAIN
GRANADA

OPEN
05/2005

RATES
EUR 310 –
EUR 1500

ROOMS
42

ADDRESS
C/ RECOGIDAS N° 11,
ESQUINA CON C/ SOLARILLO DE GRACIA
18002 GRANADA
SPAIN

WWW.DESIGNHOTELS.COM/
PALACIO_DE_LOS_PATOS

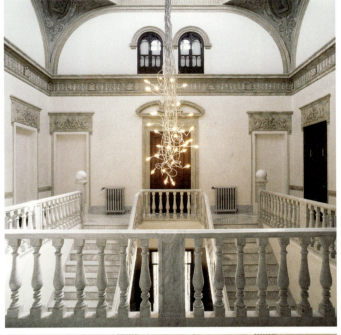
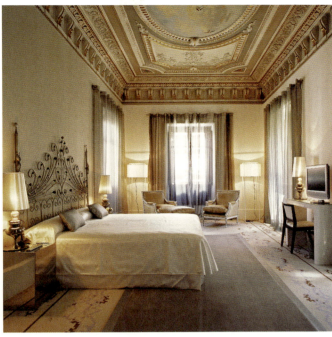
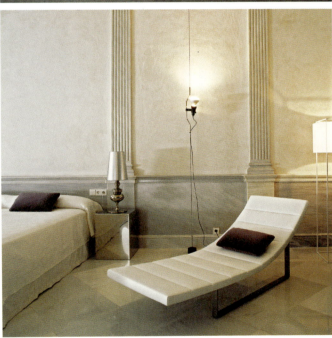
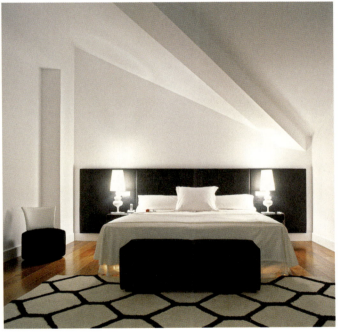

HOSPES
PALACIO DE LOS PATOS
Granada

Converted from a late 19th-century palace in Granada's historic center, the Hospes Palacio de los Patos is an urban oasis combining dramatic classical design with equally stunning modern architecture. The Hospes Design Team has retained the splendor of such original elements as the grand staircase, while 42 well-appointed guestrooms and suites ensure that guests feel at home within an environment of vivid, sultry contrasts fusing the city's Moorish influence with a Spanish-Iberian flavor. Guests can settle into modernist comfort in two buildings – a classical part in the palace's heart and a new construction housing 12 rooms, plus restaurant and spa. The subterranean area connecting the two structures is ingeniously covered with water tanks, allowing natural light to shimmer through. A lush Moorish garden showcases the sensuality of history, while guests can sample contemporary Andalusian flavors in the Senzone restaurant before they head back into the rooms. From the cuisine to the landscaping, authenticity and originality were the guiding principles for creating a sensory experience that brings the rich cultural history of Granada into the future.

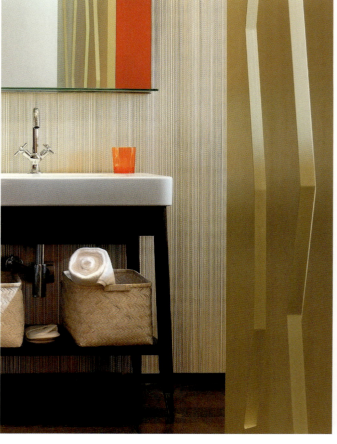
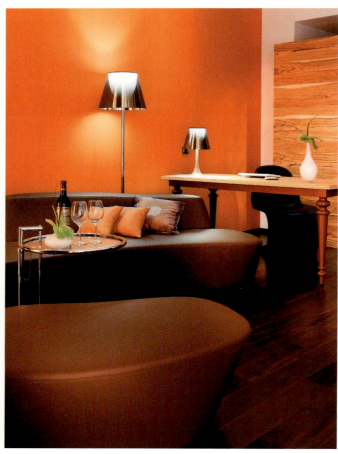

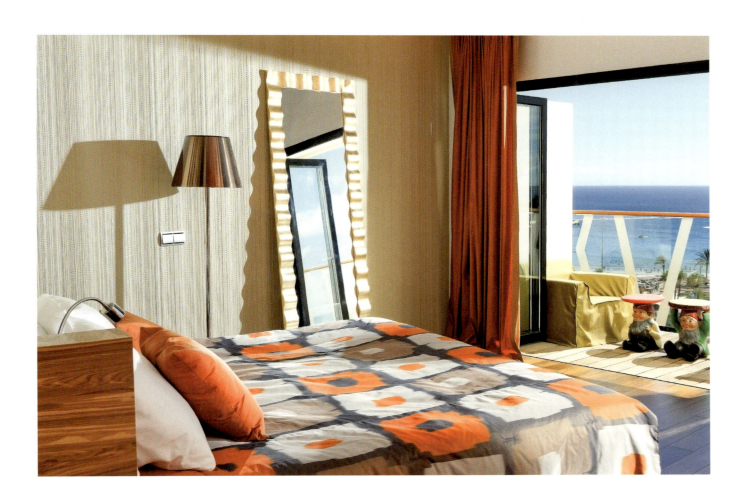

BOHEMIA SUITES & SPA
Gran Canaria

On a tranquil stretch of sand away from the throngs of tourists sits Hotel Bohemia Suites & Spa, a sophisticated lifestyle oasis for adults that's surrounded by the volcanic beauty of Gran Canaria. Combining luxury with multifunctional surroundings, it's a secluded place for guests to be pampered in total peace and privacy. By transforming what was once a run-down building into a modern, ocean-front hotel, German owner Rembert Euling has created a place where friends can meet, share ideas, and belong. At Hotel Bohemia's rooftop restaurant, a spacious indoor-outdoor space, guests mingle while soaking up panoramic views of the Atlantic Ocean and the softly undulating dunes of Maspalomas. In the sultry Siam Thai Spa, Mandala-inspired treatment marquees and rooms provide a tranquil setting for original Thai massages. Meanwhile, fragrant aromatherapy baths of jasmine, mint, and lemon let guests revel in complete secluded luxury. Outside, waves and warm breezes provide the perfect conditions for kite surfing and other watersports. Bohemia's 67 rooms and suites are fully integrated living spaces, where balconies and bedrooms merge seamlessly into one. Rich mahogany floors, native olive-wood furnishings, and shades of yellow, purple, and terra-cotta harmonize with the natural environment, rooting guests firmly in the heart of this sun-scorched volcanic island.

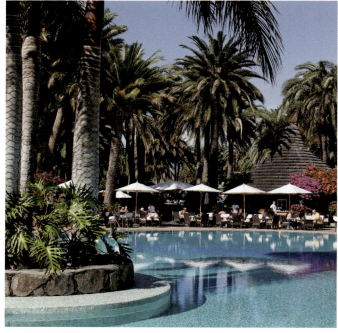
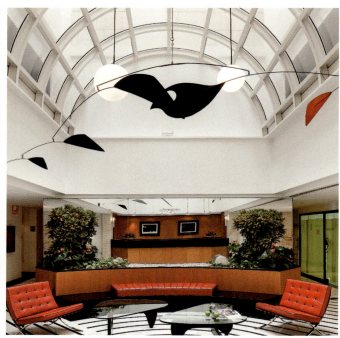
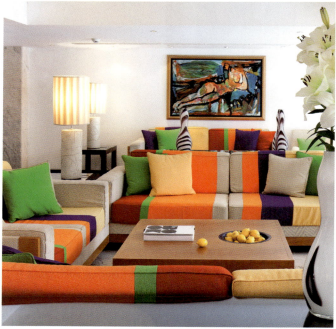
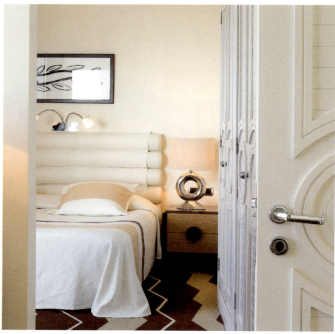

SEASIDE PALM BEACH
Gran Canaria

Alberto Pinto's redesign of the classic 1970s Seaside Palm Beach is much more than the usual superimposition of a new identity on an old structure. Pinto clarified original design elements, creating an award-winning late-modernist statement that appeals to savvy world travelers and design aficionados alike. Located in an ancient palm grove, the Miami Beach-inspired facade curves into a flowing sense of interior and exterior space. Turquoise mosaic pools and public spaces in a muted palette enhance the primal experience of sun and shade. Bold Pucci-style patterns are reinterpreted in an array of textures, and materials such as chrome, mirrored glass, travertine, and marble add a touch of old-school elegance throughout. The 328 rooms offer guests a deliciously decadent slice of seaside glamour. Walls are bathed in warm tones, floors come alive in cool colors. The overall effect is less retro than contemporary, something that shows just how forward-looking the original design was. Guests can dive into fully indulgent modernity in an extensive, state-of-the-art wellness and spa area, where Thalasso treatments are just one of the many options.

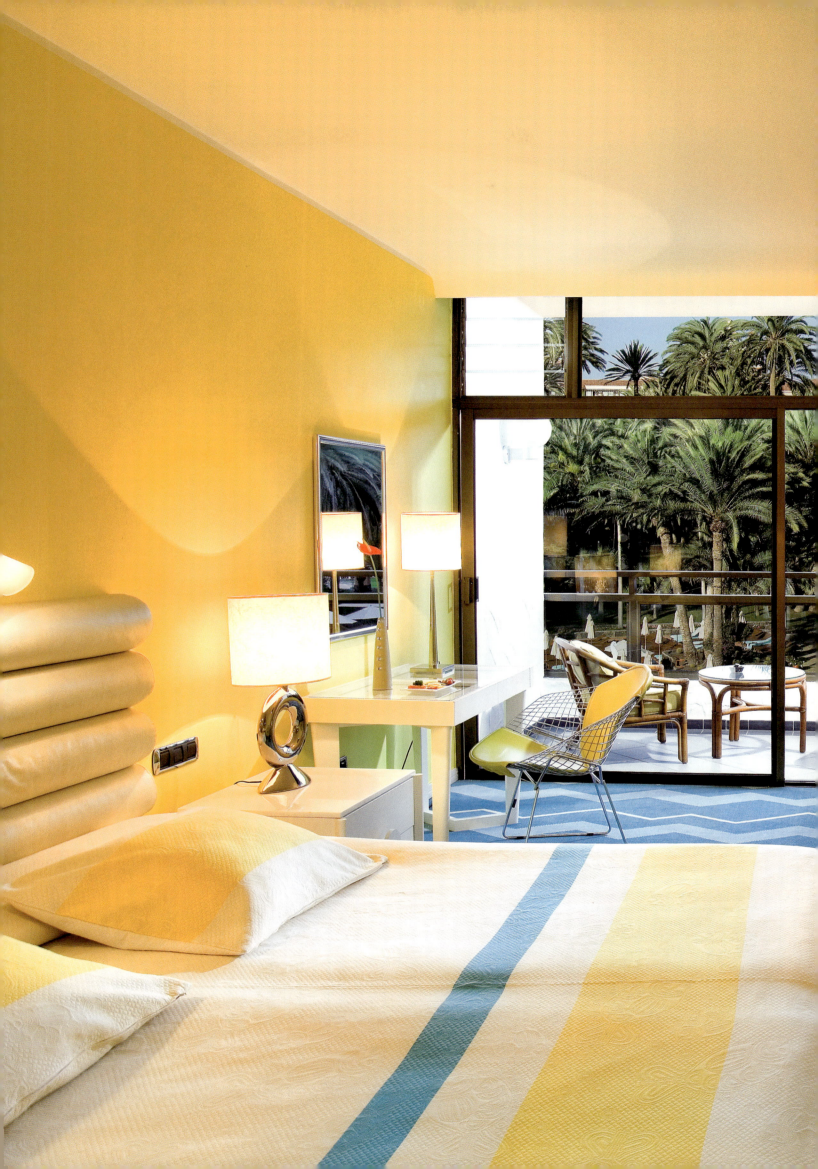

*SIGNATURE

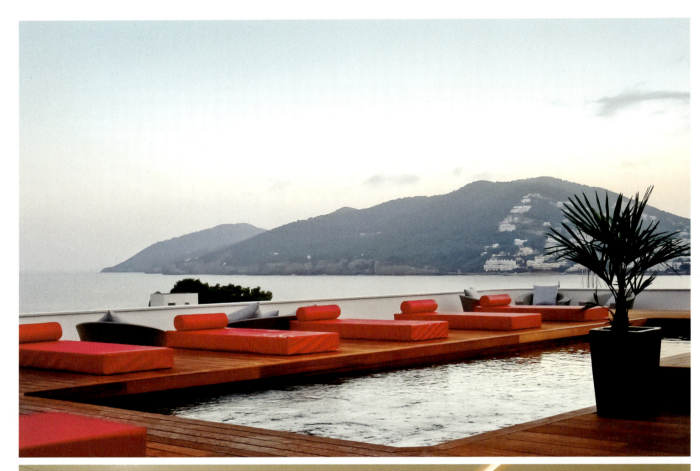

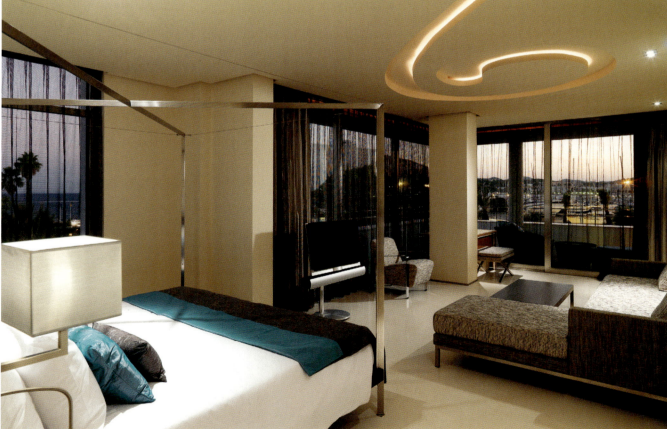

WWW.DESIGNHOTELS.COM/ AGUAS_DE_IBIZA

ADDRESS
C/ SALVADOR CAMACHO S/N
07840 SANTA EULALIA DEL RIO
SPAIN

ROOMS
112

RATES
EUR 170 –
EUR 2500

OPEN
08/2008

SPAIN
IBIZA

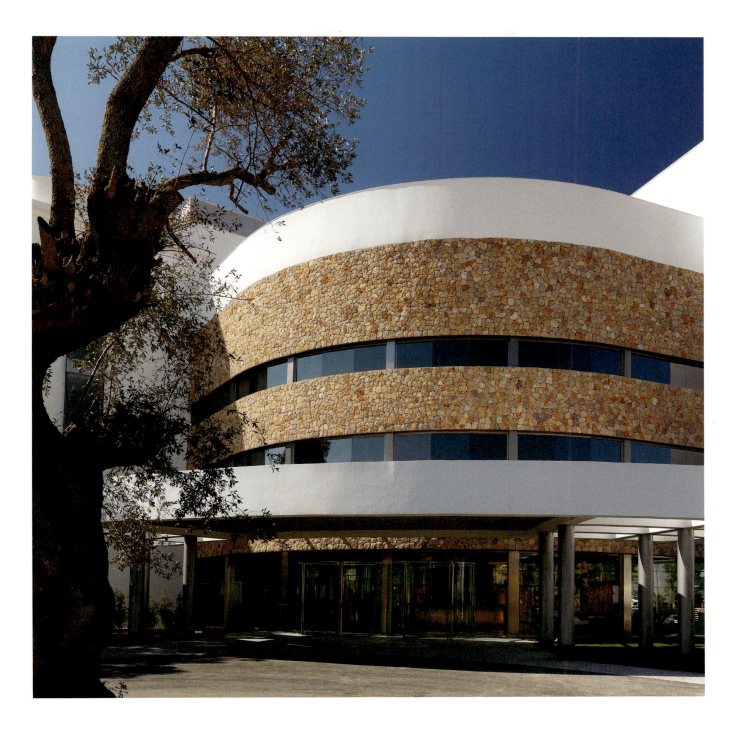

AGUAS DE IBIZA LIFESTYLE & SPA
Ibiza

With its emphasis on relaxation and revitalization, the Aguas de Ibiza offers a laid-back alternative to the typical dancing and DJ-driven Ibiza getaway. Anchored in Santa Eulalia Bay marina, with interiors by Barcelona-based Triade Studio, the Aguas blends the charming character of a family-run guest house with the high-end services of a contemporary hotel. With 35 percent lower energy consumption than similar properties guests can relax knowing their holiday is low impact and high pleasure in one of Europe's first "eco-luxury hotels." The 112 rooms and suites have private terraces and floor-to-ceiling windows, with furnishings reflecting the seaside location in sandy neutral hues, accented by turquoise blues. The VIP Cloud 9 Club is a hotel-in-a-hotel, with separate check-in and services, private outdoor bathtubs and parquet flooring. The soothing Mediterranean Sea inspires the calming evironment of the Revival Wellness Club, which offers water-themed treatments and Ibiza salts to refresh weary wanderers. Dining options range from sophisticated tapas at the cheerful Alabastro Lounge to traditional Ibizan fare at gourmet restaurant La Sal. As the day ends, the rooftop Air Ibiza bar and lounge with open-air pool offers a prime perch for taking in the Balearic sunset as it sinks below the horizon.

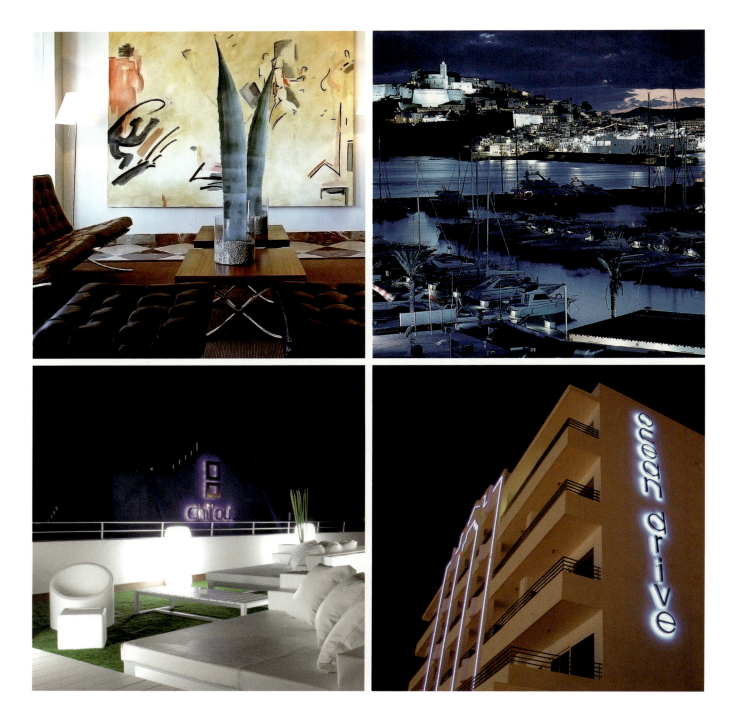

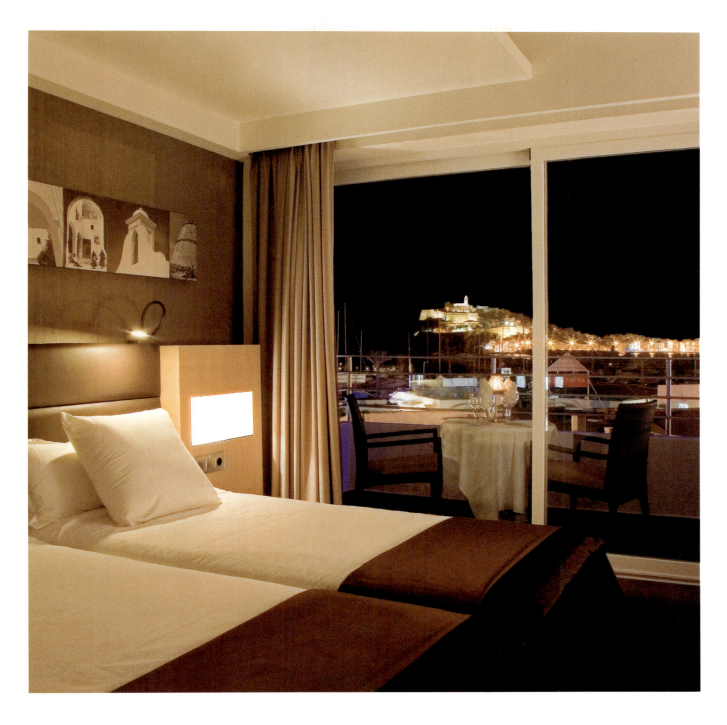

OCEAN DRIVE HOTEL
Ibiza

Perfectly situated in Ibiza's yacht harbor Marina Botafoch, Ocean Drive Hotel combines retro glamour with its instantly recognizable art-deco design. It was inspired by the architecture of Miami's South Beach, as well as New York's roaring 20s. Ocean Drive Hotel is located in close proximity to Ibiza's beautiful beaches, the famous Pacha nightclub, and the island's "Old Town," a UNESCO World Heritage site. In defiance of local custom, Ocean Drive owner Marc Rahola has officially opened the hotel all year round, offering guests a rejuvenating island retreat beyond Ibiza's legendary summer nightlife. Still, the hotel remains best known for its insider access to this island's thriving club scene and often plays host to high-profile DJs, who lure guests and locals alike to Ocean Drive's scenic chill-out lounge terrace. Unlike other hotels on the island, breakfast is served until 4 p.m., perfect for those lazy mornings after a late night of drinks and dancing. The hotel's art-deco aesthetic is reflected in its Mies van der Rohe and Le Corbusier furniture. All of the 40 elegant guestrooms were entirely renovated in 2009/10, and are outfitted in mellow tones of lavender and chocolate, with views of either the sparkling Mediterranean Sea or Ibiza's mountain vistas. Serving health-conscious crossover cuisine with Asian, Latin American, and European influences, the restaurant is decorated with classic furnishings in muted hues and soft lighting. The roof terrace of the hotel offers a unique chill-out area and bar overlooking the old town and the Mediterranean Sea.

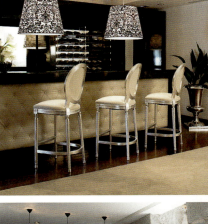

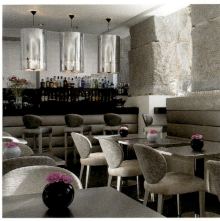
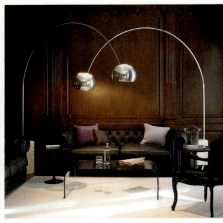
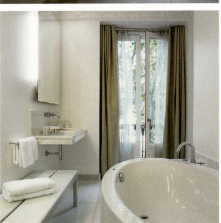
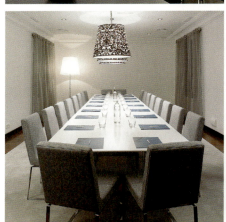
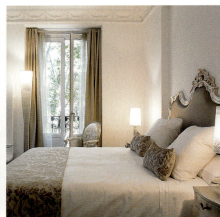
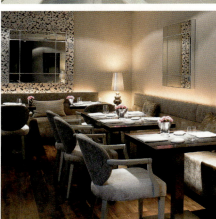

HOSPES MADRID
Madrid

Originally an affluent apartment house with wrought-iron balconies, designed in 1883 by architect José María de Aguilar, the handsome red-brick Hospes Madrid is an icon of Bourbon Restoration period architecture. Therefore the Hospes Design Team needed to take special care that their modern additions were in harmony with the building's historic elements. Guests eager to experience the landmark in its original glory will be relieved that despite a dominant minimalist style, the original moldings, columns, wrought iron, and woodwork remain intact. The lobby's high ceiling and magnificently restored wooden door offer a grand welcome through the former carriage entrance. This gracious sense of hospitality extends throughout the hotel, where a tranquil, opulent ambience is created through white marble and gold details offset by dark fine wood. The Bodyna Spa is ensconced in the former stables; the Senzone restaurant offers a formal dining room with an oak-coffered ceiling and stucco work – in contrast to the luminous interior patio, where guests can relax on comfortable sofas and listen to whispering water as they enjoy a drink at the hotel bar. Hospes Madrid's imaginative array of modern additions accentuates an overall sense of permanent privilege and eternal elegance.

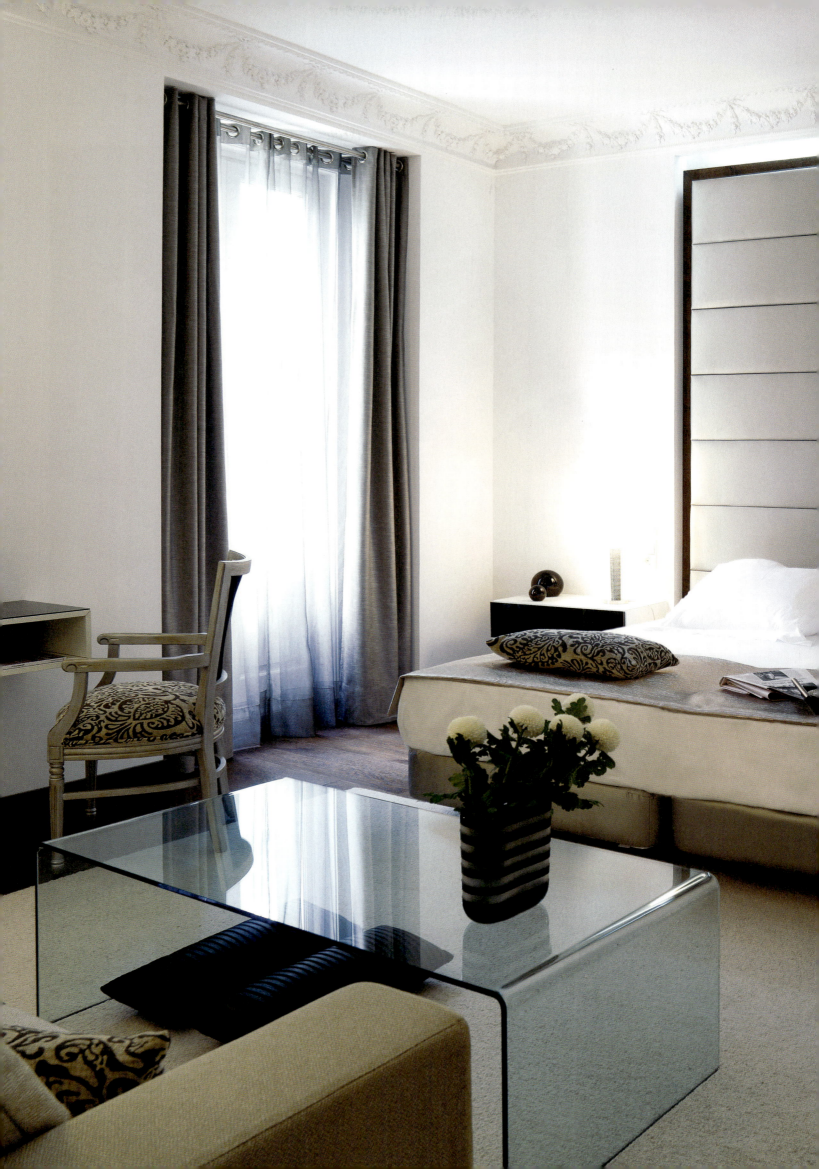

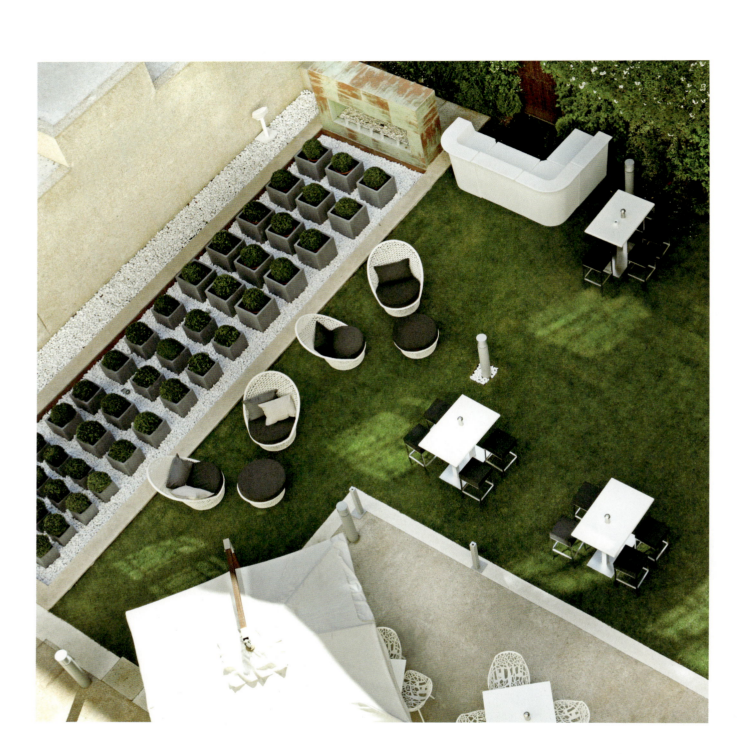

*RARE

WWW.DESIGNHOTELS.COM/
UNICO

ADDRESS
CALLE CLAUDIO COELLO 67
28001 MADRID
SPAIN

ROOMS
44

RATES
EUR 250 –
EUR 1200

OPEN
04/2011

SPAIN
MADRID

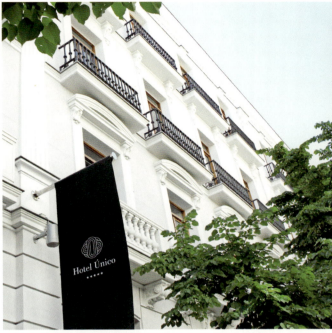
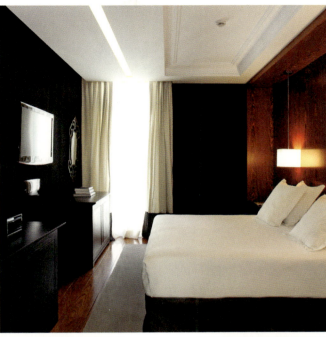

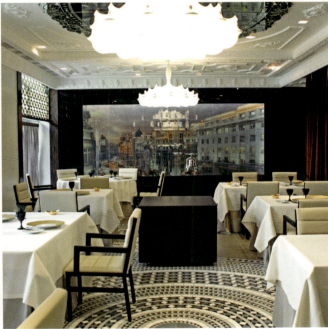

HOTEL ÚNICO MADRID
Madrid

Leaving behind the bustle of Madrid's Golden Mile and entering the tranquil 19th century palace which houses Hotel Único, you're immediately filled with a sense of peace. Behind the elegant white façade of the hotel, a majestic staircase, marble mosaic floors, high ceilings and huge windows perfectly preserve the ambiance of the former private noble home. Ideally positioned in Madrid's centre, boutique shops, museums, lush parks and endless options for eating and drinking surround this indulgent city retreat. The beating heart of Hotel Único is the tranquil garden, where guests come to relax and enjoy a drink after a busy day of shopping, sightseeing or meetings. Alternatively, there's the option to enjoy a massage in the hotel's dedicated therapy room, browse the magazines and guidebooks in the well-stocked library or sample marshmallows and chocolates (made by the hotel's own two-Michelin-starred chef) while watching a film. Restaurant Ramón Freixa Madrid has quickly become a "must" among Madrid's food buffs, having gained two Michelin stars and a reputation for fresh, creative Mediterranean and Spanish food. Creative entrepreneur Pau Guardans oversaw the hotel's entire reinvention. The result is 44 ultra-comfortable bedrooms and exceptional hospitality for every guest, complimented by all the five star services of a luxury hotel. With two meeting rooms and room for 80 people in the garden, it is well set up to host all manner of events. Meanwhile, the spa-like bathrooms have sumptuous robes and hydro-massage jets in the showers. Here in Salamanca, nothing will stand between you and total relaxation.

SPAIN
MADRID

OPEN
11/2004

RATES
EUR 275 –
EUR 1500

ROOMS
102

ADDRESS
CARRERA DE SAN JERÓNIMO, 34
28014 MADRID
SPAIN

WWW.DESIGNHOTELS.COM/
HOTEL_URBAN

✱ SIGNATURE

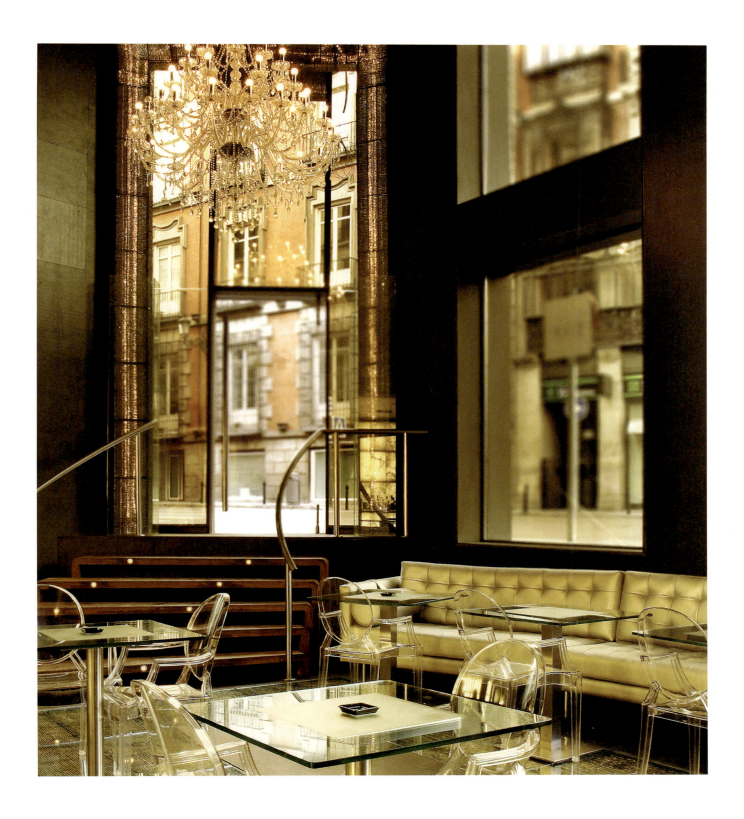

HOTEL URBAN
Madrid

In the cultural center of Madrid, on the Carrera de San Jerónimo, the Hotel Urban invites guests into a fusion of avant-garde design, art, and technology behind a steel and glass facade. The very "urban" vision begins the second guests set foot through the property's door: passing through a tubular atrium crafted in stainless steel and alabaster, they are led into a majestic reception area, paneled in black Zimbabwe stone with metallic seam finishes. But an alternative entrance – through the crystal floors, silver sofas, and transparent tables of the popular Oyster Bar – is inspiring in another way. In the Europa Decó restaurant, glass mosaics and walls covered in Brazilian rusted stone are a cosmopolitan backdrop for intelligent, convivial dining. Two transparent elevators whisk guests to 102 elegant rooms and suites. Each features a piece of ancient art – such as a 2,000-year-old Buddhist figure – as well as leather headboards, antique furniture, and bathrooms separated by glass screens that can be moved at the touch of a button. Up on the roof, the pool and restaurant offer both spectacle and seclusion, with views of the city and the sheltering Spanish sky.

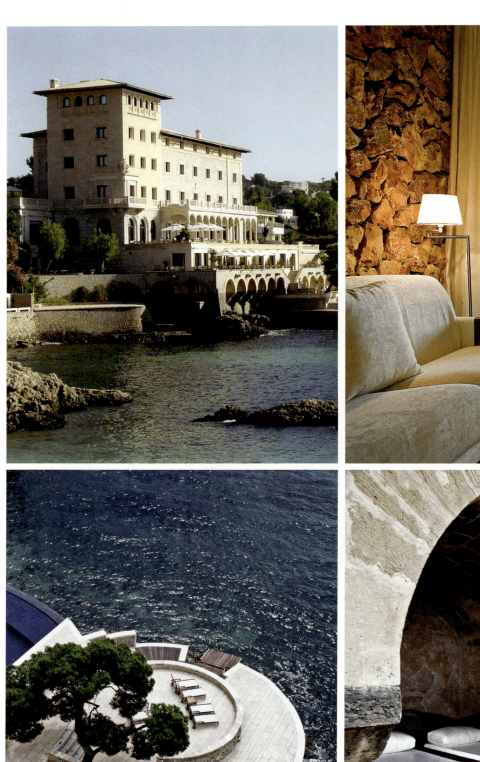

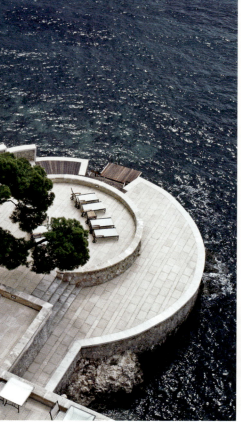
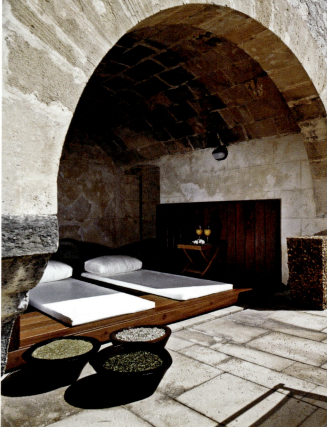

WWW.DESIGNHOTELS.COM/
HOSPES_MARICEL

ADDRESS
CARRETERA DE ANDRATX, NO. 11, CAS CATALÁ
07184 CALVIA - PALMA DE MALLORCA
SPAIN

ROOMS
53

RATES
EUR 189 –
EUR 1700

OPEN
03/2003

SPAIN
MALLORCA

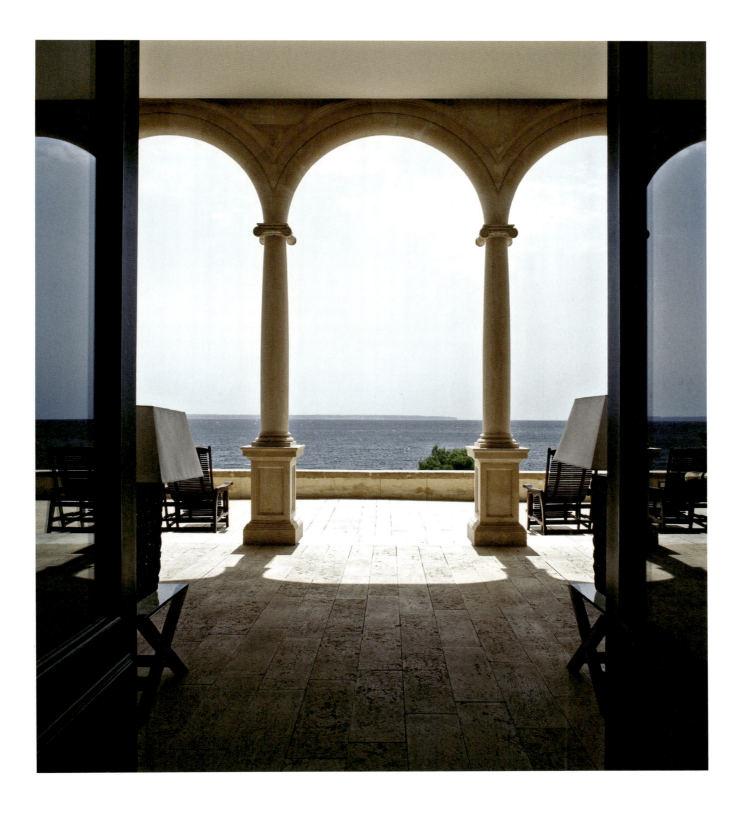

HOSPES MARICEL
Mallorca

Formerly a notorious haunt of the old-school jet set, this proud and palatial building once hosted parties that kept the paparazzi snapping. The atmosphere now is more stylishly leisurely, but today's international travelers can still savor a hint of those decadent days in the retained details – a neoclassical entrance, large windows, neo-Gothic pillars – of a 1949 building. Otherwise, a Hospes Design Team revamp has returned traditional Balearic elements of the original structure – archways and arcades, columns in marble and local stone – while modern accents supply a beautifully contemporary flair. The 53 rooms including two suites fulfill modern priorities with design that maximizes comfort, space, and light and uses neutral colors to complement brilliant views of the Mediterranean. The seafront arcade and grand terraces send guests straight to another era – or to a state of relaxed bliss. So does the refined, subtle service. Whether they arrive by private yacht or just drive in, visitors can sample an array of open-air spa treatments in the grotto-like alcoves above the waves, savor local seafood in the Senzone restaurant, or float in the stunning infinity pool, which seems to dissolve into the … yes … infinite blue of the sea.

PURO OASIS URBANO
Mallorca

The relaxed, cosmopolitan spirit of Puro Oasis Urbano also defines the hotel's owner, Mats Wahlström, the Puro Group's Swedish-born, adventure-loving founder. In 1998 he acquired the 18th-century town palace and began to turn it into a singular gathering place on Mallorca. The hotel opened in 2004, and underwent a complete refurbishment in 2010. Wahlström continues to push the boundaries with his vision for the hotel, and the result is a 21st-century style hotel with 51 rooms, including 11 suites in a new private wing and three fully equipped meeting and event spaces for up to 40 people. With the redesign, the hotel's original boho-ethnic aesthetic has morphed into a more affirmatively urban look created by Swedish designer Gabrielle Jangeby. Smart leather furniture, earth-tone fabrics, and modern art (including key pieces by Peter Gröndahl) reject the trappings of traditional prestige and embrace the new luxuries of time and ease. Public spaces are filled with chill-out music; there are numerous light-soaked lounge areas; and on the rooftop terrace is a plunge pool with cushioned seats and canopied daybeds. The light, Asian-influenced cuisine at Opio Restaurant is a perennial favorite. The Opio Bar has a new VIP area, and a music studio opened in early 2011. In-room details include flat-screen Bose televisions, spa-like bathrooms, free WiFi, and iPod docking stations on which to listen to the latest "Puro Music" releases. At "PuroBeach," the nearby beach club, there is a spa, pool, and restaurant lounge set on a peninsula overlooking the bay of Palma.

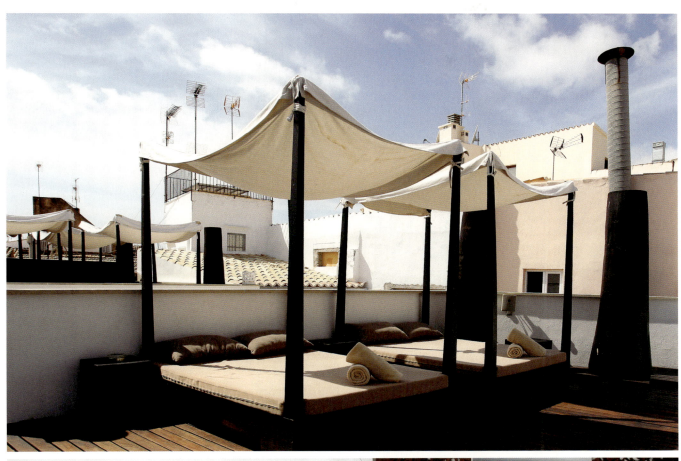
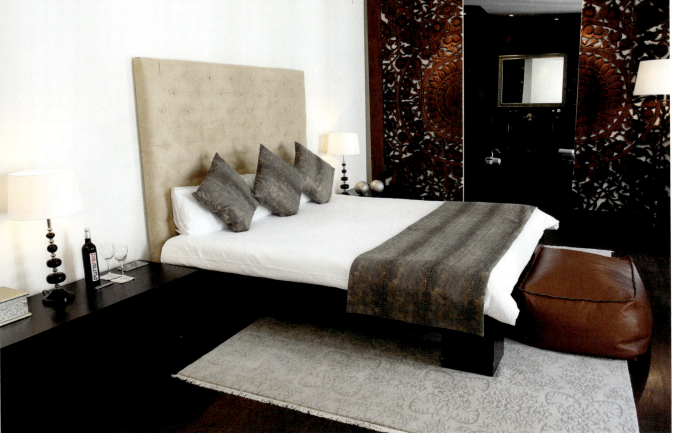

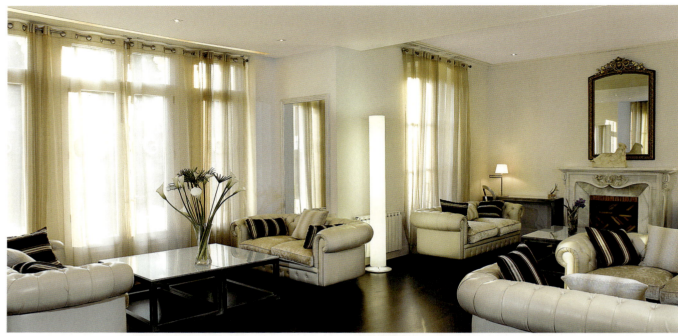

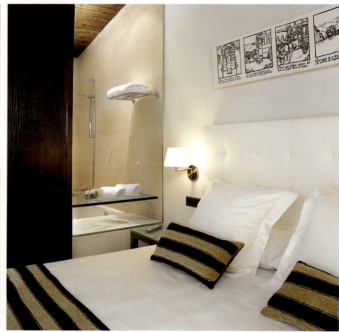

HOSPES
VILLA PAULITA
Puigcerdà

This majestic Catalan villa and spa is an ideal retreat from the urban fray. Originally built as a private summer residence equidistant from Toulouse and Barcelona, the three-story red mansion with fairytale-like turreted octagonal towers has a dollhouse quality that never fails to charm guests looking for a mix of history and modern creature comforts. Many of the 19th-century building's original features – such as forged iron balustrades, grilles, and balconies – have been preserved and antiques have been renovated: the former proprietor's late 19th-century wooden chairs, which the Hospes Design Team painted white and cushioned with shimmering gray velvet, are just one example. Guests will find particular pleasure in the rustic allure of sloped ceilings exposing original wood beams, warm wood floors, a soft gray palette, and the unique black-and-white Catalan artworks hanging over each guest bed's canopy. With its serene lakeside setting, the outdoor environment has been integrated as an additional space for socializing and relaxation. Glass pyramids are spaced throughout the manicured gardens; the light-flooded Bodyna Spa is located on the resort's lower level. The indulgence continues at Senzone L'Estany, a gourmet restaurant offering cuisine balanced between sophistication and tradition, just like the rest of this stunning property.

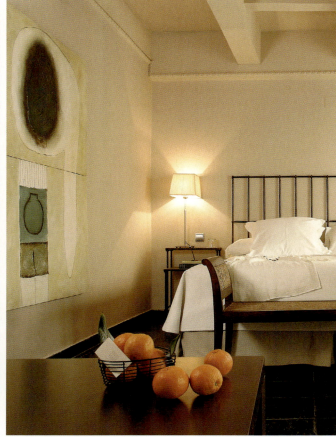
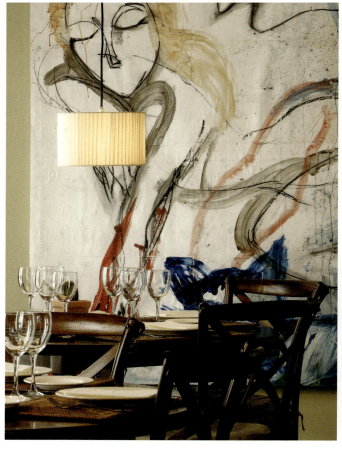

HOSPES LAS CASAS DEL REY DE BAEZA
Sevilla

Mingling elements of Moorish and European design from the two cultures that have shaped the Andalusian capital over centuries, the Hospes Las Casas del Rey de Baeza is a relaxed, sophisticated fusion of past and present. Bright, whitewashed walls are embellished with the ochers and reds of southern Spain's bullrings in the hotel's courtyards. These are shaded by arcaded walkways that tempt those who wander them into conspiratorial moments amid a forest of salvaged wooden posts and stone columns, both painted and untouched. Ah, the passion of Seville. Once inside, cool terracotta flooring and natural tones lead guests to the 41 guestrooms, where a gracious modernity takes over. Dark chocolate-colored furnishings, sisal mats, wooden beds from Indonesia, extravagant floor cushions, and soft lighting set the scene for a retreat from the sultry city outside in interiors surprisingly reminiscent of urban apartments. Natural light shines through slim passages formed by columns, bouncing off freestanding bowl sinks, water jugs, and other ornaments from bygone eras, but ready to be enjoyed in all their glory today.

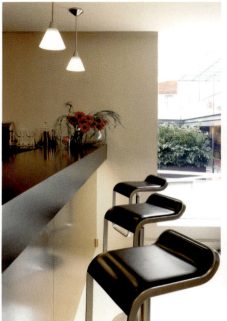
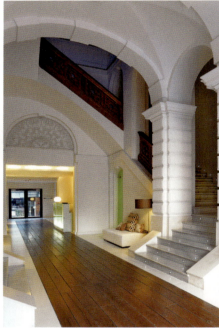
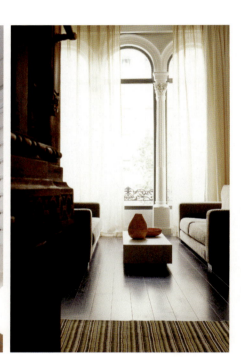

HOSPES
PALAU DE LA MAR
Valencia

The Hospes Palau de la Mar plays a significant role in the cultural and creative scene of one of Spain's most lively cities, Valencia. Continuing a tradition of fine cuisine and hospitality, the Palau de la Mar (Palace of the Sea) is a modern remodeling of two palace residences in the center of the city. An immaculately developed and advanced concept, the hotel is the work of prestigious interior designers Isabel Lopez and Sandra Tarruella. The result of their combined efforts: a welcoming space that surprises and delights. Palau de la Mar in Valencia offers a range of facilities to help guests relax, including an extensive fitness suite with heated pool and an intimate library, where quiet moments and private conversations find the perfect surroundings. Rounding off this authentic experience, the hotel's restaurant presents a range of local dishes, prepared with the finest Valencian ingredients.

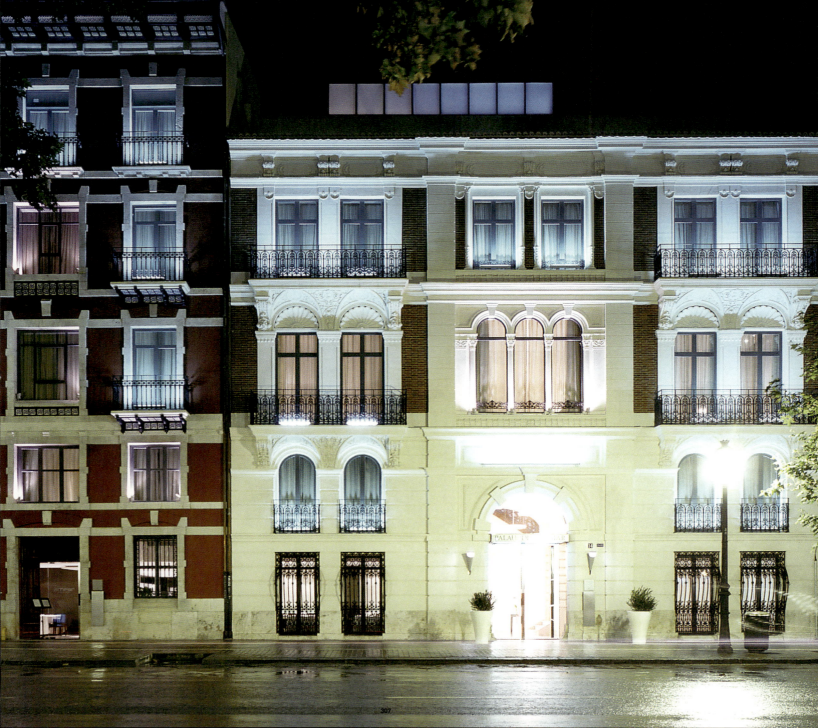

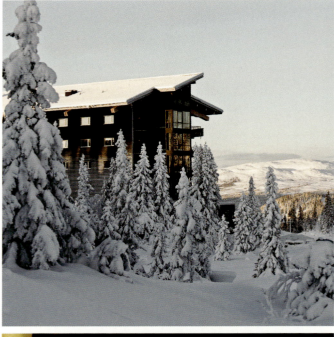
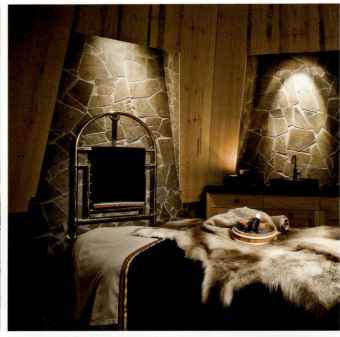
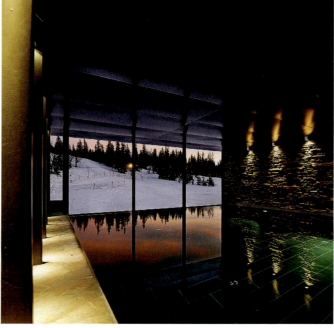
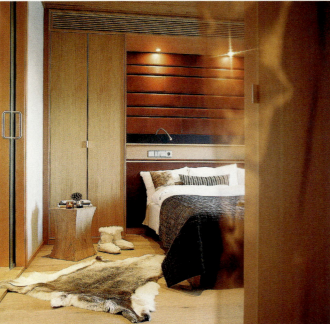

COPPERHILL
MOUNTAIN LODGE
Åre

On the very top of Sweden's picturesque Mount Förberget, more than 730 meters above sea level, rests an idyllic ski getaway. With the warmth of a mom-and-pop operation and the thrilling custom design of master architect Peter Bohlin, the Copperhill Mountain Lodge is a gem in Sweden's snowy mountains. Known for his work on the iconic Apple stores, Bohlin has succeeded in making the hotel's 112 earth-toned guestrooms feel lustrous and comfortable as well as invitingly private. Guests can take in 360-degree views of the Jämtland mountains through large bay windows. Åre's renowned Alpine ski area, the largest in Scandinavia, is just beyond the doorstep, and ski-in/ski-out access makes exploring everything as simple as strapping on a pair of skis. The comprehensive Ski Club offers lessons, mountain guides, ski rentals, and heli-skiing for the very adventurous, while the gourmet restaurant Niesti and the boîte Coppermine Co. nourish ruddy-cheeked guests with hearty European delicacies. The luxurious Level spa, as well as a pair of top-shelf watering holes, are on hand to help guests kick back after a long day on the slopes. Here's a ski lodge that is just as inviting inside as out.

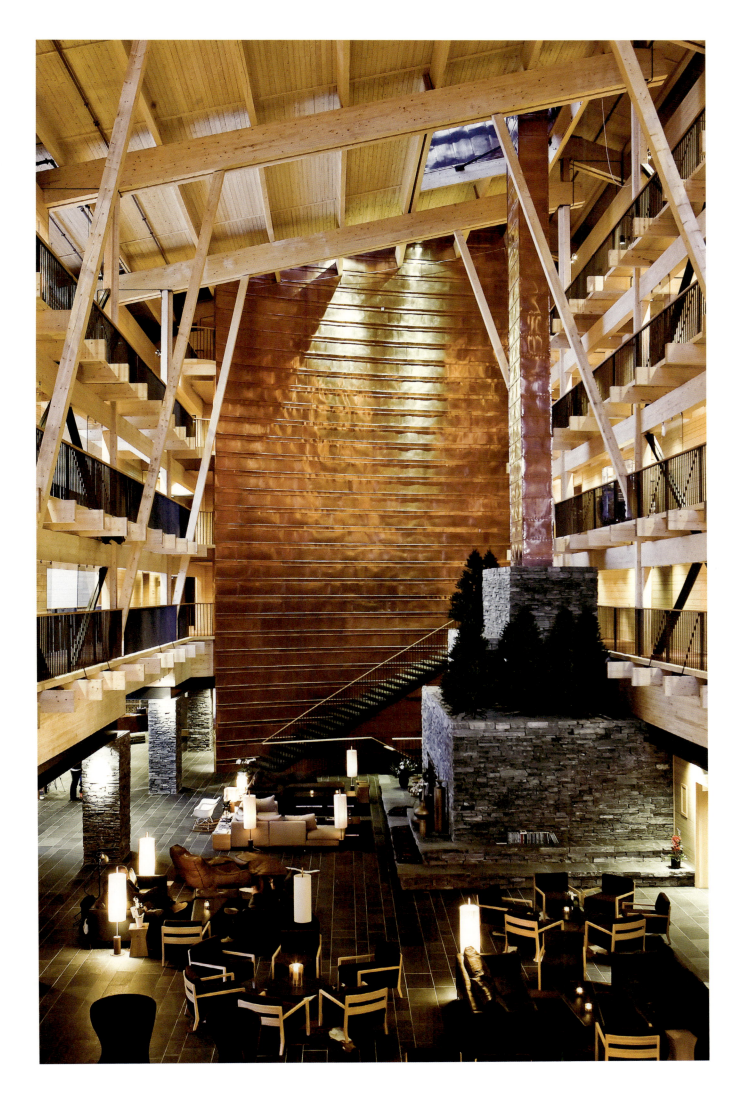

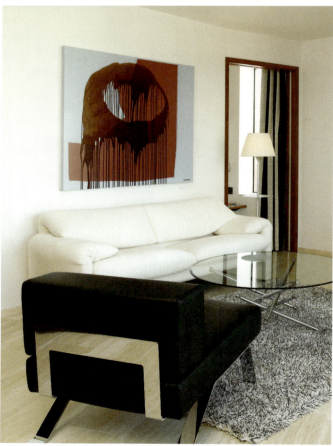

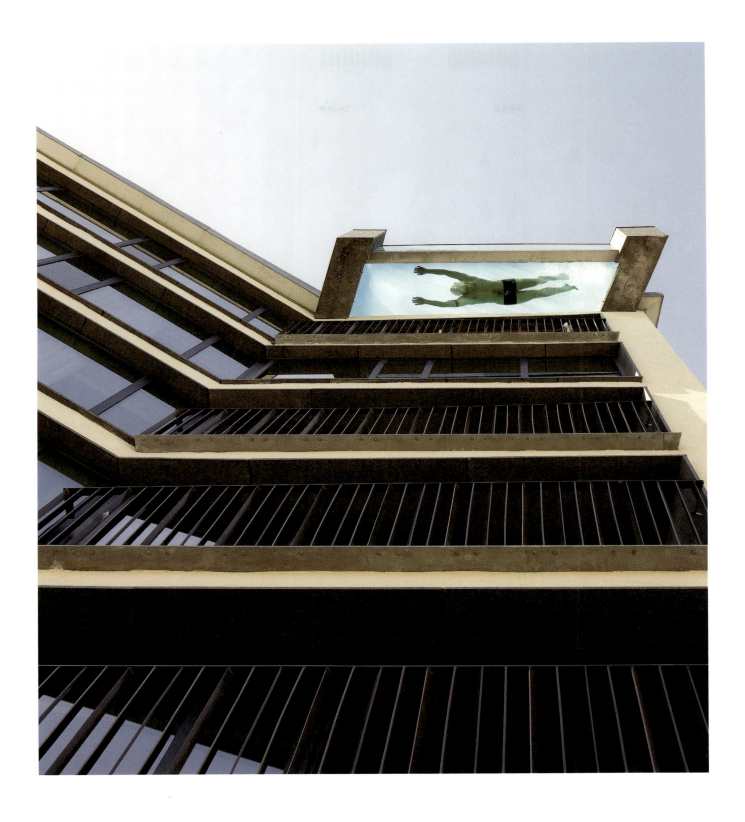

AVALON HOTEL
Gothenburg

The ultramodern and welcoming Avalon Hotel in central Gothenburg is an oasis of inspiration. The urban location combines access to shopping, restaurants, culture and nightlife, with excellent, personal service and modern design down to the smallest detail. The unique and harmonious interior milieu features selected pieces of Scandinavian design and exciting artworks while the award-winning architecture is contemporary and timeless. The facade, with its signature rooftop glass swimming pool that protrudes over Kungsportsplatsen, has become a popular element of the Gothenburg skyline. Every effort has been made in creating a serene indoor environment, making the Avalon Hotel the ideal location in which to escape from work and the rigors of city life. The walls of the hotel are home to an art collection that appeals even to the most discerning art lovers. Each of the 101 rooms is uniquely furnished in a minimalistic Scandinavian style, with an attention to detail that contributes to the international theme - a winning combination that inspires creativity and delightful relaxation. Selected rooms have unique features such as a generous balcony, an open-plan bathroom, a private gym or a round bed. The same relaxed, international atmosphere can be enjoyed at the bar and restaurant, which offers dishes made from seasonal ingredients and a fine selection of wine and cocktails. During the summer, Avalon Outside is an excellent watering hole right at the center of Gothenburg..

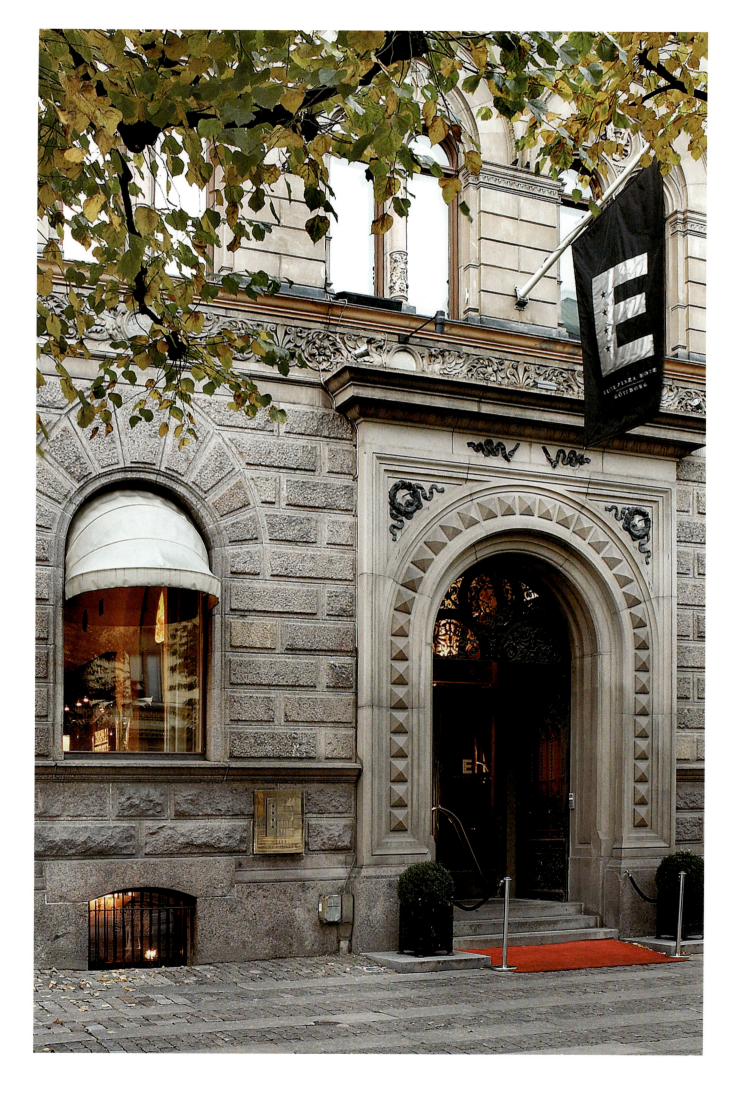

*SIGNATURE

WWW.DESIGNHOTELS.COM/
ELITE_PLAZA

ADDRESS
VÄSTRA HAMNGATAN 3
404 22 GOTHENBURG
SWEDEN

ROOMS
130

RATES
SEK 850 –
SEK 18000

OPEN
01/2000

SWEDEN
GOTHENBURG

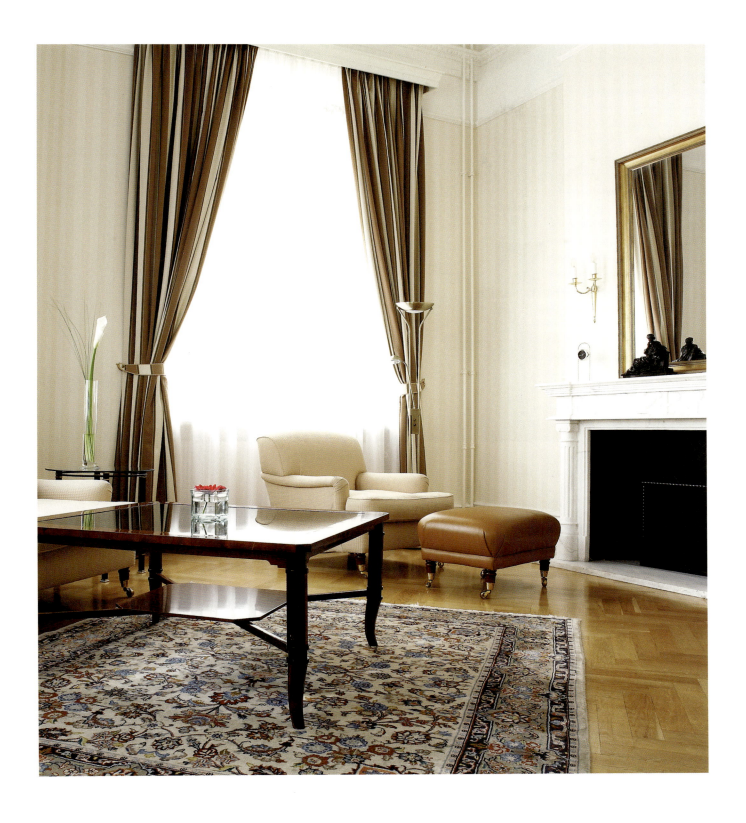

ELITE PLAZA HOTEL
Gothenburg

A remarkable entrance of fine-cut, partially polished granite welcomes guests into the embrace of this meticulously restored neo-Renaissance building. The home of the Svea Fire & Life Insurance Company in the 1880s, and the work of top architects of that era, today it has been transformed into a masterpiece of elegantly refined tradition by designers Christer Svensson and Lars Helling. An English mosaic floor in the lobby and pillared halls with arches of Italian marble stucco and wrought-iron detailing invite guests to stroll in the ornate splendor of an earlier age. Neoclassical highlights are scattered throughout the 130-room hotel; dark wood paneling surrounds clusters of deep, comfortable armchairs in the cosy bar. The same material is integrated to great effect into the design of the spacious bedrooms. On the fifth floor, a dozen new suites and doubles in an updated mood featuring shades of beige, cherry, and lime contrast a modern penthouse lifestyle with prime views of medieval Gothenburg. Wonderfully located in the heart of Sweden's second city, the Elite Plaza is a carefully understated melding of past and present and a perfect place for business and leisure travelers alike.

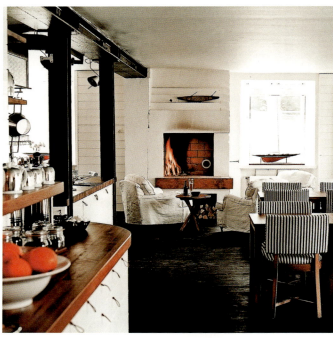

ROOM 10–18

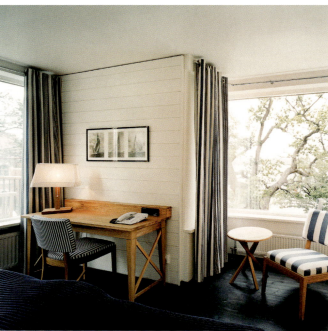

HOTEL J
Stockholm

On the water's edge at Nacka Strand, Hotel J has its own 25-berth guest harbor and offers sweeping views of the Royal Djurgården, the island of Lidingö and the boats on Saltsjön. The architects at Millimeter and designers at R.O.O.M. have transformed the 1912 brick building into a stylish shrine to seafaring – and an American one at that. The concept draws on the nautical design of historic America's Cup J-Class boats and the distinct feel of the New England coast. The evocative red, white and blue of the stars and stripes invite visitors from across the Atlantic to feel completely at home. But guests from anywhere will appreciate the homey feel of white wood, cotton textiles and solid oak furniture. In the lobby, fireside seats afford wide-angle views of the islands near Stockholm, just 15 minutes' sailing time away. The 158 guestrooms, in five different categories, feature natural materials such as wooden trim and fine linens that evoke an authentic feeling of comfort and ease. There are also four suites with a separate sleeping areas on the upper floor, downstairs lounge, balcony and views over the sea. There are two meeting and function villas: J' Fabrikörsvilla and the historic J' Tornvilla, which is home to The Club House bar and lounge. Decorated in the relaxed and comfortable style of New England yacht clubs it serves classic cocktails and American cuisine such as crab cakes and T-bone steaks. At the water's edge Marine Brasserie Restaurant J is a culinary and visual experience with views over the bay and simple, sophisticated brasserie cuisine focused on seafood.

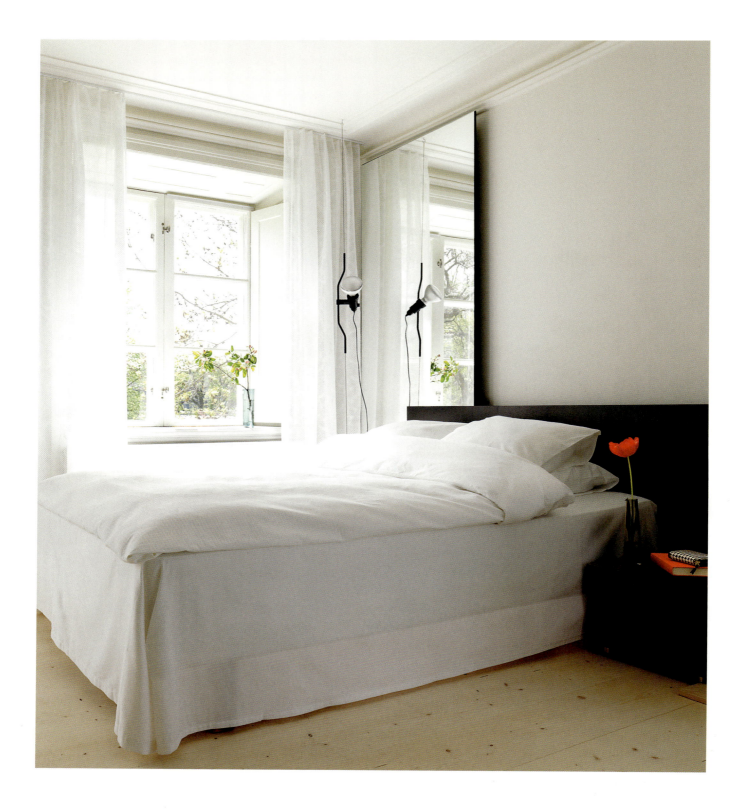

HOTEL SKEPPSHOLMEN
Stockholm

On the small, vibrant island of Skeppsholmen, in the city center of Stockholm, Hotel Skeppsholmen has its home in two long buildings that date back to 1699, when the "Long Row" was built to house Sweden's Royal Marines. Casually luxurious, ultra-modern and historically protected, the hotel gives its visitors a taste of the old, a twist of the new and a whole lot of charm. The Swedish historic landmark is paired with the very best of contemporary Swedish cuisine, art, design, fashion and music, partnering with iconic brands such as Acne and Byredo. Ideal for both the active and the culturally curious guest, the quaint yellow building is next door to the renowned Swedish Museum of Modern Art and the fascinating Swedish Museum of Architecture. The area's gorgeous antique ships and waterfront restaurants are also within walking distance. Designer/architect team Claesson Kovisito Rune fittingly chose "fog" as the hotel's artistic theme, evoking the mist of the enchanting maritime surroundings with its soft color scheme and peaceful atmosphere to create an eco-certified urban oasis.

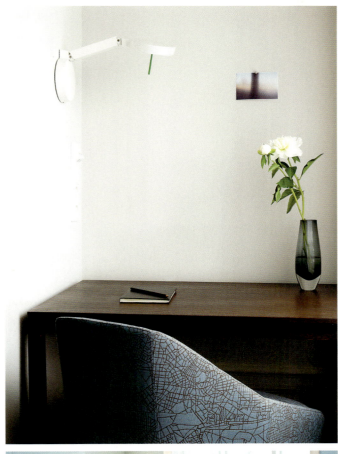
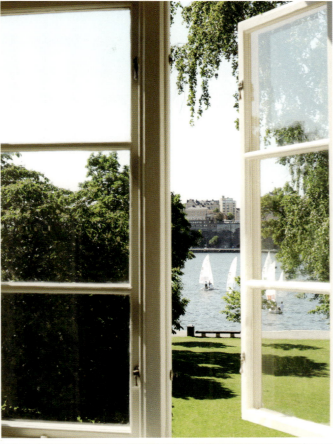
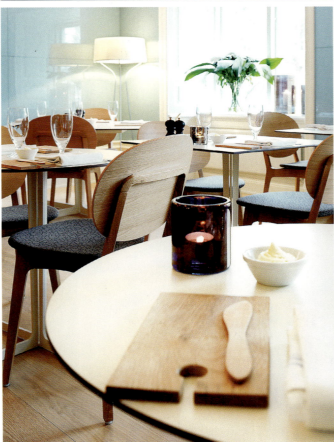

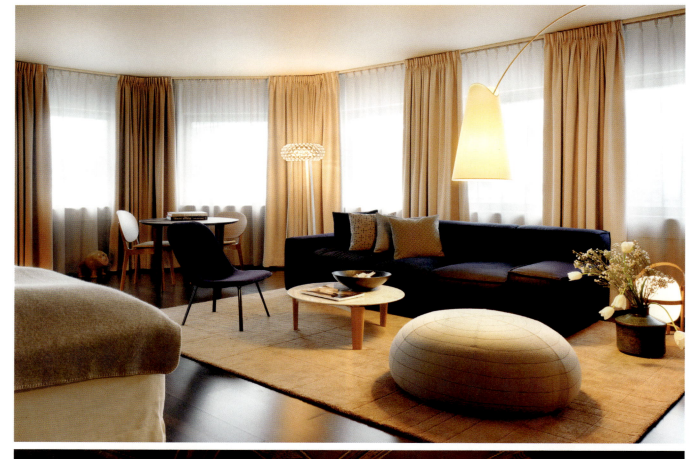
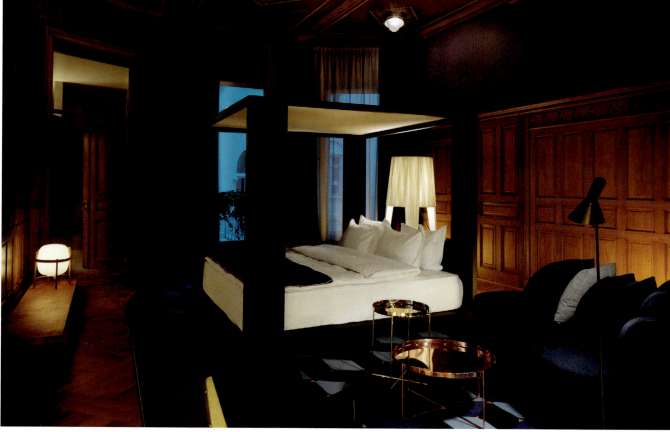

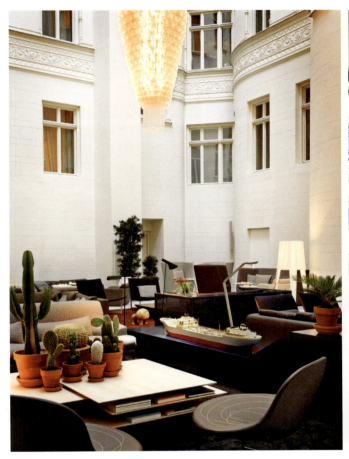
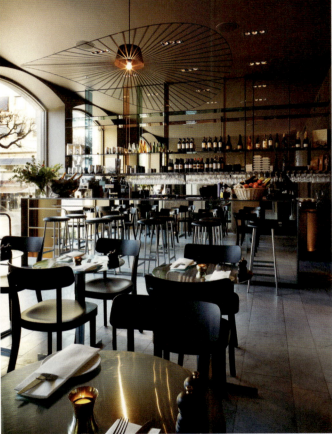

NOBIS HOTEL
Stockholm

The two grand 19th-century buildings housing the 201-room Nobis Hotel in Stockholm were originally built and used as residential apartments. "It's always been a fascinating place in Stockholm," says owner Sandro Catenacci, of Norrmalmstorg Square, the most valuable real estate in the Swedish version of the Monopoly board game, and within walking distance of the city's best shopping and sightseeing. The hotel's interiors ooze history, yet they still have the crisp look typical of the renowned Swedish architectural firm Claesson Koivisto Rune, whose understated, yet always luxurious Scandinavian aesthetic shines through. A cathedral-like lounge with 25-meter ceilings is situated in a vast 800-square-meter public space. The smaller Gold Bar sumptuously exemplifies its name with walls and ceilings covered with golden mirrors. There are several restaurants, including the new version of Stockholm's legendary Italian restaurant Caina, which now serves a menu of simple and delectable Italian cuisine by the award-winning chef, and the owner's brother, Stefano Catenacci. Service is always personal; guestrooms are designed to feel like rooms in an elegant home, put together over time and not merely assembled. Tying it all together is a sense of individuality and a uniquely Swedish brand of luxury that's far less about show than about feel. "We believe strongly in Sweden that luxury is not always big spaces and the most expensive things," says Sandro Catenacci. "It's a quality that feels different."

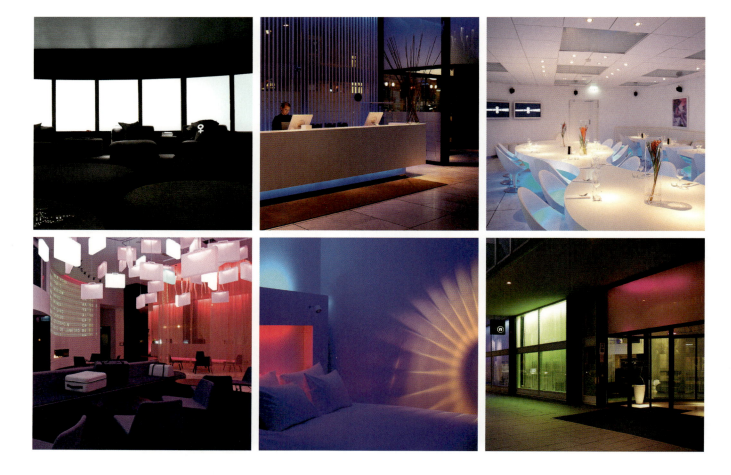

NORDIC LIGHT HOTEL
Stockholm

Nighttime passersby glancing at Stockholm's Nordic Light Hotel will observe the subtle, warm colors glowing from the understated facade's windows and wonder about the activities inside. Those who enter won't be disappointed by the welcoming world they encounter, enriched by hundreds of different light sources that vary in tone and intensity. Architect Rolf Löfvenberg and interior designers Lars Pihl and Jan Söder transformed the 1970s building into a modern design statement. In keeping with the exterior, black and white dominate the color scheme of the sober cubist furniture, but these classical touches heighten the tapestry of light provided by lighting architect Kai Piippo and play off against Sweden's naturally atmosphere-transforming seasonal sunlight. Upon entering, guests are treated to a setting that expertly mixes the stimulating with the subdued: stalactite lights hanging from a recessed circle in the ceiling create ever-changing patterns of blue, orange, and pink splashing onto the hotel's walls. These organic light shows continue throughout the Nordic Light's 175 rooms, where guests can play with the lighting to suit their own changing and certainly uplifted moods.

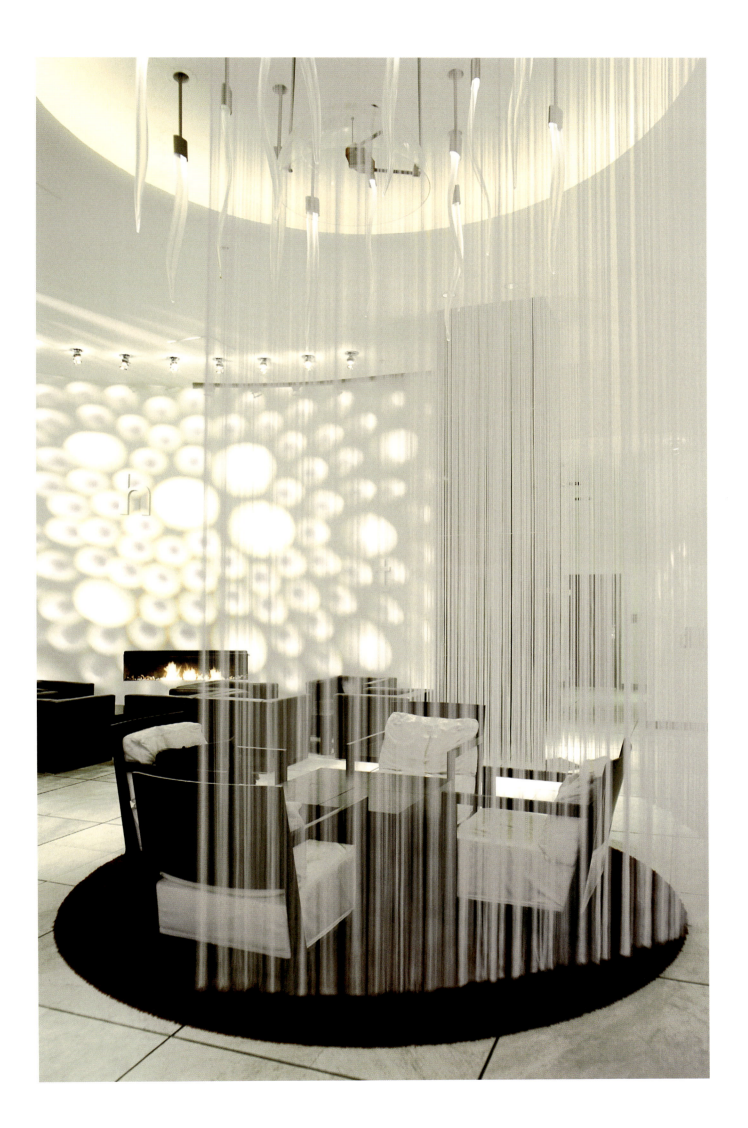

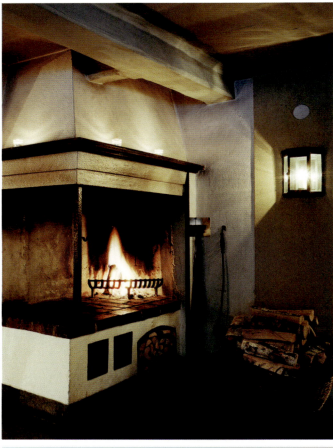
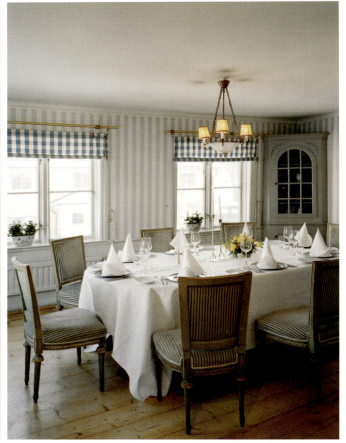
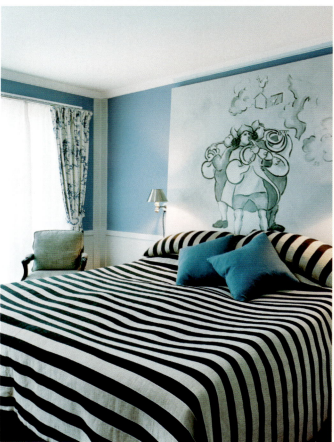

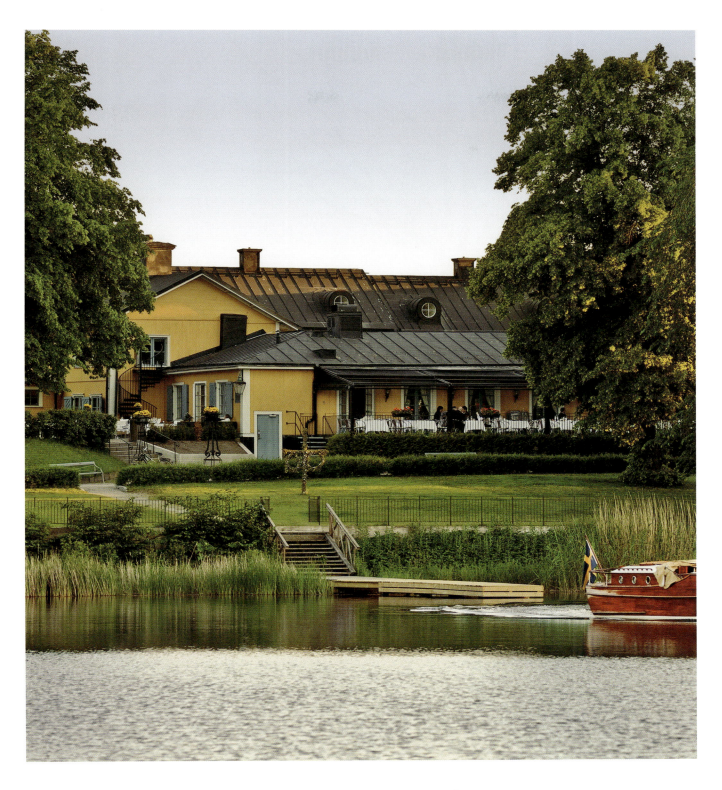

STALLMÄSTAREGÅRDEN HOTEL & RESTAURANG
Stockholm

The first inn in Stockholm, Stallmästaregården, played host to Sweden's Queen Kristina in the mid-1600s. Since then, the well-to-do residents of Sweden's island-dotted capital have continued to make it their own. Today, owner and Nobis Group CEO Alessandro Catenacci has expertly added to the original hotel building, recreating the cluster of rustic structures from the 1700s. Its peaceful and idyllic setting overlooks tree-fringed bay of Brunnsviken in the Royal National City Park and is just a short walk from Stockholm's city center. Close by are Vasastan's neo-Renaissance style buildings, which house art galleries, cafés and inventive Swedish design emporiums. The rooms at Stallmästaregården are painted in pastel shades of yellow and blue, with subtle Chinese touches and a nod to the clean lines and floral fabrics of 18th century décor. In the main restaurant, diners can watch as chefs prepare classic Swedish dishes in an open kitchen with charcoal grill, rotisserie and smokehouse. The hotel has space to suit any kind of event, from the vast old courthouse's banqueting room, with its drooping chandeliers and mural paintings, to the intimate Queen Kristina Pavilion – a garden-wrapped gazebo overlooking the bay, which seats just six guests. No doubt at all, Queen Kristina would approve.

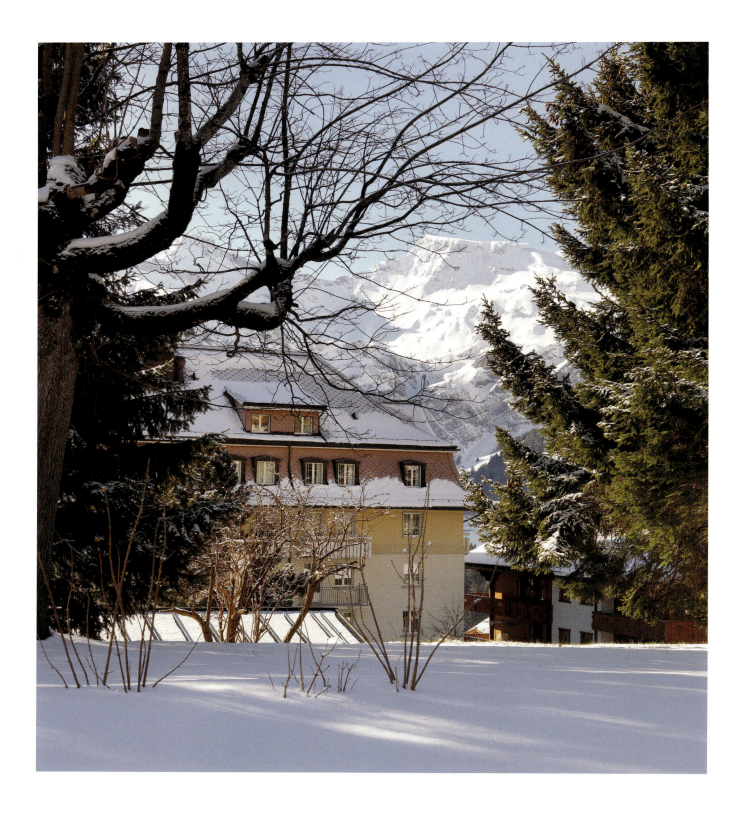

THE CAMBRIAN
Adelboden

Nestled deep in a valley in the Swiss Alpine village of Adelboden, The Cambrian looks out onto one of the world's most spectacular landscapes. Combining sleek, modern design with innovative uses of natural, local materials, The Cambrian's exquisite interior effortlessly reflects its exterior, adding to the purifying immensity of the mountains. The central lobby's stone fireplace and incredible mountain views set the tone immediately. Each piece in the puzzle, from the outstanding service to the equally wonderful spa and recreational facilities, is part of the experience of staying at The Cambrian: unforgettable. The indoor pool and waterfall, the outdoor thermal pool that actually seems as though it is flowing right into the mountains, the Finnish sauna with Bisazza mosaics, and the various treatment and fitness areas all maximize relaxation. The restaurant provides a perfect culinary experience, and Scott's Bar, the lobby/wintergarden, and the two spacious terraces are as well beautiful spaces to relax, offering exceptional mountain views and the perfect après-ski drink, or simply an opportunity to enjoy the crisp Alpine air and comfortable, warm decor. The Cambrian is known for its astounding location and superb design, but it is the hotel's fabulous service above all else that makes it truly exceptional.

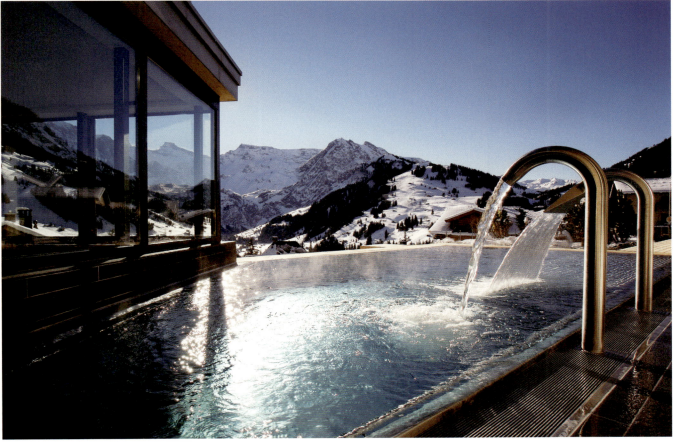

✱ RARE

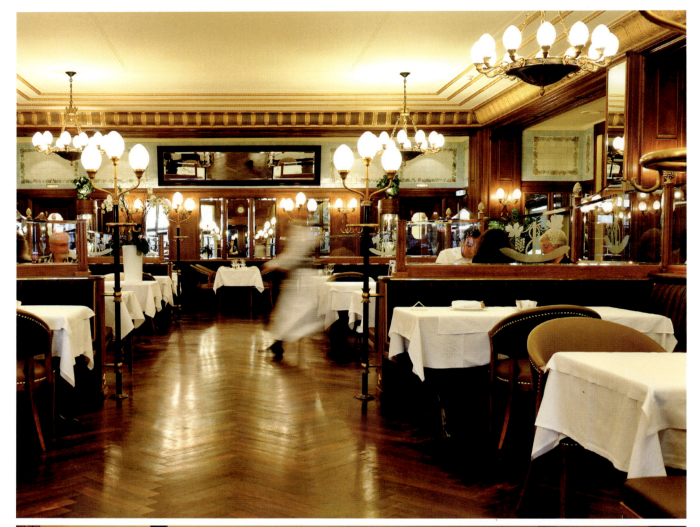

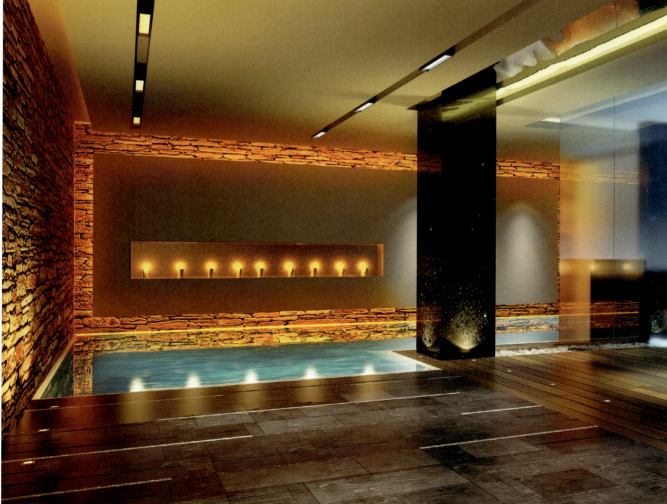

WWW.DESIGNHOTELS.COM/
SCHWEIZERHOF

ADDRESS
BAHNHOFPLATZ 11
3001 BERN
SWITZERLAND

ROOMS
99

RATES
CHF 450 –
CHF 2800

OPEN
05/2011

SWITZERLAND
BERN

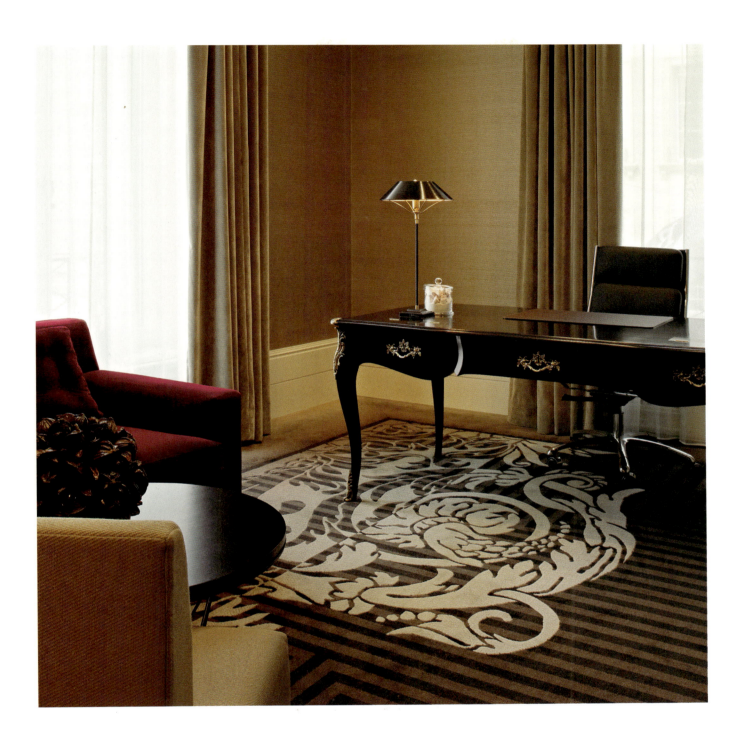

HOTEL SCHWEIZERHOF BERN
Bern

Strolling from Bern's glass-built railway station and out into the city's historic center is a true feast for the senses. Trolleybuses rattle down the Unesco-listed streets, and the pavements bustle with espresso-sipping diplomats. And there, right ahead of anyone who visits, is Hotel Schweizerhof – a listed building, and one of the Swiss capital's most recognizable landmarks. For 150 years, Bern's first luxury hotel has been building a reputation for itself based on sumptuous luxury and Swiss sophistication. Now, after a major overhaul, it's enjoying a 21st-century renaissance. The elegant arched façade has been lovingly restored, and it looks as glamorous now as it did in 1913, when it was first installed. But behind the striking frontage, there have been bigger changes. General manager Michael Thomann works magic to weave the very latest technology in and out of the building's plush historic features. Scaled-down corridors make the 99 rooms and suites more spacious and restful for guests, while some feature refreshed antique furnishings alongside modern trappings like flat-screen TVs and Nespresso coffee machines. The heart of Hotel Schweizerhof is the Lobby-Lounge, an institution favored by well-heeled locals and hotel guests alike. From Liz Taylor to Peter Ustinov or Albert Schweitzer, Jack's Brasserie, the hotel's wood-paneled restaurant serving French gourmet classics, has seen it all.

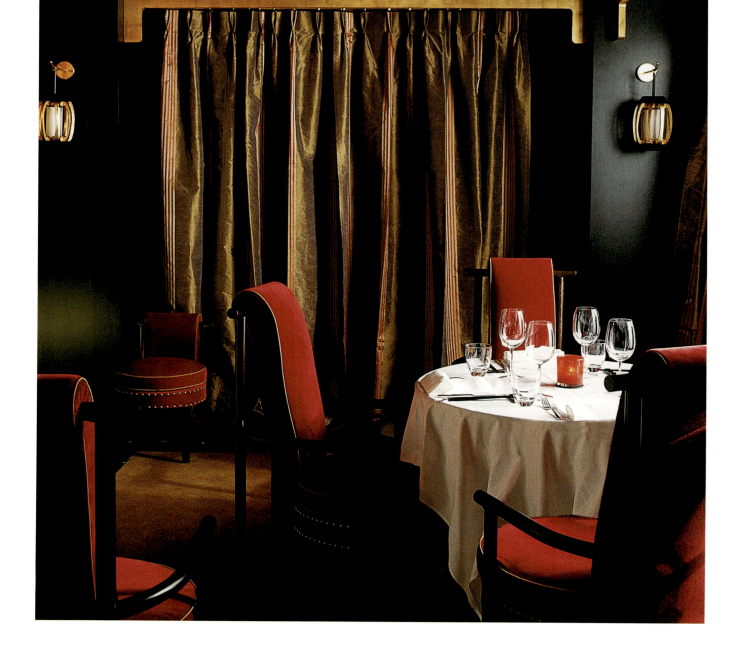

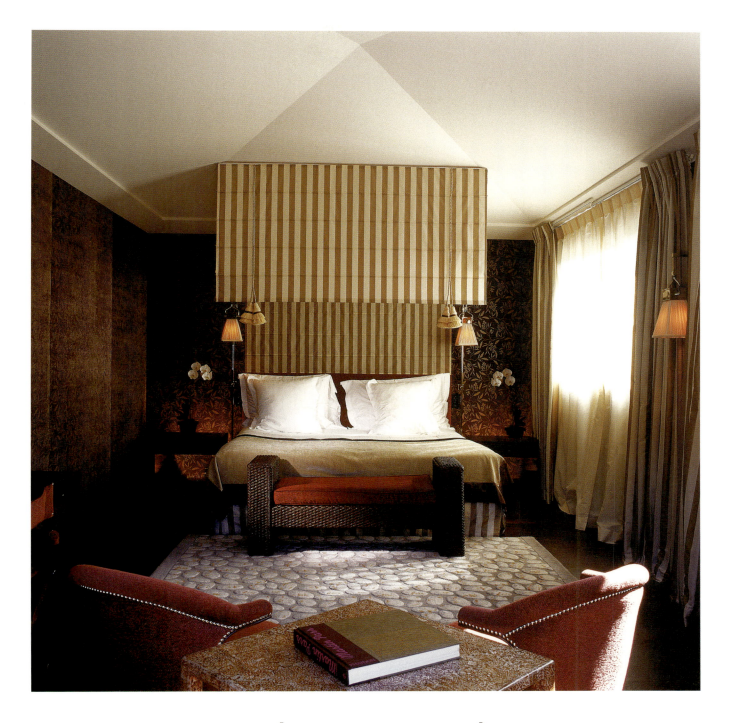

LA RÉSERVE GENÈVE HOTEL AND SPA
Geneva

In a magnificent park on the shores of Lake Geneva, La Réserve whisks guests away on a whimsical global safari. Parisian designer Jacques Garcia has transformed the 1970s hotel into a playful explosion of extravagant color, secluding shrubbery, and revealing glass galleries. A gold-leaf trim courses the lobby's upper wall. Below it, a frieze quotes a line from philosopher and Geneva native Jean-Jacques Rousseau: "Back to Nature." Perched on standing and mounted lamps are colorful plastic cut-outs shaped as parrots and peacocks. A band of leopard-print fabric cuts a horizontal line across lipstick-red chairs. An elephant guards the entrance to the Loti restaurant; inside, a copper elephant's head, originally commissioned for the 1931 Paris Colonial Exhibition, is mounted. The elegant Venetian water taxi used for trips into the city makes visiting this exquisite hideaway even more exhilarating. A summit of well-being, the 2,000-square-meter spa offers a unique atmosphere in which to revitalize: indoor and outdoor swimming pools, fitness room, sauna, steam bath, solarium, and more. Dedicated to well-being and the preservation of each individual's youth "capital," La Réserve Spa offers a personalized program built around sports, relaxation treatments, and a balanced diet tailored to individual needs.

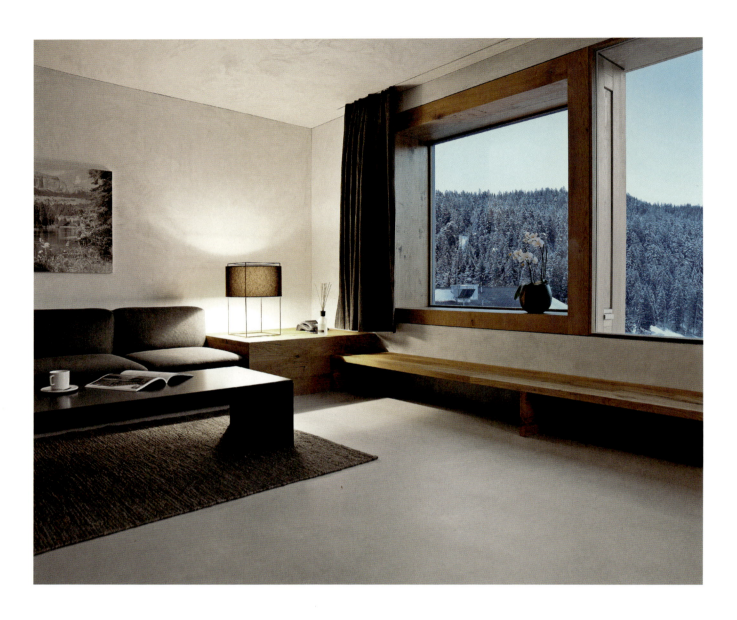

ROCKSRESORT
Laax

Rocksresort in Laax, Switzerland is one of the most striking ski hotels in the world. The eight cube-shaped, stacked-stone structures contain 122 two- and four-bedroom condos available for purchase, as well as 75 hotel rooms. Having grown up in the Laax region, Reto Gurtner drew his inspiration for the resort's architecture from the granite landscape of the Alps. The bright, contemporary interiors of the high-tech and energy-efficient units match the resort's minimalist motif and offer an effortless ski-in/ski-out experience right at the Laax base station. Unlike most other European ski resorts, rocksresort is fully integrated so you can purchase everything, even lift tickets, with your room card key. The high-elevation ski area is enormous, with slopes and snow parks for all levels, including Europe's biggest half pipe, which plays host to the Burton European Open, one of snowboarding's biggest events. And with a number of different restaurants, bars and shops clustered around a central square, après ski is just as exciting.

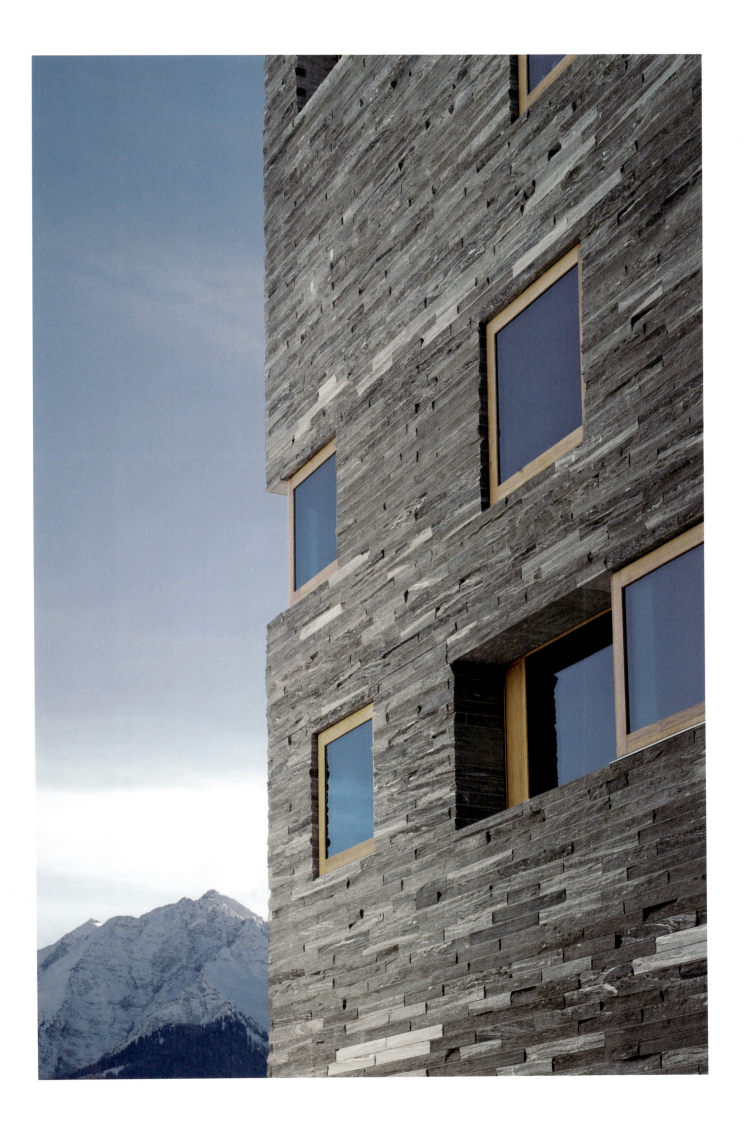

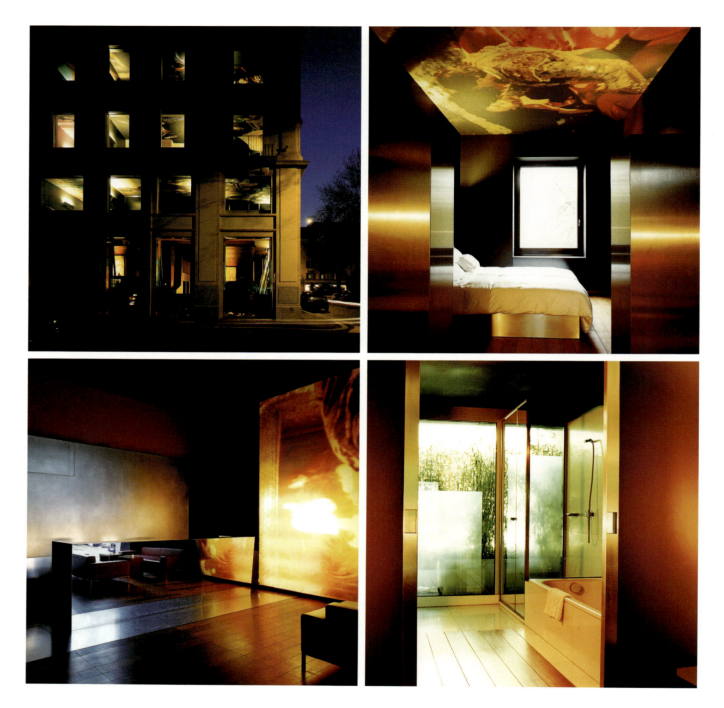

THE HOTEL
Lucerne

Any guest yearning for surprise, sensuality, and an elegant, even cinematic experience should simply check into, well, The Hotel. This small corner property built in 1907 has been transformed by none other than French star architect Jean Nouvel, a Pritzker Prize winner whose celebrated Lucerne Culture and Convention Centre is just a few steps away. Owner and hotelier Urs Karli wanted to transcend the usual hotel experience by offering not a "home away from home" but a place to be surprised and truly inspired. The strategy obviously worked. People outside feel like they're inside and vice versa, and Nouvel's restrained yet clever interplay of mirrors makes the tangible barrier between the pavement outside and the Gault Millau-awarded restaurant Bam Bou inside vanish in the eyes of the beholder. Furnishings bear Nouvel's hallmark (they should, he designed every piece himself): horizontal lines are drawn in wood, vertical ones in stainless steel. Perfecting the element of surprise, Nouvel selected film stills from his favorite directors, including Buñuel, Almodóvar, and Greenaway, to project onto all the rooms' ceilings, making iconic scenes like one taken from Fellini's *Casanova* come alive when you lie in bed.

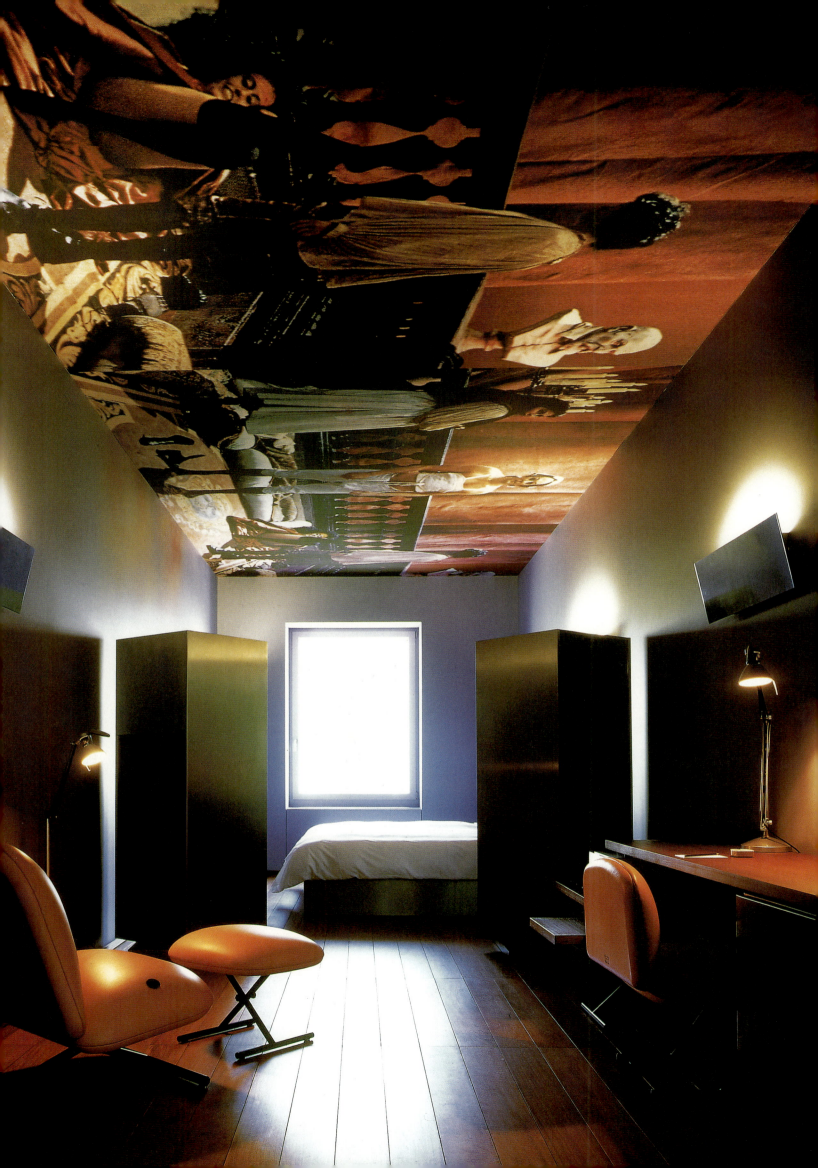

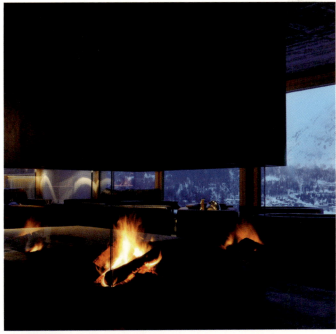
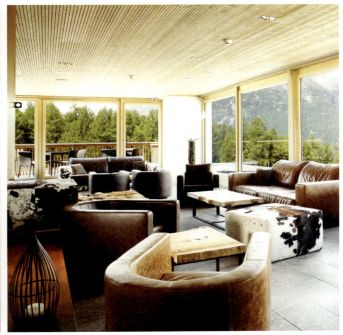
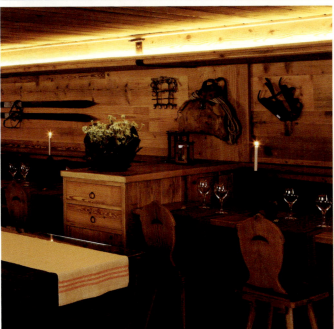

NIRA ALPINA
Silvaplana

One of the joys of staying at Nira Alpina, a glass-and-timber-built mountain sanctuary just five kilometers away from the popular resort town of St. Moritz, is being able to ski right up to the entrance. Sitting atop the village of Silvaplana, Nira Alpina is the gateway to some of Switzerland's highest mountains, including Corvatsch, the highest mountain in the upper Engadin skiing region. The hotel appeals to summer and winter adventurers: 120 kilometers of ski runs rush down the slopes towards Silvaplana Lake at the middle of the mountain range and the surrounding hills and lakes offer exceptional hiking and biking trails, windsurfing, sailing and canoeing. But it isn't just the location that makes Nira Alpina special. Throughout all 70 rooms and suites, award-winning hotelier MPS Puri has created a soothing space for travelers to enjoy the Swiss Alpine style and unobstructed views of the mountains. Locally sourced materials like wood and granite are just as likely to be seen as elegant swathes of glass, which let the outside world become a part of the building's interior. Panoramic views illuminate almost every public space, particularly in the top-floor restaurant, which bases its dining concept around fresh, local ingredients. Puri's food and beverage expertise shows in the hotel's culinary offerings, from the classic Engadin-style dishes at Stalla Veglia restaurant, to the bread and pastries, baked fresh daily at the hotel's own Bakery. The Nira Spa is a haven of calm with colored mood lighting and five large treatment rooms, offering authentic treatments for holisitic, stress-free living.

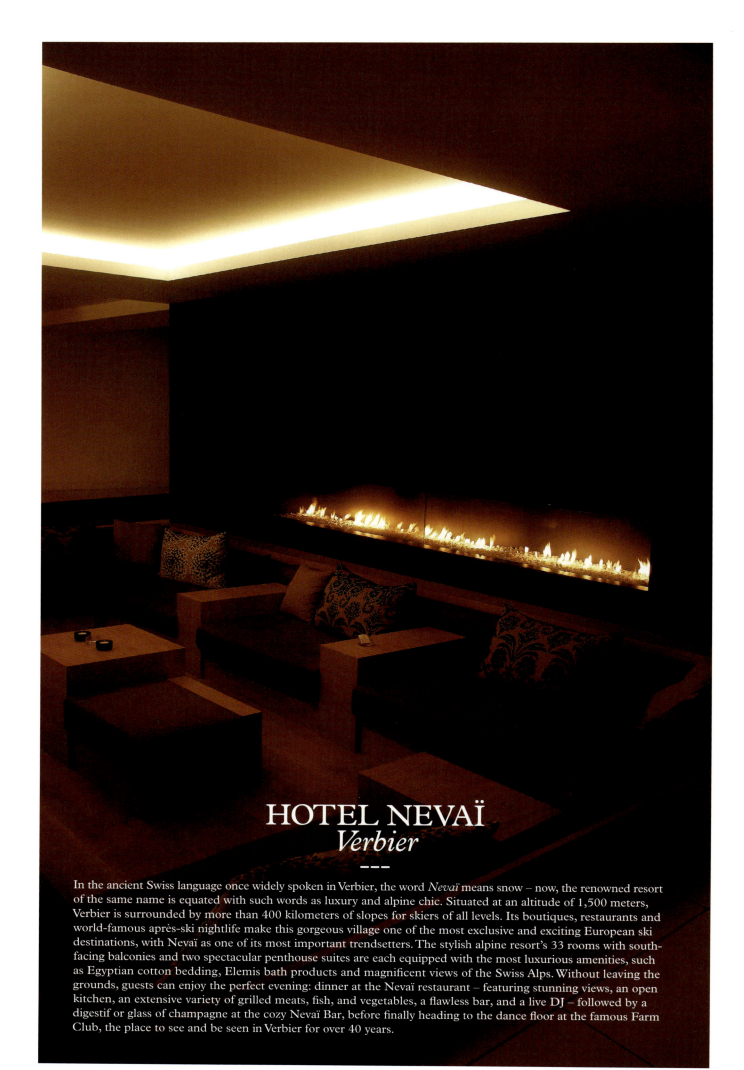

HOTEL NEVAÏ
Verbier

In the ancient Swiss language once widely spoken in Verbier, the word *Nevaï* means snow – now, the renowned resort of the same name is equated with such words as luxury and alpine chic. Situated at an altitude of 1,500 meters, Verbier is surrounded by more than 400 kilometers of slopes for skiers of all levels. Its boutiques, restaurants and world-famous après-ski nightlife make this gorgeous village one of the most exclusive and exciting European ski destinations, with Nevaï as one of its most important trendsetters. The stylish alpine resort's 33 rooms with south-facing balconies and two spectacular penthouse suites are each equipped with the most luxurious amenities, such as Egyptian cotton bedding, Elemis bath products and magnificent views of the Swiss Alps. Without leaving the grounds, guests can enjoy the perfect evening: dinner at the Nevaï restaurant – featuring stunning views, an open kitchen, an extensive variety of grilled meats, fish, and vegetables, a flawless bar, and a live DJ – followed by a digestif or glass of champagne at the cozy Nevaï Bar, before finally heading to the dance floor at the famous Farm Club, the place to see and be seen in Verbier for over 40 years.

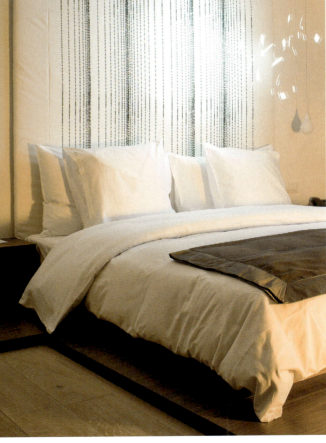

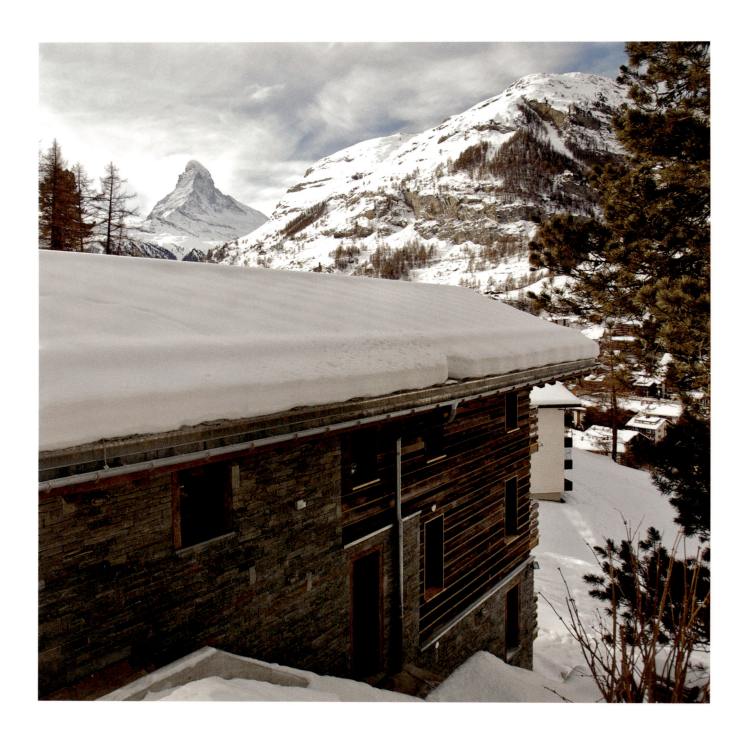

SIGNATURE

WWW.DESIGNHOTELS.COM/CERVO

ADDRESS
RIEDWEG 156
3920 ZERMATT
SWITZERLAND

ROOMS
33

RATES
CHF 260 –
CHF 1480

OPEN
12/2009

SWITZERLAND
ZERMATT

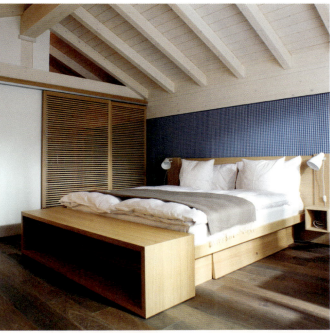
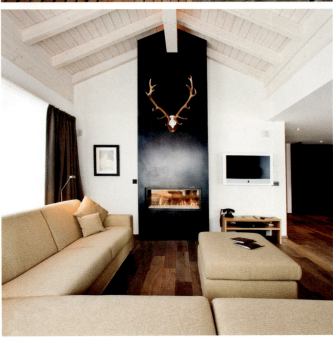

CERVO
MOUNTAIN BOUTIQUE RESORT
Zermatt

CERVO Mountain Boutique Resort is a timber-framed sanctuary nestled on the slopes above Zermatt, Switzerland's most iconic alpine resort. Guests can ski right up to the entrance where, with the majestic Matterhorn looming large on the horizon, they're greeted by a small, almost private doorway that oozes exclusivity. When they step inside, the soothing smell of warm wood and a smiling face greets them. Wandering further into the building gives guests the comforting sensation of being immersed in a contemporary alpine wonderland. Local materials like felt, loden and stone converge with vintage curios in the main building, a converted 1950s chalet that still has its original wooden floor. Young visionaries Daniel Ferdinand Lauber and Seraina Müller merge contemporary lines and homey colors throughout the property, from the Provencal-inspired restaurant to the peaceful chalets that house CERVO Mountain Boutique Resort's 33 rooms and suites. With help from local architect Roman Mooser, they've even incorporated seductive spas into each of the sunlit chalets. This dedication to accentuating life's comforts, combined with an enviable location next to some of Europe's best ski slopes, makes CERVO Mountain Boutique Resort the ideal place to savor the tranquility of the Alps.

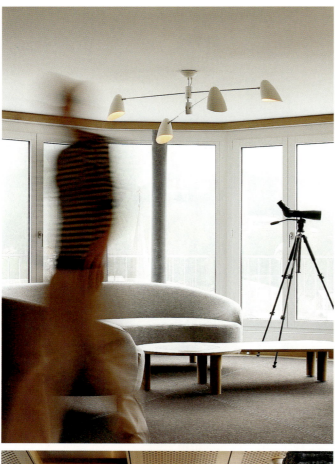

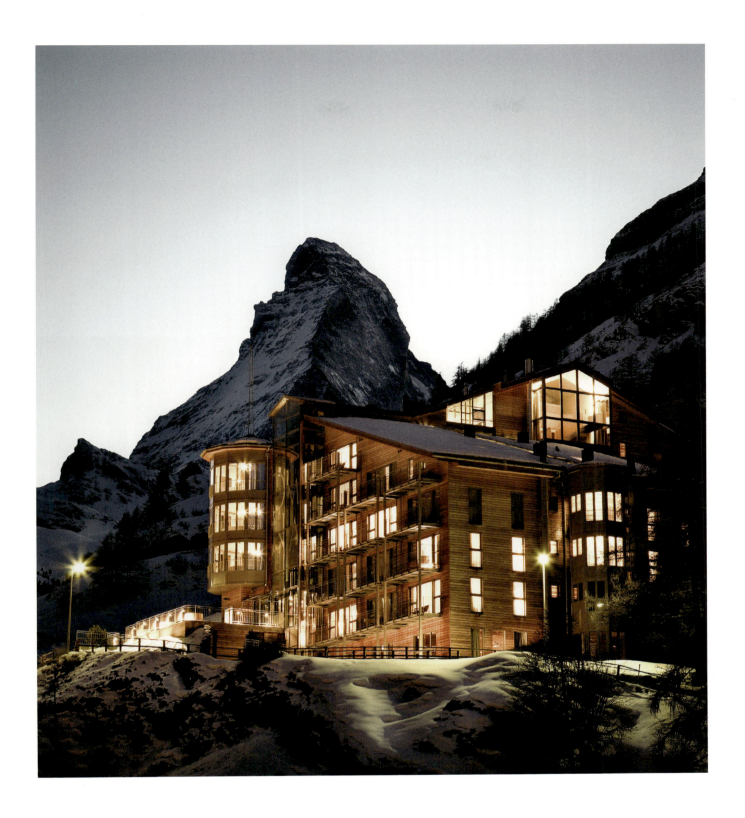

THE OMNIA
Zermatt

In the Swiss Alps, high above the snow-laden roofs of Zermatt, a conifer-studded mountainside is bisected by the sharp lines of a modern alpine hideaway. Here at The Omnia, which sits serenely in the shadow of the Matterhorn, New York-based architect Ali Tayar has fused elements of the traditional American mountain lodge with functional, modernist furnishings, creating a high-altitude space for reflection and rejuvenation. The word *omnia,* which means "the all-encompassing" in Latin, gives clues to Tayar's inclusive design philosophy. Inside his 30 individual rooms and suites, which have been left unnumbered to enhance the homely mountain lodge feel, primal elements come together as a harmonious whole. Fires crackle in black, egg-shaped stoves, while shades of dark granite and white oak accent furnishings that have been custom-made by local cabinetmakers. Private balconies offer spectacular views of the saw-toothed peaks that surround the car-free town of Zermatt. But it's inside the mountain itself that you'll see the most spectacular manifestation to help guests forget where they came from and where they are going. The multifunctional space called The Cavern is a club, conference center, and cinema floating over a sea of water in a man-made cave. Deep underground, and yet close to the epic sky, it's the perfect place for guests to reconnect with the wider world.

SIGNATURE

WWW.DESIGNHOTELS.COM/ 25HOURS_ZURICH_WEST

ADDRESS
PFINGSTWEIDSTRASSE 102
8005 ZURICH
SWITZERLAND

ROOMS
126

RATES
CHF 190 –
CHF 450

OPEN
10/2012

SWITZERLAND
ZURICH

25HOURS HOTEL ZÜRICH WEST
Zurich

Zurich West sheds old Swiss stereotypes. In this former industrial neighborhood you're more likely to spot independent cultural spaces and eclectic design stores than watchmakers or chocolate shops. Add jazz clubs, antique bookshops and graffiti-splattered streetscapes to the melting pot, and you have the perfect setting for 25hours Hotel Zürich West, a property that places the local environment at the core of its design concept. The tram from Zurich's main train station will drop you by the hotel's lobby, where flashes of raspberry and fuchsia furnishings light up the bar area, mirroring the area's artistic buzz and colorful nightlife. In addition to creating an energetic and joyous interior landscape, Zurich resident and award-winning interior designer Alfredo Häberli has scribbled his personal local recommendations on surfaces and objects throughout the hotel, encouraging guests to visit his favorite hotspots. Precious metals like gold, silver and platinum lend their names to the hotel's 126 rooms. It is bronze, however, that recurs most frequently through the Living Room – an open-plan space for mingling with other like minds – the business facilities and the top-floor wellness area overlooking the city. Visible next door is the new campus for Zurich's University of the Arts, an institution that attracts artists from across the globe and amplifies the area's creative energy.

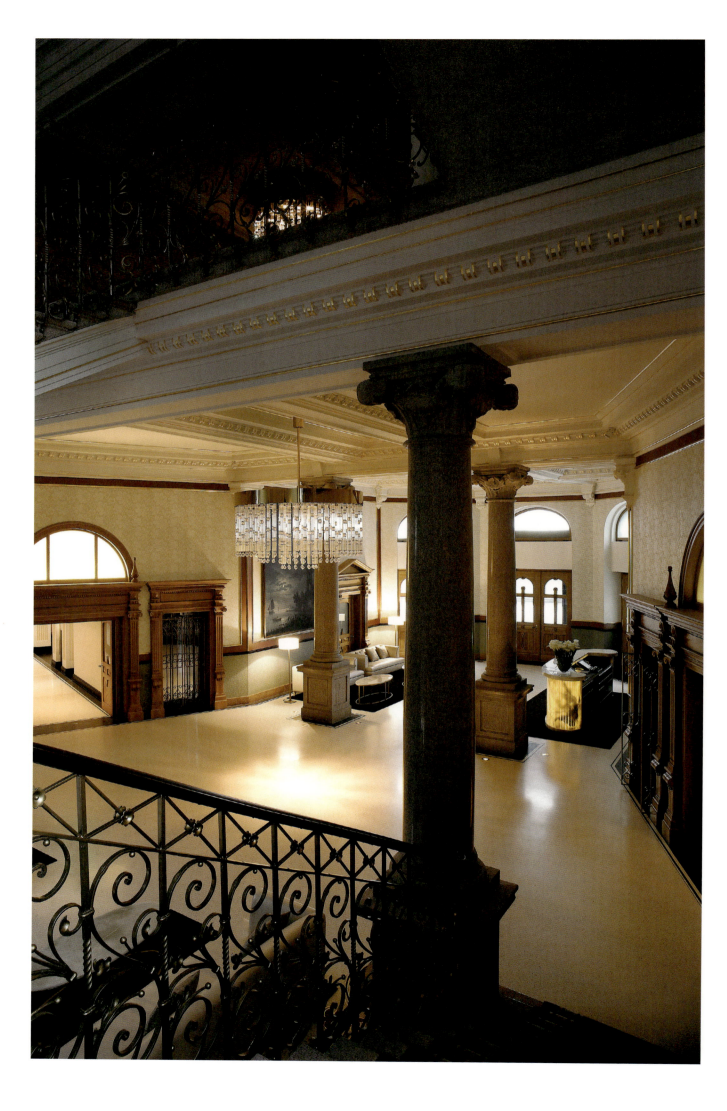

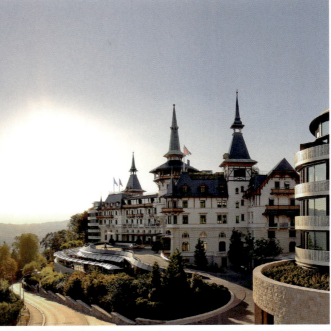
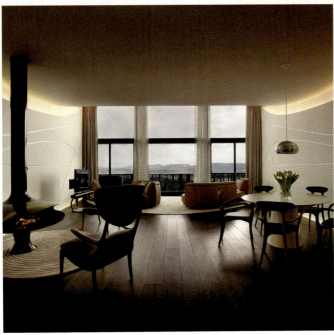
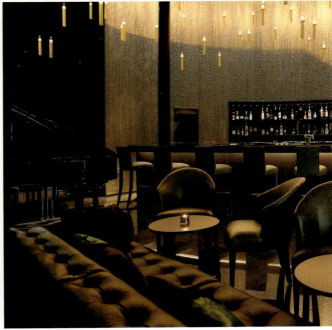

THE DOLDER GRAND
Zurich

Perched above Lake Zurich against a scenic backdrop of rolling wooded hills, The Dolder Grand is both a historic landmark and a testament to contemporary architecture. The luxury hotel boasts 173 rooms, a two Michelin-star restaurant and the Garden Restaurant with spectacular views; and a 4,000-square-meter spa. While The Dolder Grand's proximity to Zurich offers guests all the excitement of a cosmopolitan city, its pristine setting in Switzerland's beautiful nature provides a serene retreat from urban life. In 2004, Dolder Grand owner Urs E. Schwarzenbach and Managing Director Thomas Schmid sought out world-renowned architect Lord Norman Foster to helm the historic hotel's structural renovations. Foster added two modern wings with sweeping glass facades to either side of the hotel's 19th-century main building with traditional wooden framework, chiseled awnings, and fairy-tale steeples. Each room manifests a sophisticated balance of classic European elegance and innovative modern design. Ambient lighting and plush fabrics in subdued lilac create a mellow setting, while flourishes of regal patterns in dramatic hues like crimson and ochre offer an aristocratic feel. By embracing its historic origins, The Dolder Grand's updated style pays homage to the past while epitomizing modern luxury.

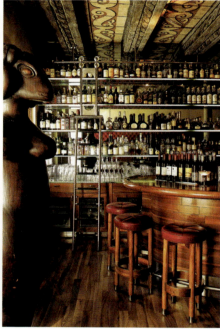
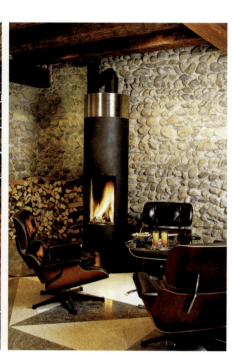

WIDDER HOTEL
Zurich

The Widder Hotel is a hamlet of nine historical residences, many dating back to the Middle Ages, expertly renovated and subtly linked with staircases and porticoes to create a feeling of home-scale intimacy and exclusive luxury. Swiss architect Tilla Theus preserved not only the individual facades, but also the internal floor plans and structures, giving rise to a somewhat labyrinthine hotel that's often been hailed as Switzerland's finest. High-tech construction techniques merge seamlessly with age-old building elements. A case in point is the glass roof atop a 12th-century stone house, or the integration of nine elevator banks, including one of glass and chrome that rises alongside a wall of river stones. Delightful original features like exposed wooden beams and frescoes are mixed with classics of modern furniture design in steel and glass. Each guestroom has its own layout and interior design, with some refreshing surprises, such as leather bedspreads, not to mention the latest modern amenities from Bang & Olufsen. Living proof that the ancient and the modern can coexist in perfect harmony, the Widder is worth a trip to Zurich in its own right.

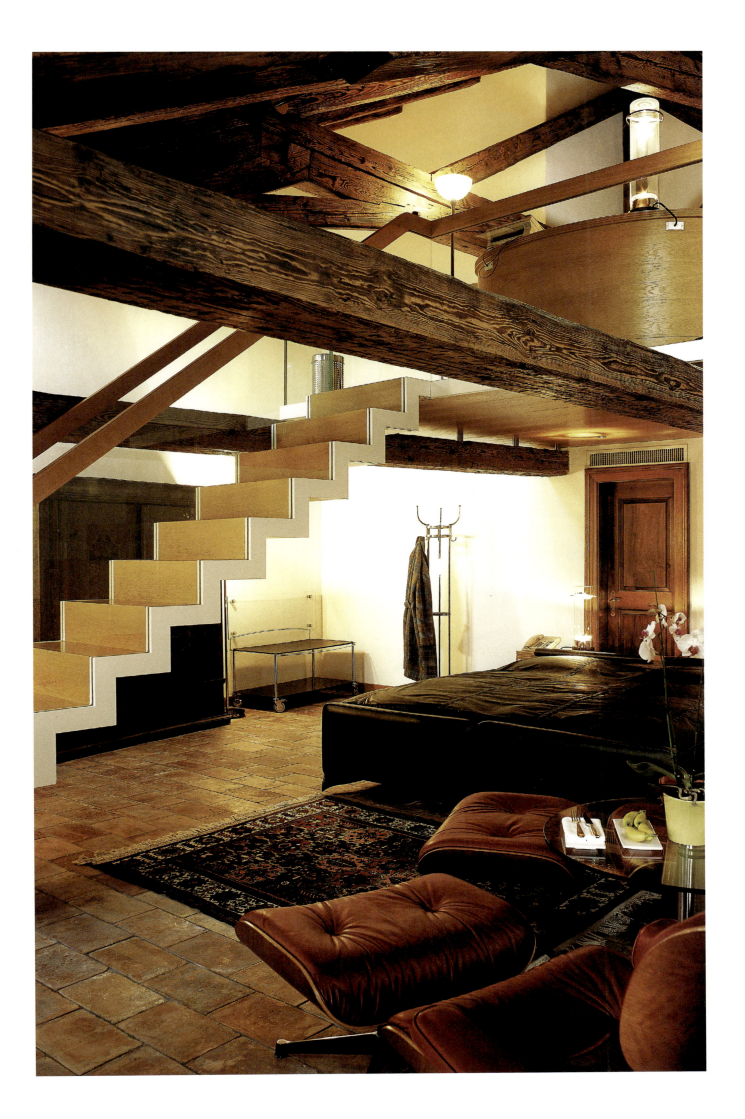

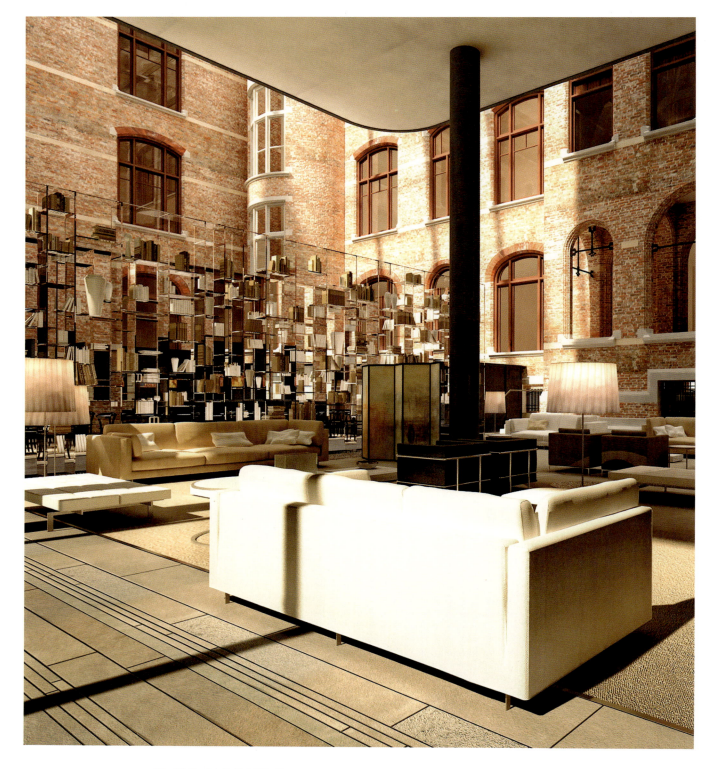

CONSERVATORIUM HOTEL AMSTERDAM
Amsterdam

Leave it to visionary owner Georgi Akirov to unveil a one-of-a-kind hotel following the meticulous transformation of one of Amsterdam's most iconic buildings. Akirov appointed the award-winning Milan-based designer Piero Lissoni, who also created the interiors of the Mamilla Hotel Jerusalem, to oversee the evolution of the property and combine a classic and contemporary aesthetic with great aplomb. Lissoni sought to pay homage to the building's history while adding his own inimitable touches such as the glass-covered atrium and ubiquitous exposed beams. The resulting property, ideally situated in the cultural heartbeat of Amsterdam, is one of the city's most eagerly awaited arrivals. The Conservatorium Hotel represents The Set Hotels' first foray outside of Israel; however, the ethos of delivering a holistic experience is visible throughout the property. The hotel will pay tribute to the Amsterdam Conservatorium's legacy as soothing classical music selections echo through its vaulted ceilings. Several communal dining outlets – three cafes, restaurants, and bars – will offer guests the opportunity to enjoy convivial outings and discover new local flavors and culinary talents. The 128 rooms and suites provide a respite for the weary, while the Akasha Holistic Wellbeing Center promises to replenish and refuel in the most inspired of settings. The attention to detail is nowhere more visible than in the caliber of personalized service: one that always seeks to forecast a guest's needs and surpass expectations.

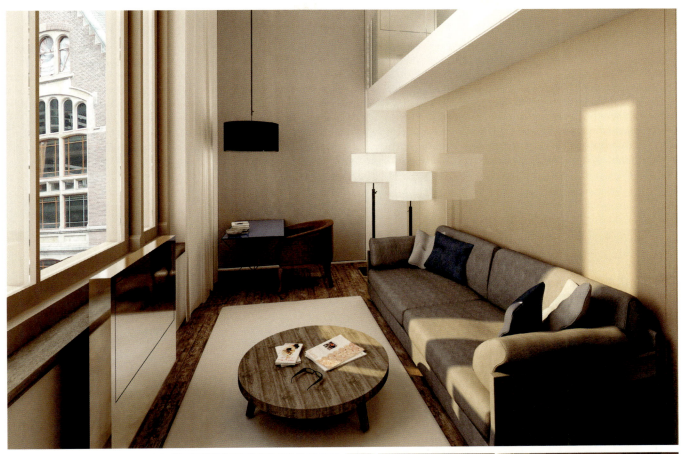

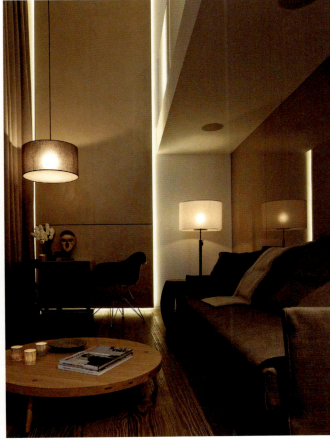

KRUISHERENHOTEL MAASTRICHT
Maastricht

Located in the city center of Maastricht, this renovated 15th-century monastery of the Crutched Friars offers you a breathtaking synthesis of a veritable Gothic exterior with a sleek, dressed-down modern interior. Many innovative solutions for structural challenges (e.g., a glass elevator connecting the church to the monastery area) only confirm the notion that the sobriety of modern style forms a perfect match for a late-medieval architectural expression of religious virtue. The 60-room Kruisherenhotel Maastricht complex consists of the original monastery as well as a Gothic church, which now houses the reception area and several hotel facilities, including conference rooms, a library, a boutique, a restaurant and a wine bar. Another spectacular feature is the newly installed mezzanine where guests are served breakfast while taking in views of Maastricht through the chancel windows. The "espace vinicole" is no less stunning, both for its impressive offering of wines as well as the strikingly large glass vault which houses them. The interior is matched by beautiful monastery gardens – a haven in the midst of a vibrant city center.

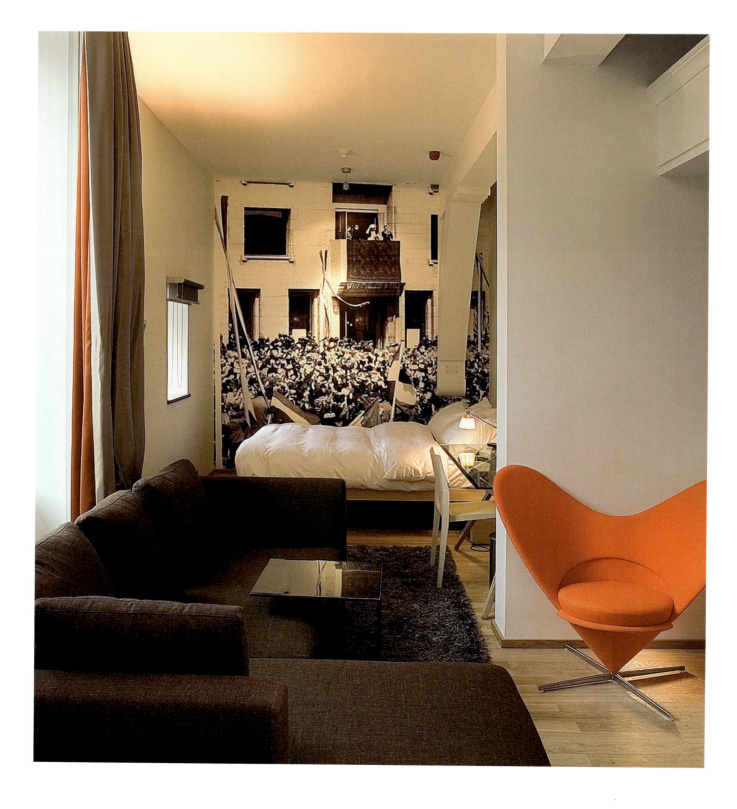

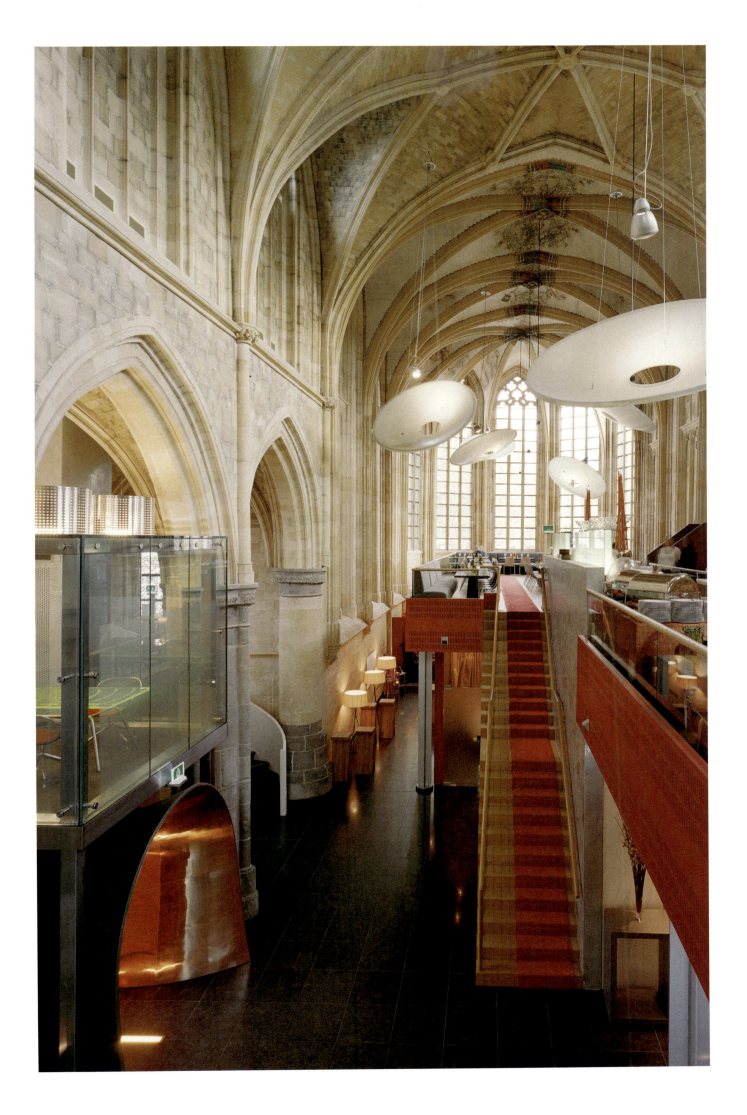

HILLSIDE SU
Antalya

On a green bank overlooking the Mediterranean, the Hillside Su hotel is a clean white stage on which guests are invited to play out Turkish designer Eren Talu's seductive disco dream – at a breezy pace and to the soft beats of ambient music. White is the color of choice, but Talu breaks up its monotony with a dazzling light display that begins the moment guests enter the reception area. Six huge disco balls hang in the six-floor atrium lobby. At dusk, they start to spin, launching a mesmerizing and playful light show that sets the tone for exploration and inner freedom. On this stage neither designer furniture nor fixed settings play the leading roles, but rather funky details that never cease to surprise. The catwalk-like lobby and the Iroko-wood deck of the expansive pool area both act as a socializing magnet, while the 294 guestrooms are sleek white cubes of calm. With a name derived from the Turkish word for water and providing endless surprises to the eyes, Hillside Su hotel is a destination in its own right.

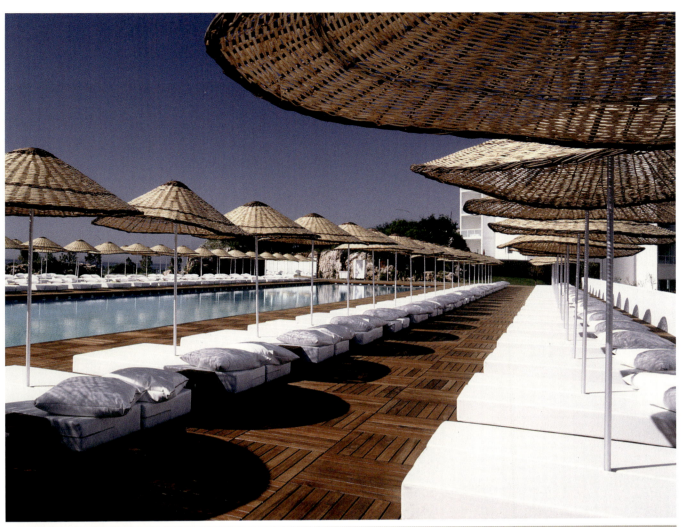

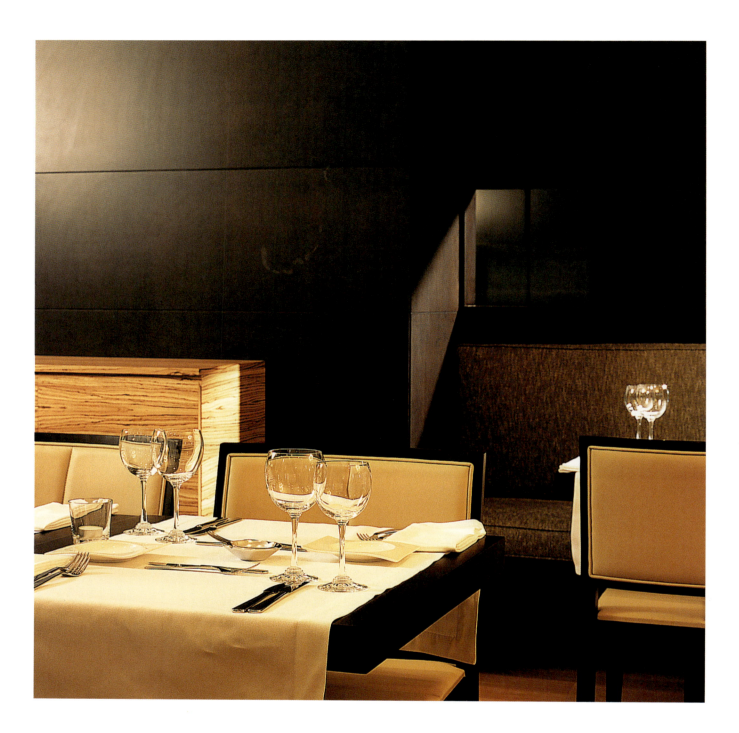

BENTLEY HOTEL
Istanbul

Befitting its location in Istanbul, the city that straddles Europe and Asia, the Bentley is a careful balance of Orient and Occident, of colorful tradition and contemporary cool. The work of Milanese architects Piero Lissoni and Nicoletta Canesi, it's a temple of radiance and light in the pulsating heart of the city's European section, and a meeting point for the young, international elite. Oversized windows usher in visual stimulation from the streets outside, enhancing an interior filled with the formal purity and colorful shades typical of Italian design. In the lounge, guests can taste a blend of eastern and western influences, as Ottoman-turquoise velvets provide a voluptuous juxtaposition with the sleek table by Finnish architect Eero Saarinen. The light-flooded interiors of 40 guestrooms and ten suites bask in pale hues of blue and beige, green and gray, with a hint of the traditional in parquet flooring and furniture of olive-stained oak. Guests can step onto private terraces with evocative views of the ancient skyline, or mingle with local trendsetters in the chilled-out lobby bar. Amid all the clamor and jumble of Istanbul, this is a haven of harmony and calm.

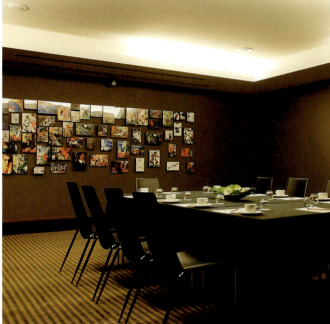

THE SOFA HOTEL & RESIDENCES
Istanbul

When renowned Turkish architect Sinan Kafadar built Istanbul's Sofa Hotel, he had something bigger in mind than just an average boutique property. His creation is a mash-up of chic atmosphere, ultramodern technology, extraordinary service, and celebrated art gallery – a true gem of the local hotel scene, dressed in minimalist chic with hints of Ottoman flair. Of course, The Sofa comes equipped with everything guests have come to expect of a modern luxury hotel: fitness room, pool, sauna, steam room, and Turkish bath. In addition, there's the Sanitas Spa and Wellness Center. The hotel also features the Longtable bar and the restaurant Café Sofa, where guests can choose from a menu of gourmet international cuisine. The Sofa's 65 deluxe rooms and 17 suites come fully outfitted with high-speed wireless Internet, interactive satellite television, video on demand, CD and DVD player, bar setup, rainfall shower, bathtub, pillow menu, and, naturally, a specially designed sofa. Their highlight, though, is a 24-hour Anything, Anytime button, which functions precisely as it sounds. Guests can be assured of receiving personalized, no-holds-barred service around the clock. The hotel's pièce de résistance, however, is its penthouse art gallery, Art*8, 300 square meters of indoor space and 350 square meters of outdoor space offering stunning city views. Down below, the chic Nisantasi neighborhood in which The Sofa Istanbul stands offers galleries, boutiques, and restaurants in abundance. For those looking to host business or social events, the hotel offers 1,700 square meters of conference space divided into several rooms and open areas.

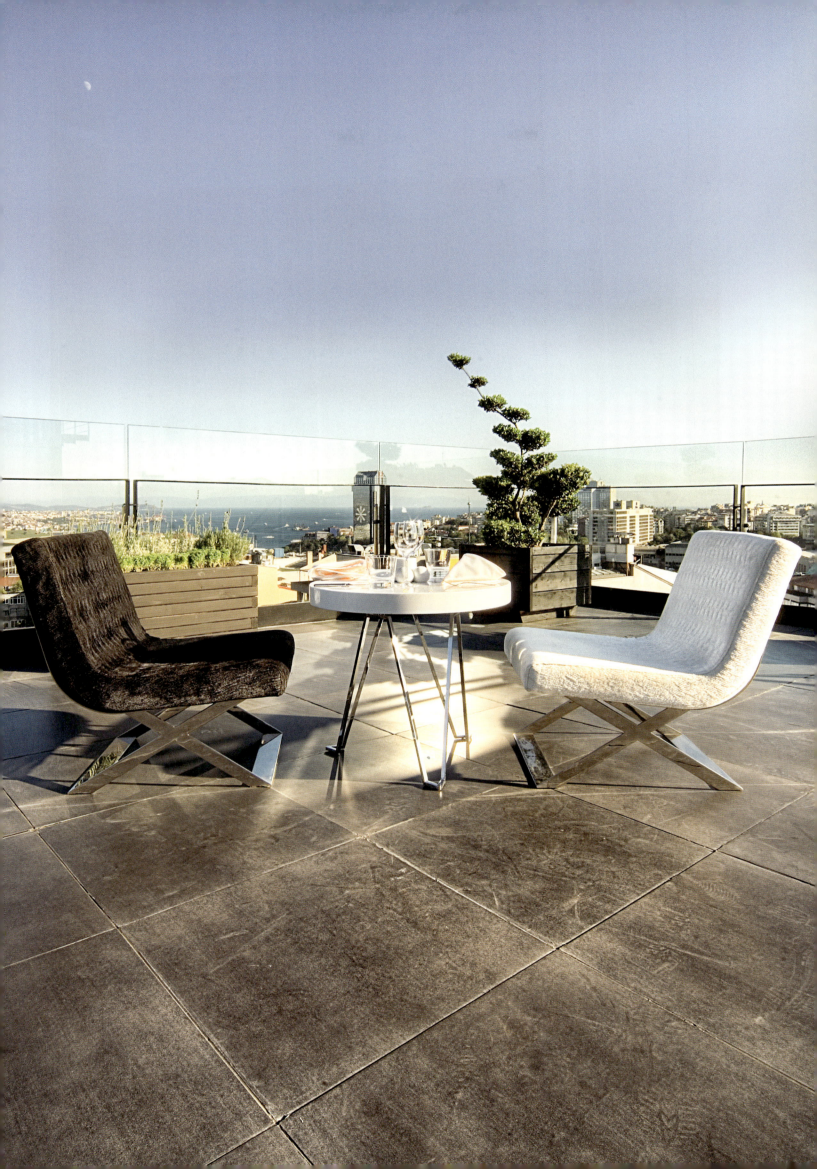

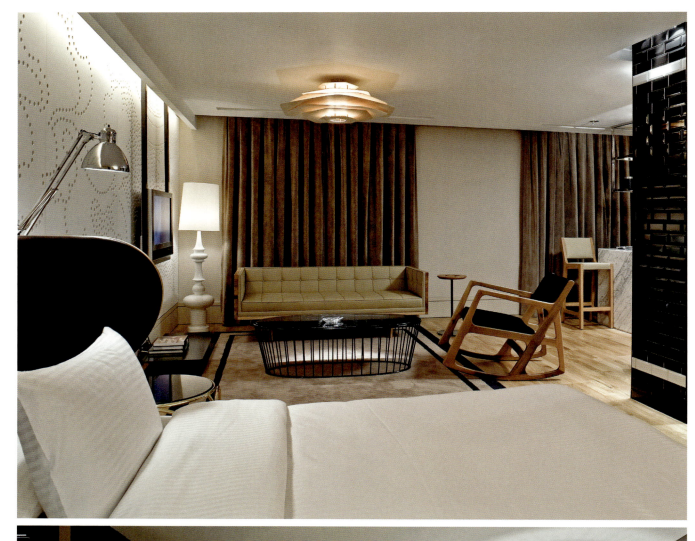

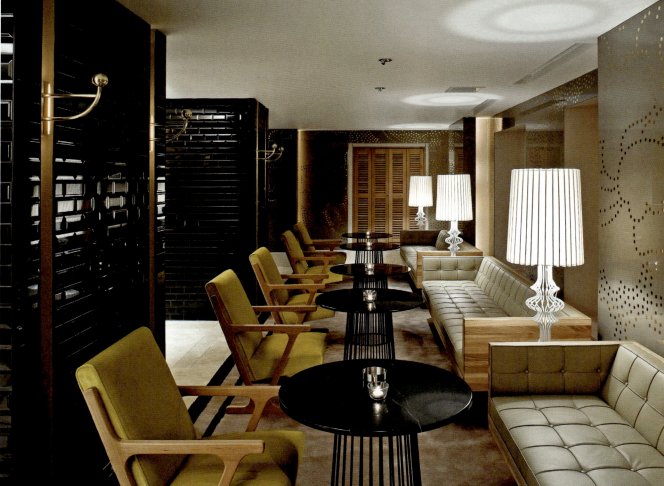

TURKEY ISTANBUL

OPEN 05/2008

RATES EUR 179 – EUR 499

ROOMS 17

ADDRESS DEFTERDAR YOKUSU NO.26, CIHANGIR 34433 ISTANBUL TURKEY

WWW.DESIGNHOTELS.COM/ WITT

SIGNATURE

WITT ISTANBUL HOTEL
Istanbul

Located on Istanbul's European side in a chic bohemian neighborhood of eclectic antique shops, cafes, and designer boutiques, the Witt Istanbul Hotel occupies an unassuming corner building on a residential street. Owner and Istanbul native Tuncel Toprak chose the Witt's location in Cihangir for its connection to a charmingly authentic local community. The Witt's stylish yet domestic atmosphere, exceptionally personalized service, and Toprak's extensive network afford guests an intimate glimpse of everyday life in the thriving metropolis, without sacrificing style or comfort. Autoban, the award-winning Istanbul-based architecture and design firm, outfitted the hotel with an array of distinctly modern furnishings. The interior's monochromatic mix of natural, earthy tones and black and white accentuates each room's sculptural elements and spacious design. Istanbul's rich history is reflected in the designers' use of materials, such as the Marmara marble of classic Ottoman architecture. Each suite is equipped with a kitchenette, bar, lounge area, and a private balcony. The latter offers captivating views over Istanbul's picturesque skyline of handsome mosques, ramshackle rooftops, and the glistening topaz waters of the Bosporus.

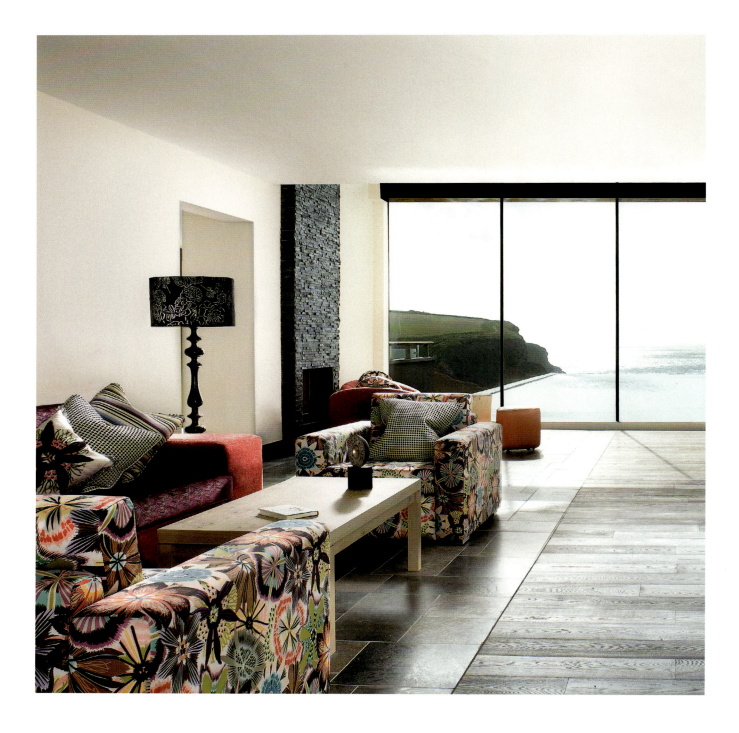

THE SCARLET
Cornwall

A stunning seaside escape perched atop the cliffs of Cornwall, The Scarlet hotel features a thoughtful philosophy, bold architecture, and a breathtaking location. Surrounded by National Trust-protected coastline, The Scarlet both capitalizes on and harmonizes with its environs, providing eco-friendly luxury and remarkable natural views in an environmentally sustainable manner. The hotel's 37 individually designed rooms ingeniously make the most of the dramatic views of the beach below. Each features a private outdoor space in the form of a balcony, courtyard garden terrace, or rooftop pod. A restorative hotel spa serves as a quiet, almost spiritual sanctuary for relaxation. There is a room full of tented, lantern-lit, and cocoon-like hanging pods. The spa includes a sauna, hammam, meditation room, natural reed-filtered pool, and two log-fired seaweed hot tubs perfect for outdoor stargazing at the cliff's edge. The Scarlet restaurant is headed by Jeremy Medley, whose hearty dishes are surprising without being pretentious. Menus change daily to take full advantage of seasonal local ingredients at their best, and a comprehensive wine list features daily selections to complement Medley's magnificent creations. A low-key deli menu and Cornish afternoon tea can be served anywhere throughout the premises for an in-between snack.

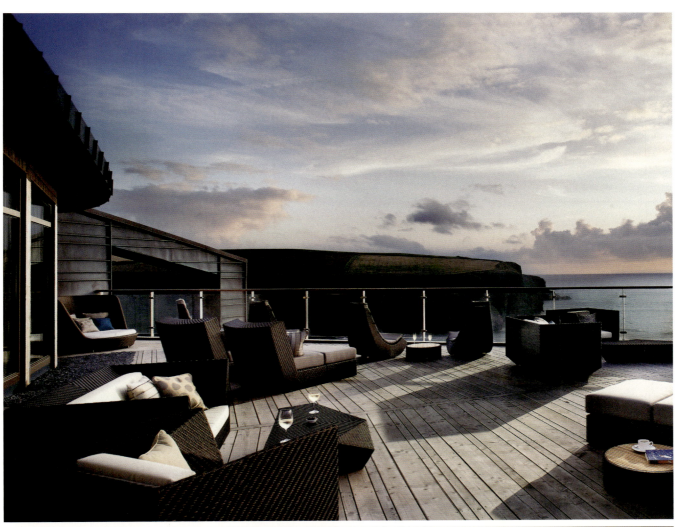
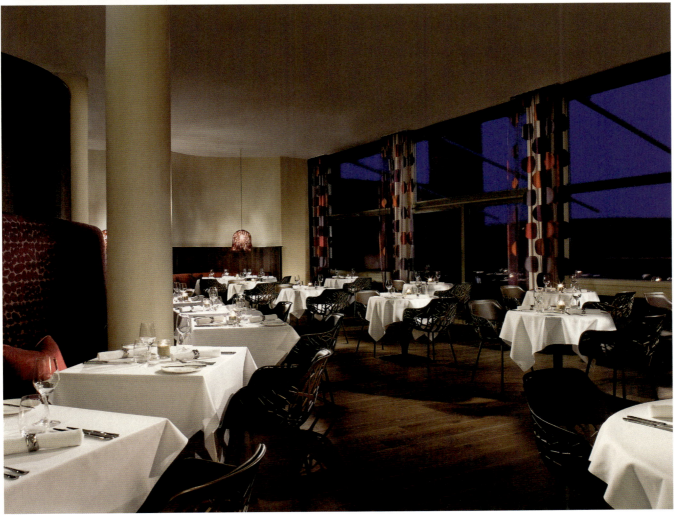

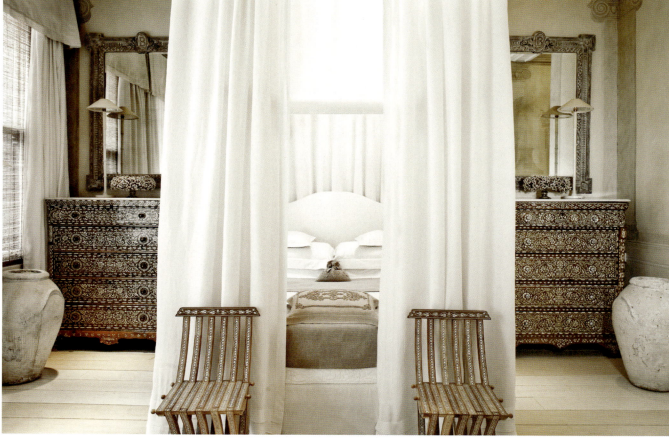
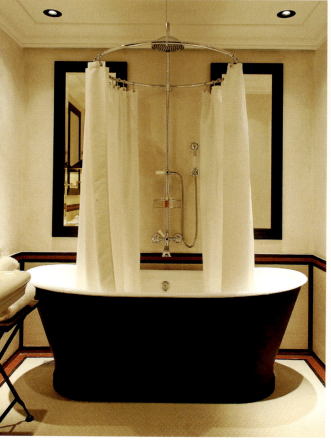
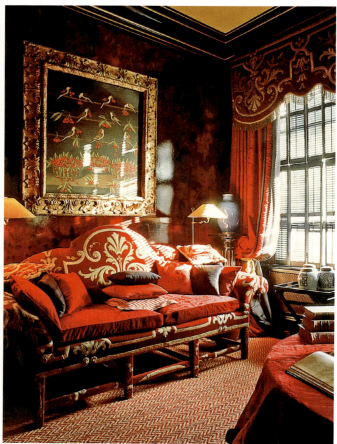

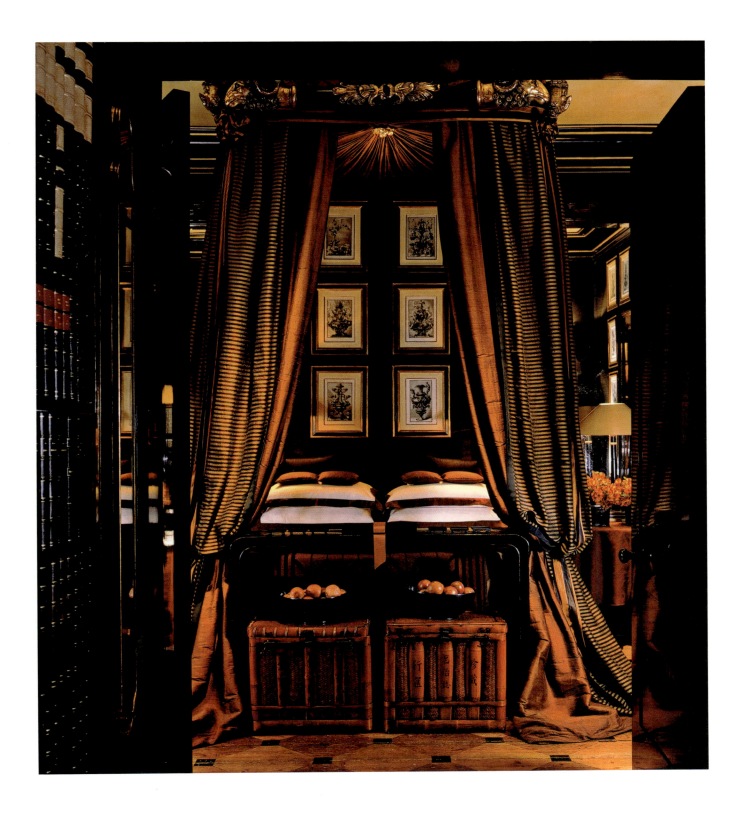

BLAKES HOTEL
London

If you ever needed reassurance that the spirit of adventure is alive and well, even in the center of London, Blakes is it. Designed by former Bond girl Anouska Hempel, now known globally for her striking interior designs, this recently refurbished multimillion pound South Kensington couture hotel is a world of grandeur and exoticism. Behind the black Victorian façade, you'll find a tantalizing fusion of eastern and western styles. Polished mirrors bounce rich walnut tones around the lobby, creating a sense of decadence and theater, while the critically acclaimed subterranean restaurant attracts some of the world's most famous movie stars, actors and designers. Each of the 47 refurbished guest rooms at Blakes takes inspiration from a different far-off land. There's the immaculate Corfu Suite, which centers around a tall four-poster bed swathed in romantic pure-white muslin, and the Empress Josephine Suite, where opulent shades of ebony and gold shroud the tented bed. TVs, telephones and iPod docks by Bang & Olufsen make it possible for every room to function as a self-contained hideaway. And with staff placing a special emphasis on respecting guests' privacy, even the luscious shared courtyard feels secluded and cocoon-like. As Hempel herself says, "Blakes is a world within a hotel. It exudes luxury with imagination, and combines fine living with a sense of theatre and panache."

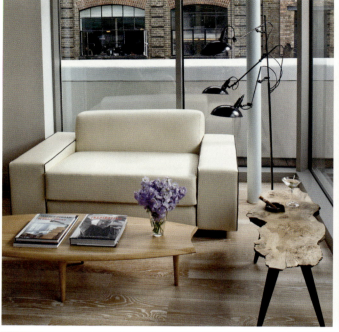
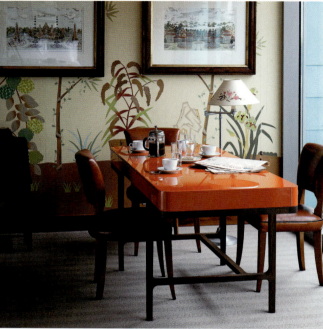
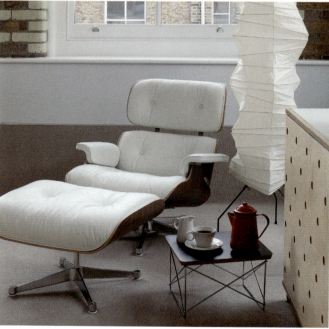
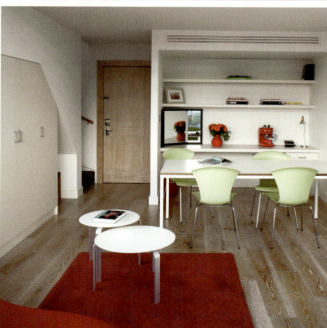

BOUNDARY
London

Lovers of art, admirers of design: Sir Boundary welcomes you. Located amid the plentiful galleries and studios of London's famed Shoreditch quarter, Boundary is a celebration of fine art and fine taste for the sophisticated traveler. Its 12 elegant, contemporary guestrooms are each inspired by a legendary designer or design movement, from Young British to Bauhaus, Eileen Gray to Le Corbusier. Above, five suites, including four duplexes, range from Modern Dickensian to Modern Chinoiserie, featuring private outdoor balconies and impressive urban views. Boundary gastronomy is just as expertly curated as Boundary design. The main restaurant pays homage to the timeless recipes and traditions of England and France: a roast leg of lamb and rib of beef are presented for Sunday lunch and various English game birds are offered seasonally. The Boundary Bar's wine list includes over 500 artisan growers and aristocratic estates from around the world. Upstairs, a separate kitchen and bar serve the Boundary Rooftop, a 48-seat grill restaurant with open fireplace set in the midst of a stunning garden by Nicola Lesbirel with 360-degree views over London. The hotel is also home to Albion, a ground-floor bakery, café, and specialty British food shop with pavement seating directly on Boundary Street.

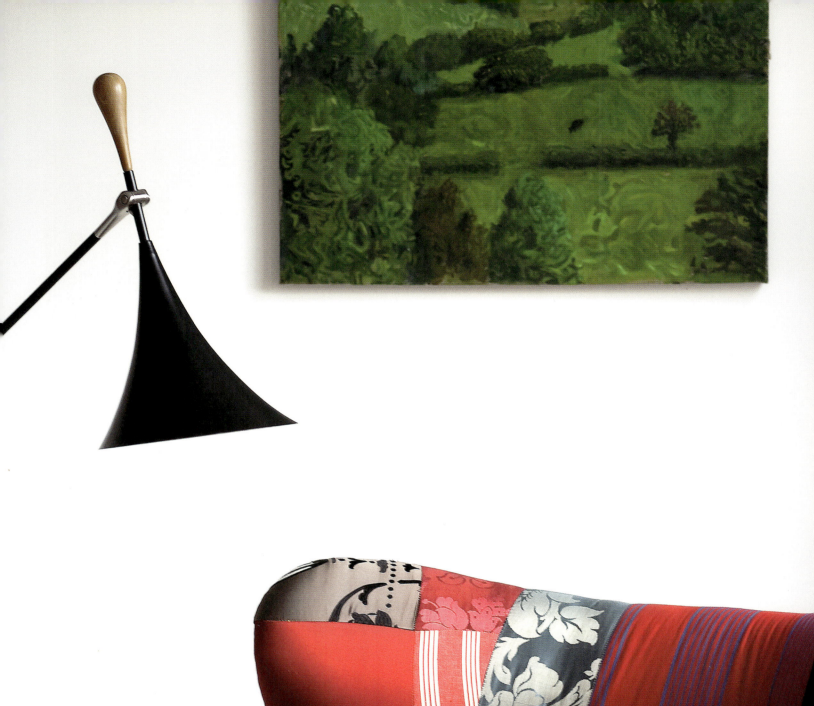

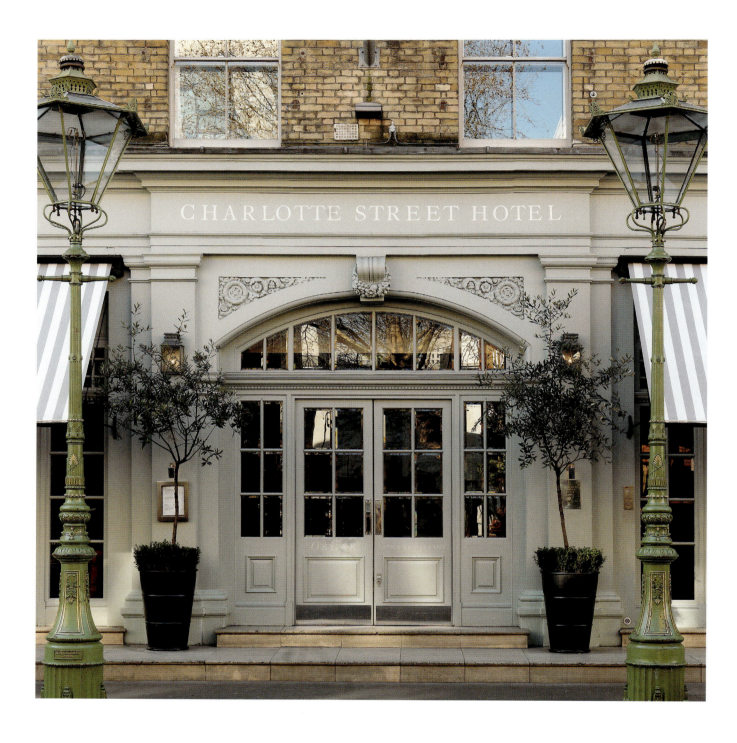

UNITED KINGDOM
LONDON

OPEN
06/2000

RATES
GBP 240 –
GBP 950

ROOMS
52

ADDRESS
15 CHARLOTTE STREET
LONDON W1T 1RJ
UNITED KINGDOM

WWW.DESIGNHOTELS.COM/
CHARLOTTE_STREET_HOTEL

✳ RARE

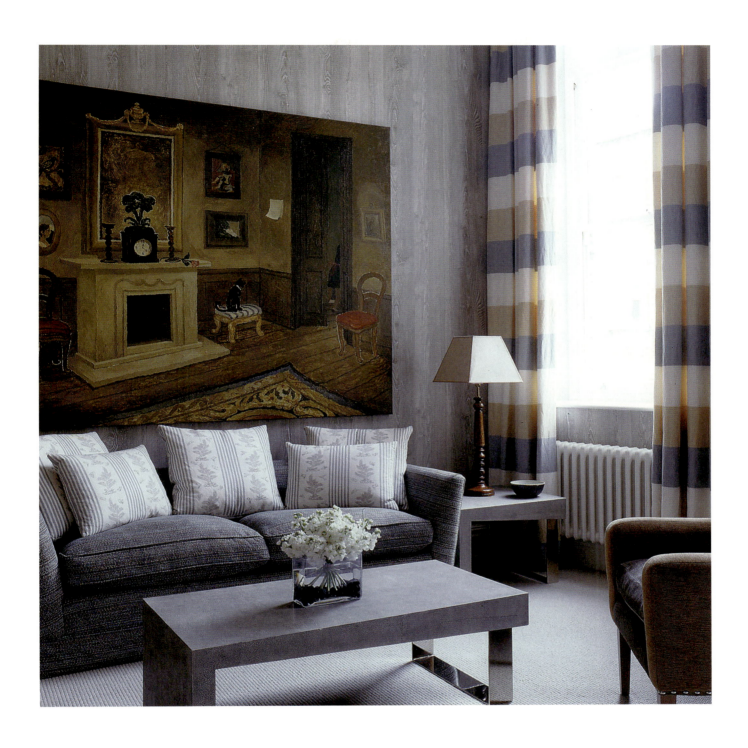

CHARLOTTE STREET HOTEL
London

At the Charlotte Street Hotel, individually decorated guestrooms, intimate drawing rooms, and an array of priceless modern art combine to inspire guests to make Kit Kemp's converted warehouse their home away from home. A sensual Botero sculpture and alluring abstract landscapes by Roger Cecil welcome arriving guests and lure them towards wood-paneled drawing rooms, where they can lounge in overstuffed furniture flanked by stone fireplaces and handpicked artwork icons of the famed Bloomsbury school. The Bloomsbury aesthetic extends to sumptuous guestrooms where period paintings, handmade furniture, and even a vintage dressmaker's doll serve as eye-catching centerpieces. Kemp's signature use of patterned fabrics as a decorative language perfectly combines function with sophistication. Although history is brilliantly presented throughout the space, business travelers' professional needs are satisfied in a state-of-the-art private screening room, fully equipped with the latest mod cons. Such compelling contrasts between postmodern practicality and old-fashioned allure are embodied by the tableau Kemp commissioned for the bar and restaurant from Alexander Hollweg, which updates Roger Fry's 1916 fresco *Scenes of Contemporary London Life* with a treasure trove of scenes from today.

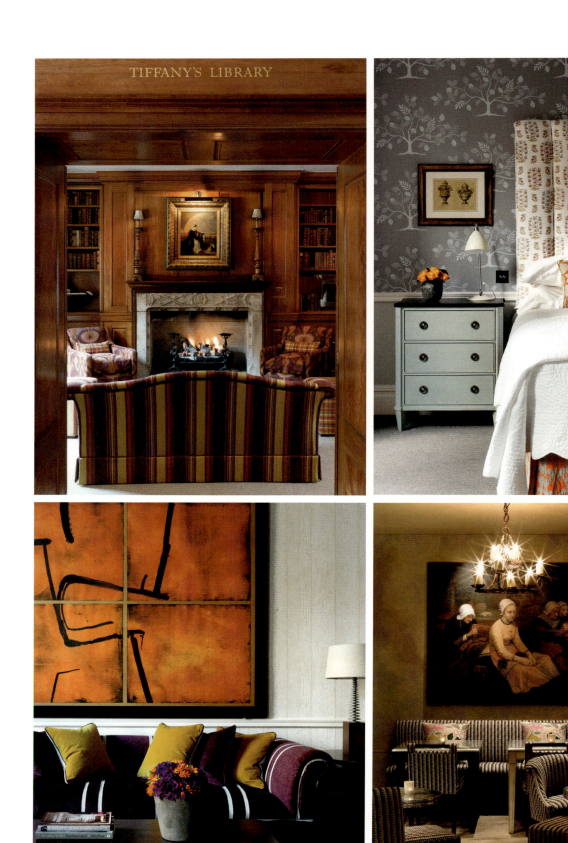

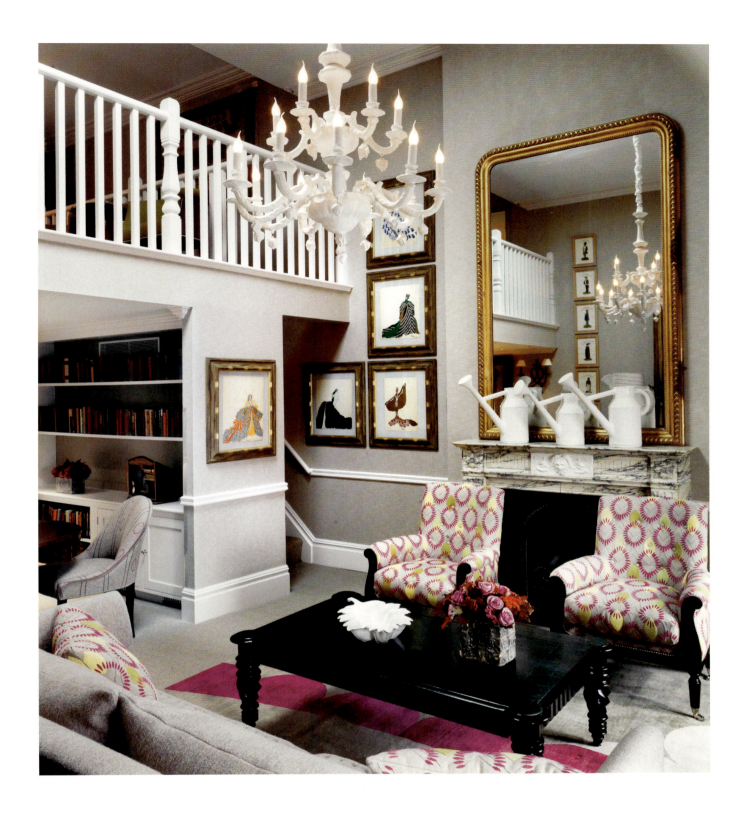

COVENT GARDEN HOTEL
London

In the midst of London's famed entertainment district, the Covent Garden Hotel's dramatic design commands center stage. In the reception area, guests pass grand curtains festooned with English roses before entering a world of aged woods, dignified architecture, and head-turning interiors by designer Kit Kemp. Her signature mix of abstract and figurative upholstery patterns, demi-canopies, decorative headboards, flowing drapes, and matching wallpaper envelop guests in archetypical English charm. Kemp taps into the surrounding theatrical energy by highlighting dignified stone stairs, maple-wood paneling in the generously sized drawing room, eye-popping upholstery, and stunning inlaid wood details on the furnishing. Guests in search of an intimate retreat can withdraw offstage into Tiffany's Library, which provides a radiant fireplace and honor bar. The gym, beauty spa, two private dining rooms, and a private screening room provide all of the most modern amenities, while the pewter-paned mirror, cosy banquettes, and tucked-away corners of Brasserie Max gain widespread applause as a pre- or post-theater retreat.

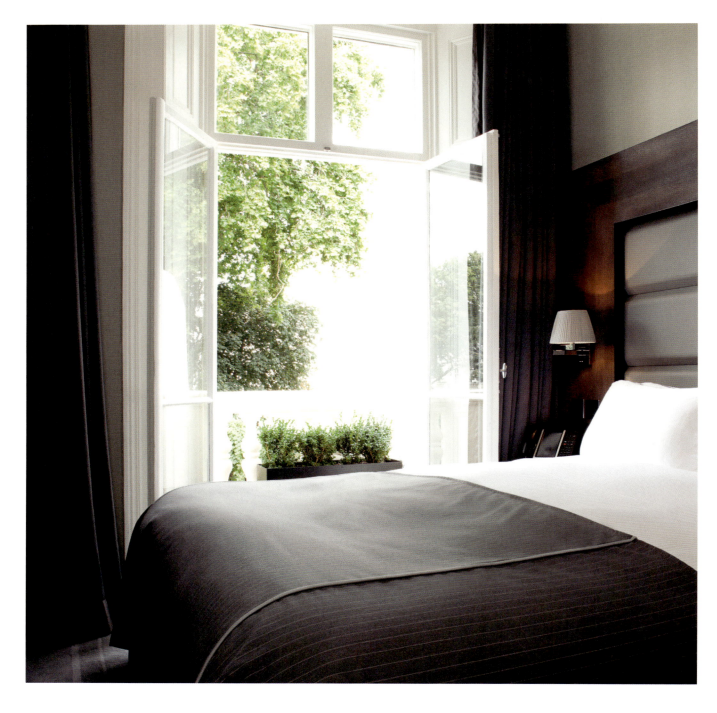

ECCLESTON SQUARE HOTEL
London

Historical on the outside, yet timeless on the inside, Eccleston Square Hotel is an elegant fusion of old meets new and one of London's most hi-tech hotels. The impressive Georgian building is located on an award-winning, pristine garden square in Belgravia. Behind its doors lies an ultra-modern hideaway – an "urban cocoon" with cutting-edge technology in every room. High ceilings and large original windows dominate the lower half of the Grade II listed building. Black Murano glass chandeliers and Promemoria furnishings provide a tasteful and luxurious feel to the guest areas, which include a reception and restaurant with bar, drawing room and media lounge. From B&B Italia wood finishes and Brinton's Axminster carpets to statutario Italian marble and light grey silk wallpaper, the look and feel of a contemporary Italian super yacht cabin features throughout the hotel. Central to each of the 39 rooms are Hästens electronically adjustable beds, with massage features and the latest 46" HD 3D Plasma screens. The technology within the rooms is powered by the iPad2, from which guests may request any of the hotel services they require – from in-room dining to booking a table at some of London's hottest clubs. High pressure rainfall showers and "smart glass" walls in the bathrooms provide the ultimate shower experience. Good sleep and well-being are central to the design concept devised by Olivia Byrne, and the attention to detail is impeccable. "The ethos of the hotel is quite simple," she said. "We want our guests to leave the hotel feeling better than they did when they arrived."

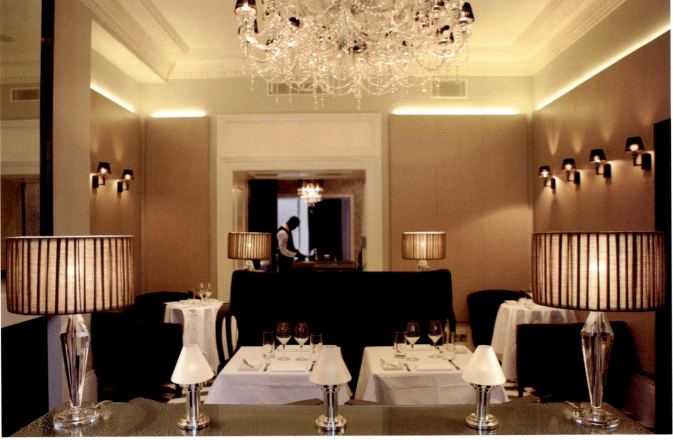

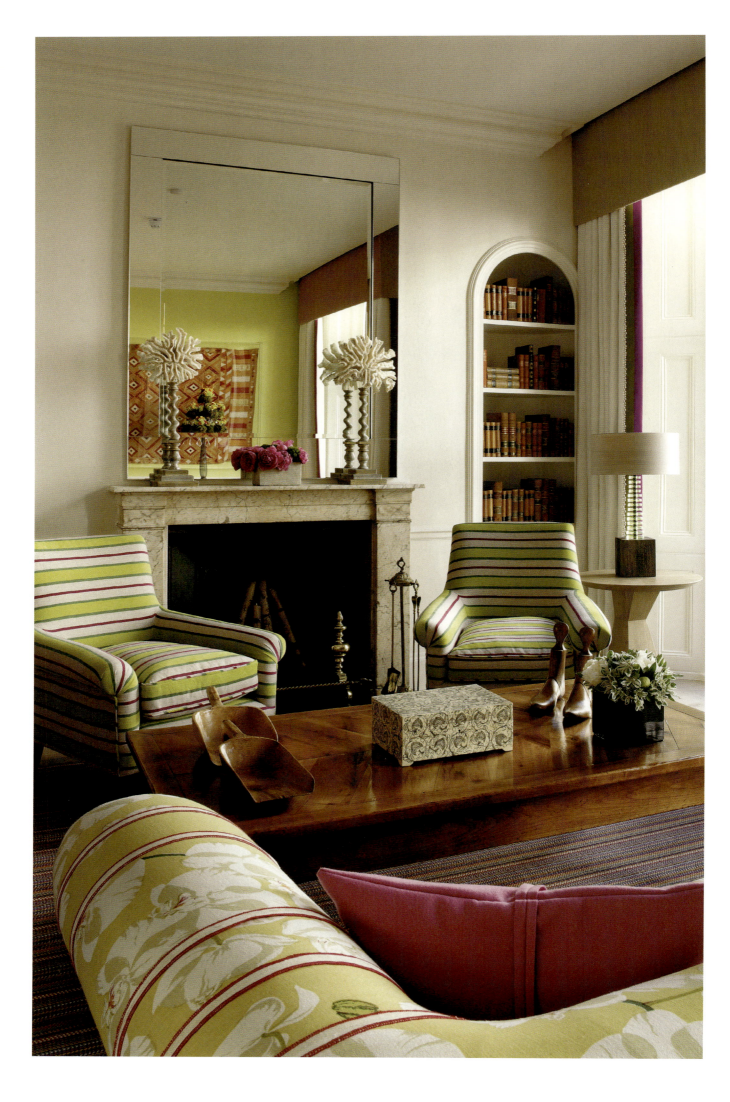

* RARE

WWW.DESIGNHOTELS.COM/
HAYMARKET_HOTEL

ADDRESS
1 SUFFOLK PLACE
LONDON SW1Y 4BP
UNITED KINGDOM

ROOMS
50

RATES
GBP 260 –
GBP 3000

OPEN
05/2007

UNITED KINGDOM
LONDON

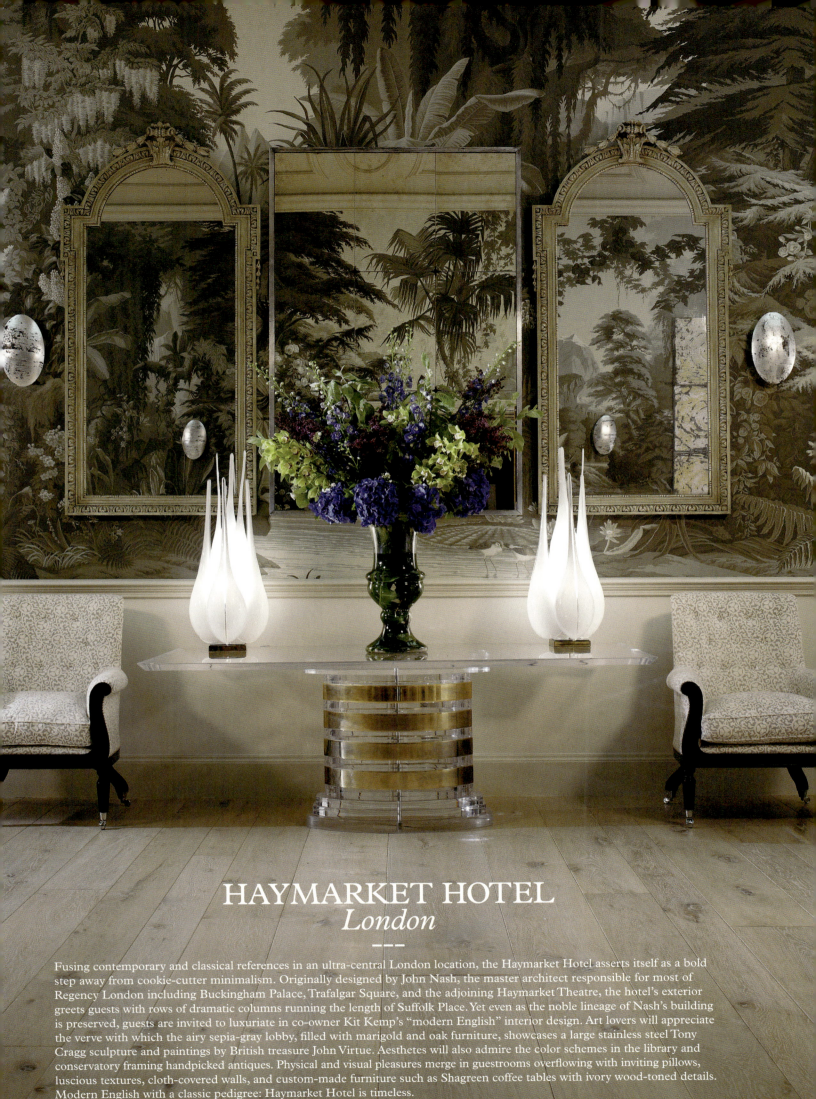

HAYMARKET HOTEL
London

Fusing contemporary and classical references in an ultra-central London location, the Haymarket Hotel asserts itself as a bold step away from cookie-cutter minimalism. Originally designed by John Nash, the master architect responsible for most of Regency London including Buckingham Palace, Trafalgar Square, and the adjoining Haymarket Theatre, the hotel's exterior greets guests with rows of dramatic columns running the length of Suffolk Place. Yet even as the noble lineage of Nash's building is preserved, guests are invited to luxuriate in co-owner Kit Kemp's "modern English" interior design. Art lovers will appreciate the verve with which the airy sepia-gray lobby, filled with marigold and oak furniture, showcases a large stainless steel Tony Cragg sculpture and paintings by British treasure John Virtue. Aesthetes will also admire the color schemes in the library and conservatory framing handpicked antiques. Physical and visual pleasures merge in guestrooms overflowing with inviting pillows, luscious textures, cloth-covered walls, and custom-made furniture such as Shagreen coffee tables with ivory wood-toned details. Modern English with a classic pedigree: Haymarket Hotel is timeless.

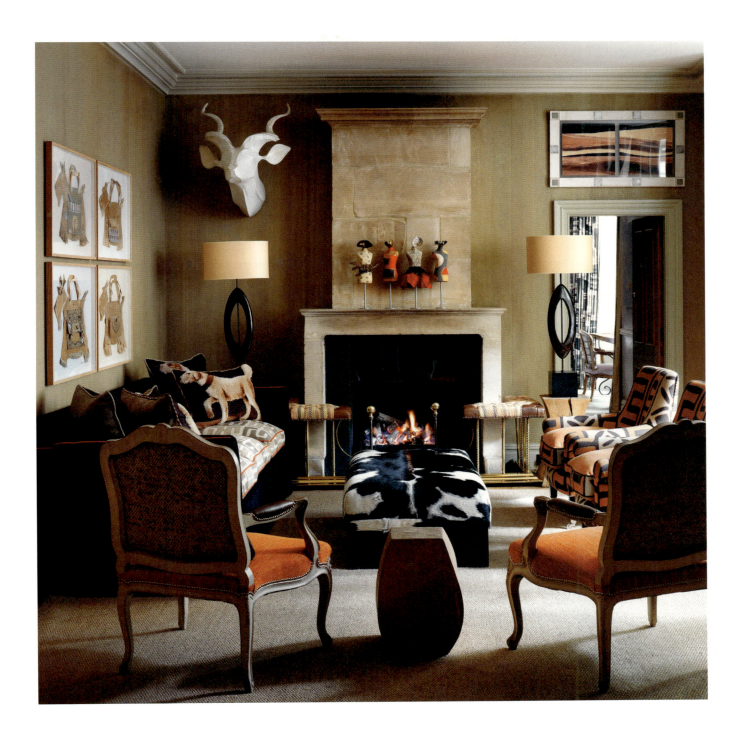

KNIGHTSBRIDGE HOTEL
London

On a quiet leafy street not far from Harrods and Harvey Nichols, designer Kit Kemp has added another chic bauble to her collection of London luxury properties. As admirers of Kemp's classically British aesthetic well know, she pays careful attention to each room, filling it with modern English style featuring clean neutrals and bold colors. In this Knightsbridge gem, the drawing room, library and lobby are adorned with original works by significant British artists. Art lovers will adore the Carol Sinclair sculpture that rises like stalagmites from the floor, but the art does not overshadow Kemp's signature harmonious mixture of patterns, fabrics and furniture styles. Setting this location apart from her other hotels are the African sculptures and fabrics, mixed with tasseled curtains and the blue neon rungs of a ladder in the library, which add adventuresome touches to the stately interior. First-floor guests gaze through floor-to-ceiling windows onto one of London's most charming areas, while the upper floors reveal tantalizing glimpses of Harrods' rooftops. Although the guestrooms' cozy cushions and array of pretty fabrics could be considered quaint, the jazzy contrast of stripes, florals, and geometric shapes injects a thrilling jolt of modernity into their comforting charm.

NUMBER SIXTEEN
London

Only the corresponding house number suggests that the white-stucco Victorian terrace situated just steps from London's major museums and Harrods is the hotel Number Sixteen and not an upscale private residence. Like the other Kit Kemp properties in town, the designer's custom textiles in each of the 41 individually outfitted guestrooms are a study in elaborate detail and dramatic patterns. Guests can mingle in the hotel's handsome drawing rooms, and some guestrooms have private courtyards overlooking the hotel's stunning English garden. One drawing room is romantically adorned with rose prints and oil paintings, while the lobby greets guests with a more austere ambience. The eclectic furnishings – a mix of antique, modern and ethnic accents – keep the aesthetic fresh and elegantly eccentric. The attentive service, however, might have guests wondering whether this isn't a gracious private home after all. Number Sixteen's sense of subdued, relaxed modernity is brought to its apex in the conservatory and exquisite private garden, whose reflecting pond, fountain and lush foliage offer the kind of seclusion that is all too rare in this bustling cosmopolitan capital.

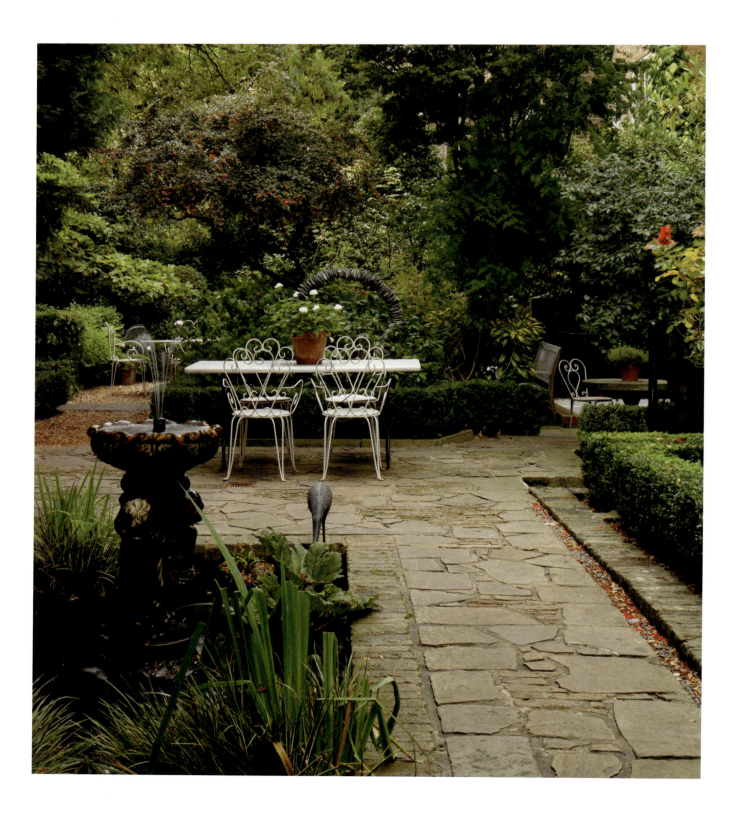

SANCTUM SOHO HOTEL
London

Paying homage to Soho's history as a center of artistic activity and bohemia, London's Sanctum Soho Hotel is a celebration of edgy glamour that fluidly integrates art and individuality into its design. The lobby is decorated with paintings and vintage light fittings. Once the sun sets, the hotel transforms into a local hot spot – the residents' bar bustles and the exclusive in-house cinema hosts screenings for up to 45 people. Those exhausted after a night of partying in the hotel, an evening of exploring Soho's bars, or a day checking out its boutiques will be grateful for the rooftop bar, secret garden, and hot tub or the variety of personalized rejuvenation on offer in the rooms. With no two rooms alike, individual attention just doesn't stop. Whether relaxing in their rooms or clinking glasses in the hotel bar, Sanctum Soho guests can be sure that they're doing it in style.

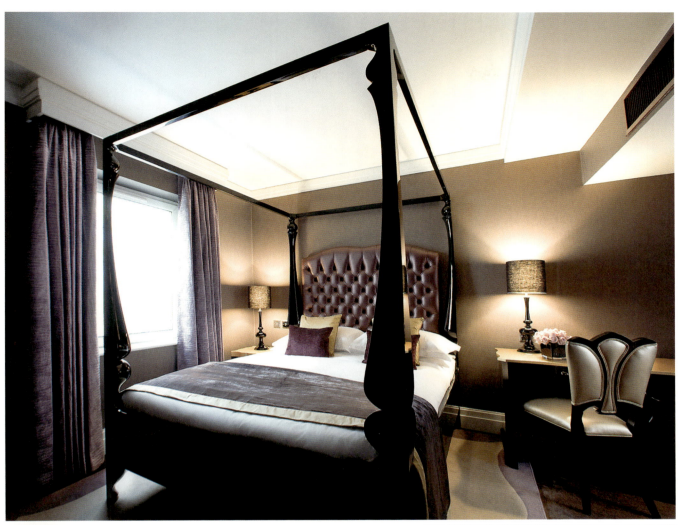
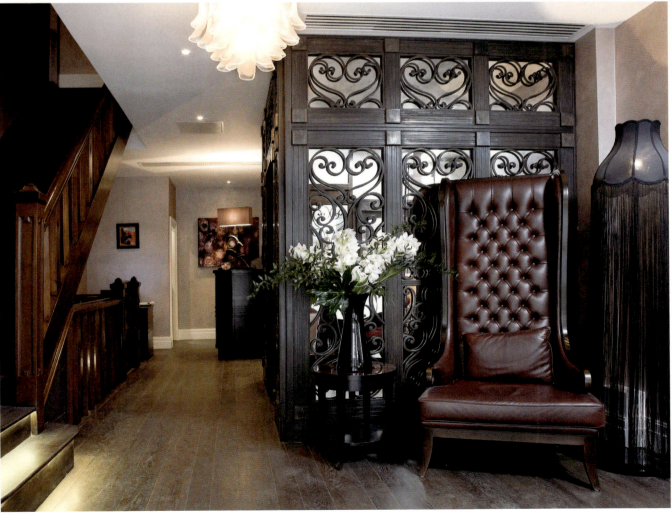

THE PELHAM HOTEL
London

South Kensington, known as the French Quarter of London, is home to the elegant Pelham Hotel. Recently pedestrianized to accommodate the many museum visitors who visit this quarter, South Kensington offers that rare glimpse into refined London living, and The Pelham is one of its finest hotels. Renowned interior designer Kit Kemp has translated English country-house style into smart city living. In this exclusive "guest only" hotel, you enter the lobby and feel as though you have just walked into your own private London residence, wrapped in style, elegance, and design. In the drawing room, complete with a luxuriously stocked honesty bar, and in the library, guests can unwind in front of period fireplaces that crackle well into the night, or just smell the always-lovely arrangements of fresh flowers. Guestrooms offer deliciously welcoming warmth and light, along with playful quirks of the finest quality. Guests at The Pelham are surprised and delighted every time they return by the thoughtful, comfortable design and exclusive luxury touches that each bedroom presents. With three event rooms, including a Japanese-inspired meeting room and a private dining room, it's a great place to party, meet, or dine for up to 35 guests. Bar and Bistro Fifteen, with direct street access, is where well-heeled locals mix with in-house guests: from the elite Chelsea crowds to the French consulate and Italian designers. It's the ultimate relaxed bistro, where the French European food speaks for itself.

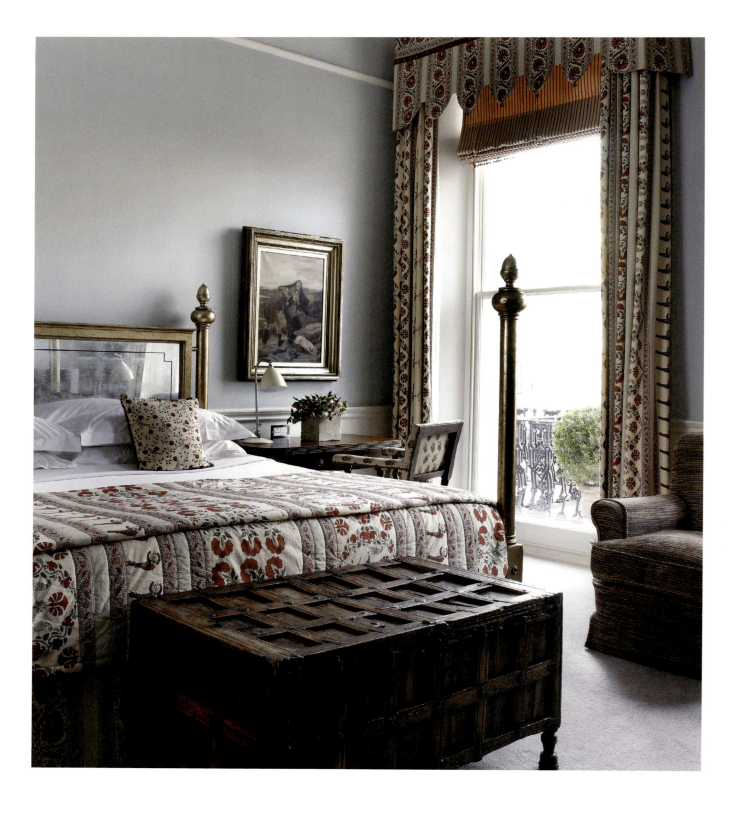

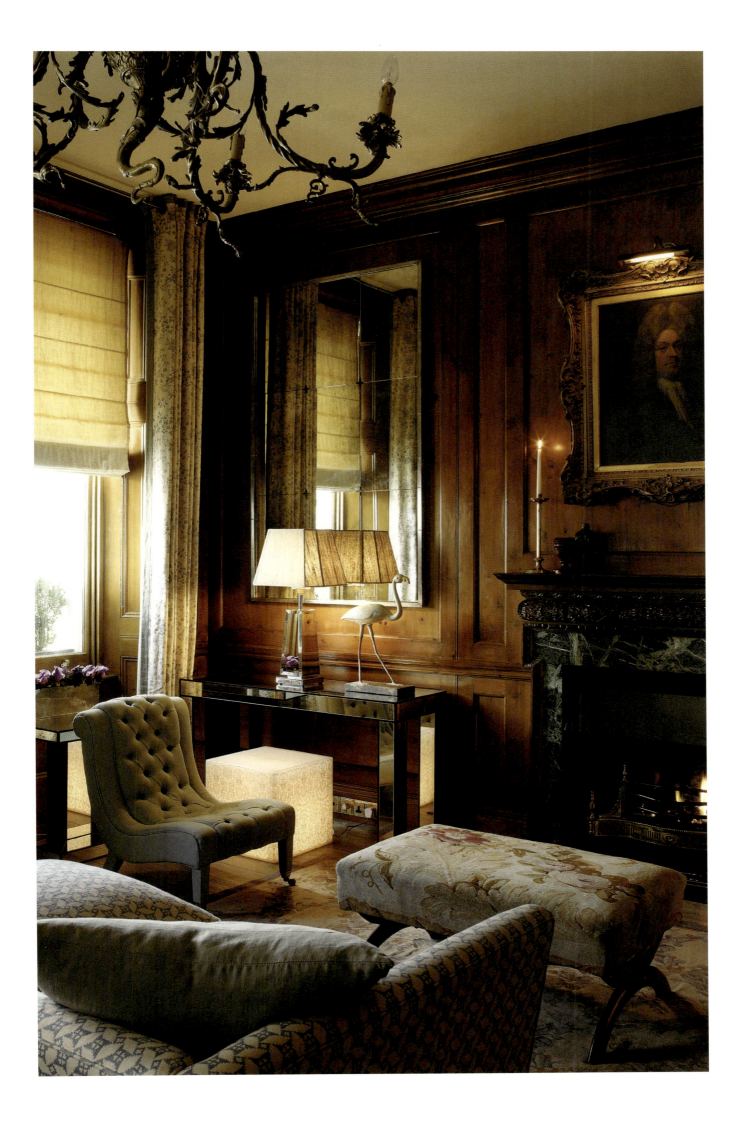

✷ RARE

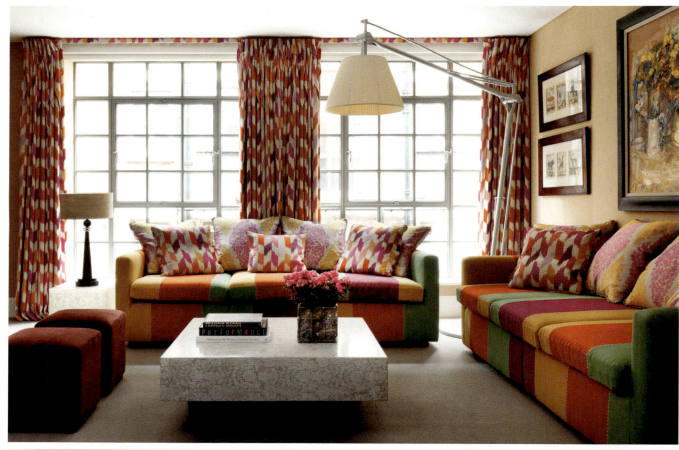

WWW.DESIGNHOTELS.COM/
SOHO

ADDRESS
4 RICHMOND MEWS
LONDON W1D 3DH
UNITED KINGDOM

ROOMS
91

RATES
GBP 295 –
GBP 2950

OPEN
09/2004

UNITED KINGDOM
LONDON

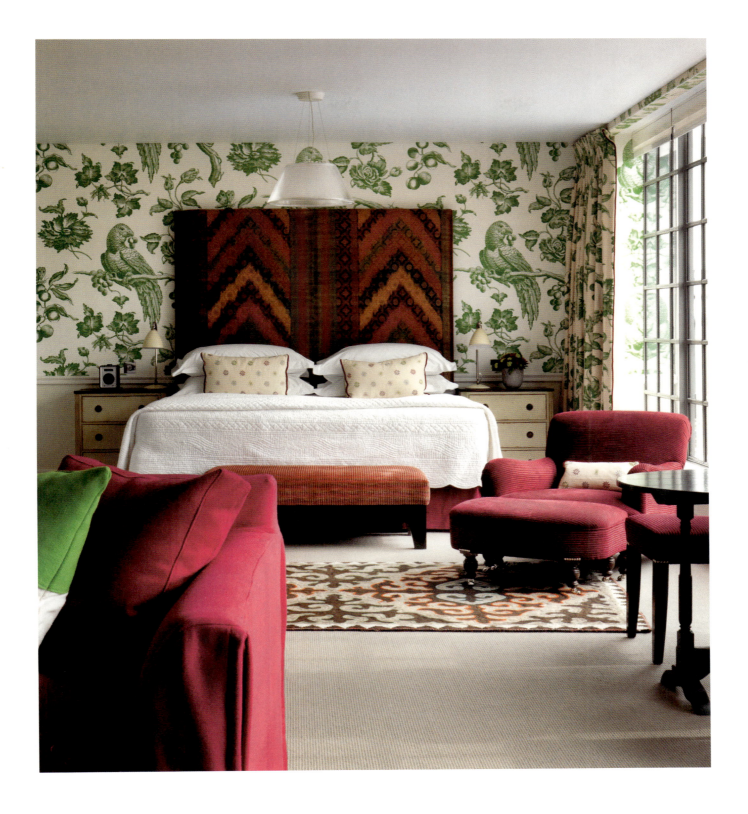

THE SOHO HOTEL
London

A style feast awaits any guest at The Soho Hotel, the flagship and largest property in Tim and Kit Kemp's London style empire. Holding court in the bubbling borough of Soho, the hotel was built on a former multi-level parking deck. In this shrine to eclecticism, guests luxuriate in unusually large rooms with floor-to-ceiling warehouse-style windows. Lovingly designed and furnished by Kit Kemp, the 91 rooms boast exciting creative tension between their design components. Kemp's contemporary British style is firmly founded on top-notch furnishings and materials deployed in an artful combination and a plethora of styles, colors and patterns. "'Eclecticism' means being interested in a lot of things: creating living interiors that aren't boring," explains the designer, whose private art collection also enriches the distinctive personal flavor of the guestrooms and public spaces. A specially commissioned mural in the hotel's Refuel Bar & Restaurant pays homage to the building's humble beginnings, but it will struggle for pride of place with the very contemporary Botero ten-foot-tall sculpture nearby in the lobby. A feast for the eyes, indeed.

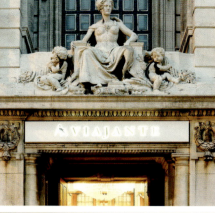
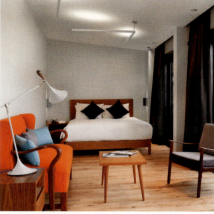
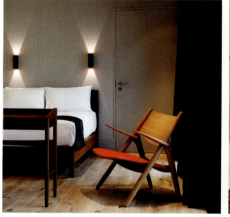

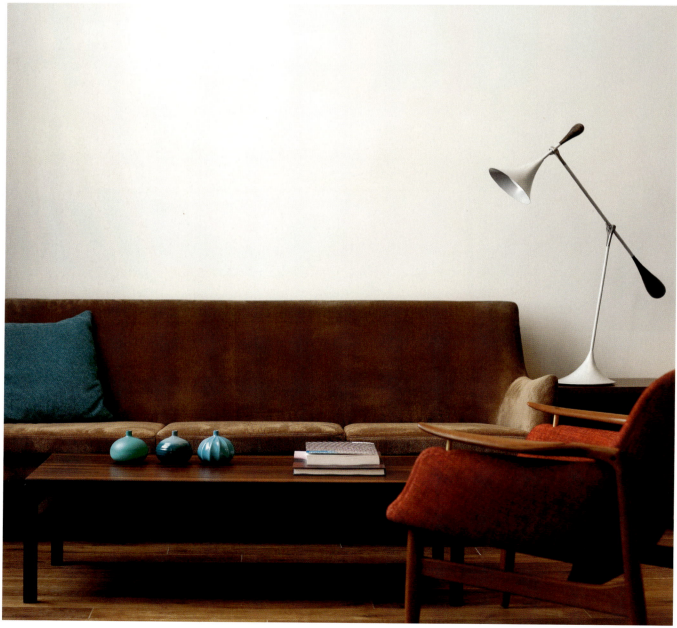

SIGNATURE

WWW.DESIGNHOTELS.COM/ TOWNHALL

ADDRESS
8 PATRIOT SQUARE
LONDON E2 9NF
UNITED KINGDOM

ROOMS
98

RATES
GBP 290 –
GBP 2500

OPEN
04/2010

UNITED KINGDOM
LONDON

TOWN HALL HOTEL & APARTMENTS
London

The year 2010 marked the opening of the Town Hall Hotel & Apartments in the former Bethnal Green Town Hall in East London. Just two minutes from the Bethnal Green tube station, with ideal connections to West London and the city's financial district, the beautifully restored establishment stylishly incorporates contemporary interior restructuring into the elegant period property – an ideal space for any business or luxury traveler. The refined art deco entrance hall's sweeping marble staircase and glass-domed ceiling whisk guests into the enthralling experience that the Town Hall so gracefully translates. The Town Hall Hotel & Apartments' 98 guestrooms and apartments are individually furnished and composed of the fluid juxtaposition of original elements with clean, contemporary furnishing and the most advanced luxury technology. The establishment also offers ample conference space, such as its unique Council Chamber, which can seat up to 70 people, or the 220-square-meter contemporary De Montfort Suite, which comfortably accommodates an exceptional private dining experience for 20. The Town Hall is also proud to call itself the home of the renowned fine dining restaurant Viajante, as well as a gorgeous cocktail bar and such recreational facilities as a gymnasium and a full-length swimming pool.

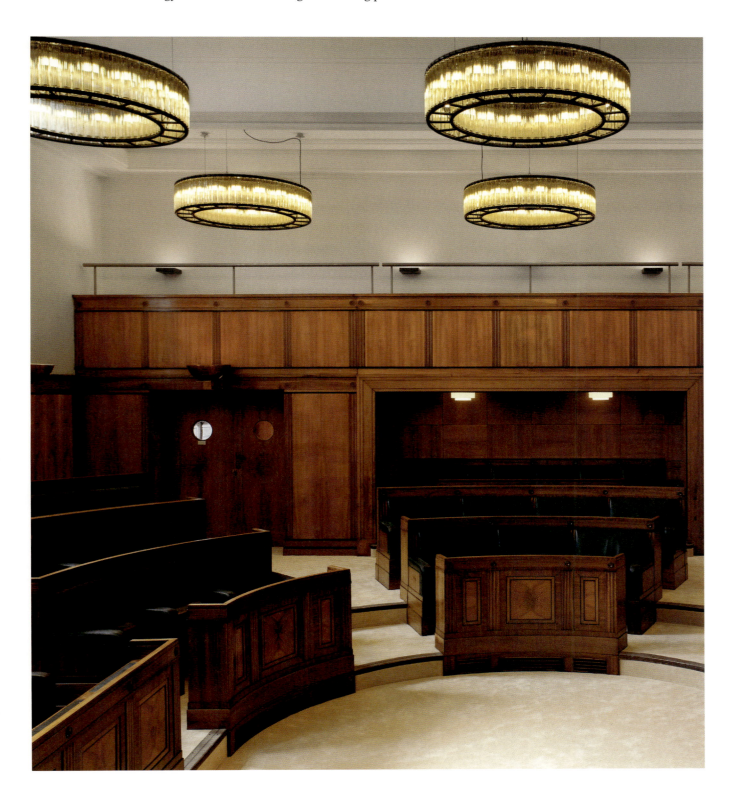

AFRICA / MIDDLE EAST

ISRAEL
388 — MAMILLA HOTEL
Jerusalem

KENYA
390 — TRIBE HOTEL
Nairobi

MOROCCO
392 — ANAYELA
Marrakech
394 — HOTEL LA RENAISSANCE
Marrakech
396 — THE GREAT GETAWAY MARRAKECH HOTEL & SPA
Marrakech

SOUTH AFRICA
398 — TEN BOMPAS
Johannesburg

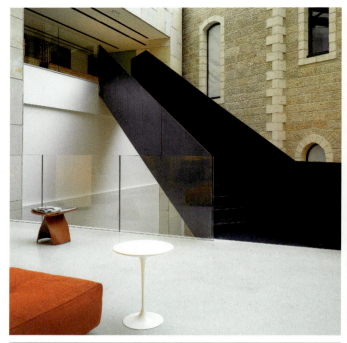
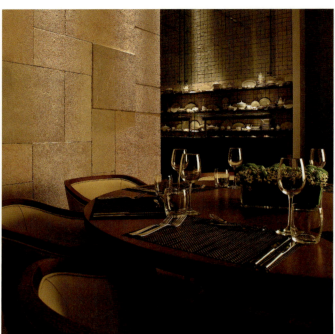
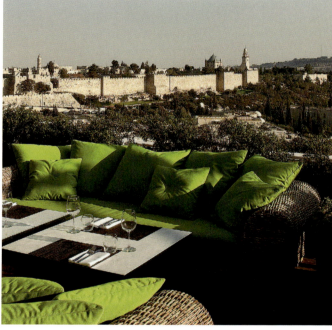
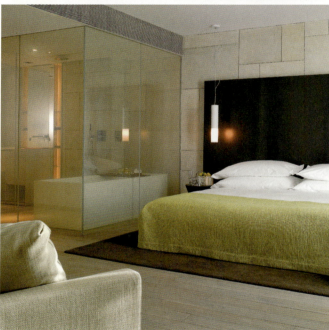

MAMILLA HOTEL
Jerusalem

Looking out over Jerusalem's Old City walls, the Mamilla Hotel is a modern masterpiece immersed in the contemporary vibe pulsing through this ancient city. Located alongside the city's new shopping and entertainment experience, Alrov Mamilla Avenue, which stretches straight into the Old City's Jaffa Gate, the hotel was developed and operated by Alrov Luxury Hotels in collaboration with world-renowned architect Moshe Safdie and the illustrious designer Piero Lissoni. Mamilla's 194 guestrooms include varying types of suites and rooms with shifting views of the city. The Mamilla Café, serving light dishes made from fresh seasonal ingredients, offers informal dining with intimate corners, long communal tables and comfy sofas on the terrace lounge. The luxury continues through to the Mirror Bar, a favorite nightspot; the Winery, offering an extensive list of exclusive Israeli wines; and the rooftop outdoor lounge and restaurant, which provides views of Jerusalem's majestic Old City. The hotel also houses the 1,000-square-meter Holistic Wellbeing Retreat and a state-of-the-art auditorium for up to 136 people, with deep, amphitheater seating and the latest digital sound and projection technologies. Safdie, a native Israeli, has laid the exteriors in Jerusalem stone, the elegant, light local limestones that lines the Old City's snaking alleyways and the New City's grand avenues. Lissoni, who created the hotel's interiors, made full use of Jerusalem's dazzling light, which he describes as "turning from white just after dawn into a blue topaz in the afternoon."

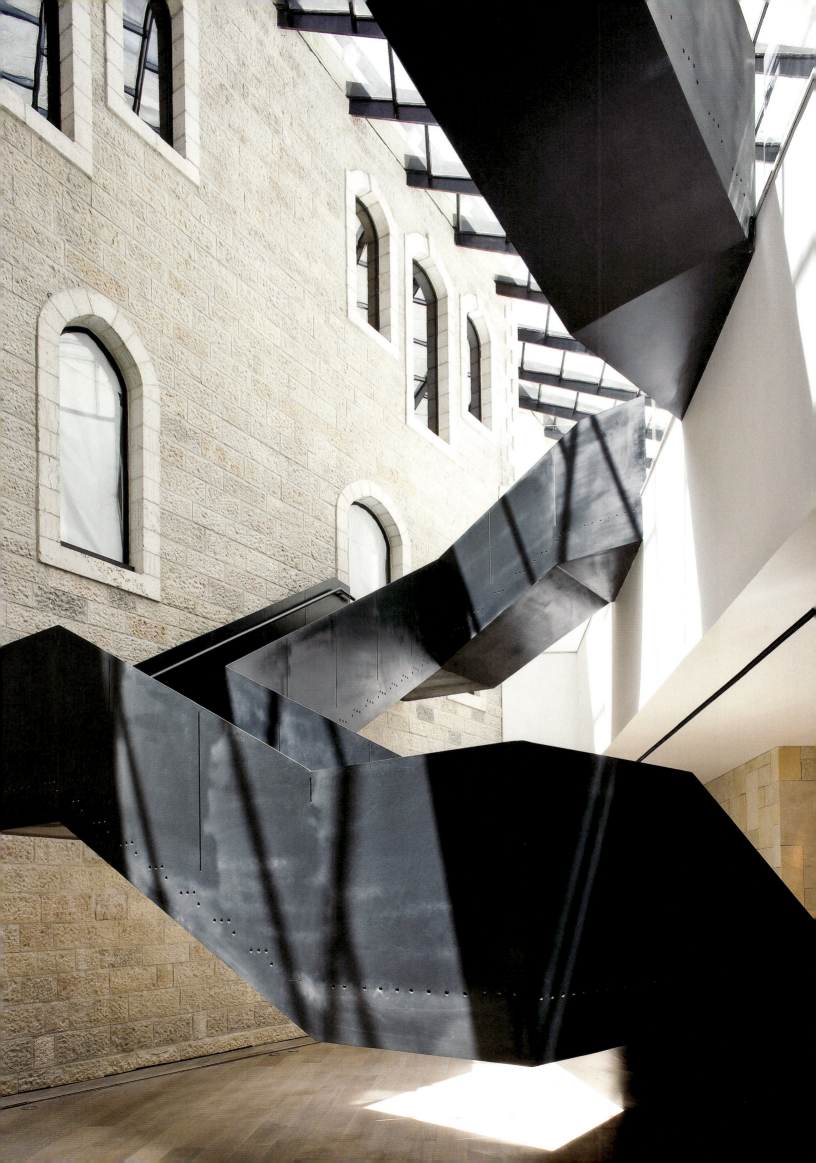

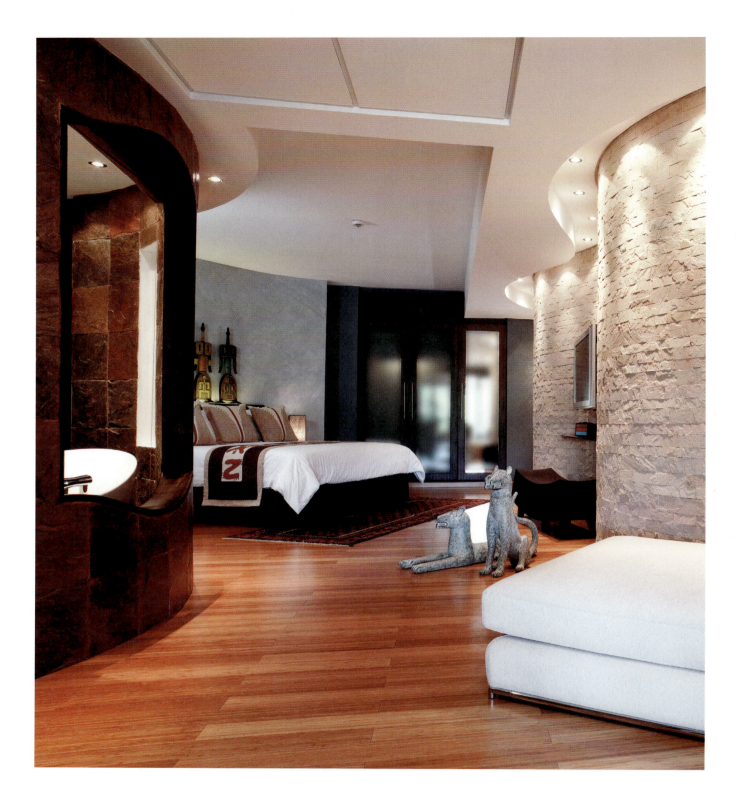

TRIBE HOTEL
Nairobi

Urban, loft-like style blends effortlessly with warm African colors at Nairobi's Tribe Hotel, a pioneering lifestyle property that sets itself apart with atypical angles and an unrivalled appreciation for tribal crafts. Some 900 hand-sculpted artifacts from all over Africa have been gathered here, capturing the diversity of the continent and evoking a sense of splendor that is raising the luxury hotel stakes in the continent. Spread across three wings in the heart of Nairobi's diplomatic district, home to the United Nations and many other institutions, a soaring sunlit atrium links the Tribe's 137 guest rooms and suites. Inside, cool granite and stretches of dark Indian slate temper earthy combinations of cumin, sandstone and brownsugar hues. Architect Mehraz Ehsani continues this balance by using authentic and tactile Kenyan materials in the public spaces. These include the curvy Kaya Spa, which takes its inspiration from the country's sacred forests; the well-stocked library, home to almost 3,000 books; the rooftop bar and the heated pool, surrounded by waterfalls and gardens. At the sophisticated Jiko restaurant, diners can enjoy melt-in-the-mouth grilled meats with fresh, seasonal vegetables, and pasta, gelato and pastries all made in-house. Adjacent to the hotel is the Village Market – a shopping and entertainment complex that is also home to a weekly Maasai market.

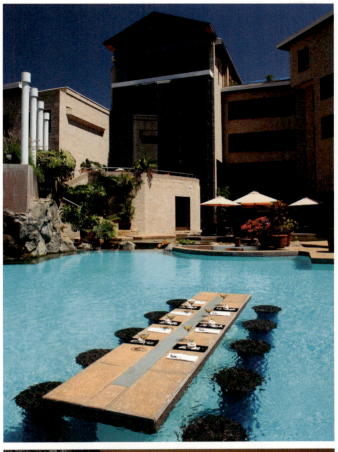
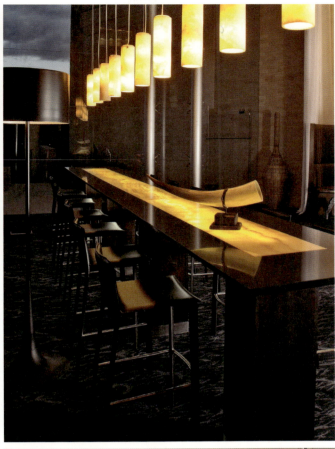

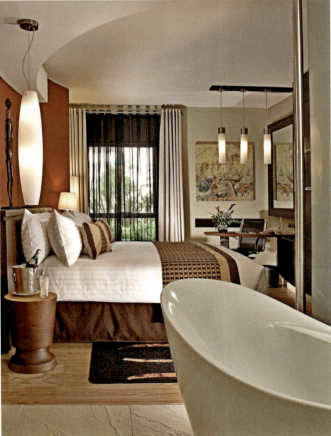

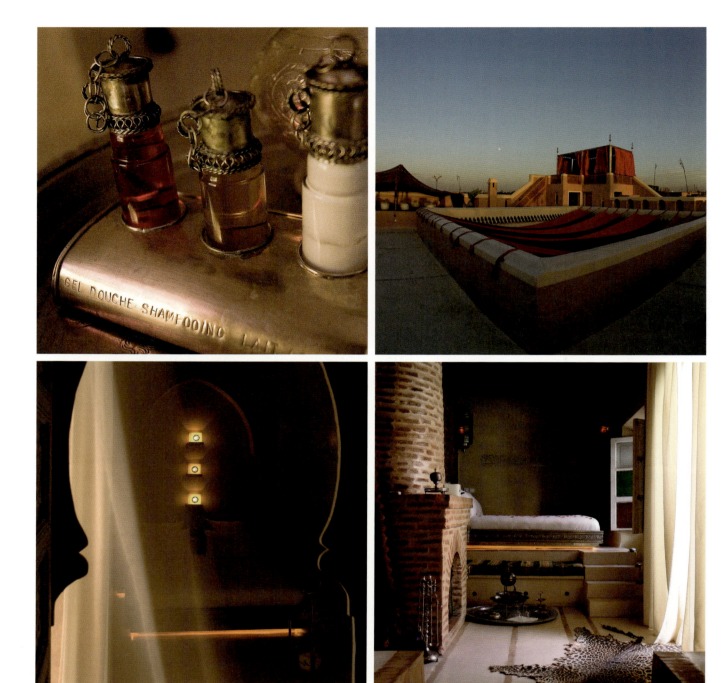

ANAYELA
Marrakech

AnaYela, a gorgeous 300-year-old palace transformed into an opulent boutique hotel, is the jewel of Marrakech's medina, or ancient quarter. A critical favorite, this four-time winner of the World Hotel Awards "Soul Experience" prize also garnered a special award for outstanding service and has been selected for the Condé Nast Hot List. AnaYela is like a passionate affair: the luminous three-room and two-suite city palace will leave lucky guests breathlessly drunk on the thrill of new discovery. More exciting than its mesmerizing appearance, however, is the love story that took place behind AnaYela's closed doors: a 16-year-old girl and her beau once had clandestine nighttime meetings in the palace's Tapis Volant, or "flying carpet" tower. During the hotel's full-scale renovation in 2007, a handwritten manuscript was discovered in a hidden room behind a wall. The lovers' tale has now been engraved in Arabic calligraphy onto every door in the property. The silver characters can be viewed chronologically while ambling through the roofless indoor courtyard, which features a heated limestone pool, and up to the beguiling rooftop terrace with its extraordinary panoramic views of Marrakech. With so much mystique it's no wonder guests report feeling as if they've stepped into a mirage.

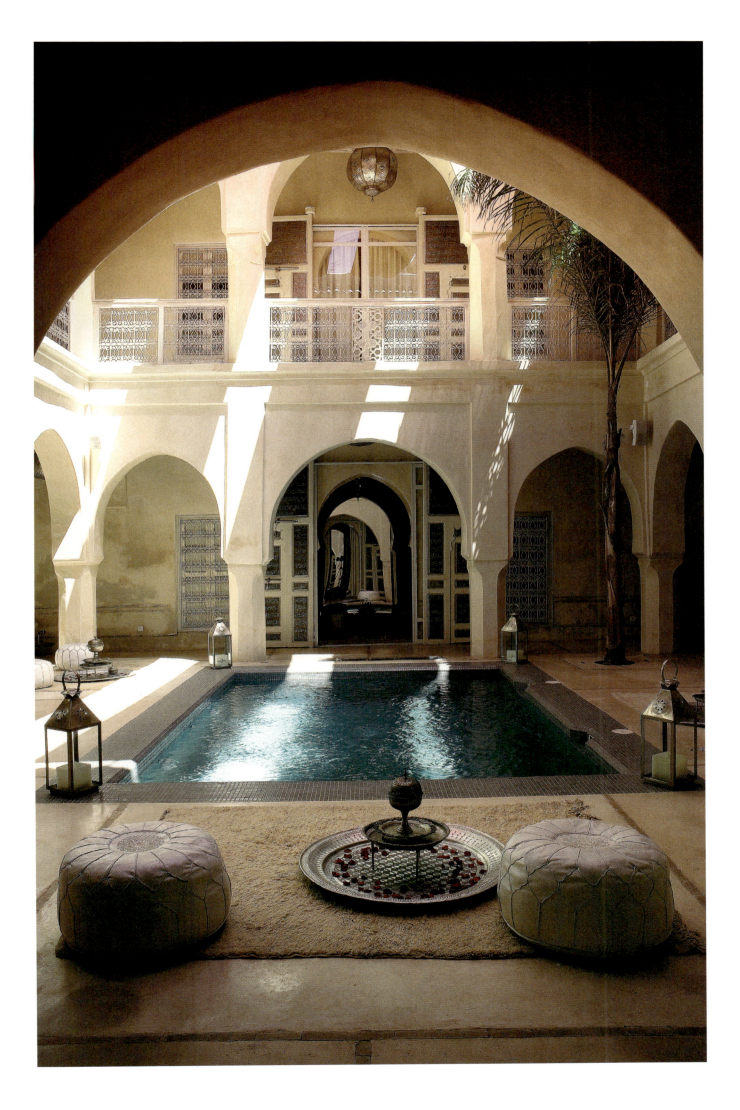

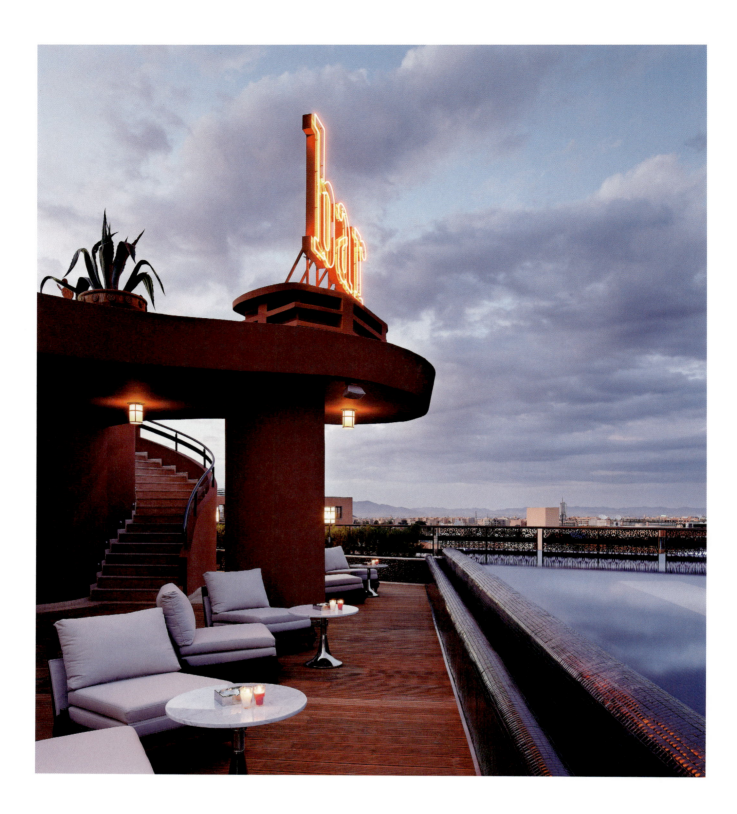

HOTEL LA RENAISSANCE
Marrakech

In the 1950s and 60s, the sophisticated Moroccan elite from Rabat and Casablanca would flock to the majestic La Renaissance in the commercial area of Gueliz, only steps away from the legendary Souk de la Medina. There they would mingle with guests from all across the globe. Yet until the design team began to breathe new life into the historic space, it had become a ghost of its former self. Now, their signature blend of high-end East-meets-West elegance has refurbished the classic building's 35 rooms and 10 suites, returning it to its heyday. Lovers of fine food will appreciate the revival of Hotel La Renaissance and the introduction of its twin restaurants and two cocktail lounges into Marrakech's sparkling social scene. "La Brasserie" and "Aqua Pazza" bring the best cuisine of France and Italy to a classically Moroccan setting. At Aqua Pazza, guests can savor European culinary delights, while feasting on the unique and unspoiled view of the city and the snow-capped Atlas Mountains. As the tallest building in Marrakech, Hotel La Renaissance provides guests with the best view of the creatively bubbling cityscape.

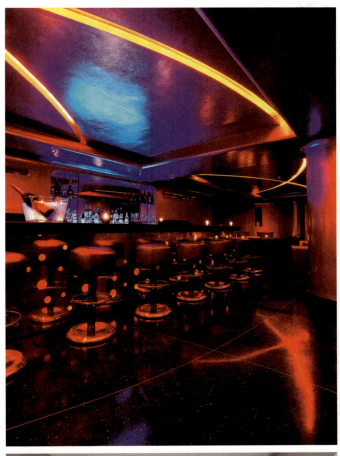
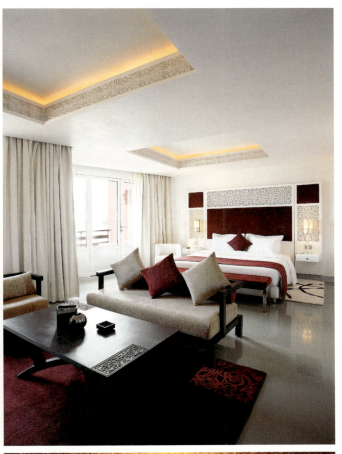
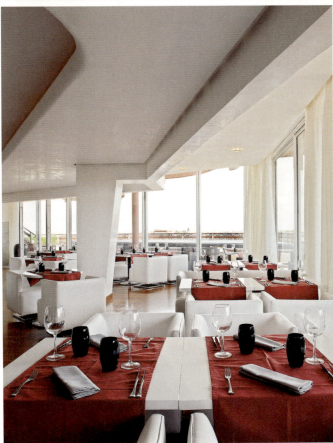

THE GREAT GETAWAY MARRAKECH HOTEL & SPA
Marrakech

The newest addition along the streets of Amizmiz, The Great Getaway Marrakech Hotel & Spa, is the first luxury lodge in the area. Located in a quiet part of the medina just fifteen minutes outside Marrakech, this lovingly restored oasis features seven spacious suites, a relaxing patio and a rooftop terrace with views over the city. An exotic refuge, The Great Getaway encourages guests to escape from the daily routine of their busy lives. From day one, the enchanted location of The Great Getaway Marrakech Hotel & Spa cast its spell over the hotel operators: restaurateur Ina Tibke, journalist Christian Krug and architect Moritz Theden. With a deep respect for the local people, their highly artistic craft forms and their customs, the three passionate entrepreneurs built the resort in the style of a southern African hideaway, creating a delicate interplay of oriental traditions, architecture and contemporary design. The result is a hotel for those who enjoy Steve McQueen, motorbikes, freedom, and nature, for those seeking adventures in the mountains, in the desert, or on the streets of the shimmering metropolis of Marrakech. At the end of the day, stories can be exchanged over a gin and tonic by the campfire. After making your way through the main building, with its restaurant, bar, library, the Moroccan Lounge and a stunning roof terrace, you arrive at a complex with an infinity pool, a subterranean hammam and artfully arranged gardens. Wherever you look, there's the backdrop of the High Atlas Mountains, and, thankfully, this view is never obstructed. Guests spend the night in one of twenty individually furnished rooms and suites in the main building, in one of the Moroccan riads, in a private lodge or in one of the beautifully furnished luxury tents.

*OFFBEAT

SOUTH AFRICA
JOHANNESBURG

OPEN
10/1996

RATES
ZAR 3100 –
ZAR 3800

ROOMS
10

ADDRESS
10 BOMPAS ROAD, DUNKELD WEST
JOHANNESBURG 2196
SOUTH AFRICA

WWW.DESIGNHOTELS.COM/
TENBOMPAS

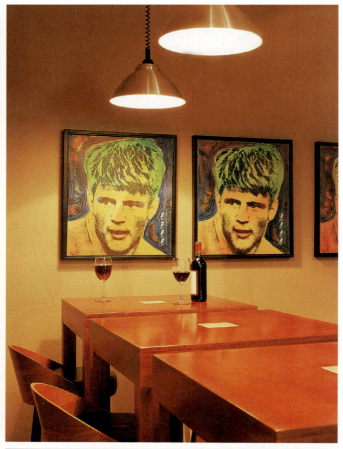

TEN BOMPAS
Johannesburg

Close to the heart of Johannesburg and Sandton's business districts, this small, suite-only retreat envelops its guests in warmth and tranquility, whether with its pool and peaceful gardens or through unlocking the wealth of experiences Africa has to offer. A different designer created each of the ten bespoke suites following a brief by proprietor Christoff van Staden to provide natural light and incorporate the lush garden setting. Gill Butler's Edwardian suite combines sand-hued walls and robustly colored leather-embossed furnishings with modern tile and steel. Other suites blur cultures, with military-style canvas and splashes of color typical of the South African landscape. The ethno-African highlights in couturier André Croucamp's silk-enhanced suite, the contemporary cool "Johannesburg" suite by Cecil Lyons and the "ethnic turned high-tech" approach in the suite designed by the project architects, Zeghers & Associates reflect the color and excitement of the new South Africa. Originally a private dwelling, Ten Bompas has been reimagined as a "home away from home in Africa," combining reassuring calm with adventure, sophisitication and a sense of discovery.

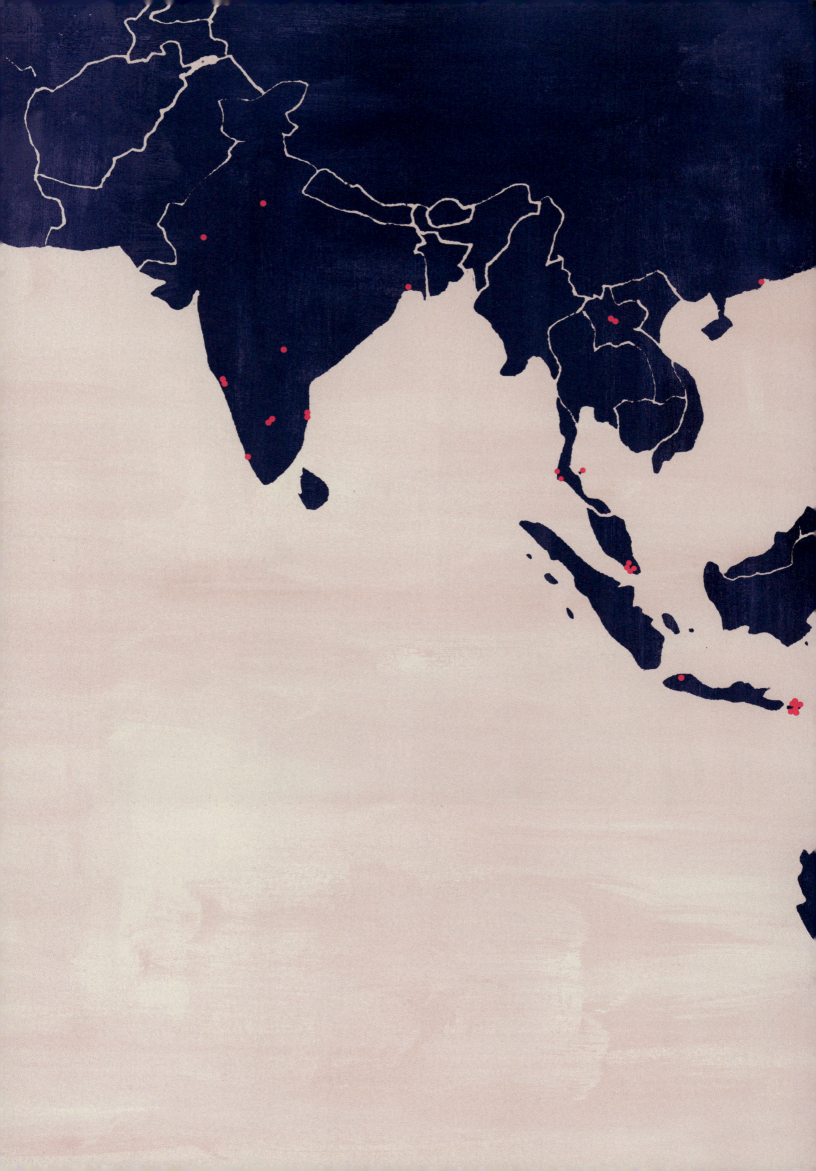

ASIA / PACIFIC / OCEANIA

AUSTRALIA
402 — LIMES HOTEL
Brisbane
404 — QT SYDNEY
Sydney

CHINA
406 — THE MIRA HONG KONG
Hong Kong
408 — THE PULI HOTEL & SPA
Shanghai
410 — THE WATERHOUSE AT SOUTH BUND
Shanghai

INDIA
412 — ALILA BANGALORE HOTEL & RESIDENCE
Bangalore
414 — THE PARK BANGALORE
Bangalore
416 — THE PARK CHENNAI
Chennai
418 — THE PARK POD CHENNAI
Chennai
420 — ALILA DIWA GOA
Goa
422 — THE PARK ON CANDOLIM BEACH
Goa
424 — THE PARK HYDERABAD
Hyderabad
426 — RAAS
Jodhpur
428 — THE PARK KOCHI
Kochi
430 — THE PARK KOLKATA
Kolkata
432 — THE PARK NEW DELHI
New Delhi

INDONESIA
434 — ALILA MANGGIS
Bali
436 — ALILA UBUD
Bali
438 — ALILA VILLAS SOORI
Bali
440 — ALILA VILLAS ULUWATU
Bali
442 — LUNA2 PRIVATE HOTEL
Bali
444 — LUNA2 STUDIOS
Bali
446 — THE ELYSIAN BOUTIQUE VILLA HOTEL
Bali
448 — ALILA JAKARTA
Jakarta

JAPAN
450 — KIMAMAYA BOUTIQUE HOTEL
Niseko - Hirafu
452 — PARK HOTEL TOKYO
Tokyo

LAO PEOPLE'S DEMOCRATIC REPUBLIC
454 — 3 NAGAS
Luang Prabang
456 — HOTEL DE LA PAIX LUANG PRABANG
Luang Prabang

NEW ZEALAND
458 — HOTEL DEBRETT
Auckland

SINGAPORE
460 — KLAPSONS, THE BOUTIQUE HOTEL
Singapore
462 — NEW MAJESTIC HOTEL
Singapore
464 — WANDERLUST
Singapore

THAILAND
466 — CASA DE LA FLORA
Khao Lak
468 — THE LIBRARY
Koh Samui
470 — THE SURIN PHUKET
Phuket

*OFFBEAT

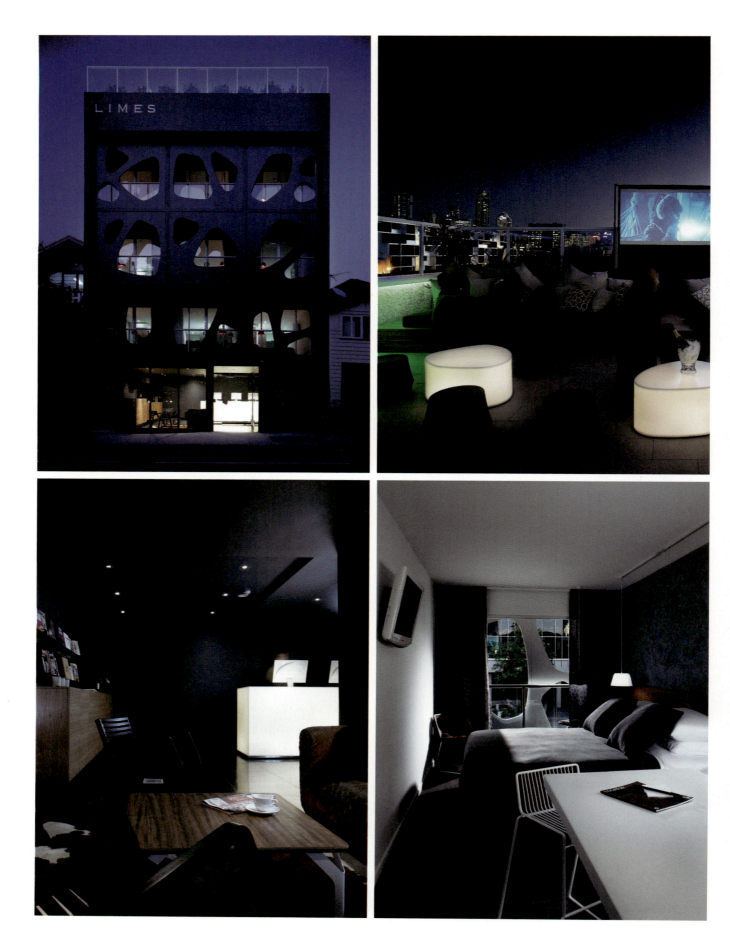

WWW.DESIGNHOTELS.COM/
LIMES_HOTEL

ADDRESS
142 CONSTANCE STREET, QUEENSLAND
4006 FORTITUDE VALLEY
AUSTRALIA

ROOMS
21

RATES
AUD 229 –
AUD 389

OPEN
06/2008

AUSTRALIA
BRISBANE

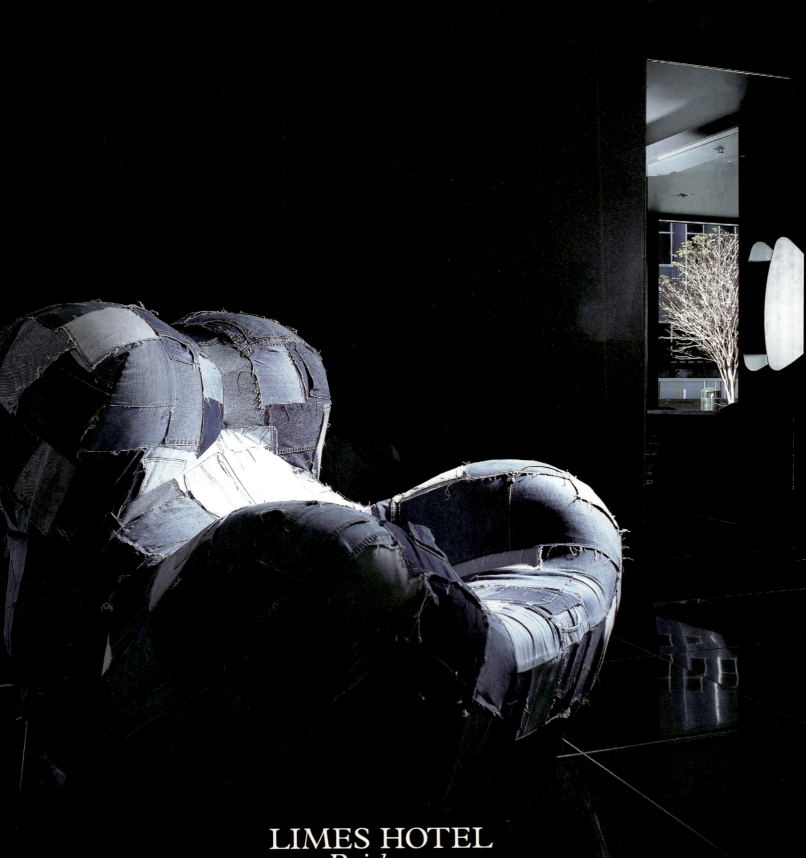

LIMES HOTEL
Brisbane

Travel-savvy urbanites will appreciate the simple sophistication and contemporary energy abuzz at the Limes Hotel, in Fortitude Valley at the heart of Brisbane's nightlife and entertainment district. Award-winning Argentinian designer Alexander Lotersztain, a true global nomad, explains that he conceived the hotel as a holistic "design experience… stripped of the associated design ideals of something unattainable. I shifted the design focus to make the guest feel special, yet not afraid of jumping into the bed like it was their own." His close attention to detail is reflected in all the hotel's facets, from each of the cozy 21 rooms to the hip rooftop lounge bar and seasonal open-air cinema. Guests are welcomed with handcrafted Dello Mano brownies, an iPod music system, wireless and broadband Internet, L'Occitane toiletries, and finest linens, not to mention a kitchenette and either balcony or courtyard. The eye-catching facade that reproduces the hotel's limestone logo on a grand scale makes it a design statement as well as an urban landmark, while its sleek, modern interior with rich textures and finishings contribute to an intimate ambience unencumbered by excessive ornamentation.

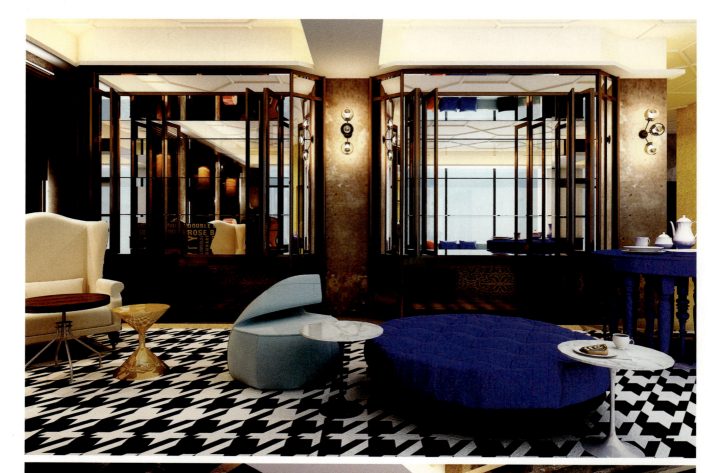

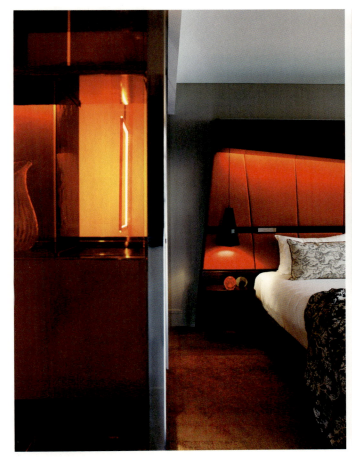

QT SYDNEY
Sydney

While preserving two of the city's most iconic buildings, QT Sydney is destined to become a new landmark by reviving its rich and colorful past in theater and retail. Set within the historic Gowings department store and heritage-listed State Theatre in the heart of Sydney's Central Business District, the surrounding area brims with culture, art, fashion, cuisine and design, while still being within easy reach of sandy beaches. With stars from stage and screen having performed in the State Theatre over the past 80 years and the classic vertical retail of the Gowings department store, the QT Sydney captures the intrigue and excitement of the past in its edgy, contemporary design. The 200 guest rooms range in size from 36 to 42 square meters, with some 12 different room styles – most equipped with a signature bathtub and oversized shower. A number of historic building elements have been retained including the original timber floors throughout the Gowings building and reinstatement of the retail showcases in the hotel entry foyer. The lower levels of the buildings have remained unchanged, but important historic fittings and fixtures such as original stone cladding, gargoyles and façade detail, which have been damaged or removed over decades, have been carefully restored. The restaurant, bar, late night lounge and luxurious day Spa attract Sydney's "it" crowd, particularly those in the fashion and entertainment industries, while the lively lobby, linked to the bustle of Market Street by a streetside Barista creates an exciting aroma and buzz as guests arrive.

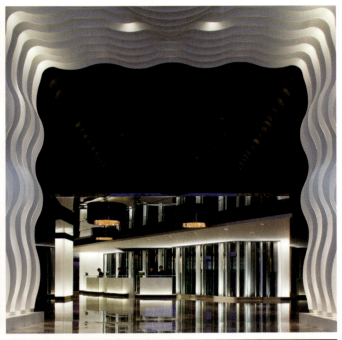
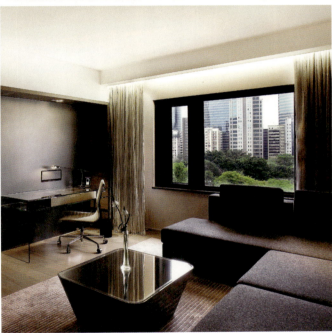
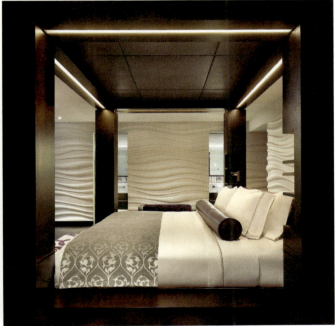

THE MIRA HONG KONG
Hong Kong

Overlooking orchid-scented Kowloon Park in Central Tsimshatsui, one of Hong Kong's elegant shopping districts, The Mira Hong Kong is an innovative urban retreat that inspires guests with polished glass panes and groundbreaking in-room electronics. From the results-oriented, über-pampering of its award-winning 21st-century spa to the mirrored walls of its crisp contemporary bedrooms, The Mira Hong Kong has been designed as a sanctuary for inner-city reflection. The curving white fins of the lobby's vaulted ceiling create a sphere of open space, while jade-green stalks of bamboo add soothing natural textures to the private cabanas at Vibes, the intimate rooftop bar. And although the landscape changes from floor to floor, personalized service remains a constant theme. Nowhere is this more visible than at WHISK, a modern-French gastro hangout with a distinctive Asian bent, where diners are tempted by the pared-down perfection of Chef William Girard's cuisine. The Mira Hong Kong's 492 rooms are dressed in shades of red, green, silver, or purple, encouraging you to creatively select a color that suits your mood. Each space is complemented by functional furnishings such as Arne Jacobsen's modernist Egg chair. Bose iPod docks create warm, resonant soundscapes that bounce off the translucent bathroom walls, while tropical-strength rain showers provide solace from the heat of Hong Kong's vibrant, neon-lit streets.

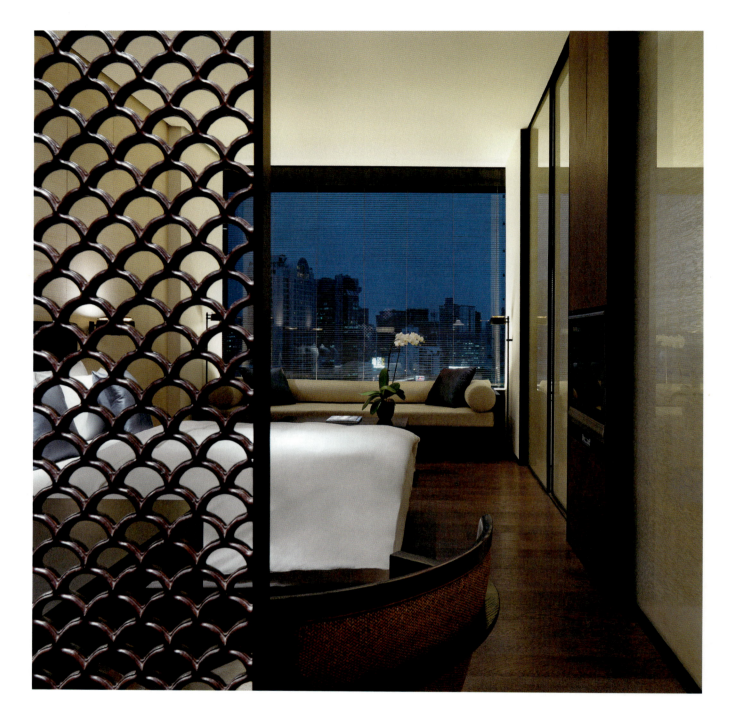

THE PULI
HOTEL & SPA
Shanghai

China's first urban resort combines traditional Asian charm with elegant contemporary design, transporting guests from their everyday lives into a world of luxury. The PuLi Hotel & Spa blends the relaxation of a resort escape with the excitement of an urban hotel. The sensitive and intuitive team behind the hotel is Urban Resort Concepts, a guest-centric management company that promotes design integrity and understated elegance. Their unique pilot destination holds 229 spacious and stylish guestrooms, which nod towards old world Shanghai with cast bronze basins and dragon-scaled screens – every chair, light fixture and table is inspired by local traditions of craftsmanship. Located in one of Shanghai's most beautiful and central areas overlooking the JingAn Park, The PuLi is not only aesthetically bound – it offers a spa operated by the celebrated Anantara Spa; delectable cuisine at the Jing'An Restaurant; the Long Bar and Garden Terrace; and a variety of meeting and private dining rooms. It is The PuLi's incredible service philosophy, one that advocates going the extra mile for every guest, that really distinguishes it as one of Shanghai's most luxurious hotels.

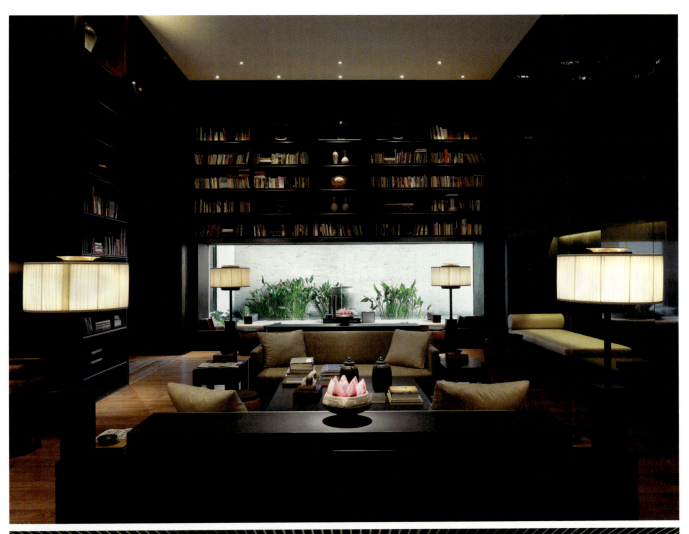

* OFFBEAT

WWW.DESIGNHOTELS.COM/
WATERHOUSE

ADDRESS
NO 1-3 MAOJIAYUAN ROAD
OFF ZHONGSHAN SOUTH ROAD,
HUANGPU DISTRICT
SHANGHAI 200011
CHINA

ROOMS
19

RATES
CNY 1350 –
CNY 4000

OPEN
04/2010

CHINA
SHANGHAI

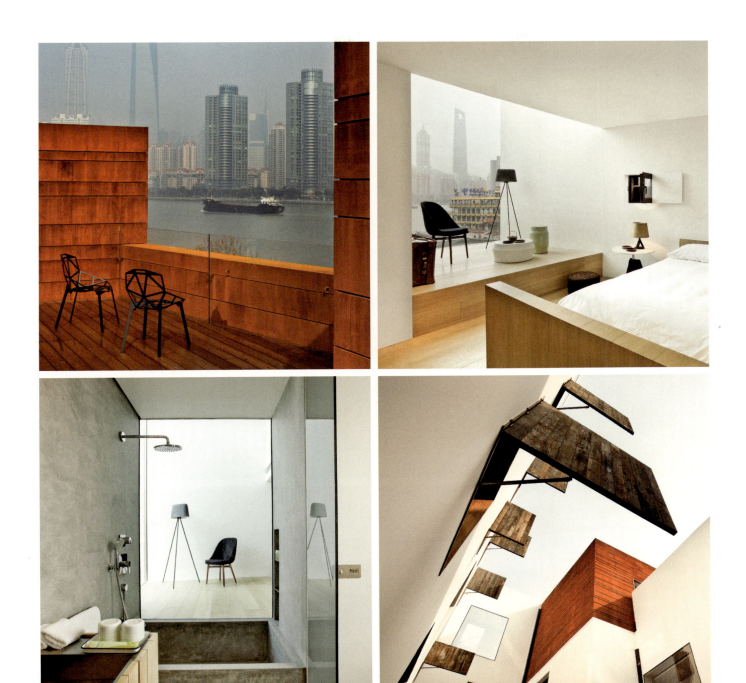

THE WATERHOUSE AT SOUTH BUND
Shanghai

The Waterhouse at South Bund, located on the banks of Shanghai's Huangpu River, inexorably raises the city's boutique hotel stakes, leaving its competitors trailing hopelessly behind. Its 19 guestrooms, destination restaurant, rooftop bar, and enormous all-purpose event space produce an exhilarating atmosphere and breathe new life into the Shanghai market. Neri & Hu Design and Research Office, one of China's leading architectural voices, entirely transformed the 1930s building but maintained the original facade. Lyndon Neri explains the design ethos for The Waterhouse: "This is a hotel that puts the emphasis on the traveler in search of some meaning, and not just the luxury component of living." A conceptual blending of the antique and the contemporary, The Waterhouse is a complex dissociation and amalgamation of interior and exterior as well as public and private spaces, leading to a unique and entirely new experience for guests and locals alike. With magnificent views of the Pudong skyline, where the city's quaint low-rise architectural heritage is still largely intact, The Waterhouse at South Bund prides itself on integrating into the traditional local environment while challenging its boundaries. It distinguishes itself absolutely in order to provide each guest with an unforgettable experience.

*SIGNATURE

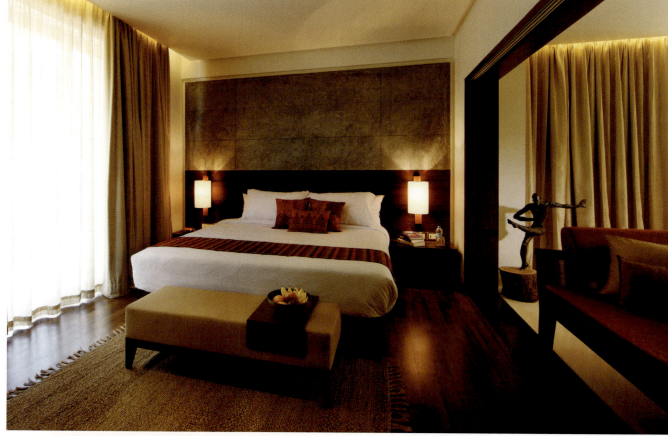

WWW.DESIGNHOTELS.COM/
ALILA_BANGALORE

ADDRESS
100/6, HAL-VARTHUR MAIN ROAD
R.G. HALLI, WHITEFIELD
BANGALORE 560066
INDIA

ROOMS
122

RATES
INR 7500 –
INR 38000

OPEN
08/2011

INDIA
BANGALORE

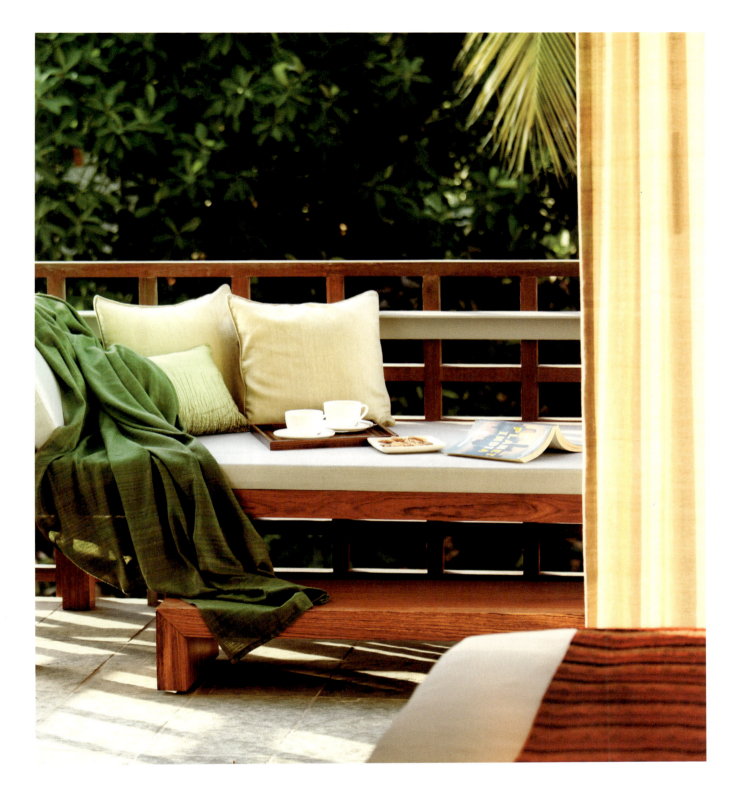

ALILA BANGALORE HOTEL & RESIDENCE
Bangalore

Located in Whitefield, a suburb of India's fastest-growing metropolis, the Alila Bangalore features all the amenities of a luxury business hotel, but in a peaceful resort setting sheltered from the city's hectic pace. The hotel's newly designed 14-story building offers a harmonious balance of sophisticated spaces for both work and recreation. Each of the 122 guestrooms, including 19 elite suites, combines contemporary design and traditional Indian decoration in classically elegant arrangements. Mark Edleson, Chairman of Alila Hotels & Resorts, envisions the Alila Bangalore as a reflection of the continent's vibrant history and future: a "crossroads of cultures and commerce." The Spa Alila and fitness center promise physical rejuvenation through ancient Asian healing techniques, as well as aromatherapy. The hotel's library has incorporated classic English accents, soft lighting and handsome lounge chairs, creating a stylish yet subdued work environment. Dining ranges from homemade pastries in the Tiffin Bar to the Asian-inspired High 5 Tapas Bar and Lounge, which overlooks the infinity pool and city skyline. The Tiffin Room serves international and gourmet Indian cuisine throughout the day, while the Tiffin Grill offers the more casual dining experience of an open-air barbeque.

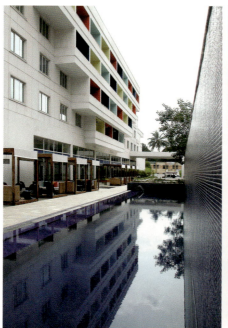

THE PARK BANGALORE
Bangalore

A pristine, white, four-story building in the center of the city's business district, The Park Bangalore is a leader in its genre. Thanks to the forward-thinking vision of Priya Paul, CEO of The Park Hotels India, this was the first property on the sub-continent to grasp the potential of India's lifestyle culture and exploding wealth. Each of the hotel's 109 rooms reflects Indian ethnicity and international influence, as interpreted by renowned design company, Conran & Partners. The hotel is an urban retreat in the capital of India's high-tech industry, offering a sensuous design experience. Lifts are decked out in rich black leather, and each floor has its own strong color theme. Aqua tones dominate the first floor, interspersed with fiery splashes of orange. Lime is prevalent in the next two stories, linked up with royal purple on the second floor, and emperor red on the third floor, evoking an abstract jungle feel. The top floor of The Park is known as The Residence, the most luxurious section of the building, where an abundance of silk, leather and wood in the guest rooms add an extra measure of Eastern opulence. Aquamarine blue and saffron underscore the effect.

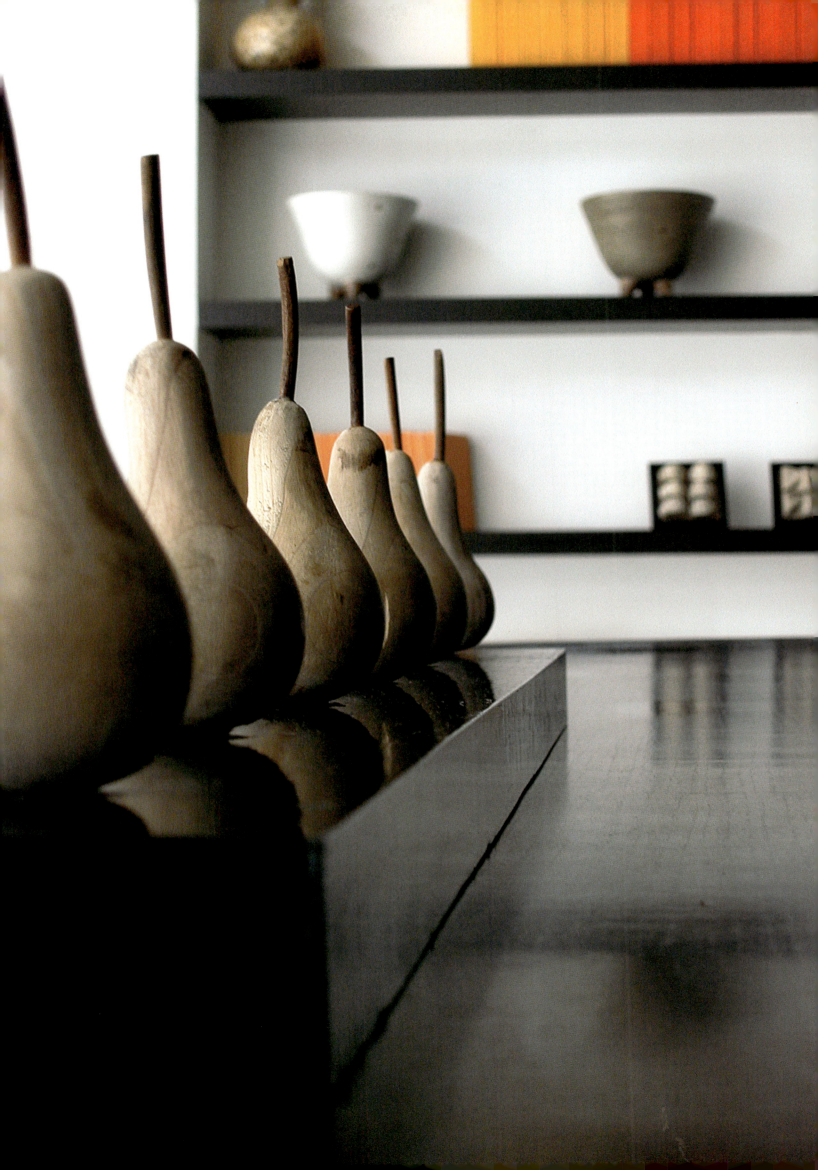

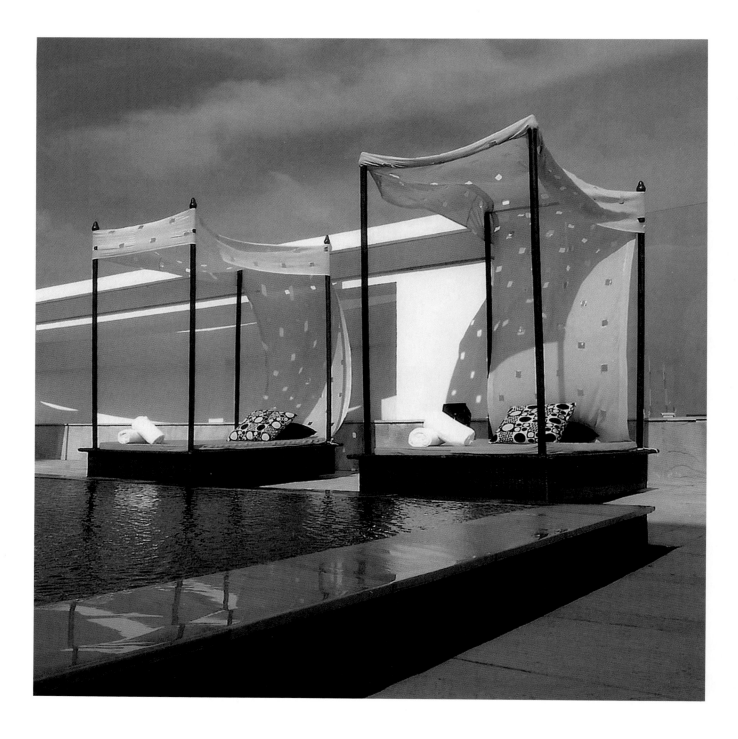

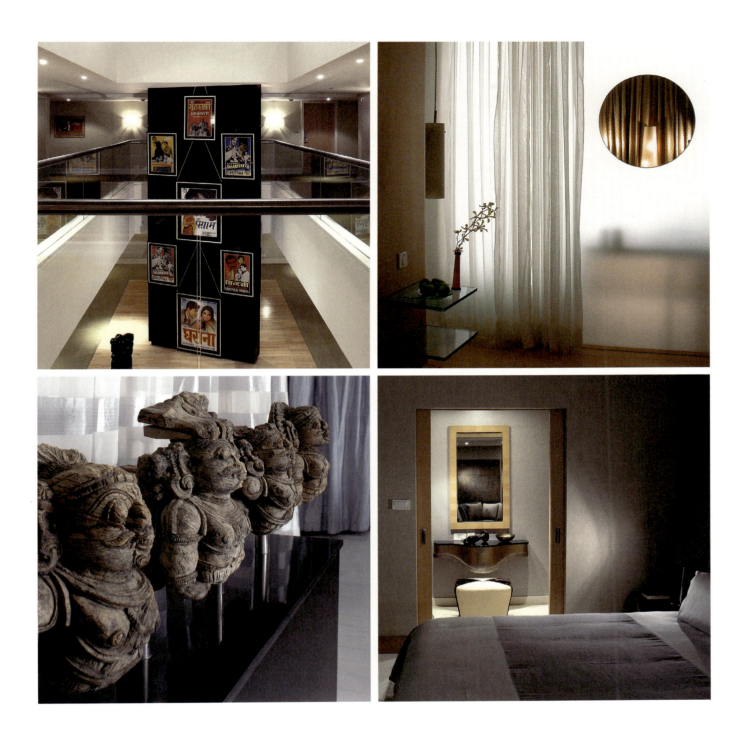

THE
PARK CHENNAI
Chennai

Inspired by the traditions of Indian film – glamour, performance and drama, the The Park Chennai was constructed on the former premises of the Gemini Film Studios, ensuring the continuation of years of theater. Typical of Priya Paul's distinctive design vision, she asked the young artist Hemi Bawa to create an artwork of welcoming lotuses on the hotel's porch. From there guests are beckoned through to the sleek atrium area, where pale cream lime stone, aqua leather and cocoa velvets generate a restful ambience. The atmosphere radically changes at night: image projections, light and sound transform the atrium into a hub of activity for Chennai's chic elite. The 214 guest rooms remain havens of calm, with muted colors and gentle lighting. Beech wood floors and frosted glass contrast with more local flavors in the shape of coconut shell inlaid tables and parchment lamps. Original film posters leave a touch of a glorious past in the hotel that reflects a very bright future.

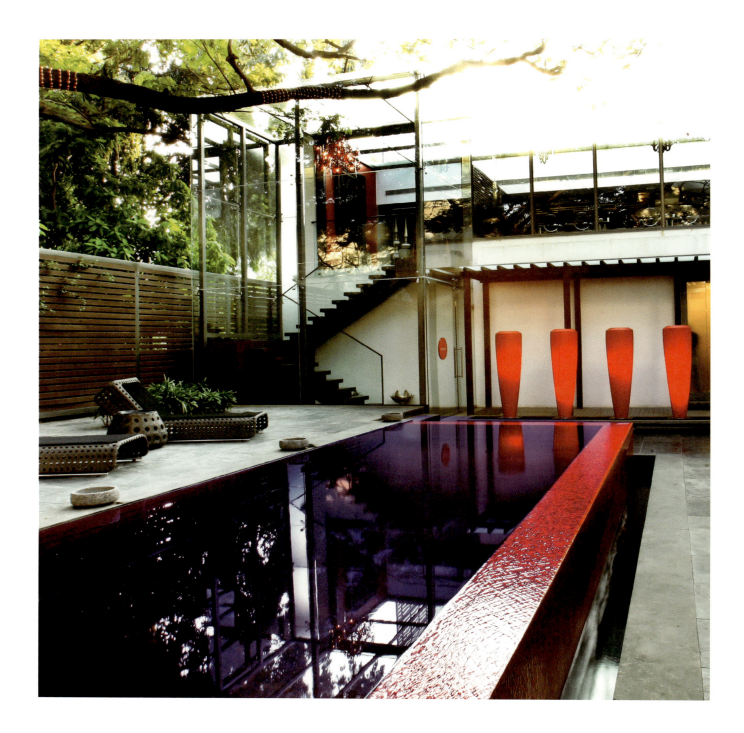

THE PARK POD CHENNAI
Chennai

Like an urban hybrid flower, The Park Pod Chennai started as a seed that grew and blossomed into a completely original entity. Atul Malhotra and Vikram Phadke of India's pioneering luxury designer shop, Evoluzione, created the bi-level glass and concrete building. Priya Paul of The Park Hotels stepped in to manage the property. Her creative input gave the final touch that made this singular design hotel a standout destination. Located on Khader Nawaz Khan Road, its discrete location, set back from the road, and the curvaceous leafy branches that embrace the building, give the feeling of an organic oasis by day. The glass facade and ceiling allow dappled light to flood into its public spaces, giving much of the building a sense of transparency. At night, there is a different, more mysterious ambience: the walkway to the hotel's reception area is illuminated with the warm glow of lit oversized red planters. Besides the funky Absolute Bar, the restaurant, Italia, is the beating heart of the hotel, a buzzing eatery and bar popular with trendsetting locals. In the courtyard the shadows of giant trees twist over a lap pool of bright red mosaic tiles as a DJ spins dance tunes. At The Park Pod, it's always a little unclear where the borders of inside and outside begin and end.

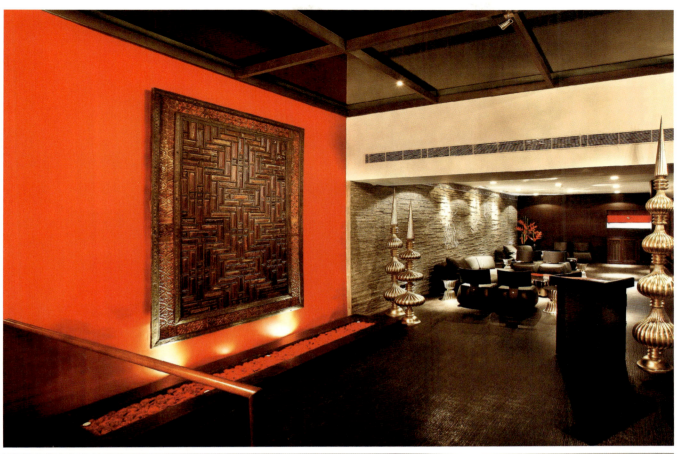
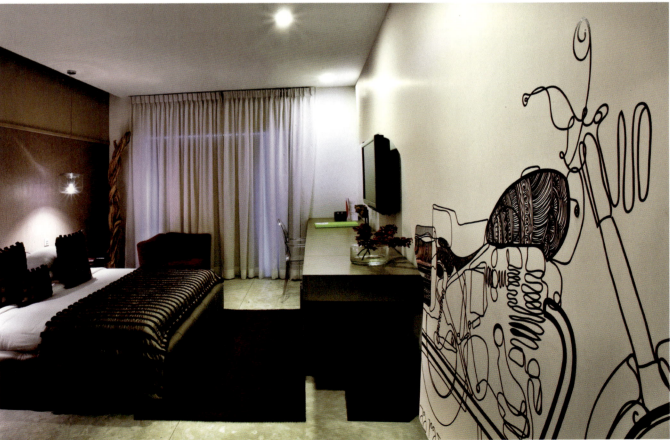

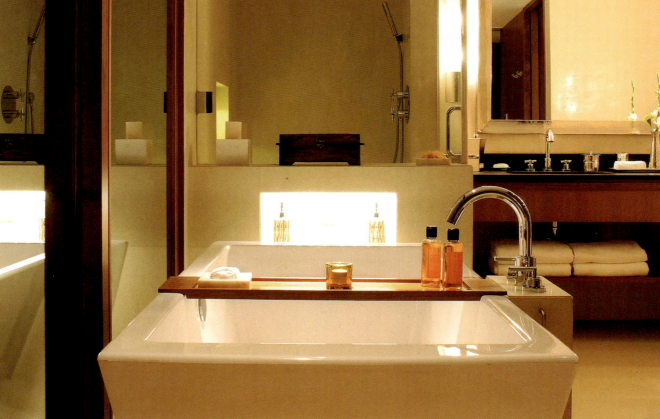

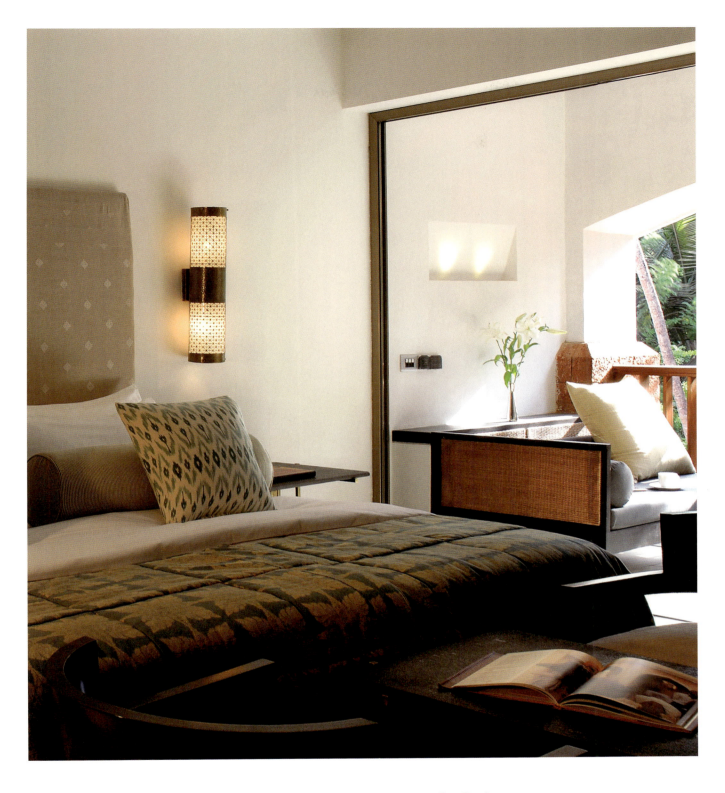

ALILA DIWA GOA
Goa

Looking out onto the Arabian Sea from the coast of Majorda Beach in South Goa, also known as "the pearl of the east," Alila Diwa Goa brings a new level of luxury to this exotic beach destination. Set amid lush paddy fields, Alila Diwa Goa has blended the best of contemporary Goan architecture with rich cultural traditions, to fashion an extraordinary experience in luxury destination travel. Each of the 153 guestrooms and suites are designed for relaxation and indulgence, enhanced by the beauty of the vibrant natural surroundings. For a more intimate experience, the crescent-shaped Diwa Wing – with 27 rooms and eight suites – offers pure luxury, with in-room check-in, anytime breakfast, access to the Diwa Lounge and its own lap pool with an open air jacuzzi. Extending outward from the heart of the hotel is the infinity pool, which invites guests to gaze out at the verdant landscape. There are several options for wining and dining: The Spice Studio coastal specialty restaurant; VIVO with live cooking stations; The Edge Bar and Lounge; and The Bistro, attached to the Diwa Wing, where guests can enjoy an all-day breakfast menu and surprising interpretations of local delicacies. At the signature Spa Alila, the treatments combine organic nutrition and health knowledge with ancient Asian healing techniques and age-old beauty recipes using natural, fresh ingredients. This laid-back atmosphere is perfectly enhanced by the resort's excellent service. The Leisure Concierge Team can coordinate customized activities and sightseeing attractions designed to give guests an opportunity to experience the local community and culture.

THE PARK
ON CANDOLIM BEACH
Goa

Pristine beach views, lush tropical rainforests and a laid-back bohemian vibe await guests at The Park on Candolim Beach. Situated on a 30km stretch of coastline in Northern Goa, Candolim Beach has a balmy climate throughout the year. Goa, which is visually and culturally distinct from the rest of India, attracts visitors with its abundant natural beauty and vibrant music and nightlife scene. Guests of The Park on Candolim Beach benefit from both, with exclusive beach access and resident DJs that provide a soundtrack of chilled music throughout the day and night. The pool deck, bar and restaurant extend out onto the unspoiled beach. From here, guests can take in magnificent sunsets and refreshing breezes from the Arabian Sea. Therapists from the Ayurvedic Aura Spa are on hand throughout the day, offering traditional ancient healing treatments to help detox, refresh and relax that can be enjoyed poolside or in-suite. The primarily white décor acts as a blank canvas which is accented by bright splashes of neon pink and deep purple. This light and contemporary style is also present in the 30 rooms, which have a minimal color palette and are decorated with contemporary works of art and custom furniture. These lively surroundings offer a unique insight into the energy of Goa and provide an ideal backdrop for a tranquil getaway.

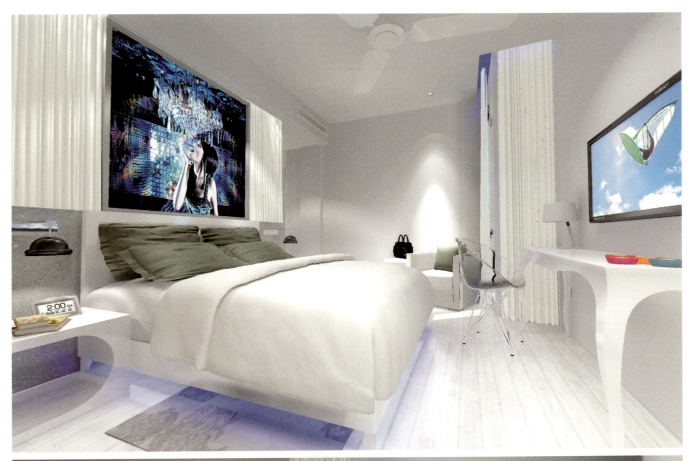
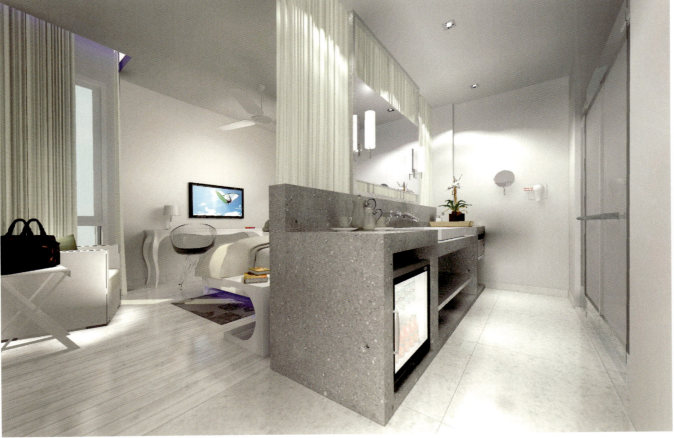

✴ SIGNATURE

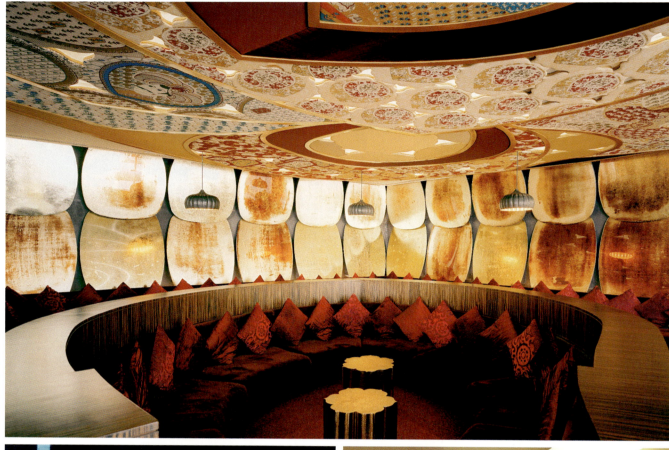

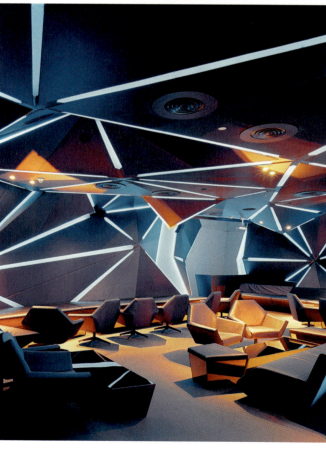

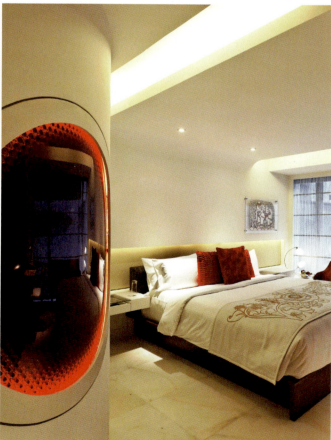

WWW.DESIGNHOTELS.COM/
THE_PARK_HYDERABAD

ADDRESS
22 RAJ BHAVAN ROAD
500 082 HYDERABAD
INDIA

ROOMS
268

RATES
INR 15000 –
INR 100000

OPEN
04/2010

INDIA
HYDERABAD

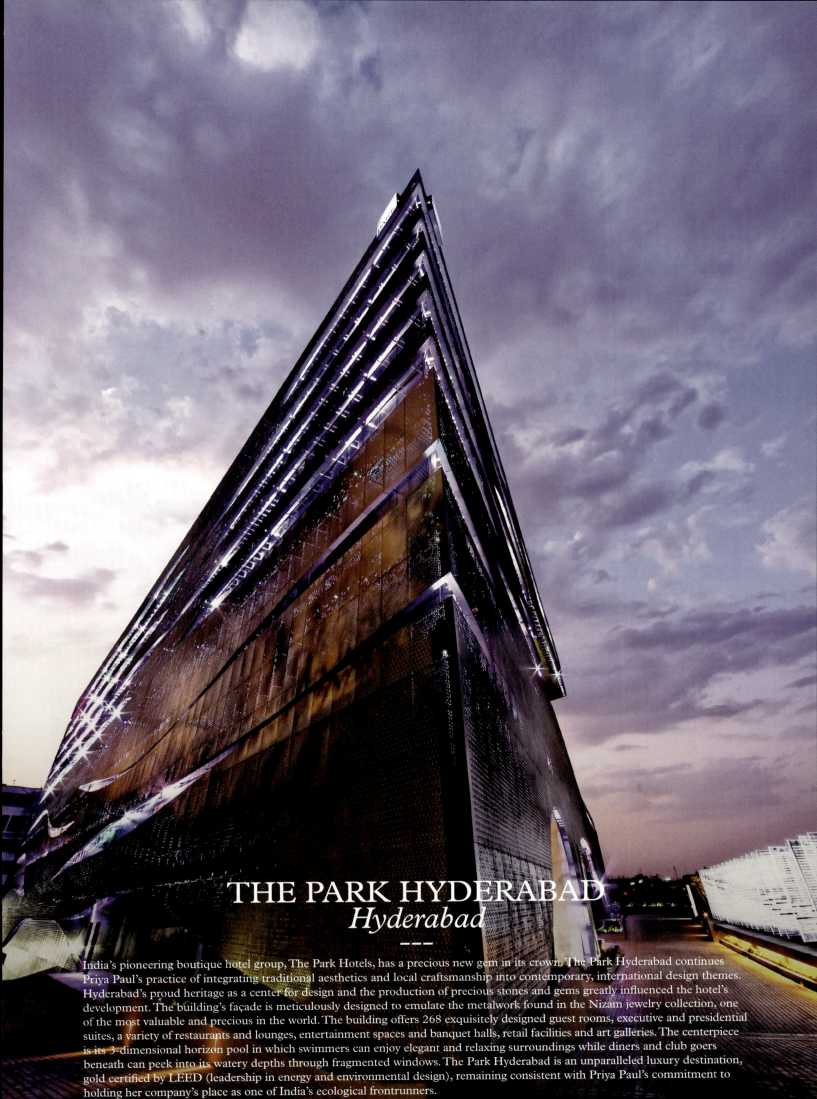

THE PARK HYDERABAD
Hyderabad

India's pioneering boutique hotel group, The Park Hotels, has a precious new gem in its crown. The Park Hyderabad continues Priya Paul's practice of integrating traditional aesthetics and local craftsmanship into contemporary, international design themes. Hyderabad's proud heritage as a center for design and the production of precious stones and gems greatly influenced the hotel's development. The building's façade is meticulously designed to emulate the metalwork found in the Nizam jewelry collection, one of the most valuable and precious in the world. The building offers 268 exquisitely designed guest rooms, executive and presidential suites, a variety of restaurants and lounges, entertainment spaces and banquet halls, retail facilities and art galleries. The centerpiece is its 3-dimensional horizon pool in which swimmers can enjoy elegant and relaxing surroundings while diners and club goers beneath can peek into its watery depths through fragmented windows. The Park Hyderabad is an unparalleled luxury destination, gold certified by LEED (leadership in energy and environmental design), remaining consistent with Priya Paul's commitment to holding her company's place as one of India's ecological frontrunners.

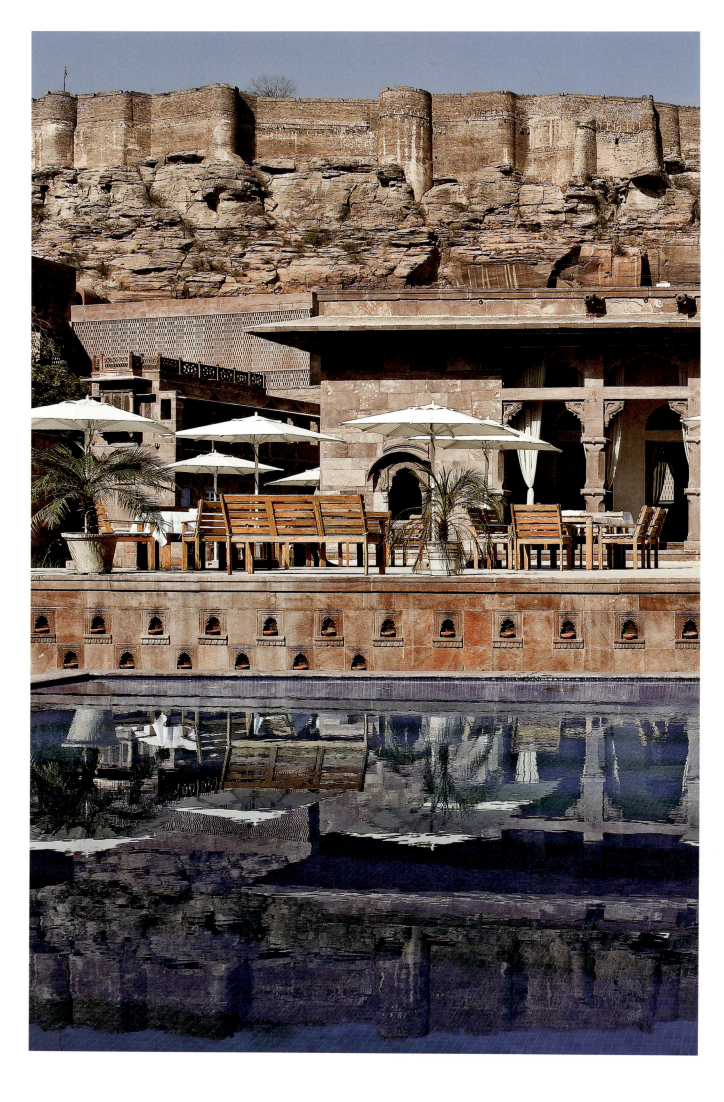

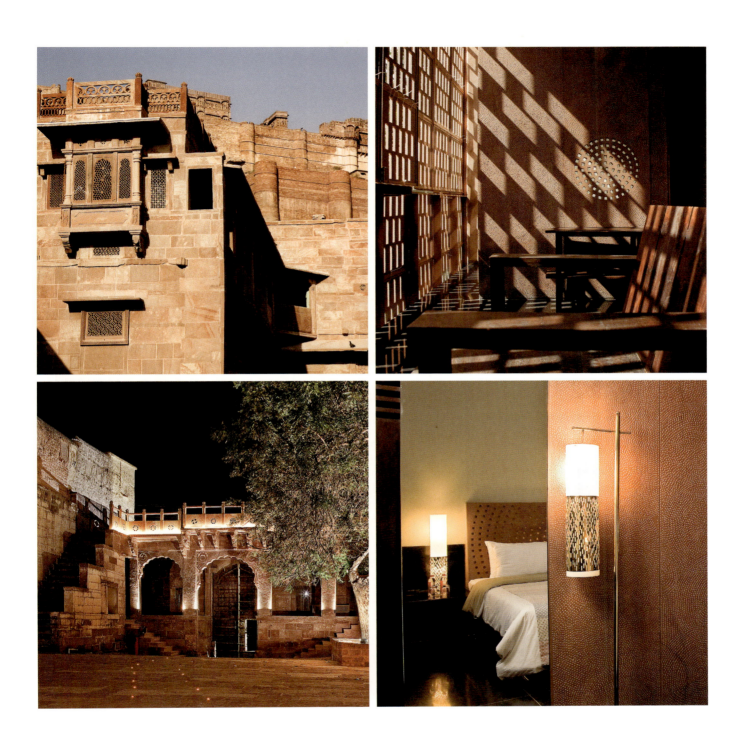

RAAS
Jodhpur

With its sensational position beneath Jodhpur's imposing Mehrangarh Fort, RAAS is the only luxury boutique hotel within an Indian walled city, embodying class with a rare and understated elegance. By grafting contemporary architecture and ambience onto the 300-year-old mansion, brothers Nikhilendra and Dhananajaya Singh have reclaimed, indeed enhanced, its grandeur. A nuanced harmony permeates the hotel's 32-room, 7-suite grounds. Striking views from the balcony of each room mean guests are privy to the exotic rhythms and color of Jodhpur. At the same time, they can find recluse in the Mogul-style terraced gardens, the secluded infinity pool, and the assorted spa treatments inspired by Ayurveda. "Jodhpur is similar to Jerusalem or Marrakech: you're not just a passive witness, you're immersed," says RAAS cofounder Nikhilendra Singh. By offsetting the city's raw charms with unparalleled tranquillity, the hotel is a place of pilgrimage for those in search of relaxation and reflection. Far from neocolonial, RAAS allows guests to share in the rebirth of past glories as something altogether more modern and inclusive.

THE PARK KOCHI
Kochi

Influenced by its location in a cosmopolitan port city, The Park Hotel Kochi blends elements of modern India with references to the seafaring traditions of this vibrant trading hub. Known as the gateway to Kerala, Kochi is in close proximity to both the sea and the mountains and has been a major port city for centuries. As one of the largest tower hotels in the city, its innovative design incorporates artwork commissioned specifically for the hotel by owner Priya Paul. These unique sculptural forms, which reference the traditional boat making skills and seafaring lifestyle of Kerala, resulted from collaborations between traditional and contemporary Indian artists. The 168 rooms and suites are opulently decorated with dark wood, creamy furnishings and rich, spicy hues like gold and burgundy that call the destination's historic trade to mind. Fragrant Kerala-style seafood dishes can be enjoyed from the rooftop restaurant, accompanied by views over the city and the Arabian Sea, while the 24-hour deli and café caters to round-the-clock cravings. Sleek white daybeds and ottomans surround the pool, which leads into the Aqua bar. Here, the box-lit tables, comfortable booths and dark indigo color scheme are all conducive to lounging late into the night. For those who prefer to detox and refresh, the Ayurvedic Aura Spa features spacious private spa suites and offers a selection of ancient healing treatments.

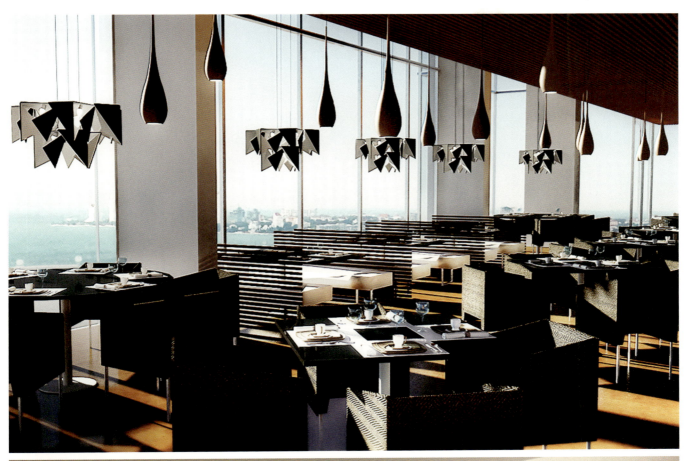

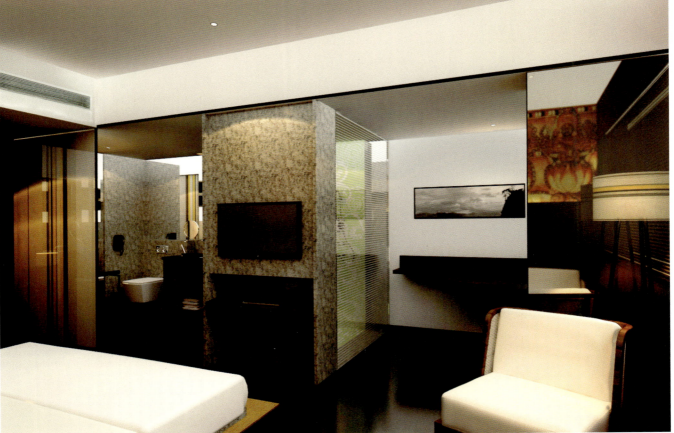

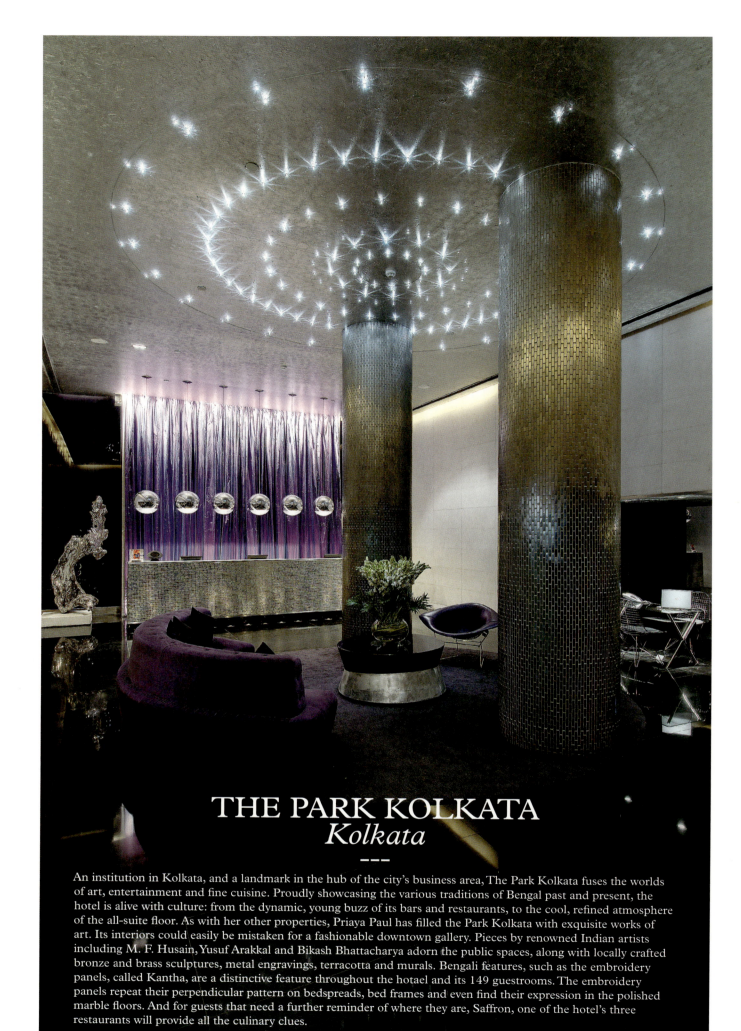

THE PARK KOLKATA
Kolkata

An institution in Kolkata, and a landmark in the hub of the city's business area, The Park Kolkata fuses the worlds of art, entertainment and fine cuisine. Proudly showcasing the various traditions of Bengal past and present, the hotel is alive with culture: from the dynamic, young buzz of its bars and restaurants, to the cool, refined atmosphere of the all-suite floor. As with her other properties, Priaya Paul has filled the Park Kolkata with exquisite works of art. Its interiors could easily be mistaken for a fashionable downtown gallery. Pieces by renowned Indian artists including M. F. Husain, Yusuf Arakkal and Bikash Bhattacharya adorn the public spaces, along with locally crafted bronze and brass sculptures, metal engravings, terracotta and murals. Bengali features, such as the embroidery panels, called Kantha, are a distinctive feature throughout the hotael and its 149 guestrooms. The embroidery panels repeat their perpendicular pattern on bedspreads, bed frames and even find their expression in the polished marble floors. And for guests that need a further reminder of where they are, Saffron, one of the hotel's three restaurants will provide all the culinary clues.

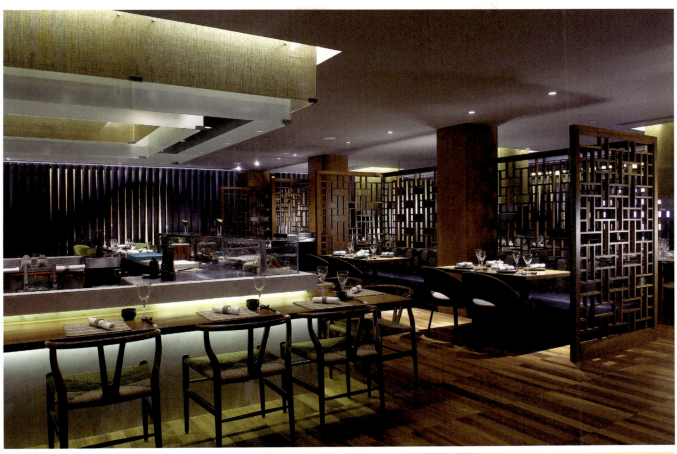
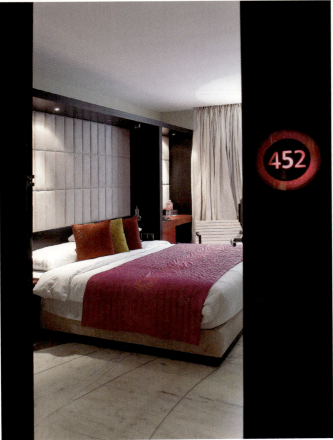
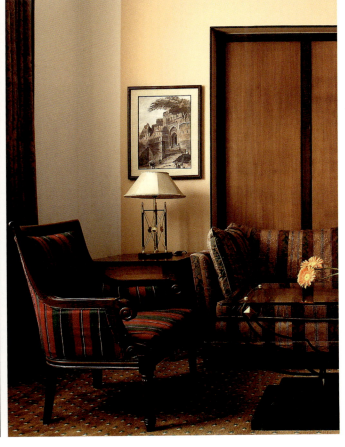

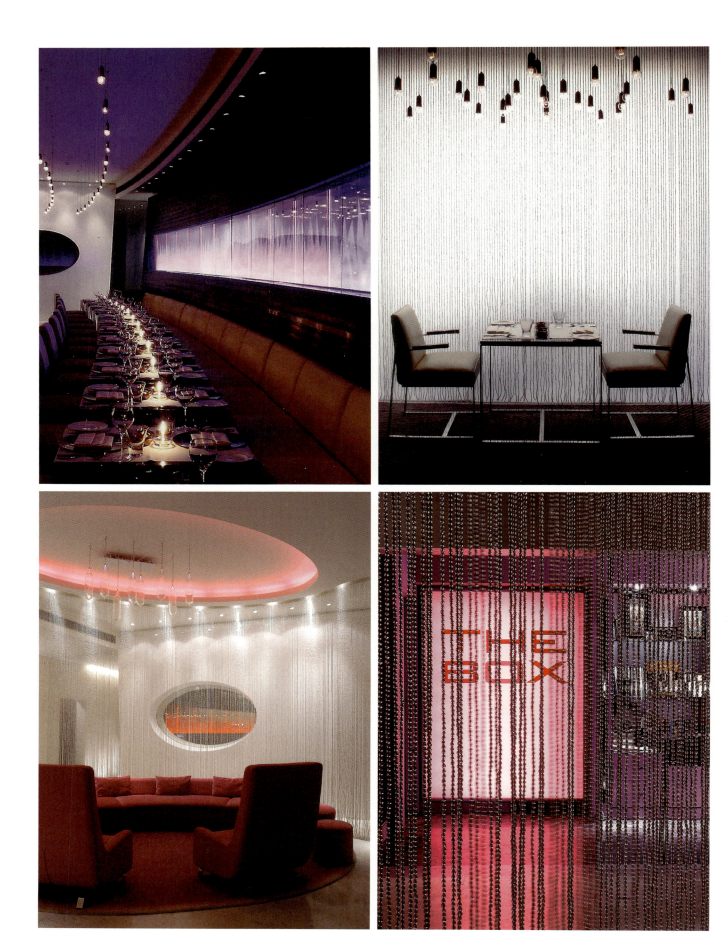

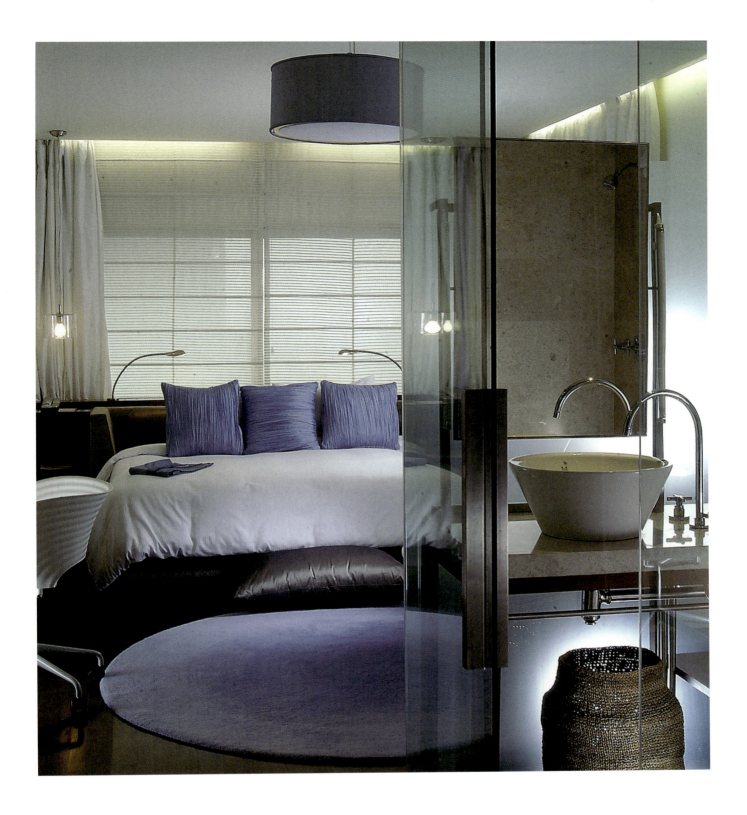

THE PARK NEW DELHI
New Delhi

This traditional property in New Delhi was face-lifted by Priya Paul in collaboration with design legend Sir Terence Conran. Modern concepts of air and space and ancient philosophies about the harmony between man and nature are the themes of the Indian capital's very own Park Hotel. The lobby and public space maintains a cool, breezy feel, sheltered from the world outside by a white-glass façade. Elements of fire and water are represented on the ground floor in both the restaurant Fire and adjoining bar, Agni. Guests can sample the delights of fine regional Indian cuisine in the leather and limestone clad Fire; or move beyond an elegantly curved bronze wall and enjoy an extensive wine list at Agni – an arced, glass-beaded 35-foot long bar surrounded by low leather divans and deep tub chairs. Drinks, however, are just a prelude to the dance floor at the end of the bar. Water makes a cool entrance in the restaurant Mist, which offers innovative Italian cuisine in a setting that echoes the entire area's overall look. The 220 guest rooms feature contrasting design touches: dark-timbered floors and pastel accents; on the two "residence" floors, private Jacuzzis and 24-hour butler service live up to the highest standards in Indian hospitality.

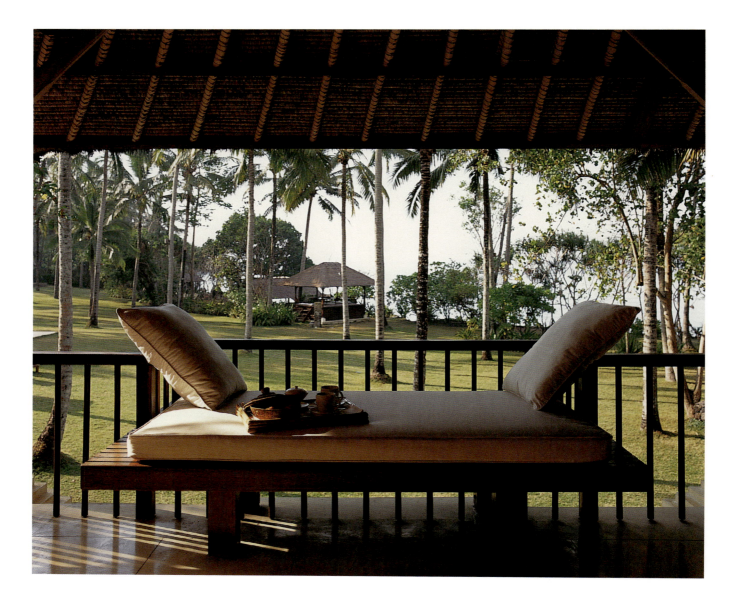

ALILA MANGGIS
Bali

With its breathtaking location between the sea and eastern Bali's sacred Mount Agung, Alila Manggis seduces guests with a free-flowing interaction between the buildings and their surrounding natural environment. The traditional, thatched roof covering the lobby is beautifully offset by floors of polished ivory-colored concrete. This immediately sets the stage for the quiet luxury that permeates the property. A latticework screen of diagonally laid stones – a trademark of Kerry Hill Architects' work for the Alila group – is set upon either end of the lobby. Four two-story buildings of cool white stone, lit after nightfall in beams of warm orange, contain guestrooms offering sea views that both soothe and inspire the soul. All of the rooms, and the two luxury suites, are set to face the sea. A golden glow of lights shimmering against the pool's cool turquoise presents an enticing visual dialogue. Each guestroom building is both an exercise in contrasting mass and lightness and a skillful study of Balinese architecture. Guests get a taste of local flavor in interiors influenced by the colors of the nearby Bali Aga valley villages: comforting shades of cream, sand, and chocolate emphasize the warmth of handwoven textiles and indigenous woods. The resort's leisure concierge can also connect guests with local life by organizing private tours of the stunning surroundings or even deep-sea fishing. No matter what visitors choose to do, they can always bask in the understated sense of luxury that enhances this Balinese getaway's peace and serenity.

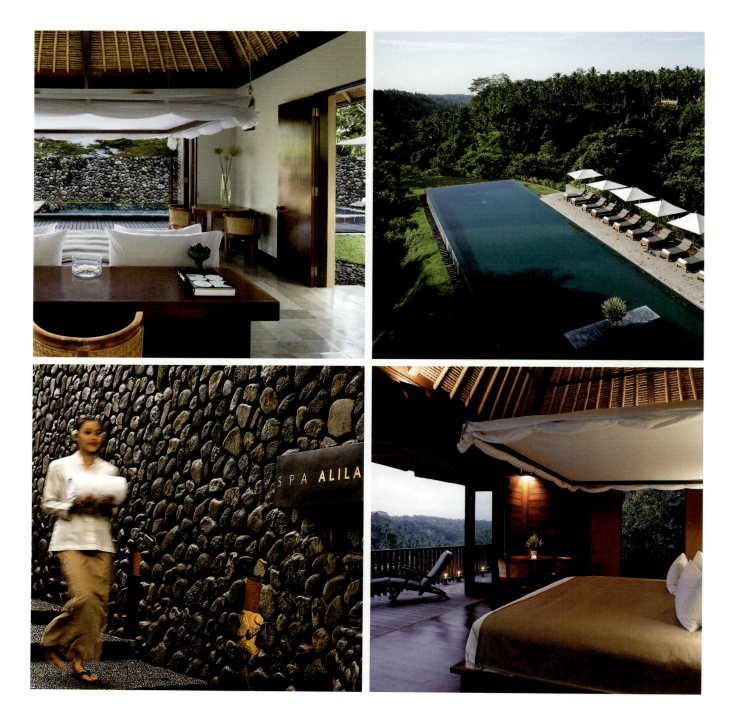

ALILA UBUD
Bali

Exquisitely secluded on a hillside in Bali's picturesque Ayung River Valley and featuring one of the world's finest infinity pools, the Alila Ubud is a spectacular retreat where guests can experience the extravagance of profound peace and quiet. It's also a place where architectural details effortlessly mix with natural elements. Straw roofs sit atop smooth plaster walls. Terracotta tiles blend into gravel and crushed rock, clearly delineating where the modern world ends and the traditional Balinese building begins. The award-winning pool spreads out to form an elongated rectangle until its edges seem to disappear into the terraced jungle hillside. Here, public spaces resemble the layout of a Balinese village; valley villas are perched on stilts and the pool villas offer a sublimely private retreat. The guestrooms – an expression of understated luxury made from the finest natural, local materials, designed to maximize wind flow and optimally ecological – lure one's gaze onto the lush, verdant green of the Ayung River Valley. Guests can hear the flowing waters of the nearby river and admire a backdrop of volcanoes. Though located only five kilometers from Ubud, Bali's cultural center, guests might find it difficult to leave the Alila Ubud for even a moment.

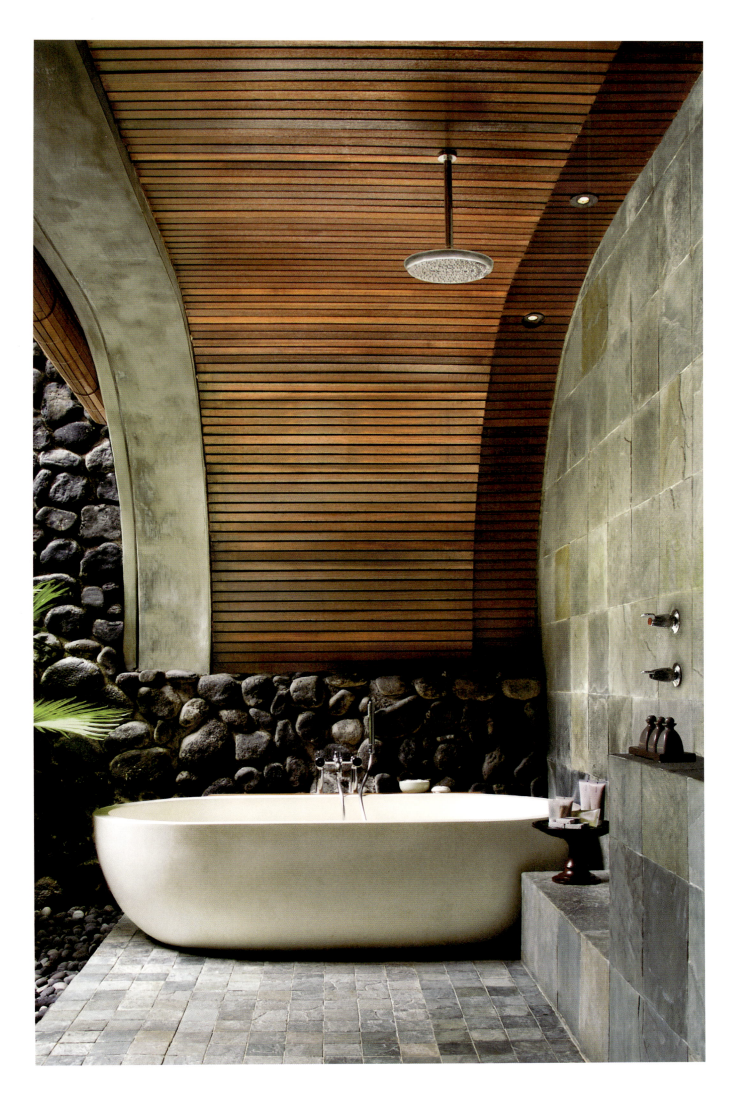

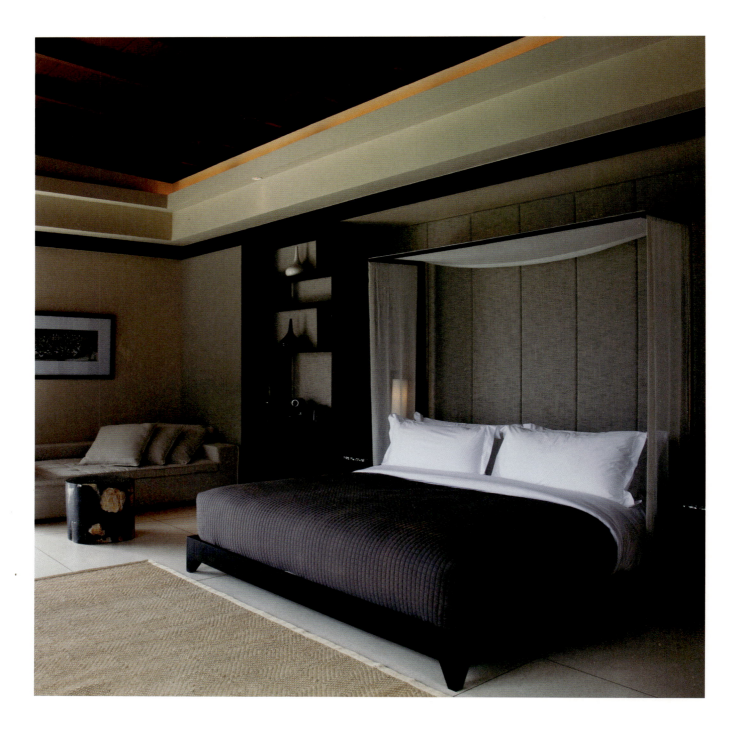

ALILA
VILLAS SOORI
Bali

Gracefully planted on Bali's southwest coast, just a few kilometers from the island's renowned Tanah Lot Temple, the idyllic Alila Villas Soori lies on a gentle slope between lush, green rice terraces and a soft, black-sand beach on the enchanting, azure Indian Ocean. Managed by Alila Hotels and Resorts, Asia's leading boutique hotel management enterprise, the Alila Villas Soori offers 44 exquisitely designed villas ranging in capacity from one to ten bedrooms. Each villa offers the epitome of relaxing luxury and unadulterated privacy. Designed by Singapore-based SCDA Architects, Alila Villas Soori integrates elements of its surrounding natural environment in an elegant expression of contemporary Asian design that is in perfect harmony with Alila's commitment to environmental sustainability. Guests are invited to experience the equilibrium between tranquillity and vitality at Alila Villas Soori by exploring Bali's rich heritage with a trek or a cycling trip, a round of golf on the Greg Norman-designed course or an afternoon of indulgence at Spa Alila, the zenith of this secluded sanctuary.

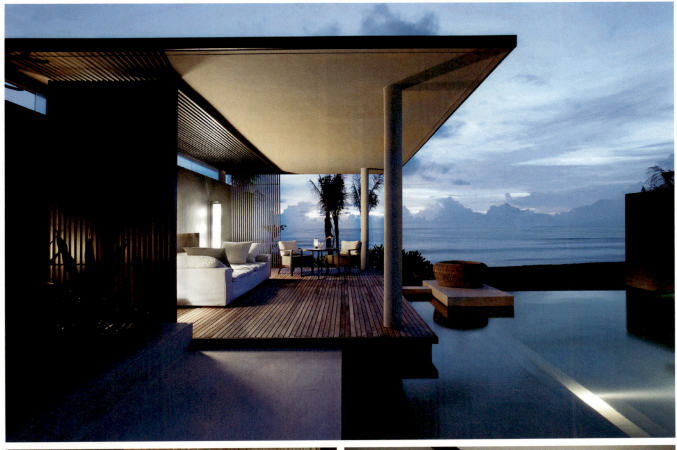
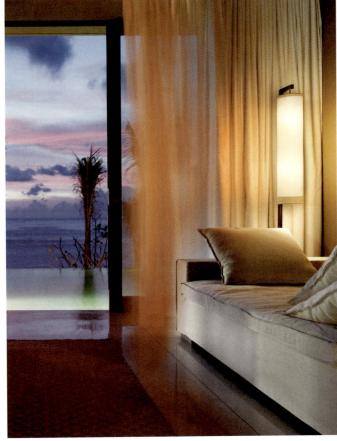
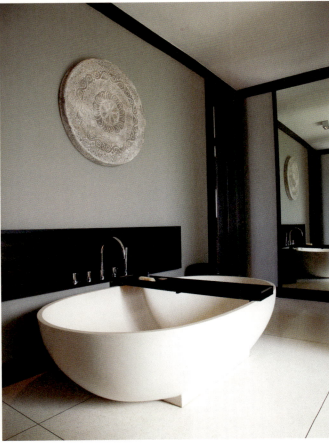

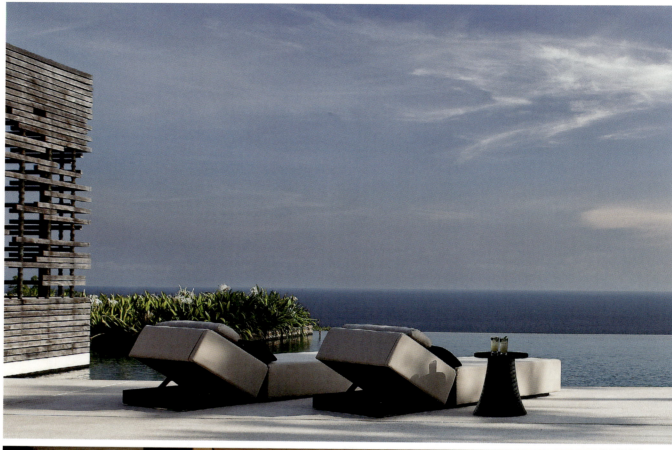

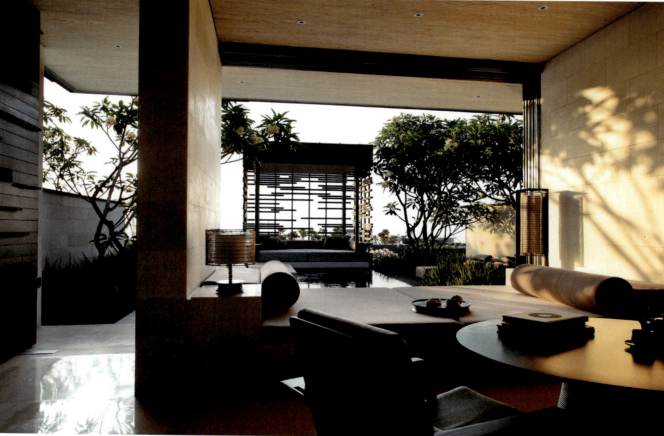

WWW.DESIGNHOTELS.COM/ ALILA_VILLAS_ULUWATU

ADDRESS
JL. BELIMBING SARI, BANJAR TAMBIYAK, DESA PECATU
80364 ULUWATU, BALI
INDONESIA

VILLAS 84

RATES USD 725 – USD 4710

OPEN 06/2009

INDONESIA BALI

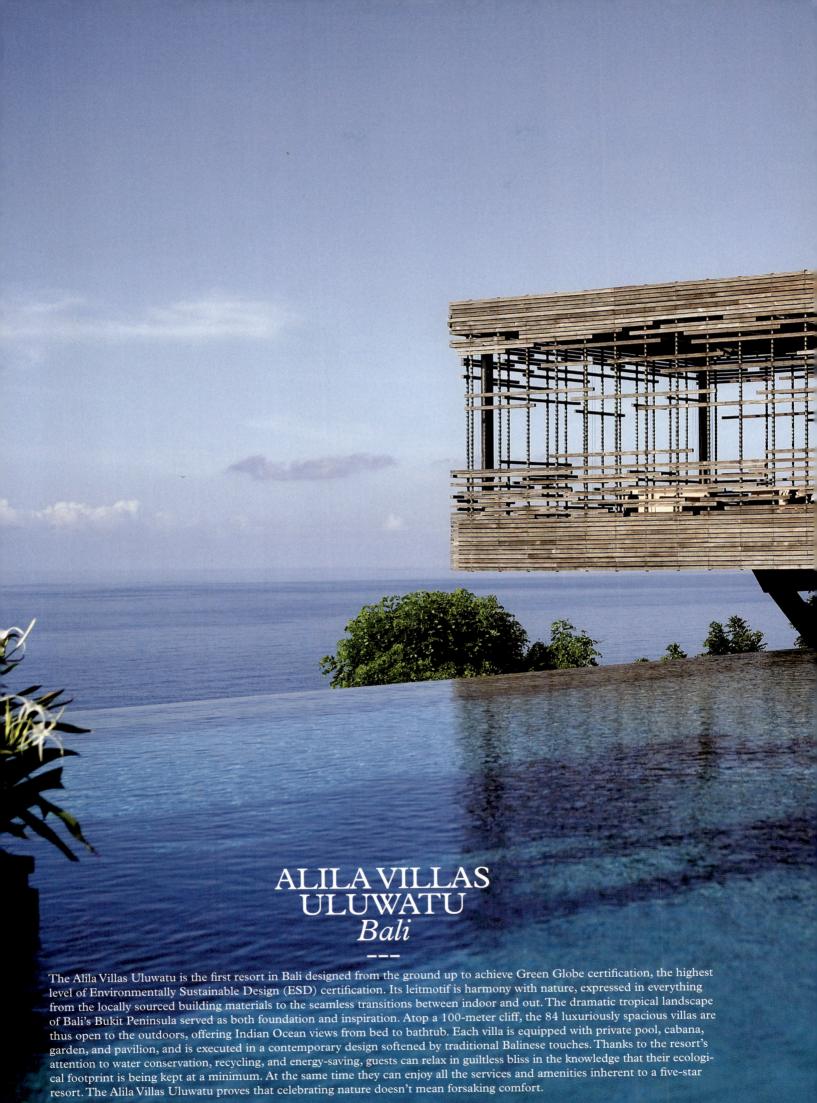

ALILA VILLAS ULUWATU
Bali

The Alila Villas Uluwatu is the first resort in Bali designed from the ground up to achieve Green Globe certification, the highest level of Environmentally Sustainable Design (ESD) certification. Its leitmotif is harmony with nature, expressed in everything from the locally sourced building materials to the seamless transitions between indoor and out. The dramatic tropical landscape of Bali's Bukit Peninsula served as both foundation and inspiration. Atop a 100-meter cliff, the 84 luxuriously spacious villas are thus open to the outdoors, offering Indian Ocean views from bed to bathtub. Each villa is equipped with private pool, cabana, garden, and pavilion, and is executed in a contemporary design softened by traditional Balinese touches. Thanks to the resort's attention to water conservation, recycling, and energy-saving, guests can relax in guiltless bliss in the knowledge that their ecological footprint is being kept at a minimum. At the same time they can enjoy all the services and amenities inherent to a five-star resort. The Alila Villas Uluwatu proves that celebrating nature doesn't mean forsaking comfort.

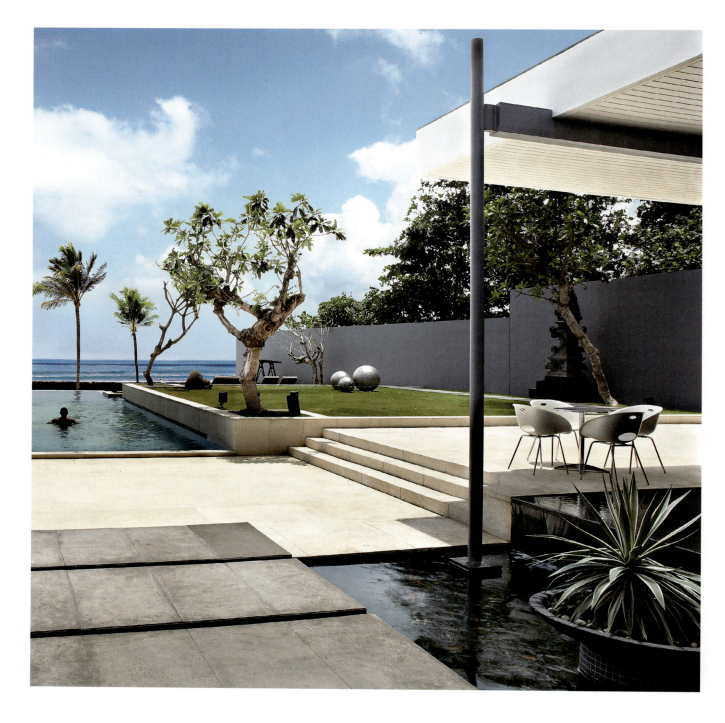

RARE

WWW.DESIGNHOTELS.COM/ LUNA2

ADDRESS
JALAN SARINANDE NO. 22
80361 SEMINYAK, BALI
INDONESIA

ROOMS
5

RATES
USD 3000 –
USD 4000

OPEN
02/2007

INDONESIA
BALI

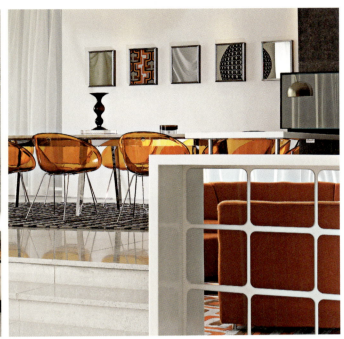
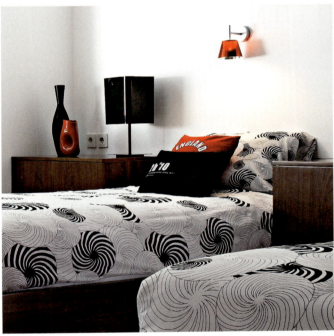
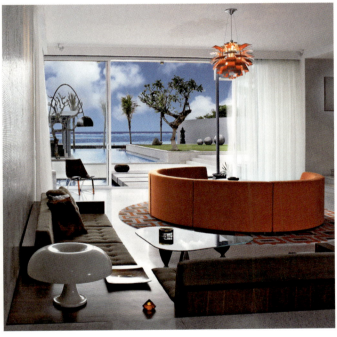

LUNA2 PRIVATE HOTEL
Bali

In stark contrast to the ubiquitous modern Bali style seen elsewhere on Seminyak's prime beachfront, Luna2 Private Hotel is making waves of its own with its retro-modernist design. Named after the first spacecraft to land on the moon in the late 1950s, its South Beach simplicity provides a backdrop for Melanie Hall's signature interiors – a feast of funky sixties-inspired custom-designed furnishings, paired with nostalgic design classics and 21st-century innovation. All Hall's interiors are color-themed, using a broad spectrum of materials, textures and prints, including walnut veneers, solid acrylics and vintage European wallpapers. Bisazza mosaics are featured throughout, even down to the base of the 20-meter pool where Marilyn Monroe lies forever young in her iconic white dress. With just five bedrooms, Luna2 boasts the super-star service of an exclusive hotel with the intimacy of a private home. General Manager and Executive Chef Danny Drinkwater helms this impressive property, leading a team of 23 staff members while they cater to guests' every whim, no matter how tall or how small. The food at Luna2's restaurant is crafted with extraordinary attention to detail, with particular attention paid to taste, produce and presentation. With its visionary design, prime location and unrivalled service, Luna2 is the ultimate destination for culturally savvy, discerning singles, couples or groups, with or without kids.

LUNA2 STUDIOS
Bali

With a design that blends great modernism of the past, with innovation of the future, this "studiotel" offers travelers to Bali a refreshing alternative to the ubiquitous "modern Bali" style. Located in Seminyak, the island's most fashionable destination for shopping, dining and relaxation, Luna2 Studios is adjacent to its sister property Luna2 Private Hotel and is just a short stroll to the beach. From the sixties inspired façade, covered in circular forms, to the wall-mounted installation in the lobby inspired by the work of Dutch artist Piet Mondrian, iconic art references are present throughout. Bright primary colors pop from the stark white walls, while geometrical patterns, bright furnishings and accessories, and walnut detailing create welcoming, vibrant spaces. Each of the 14 studios features one of four accent colors – yellow, red, green and blue – and offer modular open-plan lounges, equipped with the latest technologies. The playful color scheme continues outdoors, with color-blocked mosaics in the lap pool and matching day beds. Those seeking a respite from the sun can watch a movie in Lunaplex – Luna2 studios' own 16-seat cinema – or dine at the intimate Orbit restaurant, with just 30 seats. From the restaurant, a spiral staircase leads down to Pop! Lounge Bar, an understatedly decadent den with low ottomans and booths in deep shades of reds, blues and purples, where the DJ plays tracks to suit the mood until the early hours of the morning.

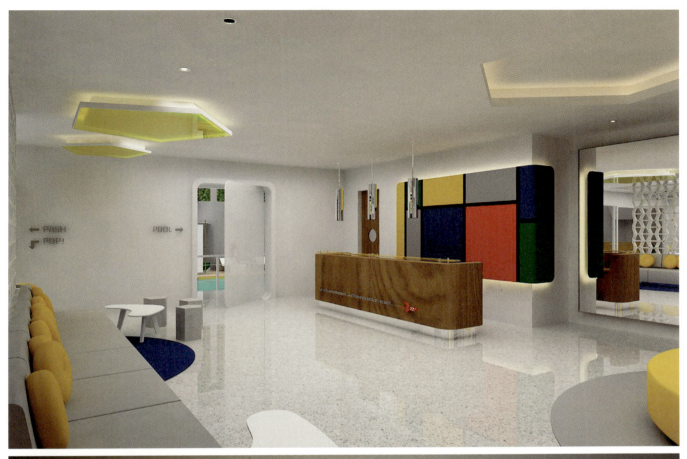
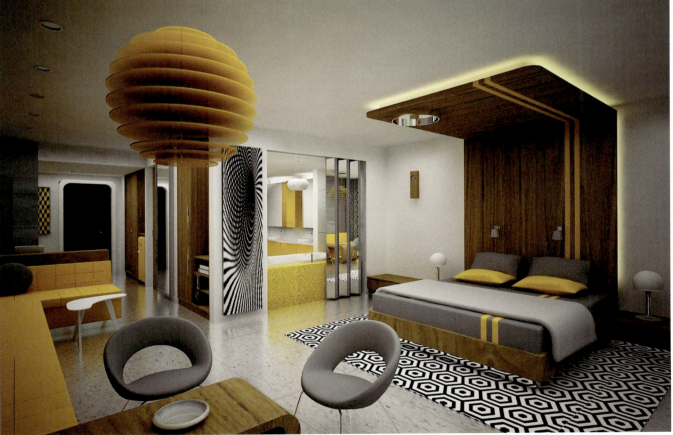

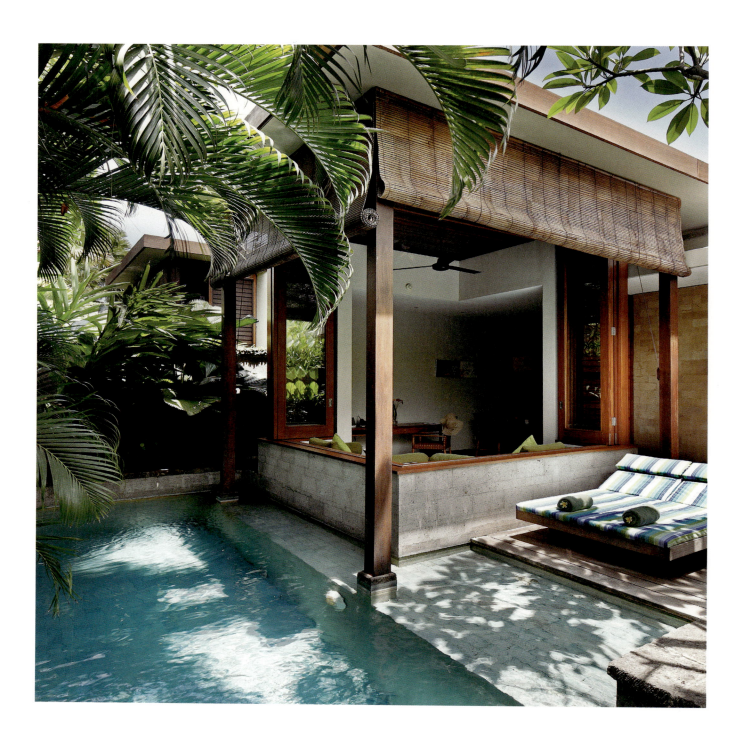

SIGNATURE

WWW.DESIGNHOTELS.COM/THE_ELYSIAN

ADDRESS
18 JALAN SARI DEWI
80361 SEMINYAK, BALI
INDONESIA

VILLAS
27

RATES
USD 385 – USD 700

OPEN
10/2005

INDONESIA
BALI

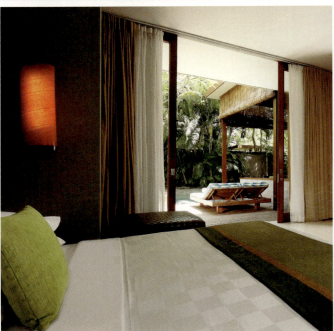
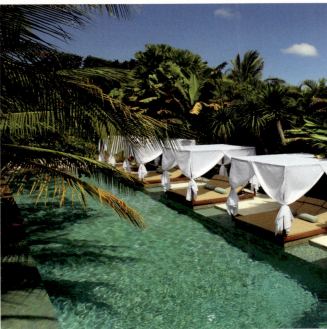

THE ELYSIAN
BOUTIQUE VILLA HOTEL
Bali

Part of a growing wave of condominium hotels, The Elysian Boutique Villa Hotel on Bali provides an island ambience that caters to short- and long-term guests. Located two minutes from Bali's white sand beaches, the hotel consists of 27 private villas, each with its own pool. The look of The Elysian design hotel is "modern Asian," a combination of traditional proportions with contemporary ambient twists: an open pavilion surrounded by water welcomes guests and a 25-meter pool runs the length of the terrace, ending in a trellised waterfall and Balinese temple. Stepped pathways meander between tall wispy grasses and groves of banana and traveler's palms. A sense of openness abounds: walled gardens abut oversized wood-framed sliding windows and doors, creating a fluid and changeable space. Extensive use of teak wood and local stone and marble in a variety of finishes provides a luxurious variety of textures for eye and touch alike. All villas are equipped with broadband Internet, iPad, Bose sound system and complimentary MacBooks subject to prebooking. But the pleasure is not limited to the indoors: that beach is calling, and the rush bamboo poolside café and bar offer cool, comfortable dining, drinking and snoozing possibilities.

ALILA JAKARTA
Jakarta

This hotel in the middle of Jakarta's central business district stays true to its name, a Sanskrit word meaning "surprise." A welcome retreat from the energy of its surrounding streets, the Alila Jakarta exemplifies simple elegance and skips all unnecessary ornamentation throughout its 27 floors. Local architecture firm Denton Corker Marshall chose a minimal design aesthetic that offers guests a sanctuary from the outside world. The care and attention lavished on its clientele shows in Alila Jakarta's unconventional policies, such as the exclusive reservation service for female guests or ample meeting space for savvy business travelers. Steel and local stone, such as Indonesian granite, provide the lobby with a gentle grace that is illuminated by large windows overlooking the garden in the peaceful inner courtyard, while the lush, yet soothing palette of dark red tones spanning the Alila Jakarta's 246 rooms subtly expresses the hotel's Asian flair. Offering a pure and abstract design experience, the Alila Jakarta is an exclusive and surprisingly isolated place to replenish your energy reserves.

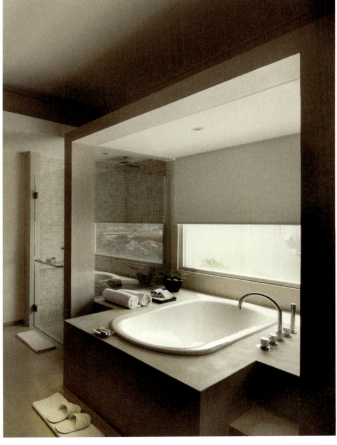
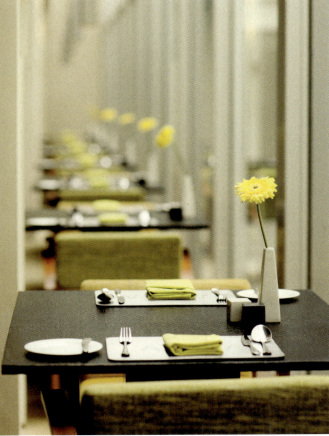

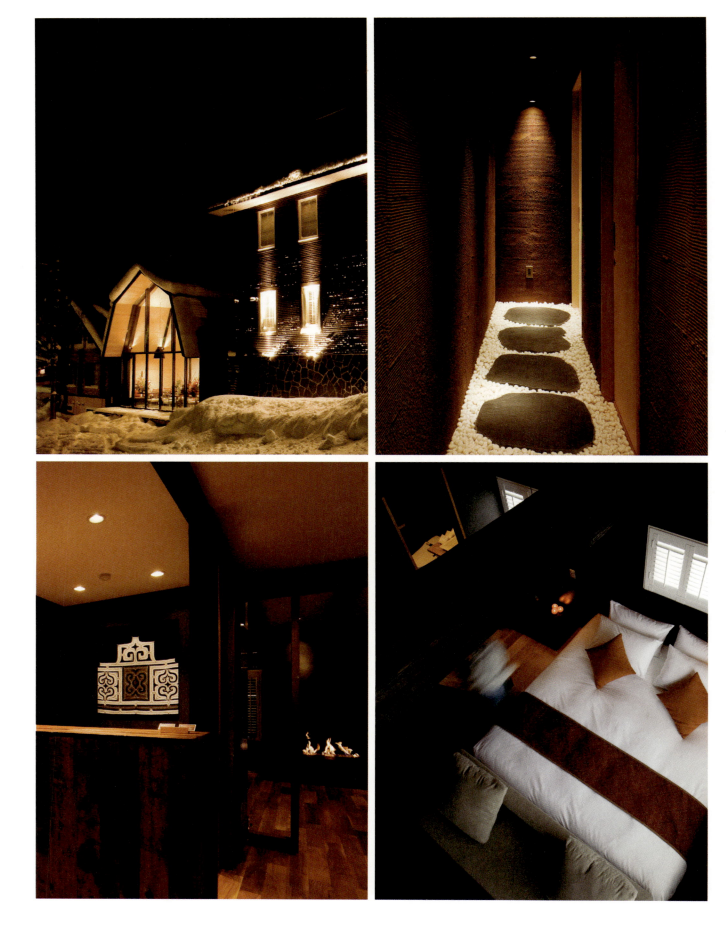

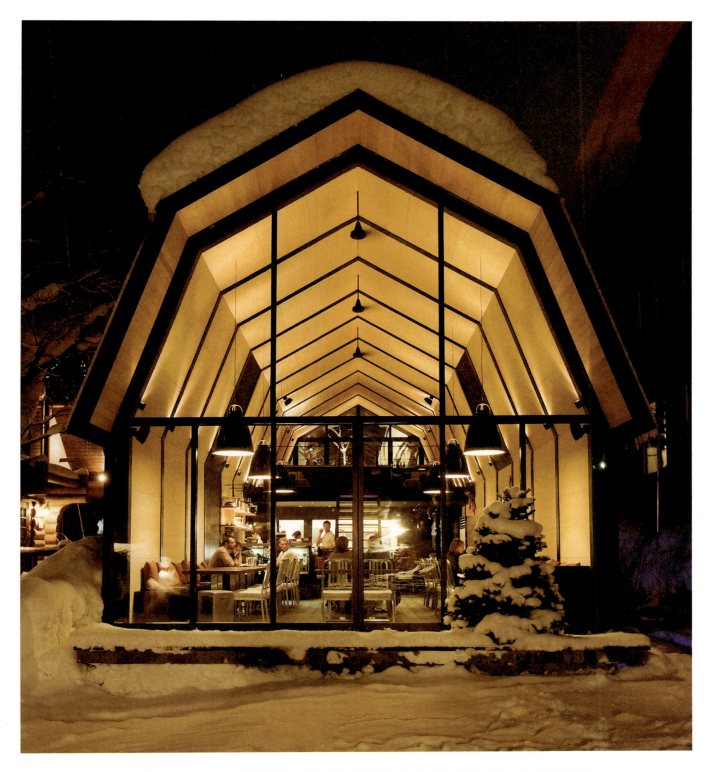

KIMAMAYA BOUTIQUE HOTEL
Niseko-Hirafu

Even as the snowflakes start to fall, adding powder to the slopes outside, Kimamaya Boutique Hotel remains toasty-warm: a cocoon upon the mountainside. Kimamaya is the Japanese word for "be yourself" and here, you can do just that. Jazz music floats through the homey Living Lounge and all that's left to worry about is which wine you'll sip as you laze by the fireplace. The vintages served here come from a vineyard owned by the family of Nicolas Gontard, who renovated this nine-room retreat to help guests get closer to the beauty of Niseko, one of Japan's most popular ski resorts. But Kimamaya Boutique Hotel's mountain location isn't only appealing in winter. In the summer and fall, pristine trails and mountain biking tracks snake through the surrounding pine forests. Hokkaido star architect Koichi Ishiguro placed special attention on using sustainable, renewable and recyclable materials, as well as the original wooden framework to retain the history of the building. The Swiss chalet style roof belies the Zen purity that awaits inside, with clean lines and a warm palette of chocolate wood, rich elm floors and black granite created by interior designer Andrew Bell. In the lofty, glowing space that houses The Barn restaurant, inspired by traditional Hokkaido farm architecture, fresh produce is served with French flare and warm hospitality. Kimamaya Boutique Hotel proudly bears the Odin brand. Created by Nicolas Gontard and his Norwegian partners Bjorn and Chris Fjelddahl, the brand is dedicated to developing real estate and creating hospitality experiences that encompass "intelligent luxury." But more than anything, Odin endeavors to create more of one of the most elusive currencies on earth: time.

PARK HOTEL TOKYO
Tokyo

The sleek triangular skyscraper that French interior designer Frederic Thomas created for the Park Hotel Tokyo embraces downtown Tokyo's lively milieu without succumbing to its fast pace. Located in the Shiodome Media Tower, Park Hotel Tokyo is home to leading international media organizations and television companies. But the tower also offers an oasis of elegant living amid the area's bustle and flow. While all of the guestrooms face outside, the curvaceous lines of the furniture, cloth-covered walls, and soft, off-white color scheme cushion guests from the city's distractions – just as custom-fitted pillows cushion necks, ensuring a good night's sleep. Those who want to explore the city have a smooth transition from the hotel's sanctuary into the Waterfront Transit Station by way of low-level exits that lead directly to the heart of Tokyo. Inside the hotel, natural light that enters via a ten-story atrium to illuminate the space is one of the business district's wonders. Equally attractive is the soothing haven of sunlit trees and greenery planted on the obsidian and teak lobby floor to embody Japan's cultural tradition of incorporating nature into even the most forward-thinking man-made marvels.

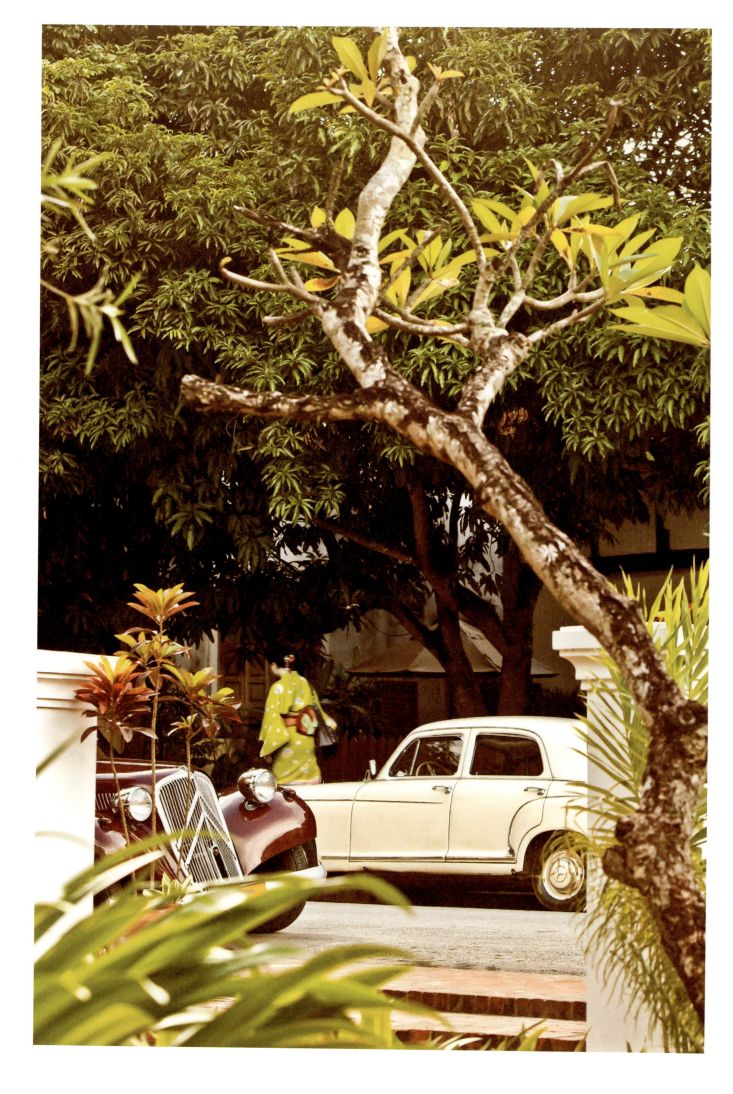

LAO PEOPLE'S DEMOCRATIC REPUBLIC
LUANG PRABANG

OPEN
04/2003

RATES
USD 125 –
USD 420

ROOMS
15

ADDRESS
BAN VATNONG, SAKKALINE ROAD, P.O. BOX 722
LUANG PRABANG
LAO PEOPLE'S DEMOCRATIC REPUBLIC

WWW.DESIGNHOTELS.COM/
3_NAGAS

OFFBEAT

3 NAGAS
Luang Prabang

Luang Prabang, a UNESCO World Heritage site since 1995, is culturally and scenically rich, with golden-tipped Buddhist temples, decaying French colonial architecture, thriving foliage and misty waterfalls. At 3 Nagas, three World Heritage buildings more than a century old have been thoughtfully restored using traditional materials and construction techniques. The result is a blend of Laotian tradition, colonial charm and modern comfort. Simplicity reigns, with elegant touches and attention to the smallest of details adding to the unique charm of the hotel. Each of the 15 individually-designed rooms and three suites has a distinct character of its own, but all are unified by exotic wood floors, traditional lime-washed walls and clay-tile roofs. The spaces are tastefully finished with fine silks and traditional weavings, opening onto private verandas to the street or garden – ideal settings to take in Laotian life's languid pace and beauty. Two restaurants serve authentic Laotian food and Western fusion cuisine. The hotel can tailor activities ranging from eco-tours to meditation, as well as interactive learning journeys that provide insight into the languid pace of Laotian life and traditions.

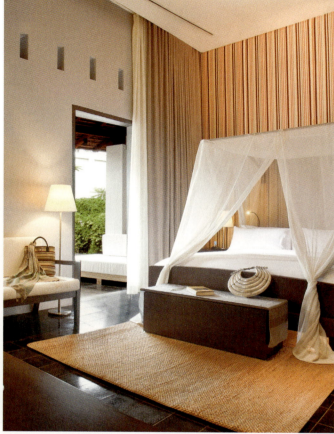

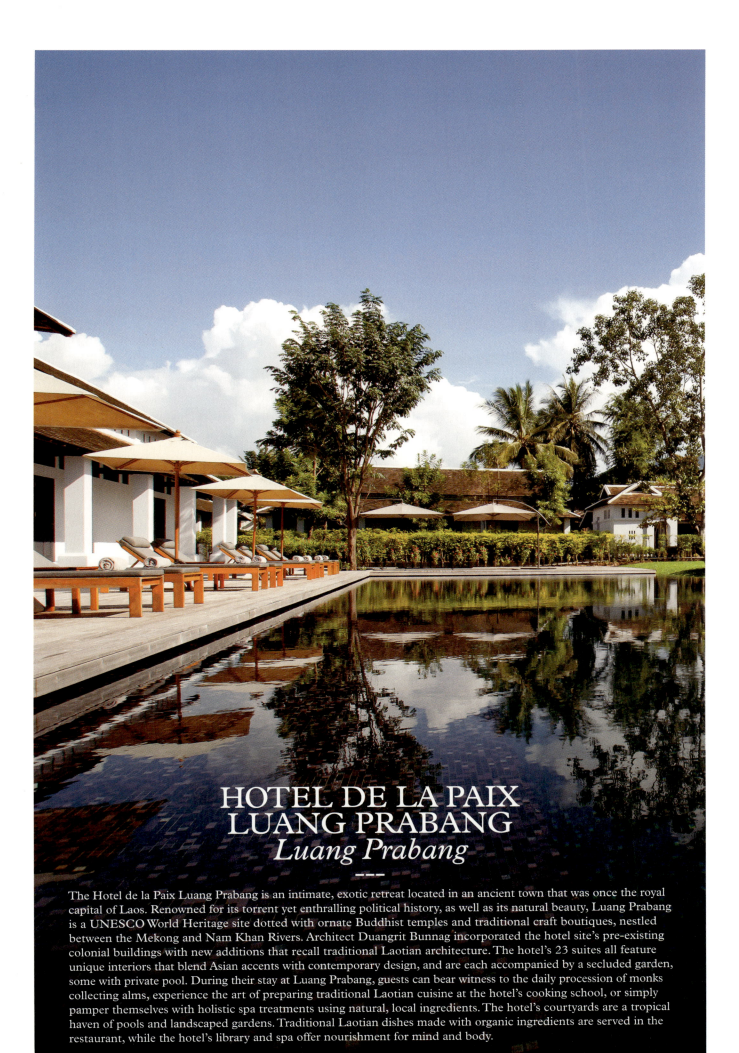

HOTEL DE LA PAIX LUANG PRABANG
Luang Prabang

The Hotel de la Paix Luang Prabang is an intimate, exotic retreat located in an ancient town that was once the royal capital of Laos. Renowned for its torrent yet enthralling political history, as well as its natural beauty, Luang Prabang is a UNESCO World Heritage site dotted with ornate Buddhist temples and traditional craft boutiques, nestled between the Mekong and Nam Khan Rivers. Architect Duangrit Bunnag incorporated the hotel site's pre-existing colonial buildings with new additions that recall traditional Laotian architecture. The hotel's 23 suites all feature unique interiors that blend Asian accents with contemporary design, and are each accompanied by a secluded garden, some with private pool. During their stay at Luang Prabang, guests can bear witness to the daily procession of monks collecting alms, experience the art of preparing traditional Laotian cuisine at the hotel's cooking school, or simply pamper themselves with holistic spa treatments using natural, local ingredients. The hotel's courtyards are a tropical haven of pools and landscaped gardens. Traditional Laotian dishes made with organic ingredients are served in the restaurant, while the hotel's library and spa offer nourishment for mind and body.

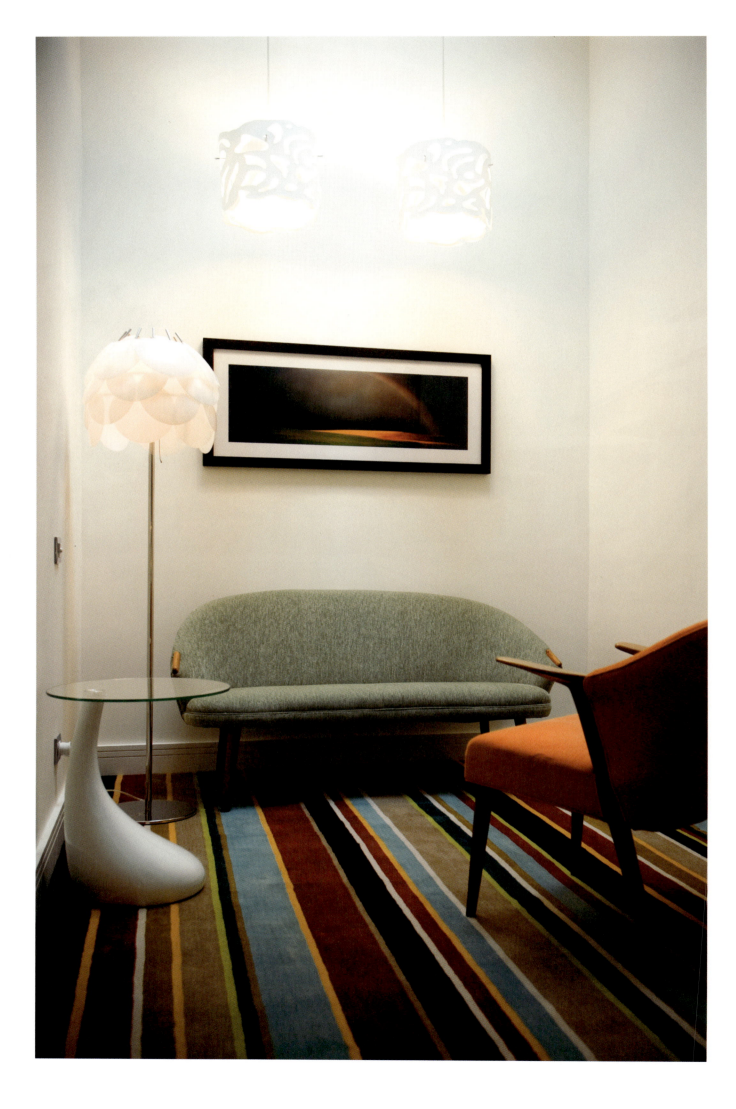

NEW ZEALAND / AUCKLAND

OPEN 02/2009

RATES NZD 300 – NZD 600

ROOMS 25

ADDRESS
2 HIGH STREET
1010 AUCKLAND
NEW ZEALAND

WWW.DESIGNHOTELS.COM/DEBRETT

*SIGNATURE

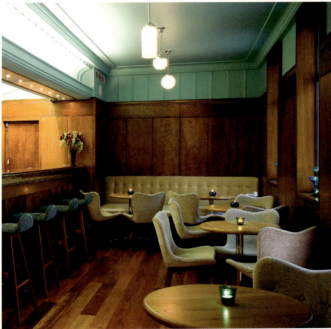
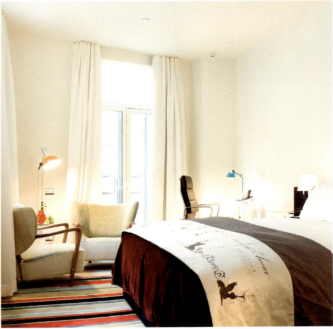

HOTEL DEBRETT
Auckland

Although it's located on Auckland's High Street, in the middle of the city's hip fashion district, Hotel DeBrett is more about enduring style than any short-lived seasonal trend. And while much of the Art Deco charm of one of Auckland's oldest hotels has been preserved, owners and designers Michelle Deery and John Courtney have managed to transform this 1920s building into a modern boutique hotel that surprises guests with warm, homey touches. All 25 rooms are one-of-a-kind, but they're stitched together by a velvety custom-made carpet striped with shades of burgundy, black, sky blue and yellow. In the public areas, meanwhile, classic mid-century armchairs and plush patchwork rugs punctuate the pine-colored floorboards. Hand-spun copper chandeliers bounce warm light off raw brick walls, while a thin, funky log-burning fire invites guests to stop and reflect on the building's illustrious history. Back in its heyday, Hotel DeBrett's wood-paneled Housebar was the city's best place to see and be seen. Business deals and romances were kindled here for decades, and, now that the original wooden bar is back in place, the tradition is set to continue well into the future. The restaurant Kitchen bases its menu around local seasonal produce and has been nominated for the "Cuisine New Zealand Restaurant of the Year 2011," while the recently renovated Cornerbar, decorated with retro touches, emphasizes local craft beers and New Zealand wines.

KLAPSONS, THE BOUTIQUE HOTEL
Singapore

As guests step through the glass doors of klapsons, one of Singapore's newest boutique hotels, the combination of five-star luxury and a distinctive sensitivity towards contemporary design is immediately apparent. William Sawaya of Sawaya & Moroni spearheaded the design team and the results are sensational. Klapsons, The Boutique Hotel attempts to change the face of both business and leisure travel to Singapore by affording a quiet sophistication and a subtle sense of luxury joined with profound functionality. Sawaya has carefully given each guestroom at klapsons an individualized design identity so that no two are alike, ensuring that visitors have a new experience, and discover new comforts and new indulgences, during every stay at the innovative hotel. The element that does unite the guestrooms is without a doubt the opulent pampering, which ranges from Egyptian cotton sheets and goose-down bedding to Wi-Fi and a Nespresso machine. Lucas, klapsons' first-floor restaurant, features down-to-earth Western cuisine infused with contemporary elegance. Also on hand is an alfresco sky terrace bar on the 17th floor. Subtle yet suitable for the savviest, klapsons brings a new frontier in hotel ideology to Singapore's Central Business District.

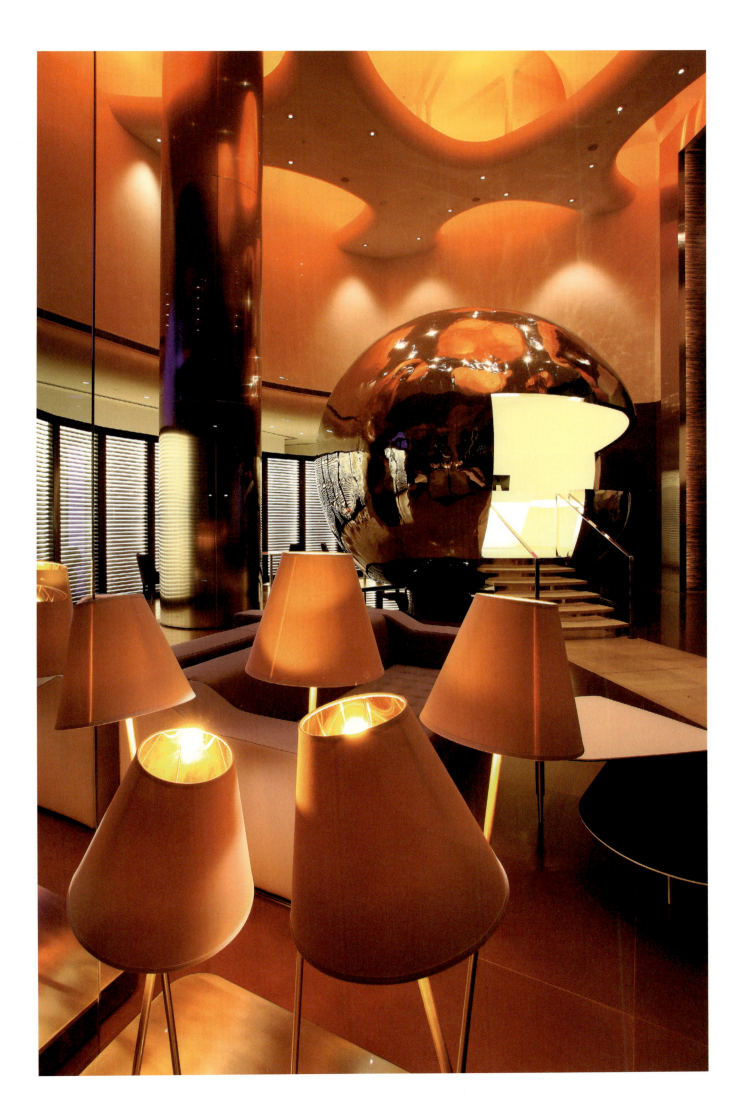

*OFFBEAT

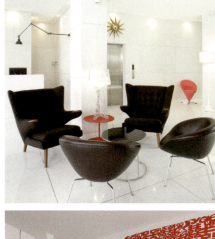
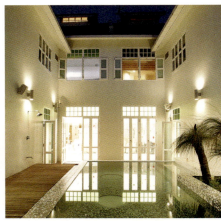

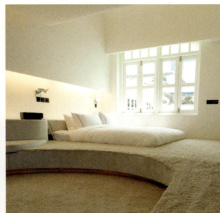

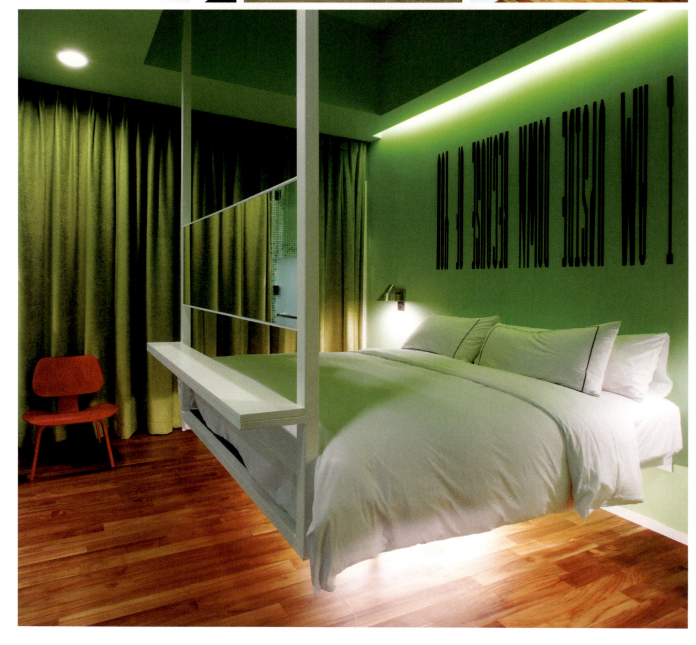

SINGAPORE
SINGAPORE

OPEN
02/2006

RATES
SGD 400 –
SGD 800

ROOMS
30

ADDRESS
31-37 BUKIT PASOH ROAD
089845 SINGAPORE
SINGAPORE

WWW.DESIGNHOTELS.COM/
NEW_MAJESTIC_HOTEL

462

NEW MAJESTIC HOTEL
Singapore

It has a certain glamour, this revamped historic hotel on a Chinatown street once notorious for housing wealthy men's mistresses. The shophouse facade blends perfectly with the neighborhood, but inside, the juxtaposition of antique and modern, interior and exterior, provides a theatrical environment where guests can indulge their imaginations. The 30 guestrooms are individually crafted visions by a diverse group of creatives enlisted by Colin Seah of Ministry of Design. His core crew came up with four room "typologies." In the Hanging Bed Rooms, larger-than-life murals span whole walls, and the sensuous Loft Room's vintage twin tubs look up on an attic-area sleeping space that appears to float. A glass-encased bathtub is placed center stage in the Aquarium Room. In the hotel's restaurant, ceiling portholes open onto the floor of the outdoor pool, as swimmers cast shadows onto the tables below. The high-ceiling lobby provides a grand space to make an entrance, and vintage chairs from owner Loh Lik Peng's personal collection can be rearranged to suit any drama. The sensuously curved white staircase seems to invite a line of chorus girls, like something from a classic Hollywood musical. Majestic, indeed.

WANDERLUST
Singapore

Combining a sense of artistic whimsy with cutting-edge design, the new Wanderlust in Singapore's Little India was created with adventurous travelers in mind. Hotel owner Loh Lik Peng, a local hero after the success of his New Majestic Hotel, gave four different design firms one floor each to create their own interpretation of contemporary style and comfort. Designed by Asylum, the lobby has a glam industrial vibe, and the hotel's casual French restaurant Cocotte has proved to be an instant hit with the locals. Upstairs, the 29 guestrooms run the gamut from vivid candy colors (Phunk Studio) and arty black-and-white minimalism (DP Architects) to one-of-a-kind duplex apartments (fFurious), guaranteed to give guests sweet dreams. Set in a historic 1920s building, the beautiful art nouveau mosaic on the Wanderlust's facade hints at the cheeky patchwork of 21st-century design it now houses within. The hotel's location in the city's colorful Little India neighborhood is the first hint that Loh Lik Peng, a lawyer-turned-hotelier, is committed to showing guests a livelier side of Singapore beyond the buttoned-up business and shopping districts.

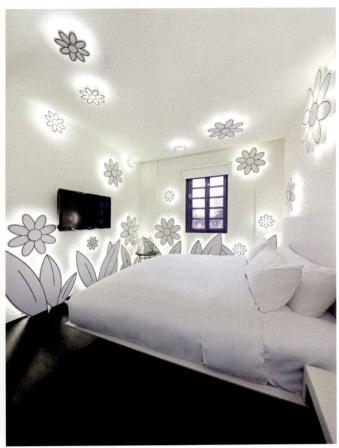

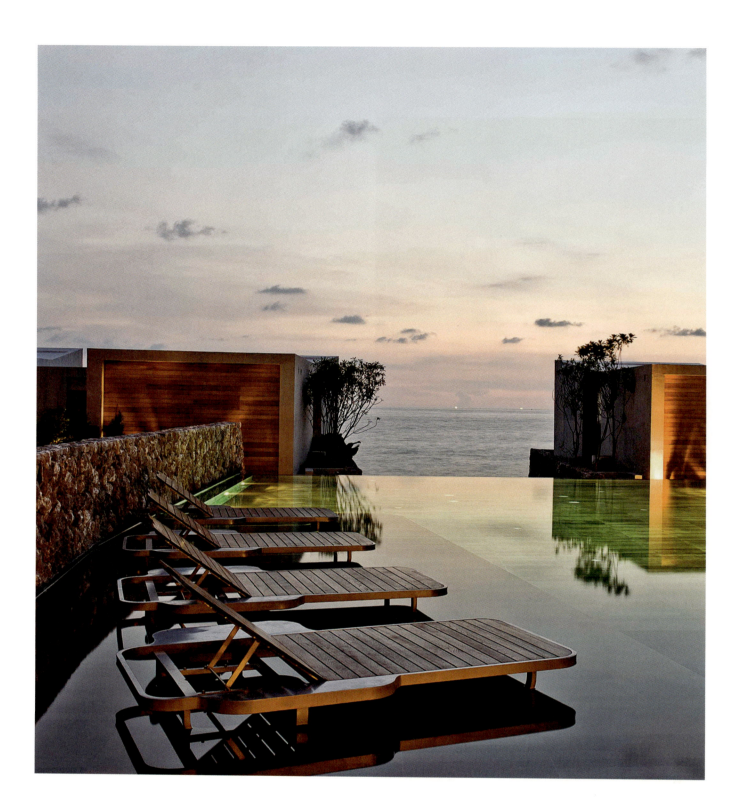

CASA DE LA FLORA
Khao Lak

An example of urban design quietly nestled among an oasis of natural serenity, Casa De La Flora sits in Khao Lak, on the shore of the Andaman Sea. The brainchild of businessman Sompong Dowpiset, this 36-villa resort is an ode to the angular geometries of Brutalist architecture, while simultaneously paying tribute to the surrounding environment. Evincing a distinct sensitivity to the adjacent landscape and achieving harmony with the local flora, the hotel by VaSLab Architecture is Khao Lak's only resort offering contemporary architecture and design. Guests are invited to experience this exceptional retreat with its pioneering interiors, personalized services, and discreet yet sincere eco-credentials. With each low-rise villa, guests are introduced to arresting sea views, private pools and a smattering of small gardens, supported by a 24-hour host service and welcome quirks such as in-room entertainment technology provided by Apple. Beyond the secluded solace of each glass-fronted villa, Casa De La Flora's public spaces include an infinity-edge pool, four treatment rooms, a sauna and a steam room. Highlights include a library where visitors can unwind while enjoying an assortment of books and DVDs and La Aranya restaurant, which lures guests with veritable feasts of Thai and international cuisine.

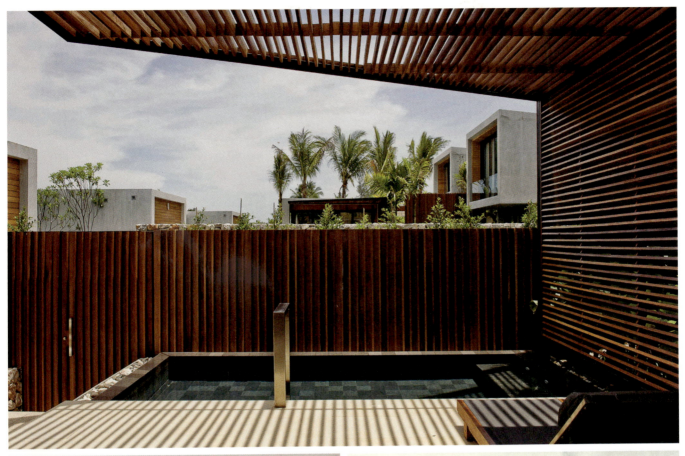
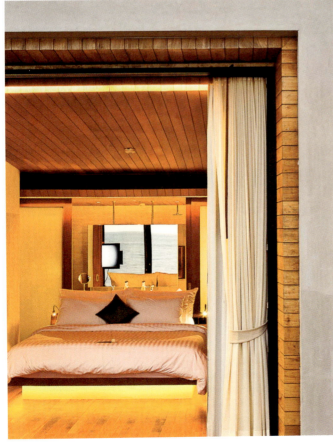
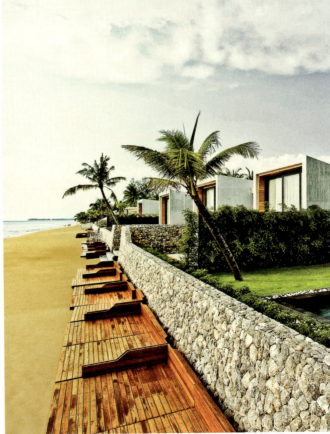

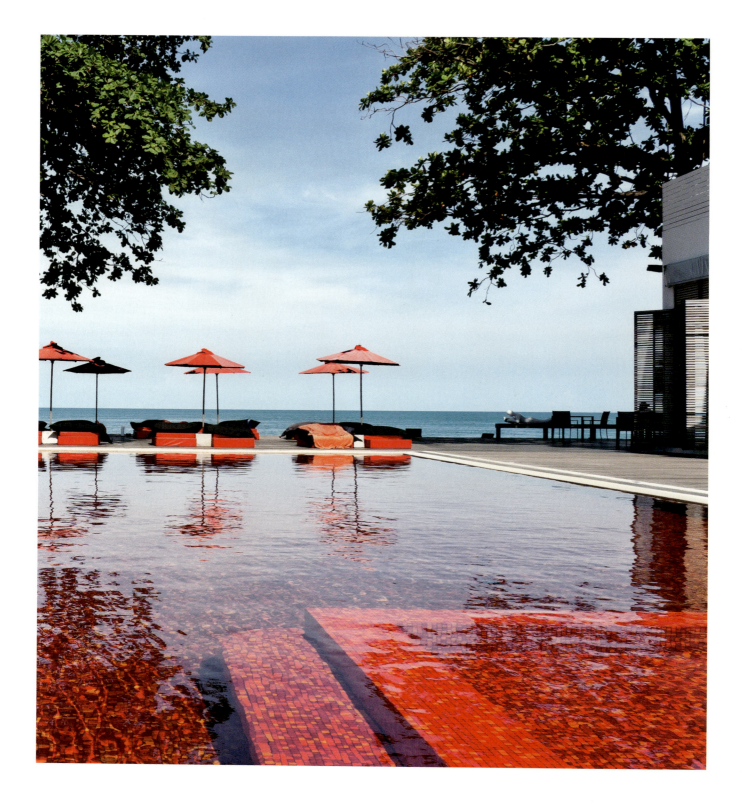

THE LIBRARY
Koh Samui

Against the seductive backdrop of Koh Samui's Chaweng Beach, The Library reads like an elegant monograph. Owned by Samui native Kasemtham Sornsong, and created with designer Tirawan Songsawat, the beachfront hotel is a refreshing and subtle play on the book. The expansive grounds provide ample space for guests to flourish, each area representing a blank page on which to write their story. With its restrained yet sophisticated design, the conceptual resort is unique to the island; its pure minimalism offers the perfect opportunity to capitalize on its thematic concept. Understated and peaceful, The Library narrates a story in which genuine harmony with the neighboring landscape is a tangible achievement. The hotel's library binds the property; its collection of over 1,300 books available to borrow or purchase provides a satisfying alternative to modern distractions. Indeed, the 26 suites and studios are interlaced with a reassuring assortment of entertainment technology, such as iMacs and plasma televisions. But the enduring respect for the surrounding landscape is unequivocal. From The Page restaurant holding fort on the beachfront, to the 270-degree sea views from the glass-enclosed gym, The Library seals the chasm between nature and modern life. Like a good book, The Library contains an assortment of interesting chapters, enticing guests to learn to live harmoniously with nature.

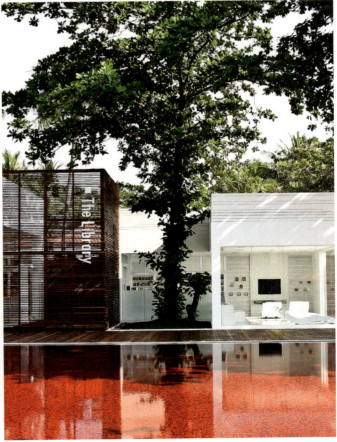

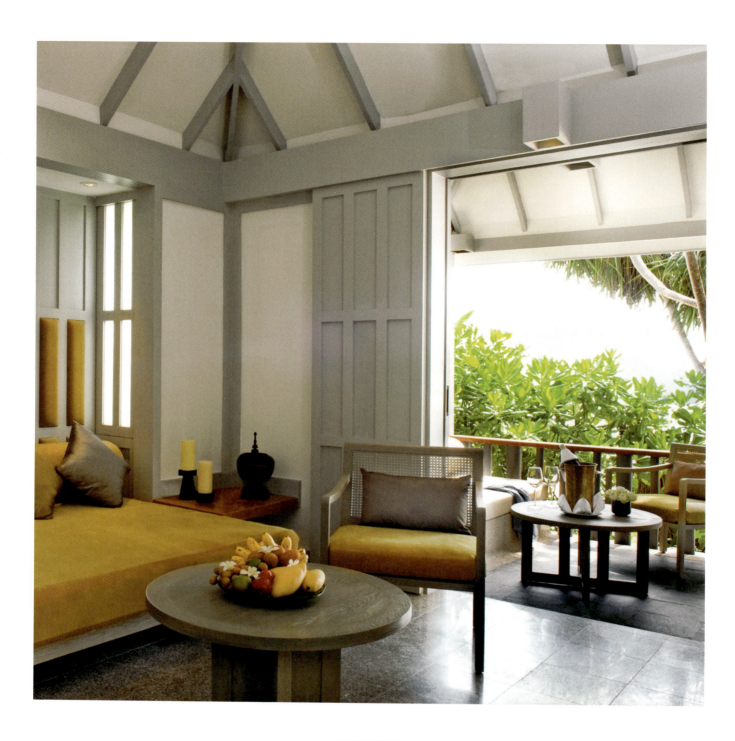

THE SURIN PHUKET
Phuket

Amidst coconut palms and gently rolling slopes, The Surin Phuket elegantly nestles in the tropical landscape along the island's finest white sandy beach at Pansea Bay. Paris-based architect and designer Ed Tuttle who originally designed The Surin, formerly known as The Chedi, returned to rejuvenate this celebrated resort. All rooms and facilities have been entirely renovated in a fresh take on Thai beach cottages that combines local materials and Thai designs with modern functionality. Elevated walkways link pavilions and public buildings, offering guests unobstructed views of the ocean, while the private cottages invite the surrounding nature inside through shuttered doors. A private veranda and secluded sun deck ensconce each cottage in its own patch of paradise. Here, guests can breathe easy in custom-made designs and earthy colors that reflect the organic aesthetic of Tuttle's tropical vision or take advantage of discreet, yet always attentive service. The restaurant's dramatic lighting and the graphic elegance of the hotel library nicely contrast the hotel's organic accents. Lustrous black anthracite makes up the hexagonal pool's tiling and creates dramatic reflections at night, enhancing the already otherworldly wonder of this tropical retreat – the ultimate in Southeast Asian seaside serenity.

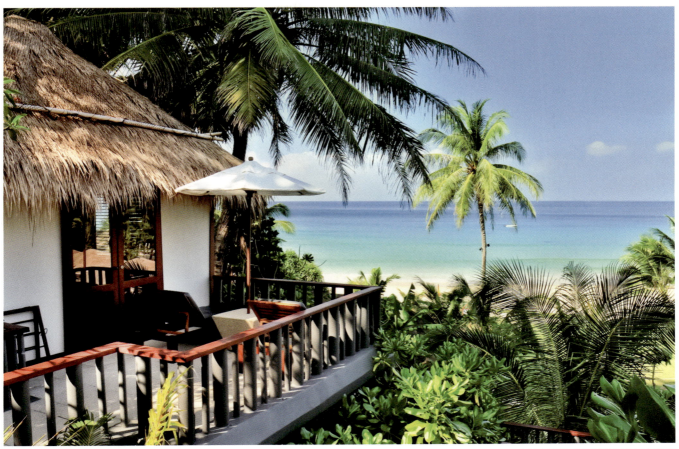
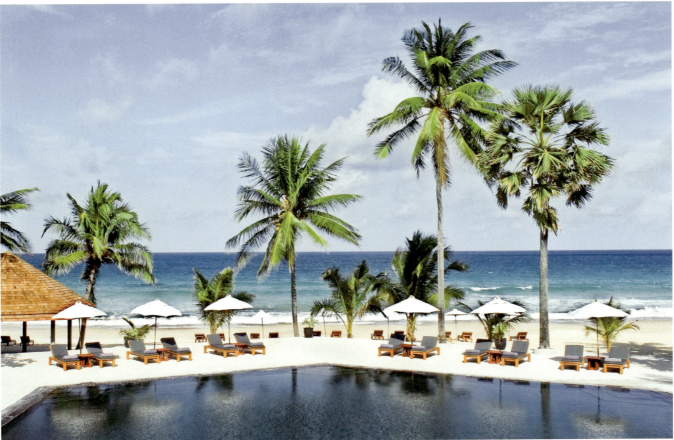

CALL TO MAKE YOUR RESERVATION

INTERNATIONAL TOLL FREE RESERVATION NUMBERS
—

AMERICAS
ARGENTINIA
00 800 37 46 83 57
BRAZIL
0021 800 37 46 83 57
CANADA
1 800 337 46 85
MEXICO
01 800 123 34 54
USA
1 800 337 46 85

AFRICA
SOUTH AFRICA
09 800 37 46 83 57

ASIA / PACIFIC / OCEANIA
AUSTRALIA
0011 800 37 46 83 57
CHINA
00 800 37 46 83 57
HONG KONG
001 800 37 46 83 57
JAPAN (KDDI)
001 800 37 46 83 57
KOREA (DACOM)
002 800 37 46 83 57
KOREA (ONSE)
001 800 37 46 83 57
KOREA (TELECOM)
001 800 37 46 83 57
NEW ZEALAND
00 800 37 46 83 57
SINGAPORE
001 800 37 46 83 57
TAIWAN
00 800 37 46 83 57
THAILAND
001 800 37 46 83 57

EUROPE
AUSTRIA
00 800 37 46 83 57
BELGIUM
00 800 37 46 83 57
DENMARK
00 800 37 46 83 57
FINLAND
990 800 37 46 83 57
FRANCE
00 800 37 46 83 57
GERMANY
00 800 37 46 83 57
GREECE
00 800 49 12 90 54
HUNGARY
06 800 122 36
IRELAND
00 800 37 46 83 57
ITALY
00 800 37 46 83 57
NORWAY
00 800 37 46 83 57
PORTUGAL
00 800 37 46 83 57
RUSSIA
810 800 20 74 10 49
SPAIN
00 800 37 46 83 57
SWEDEN
00 800 37 46 83 57
SWITZERLAND
00 800 37 46 83 57
THE NETHERLANDS
00 800 37 46 83 57
TURKEY
00 800 491 37 46 83 57
UNITED KINGDOM
00 800 37 46 83 57

Terms and conditions apply

FOR GENERAL ENQUIRES ABOUT DESIGN HOTELS™
—

DESIGN HOTELS AG
CORPORATE HEADQUATIERS
STRALAUER ALLEE 2C
10245 BERLIN / GERMANY

PHONE
+49 30 884 94 00 00
FAX
+49 30 257 698 96
E-MAIL
reception@designhotels.com

GENERAL CONTACT DETAILS
RESERVATIONS
+49 30 884 94 00 40
WEBSITE
www.designhotels.com
E-MAIL
res@designhotels.com
GDS CODE
DS

Should your country not be listed, please use the general reservation number, but be aware that international call charges will apply.

PLEASE NOTE:
The telephone numbers for the countries listed are for calls made from within that country only.

IMPRINT

PUBLISHER
Design Hotels AG
Stralauer Allee 2c
10245 Berlin, Germany
designhotels.com
publishing@designhotels.com

PROJECT MANAGEMENT
Nicola Lichtenberg
Rebecca Milz

CREATIVE DIRECTION
Anne Prinz
Johannes Schwark

ART DIRECTION
Hanni Pannier

GRAPHIC DESIGN
Claudia Collasch
Vivian Nebelin

ILLUSTRATION
Jenny Beorkrem
orkposters.com

EDITORIAL DIRECTION
Jeremy Silverman

CONTRIBUTING WRITERS
Ken Baron
Leisha Jones
Magnetic ink (Agency)

COPY EDITING
Jesi Khadivi

LAYOUT
Eva Röhrig

DATA SERVICES / PRE PRESS
Systemic, Berlin

PRODUCTION MANAGEMENT
Stefanie Sandl

PRODUCTION ASSISTANCE
Alina Soare-Rada
Hans Brexendorff

DISTRIBUTION
Holger Müller

PRINTED IN GERMANY
Grafisches Centrum
Cuno GmbH & CO, KG
Gewerbering West 27
39240 Calbe (Saale)
cunodruck.de

PAPER
IGEPA Profibulk 1.1
115 gsm

HARD COVER PRODUCTION
BUKS! GmbH
Wilhelmstr. 118
10963 Berlin
buks-berlin.de

INTERNATIONAL DISTRIBUTION
gestalten, Berlin
gestalten.com
sales@gestalten.com

COPYRIGHT
© *2012 Design Hotels AG*
No part of this publication may be reproduced without prior, written consent of Design Hotels AG.

ISBN: 978-3-89955-426-7

9783699354267.4